JOHN GAGE

Colour and Meaning

Art, Science and Symbolism

with 137 illustrations, 37 in colour

Thames & Hudson

For Bob Herbert, Thomas Lersch and Georges Roque,
whose writings have so often eased me into colour

Frontispiece: Brother Rufillus, self-portrait painting the letter 'R',
c. 1170–1200. Geneva, Bibliotheca Bodmeriana

Designed by Liz Rudderham

First published in the United Kingdom in 1999 by Thames & Hudson Ltd,
181A High Holborn, London WC1V 7QX

British Library Cataloguing-in-Publication Data
A catalogue record for this book is available from the British Library

ISBN 0-500-28215-3

Printed and bound in Singapore by CS Graphics

Contents

Introduction

THE WELCOME WHICH MET my earlier book, *Colour and Culture: Practice and Meaning from Antiquity to Abstraction*, has encouraged me to think that my curiosity about colour may be shared by a wider public, and that this public could be further interested in other topics in the history of colour which for one reason or another could not find a place there.

One controversial area of colour-studies, which has developed substantially since I wrote that book, has been in philosophy, through which colour became interesting to the philosophical school of deconstruction as it reached beyond literature to concern itself with the visual arts.[1] As it happens Jacques Derrida, who has perhaps written more than other deconstructionists on visual topics, has admitted that only words interest him;[2] and in an essay on the often wordy drawings of Valerio Adami he has concluded that 'color has not yet been named'.[3] Adami himself, who is a painter as well as a draughtsman, argues that 'color is the instrument for reading drawing as the voice is the instrument for reading writing'.[4] Colour is thus conceived of as akin to musical timbre, as the ancillary qualifier of design in its traditional role of articulating ideas in a graphic mode like script.

Another deconstructionist, Stephen Melville, has recently posed the philosophical problem of colour, again without attempting to address it:

> color can also seem bottomlessly resistant to nomination, attaching itself absolutely to its own specificity and the surfaces on which it has or finds its visibility, even as it also appears subject to endless alteration arising through its juxtaposition with other colors. Subjective and objective, physically fixed and culturally constructed, absolutely proper and endlessly displaced, color can appear as an unthinkable scandal. The story of color and its theory within the history of art is a history of oscillations between its reduction to charm or ornament and its valorization as the radical truth of painting. From these oscillations other vibrations are repeatedly set in motion that touch and disturb matters as purely art-historical as the complex inter-locking borders among and within the individual arts and as culturally far-reaching as codings of race and gender and images of activity and passivity.

And Melville continues:

> This movement of color in painting is a movement in or of deconstruction. And if deconstruction can in some sense feel at home in reading the texts of

color as they pass from the Renaissance through de Piles and Goethe and Chevreul, it is in a much harder place when it comes to actually speaking the work and play of color – not because that work and play are ineffable but because its 'speaking' just is the work of art and its history.[5]

So, what to do? The chapters that follow attempt to expose and explore the historicity of colour. They deconstruct that immanence, as well as that potential for organization in colour which has commended it, especially since Locke and Kant, to philosophical purposes. But if colour, to yield meaning, must be named (and this is a view which has a good deal to recommend it), the history of this naming should be of absorbing interest to philosophers themselves, who have so far, and for the most part, been content to accept the assumptions about colour-naming and organization current until their own times. Thus Kant, who has had such a crucial role in the shaping of Derrida's aesthetics, supposed, in the tradition of Aristotle, that simple colours might be considered beautiful on account of their unmixed purity, but that they might also be beautiful by virtue of their 'form' – that is, the 'regularity' they derived from their status as vibrations of the ether, a concept he took from the earlier eighteenth-century German mathematician Leonhard Euler.[6] Wittgenstein, for his part, assumed that it would be appropriate to work with a six-colour circle, derived from, say, Goethe or Runge.[7] Philosophers have not usually been concerned to question the grounds of these assumptions; that is the task of the historian of colour.

Any semiotics of colour must be historically contingent, and it is largely the local historical contingencies which the studies here seek to identify. But an assessment of historical contingencies must rest on a judgment of the immanent character of the colour under examination – that is, on a phenomenological approach to colour-questions, and this is what several recent philosophers of colour, as well as the older school of *Koloritgeschichte* have offered (see pp. 36-41).[8]

This book is, of course, largely a book of words, but it also presents many cases where words have been felt to be less than adequate to the task of characterizing colour. If deconstruction sees nothing beyond the 'text', colour at least can afford an instance of where text falls short of any close engagement with phenomena. Which is why, although colour has offered much to philosophers, philosophy, concerned as it has traditionally been with discursive thinking, has had little to offer for the understanding of colour. It is arguable that the reader will find more to stimulate perceptions of colour in the late painter and film-maker Derek Jarman's autobiographical rag-bag *Chroma* (1994) than in, say, Barry Maund's philosophical treatment in *Colours* (1995), even though Maund gives an admirable survey of current thinking on the subject.

My own theoretical position is implicit in the three chapters which together form Part I of this book. The first, The Contexts of Colour, proposes that an art-historical approach to colour offers the best opportunity for a unifying vision, because of the close engagement of practising artists and craftworkers in colour-perceptions, as well as because many of their works have survived to be analysed by technical methods which are daily increasing in precision and scope.

The second chapter, Colour and Culture, seeks to illustrate the historical contingency of colour-perceptions, particularly as they are exemplified in colour-language.

The third, Colour in Art and Its Literature, is intended to lay out various factors intrinsic to a study of colour in the visual art of the West – from the technological constraints, to theories accessible to artists and craftworkers, to colour-iconography and its modern interpretation, to viewing-conditions, and on to the language of colour-analysis itself. In this sense, it works in the opposite direction to the immanent method of deconstruction, which starts from the 'text' immediately present to the reader. It adopts the view that, although historiography inevitably works backwards from the present to the past, history as it is experienced does not. And it is one of the tasks of the historian to reconstitute the original order of events.

Origins are crucial, since they suggest purposes and functions which are likely to change over time; and in various studies in this collection I have attempted to go further into origins, for example, in discussing spectacles (Chapter 5: Colour-words and Colour-patches) and the triangular prism (Chapter 8: The Fool's Paradise), which may at first sight seem to have rather little to do with colour.

Although the idea of 'clearing the ground' might be used to characterize the opening section of the book, all the chapters may be read in a similar light. Since many of them have their source in occasional papers or catalogue essays they attempt to look at often familiar art from a new perspective, or to bring newly recovered texts to bear on old questions. They may thus seem at first to ignore what have been generally accepted as the central issues in the various periods under discussion, but this impression will, I hope, prove to be illusory.

If there is a unifying thread running through these chapters, it is that since colour has a vivid life outside the realm of art, its problems even within that realm cannot be understood exclusively from within the history and theory of art itself; or rather that at least in respect of colour, that history and that theory must be seen to be part of a larger picture. Until the twentieth century, when the formalism that developed in late nineteenth-century art history began to affect the attitudes of artists and critics themselves, such a view would have been assumed, rather than thought to be in need of defence.

Perhaps the most important theoretical linking-thread is the consideration that if art and science have been united in their concern for colour, this unity has not noticeably involved the subordination of one interest to the other. Historians of science have long been familiar (in the face of frequent opposition from professional scientists) with the art of science; historians of art are still perhaps reluctant – with the frequent support of artists themselves – to consider the science of art. This may be because the dominance of literary studies in the recent historiography of art has tended to limit theory to rhetoric. But if Blake and Matisse are now seen to be more, and Seurat to be less 'scientific' than was once believed, this is surely because their activities as visual artists engaged them in perceptions which, in their day as in ours, were scarcely accessible to theory. I hope by looking again at these perceptions to have restored some fluidity to the notions of 'science' and 'art' in the visual sphere.

Another underlying theme is more negative, and it is that, although there must indeed be a 'spirit of the times', which works as mysteriously as the spread of children's games or schoolboy jokes, and directs thoughtful people to common issues of the day, the history of colour ideas can give little comfort to those who believe in homogeneous cultures. I have highlighted the contradictions within Meso-American colour-direction systems, for example (Chapter 7: *Color Colorado*); pointed to the substantial differences in attitude between Goethe and Runge about the character of a coherent colour-theory (Chapter 13: 'Two Different Worlds'); and underlined the substantial divergencies of view within Neo-Impressionism about the function of the painted dot (Chapter 16: The Technique of Seurat, and 17: Seurat's Silence). The questions addressed in these cases are indeed common to the protagonists, and usually specific to their periods; but the differences they represent must also, I think, make us see the colour of the related artefacts in more nuanced ways.

Part One
1 · The Contexts of Colour

IT MAY SEEM CURIOUS that a phenomenon which is a primary sensory experience for most of us, and has attracted so many commentators from so many points of view, is far from being understood as a whole. 'Colour', runs a useful standard definition, 'is the attribute of visual experience that can be described as having quantitatively specifiable dimensions of hue, saturation, and brightness.'[1] This introduces both the subjective element in visual experience, and the objective, quantifiable stimuli which produce that experience, and helps to explain why colour has for so long been a subject of investigation and experiment in both the arts and the sciences. But it does little to show how the subjective and objective aspects of colour are related. The difficulties inherent in attempting to quantify sensations[2] have meant that 'colour' – the subjective outcome of an objective process of stimulation – has rarely been considered in a comprehensive way.[3] Since Newton the science and the art of colour have usually been treated as entirely distinct, and yet to treat them so is to miss many of the most intriguing aspects.

One way of placing colour in a broader perspective is of course to look at its history,[4] and I have traced some strands in the history of colour in my earlier book, *Colour and Culture*.

History alerts us immediately to the variety of colour-theories of the past, but also to the even greater variety of colour-usage. This is most striking, perhaps, in colour-language, whose study has enjoyed a lively and independent life ever since the 1850s, when the Liberal statesman Mr Gladstone was struck by some curious anomalies in Ancient Greek (where the apparent absence of terms for 'blue' led him to assume a visual defect akin to colour-blindness, a phenomenon which was just beginning to be systematically investigated at that time). As it developed in the late nineteenth and early twentieth century, the study of colour-language became a branch of linguistics concerned with the relationship of language to perception, investigated largely within the framework of experimental psychology.

While there have long been substantial studies of colour-vocabulary in several important historical languages, among them Ancient Greek, Hebrew and Anglo-Saxon,[5] the most wide-ranging and influential recent work, Berlin and Kay's *Basic Color Terms*,[6] paid little attention to the historical dimensions of the subject. Nevertheless the authors' findings, that in the least-evolved languages values – light and dark – take precedence over hues – redness, blackness etc. – are precisely what the historical evidence tends to reinforce, and their researches have important contributions to make to discussions on the biological basis of colour-vision.[7] Our visual mechanisms seem to be able to reconstitute the whole range of colour-perceptions

on the basis of a severely limited set of stimuli (red, green, blue and dark/light) just as colour-vocabularies seem to work with a very limited set of 'basic' or 'primary' terms. And yet, as I shall show in the following chapters, in practice the idea of fundamental colours has been far from universal.

Perhaps the most surprising absentee from most general discussions of colour is its use in the visual arts.[8] Two of the most widely used handbooks of recent years deal extensively with art,[9] but appropriately enough, since their authors are closely associated with colour-technology, they are more concerned to suggest practical possibilities in colour-usage than to analyse how colour has been (and is) used in artefacts. In my earlier book *Colour and Culture* I drew extensively on artefacts for evidence of attitudes to colour, and in Chapter 3 below I survey a number of other art-historical studies which have taken up the subject of colour in art from varying perspectives. So far there has been very little investigation of colour in non-European artefacts, although, paradoxically, non-European cultures have dominated in the ethno-linguistic studies of colour-terms. Thus the picture at present is essentially one of fragmented interests,[10] and research has long been most active in those technological aspects of the subject which have a direct commercial application.

The history of art as a unifying subject

A unifying framework for the study of colour in all its aspects might indeed be provided by the history of art, precisely that subject where it has hitherto been so meagrely treated. Its potential is due in the first place to the fact that works of art exist, and can thus be the subject of empirical investigation. Wolfgang Schöne's[11] study of light in painting (*Über das Licht in der Malerei*, published in 1954) is based on this assumption: its theoretical basis is a phenomenological one, deriving ultimately from the German experimental psychology of the later nineteenth century, from Fechner, Hering and Wundt (see pp.191-2, 257-8 below). The enormously expanding interest in problems of conservation, and its more rigorously scientific application, have also contributed directly to the study of the physical, chemical and psychological aspects of colour in the art of the past.[12]

But a work of art is not only a sense-datum: it is also, and primarily, a vehicle of sensibilities, of values and of ideas, and these have not yet proved capable of being treated phenomenologically or quantitatively. They involve the study of history and, above all, of language. Students of colour-language have however been as reluctant to draw on the evidence of artefacts as have students of the history of art to draw on linguistic studies: it is an irony of history that Gladstone's belief in the colour-blindness of the Ancient Greeks, based on his studies of Homeric language, was developed at precisely the time that archaeologists were revealing the rich polychromy of Greek architectural and sculptural decoration.[13]

Yet the interpretation of colour in older works of art is notoriously difficult, and the reticence among historians of art about questions of colour entirely understandable. The possibility of a phenomenological approach to colour in the art of the past is seriously undermined by the great changes which have taken place in the

condition and presentation of works of art themselves. Colour is particularly susceptible to change and decay, and even the larger decorated complexes of the past, such as church interiors, are rarely if ever seen in their original conditions of preservation or lighting. Moreover, the study of the history of art proceeds by means of comparisons, and comparisons necessarily involve the use of reproductions. But for technical as well as historical reasons, adequate colour-reproduction is an impossibilty for all but a tiny fraction of art-types (such as drawings and book illumination); and since it is not a commercially significant area of research, appreciably higher standards of reproduction are unlikely to be achieved in the future.[14] It is fair to say that the general standard of both black-and-white and colour reproduction in books has deteriorated since the Second World War.

Yet, to say this is to do no more than to reinforce the truth that the reconstruction of the art of the past, as of any aspect of the past, is an imaginative and not a physical activity. There is no 'scientific' art history, and this is precisely what makes its study so compelling. It is a pursuit which can be followed only by introducing a consideration of the literature, religion, science and technology of the age in question – not because we have a notion of 'influences' or of 'background', but because each activity shows us another facet of the same phase in the operations of the human spirit. The precise relationship of each of these activities to the others must always be a matter of debate, but in my view, the debate can only rest on the detailed examination of case histories.

Artefacts and attitudes

The materials of the artist cannot be regarded simply as tools, for they were often repositories of values in their own right. A particularly striking instance of this concerns the coloured materials with which art was made, and the way these materials were described. One example is the blue pigment manufactured from lapis lazuli, early described in Europe as 'ultramarine' because it had to be imported from the Middle East, 'beyond the sea'. Lapis lazuli was, and still is, a rare and costly stone, and nothing suggests more strongly the survival into the Renaissance of medieval attitudes towards the intrinsic value of materials than the fact that in Italian contracts for paintings, until well into the sixteenth century, ultramarine together with gold was frequently specified for use in the most important designated areas of the work. The method of preparation led to the production of various grades of the pigment, and sometimes a specific price is mentioned in the contract, for example for the finest grade which was to be used for the mantle of the Virgin Mary.[15] The reasons for this emphasis on a particular pigment-hue are complicated, but it seems likely that more important than symbolism, which is, of course, conveyed through the purely optical qualities of the material, was the fully justified belief in the durability of this pigment in contrast to its chief rival, azurite (basic copper carbonate), which too readily turned green on exposure to damp. A stable blue was thus a costly blue. Paint-technologists were much concerned to imitate these costly pigments with cheaper substitutes. The most important collection of colour-recipes from fifteenth-

century Italy devotes a great deal of space to cheap synthetic ('artificial') blues, which were assumed to have similar visual characteristics to these 'natural' blues, but were probably far less stable.[16] Significantly, they have not been identified in the Italian Renaissance paintings which have survived until our own times.

In the fifteenth century in the Netherlands, where oil painting was first developed in its modern form, the valuable material lapis lazuli was rather less frequently used than it was in the South. The new technique of preparation of colours had the advantage of coating each particle in a film of oil which insulated it against chemical reaction with other pigments, reducing the risk of changes in their colour. Extensive mixture was thus a far less chancy business than it had been hitherto, and a far wider range of pigments could be used than ever before.

Our understanding of the ideas which lay behind the use of particular materials in the North is not helped by the relative lack of contemporary documentation for most surviving paintings in northern Europe before the sixteenth century, but the case of one extant work for which the contract is also known, Dieric Bouts's Altarpiece of the *Last Supper* (1464-8) is instructive. Unlike Italian contracts, the contract here makes no reference at all to the materials to be used, but only to the required standard of workmanship, and technical analysis of the central panel shows that the blue used is chiefly azurite with a minimal admixture of lapis lazuli, chiefly in the sky.[17] It seems that the practice of mixture which the oil medium allowed had led to a reduction in the status of the materials themselves. The mantle of the Virgin and the blue precious stones represented in the Van Eyck Ghent Altarpiece of some thirty years earlier, for which no early documentation has come to light, are, on the other hand, painted in two layers of ultramarine over an azurite base.[18] An analysis of this particular sort of fundamental value attributed to a work of art can only be made with a clear indentification of the substances employed in the making of it – an identification which modern methods of conservation have made increasingly possible; yet the part played by artists' materials in the conception of the work can only be assessed on the basis of contemporary written documents.

To the devaluing of intrinsically precious pigments which oil painting brought with it can be added the identification of a small set of 'primary' colours, a set which became codified, around 1600, as black and white, red, yellow and blue. It was the oil-painters' capacity to mix which led to the recognition that only a few colours were needed to mix many. Although this original set was later joined by other 'basic' sets – according to whether the requirement was to mix lights (additive mixture) or surface-colours (subtractive mixture), or to identify psychologically 'unmixed' hues – the notion of reduction itself was to be a very important one, especially in the study of the mechanisms of colour-vision.[19]

The harmony of colours

Another aspect of colour in which history – and particularly the history of colour-language – has a major role to play involves the question of the harmony of colours – an aspect which perhaps still attracts the most widespread interest today. Sir Isaac

Newton's discovery in the 1660s that colours were simply a function of the variable refrangibility of white light – the red component being subject to the least refraction and the violet to most when a ray of light is passed through a triangular prism – took the development of the subject away from phenomenology for more than a century; but it remains the case that his division of the prismatic spectrum into seven chromatic areas, announced so casually in a letter to the Royal Society of 1675, reflects his interest in the eternally fruitless, eternally stimulating search for objective principles of visual colour-harmony that goes back to Classical Antiquity. It was the analogy with the seven notes of the musical octave – with its corollary that colour-harmony might be established on the same proportional basis as musical harmony – that accounts for the remarkable persistence of this error in his optical writings.[20]

Like all colour-researchers in his day Newton was hampered by the lack of standard colour-nomenclature.[21] It is interesting to note that between his letter of 1675 and the *Opticks* of 1704 he had come to regard indigo, rather than blue, as harmonious with 'golden', at the same time as the term for the most refrangible colour in his spectrum changed from purple to violet. 'Golden' itself is an ambiguous term which was not included in Newton's analysis of the spectrum: we might well suppose that it was a yellow, but reference to the 1706 Latin version of *Opticks* suggests that he used it as a translation of the usual Latin term for orange, *aureus*. Its adoption for the remarks on harmony suggest that Newton took the Classical view that gold had a close affinity with red, and that his belief in the harmony of gold and indigo or blue was related, not simply to the musical scale where they form an harmonic fourth or fifth, but also to the frequency of this combination of colours in regalia. Since the late Middle Ages the traditional royal purple of Antiquity had been replaced in robes and heraldry (particularly in France), as well as in the mantle of the Virgin Mary, by blue. That gold should have had its closest affinity with orange, rather than with yellow, is remarkable; yellow never seems to have been regarded as a noble colour in the West until the end of the Middle Ages, and it is apparently still regarded as one of the least pleasurable of individual hues.[22]

Despite the casual treatment of both perceptions and language which underlines the quantitative emphasis of Newton's work, his circular arrangement of colours in the *Opticks* (which significantly, in view of his harmonic theory, placed blue opposite orange) formed the starting-point for the investigation of complementarity in the latter part of the eighteenth century, and thus of the contrast theory of harmony which was to prevail for most of the nineteenth century, mainly through the influence of Chevreul (see Chapter 15).[23] It would be a mistake to confine Newton's influence to his contribution to the quantification of colour in what is now seen as classical optics.

The non-standard observer

One of the reasons why scientific students of colour have been reluctant to draw on the experience of art is that artists are generally considered a small, untypical and

commercially insignificant group in society. Yet Aristotle already recognized that artisans in the dye-industry were especially sensitive to problems of colour-matching; and in the early nineteenth century one of the most important discoveries in the field of colour-vision, the Purkinje shift, seems to have been part of the daily experience of painters at that time. The Czech scientist Jan Evangelista Purkinje had been stimulated to investigate the changing appearance of colours in declining light by his reading of Goethe's *Theory of Colours* (1810), and published his observations in 1825. He noticed that at dawn reds seemed to be very dark, and that blue is the first colour to show its hue in the advancing light. But at almost exactly the same time, around 1820, the English portrait-painter James Northcote described the same phenomenon (which he found rather irritating) in an evening conversation with another artist, James Ward:

> Upon going to Northcote's at the close of a beautiful day, Ward found the venerable painter quietly sitting in the corner of his largest room. He was watching, by fading twilight, the picture he then had in hand, which practice appears to have been with him a frequent one. He had retired into the darkest corner of the spacious apartment, and Ward, upon entering the room, could scarcely observe his friend till the sound of his voice proclaimed his whereabouts. Ward remarked on the utility of this method of watching a picture, and suggested that it was calculated to point out what was faulty in the light and shade.
>
> 'To be sure', responded Northcote, 'it is useful in the highest degree, not only as regards light and shade, but form and colour as well. A painter must study his picture in every degree of light…You know, I suppose, that this period of the day between daylight and darkness is called "the painter's hour"? There is, however, this inconvenience attending it, which allowance must be made for – the reds look darker than by day, indeed almost black, and the light blues turn white, or nearly so…'[24]

This is one of many instances where the perception of painters was shared and elaborated in optical science. On the other hand, later in the century the more positivist tone in general cultural attitudes led some painters to turn to the most recent formulations of scientific colour-theory for help. The most prominent of these artists was Georges Seurat, the founder of Neo-Impressionism, whose influential technique of dotting was itself based on a rather imperfect understanding of the phenomena of value-contrast and optical mixture (Chapters 16, 20). Seurat's was the first painterly style to be based on psycho-physical theory, but it was the first of many, from the early exponents of abstraction like Kandinsky and Mondrian, who drew on the experimental psychology of the latter part of the nineteenth century (Chapter 20), to the Op artists and Colour-field painters of the 1950s and 1960s, whose concerns are reflected best of all by Josef Albers's *Interaction of Color* (1963), a book which itself goes back to colour-work undertaken under the influence of experimental psychology at the Bauhaus in Weimar and Dessau in the 1920s.

1 It was the painters at the Bauhaus, Johannes Itten, Paul Klee, and Albers himself, who in the years around 1920 were examining the problem of a value-scale of equal perceptual steps between black and white.[25] Itten proposed a scale of seven steps,

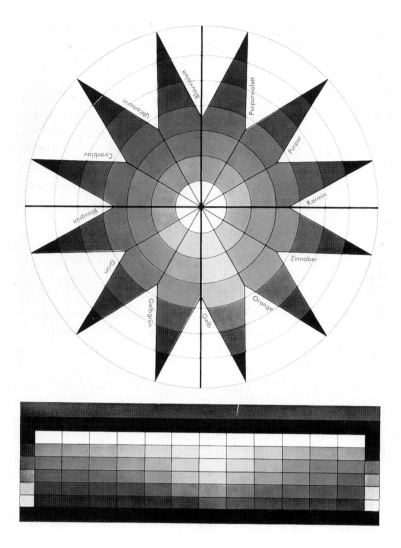

Artists are among the devisers of the numerous scales of colour and value (light and dark) proposed since the twelfth century. The Bauhaus painter Johannes Itten's *Colour-sphere* of 1921, for example, proposes a grey-scale of seven steps, shown at far left and right. (**1**)

which is slightly fewer than the number introduced at about the same time by the German theorist Wilhelm Ostwald and the American Albert Munsell in their colour-systems. Their colour-atlases and solids, arranging samples of every known surface-colour in coherent sequences, have offered perhaps the most widely used standards of colour in the twentieth century. The first, twelve-step scale had already, remarkably, been published in the twelfth century, in one of the very earliest accounts of a tonal scale, this time for red and green, in the technical handbook *De Diversis Artibus* by the German monk Theophilus.[26] Theophilus introduces this scale in a discussion of painting the rainbow, where a series of nineteen values of red and green is to be used, and the method is also recommended for the tonal modelling of round surfaces. It seems unlikely that this extraordinarily nuanced procedure was

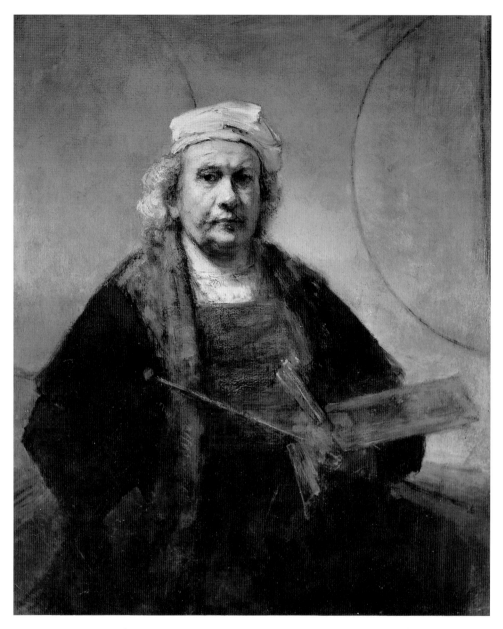

Are artists untypical cases? The greatly reduced palette of Rembrandt's self-portrait in old age, and even the large circles in the background, suggest an aspiration towards classical simplicity rather than the effects of visual impairment associated with ageing. (**2**)

ever so used by painters, and this makes Theophilus's an especially interesting account of an essentially experimental observation. Unlike Leonardo da Vinci and the nineteenth-century French chemist M.-E. Chevreul after him, Theophilus did not prescribe specific quantities of pigment for each tone, so that we cannot assess whether he was working with equal perceptual steps; but he did assert that there cannot be more than twelve values for each hue. The mid-nineteenth-century

100

French landscape painter Corot, on the other hand, spoke of a series of twenty values between the lightest and what he called the 'most vigorous', which is also the number presented by the most extensive modern system, the Villalobos *Color Atlas* of the 1940s.[27] Scaling has been a major theme in recent research in psycho-physics and colorimetry, but so far as I know there has been no analysis of these and other experiments by artists because they have been seen as untypical cases.

Another striking area where it is difficult to relate the general pattern of colour-experience to the specific work of artists is in the question of the physiology of colour-vision. Several of the greatest colourists in the history of painting have lived to a great age, and continued to be productive throughout their latest years. On the other hand, it is well known that colour-discrimination generally becomes less acute with age, quite apart from the effect of chronic eye-disorders, like cataract. This latter defect helps to account, for example, for the strident redness of much of Monet's work around the time of the First World War,[28] and we might expect such deterioration to be manifest in the work of other ageing artists.

In the case of two painters who worked vigorously until they died at advanced ages, Titian (?1480/5-1576) and Rembrandt (1606-69), it could well be argued that the more monochromatic tonality of their latest works, which in Rembrandt's case at least is linked to a reduction of the number of pigments used,[29] derives from the psycho-physiological effect of ageing. But the question is complicated by the possibility that the style of 'late Titian', which has been so prized by modern critics, is in fact 'unfinished Titian' – that in works like the *Diana and Actaeon* in the National Gallery in London we are dealing with an underpainting, and that the refined and highly coloured *Tribute Money* in the same collection is a more authentic example of the late style.[30] It is also very likely that Rembrandt's restriction of palette at the end of his life has less a physical than an ideological basis: he was anxious to develop an economical style of colouring which was then thought to be characteristic of the great masters of Classical Antiquity, whose works were known only through literary description.[31]

But if the cases of Titian and Rembrandt are more ambiguous than they might seem at first sight, what of two other aged artists, Turner (1775-1851) and Matisse (1869-1954), whose late work shows an increased refinement and subtlety precisely in the handling of colour? The greatly increased brightness of Turner's work, both in oils and watercolours, in the second half of his career and especially during his late sixties and early seventies, led some contemporaries to suppose that he had developed a cataract;[32] but this view depended on a very imperfect acquaintance with the whole range of the painter's work, where the brighter tonality and the reduction of more strictly formal elements gave him far greater scope than earlier for the exploration of infinitely subtle gradations of colour and tone – at its peak in the great Swiss watercolours of the early and mid-1840s. Similarly, in Matisse's cut-paper compositions of the 1940s and 1950s, of which perhaps the best-known examples are *The Snail* (1952) and *Souvenir d'Océanie* (1952-3) in the Museum of Modern Art in New York, the artist was working more exclusively than ever with colour, using a wide range of previously painted papers with an unprecedented freedom, but also with an unprecedented finesse.[33]

2

3

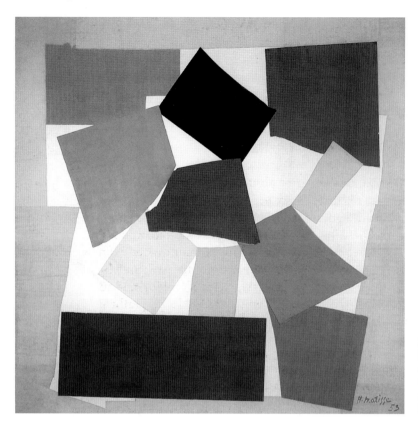

In the 1952 cut-paper *The Snail* Matisse was working directly in colour with the most exact adjustments of scale and placing, remarkable in an artist already in his eighties. (**3**)

Clearly both these painters were non-standard observers, and seem to have escaped the normal ageing processes. Their work is evidence of a constantly self-refining capacity in visual experience which must surely enter into the larger study of human responses to colour.

Colour in context

I have introduced here a few examples of the ways in which the experience of colour in artefacts, especially artefacts from earlier periods, may be enriched by the collaboration of scientific analysis, and may in turn contribute to the enrichment of the understanding of colour-perception in a scientific context. It seems to me that the aesthetics of colour have developed very little during this century precisely because they have been too exclusively concerned with laboratory testing, and too little with colour-preferences as expressed in the practical choices of everyday life. Similarly, studies of colour-language have been content, on the one hand, with the vaguest of colour-designations: 'yellow', 'red', and so on, and on the other, with the same constricting techniques of assessment through laboratory tests. As an anthropologist put it in a critique of Berlin and Kay's book: 'a semiotic theory of color universals must take for "significance" exactly what colors do mean in human societies. They do not mean Munsell chips.'[34]

2 · Colour and Culture

IN CHAPTER ONE I SUGGESTED SOME of the many obstacles to seeing colour as a whole. Many scientific writers, for example, are concerned, not with 'colour', but with radiant stimuli in light, or with the physiological processing of these stimuli by the eye, whereas 'colour' properly speaking does not come into the picture until rather later, in the mind which apprehends it. Research into a brain dysfunction called 'colour anomia' by J. and S. Oxbury and N. Humphrey, and more recently by A. Damasio, suggests a sharp distinction between the sensation of 'colour' and its identification. Patients with normal colour-vision who were able to perform purely verbal tasks with colour-names, such as naming the colour of a named object like a banana, were unable to name correctly the colours that they saw: blue, for example, was called 'red'.[1] These patients, like all of us, used verbal language as the customary tool of communication; if 'colour' is intimately bound up with language – if it is a system of arbitrary signs – it must also be a function of culture and have its own history. And yet the linkage of colour with verbal expression is highly problematic.

Colour-usage and colour-systems

Some years ago Umberto Eco published an essay under the title 'How culture conditions the colours we see', but he was unable to live up to the promise of this ambitious formulation because of the very imprecision of his term 'culture'. As a semiotician, Eco was embarassed in his discussion of colour by the almost complete absence of intelligible codes of colour-meaning within a given culture.[2] Does 'culture' imply knowledge and embody rational investigation, or may it run counter to them? Is it, in effect, largely a matter of assumption and prejudice? Who are the agents and guardians of 'culture'? Colour promises to throw some light on this problem because, in the Western societies that provide me with my material, colour-usage has long co-existed with more or less sophisticated theories of colour that are relatively well known. Several of these high-level theories have recently been discussed by Martin Kemp in *The Science of Art*,[3] but this low-level colour-usage does not encourage a belief in the cultural coherence of codifiable systems of thought. Let me illustrate this with a few homely examples.

If you look intently for a moment at the red disc illustrated, and then, while relaxing your eye-muscles, at the white disc adjacent (in each case fixing on the centre of the field of vision), most of you will see a colour that you will probably be

13

inclined to call 'blue-green', a colour close to the one which Matthias Grünewald represented encircling Christ's red-orange halo in the *Resurrection* scene in his great Isenheim Altarpiece of the early sixteenth century, now in the museum at Colmar in Alsace. Grünewald, who may have been a technologist as well as a painter, had doubtless experienced this colour, as we all do, as the negative after-image of a fiery red light.

When in the late eighteenth century the phenomenon of negative after-images began to be investigated systematically, notably by Charles Darwin's father, Robert Waring Darwin, the 'complement' to red was also usually described as blue-green, as it had been about a century earlier in Newton's experiments with the colours of
61 thin plates ('Newton's Rings').[4] But after 1800 the notion that there are three 'primary' colours of light (red, blue and yellow), and that the eye, fatigued by the strong sensation of one of these colours, 'demanded' the product of the remaining two in order to restore its balance, was allied to an interest in symmetrical, usually circular colour-systems. It became increasingly common to describe, and even to represent, the complement of red as simply green, a mixture of equal parts of blue and yellow.[5] Green is still commonly identified as the complement of red, even in perceptually oriented handbooks of colour such as Josef Albers's *Interaction of Color* (1963);[6] and this persistent idea suggests a powerful cultural conditioning of the sort Umberto Eco was concerned to expose.
4 Charles Hayter's colour-circle of 1813, however, also introduces us to experiences of colour where culture seems to have worked in precisely the opposite way, where perceptions appear to take precedence over ideas. Hayter's polar contrasts, 'warm' and 'cold', may here be making their first appearance in a colour-system, although they had been common enough in English painterly discussions for at least a century.[7] But they are contrasts which are still widely endorsed in the characterization of colour. Colours seem 'warm' or 'cool' only metaphorically, of course, but the radiation of which they are the visible sympton is radiant energy, and we have known ever since the introduction of gas heating over a century ago that it must be interpreted in the opposite sense to this metaphorical usage. The short-wave, high-frequency energy of the blue-violet end of the spectrum signals the greatest capacity to heat, and the long-wave, low-frequency red end, the least. Yet even in the modern world, gas-companies continue to show the warming effect of red-orange flames where domestic comfort in the living-room is in question, while they take a much more functional attitude to ovens, which are shown correctly with the heating flames blue. Laboratory tests in Europe and the United States, from the 1920s until the present day, have shown that the psychological interpretation of colour-temperature has been far from unambiguous, but I imagine that most people will continue to think of yellows, oranges and reds as at the 'warm' end of the spectrum and blues and greens as at the 'cool'.[8]

In recent years there has been a revival of interest in the idea of a universal or 'basic' experience of colour, which is seen to have given rise to those interpretations that conflict so much with common assumptions. Responses to colour, it is argued, go back to archetypal human experiences of black night, white bone, red blood, and so on. Thus A. Wierzbicka proposed in 1990 that:

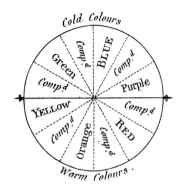

Charles Hayter's warm-and-cold 'painter's compass' from his *Introduction to Perspective*, a handbook for amateur artists published in 1813. Hayter was probably the first systematic theorist to introduce of the notion of hot-cold co-ordinates, a major theme in later thinking about colour. (**4**)

yellow is thought of as 'warm', because it is associated with the sun, whereas red is thought of as 'warm' because it is associated with fire. It seems plausible, therefore, that although people do not necessarily think of the color of fire as red, nonetheless they do associate red color with fire. Similarly, they do not necessarily think of the color of the sun as yellow, and yet they do think of yellow, on some level of consciousness or subconsciousness, as of a 'sunny color'...[9]

The problem with this approach (which is rather widespread among anthropologists) is that the stable referent has usually been more interesting and important than the colour. The colour of familiar phenomena in nature has indeed often been a matter of puzzlement and debate. As early as the first or second century AD the Greek astronomer Cleomedes pointed out the variety of colours in the sun, now whitish or pallid, now red like ochre or blood, now a golden or even a greenish yellow, and only sometimes the colour of fire (*Caelestia*, II, i). And in the fourth century St Augustine of Hippo even made the various colours of the sea – green or purple or blue, all of which may still be readily seen in the Mediterranean – one of the touchstones of variety in nature (*The City of God*, XXII, xxiv).

The spectrum and the natural world

There are good reasons for thinking that a precise recognition of all the colours we are capable of discriminating has often been a matter of indifference. Languages have never been used for labelling more than a tiny fraction of the millions of colour-sensations which most of us are perfectly well-equipped to enjoy and, we might have supposed, to name. A glance at a standard modern handbook of colour-names, such as A. Maerz and M. R. Paul's *Dictionary of Color*, which lists and represents mainly English-language trade-names, will show that although most of us are perfectly capable of discriminating among an extensive continuum of colour-nuances, very few of these nuances have been named, and modern colour-systems, following the lead of James Clerk Maxwell in the 1860s, have usually resorted to numbers in order to distinguish perceptible differences of hue or value

5

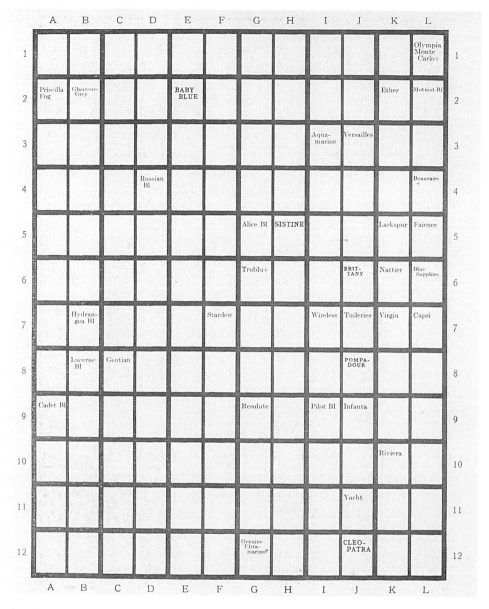

'Blue', from Maerz and Paul's *Dictionary* of American trade-names. The chart reveals both the arbitrary nature of colour-naming (note the close proximity of 'Virgin' to 'Pompadour') and the large areas of perceptible colour to which no names have been given at all. (**5**)

(lightness or darkness) in what has turned out to be a far from symmetrical colour-space.

Probably the most widely recognized of these colour-continuums in the ancient and modern worlds has been the spectrum light as manifested in the rainbow. It was the optics of the seventeenth century, notably the work of Sir Isaac Newton, that made the spectrum into the standard of 'colour'; and it is striking that in the eighteenth century even a natural philosopher such as the Viennese entomologist Ignaz

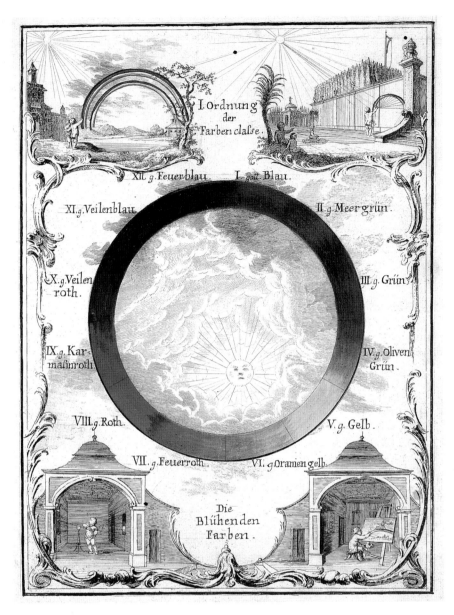

A colour-circle of 1771 by Ignaz Schiffermüller, probably the earliest attempt to arrive at a theory of harmony by this means. The twelve colours include a 'fire-red', but also a 'fire-blue' – truer to reality than the usual warm = red pairing, in that the hottest flame is at the blue end of the radiation scale. (**6**)

Schiffermüller, whose concern with colour was primarily as a means of identifying 6
butterflies, should have used the spectrum (as an indoor experiment and as an
outdoor phenomenon of nature) as the paradigmatic manifestation of colour in the
illustration to his *Essay on a System of Colours* of 1771 (which incidentally includes a
'fire-blue' in the circle; see also p. 173-4 below). Yet the number and even the order
of colours in the rainbow has always been a matter of dispute. Newton's isolation of
seven spectral colours had been anticipated by Dante in *The Divine Comedy* (*Purga-*

torio XXIX, 77–8), and illustrated very plausibly in the scene of Noah's Flood in a fifteenth-century Norman Book of Hours, now in the Bodleian Library in Oxford, but Newton repeatedly changed his mind during the course of his career, and opted for the seven-colour version only because he was anxious to sustain an analogy with the musical octave.

The patriotic English Romantic John Constable, who was famous for his sharpness of observation, seems nevertheless, in his frequent depictions of the rainbow, to have been content with red, white and blue; and in the modern world of commercial design I have found examples with five, six or seven colours, and a variety of sequences. It is chiefly the imperceptible transition from one band of colour to the next which has led to these ambiguities, and it is not surprising that we sometimes have to resort to mnemonics to remember the order. Constable, a painter who showed an unusual interest in meteorology, correctly recorded the reversal in the sequence of colours in the secondary rainbow which is sometimes observed outside the first, but this phenomenon has not always been respected. One of the most unexpected lapses was in John Everett Millais's *The Blind Girl* (1856), where the Pre-Raphaelite precision of the landscape-setting, painted at Winchelsea in Sussex, is quite remarkable, but the colours of the secondary bow were not reversed until the mistake was pointed out by a friend of the painter's, and corrected – for a supplementary fee.[10] Even in the case of a single bow, the order of colours, running from red at the top to violet inside the arc, has sometimes escaped the attention of artists. Some readers may recall the broad upside-down bow in the *Pastoral Symphony* section of Walt Disney's *Fantasia* of 1940.

What the history of the spectrum suggests is that there are real difficulties in perceiving and identifying colours in complex arrays, especially when their edges are undefined, and that the relative poverty of colour-vocabularies reflects these difficulties, and encourages representations to be far more concerned with ideas about colours than with colour-perceptions themselves.

The devising of colour-systems, allowing colours to be set out in a logical sequence which articulates relationships between them, scarcely pre-dates the seventeenth century, and if the spectrum of white light, especially after Newton rolled it into a circle in his *Opticks* of 1704, was embraced as the most coherent of these systems, it not only remained the conceptual problem to which I have alluded, but was still impossible to translate into terms of surface-colours because of the impurities in the available pigments and dyes. Aristotle had already argued that the pure colours of the rainbow were impossible to represent in painting, and well into the nineteenth century, colour-atlases for the use of naturalists might avoid the spectral colours and base their standards of hue and value on a range of natural objects. Patrick Syme's 1821 adaptation of A. G. Werner's 1774 terminology in the *Nomenclature of Colours*, a copy of which accompanied Darwin on the *Beagle*, is a prime example of this (as it is also of regional variations in colour-categorization, even within the scientific community at this date). Werner, a late-eighteenth-century German mineralogist, had subsumed purple under blue and orange under yellow, but Syme, a Scottish flower-painter, argued that purple and orange were as entitled to be considered independent colours as were green and brown (two colours which,

BLUES

No.	Names	Colours	ANIMAL	VEGETABLE	MINERAL
24	Scotch Blue		Throat of Blue Titmouse.	Stamina of Single Purple Anemone.	Blue Copper Ore.
25	Prussian Blue.		Beauty Spot on Wing of Mallard Drake.	Stamina of Bluish Purple Anemone.	Blue Copper Ore
26	Indigo Blue				Blue Copper Ore.
27	China Blue		Rhynchites Nitens	Back Parts of Gentian Flower.	Blue Copper Ore from Chessy.
28	Azure Blue.		Breast of Emerald-crested Manakin	Grape Hyacinth. Gentian.	Blue Copper Ore.
29	Ultra marine Blue.		Upper Side of the Wings of small blue Heath Butterfly.	Borrage.	Azure Stone or Lapis Lazuli.
30	Flax-flower Blue.		Light Parts of the Margin of the Wings of Devil's Butterfly.	Flax flower.	Blue Copper Ore
31	Berlin Blue.		Wing Feathers of Jay.	Hepatica.	Blue Sapphire.
32	Verditter Blue				Lenticular Ore.
33	Greenish Blue			Great Fennel Flower.	Turquois. Flour Spar.
34	Greyish Blue.		Back of blue Titmouse	Small Fennel Flower.	Iron Earth.

'Blues'. A chart from the flower-painter Patrick Syme's *Nomenclature of Colours* (1821) which accompanied Darwin on the *Beagle* voyage. Syme retains colour-names, but adds familiar natural objects as terms of reference. (**7**)

incidentally, have retained their *psychological* independence as 'unmixed' colours until our own day).[11] It is perhaps worth noting that Darwin does not seem to have used the nuanced, and hence rather precise, Symian/Wernerian terminology in his descriptive reports for long after the *Beagle* expedition of the 1830s. It was probably far too cumbersome for regular use.[12]

Colour-specification for scientists has now become exclusively mathematical, but it is, of course, only the stimuli that can be quantified, not the 'colours'; and as recently as the 1940s an English pioneer of non-representational painting, Winifred Nicholson, devised a spectrum of hues and values entirely related to natural objects. Her scale underlines the fact that surface-colours possess several characteristics apart from the hue, value, and saturation (*chroma*) which have usually been held to define the parameters of colour as perceived.[13] One of these characteristics is

98

RED	ORANGE	YELLOW	GREEN	BLUE	INDIGO	VIOLET
clay	mud	dust	earth	shadow	slate	lead
terracotta	dun	putty	khaki	mist	pewter	prune
brick	fawn	beige	faded oak leaf	sea grey	steel	mulberry
roan	bistre	hay	sage	air force blue	blue grey	vieux rose
rust	ochre	straw	willow	fell blue	knife blue	musk rose
coral	sand	amber	crab apple	turquoise	royal	wine
ruby	flame	topaz	emerald	azure	sapphire	amethyst
RED	**ORANGE**	**YELLOW**	**GREEN**	**BLUE**	**INDIGO**	**VIOLET**
sugar pink	alabaster	sulphur	duck's egg	baby ribbon blue	ice blue	pale lilac
scarlet	apricot	lemon	pea green	sky	french blue	lavender
vermilion	fire	canary	grass green	forget-me-not	hyacinth	heliotrope
tomato	fox	brass	cabbage	larkspur	ultramarine	purple
dragon's blood	copper	daffodil	forest green	lapis-lazuli	electric blue	maroon
mahogany	tobacco	mustard	laurel	horizon	midnight	damson
RAVEN	**BLACK COFFEE**	**TIGER SKIN**	**BLACK VELVET**	**ZENITH**	**PITCH**	**CHOCOLATE**

A highly individual chart of colours and substances compiled by the British artist Winifred Nicholson in 1944. (**8**)

Winifred Nicholson, *Starlight and Lamplight,* 1937. The painter is concerned here with the character of light and colour in the natural world: the strong red pentagon suggests artificial light, the soft bluish circle the light of the moon. (**9**)

texture, and especially among Russian artists and critics around the time of the First World War, texture (*faktura*) came to be recognized as a specific aesthetic category. The radically non-representational works painted by Kasimir Malevich under the banner of 'Suprematism', for example, depended in their articulation of several whites partly on very suble textural variation. One of the great masters of texture appealed to by the Russians was the Monet of the late *Rouen Cathedral* series, in which an almost relief-like handling of surface-texture was one of the most significant of his painterly tools.[14] Such a wide-ranging understanding of the phenomenology of 'colour', although it has a substantial history going back to Classical Antiquity, and has been explored extensively by twentieth-century psychologists such as David Katz,[15] runs counter to the usual modern conception of the phenomenon, which, at least since Newton, has focused almost exclusively on the characteristic of hue; that is, on spectral location.

<div style="text-align: right">127</div>

<div style="text-align: right">83</div>

'Basic Color Terms'

The widespread interest aroused, not only among ethnologists and linguists, but also among semioticians and even physiologists, by Berlin and Kay's *Basic Color Terms* (1969), which argued for the universal recognition of eleven 'basic' colour-categories, whose foci were located by their subjects on a spectrally arranged chart of Munsell colour-chips, depended very largely on an apparent convergence of experimental findings between ethnography and physiology, where modern research has identified a reduced set of colour-receptors in the retina arranged to process pairs of 'complementary' or 'opponent' stimuli: red-green, blue-yellow and light-dark.[16] Berlin and Kay identified their eleven 'basic' terms in nearly one hundred widely scattered languages, and even the far larger sample in the World Color Survey since initiated by them has hardly modified the structure of their underlying scheme. As the distinguished anthropologist Marshall Sahlins has commented, 'it is difficult to escape the conclusion that the basic color-categories are natural categories'.[17] Sahlins was unhappy with this inference, since he supported a subtle version of the cultural relativism that Berlin and Kay's research was proposing to combat; but he might have escaped from it rather easily had he taken on board the curious consideration that to the physiologists' six categories listed above, even Berlin and Kay's 'basic' set adds five others, including grey, pink and brown. Their rather arbitrary definition of 'basic' has certainly come under fire from T. D. Crawford, and more comprehensively from J. van Brakel and B. Saunders.[18]

An examination of the history of the notion of 'basic' colour-sets – often assimilated to the concept of the four elements, earth, air, fire and water, in Classical Antiquity and the Middle Ages – shows that they shared almost no common feature other than the desire to reduce the myriad of colour-sensations to a simple and orderly scheme.[19] As a leading modern student of the relationship between psychology and aesthetics, Rudolf Arnheim, puts it: 'neither man nor nature could afford to use a mechanism that would provide a special kind of receptor or generator for each color shade'.[20] 'Basic' sets of 'simple' or 'primary' colours are thus a great

<div style="text-align: right">45</div>

<div style="text-align: right">29</div>

gift to structuralists, but offer little comfort to those of us who are concerned to interpret the use of colour in concrete situations.

Marshall Sahlins shares with other modern thinkers, notably Ludwig Wittgenstein, a belief that the assumptions embodied in 'ordinary' colour-language reflect the logic of modern colour-order systems of the Munsell type, which arrange colours in a three-dimensional structure, co-ordinating hues in a circle of complementaries, and relate them to the co-ordinates of light and dark. Thus he writes:

> Blue is always different from yellow, for example: depressed ('the blues'), where yellow is gay, loyal ('true-blue'), where yellow is cowardly, and the like. Blue has a similar meaning to yellow about once in a blue moon.[21]

It is true that many Western cultures have taken on board these modern systems with their emphasis on contrasting hues; but there are instances in the Western Middle Ages, as well as in several non-Western languages spoken today, where the same term was used to cover both blue and yellow, including the Old French word *bloi*, the ancestor of English 'blue'. Similarly, the other pair of 'opponent hues' in modern perceptual theory, red-green, was also covered by a single term in the Middle Ages: *sinople*, a red in Old French poetic usage, but green in the specialized vocabulary of heraldic blazon, which was also French.[22] Even in our own times, Wittgenstein's nonsense-term 'reddish green' (*Remarks on Colour* I, 9-14) has been perfectly acceptable in some languages (for example one spoken in parts of Japan), and even in Germany in the 1920s in the context of Paul Klee's design-teaching at the Bauhaus.[23] The anthropologist R. E. MacLaury has recently drawn attention to instances of non-European languages where white has been assimilated to black; it is clear that in some cultures which have had a profound effect on Western colour-ideas, notably ancient Judaism, the semantic polarity of positive and negative which has usually been regarded as axiomatic for this pair (white=positive; black=negative) does not apply. An important tradition of Christian mysticism deriving from Pseudo-Dionysius in the early Middle Ages proposed that darkness was, indeed, the very seat of God.[24] These apparent anomalies have been noticed only recently and need much more investigation; but they suggest that in the case of Western societies as well as in non-Western ones, colour-usage cannot always be understood in terms of colour-science.

14

21

A disdain for colour

One of my favourite episodes in recent research into colour-language is the arrival in 1971 of the Danish anthropologists R. Kuschel and T. Monberg, armed with their sets of Munsell colours, on Bellona Island in Polynesia, only to be told by an islander, 'We don't talk much about colour here'.[25] In the event, their report seems to me to be one of the best modern investigations of colour-usage within a given culture, but it makes clear that colour as hue is not everybody's interest, and in many contexts we can, of course, do perfectly well without it. The black-and-white photography which in Charles Darwin's day seemed to offer a new touchstone for

the precise visual representation of the real world was only the latest phase in the history of monochrome reproduction which goes back to Classical times. Darwin himself, who as an undergraduate had frequented the Old Master print collection of the Fitzwilliam Museum in Cambridge, was content to use black-and-white engraving even to illustrate his discussions of the highly coloured plumage of exotic birds, for example in his *Descent of Man* (1871). At least since the Renaissance, sculpture in the Western tradition has also been largely uncoloured, partly because ancient Greek sculpture was thought, quite wrongly, to have cultivated this mono-chrome convention. Modern studies of colour-vision have tended to reinforce the fundamental role of the rods in the human retina which process variations in brightness or value; and it is well known that colour-blindness may pass unnoticed for many years because it is scarcely a functional disability.

In some European and Oriental cultures, moreover, a disdain for colour has been seen as a mark of refinement and distinction.[26] The taste for black clothing, for example, was a prerogative of wealth and nobility in the Renaissance, but in suc-ceeding centuries it spread in Europe to all levels of society, and black still forms part of our dress-code for some occasions.[27] On the other hand, when Vincent van Gogh made painted versions of some Japanese prints in his collection, and substi-tuted strident complementaries for the more subtle and reticent colour-harmonies of his models, it may seem to us to be no more than a case of ignorance and vulgar-ity. Yet it was one of the important achievements of the experimental psychology of van Gogh's time to have shown that a love of strong, saturated 'primary' colours was not the preserve of primitives or of children, but was also common among educated European adults (see p. 250); and this was a line of research which went hand-in-hand with the development of a new range of bright synthetic pigments and dyes. It was these psychological as well as technological developments that lay behind what has always been recognized as the enormously expanded interest in highly contrasting hues that marks the visual expression of twentieth-century Western culture, and which has sometimes been characterized, rather misleadingly, as the emancipation of colour in the modern world.

Colour psychology: chromotherapy and the Lüscher Test

The attempt to yoke the structures of colour-language to the mechanisms of colour-vision, although widespread in recent years, is still a rather specialized acad-emic pursuit, but another modern development from late nineteenth-century psychology has had far wider ambitions. The belief that exposure to variously coloured lights could have a direct and variable effect on human bodily functions (it had already been studied in relation to plant growth, by Darwin among others) was perhaps first proposed in the quantified experiments by the French psycholo-gist Charles Féré in the 1880s.[28] Féré found that red light had the most stimulating effect and violet the most calming; but for the student of visual culture his ideas can only have a limited application, since he treated coloured lights simply as variable vibrations of radiant energy that could be sensed by the skin even with the eyes

136

103 closed. This was the sort of research lying behind the development of chromother-apy, a practice which seems to have had its greatest vogue in Europe around the turn of the century, but which is still in the repertory of alternative medicine. As a review by the physiologist P. K. Kaiser[29] indicated, chromotheraphy proved highly resistant to systematic analysis; but another branch of colour-psychology, which proposes isolating non-associative scales of colour-preference based on laboratory testing, has been more widely acceptable, perhaps because it is promoted and used by powerful marketing organizations for commercial purposes.

The most familiar of these scales is perhaps the test devised in the 1940s by the Swiss psychologist Max Lüscher, which according to his organization is now used widely in ethnographical research, medical diagnosis and therapy, gerontolgy, marriage guidance and personnel selection. The Full Test uses seventy-three colour-patches, but a short and handy version includes only eight samples: dark blue, blue-green (also called 'green'), orange-red, bright yellow, violet, brown, black and grey. The subject is asked to arrange the coloured cards in a descending order of preference, and an analysis of this order over a number of test-runs allows the psy-chologist to interpret the subject's character. This interpretation is predicated on the meanings attributed to the colours. Thus blue, which Lüscher, like most modern psychologists, has identified as the most widely preferred colour among Europeans, is held to be concentric, passive, sensitive, perceptive, unifying, and so on, and thus to express tranquility, tenderness, and 'love and affection'. Orange-red, however, is eccentric, active, offensive, aggressive, autonomous and competitive, and hence expressive of desire, domination and sexuality. The section of the public to which the Lüscher Test is chiefly directed may be inferred from the interpretation it gives to an ordering which puts blue at the beginning and red towards the end of the sequence:

> Psychologically, this combination of rejected red and compensatory blue is often seen in those suffering from the frustrations and anxieties of the business world and in executives heading for heart disease... Presidents, vice-presidents and others with this combination need a vacation, a medical check-up and an opportunity to re-assemble their physical resources.[30]

What the English version of the *Lüscher Short Test*, edited by Ian Scott, does not reveal is that the conceptual framework for these interpretations was found by Lüscher largely in German Romantic theory, in Goethe's *Farbenlehre* (Theory of Colours) of 1810, and in the neo-Romanticism of the early twentieth-century non-representational painter Wassily Kandinsky, whose treatise *On the Spiritual in Art*, published in Germany in 1912 and in England and Russia a few years later, includes perhaps the most wide-ranging body of colour-ideas for modern artists (see Chapters 14, 19, 20, 21 below). At one point in the first German edition of his book, published on the anniversary of Goethe's birth in 1949, Lüscher even intro-duced the ancient and medieval notion of the correspondence of the four humours and the four elements, with one of the sets of colours attributed to them. Goethe and his fellow-poet Friedrich Schiller had been working along similar lines at the close of the eighteenth century.[31]

It is no surprise that the Lüscher Test has come in for a good deal of criticism from psychologists for its dogmatic tone, and in particular for its failure to provide a uniform standard in the colour-samples of its various editions. For the historian of culture its chief weakness is that it gives no consideration to the crucial question of whether the psychological response to colours is chiefly to their names, and hence to a general concept of each of them, rather than to their specific appearance. Recent work with animals and with infants might suggest the latter,[32] were it not that the effects of exposure to colours have hitherto been so limited. But if language is crucial, the problems inherent in colour-vocabularies outlined above must be brought into play. Nevertheless the Lüscher system certainly rests on what seems to be a universal urge to attribute affective characters to colours, and it must be taken at the very least as an important modern manifestation of that urge.

High culture, popular culture

In this chapter I have laid most emphasis on the instability of colour-perceptions because this should give pause to those many ethnographers and semioticians who have been tempted to speak confidently of colour-meanings and preferences in many cultures. I have hardly mentioned perhaps the most important issue of all: the definition of culture itself. Which sector of a given society is in question? Which age-group, which class, which profession, which gender? In the case of aesthetic preferences, we have seen a liking for black spreading from aristocratic to general usage, and a taste for bright colours spreading from less educated to well-educated groups. R. E. MacLaury has recently argued for an emphasis on brightness or value in colour-language as reflecting a belief in unity, and an emphasis on hue as indicating a belief in perceptual diversity.[33] Yet, at least for the specialized class of painters, hue itself has often been a tool for unification. Similarly, the widespread perception that women are more discriminating than men in their use of colour may be linked to the relative rarity of colour-deficiencies in female vision.[34]

Most of my examples, from Grünewald to Winifred Nicholson, and from Cleomedes to Lüscher, have come from what used to be called 'high' culture, but I cannot resist ending with an example of ways in which modern consumerism has appropriated the allure of this 'high' culture for the purposes of mass-marketing. Some years ago a British household paint manufacturer produced a range of emulsions and gloss colours which were launched under the names of a number of European Old Masters. Anyone familiar with the history of painting might well be bemused by the faded gentility of 'Turner' (pale violet) or 'El Greco' (pale blue), and equally perplexed by the close proximity of 'Chardin' to 'Vermeer' (both pale grey-greens). If by now you are thoroughly confused by how little the languages of colour relate to its perception, you may at least take heart that this manufacturer was prepared to supply a handful of these 'colours', from 'Leonardo' to 'Manet', in black and white versions as well. It may also be a welcome sign that this range of paints did not enthuse the DIY public, and the names of great artists were apparently soon replaced by numbers.

3 · Colour in Art and its Literature

I T WILL BE CLEAR BY NOW THAT the history of art may well provide the most unified platform for the study of colour – but what methods have art historians so far brought to this study? Nervousness about methods has increased enormously in recent years, as a function of the growth of art history as an academic discipline, but academics have not always recognized that methods have no autonomous status; they are tools developed to serve particular ends, and it is these ends, rather than the methods, that are the primary subject of debate. I have argued in Chapter 1 that the study of colour in art must draw on a wide range of other disciplines;[1] and these days interdisciplinarity is a fashionable notion. Yet a glance at the literature of the humanities as well as of the sciences will show that they have their own purposes and dynamic, which are not necessarily those of the history of art. Art historians must use whatever they consider appropriate in the findings of scholars in many other areas to pursue the aims that only they can identify as their own.[2]

I have introduced these generalities at the beginning of a review of the literature of colour in this century, particularly as it relates to art and visual practice (see also text notes), because colour, in spite of a widespread belief in the universality of certain colour-ideas, is like all formal characteristics ideologically neutral. It can be seen to have served a very wide range of aesthetic and symbolic purposes; and the same colours or combinations of colours can, for example, be shown to have held quite antithetical connotations in different periods and cultures, and even at the same time and in the same place.

The politics of colour

The politics of colour as a subject of study has had a lively history since at least the early nineteenth century, when Romantic commentators on the Norse Edda interpreted the three-colour rainbow-bridge of Bifröst as symbolizing the three social divisions of nobles (gold), freemen (red), and slaves (blue).[3] These colour-coded social divisions have been revived more recently by Georges Dumézil to bolster his now rather discredited analysis of the tripartite social structures of the Indo-Germanic peoples.[4] More fundamental as well as more urgent are the values attributed to black and white in many Western societies – values that have continued to underpin racial prejudice.[5] Recent work on the connotations of black has served to give a more nuanced picture of the values attributed to blackness and whiteness, light and dark, in the United States, and not least in Black Africa itself.[6] Among

European historians of art there have been occasional and rather half-hearted attempts, in the tradition of Wölfflinian formalism, to distinguish national characteristics in the colour-usages of painters;[7] and some more promising work has been done on the propaganda functions of the colours of national flags.[8]

Within the history of Western painting, the structures of power and influence may be seen in the economics of picture-making itself, in which raw materials played a major role. Since Classical times it had been usual for the patron to provide the most expensive and brightest pigments, such as ultramarine, a practice still followed occasionally as late as the eighteenth century.[9] This gives us some indication of a split, particularly developed in the High Renaissance in Italy, between the aesthetics of patrons and the aesthetics of artists. The lavish use of colour which Vitruvius and Pliny had condemned on the grounds of wanton extravagance was now interpreted as a failure to recognize the proper function of painting. This judgment is encapsulated in Vasari's sixteenth-century story of the fifteenth-century Florentine painter Cosimo Rosselli, who in seeking to curry favour with his patron, Pope Sixtus IV, smothered his contribution to a cycle of frescoes in the Sistine Chapel with the brightest and most expensive colours. The Pope (who according to Vasari 'knew little of painting') awarded Rosselli his prize for the best work in the series; but to Vasari and to later critics, the Florentine's extravagance was simply another example of his lack of invention and *disegno*.[10] The growing field of patronage-studies has usually rested on some perceived community of interest between commissioner and executant, at least before the nineteenth century: colour is one area where this was manifestly not always the case. But none of the considerations mentioned above has so far impinged upon the social history of art.

Colour and gender

In *Black Athena* Martin Bernal cites the nineteenth-century racial theorist Gobineau's equation of the male with white and the female with black, a judgment curiously at odds with the Egyptian and Graeco-Roman traditions of painting, in which pale skin was already established as a most appropriate attribute of the fair sex.[11] Feminist art historians might well find much to ponder in the history of colour, for in one phase of the post-Renaissance debate about the values of *disegno* and *colore*, even when both of them were characterized (as attributes of *pictura*) as female, colour was the 'bawd' whose wiles and attractions lured spectators into trafficking with her sister, drawing.[12] In the nineteenth century the French theorist Charles Blanc stated categorically that 'drawing is the masculine sex of art and colour is the feminine sex', and for this reason colour could only be of secondary importance.[13] When, around 1940, Matisse told a friend that for him the opposite was the case, and that drawing, the more difficult task, was female, he was still insisting on this traditional gendering of polar opposites.[14] The polarities that have since the eighteenth century increasingly been assumed in the colour-systems used by painters have also lent themselves to gendering: about 1809 the German Romantic painter and theorist Philipp Otto Runge devised a colour-circle expressive of ideal 90

86

and real values, on which the warm poles of yellow and orange represented the 'masculine passion' and the cool poles of blue and violet the feminine. When this scheme was taken up about a century later by the neo-Romantic Expressionists in Munich these values were reversed, so that for Franz Marc blue became the masculine principle and yellow the feminine, 'soft, cheerful, and sensual'.[15]

Perhaps the most interesting area for feminists to explore is, indeed, the recurrent assumption that a feeling for colour is itself a peculiarly female province, an assumption touchingly exemplified in the admission by one of the leading mid-twentieth-century German colour-theorists, Rupprecht Matthäi, that he left all judgments of colour-harmony to his wife.[16] Such beliefs, as previously mentioned, may have a biological as well as a cultural basis, for it is well known that colour-defective vision is nearly a hundred times more common among white males than among white females.[17] It is also striking that one of the most important areas of colour-study in the history of art, the study of dress, is – notably through the work of Stella Mary Newton's Department of the History of Dress at the Courtauld Institute in London – virtually a female preserve; although the most important large-scale work of costume history's ancillary, the cultural history of dyestuffs, has been carried out in recent years by the chemist Franco Brunello.[18] But if the history of costume has been attacked with great vigour by feminist historians,[19] so far the history of colour has not.

The formalist tradition

One of the longest-running debates about colour has concerned its cognitive status; ever since Antiquity there has been a fairly clear-cut philosophical division between those, like Berkeley or Goethe, who considered that our knowledge of the world was conditioned by our understanding of its coloured surfaces, and those, like the ancient sceptics or Locke, who regarded colour as an accidental attribute of the visual world, and visual phenomena themselves as an unreliable index of substance.[20] Cézanne's career as a painter might well be characterized as a sustained meditation on this theme. There is now some reason to think that there may be a biological basis for the belief that tonal variations in a scene supply the viewer with most of the information needed to interpret it.[21] Monochromatic engraving and photography are the most obvious manifestations of this belief in Western art; but it is a belief that would also help us to understand the persistence of a light and shade (value) based colour-systems in the West, from Greek Antiquity until the nineteenth century, as well as the recurrent debate on the respective places of *disegno* and *colore* in painting, a debate that took a particularly philosophical turn in the seventeenth century, when, especially among Italian artists and theorists, the cognitive independence of line and 'form' was increasingly claimed.[22]

As it happens, the only 'school' of colour-analysis in the history of art owes its development, not simply to the theoretical framework proposed in the nineteenth century by the Swiss critic Heinrich Wölfflin, who focused on the formal characteristics of visual style, including colour, but also, and more importantly, to the

stimulus of the more recent philosophical tradition of phenomenology, represented in Germany chiefly by the philosopher Edmund Husserl. Lorenz Dittmann's wide-ranging study, *Farbgestaltung und Farbtheorie in der abendländischen Malerei* (Colour-structure and Colour-theory in Western Painting), 1987, is only the most important summation of a tradition of *Koloritgeschichte* (history of colour in painting) that goes back in Germany to around the time of the First World War and has engaged a considerable number of distinguished art historians, including, most recently, Theodor Hetzer, Hans Sedlmayr, Kurt Badt, Wolfgang Schöne and Ernst Strauss.[23]

Husserl's pupil, Hedwig Conrad-Martius, took the study of the phenomenology of colours out of the psychological laboratory and into the studio and the gallery; away from a concentration on nature and into paintings, where nature was exposed in all its chromatic wholeness.

> Conrad-Martius's colour-theory [wrote Dittmann] shows us again [i.e. after Goethe] that only a developed nature-philosophy, a comprehensive ontology, will be fruitful for the perceptive, thoughtful engagement with works of art. An isolated 'aesthetic' will hardly serve, and only occasionally the individual sciences, such as experimental psychology, which are tied down to the empirical.[24]

Within the framework of a phenomenological study of colour in art, the role of light and shade (values) and the role of chromatic elements (hues) have been particularly difficult to distinguish, and it is not surprising that the only classic survey of the field remains Wolfgang Schöne's *Über das Licht in der Malerei* (On Light in Painting, 1954), which is still being reprinted after four decades.[25] The hallmarks of this school of analysis are immediate confrontation with the object, and a systematic and sophisticated technique and terminology for describing the effects of that confrontation. In his large-scale study Dittmann has been somewhat dismissive of the work of his only rival in the field, Maria Rzepińska, whose *History of Colour in European Painting*, he claims, neglects the comprehensive study of individual works.[26] But as his own work shows, confrontation is a method that is fraught with pitfalls. Many of his sensitive analyses are masterly – for example, the paragraph on Millet's *The Gleaners*, which gives a very precise sense of the way in which the almost indefinable, shifting nuances of the painter's palette nonetheless contribute to the creation of a stable, monumental structure:

18

> The *Gleaners*...is dominated by a muted brightness with a brownish and grey-violet undertone. The sky appears tinged with a tender violet, as it were a mixture of the two most evident hues in the picture: the very dull grey-blue and copper-red tones in the headscarves of the bending peasant-women. In the white sleeve of the central figure the light gathers with a 'filtered' effect. The unusually restrained colours (which seem to contradict the monumental forms) follow a closely-stepped sequence: reddish tones in the central figure, based around copper-reddish, brownish and bright carmine; delicate nuances of colourful greys in the standing figure to the right: silvery bright blue-grey, dove-grey, blue and turquoise greys. The colour-thresholds are kept so low that induction effects are made much easier, which allows the indefinite

colour-tones to appear as 'resonances'. Thus the barely definable, shimmering brownish tone of the field in the middle distance takes on a tender pink-violet tone against the grey-scale of the figure at the back, which is echoed again in the slightly darkened foreground.[27]

But a lengthy book made up of such plums, particularly one for which the publisher has (justifiably) chosen the austerity of an unillustrated text, would indeed be indigestible, and there are fortunately not many set pieces like this. In any event, Dittmann soon gets into trouble with his principle of personal encounter, because he has simply not been able to examine in the original all the artefacts he wants to discuss. His chapter on medieval book illumination – that most inaccessible of art forms, rarely available for inspection, and usually displayed one opening at a time – depends entirely on descriptions by Heinz Roosen-Runge: and indeed, Dittmann's text in general owes much to quotations from other scholars such as Theodor Hetzer and Kurt Badt, and most of all, Ernst Strauss, whose unpublished notes as well as published works (which Dittmann edited) have provided him with a good deal of material. But the visual analysis of colour can in principle never be at second hand, for different eyes will, as like as not, see quite different things.[28]

This type of detailed visual analysis works well enough for gallery paintings such as Millet's; far more disturbing than the occasional reliance on informed hearsay is Dittmann's almost complete disregard of the context of seeing. The discussions, for example, of Taddeo Gaddi's frescoes in the Baroncelli Chapel of S. Croce in Florence, or Ghirlandaio's in the choir at Sta Maria Novella,[29] do not so much as mention the stained glass in the windows which gives a pronounced colouristic atmosphere to the architectural space; and this is the more surprising in that Schöne had devoted a good deal of attention to the problematic effects of environmental light (*Standortslicht*), particularly in the context of the modifying effects of stained glass on the frescoes in the Upper Church of S. Francesco at Assisi.[30]

In dealing with the painting of the nineteenth and twentieth centuries, Dittmann gives less and less space to his own visual analyses and more and more to the statements of the painters themselves, even to the extent of reprinting Delaunay's short essay on light in both its French original and the German translation by Paul Klee. A belief in the primary importance of artists' views of their own colour-practice is also a notable feature of the approaches of Strauss and Badt, whose studies of Delacroix and van Gogh depend heavily upon those painters' abundant writings.[31] But we are increasingly aware that painters are not necessarily privileged spectators of their own works; and when they turn to words they may in fact be rather less able than other categories of writer to articulate their thoughts about the notoriously opaque world of visual sensation. One cannot but be struck, for example, by the poverty of idea and expression in, say, Mondrian's writings between 1917 and 1944, or Matisse's between 1908 and 1947, compared to the richness and variety of the work to which these writings ostensibly relate. In the case of Matisse we are dealing with a far more sophisticated thinker than Mondrian, but the simplifications that arise from an essentially propagandistic intent are no less evident. Artists' statements are not transparent; they must be unpacked like any others. For

example, it would have been helpful to have had Dittmann's commentary on the manifest differences of tone and emphasis of Delaunay's essay *La Lumière,* and Klee's version of it, in which Delaunay's loosely structured meditations on the primacy of sight and the spatial effects of light – which created what he called 'rhythmic simultaneity' – were given a far more coherent structure, and a far greater emphasis on the complementarity of polar energies.

Though my heading above characterized the German school of *Koloritgeschichte* rather crudely as 'formalist', it is clearly not formalist in any rigorous sense. Since it grew out of Conrad-Martius's theory that colour serves to identify the very essence of being, it could hardly have rested content with the mere analysis of external characteristics. It is true that one of the few Classical archaeologists to have been affected by this approach, Elena Walter Karydi, has undertaken the improbable task of draining the symbolism even from archaic Greek colour.[32] But the search for literary 'meaning' in colour has been pursued by followers of this tendency, not only where we should most expect it (for example in Uwe Max Rüth's dissertation, *Colour in Byzantine Wall-painting of the Late Paleologian Period, 1341-1458),*[33] but even in Gisela Hopp's monograph on Manet – a painter whose style has until very recently been interpreted as a 'realist' ancestor of Impressionism, and hence largely free of literary or symbolic content. Hopp's treatment of expressive colour in Manet is particularly interesting because in her analysis of a number of the major canvases she makes much of the painter's use of emerald green, a pigment that in German has quite deservedly been named 'poisonous green' (*Giftgrün*). In *The Balcony*, Hopp saw this green as overwhelming and oppressive,[34] and in her discussion of the late *Bar at the Folies-Bergère* she was even tempted to identify the characteristically bulbous bottle on the bar to the right as holding green absinthe, and, by contrasting with the 'heated orange' next to it, helping to establish a mood of tension and irritation in the picture. But, as Françoise Cachin noted in her account of this painting for the Manet exhibition of 1983, the green bottle contains, not absinthe, but the far cosier crème de menthe, which is still marketed in this format.[35] The crème de menthe sits very well with the equally identifiable bottle of English beer. Perhaps Hopp's interpretation of the greens in Manet's paintings was largely conditioned by her use of this particular German term, and thus raises the question, to which I shall return later in the chapter, of how far symbolic interpretation may simply verbalize a visual attribute.

Central to the problem of formalism in this style of colour-analysis is its relationship to a notion of history. Dittmann's meticulous and highly selective method resists historical generalization; and Schöne has stated quite categorically that the starting point of any investigation must be the impressions made on the modern investigator him- or herself.[36] It is not at all surprising that there is a certain lack of historical dynamic in this sort of writing. Dittmann, to be sure, makes historical judgments from time to time, for example that the seventeenth century saw the fullest development of chiaroscuro,[37] or, less plausibly, that colour in the twentieth century gained a quite new independence in art.[38] But these judgments are quite ancillary to the detailed characterization of a selection of 'key works'. Sometimes Dittmann is struck by what seems to him to be the earliest significant use of a par-

ticular hue. Brown is a particularly interesting case in point. As a non-spectral colour, brown has been especially resistant to theory, and philosophers and experimental psychologists have generally argued that it is simply a darkened variety of spectral yellow.[39] But, although it may be perceived to be unmixed,[40] brown also has a very wide range of affinities with the long-wave spectral colours yellow, orange and red.[41] Traditionally, and in some European cultures until remarkably recently, it has had, like blue in earlier periods, the general connotation of 'dark'.[42] Because of its importance in painting, brown has particularly attracted the attention of the German school of colour-analysis, beginning at least with Conrad-Martius.[43] Dittmann traces the 'discovery' of brown as a unifying pictorial device to the late Quattrocento in the work of the Pollaiuoli and Signorelli,[44] but other scholars have dated its coming of age to the early work of Velázquez and Ribera.[45] The identification of this rather late emergence of brown is given a certain force by the undoubted conceptual link between brown and darkness in the seventeenth century (and in French, for example, *brun* still means dark), but it is also supported by the evidence of Iberian treatises on painting in this period, which list an exceptionally large number of earth-browns as habitually in use.[46] It is contextual material of this kind that is needed to turn visual analysis into history.

The substance of colour

Koloritgeschichte is notable for a certain reluctance to consider the material condition of the works of painting it chooses to analyse.[47] Yet perhaps the most important developments in the study of painterly colour in recent years have come from conservationists, who have been making the results of their campaigns increasingly available to the general public as well as to historians of art. Technical discussions have become commonplace in exhibition catalogues dealing with all periods of art, and there have been several popular exhibitions on restoration itself.[48] It is particularly remarkable that the specialist literature of conservation, such as *Studies in Conservation* or *Maltechnik*, has now been widely supplemented by periodicals that are clearly aimed at a general readership.[49] Catalogues of single artists as well as catalogues of particular collections are now likely to be provided with far more technical information than hitherto.[50]

Not that conservation is likely to give formalist critics much joy: the enormous help that it can give in matters of connoisseurship is hardly matched by its aid to aesthetic presentation (see, for example, Leonardo's newly stripped-down *Last Supper* in Milan); and conservation methods are, of course, a very controversial area among historians of art as well as among conservators themselves. In recent years the cleaning of some Titians at the National Gallery in London,[51] the restoration of the glass of Chartres West,[52] and, most of all, the cleaning of the Sistine ceiling[53] have given rise to much excited debate, which is not, since it is primarily a question of aesthetics, ever likely to reach any settled conclusions. What restoration reports do offer the historian of colour is more reliable information than that hitherto available about the methods and materials of painting in many historical periods – methods and

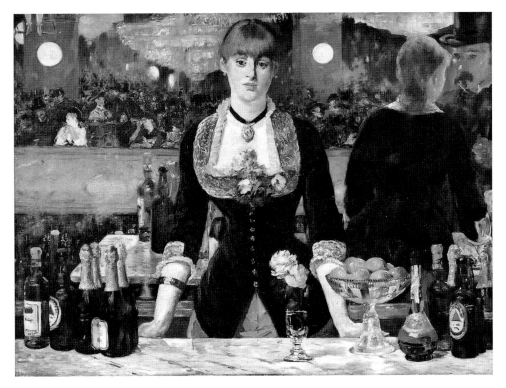

Edouard Manet, *A Bar at the Folies-Bergère,* 1881-2. A too-literary reading of colour led to the bulbous bottle at the right being identified as containing 'absinthe', and its green, clashing with a nearby orange, as contributing to a mood of tension and irritation in the picture. In close-up (right) it is revealed as the far cosier crème de menthe. (**10, 11**)

materials that have often been part of an ideology or mystique of technique specific to those periods and to particular places.

There have been a number of recent exhibitions devoted to techniques and materials,[54] but rather less attention has been given to tools. The pioneering work of F. Schmid and J. W. Lane and K. Steinitz fifty years ago on that most important conceptual as well as practical tool of the artist, the palette, has only recently been developed.[55]

Colour-symbolism itself has sometimes been thought to depend on the qualities of materials; Michael Baxandall has pointed to the way in which certain Florentine contracts of the fifteenth century prescribed specific qualities of ultramarine for the most important areas of the picture, such as the Virgin's robe, because it was the most costly of all pigments (see pp. 13-14 above); and this is an attitude also found in seventeenth-century Spain.[56] Yet, as both contracts and the technical analysis of surviving works abundantly show, other blue pigments were used as frequently in these vital places, and the most important Italian recipe book of the period described synthetic blues that were claimed to be indistinguishable from the best ultramarine.[57] Contracts often specified other particularly expensive pigments, as well as gold, and the use of these specified colours was prescribed by many Italian guild regulations:[58] rather than demonstrating a 'materialist' attitude to colour-symbolism in the spectator, they show a concern for the colour-stability of the product, which, it was assumed, could only be guaranteed by the use of the 'best' materials (see p. 13 above).[59]

One of the important conclusions to be drawn from much recent research in conservation is that artists' practice at all periods was often far more complicated than the handful of surviving technical texts would suggest;[60] and with the exception of Roosen-Runge's study of the *Mappae Clavicula* and 'Heraclius' texts in relation to English Romanesque manuscript illumination, David Winfield on Byzantine mural-techniques, and Mansfield Kirby-Talley's account of the theory and practice of the eighteenth-century English portrait-painter Thomas Bardwell, there has, it seems, been little attempt to test the texts against the practice.[61] Nor has the corpus of written texts expanded much in recent years, although there have been important new editions of some of the standard ones.[62]

A systematic survey of scientific sources, particularly medical literature, would certainly extend the range of technical sources for the arts:[63] there is, for example, some particularly rich material on dyeing and painting – including what appears to be the earliest textual reference to oil painting – in a recently published treatise on the elements by the southern-Italian physician Urso of Salerno, dating from the late twelfth century.[64]

The vastly expanding technical literature for artists in the nineteenth century has still to be surveyed and evaluated, although Anthea Callen has used some of it in her important study of Impressionist technique.[65] Virtually no work at all has appeared so far on the technical interests of twentieth-century painters, although the commercial development of new artists' materials has been greater in our time than in any earlier period, and they have as usual formed an important part of the prevailing aesthetic ideology.[66]

Theories and assumptions

It has been quite a common practice among writers on colour in art to preface their analyses with an account of colour-phenomena in general, an account for the most part based on the literature of experimental psychology of the past century or so. It is quite unrealistic to suppose, however, that the psychology of colour-perception has reached firm ground, and its relationship to the practice of painting must thus remain highly problematic. The art historian must, I think, be more concerned with the local context of colour-ideas as they relate to the artist under consideration than with any global theoretical framework; and in many cases these ideas will be assumptions rather than anything that could be plausibly be presented as a theory. The treatment of colour-theories has usually been the weakest element in the discussion of what may lie behind the choice and handling of colour in a given artefact; and this has been because historians of art have found it hard to shake off that 'progressivist' approach to their subject which historians of science have long since discarded. They have tended to expect more coherence in the handling of theory by painters than the evidence would warrant, and to see in the colour-theories of the remoter past a unity and simplicity that in most cases have barely been achieved even today, as well as a tighter fit with practice than it is reasonable to expect. This does not make colour-theory any the less important.

Stated in its broadest terms, the theory of colour in the Western tradition, from Antiquity to the present, can be divided into two phases. Until the seventeenth century the main emphasis was on the objective status of colour in the world, what its nature was, and how it could be organized into a coherent system of relationships. From the time of Newton, on the other hand, the emphasis has been increasingly subjective, concerned more with the understanding of colour as generated and articulated by the mechanisms of vision and perception.[67] At the same time, the relationship of science to colour has shifted from an earlier dependence of scientists on artists, who in their capacity as technologists of colour supplied science with the necessary technical and experimental data, to an increasing dependence, about the end of the eighteenth century, of artists on scientists, whose growing professionalism and prestige allowed them to offer more, and more that was beyond the reach of art. Even the early treatises for artists, such as Theophilus's *De Diversis Artibus* or the slightly earlier anonymous *De Clarea*, can now be seen, not merely as random collections of recipes, but as incorporating often quite sophisticated statements of theory.[68] Conversely, it is very hard to find artists capable of absorbing the colour-science of any period after the early nineteenth century.

On the other hand, attempts to reconstruct a philosophical context for ancient colour-practice – attempts that go back at least to the eighteenth century but are still an active preoccupation of Classical scholars – have not been able to overcome the brevity and unreliability of the written sources and the ambiguities of the surviving monuments. As Leon Battista Alberti noted in *De Pictura* (§ 26), and in support of his own literary efforts, several ancient artists had written on painting, but none of their writings has survived, and we are still dependent largely upon the architect Vitruvius and on Pliny for our interpretation of the styles of the earlier

Greek examples of painting that are coming increasingly to light. The key text has always been Pliny's account (*Natural History*, XXXV, 50) of the four-colour palette of Apelles and some of his contemporaries, which has been related to an archaic Greek doctrine of the 'basic' colours of the four elements. While several modern scholars have continued to use Pliny's text as a guide to colour-principles in the fifth and fourth centuries BC, others have more plausibly placed it, with the related judgments of Vitruvius and the orator Cicero, in the context of a specifically Roman polemic against extravagance in decoration.[69]

Alberti to Dürer

Alberti's *De Pictura*, which includes a number of important remarks on colour, was an entirely new kind of theoretical text in which practicalities played a very minor role, although the author was also a painter.[70] It has suffered from being seen, in its emphasis on 'variety' and on the tonal scale, as embodying a very medieval attitude toward colour, and as depending more or less exclusively on Aristotelian tradition.[71] Rather little has been published so far on specifically fifteenth-century developments in optics, but Alberti's interest in the effect of light and shadow on colours can be paralleled in some contemporary Central European, if not Italian discussions, and anticipated the far more extensive investigations by Leonardo at the close of the century.[72] Alberti's remarks on the harmonious assortment of colours in painting also reflect a preoccupation in Florence in the early fifteenth century.[73] Lorenzo Ghiberti's *Commentaries*, and particularly his *Third Commentary*, may have been stimulated by Alberti's work, although they were never shaped into a coherent treatise. But where Alberti was content to leave to 'the philosophers' the detailed discussion of the nature and effects of colours, Ghiberti drew heavily on these same (mainly medieval) philosophers, so that his *Third Commentary* is as it stands little more than an edited selection of passages from earlier authors.[74] But, as I shall attempt to show in Chapter 6, this does not detract from its relevance to Ghiberti's practice, especially as a jeweler and a stained-glass designer.

Leonardo, too, looked very widely at medieval writers on optics, but he found their opinions difficult to reconcile with his own experience and the results of his experimentation. The work of Corrado Maltese in the 1980s has sought to weld some of Leonardo's scattered remarks on the mixture of coloured lights into a more or less coherent prefiguring of the modern theory of additive and subtractive mixture; but although Maltese recognizes the many gaps in the painter's experimental procedure, he has still tried to fill too many of them with his own engaging speculations.[75]

His argument that in the course of his work Leonardo was able to reduce the traditional four-colour scheme of 'simple' colours to the modern three, flies in the face not only of Pedretti's revised dating of the *Codice Atlantico*, where much of this work appears, but also of Leonardo's frequently changing attitude to what constituted a 'simple' colour – both green and blue, for example, appear as compounded colours in various notes.[76] Least convincing of all is Maltese's attempt to link Leonardo's

perception of the formation of colours through semi-opaque media with the glazing methods used in the underpainting of the Uffizi *Adoration* and the Vatican *St Jerome*.[77]

What seems increasingly clear is that Leonardo's inability to elaborate a coherent theory of colour, and his traditional distrust of the capacity of colour to reveal truth,[78] fuelled his inclination to regard light and shade as the primary visual phenomena, and stimulated his development of techniques in drawing and painting to exemplify this truth. Recent commentators have underlined Leonardo's view of the dynamic power of darkness, superior even to that of light,[79] and his creation of a new and fruitful concept of chiaroscuro.[80] Leonardo was even suspicious of *bellezza* – beauty – because for him it implied lightness.[81] His supremely subtle interpretation of chiaroscuro in art, and particularly his technique of *sfumato*, was to involve an unprecedented experimentation with media, including the development of soft pastels,[82] and the extensive use of those most delicate and responsive of all painting tools, his fingers.[83]

Much has been made of the little that Dürer wrote on colour – effectively only a short note on drapery-painting, in which he advocated modeling without 'shot' effects, advice that, as Dittmann has pointed out, Dürer was not always inclined to follow himself.[84] More promising, perhaps, is the linking of Grünewald's unearthly colour with his experience of the theory and practice of metallurgy, although there are no indications so far that Grünewald ever turned to colour-theory as such.[85]

Although the sixteenth century was unusually productive in colour-theory relating to the arts, little of it was by or addressed to painters, and it seems to have borne only tangentially on their practice.[86]

Science into art

Only around 1600 did the theory of colour seem to offer something new and exciting to artists, and the widespread movement to integrate the art and the science of colour, which began essentially at the court of Rudolph II in Prague, was to last for nearly two centuries. In the the era of the *Kunst-* and *Wunderkammer*, colour and colours, like painting and engraving, were among the wonders of art to be set beside the wonders of nature. In Rudolph's entourage several artists and scholars – the painter Arcimboldo, the mathematician Kepler, the physicians de Boodt and Scarmiglioni (see Chapter 8) – were interested in colour, and especially in its relationship to music.[87] During the seventeenth century many artists became involved in colour-theory, and many theorists of colour looked to painting for enlightenment. It was the period when Leonardo's writings were first evaluated and published, and when artists in both northern and southern Europe turned their hands to writing. There are now studies of the theoretical interests of Rubens, Poussin, and Pietro Testa,[88] as well as of the minor painter but influential theorist Matteo Zaccolini.[89] In the burgeoning French Academy of the 1660s colour and its relationship to design became a standard topic of formal, as well as informal debate, generating an important and influential literature, especially by Félibién and De

45

57

Piles.[90] Paradoxically, since this was also the period that gave the greatest value to darkness, both in theory and painterly practice,[91] light and colour found for the first 53, 55 time a unified theory in the work of Descartes and, especially, Newton, who showed that colour was indeed illusory, and that light was its only begetter. Yet artists were at first both willing and able to draw on Newton's ideas, especially his 45, 58 conjectures about harmony, and his circular arrangement of colours which eventually gave them a clue to the nature of 'complementary' contrast (see p. 142 below).[92] Contrasts are, of course, subjective effects, and it was one of the greatest achievements of Newton to have shown that all colour is intrinsically subjective.

Science – 'the taste of all minds'

After Newton, the aspects of colour-theory most interesting to artists have been, in addition to theories of harmony, the devising of colour-systems,[93] and the exploration of how colours relate to the mechanisms of perception, and affect the feelings of the spectator. Many of these concerns had long since developed in artists' studios themselves, but they were now investigated and codified systematically. Long before the Czech physiologist J. E. Purkinje announced the principle of chromatic shift in subdued lighting that now bears his name, it had been part of studio lore that paintings could best be examined in the conditions of lighting in which they were made (see p. 16 above).[94]

78 The most comprehensive contribution to the study of colour, which laid great emphasis on these subjective phenomena, was Goethe's *Farbenlehre* (Theory of Colours) of 1810. It has a claim to being the most important single text on colour for artists, and, indeed, for historians of art, since one part is devoted to 'materials for a history of colour', including what appears to be the first historical outline of colour in painting, contributed by the painter Heinrich Meyer.[95] Recent studies of the *Farbenlehre* have tended to revive the old theme of Goethe's outspoken opposition to Newton's theory that colour is a function of light alone,[96] this campaign in favour of Goethe has ceased to be the preserve of spiritual movements, and has joined the mainstream of the history of science. Newton is, of course, no longer the rationalist idol he was in Goethe's day: we have long had Ronald Gray's *Goethe the Alchemist*, and we now have Newton the alchemist, although Newton's practice of alchemy has hardly been brought to bear on the history of his optics,[97] as Goethe's has. What is more important for us is the puzzle of why a theory of colour so patently directed at artists, and deriving partly from Goethe's theoretical and practical experience of art, should have made so little impression on artists for nearly a century (see Chapter 14).[98]

The original and extensive theory of Philipp Otto Runge, the one painter who was close to Goethe during the final stages of his colour-work, has in detail very little to do with Goethe's theory (see Chapter 13).[99] Unlike Goethe, Runge was unable to develop an integrated theory: his published *Farben-Kugel* (Colour-Sphere) of 1810 was in the tradition of European colorimetry in the seventeenth 79 and eighteenth centuries – the direct descendant, indeed, of the 1611 colour-sphere

of the Swedish mathematician Sigfrid Forsius,[100] while his unpublished thoughts were in the metaphysical tradition of the late-Renaissance speculators G. P Lomazzo or Athanasius Kircher.[101] Neither Runge's practical experiments with transparency, which may be related to his delicate watercolour technique, nor his ideas on colour-meaning, which he sought to exemplify in the unfinished cycle of the *Times of Day*, bore fruit in the rather austere diagramatic format of the *Kugel*, although Matile has shown how Runge brought his published ideas of harmony to bear on the small version of *Morning* in the Hamburg Kunsthalle.[102]

84

Whereas in the seventeenth century the scientific theory of colour drew largely on the experience of painting, not least in the search for a set of 'primary' colours,[103] by about 1800 the balance had shifted, and the very extensive development of scientific colour-theory since Newton was now directed to artists through many popularizations, sometimes at the request of the artists themselves.[104] This does not mean that artists were invariably willing, or even able, to use the colour-information supplied to them in this way; and the more circumspect studies of the relationship of colour-theory to painting in the nineteenth century have shown that theory and practice very rarely went hand in hand. But then we should not have expected that theory, any more than 'nature', would have been ready for direct and complete transposition into art. The extraordinary vitality and tension of much nineteenth-century colouristic painting derives precisely from the struggle with the intractable ideas and sensations of colour. The Newtonian solution to the problem of an antithesis between 'apparent' and 'material' colours had thrown the scientific emphasis entirely on to the study of light, and decisively separated the procedures of the laboratory from those of the painter's studio. Runge, who experimented in both traditions, remained hopelessly, if fruitfully, confused about the relationship of theory to practice (see Chapter 13).[105] Most painterly theory in this period was more or less anti-Newtonian, and it is not surprising that Turner, for example, felt himself drawn even at an advanced age to study the theory of Newton's leading opponent, Goethe. But Turner's theory of colour mingled traditional and modern elements in a thoroughly idiosyncratic way, and it remains an open question how far he understood the main issues at stake.[106]

Delacroix's thoughts on colour have also generally been linked with the publications of a single theorist, the chemist M.-E. Chevreul (see Chapter 15).[107] But, for example, the well-known colour-triangle with a note on primaries and secondaries in Chantilly derives from a less abstruse source, J. F. L. Mérimée's *De la Peinture à l'huile* of 1830,[108] and it was not until about 1850, when Delacroix was deeply involved with the technical problems of large-scale ceiling-painting, that he seems to have turned to Chevreul for advice, acquiring a set of notes from a lecture-series of 1848, and proposing to visit the chemist in person.[109] It was at this time, too, that Delacroix came to know Charles Blanc, whose Chevreulian interpretation of the painter's colour-handling served to assure the younger generation of the 1880s that Delacroix was indeed a 'scientific' colourist.[110]

95

Blanc was perhaps the most important of the mid-nineteenth-century French writers on colour because he was read so avidly – by Seurat, Gauguin and van Gogh among others.[111] An admirer and follower of Ingres, he regarded colouring, para-

doxically, as an inferior part of painting; and it was from a pupil of Ingres, Jules-Claude Ziegler, that he took his colour-diagram and, probably, his first knowledge of Chevreul.[112] Like Ziegler, Blanc moved easily between the fine and the applied arts – he also wrote a *Grammaire des arts décoratifs* – and he saw no contradiction in applying the same colour-theory to both. With far-reaching consequences, he also praised Oriental cultures, especially the Chinese, as expert in colour and models for European colour-usage. It was on to an Oriental – albeit a Turk – that Gauguin foisted his amusing pastiche, the brief essay on colour-harmony that he circulated among some friends in Paris in 1886.[113]

Seurat's reputation as a theorist has suffered somewhat in recent years, and it is certainly not easy to understand why he remained so loyal to Chevreul, when the literature of colour for artists in the 1870s and 1880s had introduced the far more sophisticated notions of Hermann von Helmholtz (see Chapters 16, 17).[114] The explanation may lie in Seurat's belief in Blanc's view of Delacroix as a Chevreulian painter; for it seems that the colour-circle that Seurat drew on a sheet of sketches for *La Parade* is a reminiscence of the circle that Delacroix sketched in a notebook of about 1840, and that had been published by Auguste Laugel in 1869. Laugel's commentary is interesting for he introduces the new research of Helmholtz into the colours of light, with its scheme of complementaries red-blue/green, orange-cyan, yellow-indigo, yellow/green-violet, but he argues that Delacroix's 'crude diagram' of Chevreulian complementaries is far more practical for artists. Seurat clearly agreed.[115] The context of Seurat's scientism has still be be fully examined, but it seems likely that in future less emphasis will be placed on the physics of Helmholtz and more on the psycho-physics of Charles Henry.[116]

106
110

109-10, 105

If Seurat as a colour-theorist has been the victim of revisionism, knowledge of van Gogh's approach to colour has remained essentially where Kurt Badt left it in his 1961 study, which gathered a large number of references to colour from the painter's extensive correspondence and related them only very loosely to his work.[117] Vincent's own writing has continued to be the almost exclusive source of documentation, and although we know a good deal about his reading of the theoretical literature of the period, very little has been done to evaluate his use of it.[118] Nor has the crucial friendship with Gauguin in 1887 and 1888 been looked at closely from the point of view of their rival conceptions of colour. Gauguin's sympathy with Vincent's notions, shown in the very flatly painted and strongly coloured *Vision after the Sermon* in Edinburgh, and in the lesson he gave to Paul Sérusier in 1888, gave way increasingly to dislike for what he considered to be van Gogh's very crude colour-aesthetic. Although Gauguin never showed much interest in colour-theory as such, the colour-system later published by Sérusier, with its emphasis on warm browns and cool greys and its avoidance of complementarity, may substantially represent Gauguin's views.[119]

Cézanne's late work is perhaps the highest exemplification of a nineteenth-century theory of colour-perception as a sequence of naively apprehended flat patches, made popular in France by the publications of Helmholtz and his followers. Shiff has drawn attention to this strand of thought,[120] but he has not explored the consequences of these ideas for Cézanne's style; and the debates continue about

COLOUR IN ART AND ITS LITERATURE

whether Cézanne may be considered to have had a 'theory', and the relationship of theory to his painterly practice.[121] Here is one area where formal analysis still has a major role to play.[122]

Twentieth-century theory

The historiography of colour in the art of the recent past has faced two intractable problems. The first is that the categories of colour-analysis – the terminology introduced in modern colour-systems, and the concepts of the psycho-physiological effects of colours – are the very same ones that have been developed over the past century or so; and they have thus tended to be taken for granted and exempted from historical analysis. The second problem has been the hermetic character of modernist criticism, and, together with this hermeticism, the extensive self-analysis of artists themselves, which this criticism has often seen as sufficient. Criticism, that is to say advocacy, has naturally taken precedence over the more analytical procedures of history. Thus, although the more or less collected writings of some of the major movements, such as Russian Constructivism and the Bauhaus, and some of the major figures, like Matisse and Mondrian, and minor ones, like Marc and van Doesburg, Hans Hoffmann and Winifred Nicholson, are now readily available, there has been remarkably little secondary discussion of the colour-ideas of twentieth-century artists.[123]

Several general treatments of individual artists, however, such as Hoelzel, Itten, Matisse and van Doesburg, and of groups such as the Orphists, Russian Constructivists and De Stijl, have included important considerations of their theoretical interests in colour.[124] There has also been a handful of short essays on Orphism, on Russian Constructivism, on Marc, Klee, Picasso and Rothko, that have focused on colour,[125] and a few monographic studies with the same emphasis.[126]

Several exhibitions in recent years have dealt with colour-theory in the twentieth century, or have given a large place to it in the context of some other concern.[127] What these studies have usually lacked has been some sense of the ways in which the discussions and usages of artists have related to the more general concerns of colour-theory in their time. I have made a limited attempt to point to the psychological context of Kandinsky's, Delaunay's and Mondrian's ideas (see Chapter 20), and to the debates on the structure of colour-space that form such an important part of early twentieth-century colour-science (see Chapter 19).[128] The wide range of attitudes toward colour as dynamic and affective that Kandinsky deployed, for example in his *On the Spiritual in Art* (1911-12), including a colour-system that owes as much to the late-nineteenth-century Viennese psychologist Ewald Hering as it does to Goethe, can be paralleled closely in the responses revealed in a long series of interviews and experiments, chiefly with artists and professional people, conducted by the psychologist G. J. von Allesch in Germany in the decade before the First World War.[129] At the Bauhaus in the 1920s Kandinsky was probably the teacher most inclined to draw, as we know from his lecture notes, on the recent literature of experimental psychology, notably *Neue Psychologische Studien* (1926f).

The Bauhaus represents a particularly rich field of colour-study, where the traditional concentration on the ideas of the most famous of the individual teachers has given quite a false impression of what was actually taught about colour there. It never seems to have been a central issue. Itten is assumed to have taught the Basic Course (*Vorkurs*), compulsory for all students, from the outset in April 1919, but the first prospectus makes no reference to it, and it does not appear in the deliberations of the Masters' Meetings until October 1920.[130] At Weimar, after Itten's departure in 1923 colour was taught in the *Vorlehre* by Kandinsky for a mere hour a week, compared to the eight hours of form-study under Moholy-Nagy plus an hour of the same with Klee, two hours of drawing with Klee, and two of analytical drawing with Kandinsky.[131] Klee's colour-lectures of 1922-3 (excerpted by Spiller in his edition of the Notebooks and now available in facsimile) must have been given to more advanced students in only some of the workshops.[132] After the move to Dessau, under Moholy-Nagy and Albers colour appears to have been dropped from the *Vorkurs* entirely.[133] Albers, however, came to put colour at the centre of his interests, and after his move to the United States he taught the colour-course that gave birth to his great *Interaction of Color* of 1963. In this beautiful and influential book, Albers relegated 'theory' to the final stages of practice; and it is certainly questionable how far he had a coherent conception of colour-theory at all.[134]

Colour as content

In a review of the Titian exhibition in Venice of 1935, and of Hetzer's book on Titian's colour, which coincided with it, Oscar Wulff accused Hetzer of setting up far too abstract a model of that painter's colour-concerns, and of neglecting colour's *Darstellungswert*, or representational function.[135] Since Hans Jantzen's pioneering essay 'On the Principles of Colour-composition in Painting' of 1913, which introduced the concepts *Eigenwert* (autonomous function) and *Darstellungswert* of colours,[136] German scholars have sought to understand the role of colour in painting as moving essentially between these two poles. Hetzer himself argued that in the 1530s Titian solved a colouristic problem that had plagued painters since the early fifteenth century: that of striking a balance between the function of colour to articulate space (*Raumwert*) and its surface function (*Flächenwert*), between its nature as phenomenon (*Erscheinung*) and as material pigment, between colour as beauty and colour as meaning.[137] But what these scholars understood by representational or meaningful colour was essentially its capacity to imitate the object; that it had any intrinsic capacity to convey meaning they left entirely out of consideration. Wulff suggested, for example, that Titian's great command of black may have derived from his experience as a portrait-painter rendering the black dress of his many male sitters; but he did not inquire why black was such a high-fashion colour in the mid-sixteenth century.[138]

In figure-painting, of course, the deployment of coloured drapery has always been a major vehicle for the free exercise of aesthetic choice; and Cennini, for example, in a little-noticed passage of the *Libro dell'arte*, argued that the colour-

designs of leaves or animals used in block-printed fabrics were entirely a matter of *fantasia*, provided they created an appropriate contrast. Here, of all places, we might expect colour to be unencumbered by any but formal considerations.[139] And yet textiles are perhaps the coloured artefacts most expressive of social values, and, through these values, of ideas.

Colour-change: shot fabric and modelling

Historians of textiles and costume have not yet given much attention to question of colour,[140] and historians of art have so far used costume almost exclusively as an aid to dating. There has indeed been a tendency to treat the handling of colour-composition in painted draperies as if it were entirely an aesthetic matter. The art-historical treatment of 'shot' materials (*cangianti* or *changeantes*), is particularly instructive. Since Siebenhühner's study of 1935,[141] several historians of Italian Renaissance art, notably John Shearman, have discussed the technique of colour-modelling by hue rather than value-shifts, resulting in effects that seems close to those of silks woven so the weft of one colour is dominant when seen from one direction, and the warp of a contrasting colour is dominant viewed from another. Although not directly related to the distribution of light and shade, colour-changes do relate to the three-dimensional character of folds, and can thus serve as a form of modelling. The question is, whether they were adopted, as modern scholars have suggested, because of their formal capacity to model without value-contrast, and hence maintain a high key throughout a particular form, or whether they bore the connotations that derive from representing a particular sort of fabric. Shearman, for example, has argued that Andrea del Sarto used colour-changes 'of an entirely new order of subtlety'. Unlike those of the Quattrocento,

> which make a sharp contrast of chromatic and tonal value, from yellow to red or green to rose…they [del Sarto's colour-changes] move between values that are deliberately selected for their close association. Highlight and shadow are not, to a greater or lesser extent, made from separate pigments, but are care-fully adjusted mixtures; cream-grey and lilac-grey may be coupled together, or shell-pink and lavender, turquoise and grey-green. When the colour-change is a matter of nuance, like these, it can appear to be the fall of light on a lively and uniformly coloured material.[142]

Very little is known about the early history of shot fabrics; none has apparently sur-vived from the Middle Ages or the Renaissance, perhaps because they were not figured and were thus less valued, and perhaps for the same reason very few were mentioned in the early sources. The earliest literary references seem to be in early fourteenth-century commentaries on the *Sentences* of Peter Lombard,[143] and the earliest inventory reference I have discovered is at Assisi in 1338.[144] The related dis-cussion of lightening or darkening the colours of drapery in manuscript painting occurs in treatises from the mid-thirteenth century onwards;[145] but here it is often difficult to separate the idea of value from the idea of *chroma* (colour); yellow and

green, for example, so often encountered together in the drapery of Trecento paint-ing, had been since Antiquity regarded as the light or dark species of the same genus of hue.[146] The pairing of black and blue, mentioned by Cennini in his chapter on block-printing, and recognizable in many paintings, is subject to the modern eye to similar confusions. Cennini (ch. LXXVII) assumed that *cangianti* draperies were suitable for angels, and this is often, though not exclusively, where they appear in Italian Trecento and Quattrocento painting. But what was perhaps most important was that they clearly connoted silk, probably exotic silk, and hence great expense: at the end of the sixteenth century Lomazzo, who provides the most extensive treat-ment of *cangianti* combinations (*Trattato della pittura*, III, X) and regards them as appropriate to nymphs and angels, insists that they are silks, and seeks to restrict the vast range of colour-possibilities to those giving a convincing rendering of actual stuffs.[147]

Colour and symbol

Historians of colour-meaning need not only to look at the recent literature on the affective characteristics of colour,[148] but also to embrace that area traditionally called colour-symbolism. By far the most useful source for the Middle Ages is still G. Haupt's dissertation of 1940, *Colour-symbolism in the Sacred Art of the Western Middle Ages*,[149] which surveys and excerpts the medieval literature with admirable thor-oughness. But Haupt, like more recent students of medieval colour-iconography, notably Peter Dronke,[150] depends very much on texts, and he is naturally somewhat at a loss when colour-terms and colour-usage do not seem to marry.[151]

In the pre-modern period the study of coloured artefacts or materials seems to be a more fruitful line of inquiry than the study of abstract hues, and some excellent work has been done along these lines by Christel Meier, who is preparing a com-prehensive dictionary of medieval colour-symbolism. In her study of the interpre-tation of gemstones from Antiquity until the eighteenth century, Meier has shown a subtle understanding of the way in which perceptions of colour may be affected by conceptions of what the stone in question means: the same material may be seen as variously coloured according to the need for meaning, and this imagined need is primary, rather than flowing from the perception of the colour.[152]

Many observers may share my experience that the identification of a colour in a given array is a conscious and verbalized act, and that it is thus dependent upon the available colour-language.[153] On the other hand, a good deal of the colour-terminology in European languages is derived, not from perceptions of hue, but from the materials that characteristically embodied those hues, and from which the hues derived their value and meaning. The most studied example of this is scarlet (see also pp. 110-12),[154] but the most striking instances are to be found in the lan-guage of heraldry, all of whose specialized colour-terms derive from precious mate-rials. In a remarkable series of books and articles, Michel Pastoureau has transformed the modern study of heraldry, and brought it out of the almost exclu-sive province of genealogists and into the history of ideas.[155] He started from the

brilliant perception that imaginary coats of arms might be more revealing of atti-
tudes to symbolism than historical ones; and he has gone on from there to survey
the vast field of medieval secular and ecclesiastical symbolism. Heraldry offers a par-
ticularly fruitful area for the study of colour-language because of the abundance of
more or less datable armorials, from the early thirteenth to the seventeenth century,
many of which are illuminated. The detailed analysis of this language remains to be
done, but it is likely to reveal a gradual shift from object-based terms to more
abstract ones, a shift in line with the greater capacity for conceptualization percep-
tible in other areas of colour-experience in the later Middle Ages. Closely allied to
heraldic attitudes to colour-meaning are those of liturgical usage in the Christian
Church; and the study of liturgical colour, both Catholic and Protestant, has now
received an incomparable boost from the exhaustively documented articles in the
Reallexikon zur deutschen Kunstgeschichte, which, as usual in this encyclopaedia, are
far from confined to German examples.[156]

 In the post-medieval period the colour-content of paintings has sometimes been
extended far beyond symbolism and into the often highly complex iconography of
colour. Painters began, from around 1600, to refer in some works directly to the
colour-theories of their day, for example to the new doctrine of primary colours, in
Rubens's *Juno and Argos* (1611) or Poussin's *Christ Healing the Blind* (1650). Even
more explicitly, Turner took up a contemporary debate about the relationship of
the hues to light and dark in a pair of paintings of 1843: *Shade and Darkness,* and
Light and Colour (Goethe's Theory).[157] A conspicuous modern instance, characteristi-
cally more self-referential than these, is Joseph Albers's long series *Homage to the
Square,* beginning in 1950 and continuing until the year of the artist's death, 1976,
which relates very closely to his experimental work published in 1963 as *Interaction
of Color.*[158]

76, 77

Reception and response

A good deal of recent art-historical writing has been concerned with the reception
of artefacts, and it would be surprising if colour did not find an appropriate place in
these discussions. Museology has certainly given an impetus to the study of the
visual context, in particular to the history of frames and hanging, and to the lighting
of the gallery environment. Framing is perhaps closest to the interests of the origi-
nating artist, who at least from the mid-nineteenth century often designed his
frames himself; but, like the conservationist, the modern framer is often at a loss
to know what the original character of the artefact was.[159] Lighting has naturally
been far more the preserve of curatorial specialists, but even here the experience of
conservators and other optical scientists is emerging from the technical literature
and appearing in more general art-historical publications.[160] Framers and lighting-
technologists are usually, I suppose, animated by the same urge to recreate an
'original' state of affairs that stimulates conservationists and even art historians:
Wolfgang Schöne once proposed – seemingly without irony – that historians of art
should equip themselves with sets of dark glasses that approximated as closely as

possible the original lighting-levels of the artefacts under examination.[161] But the technician, like the conservationist, has to come to terms with the fact that the history of the object in question may include the history of its presentation in an inappropriate frame or environment; and that the response of the public to the work in these unoriginal circumstances must be seen as no less valid than that of the originator and his or her circle.

Perhaps the least developed area in the history of colour is indeed the area of spectator-response, and this is probably because the very impressive advances in the modern understanding of colour-vision have not been matched by advances in the theory of colour-perception. As I have suggested in Chapter 1, it may well turn out to be in this area that the historian of art has most to offer the sciences at large. The distinction is, of course, that vision is a matter largely of bio-physical mechanisms, whereas perception depends upon the psychological controls to which this vision is subjected. The one is relatively easy to examine and test by laboratory methods; the other is not. This distinction is very graphically illustrated by the fact that the number of colour-sensations that can be discriminated by the human visual system is numbered in millions,[162] while the number of 'basic' terms used to classify these sensations in most languages is believed to be around a dozen (see pp. 29, 68). The number of these 'basic' terms can be further reduced to three or four 'primary' colours, relating to the mechanisms of the eye which translate incident light into sensations of colour; and the idea of primariness itself has had a particular resonance in modernist art.[163]

Several researchers into colour-defective vision have turned their attention to artists: Patrick Trevor-Roper's major study *The World Through Blunted Sight* has now appeared in a revised edition.[164] The effects of congenital or temporary abnormalities, of ageing, and even of drugs[165] might have been expected to be very marked on the colour-practice of artists; yet the very tentative results these studies have produced must remind us that, in its broadest sense, psychology is more important than physiology for colour-usage, and psychology depends upon a wide range of often imponderable cultural factors.[166]

The study of the effects of colours on the physiological functions, a branch of research that was especially active in Europe in the late nineteenth century (and, in the form of chromotherapy, especially interesting to Kandinsky), has also proved surprisingly inconclusive, although this therapy is a form of alternative medicine still practised in several countries.[167] A century of research seems to have shown little more than that, as previously mentioned, exposure to red light increases the pulse-rate and blue and violet light retards it.

Also heavily implicated in modern practices is the use of colour in psychological tests, notably in the personality-testing developed in the 1940s by the psychologist Max Lüscher (see pp. 31–3 above). In the Lüscher Test (in which the subject is asked to arrange eight coloured cards in descending order of preference of hue), the order which, according to Lüscher, gives the 'surface indications of complete normality'[168] – dark blue, blue-green, green, orange-red, yellow, violet, grey, brown ('a darkened yellow-red'), black – is close, in the broadest terms, to the results of earlier tests with many thousands of subjects.[169] Lüscher's widely used Test[170] has as we have seen

136

come in for a good deal of criticism for its lack of precision and concreteness.[171] But there has also been some scepticism about the capacity of colours to evoke or expose states of mind at all[172] – a scepticism that has spread to the very notion of colour-harmony which was such a sustaining ideal for colour-theorists until well into this century.

Theories of harmony

Traditional theories of colour-harmony may be grouped roughly into three classes: those regarding the spectrum of white light as in some sense analogous to the musical scale, so that it could be treated in a 'musical' way (Newtonian); those 60 requiring the presence of all 'primary' colours in any harmonious assortment, often in a 'complementary' arrangement (as in Goethe's theory); and those regarding the 78 value-content of hues as the primary determinant of their harmonious juxaposi- tion (as expressed in Ostwald's colour-solid).[173] More recently, experimental psy- 133 chologists have sought to ground theories of colour-harmony in the empirical study of responses to single and paired colour-samples by a variety of subjects.[174] This empirical work has done little either to substantiate any of the traditional systems, or to replace them;[175] and yet it remains that harmony is still a very promi- nent concept among students of colour, and that behind several of the colour- systems currently in use among painters and designers as well as art historians, in Europe and the United States, lies the urge to organize colour in a harmonious way.[176] Is this another instance of the gap between theory and experience in modern colour-practice?

One aspect of the doctrines of harmony that has maintained a certain buoyancy among historians of art is the analogy with musical harmony, whether through that branch of psychology known as synaesthesia (not necessarily involving musical, i.e., pitched sounds), or through looser associations. The high period of synaesthetic research was from about 1890 to about 1930, and it made a notable impact on atti- tudes toward colour among painters during this period, especially in Germany and Russia (see Chapter 21).[177] In recent years there has been something of a revival of interest among psychologists in cases of synaethesia;[178] but it no longer seems to play a role in visual aesthetics, as it did at its beginnings in the nineteenth century.[179] The looser affinities between colour and music, on the other hand, con- tinue to fascinate painters and other students of the harmony of colours. The links between colour-interests and musical skills in Matisse, Kandinsky and Klee, for 129 example, have always impressed critics; and in the case of Kandinsky we can now be more certain that his friendship with Arnold Schoenberg helped him to move away from a traditional striving after colour-harmony. It was, as he wrote in *On the Spiritual in Art* (1911–12), no longer in tune with the age:

> From what has...been said about the effects of colour, and from the fact that we live in a time full of questions and premonitions and omens – hence full of contradictions...we can easily conclude that harmonization on the basis of

simple colours is precisely the least suitable for our own time...Clashing discords, loss of equilibrium, 'principles' overthrown, unexpected drumbeats, great questionings, apparently purposeless strivings, stress and longing (apparently torn apart), chains and fetters broken (which had united many), opposites and contradictions – this is our harmony.[180]

Representing colour

In sharp contrast to the fitful light thrown by experimental psychologists on the effects of colour is the illumination offered by philologists and theorists of language over the past two decades. The puzzle of colour-terminology – why such a rich human experience of colour has issued in such a universally impoverished vocabulary – is one that has taxed students of classical philology for well over a century; but it has also attracted the attention of art historians anxious to bring greater subtlety and precision to their own subject.[181] The mapping of colour-space through language can of course suggest far-reaching consequences for our understanding of mental structures, and the extensive discussions that have been generated by Berlin and Kay's synthesis *Basic Color Terms* of 1969 have extended into many areas of psychology, ethnology and psycho-biology.[182] Much of the raw material has been taken from non-European cultures, but it is clear that very similar structural patterns apply in Europe, especially in early periods, and that the use of linguistic material must be drawn into the assessment of colour-meaning in a far more systematic way than has been done so far.[183]

But of course, language is also the tool of the art historian, who can learn much from masters of colour-description such as (to name only those writing in English) Robert Byron, Adrian Stokes, Lawrence Gowing, John Shearman and Paul Hills – writers who have sought to extend the range of hue-description, and to introduce important considerations of surface texture as well as of synaesthetic effects into the taxonomy of pictorial colour. Here is Byron on one of the versions of Andrej Rublev's *Trinity* in the Tretyakov Gallery in Moscow:

19

> The central angel and that on the beholder's right wear full-sleeved robes, round which cloaks are draped to cover one arm and shoulder. On the central angel these garments are respectively of rich flat chocolate, tinged with red, and of a brilliant lapidary blue, a colour so emphatic, yet so reserved, that in all nature I can think of no analogy for it. The angel on the right wears a robe whose tint is of this same blue, but whose intensity is less. Across this is draped a cloak of dry sapless green, colour of leaves at the end of summer, whose high-lights are rendered in light grey-green shading off into pure white... All the faces and hands are nut-brown, modelled only by variations in the tone of the same colour, and outlined in black. The outspread wings, whose feathers are denoted by thin gold lines, are a flatter and paler brown, something between tea and toffee, which strikes a mean plane between the figures and the tree.[184]

In the early Middle Ages blue was seen as akin to darkness – it is even associated with the dark angel of evil in a sixth-century mosaic panel in S. Apollinare Nuovo, Ravenna. Later, blue became the colour of light. In the eleventh-century book-cover of Aribert (above) the cross and mandorla are coloured in two shades of blue, and in an inscription Christ is characterized as *Lux Mundi*. (**12**)

Red and green

Stare for a moment at the red disc (right), and then, with eyes unfocussed, at the white disc (left). Most people will see an after-image they would call 'blue-green'. Yet since about 1800 red's complement has usually been described simply as 'green'– partly because in the system of the three primaries red, blue and yellow, the complement of each colour was deemed to be an equal mixture of the other two. The optical evidence is secondary. (**13**)

In his Bauhaus exercises and watercolours such as *Crystal Gradation* of 1921 (below), Paul Klee constructed a scale of colours from red to green, one of whose steps must be the 'red-green' which the philosopher Wittgenstein declared to be a logical impossibility. (**14**)

58

Unstable hue

During the successive stages of the ancient and medieval technology of alchemy, identical substances might be characterized by entirely different colours. Similarly in the process of glassmaking, the identical additive, copper oxide, coloured white glass both red and green, according to the degree of heat applied – as would have been the case for the red-green tonality (right) of one of the earliest surviving stained-glass windows, the King David window in Augsburg Cathedral (*c.* 1135). Hue was not stable. The only fixed points were those of light and dark. (**15**)

Blue and the advent of oils

Artists' materials are more than mere tools,
they are repositories of values in their own
right. For the mantle and gems of the Virgin
in Majesty of the Ghent Altarpiece (left),
painted in 1432, Jan van Eyck uses the most
precious of blue pigments, ultramarine. (**16**)

With the advent of the oils in the Netherlands
in the fifteenth century the mixing of colours
became a less chancy business. The medieval
concentration on the intrinsic value of
materials gave way to another type of richness
– that of variety. The surviving contract for
Dieric Bouts's Altarpiece of the *Last Supper* in
St Pierre, Louvain (right), painted in 1464-8,
is instructive, for it does not stipulate the
quality of the materials, and the blues used are
mostly the cheaper pigment azurite. From the
mixing of few colours to make many arose the
fruitful notion of a set of 'basic' colours. (**17**)

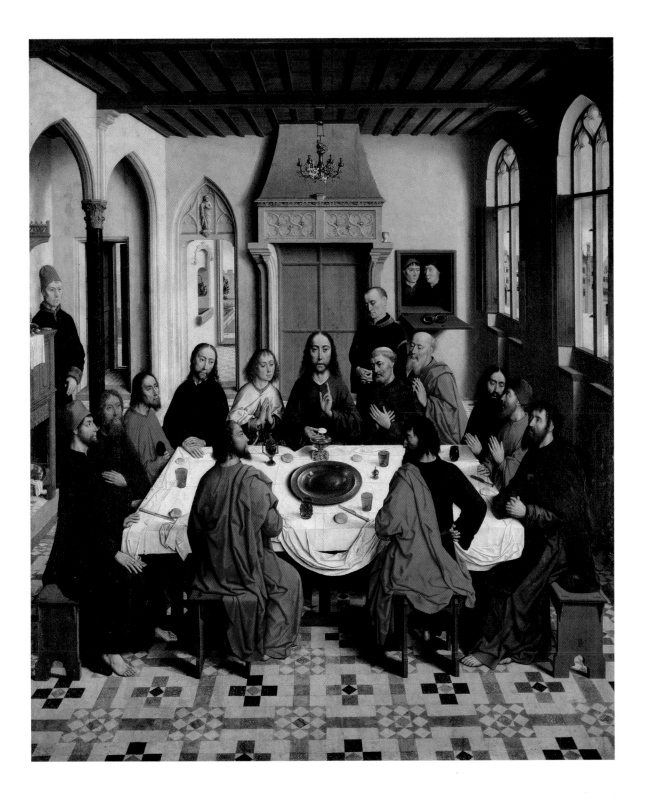

Confronting colour

Millet's highly nuanced handling of colour in the monumental composition *The Gleaners*, 1857, gave rise to one of the great set-pieces of German formalist criticism. Lorenz Dittmann observed in 1987 how: 'The unusually restrained colours (which seem to contradict the monumental forms) follow a closely stepped sequence: reddish tones in the central figure, based round copper-reddish, brownish and bright carmine; delicate nuances of colourful greys in the standing figure to the right; silvery bright blue-grey, dove-grey, blue and turquoise greys. The colour-thresholds are kept so low that induction effects are made much easier, which allows the indefinite colour-tones to appear as 'resonances'...' (**18**)

The rich, close-toned palette of Andrej Rublev, the greatest master of Russian Renaissance painting, has inspired a vivid modern *ekphrasis* by the traveller and art historian Robert Byron. Of the hues of the robes and cloaks in *The Trinity* he writes: 'On the central angel these garments are respectively of rich flat chocolate, tinged with red, and of a brilliant lapidary blue... The angel on the right wears a robe whose tint is of this same blue, but whose intensity is less. Across this is draped a cloak of dry sapless green, colour of leaves at the end of summer, whose high-lights are rendered in light grey-green shading off into pure white...The reddish mauve and the pale slate, the leaf-green lit by grey-green and white, are seen to compose, on examination of the miracle, all the colours of the pearl spectrum. (**19**)

Even formalist critics have sometimes been tempted to ascribe literary meaning to colour. Perhaps because of the German rendering of emerald green as 'poisonous green' (*Giftgrün*), the characteristic Parisian green of the woodwork and rail in Manet's *The Balcony* has been identified by a German scholar as heightening the sense of anxiety conveyed by Manet's figures, and establishing a mood of oppression. (**20**)

It hardly needs to be emphasized that the capacity to convey visual sensation with this degree of nuance will draw untold benefits from the reading of descriptive fiction.

On the other hand, several historians of art have sought to avoid the snares of subjective language by recourse to one or other of the colour-order systems available since the early years of this century. Some early German monographs made use of home-made colour charts,[185] but soon after Wilhelm Ostwald published his first manuals of colour during the First World War, one gallery at least, the Fürstlich Fürstenbergische Sammlungen at Donaueschingen, attempted to introduce references to his numerical colour-solid into its catalogue entries on paintings, if only as a supplement to lengthy verbal analyses.[186] In recent times the American Munsell system has found some favour among art historians in the United States.[187] But it is clear that glossy or matt colour-chips can only approximate the nuances encountered in artefacts themselves, and that these nuances are equally subject to the reservations about condition, setting and lighting that I have outlined in my discussion of visual analysis above.

The colour-reproduction, whose history is only just beginning to be written, is another tool with which some art historians have hoped to outflank language. The development of a theory of three 'primary' colours in the seventeenth century provided the basis for mass-produced colour-reproduction that could imitate paintings, and the first technician to exploit this possibility was the German J. C. Le Blon (see pp. 138-9).[188] Although the rarity of Le Blon's prints today may suggest that they were mistaken for paintings, the technical difficulties of his and his successors' processes[189] meant that very little could be done in the way of colour-facsimiles until the development of chromo-lithography in the nineteenth century, and even here, the results were far from impressive until the 1890s.[190] Colour photography, announced as early as the 1840s, did not become a viable reproductive technique until the early years of our century;[191] and it took almost as long – until the 1950s – for it to be widely accepted as a research tool, although Aby Warburg and, surprisingly enough, Bernard Berenson used it in the form of lecture-slides around the time of the First World War.[192] The English art magazine *Colour*, which started then, depended upon the extraordinary new developments in mass-produced colour-reproduction; and in 1920 it carried testimonials to the reproductions' fidelity from a number of 'great artists'.[193] But for the scholar, acceptance of colour either in books or in slides came very much more slowly: in the early 1930s the possibility of colour-documentation through photography still seemed to be in the future.[194] Twenty years later a conservationist wrote that colour-reproduction seemed 'fast approaching perfection' as a research tool,[195] but there was still only a grudging acceptance in other parts of the profession.[196] In the early 1950s, when UNESCO began its catalogues of good colour-reproductions, the Skira series *Peinture-Couleur-Histoire*, the first series of art books, it seems, to print all the illustrations in colour, appeared to Roberto Longhi to usher in a new era when all art archives would be stocked with colour-photographs.[197]

The case of colour-slides is somewhat different, although in the United States they were widely recognized as teaching aids as early as the 1940s, not long after-

commercial colour film became generally available.[198] This was not the case in Europe: Edgar Wind never used them at Oxford in the 1950s,[199] and when I first lectured at Cambridge a decade later they were the exception rather than the rule. This is not the place to argue the pros and cons of photographic colour-reproductions, whose limitations are as well known to technologists as to their clients;[200] it is only necessary to point out that, as Wind recognized, these limitations are themselves part of the history of colour in art.

The history of colour

It will be clear from my comments, ommissions and emphases in this largely bibliographical essay that I think that some lines of inquiry have proved, or are likely to prove, more fruitful than others. Like Michel Pastoureau, I believe that the study of colour in Western art must proceed along broadly anthropological lines. But in many cases its raw materials and artefacts and their documentation are more sophisticated and complex than those familiar to anthropologists, so that their methods cannot always be usefully brought to bear. Like Pastoureau, too, I believe that an overview of the history of colour is essential if we are to overcome the standard misunderstandings of local and period-specific aspects of colour in art (for example the notion of a fixed set of colour-values in medieval art, or of the scientific competence of Seurat).

Historians of colour must also face the possibility that throughout much of European history their interest has, indeed, been a very marginal one; that, for example, coats of arms were often presented in a monochromatic form on tiles and seals, and that when they came to be engraved, there was little attempt, until the early seventeenth century, to convey the identity of the colours of blazon by graphic signs. But this possibly marginal concern must itself be a fact of the history of colour; and even the shifting identity of certain hues (such as yellow/gold, red/purple) must be understood as part of the historical experience of colour itself. In this sense disputes about colour in all periods can be particularly valuable to the historian.

Colour seems to me to be of special importance to the art historian precisely because it obliges him or her to engage with so many other areas of human experience. Because it is almost invariably itself, and very rarely a representation of itself, and because it is the stuff from which representations are made, colour must be be experienced concretely in artefacts. Thus it offers a corrective to that lively branch of our subject that, despite the voguish topic of 'the gaze', has sought in recent years to exclude visibility from its discourse and to focus on 'text'. In short, colour must redirect the history of art toward the assessment of the visible; and this alone should put it high on any future art-historical agenda.

Part Two

4 · Colour in History – Relative and Absolute

IT HAS SOMETIMES SEEMED THAT our mental images of colour as expressed in language, and the colour-perceptions deriving from our experiences of nature and visual art, are incommensurably distinct. A bibliographical essay on colour in literature, published in 1946, could discover from a total of nearly twelve hundred items, chiefly psychological and literary, only some thirty relating to the visual arts, and the compiler concluded that there could indeed be little interchange between colour in art and colour in literature:

> The colors of the painter are relatively unambiguous and stable. The hues may be defined with considerable exactitude and the composition often may be brought down to simple formulas. In this regard the painter's colors have little in common with the vague, suggestive and elusive means of expression in language.[1]

One reason for his reaching this conclusion was probably that most of his references in visual art were to the only substantial school of colour-studies, namely the German post-Wölfflinian one which has been crowned by Wolfgang Schöne's *Über das Licht in der Malerei* (see pp. 36-41 above). It is a school whose objective has been in the main to discuss absolute colour, to develop an adequately subtle descriptive vocabulary of colour-analysis which may be applied by the modern observer of earlier art; Schöne's key concepts, for example *Eigenlicht* (autonomous light) and *Beleuchtungslicht* (illuminating light), were deliberately framed without reference to ideas of light contemporary with the art he was treating.[2] The study of colour in art must inevitably depend upon accurate and sensitive observation – something that is often made difficult in practice by poor preservation or unfavourable viewing-conditions – but it is no less inevitable that colour-observation is at the same time colour-interpretation; that colour is not simply a sensible and measurable datum, but that, like space or physiognomy, it has a history, and that the reconstruction of this history is an act of historical imagination which must draw, not simply on the surviving monuments, but also on a wide range of contemporary writing: imaginative, philosophical, scientific, and above all, technical. Given the still exiguous literature of colour in art we cannot expect to contribute to a running debate. What this chapter does offer is a number of synchronic and diachronic ways of looking at the uses of colour in medieval and modern art.

Something like a framework for this study has already been offered in linguistics, where there have recently been attempts to arrange the development of colour-terminology in many languages into an evolutionary scheme. In an analysis of interviews with native speakers of twenty languages, and written studies of a further

seventy-eight, Berlin and Kay in 1969 drew up a list of eleven basic colour-categories which they suppose to have entered these languages in the following order: white and black, red, green or yellow, blue, brown, purple, pink, orange and grey.[3] While as we have seen their study has been criticized both on account of its method and for its handling of detail, it agrees substantially with independent studies of three obsolete languages of special interest to students of early medieval art: Classical Greek, Latin and Old English.[4]

Iconography in the early Middle Ages: brightness versus hue

In the present chapter we are not concerned with the evolution of languages, but we are concerned with the scale of values which seems to underlie such an evolution — with the fundamental opposition of white and black, or lightness and darkness, and the third basic discrimination of red, all of which offer us a standard against which the detailed colour-preferences of the early medieval period may be tested.[5] It will become clear that the conception of colour in this period was, like Berlin and Kay's examples, essentially a brightness or value-based one. The modern understanding of colour depends upon a three-dimensional model — for example the Munsell system — co-ordinating hue, brightness or value, and saturation or purity. When we think of colour, we think in the first instance of hue: we discriminate colours by their redness, blueness, etc. In the period that I shall deal with here, this hue-based conception had not yet been developed; colours were chiefly recognized as degrees on a scale of *brightness*, for their position between white and black, or light and dark. And this scale itself was not established by an exact notation of degrees of reflectivity, in the modern way, but as much as anything by a process of association.

The dangers of approaching a value-based conception of colour with assumptions based on hue may be illustrated by the philological studies of two obsolete medieval colour-terms, *perse* and *pandius*. Students of *perse* in the Romance languages have shown that the term was applied to a wide range of hues, from blue-black through light blue to a shade of red.[6] Since several of the earliest usages are in the context of textiles, it may be that, like a number of other medieval 'colour' terms, *perse* refers simply to cloths, in this case regarded as of Persian origin.[7] *Pandius*, which occurs in the early technical literature of colour-making, has been found by experiment to include hues as various as fiery red, ice-blue, and a sandy yellow with an olive cast. One treatise alone, the eighth- or ninth-century *Compositiones Lucenses*, lists recipes for green and purple *pandius*, as well as one for *pandia omnia*. The most recent study of the term has sought to derive it from the Greek *opantios* = manifold, rather than from *pandios* = divine as had hitherto been suggested,[8] but although some of the colours produced by recipes for *pandius* are decidedly dull, it is perhaps premature to dismiss an interpretation which may well have pointed to some other quality than hue, for example lustre.

The early medieval assumption that colour was not primarily a matter of hue will come as no surprise if we consider the Classical tradition of colour-science to which

it was heir. Classical colour-theory had passed on very little about the nature of colour that could be regarded as certain. Medieval readers of the then best-known of the Platonic dialogues, the *Timaeus*, can hardly have been other than confused:

> But in what proportion the colours are blended it were foolish to declare, even if one knew, seeing that in such matters one could not properly adduce any necessary ground or probable reason…Should any enquirer make an experimental test of these facts, he would evince his ignorance of the difference between man's nature and God's – how that, whereas God is sufficiently wise and powerful to blend the many into one, and to dissolve again the one into many, there exists not now, nor ever will exist hereafter, a child of man sufficient for either of these tasks. (67D-68D, trans. Bury)

The more empirical Peripatetic tradition was hardly more reassuring:

> We do not see any of the colours pure, as they really are, but all are mixed with others; or if not mixed with any other colour they are mixed with rays of light and with shadows, and so they appear different, and not as they are…
> (*De Coloribus*, 793b, trans. Hett[9])

In Greek thought the idea of colour (*chroma*) was itself related on the one hand to skin (*chros*), that is, to the surface rather than to the substance, and on the other to movement and change.[10] A sixth-century Christian commentator on Aristotle, Johannes Philoponus, denied that colour was itself an indication of substance, and in the twelfth century a south-Italian theorist came to the remarkable conclusion that even taste was a better guide than colour to the real nature of things.[11]

This theoretical uncertainty was fully supported by the experience of ancient and medieval technology. The most important colour-technology in the ancient world was the manufacture of purple dye from the *murex*, or whelk. The process involved a photo-chemical development in the dyestuff, which passed through a sequence of colours from yellow, yellow-green, green, blue-green, blue and red, to violet. The technical literature, from the Peripatetic *De Coloribus* of the fourth century BC (795b10, 797a5) to the *Onomastikon* of Julius Pollux, compiled in the second century AD (I, 49), laid particular emphasis on this colour-change.[12] A similar colour-sequence also characterized another technology which was developed in Antiquity and much amplified during the Middle Ages, namely alchemy, by virtue of which base and unstable substances were supposed to be transmuted into the stable substance, gold, by a process whose stages were marked by the successive appearance of black, white, yellow and violet, or, later, black, white, perhaps yellow, and red.[13] The identical substance might be characterized by entirely different colours: in the manufacture of stained glass the same copper oxide was used to colour white glass red *and* green, simply by varying the time of heating, and this too was noticed in the early literature of glassmaking.[14] The dominant red-green tonality of the earliest surviving figurative glass (*c.*1135), in Augsburg Cathedral, suggests 15 what a very significant process this was. Thus the world of colour in the early Middle Ages was an essentially unstable one in respect to hue: the only fixed points are those of light and dark. What are the consequences of this for the history of art?

Colour as symbol

The most obvious consequence of this pre-eminence of light and dark is that we shall not be able to expect an early medieval colour-symbolism or iconography based upon hue, and the few serious attempts made by historians of art to establish such an iconography do not carry much conviction.[15] This is not to say that there were no instances of the use of hues symbolically during the early Middle Ages; there is, indeed, an abundance of them, and they are often mutually incompatible: in a single twelfth-century manuscript of Joachim of Flora's *Liber Figurarum*, even the colour-symbols of the Trinity are not constant: Christ appears as blue and the Holy Spirit as red in one context, but in another, these equivalents are reversed.[16] As in the case of the interpretation of colours in primitive societies, their connotations must be inferred from their cultural or ritual context, rather than the context from the colours.[17] In an area where we might have expected a uniform system of colour-values to have established itself at an early stage, namely in the Christian liturgy, we find what the linguistic studies of colour-terminology have already suggested: although by the early twelfth century, black, white, red, yellow, blue and possibly green vestments were in use in the Western Church, only black, white and red had achieved any general acceptance for specific offices. Black, wrote Innocent III about 1200, is emblematic of penance and mourning, and was thus used for Advent and Lent, white of innocence and purity, and was used on the feasts of the Virgin, and red was used for the feasts of both Apostles and Martyrs, since it symbolized both blood and the Pentecostal fire.[18]

Yet there are some remarkable constancies in medieval colour-usage. The white robe of Christ in the Transfiguration – one of the very few colour-traditions recorded in the Byzantine *Painter's Manual* of Dionysius of Fourna[19] – seems to pre-dominate in the painted iconography from the sixth century onwards (Sinai, apse mosaic in the Monastery of St Catherine), although there are examples of the use of gold (e.g. Chios, Nea Moni), and an interesting variant appears in the eleventh-century mosaics of Daphni, in the twelfth-century wall-paintings at Nerezi in Macedonia and in a thirteenth-century iconostasis beam at Sinai, where His robes are pale red and green. This pair was important in a tradition of rendering the rainbow in medieval art and thought: in a literary convention which goes back at least to Gregory the Great (*Homiliae in Hiezechihelem Prophetam*, VIII), and a visual one which is seen as early as the miniature of the Flood in the *Vienna Genesis*, this type of bow presents the colours of fire and water, and it was glossed as a symbol of the destruction of mankind by water at the Deluge and by fire at the Last Judgment.[20] The combination of colours was also used in the rainbow mandorla and throne of the *Maiestas Domini* type, in the West as early as the Carolingian period, and it is surely from this connotation of Christ as God and Judge that it passed into renderings of the Transfiguration, where He appeared, according to the Gospel accounts, as an aweful manifestation of *light*.[21] I shall discuss other readings of the same episode later in this study.

There is, too, a surprising uniformity in the rendering of the robes of St Peter in both the Eastern and Western Churches over a period of many centuries. His usual

dress was a blue tunic and a yellow cloak, or *pallium*, although in the fourteenth and fifteenth centuries in the West this cloak was increasingly coloured vermilion or (in the north) pale greenish-blue.[22] But the blue and the yellow were clearly considered less as simple hues than as families of related hues. The blue might be a positive blue (Chios, Nea Moni), or a pale green (eleventh-century mosaics at Hosios Loukas). The yellow might be a clear yellow ochre (fourteenth-century wall-paintings at Sopočani in Serbia), a pale chocolate-brown (Sinai apse) or a pale pink (thirteenth-century Psalter, Bologna, Biblioteca Universitaria, Cod. 346) – hence perhaps the later transition to vermilion. There are discrepancies of hue even within the same building: in the mosaics of S. Marco in Venice Peter's cloak varies from brownish-grey to pale green and yellow ochre, and his tunic from blue to purple; at Hosios Loukas, in the scene of Doubting Thomas among the wall-paintings of the crypt, he wears a pale green cloak over a blue tunic, but in the contemporary mosaic of the same subject upstairs, he is in a dull-brown cloak over pale green. In the Nea Moni on Chios he has a deep blue tunic and a greyish cloak in the scene of the Raising of Lazarus, but as he cuts off the High Priest's servant's ear he wears greenish-yellow over deep purple. The medieval spectator would clearly have been able to recognize Peter more readily by his physiognomy, which had been estab-lished as that of 'an old man with hair and beard cut short' by the end of the fourth century,[23] than by the colour of his robes: in the scene of Foot-washing in the Nea Moni three other Apostles wear exactly the same combination of colours as he. Yet it was none the less clearly felt appropriate that he should be clothed in robes of the same general family of hues.

Red and purple in the scale of colours

How are we to reconstruct these medieval hue-families? There is no difficulty in establishing the fact that the *termini* of the colour-scale were black and white, but it is far less easy to locate the other hues between these two poles. Green was some-times seen as the median colour: Innocent III justified the use of green vestments for minor feasts on the rather puzzling ground that it was intermediate (*medius*) between white, black and red, a remark which suggests he was thinking in terms of a planar rather than a simply linear scale; and a slightly later writer, William of Auvergne, claimed that green was more beautiful than red precisely because it 'lies between the white which dilates the eye, and the black which contracts it'.[24] Later theorists of colour – Roger Bacon is the earliest I have noticed – have regarded red as the median colour, but in the Byzantine dictionary compiled about 1000 by 'Suidas', red is clearly associated with the light end of the scale and placed directly after yellow in the tonal sequence: white, yellow, red, brown, blue, black.[25] This is a thoroughly Antique view of red, which had been seen as a surrogate for white or gold, and the most highly-prized gold had been that with a reddish cast.[26] The close affinity of red and gold had been perpetuated in medieval art by the procedures of grounding gold in mosaic, panel- and miniature-painting with red, and even by the making of gold thread round a red core. It can be seen iconographically in the two

scenes of the Crucifixion at Hosios Loukas: in the mosaic of the church the haloes are gold; in the Deposition mural in the crypt they are red.

What may seem even more surprising to the modern observer is the Antique and medieval location of purple at the light end of the colour-scale. According to his commentator Theophrastus, Democritus referred to a purple (*porphurios*) which was a mixture of white, black and red: red constituted the largest proportion, black the smallest and white the intermediate. 'That black and red are present is patent to the eye; its brilliance [*phaneron*] and lustre [*lampron*] testify to the presence of white, for white produces such effects.'[27] The beauty of this colour as a dye was also attributed to its surface lustre by Pliny and by Philostratus, who in his *Imagines* (I, 28) noted, 'though it seems to be dark, it gains a peculiar beauty from the sun and is infused with the brilliancy of the sun's warmth'. Pliny's account in the *Natural History* is the fullest and the most interesting: of the Tyrian purple manufactured from *murex* he wrote, 'it brightens [*illuminat*] every garment' (IX, xxxvi, 127); and although he claimed that a frankly red colour was inferior to one tinged with black (*Rubens color nigrante deterior*: IX, xxxviii, 134), he later explained precisely how this blackness was achieved. Distinguishing between two types of shellfish yielding dyestuff, the small *buccinum* (?*purpura haemastroma*) and the *purpura* (?*murex brandaris*), he explained, 'the buccine dye is considered unsuitable for use by itself, for it does not give a fast colour, but it is perfectly fixed by the pelagian [*purpura*] and it lends to the black hue of the latter that severity [*austeritatem*] and crimson-like sheen which is in fashion' (*nitoremque qui quaeritur cocci*: ibid.). 'The Tyrian colour is obtained by first steeping the wool in a raw and unheated vat of pelagian extract and then transferring it to one of buccine. It is most appreciated when it is the colour of clotted blood, dark by reflected, and brilliant by transmitted light' (*colore sanguinis concreti, nigricans adspectu, idemque suspectu refulgens*: IX, xxxviii, 135). In a later passage (IX, xxxix, 138), Pliny noted that a paler shade of purple was fashionable in his own time (*laudatus ille pallor*).

Pliny's account was well known in the Middle Ages. Descriptions of the amethyst — whose colour Pliny had cited to characterize the best purple (IX, xxxviii, 135) — by Isidore of Seville, Bede and Marbod of Rennes related it, as he had done, to the colour of a rose.[28] Pliny's formula, 'that precious colour which gleams with the hue of a dark rose' (*nigrantis rosae colore sublucens*: IX, xxxvi, 126) may derive from a Greek source, for a version of it appears in Greek in some eighth- or ninth-century technical treatises, the Lucca MS and the *Mappae Clavicula*.[29] The stress on lustre which is such a feature of his account also emerges from some late Antique Greek technical literature, and from that of the medieval West. The Stockholm Papyrus of the late third or early fourth century AD has three recipes for dyeing with other purple dyestuffs which refer to lustre; one of them has the prefatory remark, 'keep this a secret matter, because the purple has an extremely beautiful lustre'.[30] And the craftsman known as the Anonymus Bernensis, who discussed egg tempera in the late eleventh century, claimed that his preparations would give a shine to red, that is 'almost the effect of the most prized purple'.[31] Rabanus Maurus, in his ninth-century encyclopaedia *De Universo* (XXI, xxi, *Patrologia Latina*, CXI, col. 579), derived the very word *purpura* in Latin usage from *puritate lucis*. Thus the

linking of purple with red, and hence with light, is rooted in the early medieval conception of this colour; and it may be sensed in the sumptuous 'purple' codices of the Carolingian period (for example the Centula Gospels at Abbeville and the Coronation Gospels in Vienna), which interpret the hue in a remarkable range of fiery reds and pinks.

Medieval blues

The question of the enormous prestige of purple in Antiquity is too large a one to be entered into here; but it is worth noting that Bede characterizes the purple amethyst as emblematic of Heaven, and in this he is following Classical precedents.[32] This heavenly connotation of purple passed during the Middle Ages increasingly to blue (quite apart from the more purely naturalistic identification of blue with Heaven in the mosaics of Ravenna and Rome), especially in its precious form of lapis lazuli, although the purple cast of this latter was prized as late as the fourteenth century.[33] In one of the very rare attempts to trace the history of a colour, Kurt Badt has pointed to the double nature of blue as a hue related both to light and to dark.[34] The later medieval appraisal of blue, which may well be linked to the development of stained glass, tended to move the colour from the dark to the light end of the colour-scale, for there can be no doubt that, for the early Middle Ages, blue was seen as essentially akin to darkness. An essay on the red and blue angels in a mosaic panel in S. Apollinare Nuovo in Ravenna has shown brilliantly that the red figure, who is on the side of the sheep, represents the fiery nature of the good angels, and the blue, on the side of the goats, the dark angel of evil, whose element is the air.[35] The concern to associate the 'primary' colours and the four elements is one which goes back to the earliest period of Greek colour-theory, but these early systems do not include blue, and air is designated red and fire yellow, for example, in the scheme of the second-century AD astrologer Antiochus of Athens.[36] But in a study with the playful title, 'What color is Divine Light?', Patrik Reuterswärd discovered that this light could be both red *and* blue.[37] The examples of blue light he adduced are all late; an earlier one is on the eleventh-century Crucifixion book-cover of Aribert in the Cathedral Treasury at Milan, where the cross (and Christ's mandorla above) is in two shades of blue, and Christ himself is characterized in an inscription as *Lux Mundi*.[38]

 One of Reuterswärd's examples, the Transfiguration in a fourteenth-century manuscript of John Cantacuzenos in Paris, is of a type which goes back to the sixth-century apse mosaic of St Catherine's on Mount Sinai.[39] The treatment of Christ's mandorla in this mosaic, and in many subsequent versions of the theme such as those at Daphni, is an unusual one, for it is dark at the centre and becomes progressively lighter towards the edges: precisely the reverse of what we expect from a source of light, whose effect grows weaker the farther it extends. Where the rays emitted from this mandorla touch the cloaks of Saints Peter and James, they turn the pale chocolate-brown and purple of the material to a pale blue. This inconsistency might not itself be a very significant one; other scenes in the mosaics of St

12

21

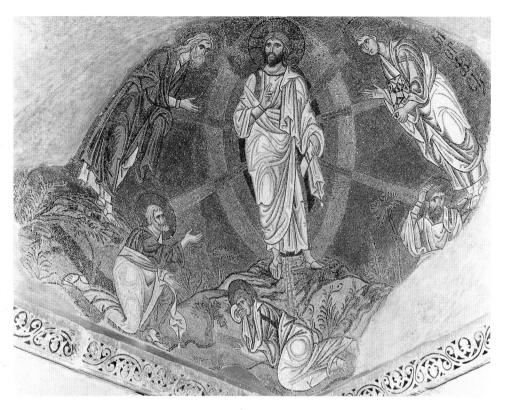

The dark blues of the mandorla surrounding the transfigured Christ suggest the 'dark cloud of unknowing' which had been given great prominence in the theological writings of the Pseudo-Dionysius. *The Transfiguration, c.* 1100, church of Daphni. (**21**)

Catherine's themselves show the more expected sequence, from light in the centre to dark at the edges;[40] but if we look at a twelfth-century Byzantine commentary on this iconographical type of the Transfiguration, we see that it may well illustrate a rather precise doctrinal idea. Of the (lost) version of the subject in the Church of the Holy Apostles in Constantinople, Nikolaos Mesarites wrote:

> The space in the air supports a cloud of light and in the midst of this bears Jesus, made more brilliant than the sun, as though generated like another light from his Father's light, which, as though with a cloud, is joined to the nature of man. For a cloud, it is written, and darkness were about Him (Psalm 96-7: 2) and the light produces this [cloud] through the transformation of the higher nature to the lower, because of this union which surpasses all understanding, and is of an unspeakable nature...[41]

There are elements in the Gospel accounts of the Transfiguration which support Mesarites's view that the union of God and man in the transfigured Christ was productive of darkness, and that it was a phenomenon beyond understanding. Matthew (17:5,6) records the bright cloud that overshadowed the Apostles after the appearance of Christ, and from it God's voice proclaiming His Son: 'And when the disciples heard it they fell on their face and were sore afraid.' The frightened, falling

The hand of God transmitting the Tablets to Moses emerges from a cloud whose centre is far lighter than the darkness that shrouded the transfigured Christ in the Daphni mosaic (21), even though Moses 'went into that darkness where God was'. *Moses receiving the Law*, c. 560, monastery of St Catherine, Sinai. (**22**)

postures of the three Apostles in this type of the scene suggests that this was indeed the moment represented, and that the dark mandorla is a solution to the problem of representing the obscured Christ without in fact obscuring Him from the spectator. Mark (9:7) and Luke (9:34) emphasize the darkness of the cloud which overcame the disciples, and Mesarites himself refers in this passage to the Old Testament tradition of the ineffable darkness surrounding God.[42] It was a tradition particularly associated with Mount Sinai, for it was there that Moses 'went into that darkness where God was', to receive the Tablets of the Law (Exodus 20:21), an episode represented on the triumphal arch at St Catherine's, where, however, the cloud from which God's hand emerges takes a more rational course, from light to dark. The tradition had been revived in the fourth century by Gregory of Nyssa, but it was especially developed at the end of the fifth in the body of writings attributed to Dionysius the Areopagite.[43] The Dionysian 'negative theology' gave particular prominence to the concept of God as darkness: 'Intangible and invisible darkness', wrote the Pseudo-Dionysius in his treatise *On the Divine Names* (VI, 2), 'we attribute to that Light which is unapproachable because it so far exceeds the visible light'; and in his fifth *Epistle*: 'the Divine Darkness is the inaccessible light in which God is said to dwell' (1073a f). In his gloss on the four horses of the Apocalypse (Revelations 6:2ff), he attributed the blue (*kuanos*) of the dark horses to the 'hidden depths

22

[*chruphion*] of their nature'.[44] The link with Sinai is an interesting one, for the mystical role of Moses on the mountain is underlined in the Dionysian *Mystical Theology* (I, 3), and the author also cites the episode of the Burning Bush (*Celestial Hierarchy*, I, 5) – which was located in the Monastery of St Catherine itself, and is the subject of another mosaic scene on the triumphal arch – as a further symbol of the nature of God, for fire 'burns with utter brilliance and yet remains secret, for in itself it remains unknown outside the matter which reveals its proper operation' (*Celestial Hierarchy*, XV, 2).

The identity of Pseudo-Dionysius is still mysterious: the first references to him appear in Syria (Antioch) about 520; his writings were defended as Apostolic by John of Skythopolis about a decade later.[45] None of the seven manuscripts from the Corpus in the library of St Catherine's is earlier than the eleventh century,[46] but there may be good reason to associate the apparently novel programme of the apse mosaics, which date from after 548, with his views.

Because of his ostensible Apostolic connection, as the philosopher converted by Paul in Athens (he also claimed to have been present at the death of the Virgin, and is sometimes included in this scene, for example in the Martorana at Palermo), Pseudo-Dionysius was perhaps the most discussed theologian of the Middle Ages, especially in the West, where the Corpus was translated several times before the twelfth century. Later commentators, however, tended to stress the exoteric rather than the esoteric aspects of his doctrine, and in this sense they interpret the Nature of God increasingly simply in terms of light.[47] Similarly, some twelfth-century accounts of the Transfiguration no longer allude to the element of darkness,[48] and in the representations of this subject in the *Life of Christ* window at Chartres (*c.* 1150) and in some late Byzantine versions (e.g. ceiling painting in the Church of the Hodgetria at Mistra of the fourteenth century, and Asinou, Cyprus, Panagia Phorbiotissa of the fifteenth century), Christ's mandorla is red. In the twelfth-century mosaics at Monreale, and on a possibly contemporary iconostasis beam in St Catherine's on Sinai, there is no mandorla at all: the rays emanating from Christ are simply rays of golden light. And blue itself, as I have suggested, came increasingly to be seen as emblematic of Heavenly light.

I have tried to show in the first part of this chapter that our understanding of colour in remote historical periods, and of the symbolic language that has been attracted to colour, must be an historical and a relativistic understanding. What I propose to do in the second part is precisely the opposite: to suggest that there may indeed be colour-preoccupations in painting which remain constant over a period of many centuries.

The point of pointillism

Fifty years ago, Otto Demus noticed a remarkable technical device in some Byzantine mosaics which he interpreted in terms familiar from the study of French Impressionist and Neo-Impressionist painting. In a discussion of the figure of the Virgin in the *Crucifixion* scene at Daphni he suggested that the oddly serrated edge

24

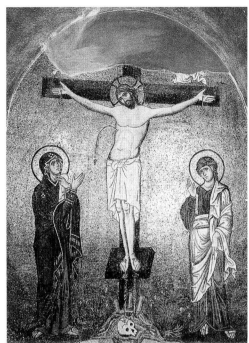

Crucifixion scene, *c.* 1180, church of Daphni. The 'staggering' of the dark cubes defining the Virgin's chin (left) creates a soft and shimmering flesh-tone. (**23**, **24**)

of the shadow along her upper jawline was due to an attempt by the setter to mix optically the tones which he could not make from a rather restricted range of individually coloured cubes.[49] In a slightly later study he expanded the analogy by referring to the way in which fifth-century setters (e.g. at S. Vitale in Ravenna) used several small cubes for each detail to be represented, 'very much in the way of nineteenth-century pointillism. Like illusionistic painting in general, this technique of mosaic was meant for the distant view. Looked at from a distance, the colour-dots appear as modelled forms...'. 'The evolution from the fourth to the eighth century', he concluded, 'may be likened to the stylistic developments of modern French painting from Monet to Seurat.'[50] The analogy, as Demus's own examples suggest, is not perhaps a very helpful one for the understanding of the development of early mosaic style: an 'Impressionist' and a more regular, disciplined 'Neo-Impressionist' method of setting seem to have co-existed ever since Antiquity, and to be characteristic of places rather than of times; but it is an analogy which deserves examination from the point of view of the rationale of the technical device it so sensitively describes.

The paintings which were nicknamed 'Neo-Impressionist' at the last Impressionist exhibition of 1886 have a very good claim to being the first modern pictures, in that they show an unprecedented unity of method and style: in them oil paint, which had been developed as a supremely flexible medium for representing appearances, was wilfully deprived of this capacity, and used to make layers of dots

23

104

and short strokes related, in size, shape and even colour, far more to each other than to the subject-matter of the painting, which was for the most part left to the spectator to reconstitute for himself. Georges Seurat, the leader of the group who produced these works, claimed that his paintings were simply a matter of method,[51] which he preferred to call *Chromo-Luminarism*, or 'optical painting', and the origins of this method have been hotly debated. The sketching-techniques of Delacroix and of Seurat's master, Henri Lehmann, the more regular and divided brushwork of late Impressionism, the teaching of Charles Blanc and Thomas Couture and the colour-theories of M.-E. Chevreul and Ogden Rood, early colour-photography, Japanese prints, and a method of colour-printing developed during the 1880s have all been advanced to account for the astonishing procedure which made its appearance in Seurat's *Grande Jatte* of 1884-6.[52] Although critics of later Neo-Impressionism, where the paint is applied in far larger and more homogeneous colour-patches, occasionally related it to mosaic,[53] and although the discussion of mosaic methods in France during Seurat's lifetime — an interest much stimulated by Garnier's use of the medium at the Paris Opéra — sometimes interpreted it in optical terms,[54] I do not propose to burden these richly suggestive sources still further by proposing medieval mosaic as yet another precursor of Neo-Impressionist dotting. I have not discovered that Seurat was aware of it, and the chief propagandist of the movement, Paul Signac, seems to have been surprisingly uninterested in the medium when he visited Venice and Constantinople in the early years of this century.[55] To the earliest practitioners and supporters of Neo-Impressionism, there was no doubt that the essential rationale of the method was to be found in the science of optics: a friendly and well-informed critic wrote in 1886 of their 'intransigent application of scientific colouring';[56] and Camille Pissarro, a convert from the older Impressionist movement of the 1870s, referred to Seurat in the same year as the first painter to have the good sense to apply to painting the discoveries of Chevreul.[57] We must leave aside here the question of how far these claims to being scientific were justified (see Chapter 16),[58] and return to the mosaicists of the early Middle Ages to ask whether, and in what sense, they may have shared the Neo-Impressionist preoccupation with optical phenomena.

27-8, 104

The crucial justification of the Neo-Impressionist dot was the phenomenon of optical mixture: the light reflected from contiguous patches of two or more colours will mix on the retina to form a third colour, more luminous, it was claimed, than if it had been mixed beforehand on the palette.[59] It was a phenomenon known to Antiquity, and it had been treated in some detail by Ptolemy in the *Optics*, written, probably in Alexandria, in the third quarter of the second century AD. Ptolemy discussed two causes of optical fusion, the confusion of images caused by distance, and that caused by motion:

> Now we see…how, because of distance or the speed of movement, the sight in each of these [cases] is not strong enough to perceive and interpret the parts individually. For if the distance of the objects to be perceived should be such that, even though the angle [of vision] which includes the whole be of the appropriate size, the individual angles which include the various colours

would none the less be imperceptible; and it would appear, by the grouping together [*comprehensione*] of parts which cannot be distinguished individually, that the perception of each of them is gathered into one perception [*omnium sensibilitas congregabitur*], for the colour of the whole object will be unified, and different from [that of] the individual parts.

Something similar occurs through movement at high speed, as in the case of a [spinning] disc [painted] with several colours, since a single visual ray cannot fix [for long] on one and the same colour, as the colour flies [*recedit*] from it on account of the speed of turning. And so the single visual ray, falling on all the colours [in succession], cannot distinguish between the original one and the most recent one, nor between those which are in different places. For all the colours, spread over the whole disc, seem to be one colour at one and the same time, and what is in fact made up of a mixture of colours, one uniform colour…if lines are drawn across the axis of the disc, when it is in motion the whole surface will appear to have a single uniform colour…[60]

Although this latter discussion of mixtures on a spinning disc is of the greatest interest for later techniques in colour-experiment, some of which were of direct concern to the Neo-Impressionists, for the present we are more concerned with optical mixture by distance, for, as Ptolemy's most recent editor has implied,[61] his studies in this regard may well have been stimulated by the experience of mosaic decoration.

Late Antique mosaics have survived almost exclusively in the form of pavements, where the viewing-distance is small and the cubes generally rather large, but we know from literary references that the medium was used widely on the walls and vaults of large bathing-establishments, and at least one such building, dating from Ptolemy's time, has been excavated at Alexandria itself.[62] Given the rarity of surviving wall- and vault-mosaics[63] it is not surprising that few Antique examples of the optical device noted by Demus in some Byzantine work have come to light so far;[64] and the method of 'staggering' tesserae, or arranging them in a chequerboard pattern to create a tone optically, does not seem to have been employed in Antiquity where it might most be expected, namely in the rendering of brilliance. The 'rainbow' pavement at Pergamon (early second century BC) does not use the device: the tesserae are set in rows graduating tonally into each other, but it is a device which became common in pavements during the Middle Ages.[65] If we look at the uses to which 'staggering' was put, we find that for the most part it was expected to convey softness and brightness. It was employed for the modelling of soft surfaces: flesh,[66] animal- and fish-skins, tree-trunks[67] and water,[68] and also to convey the lustre of haloes: two kinds of iridescence and movement in colour for which the phenomenon of *lustre*, produced by the near but not complete fusion of colour-patches in the eye, was especially valued in the nineteenth century.[69] An understanding of the related case of optical fusion, called *colour-spread*, is also implicit in the widespread use of a scattering of contrasting cubes in gold grounds, to vary the surface-effect and to give, in the instances where they are red, that rosy cast which was so prized in gold.[70] It is also clearly behind the apparently random use of vermilion

26

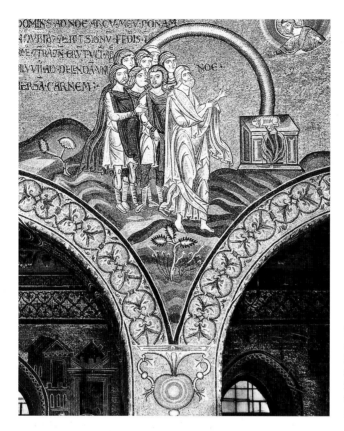

The mosaicist of the rainbow of *The Covenant of Noah* in Monreale Cathedral conveys the almost imperceptible transition from hue to hue by means of the shimmer of 'staggered' edges (below). (**25, 26**)

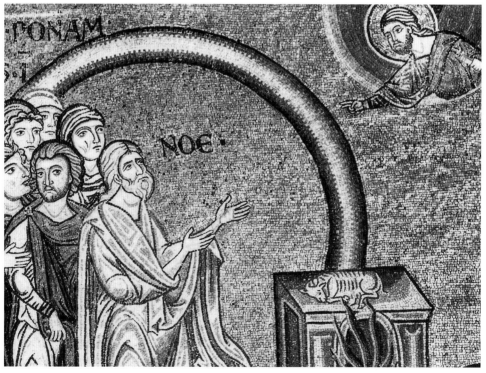

touches in flesh, a procedure not unknown in Antiquity, but which became such a striking characteristic of Italian mosaic, from the Chapel of S. Aquilino in S. Lorenzo at Milan and the nave mosaics of Sta Maria Maggiore in Rome to the ninth-century Roman mosaics of Sta Prassede.[71]

The mind of the mosaicist

All these examples demonstrate a thoroughly calculated use of some of the optical effects described by Ptolemy – attempts at optical-mixing which can hardly have been arrived at empirically since they are often very apparent to the unaided eye. But they do not necessarily imply a knowledge of the *Optics* on the part of those who planned or executed mosaic-decorations. The Neo-Impressionist method was evolved in an atmosphere where science – as the Goncourt *Journal* put it on 8 January 1890 – 'has become the taste of all minds, from the highest to the lowest'; can we suppose the same for patrons and craftsmen in the early Middle Ages? We can, I think, presume something of the sort among the educated consumers of this most luxurious form of art: as I hope to show later in this chapter, analogies between the operations of nature and the procedures of the artist had been commonplace among writers on the physical sciences since pre-Socratic times, and these writers were not unfamiliar to educated men in the early medieval period.

More problematic is the relation between the knowledge implicit in these effects and the craftsmen who achieved them, for they are functions of technique, and technical interests have generally been considered to be exclusive to the workshop rather than cultivated in the study. There are good reasons for thinking that, however justified by medieval theory, this is too rigid a division to correspond with early medieval practice: the twelfth-century *De Diversis Artibus* of Theophilus, for example, is clearly the production, not only of a practising craftsman, but also of a man with some literary background. But in the present case it may be helpful to review the evidence which suggests that, in the making of mosaics, designer and setter collaborated very closely with each other, and that on occasion they may have been one and the same.

Diocletian's Edict on Prices of AD 301, which was once thought to show a division of labour between the highly paid designer, the lesser artist who transferred the design to the wall, and the humble setter,[72] is now known to have no special reference to mosaic practice;[73] and a twelfth-century inscription in Bethlehem styles a single artist as 'designer and mosaicist' (*historiographos kai musiator*).[74] Recent restorations of Byzantine mosaics which have involved a study of their underpaintings have shown, on the one hand, that these underpaintings were sometimes as elaborate as frescoes, and on the other, that the mosaic-setters, who worked directly on the wall, rather than, as was formerly assumed, on the basis of cartoons in the workshop, were sometimes very free in their interpretation of the detail painted on the plaster.[75] This suggests that mosaicists worked in continuous consultation with designers, and may have made modifications on their own initiative even if they were not designers themselves.

Further light may be thrown on these arrangements by the earliest literature on mosaic-technique. Brief instructions for making mortar (*temperamentum*) and setting cubes (*tabselli*) which have been found, curiously interpolated together with medical and other recipes, in a Carolingian Grammar and Vocabulary now in Leyden, distinguish between the *pictor*, who supervises the laying of the mortar, and the *artifex*, who does the laying and the setting itself; but they also confirm that setting was done *in situ*, and in sections (*pars parva tonicetur*), like the *giornate* of the fresco-painter, to allow for the rather fast drying of the mortar.[76] Fifteenth-century accounts of mosaic-practice in Venice show the survival of this *giornate* method, as well as of other traditional procedures, and it may well be that the possibility expressed there, that designing, underpainting and setting might be carried out by one craftsman, was also traditional.[77] All this tends to re-establish the medieval mosaicist as a craftsman capable of making his own aesthetic, as well as purely technical decisions, and thus open to the sort of understanding which lies behind the remarkable optical devices he employed. This is not to suggest that he either wanted, or was able, to read Ptolemy's *Optics* – which in any case seems to have been little known in the West between the fifth and the ninth centuries[78] – but that both the scientist and the craftsman were exploiting a body of shared optical knowledge.

What was the mosaicist hoping to achieve by the use of such optical devices? I have mentioned some instances where the techniques were employed to convey an especial softness or a flickering brilliance demanded by the subjects to which they were applied, and they are thus a symptom of that realism in Byzantine art which has been brought out in some recent studies of contemporary Byzantine criticism.[79] The variation in the size of tesserae according to the degree of subtlety appropriate to different parts of the subject, and the use of the smallest cubes for flesh, which is such a feature of Greek as opposed to Italian methods, also demonstrates a nice sense of the way in which modelling may be made softer by the effect of greater optical fusion at a constant viewing distance.[80] Seurat also followed such a

29 procedure, for example in the heads of the *Poseuses*;[81] but Seurat is generally more homogeneous in his use of the brushmark, and where he does make striking variations, as for example in *La Grande Jatte*, this is not done to describe differences in surface-textures so much as to establish sharp contours by making the dot smaller (and hence the colour-area denser) towards the edges. In this large canvas:

27-8
> Seurat varied the method considerably. In the plane of the sunlit grass, for example, the paint is applied in short strokes laid over one another. Throughout the picture this becomes his favourite manner. Another means is by close, almost parallel stitches, observable on the monkey and on many of the bustles; these stitches follow the contour and help to give an effect of roundness to the form. The bouquet which the seated girl holds up before her is painted in flat, uneven strokes. Here and there only, at significant edges or as boundaries to contrasting planes, are the colours broken into complementary dots.[82]

And yet it is clear that the medieval mosaicist was not simply concerned with realism: he showed, among other things, a remarkable vagueness in the matter of viewing-distance, which is of course the key to optical fusion. The fifth-century

Seurat's varying brushmarks in *La Grande Jatte* of 1884-6, ranging from the parallel stitches used to firm the contours of the bustle (right) and the monkey (below), to flat, even strokes for the grass. (**27**, **28**)

figure-mosaics of Haghios Georgios at Salonika are some of the most refined productions of Greek craftsmanship, yet they are placed some sixty feet (*c.* twenty metres) above the spectator's head, and their workmanship cannot be appreciated by the unaided eye, whereas the astonishing broadly handled ninth-century mosaics in the Chapel of S. Zeno in Sta Prassede in Rome are only a few metres above eye-level. The fine 'chequerboard' shadow on the neck of the Virgin in the Deesis panel at the Church of Christ in Chora (Kariye Djami) in Istanbul can never be made to fuse into a tone in the rather cramped narthex where it is seen. Totally different setting-styles and textures are to be found in the same work, from the second-century BC pavement in the House of the Masks on Delos, where the minutely detailed inset panel of Dionysus is flanked by coarsely executed centaurs, to the sixth-century triumphal arch in S. Lorenzo fuori le Mura in Rome, where the heads of Sts Pelagius and Lawrence are in a broad 'local' style while St Paul is clearly by a craftsman trained in the more refined, linear manner of Byzantium.[83]

And yet, this anomaly is itself very close to Neo-Impressionist practice. Although the critic Fénéon once claimed that the dots could be fused by retiring 'deux pas',[84] it is clear to the viewer that they do no such thing, and that the Neo-Impressionists are direct heirs to that tradition of painterly painting, whose aesthetic enjoyment derives from an interplay between the forms represented in the subject and those which are entirely in the medium of representation, and which invite a continual advance and retreat on the part of the spectator. It is a tradition whose earliest formulation is perhaps in Vasari's account of late Titian, and whose *locus classicus* is Reynolds's somewhat grudging admiration of Gainsborough's last, broad style, but which in France had been ushered in above all by the arrival of Constable's *Hay Wain* at the Salon of 1824.[85]

The attitude is, at least in germ, one which goes back to Antiquity, to Horace's *ut pictura poesis*: some poems, like some paintings, are best studied at a distance, others examined closely; and there are hints of precisely this 'painterly' attitude to mosaic in Byzantium itself. Several writers of the ninth century play on the dual identity of mosaic, as material and as representation: a biographer of the Emperor Basil I described what appears to be a bedroom in his palace in these terms:

> In the very centre of its pavement by means of the stone-cutter's art is represented the Persian bird [i.e. the peacock] all of gleaming tesserae, enclosed in an even circle of Carian stone, from which spokes of the same stone radiate towards a bigger circle. Outside the latter there extend into the four corners of the building streams, as it were, or rivers of Thessalian stone (which is green by nature) encompassing within their banks four eagles made of fine, variegated tesserae, so accurately delineated that they seem to be alive and anxious to fly.[86]

There is good reason for thinking that the early medieval spectator was impressed, not simply by precious materials, but also by the craftsman's power to transform them into images, and he often repeated Ovid's tag to this effect: *materiam superabat opus.*[87]

Atoms and mixtures

A clue to some of the larger assumptions that lie behind the early mosaicists' use of the techniques of optical mixing may be found in a deceptively casual conceit presented by the Patriarch Photius in a sermon on the Church of the Virgin of the Pharos in Constantinople:

> The pavement, which has been fashioned into the forms of animals and other shapes by means of variegated tesserae, exhibits the marvellous skill of the craftsman, so that the famous Pheidias and Parrhasius and Praxiteles and Zeuxis are proved in truth to have been mere children in their art and makers of figments. Democritus would have said, I think, on seeing the minute work of the pavement and taking it as a piece of evidence, that his atoms were close to being discovered here actually impinging on the sight.[88]

Although no mosaic pavements of the ninth century have come to light in Constantinople, we know from those in the Imperial Palace, which date perhaps from two centuries earlier, that the Imperial court (and the Virgin of the Pharos was a Palatine Chapel) commanded at a very late date mosaic craftsmanship of a finesse unmatched elsewhere. But the real interest of Photius's remark lies in its reference to Democritus and his atomic theory, for this theory was intimately bound up with the idea of the mixture of elements, with the theory of colours, and in a tradition which goes back at least to Empedocles, with the analogy between the organization of nature and the processes of the painter.[89] Democritus himself wrote treatises on colour and on painting, although neither of them has survived.[90] The clearest statement of the relationship of the atomic structure of matter to optical mixture is in an account written in the third century AD by Alexander of Aphrodisias:

> Democritus, therefore, considering that [chemical] 'mixture', so called, occurs by the juxtaposition of bodies, which are divided into minute particles and produce the mixture by the positions of the particles alongside of each other, asserts that in truth things are not mixed even in the beginning, but the apparent mixture is a juxtaposition of bodies in minute particles, preserving the proper nature of each, which they had before the mixing. They seem to be mixed because, on account of the smallness of the juxtaposed particles, our senses cannot perceive any one of them by itself.[91]

The extent and accuracy of Photius's knowledge of Democritus must remain doubtful until the contents of his large library has been analysed in detail; perhaps it was no greater than his rather shaky grasp of ancient art and artists. But the Patriarch did show a particular penchant for scientific analogies, and Democritus's views on the relationship of colour to the elements, for example, had been widely discussed in Antiquity – by Theophrastus, by Aëtius and by Galen, as well as by Alexander – and they were summarized in the chapter on colour in the *Eclogues* of Johannes Stobaios (fifth century AD), of which Photius owned a more complete version than any that has survived.[92] Just as in his atomic theory Democritus had sought to reduce the structure of matter to its simplest constituents, so, following

Empedocles, he reduced the number of simple (*hapla*) colours to four: white, black, red and yellow (or green), which were themselves simply the function of particular arrangements of atoms:

> Such are the figures which the simple colours possess; and each of these colours is the purer the less the admixture of other figures. The other colours are derived from these by mixture.[93]

This emphasis on the primary and on purity in colour is an interesting one, and is clearly also related to Neo-Impressionist practice. In 1885 Seurat seems to have been working with a palette of three primary colours (*colorations*), red, yellow and blue, plus white; later, in order to avoid palette-mixtures with anything but white and so retain the greatest purity, he used eleven colours, including a violet, two greens and two oranges, arranged on his palette in prismatic order, next to a row of these same colours mixed with white, and then a row of pure white.[94]

More important, Democritus's emphasis may be related to a preoccupation with unmixed purity of hue which seems to characterize the early medieval approach to painting. Mixture in general had been stigmatized as violent and morally reprehensible by Plutarch, who referred to the workshop-term 'deflowering' (*phthoras*) which was still in use in the Middle Ages;[95] for the craftsman himself it seems rather to have been a matter of chemistry, but the effect on practice was essentially the same. When the compiler of the most complete (probably late twelfth-century) manuscript of the *Mappae Clavicula* prefaced the treatise with a jingle claiming that the first stage of the *artis pictorum* was to know how to make colours, and the second to know how to mix them, he did not understand by *mixtione* the blending of pigments on the palette, but the laying of one colour over another, when the first was dry, in order to model drapery.[96] Medieval painting-instructions of this sort invariably specify a pigment rather than an abstract 'colour'; and with the exception of a green made from orpiment and black, which appears in the *Mappae Clavicula* and a number of later manuscripts, and one or two instances in Theophilus (who, perhaps because he was not himself a painter, seems to have had a more relaxed attitude to mixture), I have come across no colours mixed by the artist in this context. Mixtures are, however, occasionally described as a process of glazing one transparent or semi-transparent colour over another, which is, again, a form of optical mixture.[97] In two cases where the physical composition of samples of medieval fresco has been analysed – some thirteenth- and fourteenth-century examples in Trebizond and Istanbul – it has been discovered that the pigments used had been mixed only with black and white (the most 'primary' colours), never among themselves, and this agrees precisely with the treatises on method.[98]

Thus the early medieval painter had little or no recourse to the palette for the immediate preparation of mixtures, and this tool seems to have made its appearance only about 1300 (see the following chapter), by which time a great relaxation of the early inhibitions about physical mixture had made itself felt in the technical literature, and, most importantly, in the methods of painting themselves.[99] Curiously enough, it was in flesh-painting that physical mixtures seem to have been most commonly used, in those greenish shadows whose blending is described by

34

Theophilus and several later writers. This flesh-green was taken over by mosaicists from the painters – a particularly strident example is in the thirteenth-century mosaics at Arta[100] – and used, of course, in just those places where optical mixture was also most cultivated. For mosaicists as for the Neo-Impressionists, optical mixture was an aid to purity; for both, it was close to the elemental operations of nature (Signac quoted Ruskin to precisely this effect),[101] and the mosaicists chose to use it chiefly in areas where purity and luminosity were the most important aims.

The luminous imperative

It was an urge towards luminosity which gave direction to the technical innovations of both the Early Christian mosaicists and the French painters of the 1880s. This urge is expressed especially clearly in the language of those rather neglected statements of medieval aesthetics, the inscriptions or *tituli* which so often accompanied mosaic decoration, especially in the West. It is a language full of terms for radiance, brilliance, sparkle, and it reinforces the imagery of light (Christ as *Sol Invictus*, amid the rosy clouds of morning; the Virgin as *Stella Maris*) which is such a feature of the earliest mosaic programmes.[102] But there is an essential difference in the means of rendering this luminosity available to the mosaicists and to the painters of the nineteenth century. The medieval artist had no conception of the dependence of colour on light, except in the sense that light was necessary for colour to be perceived. Light was regarded as homogeneous – hence its supreme aptness to the task of representing the Godhead – it was not analysed in terms of colour (i.e. of constituent hues), and the possibility of using two colours to reconstitute white light – the principle of complementarity which is so crucial to Seurat's method[103] – was a discovery of the eighteenth century. It is remarkable that in the most important medieval development of Ptolemy's procedure for disc-mixture, a series of experiments carried out by the Arab philosopher Ibn al-Haytham (Alhazen) in 1038, the emphasis is entirely on *values*, not on hues, and Alhazen did not even care to state which colours he used.[104]

With the exception of the rather special case of flesh-modelling, imitated from painting, where green shadows had been used on occasion since Antiquity, and in the case of the red cubes interspersed among the gold, I have found no instances in mosaic-mixtures which are not clearly tonal in emphasis: the mosaicist achieved luminosity, not through the use of contrasting colours, but by employing materials with a high reflectance: glass, and increasingly, metallic surfaces of gold and silver. These surfaces were manipulated to give a soft and irregular texture; sometimes, at points of great emphasis, particularly in haloes, the tesserae were raked at angles of up to thirty degrees to the plane, so that the light that caught them would be reflected more directly down to the spectator.[105] This studied irregularity is the most original development away from the techniques of Antique pavement mosaic, which had been entirely flat, and even ground and polished to give a completely uniform lustre.[106] It implied hand-setting, cube by cube, on the wall or vault itself. It also implied a lighting far softer and more mobile than that which these mosaics

Seurat's *Les Poseuses* (1886-7), showing the artist's cramped studio-space, with *La Grande Jatte* viewed obliquely in the corner behind the models. (**29**)

generally receive now: the even glare of modern Italian floodlighting is especially inappropriate to them. The Early Christian and Byzantine sources insist on a proliferation of lamps and candles, and it seems a good deal of emphasis was placed on nocturnal offices. But the technique implied, too, that the spectator was not static; he was constantly moving his eyes about over the mosaic surface, which is, indeed the only way a surface part-matt and part-highly reflective can properly be seen. Movement is a feature of both Byzantine and Western *Ekphrases*. In the sermon by Photius from which I have already quoted, there is a remarkably vivid account of the spectator's reaction on entering his church:

> It is as if one had entered heaven itself with no one barring the way from any side, and was illuminated by the beauty in all forms shining all around like so many stars, so is one utterly amazed. Thenceforth, it seems that everything is in

ecstatic motion, and the church itself is circling round. For the spectator, through his whirling about in all directions and being constantly astir, which he is forced to experience by the variegated spectacle on all sides, imagines that his personal condition is transferred to the object.[107]

The arrangement of small narrative scenes, where they exist in mosaic (as for example along the naves of Sta Maria Maggiore in Rome and S. Apollinare Nuovo in Ravenna), also require a good deal of movement on the part of the spectator.

Nothing could be further from the viewing-conditions of Neo-Impressionist pictures, where the spectator moved at right-angles to their surface. In Seurat's *Poseuses*, set in the painter's own studio, where we see the picture of *La Grande Jatte* 29 in the left background, the heavy white frame is pressed into the corner of the room, and the large canvas will rarely have been seen at an angle (as it is in the *Poseuses* itself).[108] The Neo-Impressionists cultivated a uniformly smooth surface so that there should be no shadows cast from ridges of paint, and their practice of putting their paintings under glass, rather than varnishing them, had the effect (at least with their customarily small works) of anchoring the spectator to a single viewpoint.[109] It is worth noting that the Classical ideal of an impeccably even mosaic-surface of tightly-packed tesserae, even for walls and vaults, re-emerged in fifteenth-century Venice, where the mosaicists of the Mascoli Chapel in S. Marco were using a single-point perspective system with a narrow angle of vision, quite unlike the more casual perspective arrangements of the early Middle Ages.[110] The codifier of this novel perspective scheme was Leon Battista Alberti, who also attacked the use of real gold in panel-painting on the grounds that it had a variable value, a phenomenon due, of course, to its high reflectivity and the varying angles from which it was seen in different parts of the panel by the static spectator.[111] Alberti and the artists of the Mascoli Chapel mark the beginning of an attitude towards looking at pictures to which the Neo-Impressionists were heir; cabinet-pictures are, after all, not architectural mosaics, and their conventions cannot be entirely interchangeable. The cultural and ritual context is decisive. Which is perhaps to say no more than that, however enticing the idea of the universal pattern of optical responses in the history of art, we must be historical relativists in the end.

5 · Colour-words and Colour-patches

PROBABLY THE MOST COMPREHENSIVE shopping-list for a medieval scriptorium is to be found in the very popular Latin vocabulary *De Nominibus Utensilum*, compiled for schoolboys by the English scholar and teacher Alexander Nequam, and probably written at Paris around 1180. Nequam's book checks off the scrapers and pumice needed for preparing parchment, the lead-weighted cords for ruling lines, the chair and footstool for the scribe and the chafer for warming his hands, the knives for cutting pens, the boar- or goat's-tooth burnishers for smoothing the parchment after making corrections, the magnifying lenses, the stoves for drying the ink on overcast days, the skylight, the linen or skin blind, and finally, the various black and coloured inks.[1]

Scribes and spectacles

Perhaps the most immediately striking feature of this list of tools is the inclusion of what may be interpreted as two types of magnifying lens, *cavillam et spectaculum*, which were to be used 'lest uncertainty should occasion costly delay [*ne ob errorem moram faciat disspendiosam*]'. *Cavilla* is recorded as a 'magnifying glass' around 1200, and *spectaculum* as a lens about the same time; yet there is also an ambiguity in the meaning of *cavilla*, which a modern translator has interpreted as 'line-marker', probably because it is also a term used to refer to a 'pin' which, according to an early dictionary, was used to perforate the parchment.[2] But it is equally clear that in several of the MSS, both in the Latin and the frequent Anglo-Norman glosses, *cavilla* and *spectaculum* were regarded as synonymous.[3]

The early history of magnifying lenses is still very obscure. Their use to bring distant objects nearer seems first to have been described clearly by Robert Grosseteste in his study of the rainbow in the 1230s, and as an aid to weak eyes in reading by Roger Bacon in his *Opus Maius* of the 1260s.[4] Until very recently the origin of spectacles has been traced to Tuscany and northern Italy towards the close of the thirteenth century;[5] but it now seems plausible to push their development further back, and specifically into the context of manuscript-production in northern Europe.[6] Nequam's reference to *two* kinds of magnifier (although at least one of the thirty or so surviving MSS of his vocabulary identifies them as the same)[7] might well indicate a distinction between a hand-held magnifying-glass (*cavilla*) and a type fixed close to the eye (*spectaculum*) which would allow the scribe or illuminator to keep both hands free. This is indeed what appears in one of the earliest representa-

Tomaso da Modena's portraits of the cardinals Hugh de St Cher and Nicholas de Fréauville, showing the one (left) wearing spectacles, leaving both hands free for writing, and the other (right) reading with a magnifying glass. These images of around 1352 are the earliest known depictions of the use of lenses. (**30**, **31**)

tions of a scribe wearing spectacles, Tomaso da Modena's 'portrait' of Hugh de St Cher in Treviso, of about 1352, which is one of a series of fresco 'portraits' of Dominican cardinals, another of whom, Nicholas de Fréauville, is using a hand-held glass.[8] Certainly spectacles figure prominently in some later portraits of manuscript-illuminators, such as the miniature self-portraits by Simon Bening of 1558 in the Victoria and Albert Museum and the Metropolitan Museum of Art in New York,[9] or the remarkable portrait of an unidentified illuminator by the Flemish

30

31

Willem Key's painting of an unknown Flemish illuminator of the sixteenth century. Wearing spectacles such as those the artist is holding (left) had become a common practice among painters. (**32, 33**)

32-3 painter Willem Key, dated 1565, now in the National Museum of Fine Arts at Valletta in Malta.

Whether or not the introduction of spectacles is closely related to the production of manuscripts, their diffusion in the fifteenth century – when the convex lenses for the myopic were supplemented by the concave lenses for the long-sighted – does seem to be associated with the development of the printed book, and consequent spread of reading and small print.[10]

Nequam's colour-terms

The considerable difficulty faced by the modern interpreter of these unfamiliar terms for lenses is matched, and even surpassed, when attention turns to Nequam's terms for the illuminators' colours. He lists only red and two blues, one simply a 'dark' (*fuscum*), but glossed in Norman French in at least four of the MSS as '*bloye*'. It is striking that after the many very specific technical terms for the scribe's equipment, Nequam's colour-terminology is remarkably vague. Black is admittedly only *incaustum* or *atramentum*, the ancient ink made from carbon obtained by the combustion of resins,[11] which remained untranslated in the Norman glosses. But red is

minium (red oxide of lead), which is used here to make *rubeus* or 'Phoenician' (*puniceus* or *feniceus*) letters. *Puniceus* is described in the early fifteenth century by the French student of colour, Jehan Le Begue, as a reddish yellow, but he lists *feniceus* separately as a rose-red.[12] *Minium* is glossed in Nequam as *vermiloun*, and *puniceus* as *vermeilles* or *ruge*; and vermilion was, of course, derived from natural cinnabar or made artificially by processing mercury and sulphur.[13] We need not worry too much here about the chemistry of these pigments, even though Nequam was something of a natural philosopher,[14] but we should note that he and his glossators were happy to qualify 'red' with a number of different terms. It may, however, be significant that in the early French treatise on making paints by Peter of St Omer it is advised that, in order to give the illuminator's red some body, *minium* should be mixed with vermilion, *ut pulchriores sint* (so that they may be more beautiful by being less pale).[15]

Nequam's blues are similarly imprecise. His *fuscum pulverum* may conceivably, from the phrasing of the passage, be the same as the *azuram a Salamone repertam*, that is, lapis lazuli from King Solomon's mines, a formulation which is remarkably early for the reference to its origins in the Levant (Badakshan). The Norman glosses translate it as *asure*. Peter of St Omer says that *azurium* or *lazurium* is also called *perse*, and this may also offer a hint of a Levantine origin, although *perse* is still one of the most contested colour-terms of the Middle Ages, and like *fuscus* (*bloye*) may sometimes mean little more than 'dark' (see p. 68 above).[16] In a list of equipment for the scriptorium in a manuscript in Cambridge (Gonville and Caius MS 385), also attributed to Nequam, *venetus* is added to the blues, and green to the colours required for painting capital letters.[17]

Nequam's colour-list, short as it is, thus introduces us to ambiguities both in the Latin originals and in the Norman-French translations. We might have expected that such ambiguities would have been an obstacle to communication in the scriptorium, especially since manuscript scholars are increasingly finding that instructions to illuminators were often in verbal form, and not simply dependent on visual models.

Marginal notes

One of the most expansive areas of recent codicological studies is in the interpretation of marginal notes to scribes or illuminators, and many of those so far discovered refer, either in Latin or in the various vernaculars, to the colours which were to be used in decoration. Sometimes, as in a loose late-fourteenth-century leaf in the Bibliothèque St Geneviève in Paris (MS 1624), whole words were used, even the enigmatic French term '*fausse rose*';[18] but far more commonly they are simply initials, or the first two or three letters of the words. They can tell us something about the working language, or languages, of a particular scriptorium; they can show that in a few cases illuminators were either unable or unwilling to follow instructions and, most important in the present context, they can tell us something about the precision of colour-terminology in common use in the High Middle Ages.

One unusual example is the use of a cross to signify red in a late twelfth-century Psalter in London (British Library Harley MS 2895).[19] This is surely a cross rather than an 'X', and it probably refers to Christ, whose frequent depiction in red robes was due to the traditional associations of red with light and royalty; and perhaps, in the painterly context, to the process of manufacturing vermilion from sulphur and mercury – well described by Peter of St Omer – which was regarded as re-creating all metals, including the most precious, gold.[20] So the meaning of colours was not confined to their optical properties, but may be a function of their 'chemistry' or composition; and it is also remarkable how often red was designated merely by 'v' (*vermiculum*, *vermeille*), even though this might be easily misinterpreted as green (*viridis*, *vert*).

But it has also been pointed out that most colour-terms in the Romanesque MSS which have been surveyed so far are not pigment-terms, but general colour-words: *minium* and *vermiculum* are exceptions to this rule;[21] The letter 'p' for *pourpre* or *purpureus* may be an example of this; but this initial has been found set against grey paint in the Bible of Manerius in the Bibliothèque St Geneviève, where 'AV' and 'N' are also used, as well as 'p' for violet.[22] 'N' has been interpreted as '*nubilus*' (cloudy), and 'AV' as a mixture of *azurium* and *vermiculum*.[23] But although Le Begue described *violetus* quite properly as a mixture of *rubeo et perso, seu azurio*, his *rubeo* is a vegetable lake, and a mixture of vermilion and lapis lazuli is chemically very risky as well as costly, so that 'AV' probably refers to the appearance of the colour, not its chemistry. *Purpureus* need not refer to the hue we call 'purple', but 'p' might equally denote *perse* or *persus*, that tricky obsolete term which was used to characterize dark greys and violets as well as blues. The use of 'w' (*waeden* = woad) for purple-blue has been noted in an Oxford MS (Bodleian MS 156);[24] and in some mid-thirteenth-century English dyeing regulations woad (*wayda*) is reported as producing *perse* cloth.[25] Here the English term for a known dyestuff gave the illuminator some guarantee that a particular hue was in question. These ambiguities present problems to the modern reader, but did they also present problems to the illuminators themselves? How did artists in the scriptorium organize their colours? Did they organize them at all?

The medieval palette

There is some evidence of late twelfth-century interest in a perceptual colour-scale in a text by the south-Italian physician and theorist Urso of Salerno, but his argument was not illustrated, and indeed he said that only a painter could make such a scale.[26] The earliest known European artist's palette, recently identified in a French Bible of around 1300, like its successors before the sixteenth century gives no opportunity for a particular arrangement, since it holds only two colours, a black and a pink.[27] Possibly the first visual diagram of a set of artist's colours is the illustration to the article on *color* in the Latin encyclopaedia *Omne Bonum*, compiled by the Englishman James Le Palmer late in the fourteenth century and now in the British Library. Le Palmer's painter takes his colours from shells very like the hand-held

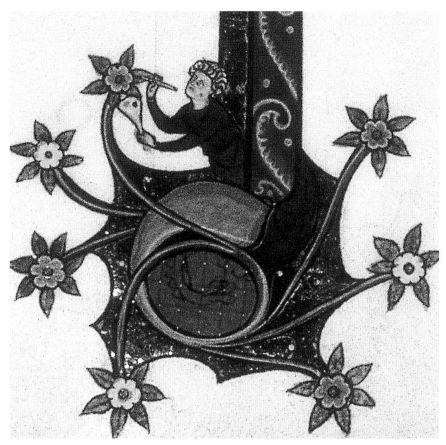

The earliest illustration of a painter using a palette, from the initial P of a French Bible of around 1300. Unmixed purity of hue had been prized since Antiquity, and evidence of colour-mixing is rare at the period. (**34**)

James Le Palmer's letter C (for *Color*) from the fourteenth-century encyclopaedia *Omne Bonum*. The collection of nine colours shown tallies loosely with the ten of the text. (**35**)

The late twelfth-century German illuminator Brother Rufillus painting from a shell. Each colour is mixed individually with the medium. (**36**)

95

36 receptacle in the self-portrait of a named German illuminator, Brother Rufillus, some two hundred years earlier;[28] and Le Palmer's shells contain some nine paints, including two pinks, two yellow ochres, two greens and two vermilions. Yet these painted colours refer only rather loosely to the ten colour-terms listed in the text.[29] The pinks might render *rubeus* and the vermilions *mineus*; the yellows might represent *flavus*, *pallidus* or *croceus*, the greens *viridis* and *lividus*, and the pale blue *vinetus*. Black and white (*nigredinis*, *candor*) are listed in the text but not represented in the image.[30] Only a very small proportion of the colour-words in this text are pigment-words, so that the illuminator would have had to choose appropriate pigments for himself. It is now clear, too, that the instructions to illuminators which occur in some later sections of the encyclopaedia refer only to subjects, and give no indications of the colours to be used.[31]

Much of Le Palmer's information derives from one of the most popular of thirteenth-century encyclopaedias, by another Englishman, the *De Proprietatibus Rerum* of Bartholomeus Anglicus (*c.* 1230–60); but an examination of the extensive colour-vocabulary in this compendium tells us very little about Le Palmer's choice of terms. All his colours are in Bartholomeus, but their classification in the *De Proprietatibus Rerum* is sometimes far from obvious. *Candor*, *pallor*, *livor* and *flavor* are classed as white,[32] but *flavus* is also a yellow, as are *croceus* and *puniceus*.[33] Jehan Le Begue, who cited the *De Proprietatibus Rerum* in his table of colours, was naturally puzzled by the discrepancy, and suggested, surprisingly, that *puniceus* contained less red than did *citrinus*.[34] But in a later chapter of Bartholomeus *puniceus* is also identified with shellfish-purple; and again *pheniceus*, 'therewith chief lettre of bookes ben ywrite', in the Middle English version of John of Trevisa (which, interestingly, does not usually translate the Latin terms) is made of *siricum*, another word for *minium*.[35] *Mineus*, according to Bartholomeus, is also called *coccinus* or *vermiculus*, and is an earth from the Red Sea used by scribes and especially by dyers, although *coccus* and *vermiculus* were not usually terms for mineral colours, but synonyms for the animal-dye *kermes*.[36] In the prevailing confusion, it is hard to see how painters could handle colour by any means other than local conventions and rules of thumb.[37]

Red and green: the psychological effects of colour

There is, however, one important way in which Alexander Nequam seems to be close to the later *De Proprietatibus Rerum*, and which may help to explain why the colour-vocabularies of the twelfth and thirteenth centuries are indeed so confused. It is bound up with the widespread medieval view of the inherent instability of colour-sensations (see p. 69). Nequam's list of the equipment of the scriptorium includes black or green blinds of cloth or skin, and he offers a psychological explanation of why the colours green and black rest the eyes, where white dazzles and tires them.[38] A low-toned surface on which to rest the eyes had been used in scriptoria since Antiquity, when green had also been regarded as serving a similar function, and green gemstones were powdered for use as an eye-ointment.[39] Following

the Pseudo-Aristotle's interpretation of colours as arising from various mixtures in the four elements, Bartholomeus observed (in John of Trevisa's version):

> Grene colour is most liking to the sight for comynge togyderes of fuyry parties [fiery parts] and of eorthe. For briytnesse of fuyre that in grene is temperat pleseth the sight. And dymnesse of eorthe and blaknesse, for it is noght most blak, gadereth mereliche the sight and comforteth the visible spirit...[40]

Later he expanded on the place of green in the colour-scale, and its extraordinary effect, not only on men but also on animals:

> Thanne grene colour is mene bytwene rede and black, and draweth and conforteth the yhen [eyes] to byholde and loke theronne, and restoreth and conforteth the sight. Therefore hertes and othere wilde bestes loveth and haunteth grene place, and nought oonliche for mete but also for liknge and for sight. Therefore hunters clotheth hemself in grene, for the beste loveth kyndeliche grene coloures and dredeth the lasse the periles of hunters whanne they biholdeth on grene...[41]

This is the subjective dimension of a quasi-objective theory of colours as embodying proportions of the four elements, which were, of course, related to the mixture of humours in the human and animal body. But Bartholomeus also argued that, although red stood, strictly speaking, mid-way between black and white on the colour-scale, it did not appear to do so, since it 'accordeth more in blasynge [i.e. in heraldry] with white than black'.[42]

> And therefore deep rede toschedeth [separates] the sight, as bright light doth, and gadereth nouyt the sight, as blak doth. Therefore draperes that selleth clothe hongeth rede clothe tofore the light, for rednesse scholde toschede the spirit of sight, and men that seeth othre clothes of other colour schulde knowe the worse the verrey colours.[43]

This was precisely the opposite effect to that of green.

Thus both Nequam and Bartholomeus showed an acute awareness of the fallibility of colour-judgment, which is amply reflected in the great variety of terms in use in the scriptoria of the twelfth and thirteenth centuries. It would be thoroughly consistent with this awareness of human frailty that spectacles should have made their first appearance in the context of manuscript production. Only perhaps the personal, 'hands-on' experience of the workshop and its tools and materials could bring order to this chaos – if indeed that was ever seriously required.

6 · Ghiberti and Light

AMONG THE LEAST STUDIED OF Lorenzo Ghiberti's activities is his work as a goldsmith and jeweler, and as a designer of stained glass. This is hardly surprising, since none of his jewelery seems to have survived in the original – although

37
42

we may gain some idea of its style from an early cast – and the windows which he designed for the cathedral in Florence between 1404 and 1443 are not always easily seen, and have been frequently and heavily restored. What we know of the window designs, as well as what may be inferred from written accounts of some of the jewelery by Ghiberti himself, underlines his stylistic connections with the Trecento; and this aspect of his work may rightly be felt to pale into insignificance beside the brilliant and original achievements of the Baptistry doors and the figures for Orsanmichele in Florence.[1]

Ghiberti's theoretical *Third Commentary*, dealing with optics and the proportions of the human figure, and by far the longest of his written works, is also relatively little known. Compared, too, with the ideas of Leon Battista Alberti, Ghiberti's seem old-fashioned, although it would on the face of it be unfair to treat the imperfect and incoherent text which has come down to us as in the same category as a treatise like Alberti's *Della Pittura*.[2] An early scholar who gave detailed attention to the *Third Commentary*, and who performed the useful service of listing Ghiberti's sources, dismissed it as a thoroughly unoriginal compilation.[3] What has not been done even now is to make a complete collation of Ghiberti's words and those of his authorities, or even to identify these authorities precisely.[4] What I am suggesting here is that, so far from copying haphazardly, Ghiberti was selective in his choice and use of sources; that he modified and amplified them in the light of his own interests and experience;[5] that this shaping experience was often that of the goldsmith and glass-designer; and that the interrelation of practice and theory was at one with the tendencies of his humanistic milieu.

Ghiberti had made his intention, when treating of optics, quite clear in the autobiographical section of the *Second Commentary*:

> In order that I might always hold fast to basic principles, I tried to find out in what way nature functions [in art] and in what [way] I could come close to her; how visual images reach the eye; how the power of vision functions and by what procedures; and in what way the theory of sculpture and painting should be worked out.[6]

The emphasis on the 'first principles of nature' is identical to Alberti's,[7] and there are some indications that the *Third Commentary* was a specific response to *Della*

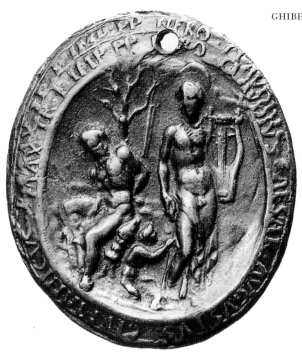

All the jewelery designed by Lorenzo Ghiberti is lost, but this early cast of a cornelian carved with *Apollo and Marsyas,* set by him in a modern frame, may give an idea of his style. The setting was already lost by the eighteenth century. (**37**)

Pittura, which had probably appeared in Italian in 1435 and in Latin a year later. Ghiberti's text is generally dated to the late 1440s, but it probably reflects his reading over many years – he was certainly working on the *First Commentary* as early as 1430.

Ghiberti and gemstones

Both Alberti and Ghiberti began by stressing the unique importance of the visible for the artist, but whereas Alberti proceeds to discuss the geometrical properties of the plane surface, Ghiberti considers light as the condition of vision, and treats of its nature and its effect upon the eye. His opening theorems on the nature of light are derived, as he himself acknowledges, from the beginning of the second book of Witelo's *Perspectiva* (*c.* 1280), but he amplifies Witelo's bare statements with a series of examples which proclaim his own direct interest in the subject. Distinguishing light-giving, opaque and translucent bodies, he writes:

> The first is the sun and fire and some precious stones; the second...is that which is of earth or other hard or dark [tenebrosa] material. The third is the translucent [diafano] body: air, water, glass, crystal, chalcedony, beryll.[8]

Some of these examples of light and translucent bodies come directly from Ghiberti's practice as a jeweler, the craft he had recorded enthusiastically in the *Second Commentary*, where he recalled, for example, that

> Pope Eugene [IV] came to live in the city of Florence; he had me make a mitre of gold which weighed fifteen pounds, the gold alone; the stones weighed five-and-a-half pounds. They were valued by local jewellers at 38,000 florins:

they were rubies, sapphires, emeralds and pearls…it was a magnificent piece of work.[9]

Before the later Renaissance practice of facetting stones was widely developed they were usually cut *en cabochon*: round or oblong with a smooth and rounded surface. When they were treated in this way the coloured light did not seem to be received and refracted in flashes, but to glow softly, as if generated from within, as Ghiberti suggested in his example of light-giving bodies.

Most of the first part of his *Third Commentary* is devoted to an account, taken from Alhazen, of the effects of the persistence of vision, of the after-images produced within the eye by strong light-stimuli, and of the varying appearance of objects seen under different conditions of lighting. Here there are again indications that Ghiberti was not merely copying what he had read, but had repeated some of Alhazen's experiments himself,[10] and again he was ready to elaborate on his source by reference to familiar examples. Discussing the dazzling effects of lustre, which hinder the perception of form in delicate carvings, Ghiberti adapted his source so as to modify its sense completely.[11]

Alhazen had been concerned with the problem of perceiving forms where there was no contrast of colour, Ghiberti with the added complication of parti-coloured gemstones, such as a chalcedony engraved with the *Rape of the Palladium* of which he later gave a celebrated description:

> among the [most] remarkable things I ever saw is a wonderfully engraved chalcedony which was in the collection of one of our citizens, by the name of Niccolò Niccoli, a very energetic researcher and investigator of many and excellent antiquities in our time, and into books of Greek and Latin writings. And among his other antiques he had this chalcedony which was more perfect than anything I had ever seen. It was oval in shape, and on it was the figure of a youth holding a knife. He was almost kneeling with one foot upon an altar, the right leg resting on the altar with its foot on the ground, and foreshortened so cunningly and with such skill it was marvellous to see. In his left hand he held a small idol in a napkin; it seemed he was threatening it with his knife. This carving was said by every expert in sculpture and painting, without exception, to be a marvellous thing, and with all the measurements and proportions that any statue or sculpture should have: it was praised to the skies by all the intellectuals. You could not see it well in a strong light, because when fine and polished stones are deeply cut [*essendo in cavo*], the strong light and reflections obscure the understanding of the form. This carving could be seen best when the deeply-cut part was held against the strong light, when it could be seen perfectly.[12]

This example, as well as the immediately preceding descriptions of the Antique sculptures Ghiberti had seen in Rome, Padua and Siena, grew out of Alhazen's discussion of the need to view fine and delicate carving in a moderate light, a preoccupation which may well be understood as close to the heart of a sculptor who was concerned above all with chasing and gilding bronze, and whose supreme qualities as a goldsmith were, according to Benvenuto Cellini – himself of course a fine

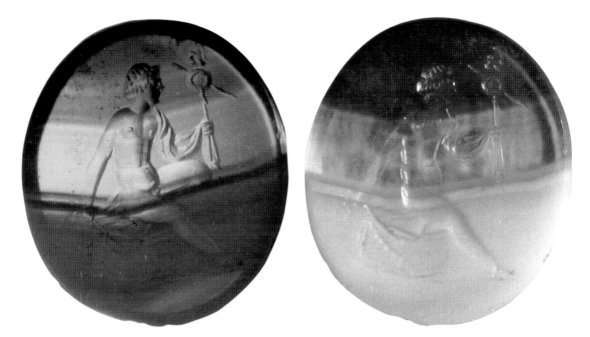

The admired chalcedony carved with the *Rape of the Palladium* has not survived, but another version of the same subject, a cornelian formerly in the collection of Lorenzo de' Medici, demonstrates the problem discussed by Ghiberti, of reading gemstone carvings by (right) reflected and (left) transmitted light. (**38**, **39**)

goldsmith to a succeeding generation – an infinite finesse (*pulitezza*) and extremely careful workmanship.[13] We may imagine that these examples would have been multiplied and integrated into the coherent treatise for which Ghiberti's notes were presumably intended.

The art of glass

Nor were Ghiberti's activities as a jeweler and his search for some theoretical discussion of the art in the *Third Commentary* unrelated to his work as a stained-glass designer. Ever since Antiquity the art of the jeweler, and especially that branch of the art concerned with the art of making artificial gemstones, had been closely associated with the art of glass, and in the Middle Ages, with the art of making stained and painted windows.[14] In Italy, furthermore, it seems that within the craft of glassmaking a relatively self-conscious body of art theory, not confined simply to transmitting technical recipes, had emerged rather earlier than within the arts of painting in tempera and fresco. The late fourteenth-century treatise on glass-painting by Antonio da Pisa, who has usually been identified with the artist signing and dating a window after a design by Agnolo Gaddi in the south aisle of Florence Cathedral in 1395,[15] offers hints on professional conduct which remind us of the contemporary *Libro dell'Arte* of Cennino Cennini, and precepts on colour-contrast and harmony which look forward to Alberti's *Della Pittura*.[16]

Antonio da Pisa's workshop has been seen as very active in Florence during the last quarter of the fourteenth century,[17] and, although too little is known of its personnel to determine whether the executants of Ghiberti's designs came from it, a number of the features in the windows designed by him are recommended by Antonio – for example the ubiquitous blue grounds and the yellow capitals and white or flesh-pink columns seen in the St Barnabas window of 1441 in the Chapel of Sts Barnabas and Victor in the south tribuna of Sta Maria del Fiore.[18] Between 1404 and 1443 Ghiberti submitted some thirty window-designs for the Cathedral, not all of which were accepted or executed. Modern scholarship is divided as to the extent of his freedom of operation in these designs and the degree of his participation on their execution, and the documentary evidence is certainly full of ambiguities.

The only specific reference to the nature of Ghiberti's contribution speaks of some designs of 1438 as being on paper (*in charte di banbagia*),[19] which may or may not imply indications of colour. Antonio da Pisa had recommended the glass-painter to study frescoes in order to work out his colour-schemes, which suggests that the cartoons supplied to these painters were usually uncoloured; and Cennini implied that it was rare for the non-specialist painter to work on the glass himself, although he gave instructions how to do so.[20] On the other hand, we know that coloured cartoons *were* used in Florence, for in 1395 Agnolo Gaddi was paid by the Cathedral *pro pingendo designum dicte fenestre*:[21] and the first glass-painter to execute a design by Ghiberti, Niccolò di Piero, who made the magnificent *Assumption* for the oculus in the Cathedral façade in 1405, was soon to execute windows in Orsanmichele after coloured cartoons by Lorenzo Monaco.[22] Paolo Uccello, who had trained in Ghiberti's workshop, was paid in January 1444 '*pro suo labore in pingendo unum oculum factum per dictum Bernardum [di Francesco]*': the *Ascension* for the drum of the Cathedral, the design for which had prevailed over Ghiberti's own in a competition the previous summer.[23]

But whether or not Ghiberti chose his own colour-scheme, and painted on the glass from his designs, the long series of commissions for the Cathedral windows will surely have brought him into close contact with the glass-painters' milieu, where it is likely that he will have discussed technical and even aesthetic problems common to the jeweler and glass-painter. And in the *Third Commentary*, quoting from Roger Bacon (*Opus Maius*, V, I, dist. vi, ch. iv) on the substantial and sensible nature of images (*species*), Ghiberti included the observation that, 'when the sun's ray passes through a glass [window] or through a strongly coloured [oiled] cloth, the image of the colour appears upon the dark body [opposite]'.[24]

The humanists and light

The central preoccupation of Ghiberti's optics is light: its effects and how the eye receives it; and it is a concern which seems to have affected no other artist of his period so profoundly.[25] It is his achievement to have related the medieval science of vision to the practice of sculpture and painting. But the discussion of light was by

42

no means an uncommon topic in the humanistic circle in which he found himself towards the end of his career. He had studied the chalcedony with the *Rape of the Palladium*, which he later described so enthusiastically and so acutely, in the collection of Niccolò Niccoli, and Niccoli was a humanist scholar of some aesthetic sensibility, whose love of Antiquity was by no means purely antiquarian or merely bookish.[26] His scholarship and connoisseurship were of the sort that affected his style of life. The bookseller and biographer Vespasiano da Bisticci described how he 'was accustomed to have his meals served to him in beautiful old dishes; his table would be decked with vases of porcelain and he drank from a cup of crystal or of some other fine stone'.[27] If it was through Niccoli's researches that Ghiberti was introduced to the complete *Natural History* of Pliny, whose history of ancient art in that book provided the substance of Ghiberti's *First Commentary*,[28] the scholar may also have drawn Ghiberti's attention to the account of the manufacture of artificial gems in Book XXXVII of the same source, for this was an interest shared by both of them.

Niccoli's taste for Antique gems was recognized by another member of the circle, the Calmodolese friar Ambrogio Traversari, whose travels on Church business were combined with the searching out of antiquities for his friend. Traversari clearly knew his man: of a portrait of the younger Scipio in onyx, owned by the antiquarian Cyriac of Ancona, he wrote to Niccoli that it was 'of supreme elegance; never had I seen a more beautiful one'.[29] And it was to Niccoli that he wrote a remarkable letter in December 1433, describing the beauties of the magnificent Basilica Ursiana (*c.* 400; demolished 1733) and S. Vitale in Ravenna:

> I first looked at the superb cathedral with its silver altar, from which rise five silver columns, and with its silver baldaquin. As if this were not enough, there are also marble capitals jutting from the altar, for the decoration of the church, and which in ancient times were clad in silver, most of which has survived. I must admit that I have not seen more beautiful holy edifices even in Rome. There are rows of huge marble columns, and the interior of the building is clad almost entirely with sheets of variegated marble and porphyry. I have scarcely seen more beautiful mosaics anywhere. I inspected the highly decorated Baptistry next to this large church, and then went to look at the most astonishing and magnificent church of St Vitale the Martyr, which is actually circular, and is decorated with every superior and excellent kind of mosaic. There are columns around the circumference of the Sanctuary, and various marble incrustations cover the inner walls. It has a raised platform [*peripatum*] from which the columns spring, and an altar of such shining [*lucidam*] alabaster that it reflects images like mirrors...

In the monastery of Sta Maria in Porta Traversari found 'a beautiful twisted porphyry urn' which the *simpliciores fratres* held to be one of those used by Christ at Cana of Galilee when changing the water into wine.[30] His response to Ravenna may be seen on the one hand as the revival of a peculiarly Early Christian and Byzantine aesthetic;[31] but it was also a response in sympathy with the Neo-Platonism of the Niccoli circle, which Traversari was himself very active in promoting. For in the

early 1430s Traversari was engaged upon a new Latin translation of the fifth- or sixth-century Greek works of the Pseudo-Dionysius the Areopagite, a translation which he carried out in consultation with Niccoli, and which gained the warm recognition of both his friend and other humanist scholars for its clarity and its improvements on the ninth-century versions of Hilduin and Johannes Scotus Eriugena.[32] Pseudo-Dionysius's writing was essentially theological, but his treatise *On the Divine Names* included a chapter, 'On the Good and the Beautiful', which became one of the most important texts in medieval aesthetics, and was extensively glossed by, for example, Albertus Magnus and Aquinas.[33] In this account, the qualities of beauty (itself identified with good) are recognized as harmony (*consonantia*) and luminosity (*claritas*), which are said to extend over the created world 'in the likeness of light'.[34] Light thus becomes the chief manifestation of beauty, and clarity and lucidity become the highest qualities in a work of art.

The connection of such an aesthetic outlook with the work of the glass-painter and jeweler is inescapable: it has been long recognized in the patronage and propaganda of Abbot Suger at Saint-Denis in the twelfth century.[35] But it was also an attitude of some importance to Ghiberti, who had been in touch with the latest translator of the Pseudo-Dionysius at least since 1430, when through him he had sought to borrow another Greek manuscript for use in the *First Commentary*.[36]

Ghiberti's thoroughly eclectic discussion of optics in no way constitutes a manifesto of Neo-Platonism, although Plato is mentioned from time to time among his authorities; but in proposing to give a scientific basis to the study and use of light in the arts of sculpture and painting, and especially in the arts of gem-cutting and glass-painting, he was adding substance to the aesthetic of light which was so alive in the Niccoli circle; and in so doing, he contributed to that strand of artistic theory which passed, not through Alberti, but through Marsilio Ficino (who re-translated the Pseudo-Dionysius) to the synthesis of Leonardo da Vinci.

7 · *Color Colorado* – Cross-cultural Studies in the Ancient Americas

T HE COHERENCE OF THE EARLY RENAISSANCE humanistic culture which we saw in the last chapter is uncharacteristic. In Chapter 5 we saw that medieval Western colour-language poses great problems of interpretation, and these problems are compounded in the case of exotic cultures confronted by Western travellers and conquerors in the Renaissance period. One of the central problems in the modern study of cultures has been, of course, the problem of origins: the question of whether similar cultural practices are to be understood as independent developments within particular societies; whether they can be accounted for by intrinsic, quasi-biological mental characteristics common to the whole of humankind, or only by the diffusion of ideas from a small number of geographical centres. Over the past three decades the universalist model has tended to prevail in ethno-linguistics, and the example of colour-vocabularies has been seen as central to it.[1] What the historian of art can contribute to this debate are considerations arising from the history of the technology of artefacts, which bear on the question of how some cultures understand colour, and how this understanding may be embodied in language. Here I shall discuss instances from the linguistic usages and craft-practices of some of the indigenous peoples of Central and South America around the time of the Spanish Conquest, and in the nature of the case, most of my information will be drawn from Spanish reports of these, to them, alien cultures.

'Basic Color Terms' – the problems

Berlin and Kay's seminal evolutionary scheme of linguistic development (p. 29 above) depends on the assumption that in any language there is a set of 'basic' colour-terms, which expands in a more-or-less regular sequence of seven stages, over time, from two terms, for 'black' and 'white', to eleven, for 'black', 'white', 'red', 'green', 'yellow', 'blue', 'brown', 'purple', 'pink', 'orange' and 'grey'. Thus among the Mexican languages examined in their study, all the indigenous colour-vocabularies, in Ixcatec, Mazatec, Sierra Popoluca, Tarascan, Tzeltal and Tzotzil, were at their Stage IV, with five basic terms, for black, white, red, green or else blue, and yellow or else orange, where Mexican Spanish was at Stage VII, with a full complement of eleven.

Critics of Berlin and Kay's scheme have drawn attention to the problems inherent in their notion of 'basic'.[2] In their 1969 book they argued that a basic colour-term must be monolexemic, that is, its meaning must not be predictable from the meaning of its parts (as would be the case with, for example, 'crimson' among reds);

that it must be psychologically salient (that is, in common use among all users of a language); that its application must not be confined to a narrow class of objects; that it should not also be the name of a coloured object; and that it should not be a recent loan-word.[3] In the absence of any agreement about what constitutes 'recent', according to these criteria at least five of the eleven 'basic terms' in Spanish are problematic, since all of them derive from concrete objects and are borrowings from other languages. *Azul* and *anaranjado* derive from the Arabic for a blue stone and probably a fruit; *café, gris* and *rosa* derive from the French.[4]

Berlin and Kay's method for establishing the corpus of basic colour-terms in the various languages is similarly suspect. They first elicited a list of colour-terms from each informant – sometimes only one informant for each language – and as most of their informants were living in the San Francisco Bay area of California, the question of the influence of bilingualism should have been addressed at every stage of their enquiry.[5] Berlin and Kay did indeed address it in the context of their most important procedure, which was to ask each informant to plot both the focus and the perimeters of each colour-category on a chart made up of Munsell chips arranged in a broadly spectral order, but also showing light and dark values of each hue. They argued that English usage could hardly influence the identification of foci in a range of twenty genetically diverse languages; and in the case of Tzeltal, where a group of forty informants was tested in their own region of southern Mexico, no appreciable difference was found between the responses of monolingual informants and those bilingual in Tzeltal and Spanish.[6]

Tzeltal, as a Stage IV language, has a single term, *yas̆*, covering green and blue, although most of Berlin's informants interpreted it as having its focus in the green area; and all the twenty-six Mayan languages included in Berlin and Kay's survey also show this Stage IV characteristic of a common term for green and blue. It is worth noting that a very prominent type of indigenous Mexican artistic practice is the incrustation of objects with a mosaic of turquoise and jadeite, or the decoration of earthenware with a turquoise glaze, probably in imitation of these precious materials.[7] The earthenware glaze might well be described by most English-speakers as 'blue-green', or, indeed, 'turquoise', and the coloured stones incorporate a range of blue-green and green tones in the same object (and are of course made of the same materials), so that a single term would certainly be appropriate to describe them. In his wonderfully comprehensive Nahuatl encyclopaedia of life in Mexico after the Spanish Conquest, Fray Bernardino de Sahagún describes the dealer in turquoise, green jade and blue obsidian under the heading of 'green-stone-seller' (*chalchiuhnamac*). Thus sixteenth-century Nahua usage comes close to modern Tzeltal usage, even though it was perfectly possible in classical Nahuatl to find more than one term even for 'blue'.[8] According to the late sixteenth-century dictionary of Fray Alfonso de Molina, which was consulted by Sahagún, classical Nahuatl had a colour-vocabulary of at least eleven terms, and would thus have been, like modern Spanish, one of Berlin and Kay's Stage VII languages.[9]

Berlin and Kay's scheme of evolution depends upon the location of foci for each basic colour-term; they found that the perimeters of colour-categories, where they shaded into the areas of other colours, were far more fluid, and that even the

43

same informant might draw these perimeters in different places on different occasions. They were thus unable to use category-boundaries or total 'colour' area as indicative of the identification of 'basic' colours.[10] But in excluding these peripheral judgments they were surely disallowing what is precisely our normal experience of colour-usage. Disputes about colour hinge, more often than not, on the identification of these liminal areas as belonging to one colour-category or another. We still have many difficulties in assigning particular nuances to one or other category, and attempt to resolve them by discussion.

In everyday life we are, I suggest, far more concerned with nuances than with the saturated 'primary' colours whose identification has been relatively recent, and whose importance has largely been confined to the specialized contexts of the painter's workshop and the physical or psychological laboratory.[11] The search for the 'primaries' or 'basics' of colour, whose linguistic dimension is encapsulated in Berlin and Kay's enterprise, has proved to be remarkably inconsequential, and it has been freighted with a heavy burden of ideology which seems far from the concerns of the ordinary user of colour-language. Richness and variety are far more characteristic of colour-vocabularies than restriction, and in Meso-America and South America this richness is amply embodied in the artefacts, especially the feather-work,[12] textiles and painting which are so characteristic of the periods before the Spanish Conquest.

Colour-terms and colour-products

Alfonso de Molina lists around fourteen Nahua colour-terms, and the Inca languages Quechua and Aymara each included some dozen in the sixteenth century. Quechua, interestingly, had a particular term, and possibly two distinct terms, for a combination of black and white; and it is striking how frequent was the black-and-white chequerboard pattern of Inca textiles.[13] The extremely complex forms and colour-juxtapositions in the Aztec *tonalamatl*, as well as in Inca weaving, indicate not only a taste for a great range of decorative colours, but also a capacity to discriminate between them, and to contrast them with great skill. The taste for variety in colour is witnessed by many of the early documents. In Hernàn Cortès's second letter of 1520 to the Emperor Charles V he reports of colour-vendors in the market at Temixtitlan: 'They sell as many colours for painters as may be found in Spain, and all of excellent hues.'[14] Sahagún lists a dozen nuances of dyed fur available at the market;[15] and he also retells a Nahua legend of the Golden Age of Tula, when cotton grew already dyed in twelve colours. In his Spanish version of this legend he lists only eleven hues, another indication that the Aztecs were no less capable than their conquerors of handling an extensive range of colour-ideas.[16]

But perhaps the most vivid and compelling evidence of this highly developed colour sensibility is the artefacts themselves. The complex interweaving forms of the *tonalamatl* demanded a careful distribution of colour-areas using less than a dozen paints; but the technology of weaving ensured that, with a far more extensive palette, the arrangement of colours in complex designs was the result of careful

40
44

An Inca poncho woven with a typical black-and-white step-design. One Inca language, Quechua, has specific terms for both 'black-and-white' and this chequerboard motif. (**40**)

44 planning, and planning, of course, involves a high degree of conceptualization. It is the remarkably well preserved textiles from the desert cemeteries of Paracas in Peru which have received most attention from modern scholars – textiles which seem to have been constructed on the simplest of looms, but with an extraordinary degree of craft-skill and imagination. The Peruvian techniques of weaving have hitherto been more studied than their methods of dyeing, but it is at least clear that they used a wide range of organic and inorganic dyestuffs, including indigo, cochineal, and the purple dye from a variety of coastal mollusc.[17] The distinguished anthropologist Franz Boas, in his implausibly titled *Primitive Art* (1927), gave perhaps the first detailed analysis of the highly-controlled rhythms of Peruvian weaving,[18] and this type of analysis was developed by L. M. O'Neale in the case of a complicated patch-work fragment (Supe Middle Period), where in a repeated jaguar motif, she identified a total of seventeen nuances of colour.[19]

Although there seem to be no very early written documents of craft-practice among the Inca, an early eighteenth-century Jesuit manual of dyeing, which records traditional Indian methods in Quito and Cajamarca, described the use of more than twenty colorants, some of them labelled in Spanish, some in indigenous terms.[20] Many of these terms are evidently idiosyncratic and highly specialized, and it would be quite misleading to suggest that they ever came into everyday use. But they are evidence of a capacity for colour-discrimination and description among a particular group in a given culture on a par with what has long been known in the context of animal-husbandry, where the discrimination of hide-colours has been crucial to effective economic activity. This capacity for extensive discrimination has also been identified in the twentieth century among the Andean shepherds and

An Aztec cosmic map distinguishing each of the four cardinal directions with a colour – north (right) with yellow, south with green, east with red, and west with blue. (**41**)

herdsmen, who use a vocabulary of at least nineteen nuances between 'absolute' white and 'absolute' black.[21] In colour-usage the tendency towards the construction of 'basic' categories – reinforced by the reductive procedures of optical and physiological science[22] – has been matched or, in my view, outweighed, by the tendency towards an increasingly subtle discrimination in certain crucial areas; and this pattern of development does not, it seems, conform to the model of cultural evolution proposed by Berlin and Kay.

Colour and direction

So far I have focused on colour-perception as embodied in language and in the making of complex coloured artefacts; but of course the realm of colour in the Pre-Columbian cultures of Central and South American is also, and pre-eminently, the realm of symbolism. Symbolizing belongs to metaphor rather than to perception, and is thus a linguistic, and specifically rhetorical, not an immediately psychological function of the mind, which is one of the reasons why it has proved so difficult to establish anything like a 'basic' universal system of colour-symbols. In the European contexts I have studied, local and even individual usage has prevailed, so that even the notion of 'languages' of colour-symbolism is problematic.[23] Might not the same be true of Pre-Columbian American cultures?

One of the commonest occasions for the use of colour symbolically was in the attribution of colours to directions, a practice widespread in Asia and the Americas, and notably among the Maya and Aztecs in Mexico. But in the many examples

41

gathered by the anthropologist C. L. Riley, north could be symbolized by black, white, red, yellow, blue or grey; south could be blue, red, black, white, green or yellow; east might be white, yellow, blue, grey or green, and west be black, white, yellow, red, blue or green. Among the Maya, both south and east were identified as red or yellow, and in the records of the Aztecs we find north as black, white, yellow or red; south as blue, red or yellow; east as red, green-white or yellow; and west as white or black, yellow, red or green. Modern commentators on a single manuscript, the *Codex Borgia*, have been puzzled that the colours given to the directions have varied from page to page.[24] Riley has summarized the problem in by now very familiar terms:

> One of the most striking things about the colour-direction symbolism through-out this entire Meso-American-Southwestern area is the remarkable lack of uniformity in associations from one culture to another. Even within the same group, two informants may give different colour-direction associations.[25]

She speculates that the discrepancies may be due to different usages for different ritual occasions, and so they may; and they may thus yield to further investigation. But, quite apart from the inherent fluidity of colour-perceptions, so that we can never be quite sure in some cases whether we are looking at a red or a yellow, not to mention a blue or a green,[26] this instability in Pre-Columbian colour-symbolism is paralleled precisely in medieval and Renaissance examples in Europe, and may be attributable to nothing more compelling than the individual imagination of the artists responsible for colouring symbolic objects.

The significance of red

Few colours have been so heavily freighted with symbolic resonances as red. In the Indo-European languages this may have been because 'red' has been seen as the colour *par excellence* of life-giving blood. Indeed, the terms 'red', 'rouge', 'rot', or 'rosso' derive from the Sanskrit word *rudhirā* meaning 'blood'. In the Inca language Aymara, a synonym for *grana* (Spanish: crimson), beside *puca*, was *vila*, a term for 'blood'; and Sahagún includes in his encyclopaedia an Aztec version of the widespread belief that the bloodstone (*eztetl*) could be used in a process of sympathetic magic to staunch menstrual or other bleeding.[27] The Spanish 'rojo' (from the Latin *russeus*) is a particularly interesting case because it appears to have arrived rather late in common usage; 'bermejo', from the natural or artificial cinnabar 'bermellon' (vermilion), was by far the commonest Spanish term for 'red' in the Middle Ages.[28] Little seems to be known of the earliest history of the indigenous languages of Central and South America, so that we are scarcely able to make judgments of meaning based on an analysis of semantic change; but it is notable that a semantic link has been proposed between an Aztec term for red ochre, *tlauitl*, and the verb 'to illuminate' or 'to shine', *tlauia*, in a way which has a clear parallel in Greek and Latin.[29]

By far the most important red of this region was the dyestuff cochineal, known in Nahuatl as *nochetzli*, in Quechua as *llankapuca*, or simply *puca*, in Aymara as *chupica* and in Spanish as *grana*.[30] In the classic seventeenth-century account of South

American weaving, Bernabé Cobo dwelt on the fine and multicoloured cloths he found there, woven of yarns dyed

> yellow, black and many other colours, and above all crimson or *grana*, which makes them famous throughout many parts of the world, and their dyes can compete with the best to be found…[31]

Cobo is echoing Sahagún who, at least for the benefit of his Spanish readers, included an enthusiastic endorsement of the international fame of this Mexican dye:

> This *grana* is well-known inside and outside this country, and it is big business. It has been exported as far away as China and Turkey, and it is prized and respected throughout almost the whole world. The *grana* which is already refined and made into cakes is called strong [*recia*] or fine *grana*. They sell it in the market-place in cake-form, and in this form it is purchased by painters and dyers…[32]

So valuable were these coloured grains, the dried bodies of the female insect *Dacty-lopius coccus cacti*, that they were used as tribute money by the Aztecs: we have records of such tribute to Moctezuma from the cities of Oaxaca and Cuyalapa (?Coyolapan).[33]

The use of the Spanish term *grana* for cochineal arose from a confusion with the very similar European and African insect, *coccus illicus*, which also yielded the most important red dye of the Middle Ages and the Renaissance, *kermes* (Arabic: *qirmiz*), not least in Spain, where it had long been harvested in Andalusia. *Grana* was simply the Italian word for the grain-like bodies of the insects processed to make the dye. *Kermes* was the colorant often used to dye the expensive woollen cloth known in England as 'scarlet'; and by the later Middle Ages, again notably in Spain, *escarlata* had come to signify the red colour itself.[34] Scarlet was enormously prestigious: the thirteenth-century sumptuary laws of the kingdom of Castile and León restricted its use to the king.[35] It was the natural successor to the Roman Imperial purple, and had, indeed, by the end of the fifteenth century in Spain acquired the same meaning as *purpura*.[36]

This prestige and these royal associations also characterized *puca*. When Francisco Pizarro met the Inca Atahualpa at his residence near Cajamarca the Inca's headdress included his specifically royal tassel, '*de lana muy fina de grana*'.[37] The second Inca language, Aymara, had a particular phrase for 'parading about the town dressed in red' (*pucaq thaaratha*), using in this instance the Quechua term *puca* for the dyed cloth. Since it is a Spanish report of Pizarro's audience with Atahualpa, and since all our records of these linguistic usages are by Spanish-speaking lexicographers, it may be that we are simply witnessing the attitudes of the Spanish conquerors, whose colour-language was absorbed in the sixteenth and seventeenth centuries into indigenous usage.[38] But there is at least a hint that the traffic in ideas was not all one way, in the case of the developing meaning of the Spanish term *colorado*.

Colorado, from the Classical Latin *coloratus*, had been used in medieval and Renaissance Spanish sometimes to mean simply 'well-coloured', but usually in con-nection with the pink colour of flesh (as in the English 'to colour', meaning 'to blush').[39] But during the sixteenth and seventeenth centuries, especially in Spanish

America, the term came to replace *bermejo* as a general term for 'red'. Molina's Nahuatl dictionary records the phrase *chichiltic tlapalli* (chilli-red dye) for *color bermejo o colorado*, but also shows that *tlapalli* was used alone to refer to *grana*; and gives the term *tlapalteoxiutli* for the ruby, which Sahagún, in his chapter on precious stones, explained as made up of *tlapalli* (red) and *teoxiutl* (fine turquoise), since the stone was simply a chilli-red turquoise.[40] Sahagún also glossed *tlapalli* as 'good', 'fine', 'precious' and 'wonderful', so that it was, like *colorado*, a general term for colour which had come to mean specifically 'red', and red of the finest and most precious kind.[41] Although this usage was in line with far earlier developments in Europe (*cf.* scarlet) there is no reason to assume that it originated there, since the technology that lay behind it had long existed in Central and South America; and the spread of the new connotations of *colorado* in this region suggests that the Spanish was itself inflected by indigenous ideas.

Critics of Berlin and Kay's treatment of colour-vocabularies have remarked that their experimental methods overlooked the practical contexts in which these vocabularies developed. An historically oriented study of colour-language can help to establish the ways in which particular terms come to be used, and how usages change. The Munsell colour-charts which Berlin and Kay employed in their research present a highly specialized view of colour-relationships, hence the difficulties many informants had in knowing how to use them. Their spectral sequence has become generally familiar only relatively recently, and the apparently 'natural' spectrum of the rainbow has always presented problems to perception.[42]

I have suggested in this study that the notion of 'basic' colours has been far from common among the Central and South American cultures, which have made an exceptional use of a variety of colours in their artefacts, and have developed an extensive vocabulary to describe this use. Most of the historical examples of colour-usage available to us are inevitably from the highest strata of these traditional societies; extensive access to bright colour was the prerogative of the wealthy and the well-born, and it was usually only in the context of public ceremonial that colour impinged upon the population at large. Hence the hierarchy of colour as a system of values, with red at the top. There could scarcely be a greater contrast with Berlin and Kay's informants in and around San Francisco, for whom the spectacle of the polychrome consumer society has become one of the more commonplace, if more attractive aspects of modern life.

Modern ethno-linguistics, with its emphasis on 'basic' colours, has tended to look for, and to find, its allies in physiological optics and experimental psychology, where the method of procedure has normally involved a small number of subjects and a straightforward notion of stimulus and response. We have learned a good deal from this direction about the mechanisms of colour-perception; but we have learned far less about the preferences and interests which shape the uses of colour in human societies. Students of the development of colour-language cannot afford to ignore the artefacts which usually offer the most vivid evidence of a concern for colour-discrimination; and among the Aztecs and the Inca who had been the subject of this study, the highly developed capacity to discriminate was clearly intrinsic to the formal inventiveness of their art.

49

Stained glass is above all
the medium of light, and
Renaissance glaziers often
used lighter colours than
medieval glaziers (15).
Lorenzo Ghiberti made the
design, but it was probably
Antonio da Pisa, author of
one of the most important
technical treatises of the
Early Italian Renaissance,
who executed the St
Barnabas window of 1441 in
Florence Cathedral (right).
Some of da Pisa's
recommendations for
colour-composition (such
as yellow capitals and pink
columns) appear to have
been followed here.
Da Pisa went so far as to
advise the use of white
glass to make a window
'joyful'. (**42**)

Colour-terms and colour-products

The incrusted turquoise and jadeite of this Pre-Columbian Mixtec mask (left) will most likely be described as 'blue-green' by English-speakers, but in the various Pre-Columbian languages it could only have been 'green', for green and blue were not discriminated. In *Basic Color Terms* Berlin and Kay categorize as at Stage IV of development such languages in which green and blue are denoted by a single term. (**43**)

The figured textiles of Pre-Columbian America reveal colour-designing at its most complex and sophisticated. Woven designs such as this tapestry Inca tunic (above), rhythmical with irregularly repeating motifs, offer the most compelling evidence of colour-discrimination at a given period in a particular culture. (**44**)

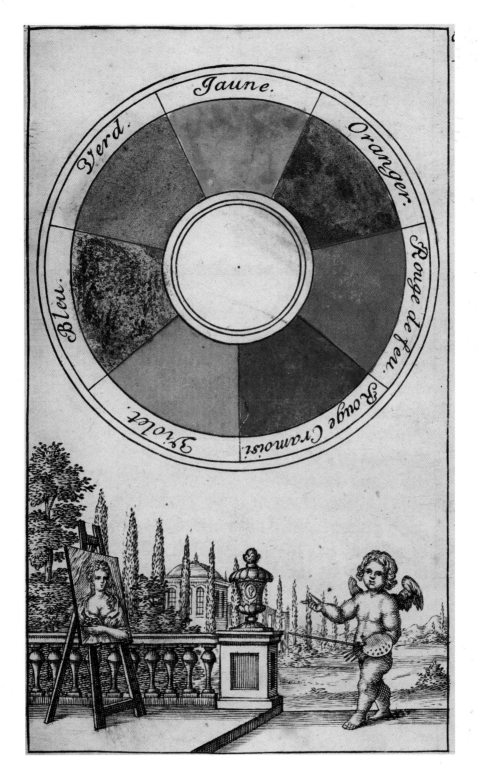

Colour as substance, colour as light

Earth (*c.* 1570) by Giuseppe Arcimboldo (left) is less playful than it seems. The ancient doctrine of the four elements comprising substance, earth, air, fire and water – and the colour proper to each – were subjects much debated in the scientific circles of Rudolph II's Prague, to which the artist belonged. (**45**)

Artists were fascinated by Newton's clear demonstration that light was the only begetter of colour, and his division of the spectrum into seven. Claude Boutet's painter's circle of 1708 (above) was probably the first to be based on Newton's (**58**). But unable to match spectral red with pigment, Boutet substitutes two reds – fire-red and crimson – omitting one of Newton's two blues. To compound confusion, the colourist has evidently misread two of the labels, '*oranger*' and '*violet*'. (**46**)

The following is the text within the illustration:

[8]

Nor owns itself a Cheat, till It expires :
Its little Joys go out by One, and One ;
And leave poor Man, at length, in perfect Night ;
Night darker, than what, *now*, involves the Pole.

O THOU, who dost permit these Ills to fall,
For gracious Ends, and wouldst, that Man should mourn !
O THOU, whose Hand this goodly Fabric fram'd,
Who know'st it best, and wouldst, that Man should know !
What is this sublunary World ? A Vapour ;
A Vapour, all it holds ; Itself a Vapour ;
From the damp Bed of Chaos, by Thy Beam
Exhal'd, ordain'd to swim its destin'd Hour,
In ambient Air, then melt, and disappear ;
Earth's Days are numbred, nor remote her Doom ;
As Mortal, tho' less Transient, than her Sons ;
Yet they doat on her, as the World, and They,
Were both Eternal, Solid ; THOU, a Dream.

— THEY doat, on What ? *Immortal Views* apart,
A Region of Outsides ! a Land of Shadows !
A fruitful Field of flow'ry Promises !
A Wilderness for Joys ! perplext with Doubts,

And

Newton and painting

Newton's ideas about colour have inspired one modern series of paintings: František Kupka's *Discs of Newton* of 1912 (left). Kupka's white segments may refer to the mixture of all colours to white on a spinning disc, although a preparatory work in Paris including a black centre suggests that Newton's Rings (61) may also be a source. (**47**)

The rainbow in William Blake's illustration to Young's *Night Thoughts* of 1797 (above) exemplifies the transient, perishable nature of the sublunary world. As usual with Blake, this is a 'Newtonian' bow with seven colours. (**48**)

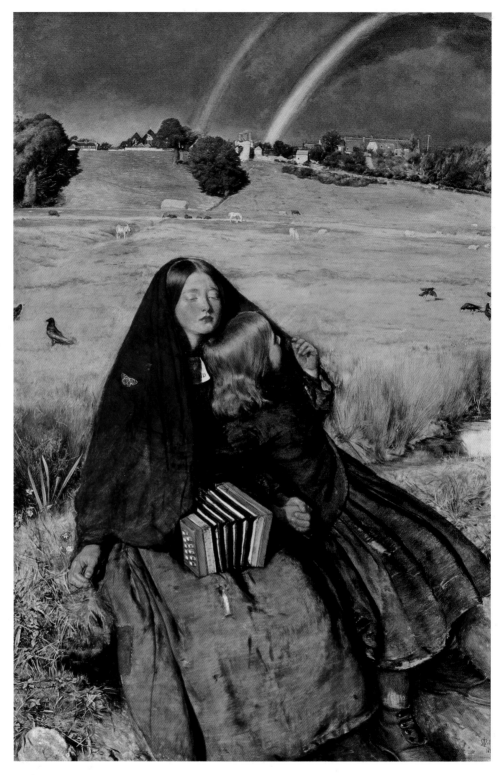

In his poignant study of visual deprivation, *The Blind Girl* of 1856, Millais's exact rendering of the landscape-setting did not extend to the secondary rainbow, where he failed to notice the reversal of the spectral colours until the mistake was pointed out to him by a friend. Imperceptible transitions of hue make the bow a particularly subjective scale of colour. (**49**)

8 · The Fool's Paradise

…that Triangular Glass call'd the fool's Paradise, though fit for the wits of wiser men, which representeth so lively Red, Blew and Green, that no colours can compare with them…

(Christopher Merrett, 1662[1])

IN AN ESSAY OF 1983 THE DOYEN OF modern students of medieval and Renaissance optics, David Lindberg, argued that 'there was much in sixteenth-century optics that was new, but nothing that was revolutionary'.[2] This was not a surprising conclusion given that Lindberg dealt with only two sixteenth-century writers, Francesco Maurolico and Giovanni Battista della Porta, and that his understanding of the history of optics was essentially confined to its geometrical branch, which traces a line from Euclid, through Robert Grosseteste and Theodoric of Freiberg to Descartes and Newton in the seventeenth century. But there are of course several histories of optics: one of them involves the medieval and Renaissance metaphysics of light,[3] and another, which I shall call 'perceptualist', runs from Aristotle through Alhazen and Witelo to Leonardo da Vinci and on to Chevreul in the nineteenth century (Chapter 15) and takes in Newton on the way. It is this 'perceptualist' history which is the subject of the present chapter.

These histories are not, of course, mutually exclusive; it is rather a question of emphasis; but I think it has been generally understood that the geometrical optics of the seventeenth century presented a quite new evaluation of the relationship of light to colour: where for Aristotle light was the activator of colour, and where for most medieval thinkers it was the vehicle of colour, for many scholars in the seventeenth century, notably Descartes and Newton, it came to be identified with colour itself. Colour was inherent in light, and light was the efficient cause of colour in all its manifestations, for colour was the inevitable consequence of the variable refraction of light. And so, by and large, it has remained. The 'perceptualist' account, on the other hand, is concerned, not with the causes of colour, but with its effects, with the way in which a radiant stimulation of the human visual system becomes identified as colour at all. In this account, which developed essentially within a tradition of medical research, the experimentation of the sixteenth century had indeed a major role to play.

The history of the rainbow, characterized in the classic study by Carl Boyer as 'from myth to mathematics', shows how a phenomenon which was traditionally seen as an exemplar of the nature and meaning of colour, became from the seventeenth century a demonstration of the nature of light, to which the perceptual characteristics of colour were largely irrelevant.[4] Seeing the rainbow continued

52

51, 50

53, 55

49

to be a thoroughly uncertain business, since the number and order of the colours was far from easy to ascertain, and this was true not only of the celestial bow, but also of the terrestrial spectrum, created in the laboratory precisely for the purposes of study.

The hexagonal stone

The study of the rainbow in the Latin West had been aided by indoor experiments with the prism since at least the thirteenth century. The perspectivist Roger Bacon had been particularly anxious to test the characteristics of the bow by experimenting with various types of crystal, as well as by making observations of the bows formed in the spray of mill-races or oars. The first modern theory, which proposed that the colours of the bow were produced by double refractions in individual drops, was elaborated by Theodoric of Freiberg in the early fourteenth century, employing spherical flasks of the type used for the collection of urine for medical diagnosis, as well as spherical berylls and hexagonal prisms of natural quartz crystal.[5] Rock-crystal had long been associated with the rainbow; in Antiquity it was already noted for its capacity to intercept the rays of the sun and project rainbow-colours on to a surface.[6] The late-Antique encyclopaedist Solinus held that quartz was mined in the Red Sea by the Arabs, and this was an opinion which passed through Isidore of Seville into general currency in the Middle Ages. But by the thirteenth century this stone was also being discovered in the Italian Alps, in Germany and in Ireland.[7] Half a century before Theodoric, another German Dominican, Albertus Magnus, who wrote on minerals as well as on the rainbow, described the effect of light on a crystal he had himself found in the Rhineland:

> If it is held up indoors so that part of it is in sunshine and part is kept in the shade, it casts a reflection of a beautiful rainbow on the opposite wall or anything else, and therefore it is called *Iris*...[8]

Albertus explained that the crystal was formed of water 'from dried-out moisture escaping from the material of a stone produced from red clay...just turning into dew, hardening partly from vapour and partly from dewdrops melting away', a view which persisted into the sixteenth century.[9] It thus provided a close analogy with the raindrop, which Albertus, like Theodoric, regarded as the source of the colours in the rainbow. But the natural hexagonal form produced internal refractions and reflections which were far too complex for systematic study: as the scientific Archbishop of Canterbury, John Pecham, put it in the late thirteenth century, 'the colours are seen from every direction';[10] and already by this time the Polish scholar Witelo, investigating the bow at Viterbo in the 1270s, was masking off some of the facets of the stone in order to concentrate the refractions. Witelo gave what was at that time by far the longest and most circumstantial account of experiments with the hexagonal stone. He had a clear sense that the various colours of the spectrum were functions of the various angles of refraction of the incident ray of light. He covered two of the faces with wax so that this incident ray would pass through the

50

Theodoric of Freiberg's refraction-diagram of *c.* 1304 showing the passage of a ray of light through a hexagonal crystal (to the eye or to another surface, a–d). The perpendiculars to the faces of the crystal (c–f and b–g) allow the angle of refraction to be calculated. Freiberg's important discussion on the rainbow was based partly on such prismatic experiments. (**50**)

intermediate face in one half of the crystal and emerge through the three remaining faces. Witelo believed that the three colours of the spectrum, which, following Aristotle, he identified as *puniceus, xanthus* (in Latin *viridis* or *indicus*) and *alurgus,* were directly related to the three active faces of the modified crystal:

> The variety of colours is a function of the shape of the body, since different colours appear with whatsoever other crystal or transparent body of a different shape, although they have the same order of colours as in the rainbow.[11]

The colours produced by this modified crystal were stronger and brighter than those produced by the unmodified stone; and Witelo even found it hard to accept that the colours resulting from the passage of light through a spherical flask filled with water were the true rainbow-colours, since they were not, he said, the same three in number.[12]

The reduction of means

The arguments derived by Witelo from this 'jolly game' (*ludus iocosus*) with the hexagonal crystal were developed more systematically by Theodoric of Freiberg, who argued that the spectral image would be stronger if the rays of light were allowed to pass through a minimum of denser medium; and in some of his experiments he calculated in terms of three, rather than six angles in the prism.[13] The principle that nature worked by the simplest means was gathering momentum during the thirteenth century. Bacon's Franciscan predecessor Robert Grosseteste had argued in his important discussion of the rainbow that 'every operation of nature is by the most finite, most ordered, shortest and best means possible'.[14] This economic attitude led in Theodoric's time to the formulation of 'Ockham's Razor' (the principle that entities must not be multiplied unnecessarily, an agument against the real existence of universals), and it was of course very crucial to the mechanization of optics in the seventeenth century, for example in Fermat's principle of least time (the geometrical proof that the refraction of a ray of light in its passage from a

less dense to a denser medium shortens the distance travelled, and thus compensates for its slower velocity in that denser medium).[15]

Given that Grosseteste had proposed that sight and colour offered a paradigm of the corporeal and incorporeal elements in the Holy Trinity, and that his follower Bacon had urged the important theological significance of numerology, and had indeed argued that the equilateral triangle gave insights into the nature of the Trinity itself,[16] we might well have expected that Witelo's emphasis on the three active faces of his crystal would have led, by the power of symbolizing as well as by the principle of simplicity, to the development of the modern triangular prism. Certainly, in the fourteenth century the notion of the three colours of the Trinity was articulated very forcefully in a popular French devotional poem, Guillaume de Digulleville's *Pilgrimage of the Soul* (c.1355). But so far from appealing to the rainbow, with all its traditional connotations of the Covenant between God and man, the bridge between Heaven and Earth, Digulleville exemplified his triad of colours in the unity of a single phenomenon, colour-change: the unchanging gold of the Father, the scarlet (*vermeil*) blood of the Son and the comforting green of the Holy Spirit, in the colours of the peacock and the shot-silk cloth which was also commonly associated with the colours of the peacock's feathers.[17]

Bacon, in his lengthy discussion of the crucial usefulness of physics and mathematics in the *Opus Maius*, had adduced the equilateral triangle as a perfect image of the Trinity precisely because it was a figure which could be found nowhere else in nature. And of course, unlike the lense, whose early development was based on an analogy with the crystalline lense of the eye, the triangular prism is in no way a natural shape.[18] Perhaps in the thirteenth century the association of the Trinity with the triangle, a Manichean notion which had been roundly condemned by St Augustine, was still too theologically suspect; it only became less so in the early Renaissance, when the triangle appeared increasingly as the form of the halo of God. This suspicion was in spite of the growing popularity in the later Middle Ages of the triangular devotional image of the Trinity known as the *Scutum Fidei* (Shield of Faith), which seems to have been devised by Grosseteste himself.[19]

The triangular prism was thus an astonishing development: a purpose-built tool for which there were no precedents either in nature or in the Ancient world. The philosophical and theological contexts would have led us to expect its appearance no later than the fourteenth century, but there seems to be no evidence for it before the middle of the sixteenth.

The prism in the sixteenth century

Albertus Magnus in his *Meteorology* (III, iv, 19) appears to have distinguished between the hexagonal rock-crystal called the *iris*, and a '*crystallo angulosa longa*' which had the same properties as the *iris*; but he gave no further details.[20] Witelo's *Optics* was well known in the early Renaissance – in Italy it was consulted by both Ghiberti and Leonardo da Vinci, who may have been introduced to it by the mathematician Luca Pacioli.[21] Ockham's logic of economy was also particularly

Robert Grosseteste's triangular diagram of the Trinity, the *Scutum Fidei* (before 1231), with Father, Son and Holy Ghost united in God at the centre. (**51**)

cultivated in Renaissance Italy, where his works were studied and published at Bologna in the 1490s.[22] Theodoric of Freiberg's work was less known, although it was summarized by Jodocus Trutfetter in his *Philosophie Naturalis Summa*, printed at Erfurt in 1517. Trutfetter's version is especially interesting, not least because it gives some precocious attention to the shifting Latin vocabulary of the rainbow-colours; and it also offers perhaps the earliest published analysis of the use of tonal contrast by painters in order to create the effect of space.[23] But in the present context what is most striking is Trutfetter's description of the optical experiments he conducted, using a darkened room with a single hole in the shutter to allow the sun's rays (*radii solares*) to enter and create colours by the interposition of various optical devices. Trutfetter mentions a mirror, a *cristallo longa ac angulosa*, and also the glass rod cited by Seneca in the first century AD (*Natural Questions*, I, vi, 7). He also lists the hexagonal stone called *iris*.[24] But he does not refer to the triangular prism; nor is it mentioned in the very popular sixteenth-century encylopaedia, the *Margarita Philosophica* of the German Carthusian monk Gregor Reisch, which was published in a dozen editions, including Italian translations, between 1503 and 1600, although Reisch, too, mentions the hexagonal stone.[25]

It does not seem to be before the middle of the sixteenth century, and in Italy, that triangular prisms came to be part of the equipment of optical experiment. The Milanese physician and philosopher Gerolamo Cardano seems to be the first to mention the 'triangular crystal, or prism' in his scientific encyclopaedia *De*

The earliest known diagram of the triangular prism in action – although the geometry is pure fantasy. From the *De Refractione* of 1593 by Giovanni Battista della Porta. (**52**)

52 *Subtilitate*, first published in 1550; and by the time of Giovanni Battista della Porta's *De Refractione* of 1593, which may be the first text to illustrate this triangular form, it seems to have become the standard shape.[26]

The triangular prism was, however, not yet a shape widely known and used in optical experiments. Perhaps the most substantial sixteenth-century discussion of the prism and its uses occurs in the fourth book of *Opticae Libri Quattuor*, the product of a collaboration between the French philosopher Pierre de la Ramée, who had a strong interest in empiricism, and his German pupil Friedrich Reisner (Risner) during the 1560s, although their work was not published until 1606.[27] In a chapter on the elemental structure of the rainbow Ramée and Reisner reviewed the instruments used in creating artificial spectra, including the natural hexagonal crystal which, according to Pliny, could not be matched by art. Sometimes its shape was that of a truncated pyramid, sometimes that of a prism with six lateral faces and two bases. Witelo's prism, they argued, should be understood as a hexahedral parallelepiped; and they made the especially striking observation that the pentahedral prism (i.e. the new triangular form, with three sides and two bases) was the wonder of France and Italy (*quaquam et prisma pentaedrum tota Italia Galliaque his etiam miraculis celebratur*). Yet they were only concerned to examine the various properties of the traditional hexagonal prism of crystal or glass.

Ramée and Reisner, following Witelo, argued that the rainbow-colours, which they had already accepted as the Aristotelian *puniceus*, *viridis* and *purpureus*, were three because the incident light underwent a triple refraction from the three upper surfaces to the three lower. They described the effect of masking off first one, then two faces of the prism, adducing Witelo's experiment where two sides were covered with wax and sunlight was admitted into a darkened room through a small hole. The spectrum cast in this case was large (*maxima*) and very beautiful, with especially bright colours as a result of concentrating all the refractions into one. They also described the colour-generating properties of clear gemstones and Seneca's glass wands; but they gave no discussion at all to the characteristics of the new triangular prism.[28]

Scarmiglioni on colour

Around 1600 the triangular prism was being used in experiments by the English mathematician Thomas Harriot and by an Italian physician working in Vienna, Guido Antonio Scarmiglioni, whose book, *De Coloribus*, published at Marburg in 1601, offers a very useful benchmark for the perceptual approach to colour at the end of the sixteenth century – not because it is particularly original, but because it presents a remarkably comprehensive overview of colour-problems in optics, in psychology, in language and in art. Scarmiglioni was well read in ancient, medieval and modern authors on colour, and he also seems to have conducted some experiments himself. Of his life we know nothing but what he tells us in his short book, which is apparently his only published work. But as a synthesizer, he is worth giving more attention than history has accorded him so far.

Scarmiglioni was born at Foligno in Umbria and educated there, possibly at the still-mysterious Accademia Medica, set up around the middle of the sixteenth century and with some claim to being the first scientific academy.[29] Scarmiglioni related how the Archbishop of Naples, Prince Annibale di Capua, whom he served as personal physician, sent him on a 'serious mission' to the Emperor Rudolph II. While he was in Vienna he was invited by the Chancellor of the Archigymnasium in Prague, Melchior Khlesl, who was Chancellor of the Jesuit College, the Clementinum, after 1579, to move to Prague to teach and practise medicine, which, as Scarmiglioni writes in 1601, he had done ever since. By that time he was also Professor of Theoretical Medicine in Prague and Vienna.[30] The American National Union Catalog tells us that he died in 1620. Otherwise he seems to be almost entirely unknown to history.[31]

It was the Prague lectures that Scarmiglioni's pupils persuaded him to publish in 1601, and they are a very remarkable document. His wide reading is freely acknowledged, but he was very conscious of his own originality, and many of his chapters, after reviewing the opinions of others, advance his own contributions to the debate. In some cases these contributions appear to be based on Scarmiglioni's visual experience, for example of the mixing-practices of painters and dyers, of the spectrum cast on the floor by light passing through the edge of a window-pane, or of the colour of German beer.[32] In this he was perhaps most clearly in the tradition of Leonardo, but, unlike Leonardo, he was never really concerned with the problems of geometrical optics, and although he was familiar with a number of scholastic writers, including Albertus Magnus, he never cited the medieval perspectivists who were.

One area in which Scarmiglioni went beyond the medieval optical tradition was in his treatment of 'real' and 'apparent' colours. The rainbow had been for the Middle Ages and the Renaissance a prime example of 'apparent' colours: those colours whose existence was dependent on the position of the spectator viewing them, and opposed to the 'real' colours inherent in objects themselves. These 'real' colours subsisted in matter by virtue of its being a mixture of the four elements, earth, air, fire and water, and the four related temperaments, hot and cold, wet and dry. This Aristotelian doctrine of the temperaments was still very active in

sixteenth-century thought, particularly, through its variant the four humours, in the theoretical medicine of which Scarmiglioni was a professor.[33] All his major modern sources engaged with this question, although several of them were concerned about a conflict between the theory and their own experience. How, for example, asked Filippo Mocenigo, could fire, which was light and thus close to white, be embodied in coal, which was black? And how, asked the physician Girolamo Capodivacca, could cold snow be white? The Neapolitan polymath della Porta, who also wrote on botany, used many examples from plant-life, including one called the *chameleon* by the Greeks, to argue that colour and substance were only tenuously related.[34] The visual characteristics of the four elements were indeed much in evidence in Scarmiglioni's Prague, where the Milanese painter Giuseppe Arcimboldo had made a speciality of fantastic agglomerations of their respective attributes.[35]

52

45

In *De Coloribus*, Scarmiglioni, who had also lectured specifically on the temperaments,[36] reviewed the ancient and modern doctrines of the colours of the elements and could find little agreement among them. He claimed that the four temperaments cannot produce colours, since they are not themselves visible qualities; conversely, the essential causes of colours, opacity and transparency, are not among the traditional qualities attributed to the elements.[37] Scarmiglioni also argued that light, for example, may manifest itself in many colours: the sun may be yellow or red, the moon silver or blood-red, a flame blue (*coerulea*) or white.[38] Yet, unlike his contemporaries, he was not content to let matters rest there; he boldly advanced a theory that 'real' and 'apparent' colours were, in vision, essentially the same:

> Apparent colour does not differ in respect of representation from real colour, for green is equally seen in the emerald and in the neck of a dove, blue in the sky…and in the peacock, in the triangular crystal and in the painted rainbow. They are called apparent colours because they only appear from one angle [*situ*] so that if the sun paints a rainbow in any falling drop of water, or thread of a spider's web seen from such an angle, it will be looked at from another [angle] in vain.[39]

And he explained that they are alike since they are all nothing but visible *species*, those emanations from objects which entered the eye, and whose propagation and characteristics had been the subject of much discussion in the Middle Ages.[40] Scarmiglioni adopted the traditional Aristotelian position that *species* rise from 'light and shadow',[41] but his subjective view that they were the cause of *all* colours seems to be original, and came to be reinforced by Decartes and Newton in the seventeenth century.

Scarmiglioni also argued that the Aristotelian notion of colour as activated by light on the surfaces of bodies was manifestly untrue, since gold, for example, looked yellow by moonlight but silver in the sun; thus the colour must be in the light, not in the surfaces.[42] Similarly he came to the unusual conclusion that, since colours are simply visible *species*, all colours must have equal validity. Instead of adopting the then-traditional division of colours into 'simple' and 'mixed', he said that 'all colours are equally simple'.[43] The important distinctions

were between the 'light' (*lucidi*) colours, as in the spectrum, and the 'obscure', as in matter.[44] All this looks remarkably familiar from a seventeenth-century point of view, but Scarmiglioni had reached his conclusions, not by the mechanical interpretation of refraction, but largely, as he said, through *quotidiana experientia*, everyday experience.[45]

Scarmiglioni was, nevertheless, far from indifferent to the problems of colour and refraction. We saw his reference to the 'triangular crystal' in the passage on apparent colours quoted above, and there are other chapters in his book where he dealt with the creation of spectral colours, for example the weak spectrum cast by the edge of the window-pane, and that produced by the triangular prism itself. Like so many of his contemporaries, Scarmiglioni seems to have used the prism as a lense to examine the prismatic fringes between the light and dark areas of surfaces. He was clearly impressed by the bright cyan blue at the junction of light and dark, which he called *hyacinthinus*, and by the appearance of red next to the dark, as light was replaced by dark, so that, like his immediate source, Filippo Mocenigo, who was also an experimenter with the triangular prism, he took the unconventional view that, in a tonal scale of hues, red is closer to black than is blue.[46]

Like Mocenigo too, Scarmiglioni thought that the appearance of colours depended on the thickness of the prism; and Mocenigo speaks of reversing the instrument, so that the red and the blue change places, while green remains constant between them.[47] This was an interpretation close to that of Albertus Magnus, and depended on the still very active notion that colours were the product of obscuring or modifying light, in this case, by the glass of the prism. The manipulation of the triangular instrument became a key procedure in seventeenth-century optics, notably in Descartes, Boyle and Newton, whose observations, of course, were far more precise and whose conclusions far more radical than any in the sixteenth century.

53

The philosopher René Descartes' prism-diagram of 1637. He shows a right-angled prism instead of the more usual equilateral form – whether of crystal or glass is not known. (**53**)

Glass versus crystal

Giovanni Battista della Porta, like Scarmiglioni, referred both to glass and crystal triangular prisms, although Cardano at the middle of the century had only mentioned crystal. It might well have been thought that the rapidly developing Italian glass-industry of the Renaissance supplied one of the necessary conditions for the development of the prism as an optical instrument. But crystal prisms, cut from the larger hexagonal stones, seem to have been in use at least until the end of the sixteenth century: the English mathematician Thomas Harriot, who did very significant but unpublished work on refraction, mentions a badly-ground crystal prism lent by an acquaintance in a note of around 1610.[48] Perhaps the problems of the precision-cutting, grinding and polishing of crystal were too great, although ever since the late thirteenth century Venetian rock-crystal workers had been making spectacle lenses, which their guild allowed glassmakers to produce from 1301.[49] Venetian crystal-glass was internationally famous for its purity and transparency by the early sixteenth century, and it is perhaps no coincidence that it is in an account of using the prism by the Venetian Mocenigo, Archbishop of Nicosia, published in 1581 and one of Scarmiglioni's major sources, that, so far as I have been able to discover, the term 'vitrum triangulare' first occurs.[50]

As Albertus Magnus and Jodocus Trutfetter had noticed, glass rods had been used by the Romans to generate rainbow-colours, and the sixteenth-century Sienese technologist Vannoccio Biringuccio already marvelled at the glass of Murano as, 'most clear and transparent like the proper natural crystal...so that it seems to me that all other metals must yield to it in beauty'.[51] That Scarmiglioni refers to glass prisms may also reflect the great development of Bohemian glass in his day under the specific sponsorship of Rudolph II, so that it too reached new levels of purity.[52] However, no glass of this period was of optical quality in the modern sense, and as late as the end of the following century Newton and his contemporaries were complaining that the available prisms were optically very imperfect.[53] Nevertheless, the use of glass in the long run solved the problem of size and expense, and made these triangular glass prisms a very common commodity in the seventeenth and eighteenth centuries.

The spectral colours

Albertus Magnus, as we saw above, had observed that the rainbow-colours were generated by the *iris* at the junctions of light and dark; and perhaps the most important early use for the triangular prism was in the detailed study of the coloured fringes observed through it at the edges of a displaced image. Thomas Harriot in 1604 was able to calculate the degrees of refrangibility of the green, orange and red rays by measuring the width of these fringes, and in the early 1640s the Catholic virtuoso Sir Kenelm Digby was shown a whole series of experiments of this type at the English Jesuit College in Liège by Francis Line (otherwise known as Hall), who was later to enter into controversy with Newton.[54] The best-known experiments

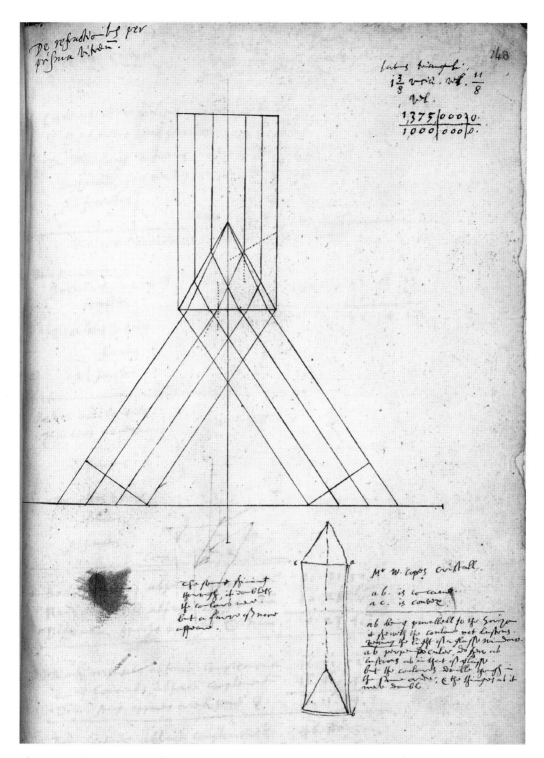

Thomas Harriot's prism-diagram of around 1610. His note that 'Mr Cope's Cristall' was concave underlines the difficulty of cutting and grinding large quartz prisms at the time. Harriot may have a claim to being the first scientist to measure the width of the spectral colour-bands. (**54**)

of this sort are those made and publicized by Goethe about 1790, observations which led him to refute Newton's theory that colours are a function of the variable refrangibility of rays of light.[55] But just as these indoor experiments prevailed, in Goethe's case, over his observation of the rainbow outdoors, so experiments with the prism before Newton brought little clarity to the question of the number and nature of the spectral colours.

The thirteenth-century German encyclopaedist Arnoldus Saxo identified four colours, *rubeo, flavo, viridi ac citrino*, in the spectrum projected by the *iris*;[56] Albertus Magnus, although he was familiar with Arnoldus's work, opted for the Aristotelian triad of red, green, and that confusing colour *caeruleus*, which sometimes meant blue and sometimes yellow, although here it clearly means the latter.[57] Theodoric argued for four colours in the rainbow and the hexagonal prism, specifically including the yellow which Aristotle had regarded as a mixture of red and green, but which Theodoric and della Porta after him insisted was a principal colour. Yet in his prismatic experiments he mentions only red and blue.[58] Cardano in the sixteenth century saw four or five colours; Mocenigo identified three, although he also admitted that there might be others in between; and Scarmiglioni himself also seems to have been reluctant to identify the precise character and number of the colours, although he claimed that they were plain enough to see.[59] Harriot calculated the angles of refraction of five colours,[60] but della Porta's prismatic experiments revealed only three colours to him: red, yellow and blue (*rubeus, flavus, caeruleus/halurgus*).[61] Even Newton was to divide his visible spectrum into as many as eleven colours and as few as five, before finally settling on the seven, which, as we shall see in the next chapter, he was to adopt for the largely metaphorical reason that he was pursuing the analogy with the notes of the diatonic scale.[62] It is difficult to resist the conclusion that, as in the case of the rainbow at large, the perception of the prismatic spectrum was very much in the shadow of preconceptions.

60
49

Whatever the perceptual difficulties in identifying the colours in a prismatic spectrum, the origins of the triangular prism would still be of compelling interest even if it had been no more than the toy (the popular creator of the multicoloured 'fool's Paradise') which provided Descartes and Newton with their proofs of the quantitative nature of colour. The elegant simplicity of their arguments was made possible partly by the elegance of this simplest of tools. At some time during the two centuries between Theodoric of Freiberg and Gerolamo Cardano, some perspectivist must have decided to reduce the hexagon of the quartz crystal to a triangular form. It may well have been that a large hexagonal crystal was first sawn in half and polished; but this would still leave a good way to go before the adoption of the equilateral triangle which we see in the sixteenth- and early seventeenth-century illustrations.[63]

The balance of evidence suggests that this reduction took place during the early sixteenth century; but it is unlikely to have been achieved by Cardano himself, since, although he was proud of a number of his efforts to provide simpler explanations of the structures of nature, he included no allusions to optics in his autobiography, *De Vita Propria Liber*, where he listed his various and notable achievements.[64]

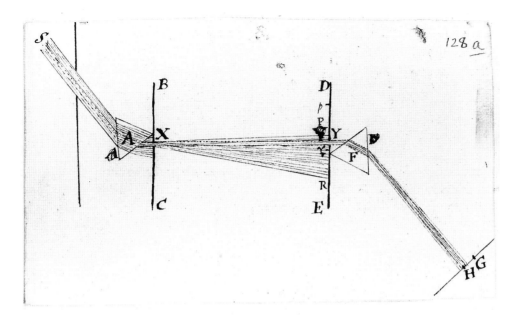

The diagram of Sir Isaac Newton's crucial experiment, 1666-72. A ray of light is divided into its constituent colours by the first prism, and the resulting bundle of coloured rays is reconstituted into white light by a second. (**55**)

Newton's *experimentum crucis*, developed between 1666 and 1672, in which two prisms were arranged so that the colours of the spectrum formed by the first were shown to be unmodified by the second, and were thus each the product of a single refraction,[65] depended upon the complete symmetry and reversibility of the triangular prism, noticed but not interpreted by Mocenigo about 1580. Seldom can so simple a device have been so freighted with important consequences, but seldom, too, can it have developed so slowly as did the prism, from its theoretical grounding in the thirteenth century to its practical realization in the fifteenth and sixteenth centuries, and its effective use in the seventeenth.

55

9 · Newton and Painting

That God is Colouring Newton does shew,
And that the devil is a Black outline, all of us know.
(William Blake, *To Venetian Artists*[1])

BLAKE'S WORDS REFER TO a Newtonian inflection of the traditional notion of
God as light, for after Sir Isaac Newton, light was understood first of all as
colour. Their context, an attack on Sir Joshua Reynolds and the colouristic Venetian
style (see Chapter 11), also suggests that at the close of the eighteenth century
Newton's *Opticks* had become as much a preoccupation of the painters as it had
already been so abundantly of the poets.[2] Long before the Romantic period it
had been regarded as essential reading for landscape artists, who were themselves
seen as something of experimenters in natural philosophy;[3] but I am concerned in
this chapter not with the general background to the acceptance of Newton's work
among painters, but briefly with two of the more precisely documented instances
of its effect. One effect is rather practical, and involves methods of colour-mixture;
the other is almost purely theoretical, representing a Newtonian phase in the search
for principles of colour-harmony. Both involve the concept of primary colours.

Newton's theory of colours, which was first published in the 1670s in the *Philo-
sophical Transactions of the Royal Society*, appeared at a time when painters, especially
in Rome and Paris, were seeking some firmer theoretical basis for the study of this
aspect of their art. Nicholas Poussin in an early self-portrait, painted the year after the
foundation of the French Academy of Painting and Sculpture in 1648, shows himself
holding a book later inscribed with the title *De Lumine et Colore*; this is certainly not
the most up-to-date treatment – which was that by Descartes in 1637 – but perhaps
the eclectic and conservative compilation by Matteo Zaccolini;[4] it nevertheless
proclaims an interest which was to play a prominent role in the discussions of the
Academy after it became primarily a teaching institution in 1664.[5] It was an interest
which united the Poussinistes and their rivals the Rubenistes within that institu-
tion, and it was the chief spokesman of the Rubenistes, Roger de Piles, who in his
Dialogue sur le Coloris of 1672 best outlined the problem facing the painter:

> During the all but three hundred years since the revival of painting we can
> hardly reckon half-a-dozen painters who have used colour well: and yet one
> could list at least thirty who have been outstanding draughtsmen. The reason
> for this is that drawing has rules based on proportion, on anatomy, and on a
> continual experience of the same data [*de la mesme chose*: i.e. the human

57

Left: the precedence of drawing over the less-easily-schematized painting in a seventeenth-century Academy (note the neglected palette and brushes). Engraving after Carlo Maratta.(**56**)

Above: Nicholas Poussin's self-portrait as reproduced in a seventeenth-century engraving, depicting the French Academician holding a treatise on light and colour. (**57**)

figure]: whereas colouring has yet hardly any well-known rules, and since the studies made have differed according to the different subjects they treated, no very precise body of rules has yet been established.[6]

A French didactic print of 1677/83, after a design by the influential Roman teacher Carlo Maratta, sums up this situation: students busy themselves with the study of drawing, perspective, anatomy, and above all, ancient sculpture, while a palette and brushes stand idly by.[7] Since the French Academy was the mother of all the many art academies founded during the eighteenth century, and the large body of theoretical writing it engendered was the model for most subsequent theory, these colouristic concerns carry a good deal of weight.

56

Doctrines of mixture

It may at first sight seem surprising that Newton's theory had any part to play in these developments, for it was chiefly concerned with the causes of colours, and only marginally with those subjective effects which were the central concern of painters. This is especially so in the case of the notion of primary colours, which

had been clarified over the previous half-century or so through the experience of mixing paints. Robert Boyle, in a treatise of 1664 which stimulated Newton to make some of his earliest colour-experiments, claimed that

> much of the Mechanical use of Colours among Painters and Dyers, doth depend upon the Knowledge of what Colours may be produc'd by the Mixtures of Pigments so and so Colour'd. And...'tis of advantage to the contemplative Naturalist, to know how many and which Colours are Primitive...and Simple, because it both eases his labour by confining his most solicitous Enquiry to a small Number of Colours upon which the rest depend, and assists him to judge of the nature of particular compounded Colours, by showing him from the Mixture what more Simple ones, and of what Proportions of them to one another, the particular Colour to be consider'd does result.[8]

Boyle had already stated that these few 'primitive' or 'simple' colours of the painter were black, white, red, yellow and blue.

But Newton had thrown this neat symmetrical scheme of simple colours into confusion in his first paper of 1672 by showing that there were as many 'simple' (or 'primary', 'primitive', 'uncompounded', 'original', or 'homogeneal') colours as there were refrangible rays of light,[9] and that these same colours (for example green, and even yellow) might occur in both a simple and a compounded form. Newton's leading opponent on this occasion, Robert Hooke, who had himself developed a radically reductive theory of only two primary colours, understandably sought to apply Ockham's Razor;[10] and during the eighteenth century Newton's number of primaries (which was generally and erroneously thought to be seven) continued to present something of an obstacle to students with painterly connections. And yet the circular diagram of colour-mixtures which Newton introduced in the *Opticks* of 1704 gave promise that a white might indeed be compounded from two or three of the colours lying opposite each other, which could thus be regarded as primary by themselves.[11] Newton claimed in the text to this figure that he was never able to mix more than a 'faint anonymous Colour' by means of the proportions indicated; but in his experiments with the mixture of coloured powders (I, ii, prop. v, theor. iv, exper. 15), he had succeeded in making a 'mouse-colour' (his surrogate for white in

58

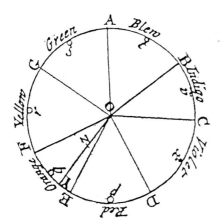

Sir Isaac Newton's colour-circle, from the *Opticks* of 1704. It was devised for mathematical calculation of the constituents of mixtures, and its asymmetry reflected the proportions which Newton ascribed to the spectral colours. (**58**)

RED

Purple

Orange

BLUE

YELLOW

Green

Colour-circle from Moses Harris, *The Natural System of Colours, c.* 1776. Harris's is probably the first completely symmetrical circle of primary and secondary colours, and it also suggests the progressive darkening of each hue to black at the centre. (**59**)

pigment-mixtures) with only two: one part red lead and five parts copper-green, which he concluded, to save his theory, must themselves be compounds of other colours.

This circular diagram became the model for many colour-systems in the eighteenth and nineteenth century, from the supplement to the *Traité de la Peinture en Mignature*, attributed to Claude Boutet, in The Hague edition of 1708, where the seven-colour division (with two reds) seems clearly to reflect the Newtonian arrangement of four years earlier, to the first completely symmetrical and complementary colour-system of Moses Harris, *The Natural System of Colours*, published about 1776. Newton's scheme provided, too, the starting-point for the first attempt to apply the Newtonian system to the practical problems of colour-mixture, published by the Cambridge mathematician Brook Taylor in the second edition of

46

59

his treatise *New Principles of Linear Perspective* in 1719. Taylor amplified Newton's conception of mixture to emphasize the co-ordinate functions of hue, value and saturation in each colour; and he observed that white 'breaks' (i.e. desaturates) colours far more than black, hence the prime importance of the lightest pigments, for 'it is easier to make clean dark tints with light Colours and Black, than to make the bright light ones with dark Colours and White'. Taylor also noted that because of the impure nature of pigments, mixtures could not always be accurately predicted: and although he seems to have been an amateur painter himself, he concluded, 'these Properties of particular Materials I leave to be consider'd by the Practitioners in this Art'.[12]

In search of harmony – printing the primaries

The establishment of an irreducible number of primary colours and their embodiment in available colorants became of practical significance in a new development in colour-engraving, introduced about 1715 by the German artist J. C. Le Blon. The earliest reference to Le Blon's process, which employed the technique of mezzotint, suggests that he was chiefly interested in manipulating hues and values according to Newtonian principles in order to achieve harmony.[13] This account refers to his period in Holland about 1715, but the emphasis is renewed in his treatise, *Coloritto: or the harmony of Colouring in Painting*, published in London in 1725[14] after the failure of his large-scale English engraving enterprise, The Picture Office. *Coloritto* also makes it clear that Le Blon's printing-methods were themselves a matter of Newtonian principle:

> Painting can represent all *visible* Objects with three Colours, *Yellow, Red* and *Blue*: for all other Colours can be compos'd of these *Three*, which I call *Primitive*... And a *Mixture* of those *Three* Original Colours makes a *Black*, and all *other* colours whatsoever; as I have demonstrated by my Invention of *Printing* pictures *and* figures with their natural *Colours*.
>
> I am only speaking of *Material* colours, or those used by *Painters*: for a *Mixture* of *all* the primitive *Impalpable* Colours, that cannot be felt, will not produce *Black*, but the very contrary, *White*, as the great Sir ISAAC NEWTON has demonstrated in his *Opticks*.[15]

Le Blon thus removed black and white from the category of primary colours as, indeed, had Boutet, and even Alberti before him,[16] and invoked the authority of Newton, for whom black and white had also been a compound of the same genus of colour, just as red, for example, might be either light or dark. By about 1718 Le Blon had begun to supply the 'Curious' with colour-separations of his prints: the three constituent colours, plus an example of a mixture of two of them, to demonstrate the process[17] – one such set, after a self-portrait by Van Dyck, is now at Yale. This particular example seems, however, to show the use of a fourth, black plate, and there is ample evidence, including a number of references in *Coloritto* itself, that at least as early as his period in England Le Blon was prepared to adopt

this expedient in order to make the process faster, and hence cheaper. The question of three or four plates became a matter of controversy after his death in 1741, when a former pupil, Jacques Gautier d'Agoty, was anxious to protect his own patent for this four-colour process, and disputed the claims of Le Blon's workshop that the master had ever used more than three. The debate was long and tedious, but it is of some interest to us because Gautier d'Agoty sought to bolster his method with a vigorously argued anti-Newtonian theory of colour, which was essentially a revival of the traditional Aristotelian view that all hues are generated by the interaction of black and white, or light and darkness.[18]

The apologists for Le Blon in this exchange argued that their master never spoke of his fourth plate precisely because he used it in spite of himself, and felt that it would dishonour the system.[19] If we cannot establish the formative effect of theory on the practice of these print-makers, it was certainly in the forefront of their public relations. Le Blon's appeal to Newton was not itself essential to his three-colour system, for that system had already been proposed by Boutet in his treatise of 1708, where Le Blon, as a miniature-painter himself, may well have found it. Perhaps what had really attracted him to Newton's theory of colours was the promise it presented of a quantifiable theory of colour-harmony. The Venetian writer Antonio Conti, to whom we owe the first record of Le Blon's ideas, reported that he was indeed preoccupied with harmonic proportions:

> ...the Newtonian theory of colours has given many [painters] the opportunity of determining their compositions by the mechanical rule of the centres of gravity [a concept deriving from Newton's circular mixture-diagram]. That German painter who prints pictures [Le Blon] derived his secret from this source...I met [him] at The Hague, and he assured me that following Newton's principles of the immutability and unequal refrangibility and reflexibility of the rays of light, he had established the degrees of strength and weakness which colours required to be harmonized...[20]

58

The principles of harmony: colour and music

Newton's great achievement in optics was of course to have quantified the components of white light, and his mixture-diagram was based on this quantification. It was also arranged according to the proportion of the colours in the spectrum of white light, which for Newton was a musical proportion; and it was this analogy which gave a new impetus to the ancient attempt to assimilate the aesthetics of sight to those of hearing, and to give the new science of colour the benefit of the many centuries of investigation into the principles of musical harmony. In the *Opticks* the analogy between aural and visual harmonies, based on that between the vibratory characteristics of light and sound, is relegated in a very summary form to Query 14; but Newton had given a fuller exposition in a letter to the Royal Society of 1675 which remained unpublished until the middle of the following century:

60

Sir Isaac Newton's correlation of the intervals of the spectrum with the musical scale, first devised in the 1670s though not published until the following century. (**60**)

...as the harmony and discord of sounds proceeded from the proportions of the aereal vibrations, so may the harmony of some colours, as of golden and blue, and the discord of others, as of red and blue, proceed from the proportions of the aethereal. And possibly colour may be distinguished into its principal degrees, red, orange, yellow, green, blue, indigo and deep violet, on the same ground that sound within an eighth is graduated into tones.

For, some years past, the prismatic colours being in a well darkened room cast perpendicularly upon a paper two and twenty foot distant from the prism, I desired a friend to draw with a pencil lines across the image, or pillar of colours, where every one of the seven aforenamed colours was most full and brisk, and also where he judged the truest confines of them to be, whilst I held the paper so, that the said image might fall within a certain compass marked on it. And this I did, partly because my own eyes are not very critical in distinguishing colours, partly because another, to whom I had not communicated my thoughts about this matter, could have nothing but his eyes to determine his fancy in making those marks. This observation we repeated divers times, both in the same and divers ways, to see how the marks on several papers would agree; and comparing the observations, though the just confines of the colours are hard to be assigned, because they pass into one another by insensible gradation; yet the *differences* of the observations were but little, especially towards the red end...[21]

It seems clear that, in spite of Newton's efforts to make the experiment 'objective', the isolation of seven prismatic colours was itself the result of the musical analogy, in which he had been interested for some years.[22] The conception of the especially harmonious character of a combination of gold and blue which (shifted to indigo in the *Opticks*, as purple was renamed violet), and the discord of red and blue, have no justification other than their relative places in Newton's scale.

The general conception of numerical harmonies in colours had an Aristotelian origin, but Aristotle (*De Sensu*, 439b) had confined it to the light and dark components of single hues rather than an assortment of hues; and the closest precedent for Newton's view is in a remarkable study of the rainbow published by Marin Cureau de la Chambre in 1650. Cureau de la Chambre, however, did not use a prismatic spectrum, but an Aristotelian scale between black and white, yet he agreed with Newton that blue was dissonant with red and consonant with yellow.[23]

It was Newton's suggestion in Query 14 of the *Opticks*, however tentatively expressed, which provided the chief stimulus to the study of colour in the first half of the eighteenth century, both for Le Blon and for another unsuccessful projector who sought to materialize the theory of correspondences, the French Jesuit Louis Bertrand Castel, the inventor of the ocular harpsichord, which became a *cause célèbre* throughout Europe in the latter part of the century.

In the first brief outline of his idea in 1725, Castel traced its inception to some hints by the mid-seventeenth-century polymath Athanasius Kircher, but more immediately to Newton's *Opticks*, 'that excellent book', which had 'verified' the link between sound and light. He secured professional help to design an instrument embodying the analogy by means of a keyboard controlling coloured-glass filters and mirrors; but the prototype, which was ready by 1730, appears to have been rather simpler. Castel began the building of a full-scale version in 1734, but the account which he published the following year shows that he had by now moved away from any Newtonian scheme. He had come under the influence of the composer and theorist of harmony, Jean-Philippe Rameau, who had encouraged his project from the first, and he had adopted a scale based on the three primary colours, red, yellow and blue, of which blue was analogous to a musical ground-bass (*basse fondamentale*). Castel thought blue to be equally close to white and black, the traditional origins of all colours, and it is indeed a colour which retains its true identity over a remarkable range of tonal values. Blue he gave the note-value of C, yellow of E, and red, 'the dominant colour of nature', of G.

Rameau had published his first treatise on harmony in 1722, and also regarded the base as fundamental; he, too, had developed a triadic theory of harmony in which the consonances of the fifth and the two thirds were primary, and gave rise to the three secondary consonances, the fourth and the two sixths.[24]

It may well be that Castel adopted his scale of three colours from Le Blon, whose printing-process he had witnessed in 1732, for, as he noted in a review of *Coloritto* a few years later, that process also treated blue as the fundamental colour, with which the sequence of impressions began.[25] But notwithstanding Le Blon's Newtonian pretensions, by the time of his most important publication, *L'Optique des Couleurs* of 1740, Castel had become the most extravagant of anti-Newtonians, and had rejected all prismatic studies in favour of the exclusive investigation of colouring-materials. The ocular harpsichord, which was now based on a twelve-colour circle and a chromatic scale of twelve notes over twelve octaves, was apparently completed in the 1750s, and may have been demonstrated in London and Paris.[26] In any case it was the ancestor of the many instruments which have sought to present colour in motion, with or without a musical analogy, until our own times.[27]

Harmony and complementarity

A rather more durable theory of the harmony of colours, current among painters, was based on the idea of complementary colours, and this too derives from Newton. In his experiments on the colours of thin plates Newton had long recognized that certain colours were 'opposite' or 'contrary',[28] and the diagram in his

61 classic exposition of what came to be known as 'Newton's Rings' in the *Opticks* became the starting-point for the study of complementarity in the latter half of the century.[29] The experiment with the mixing of red and green powders (pp. 136-7) could also be interpreted in terms of the complementarity of these colours. By about 1800, both scientists and painters[30] had come to believe that the simplest form of colour-harmony was in the juxtaposition of complementaries. This view became canonized for the nineteenth century in Chevreul's *On the Law of Simultaneous Contrast of Colours* (1839), and through him, became a decisive stimulus to the developing painterly methods of Seurat, for whom, too, harmony was implicit in contrast (see Chapter 16).[31] It is appropriate that what is perhaps the only series of

47 paintings to be based directly on Newtonian ideas about colour, František Kupka's *Discs of Newton* of 1912, should look back to these influential experiments.[32]

I have tried to show that during the late seventeenth and eighteenth centuries the scientific and painterly students of colour, under the dominant influence of Newton, shared several common interests, and were each prepared to draw on the experience of the other. These interests were not yet considered to be antithetical,

Sir Isaac Newton, *Colours of Thin Plates* (*Newton's Rings*), from the *Opticks*, 1704. 'Newton's Rings' are the concentric circles of colour spreading out from the point of maximum pressure when two thin transparent plates (or here, a convex lense and a plane glass surface) are pressed together. They gave the first clear demonstration of complementarity in colours – although this was not something that interested Newton himself. Black appears at the centre by reflected light, white by transmitted light, red opposite blue or green, violet opposite yellow, and so on. (**61**)

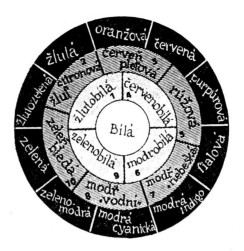

František Kupka's *Newton's Wheel, c.* 1910. Kupka evidently depends more on Newton's colour-circle (58) than on 'Newton's Rings' (below): the white centre is surrounded by progressively saturated circles of ten named hues, including 'indigo', a clear indication of Kupka's interest in Newton's theory of colours. (**62**)

although by the middle of the eighteenth century some writers, like Castel, and Gautier d'Agoty who owed a good deal to him, sought to drive a wedge between the quantitative study of the colours of light and the qualitative study of colorants. Both controversialists were much used by Goethe.[33] It was not until the close of the century that Wünsch in Germany and Young in England began to bring clarity to the notions of additive and subtractive mixtures, and not for another half-century again that these ideas became widely accepted. As late as Mondrian in the 1920s the whole universe of colour could be symbolized in terms of the subtractive primaries, red, yellow and blue.

The fascinating question of the harmony of colours also led Newton to propose some far-reaching, but ultimately unsuccessful hypotheses about the relationship of colours to musical sounds; but it was a notion of complementarity, latent if undeveloped in his work, that came to have the greatest resonance in the history of painting.

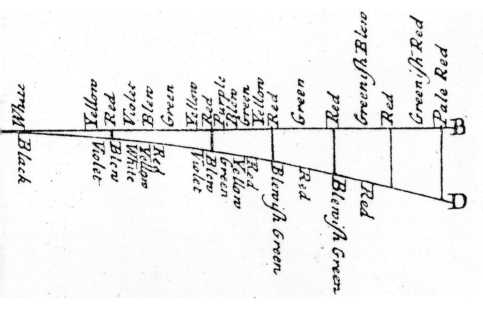

10 · Blake's Newton

Adapting Michelangelo

AMONG THE EARLIEST DOCUMENTS OF William Blake's activity as a graphic artist is a series of copies in pen and wash from Adamo Ghisi's engravings after Michelangelo, now in the British Museum.[1] These copies already show a characteristic freedom in handling their source: just as the engraving *Joseph of Aramathea* (1773) was adapted by Blake from the Centurion in Michelangelo's *Crucifixion of St Peter* in the Cappella Paolina, so Blake's group of Matthan from the Sistine lunettes (LB6r) transposes the titular great-grandfather of Jesus into a young mother, and Aminadab (LB7v) has become, in a pencil caption possibly contemporary with the copy, *The Reposing Traveller*.[2] But twenty years later Blake seems to have become far more concerned with Michelangelo's own iconography of the Sistine ceiling, and in adapting the figure of Abias (LB6v), long recognized as the prototype for the posture of Newton in the colour-print of 1795,[3] he extended visually the connotations of this symbol of oppressive rationalism by his borrowing.

Blake had been in touch with the painter Henry Fuseli since the late 1780s, and it was from Fuseli that he may have understood the programme of Michelangelo's great cycle. 'The subject', as Fuseli put it in a later lecture, 'is *theocracy*, or the empire of religion...the progress, and the final dispensation of Providence...the relation of the race to its Founder.'[4] From Fuseli, too, Blake may have learned the role of Abias (= Abijah) in the genealogy of Christ, a role of absolute submission to the Divine Authority. In II *Chronicles* 13 Abias upholds Judaic orthodoxy against the rebellion of Jeroboam, which he put down with great slaughter.[5] He would thus serve in Blake's eyes as a fitting model for Newton, who was also associated in his imagination with the tyrannical figure of the Ancient of Days.

Fuseli was certainly familiar with the details of the Sistine lunettes in the sixteenth-century engravings of Giorgio Ghisi, which had served as models for his Shakespearean fantasies;[6] and Ghisi's arrangement may also have affected Blake, for it brought the Ancestors into direct visual relationship with the Prophets and Sibyls between them. Abias appears here as one of the supporters of the Persian Sibyl, whose shadowed and obviously short-sighted features are buried in a book.[7] The mystical darkness she engenders has cast both her flanking Ancestors into postures of sleep, one of which postures Blake has adapted to his *Newton*, who sits similarly shrouded in darkness. While it seems improbable that he is seated on the sea-bed (i.e. beneath the waters of materialism) as has been suggested,[8] the encircling darkness may be related to the gloomy bottom of the Cave of the Neo-Platonic

63
64

66
65

William Blake after Michelangelo: *Abias*, the Old Testament ancestor of Christ, in the lunettes of the Sistine Chapel, 1770s. (**63**)

William Blake, *Newton*, *c.* 1795, the figure based on Michelangelo's Abias. Blake's materialist is shown using a pair of compasses (dividers). (**64**)

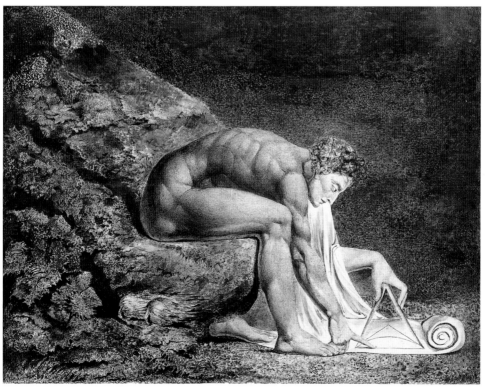

145

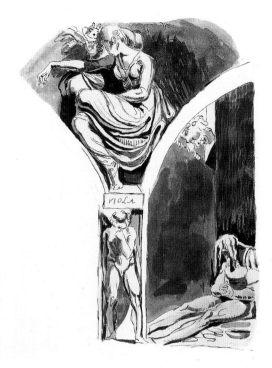

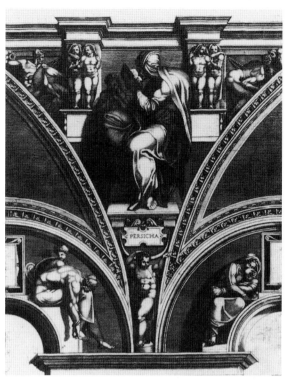

Henry Fuseli, *Twelfth Night*, 1777, a design for a proposed chapel to Shakespeare based on Michelangelo's Sistine Chapel lunettes, known to Fuseli via Giorgio Ghisi's engravings (66). It was probably Fuseli who instructed Blake on Michelangelo's programme. (**65**)

Giorgio Ghisi, *The Persian Sibyl*, after Michelangelo. Ghisi's illustration-format separated the left and right figures of each lunette, so allowing Blake to associate the sleeping Abias-figure, left, with the defective vision of the Sibyl, centre. (**66**)

material world, which had recently been expounded by the leading English Platonist of the period, Thomas Taylor, in his translation of *The Hymns of Orpheus*;[9] and perhaps Blake, in his conception of Newton's lichen-covered seat, was thinking, too, of the 'oozy rock, inwrapped with the weeds of death', which in his own prophetic book *Vala* (1795–1804) supported the Eternal Man, who 'sleeps in the earth'.[10]

Newton in Blake's print is wide-eyed and active, but his posture and his setting are, on our showing, those of somnolence: he seems the visual embodiment of Blake's prayer in the verse-letter to his patron Thomas Butts of 1802 (p.826):

> *...May God us keep*
> *From Single vision & Newton's sleep.*

Blake's interest in optics

In a later passage in *Vala* (Keynes ed., p.350), the Eternal Man invoked Urizen as Prince of Light:

where art thou? I behold thee not as once
In those Eternal fields, in clouds of morning stepping forth
With harps & songs when bright Ahania sang before thy face
And all thy sons & daughters gather'd round my ample table.
See you not all this wracking furious confusion?
Come forth from slumbers of thy cold abstraction . . .

The tone and the imagery are very close to Goethe's polemic in his poems against the abstraction of Newton's optics; and near this passage, on p. 120 of his own manuscript of *Vala*, Blake drew what seems to be sketch of the Eternal Man, seated beneath a pair of compasses.[11] If Blake's Newton is presented in darkness – in the 'dark chamber' which formed the setting for his optical experiments – it is perhaps in Newtonian optics that we shall find amplification of Blake's motif.

Although an association has been recognized between the compasses of *Newton* 64 and the *Ancient of Days*, and Motte's frontispiece to his English translation of Newton's *Principia*,[12] there seems to be no relation between the diagram Newton is measuring in Blake's print and any published in that book.[13] The relationship of the chord of the circle to the triangle is closer to Fig. 2 of Newton's *Opticks* (I, i), which 67 illustrates the passage of a ray of light through a prism.[14] Blake seems to have taken up the idea of a ray of light formed by the prism into a rainbow by showing the arc of the bow within the prism itself, and thus making the diagram far more legible than Newton's construction would have been on this scale. This interpretation of the diagram is reinforced by the introduction of the white cloth over the scientist's 64 shoulder[15] which may symbolize the ray of white light from which Newton derived his prismatic colours, for later, in another prophetic book, *Jerusalem* (iii, 63-4), Blake alluded to the weaving in a cavern of what appears to be a rainbow. If in this print Blake made a formal association between Newton and God, as Ancient of Days, he may have taken a cue from a recent commentary on Newton's optics by Joseph Priestley in his *History and Present State of Discoveries relating to Vision, Light and Colours* (1772). Priestley, in claiming that the *Opticks* were Newton's greatest mathematical achievement, referred to the opinion of Plato that 'to pry into the mysteries of light, was to encroach upon the prerogatives of divinity'.[16]

The probable source of the figure which Newton draws in Blake's print (64): Sir Isaac Newton's diagram of refraction through a prism, *Opticks*, 1704, Fig. 2. (**67**)

In his 1802 letter to Butts (p.860) Blake had already referred to the spiritual idea of double vision:

Double the vision my Eyes do see
And a double vision is always with me.

Here the idea is that the perception of the material world must be complemented by the visionary's perception of a second world. On a purely material level, Priestley was also occupied by the contrast between single and binocular vision, which a number of eighteenth-century ophthamologists had brought on to the optical agenda. He quoted the Cambridge philosopher Robert Smith's view that 'Objects seen with both eyes appear more vivid, and stronger, than they do to a single eye'; and he gave an anatomical explanation of why this should be so which showed that Newton's account of the matter had now been superseded:

It was the opinion of Sir Isaac Newton and others, that objects appear single because the two optic nerves unite before they reach the brain. But Dr [William] Porterfield shows, from the observations of several anatomists, that the optic nerves do not mix, or confound their substance, being only united by a close cohesion; and objects have appeared single where the optic nerves were found to be disjoined...Originally, every object making two pictures, one in each eye, is imagined to be double; but by degrees, we find that when two corresponding parts of the retina are impressed, the object is but one; but if those corresponding parts be changed, by the distortion of one of the eyes, the object must again appear double as at the first...[17]

The implication of the priority of double vision over single would have appealed especially to Blake; and in a later account of the experiments of Dr Smith, Priestley showed that, as in the case of Blake's Newton, it was with the aid of a pair of compasses that the transition from double to single vision might be demonstrated.[18]

Priestley's *History and Present State* offered Blake, in its account of 'fallacies in vision', many testimonies to the imperfection of the corporeal eye which he did not hesitate to adopt. A draft for *The Everlasting Gospel*, a poem which linked Priestley and Newton as doubters and experimenters, concluded with a passage closely related to part of Priestley's explanation of the apparent size of the horizontal moon:

This Life's dim windows of the soul
Distorts the Heavens from Pole to Pole
And leads you to believe a Lie
When you see with, not thro' the Eye
That was born in a night to perish in a night,
When the Soul slept in the beams of Light.[19]

The well-known passage at the close of the *Vision of the Last Judgement*: ' "What", it will be Questioned, "When the Sun rises, do you not see a round disc of fire somewhat like a Guinea",' relates to the use of a wafer to simulate the moon in an experiment in the same chapter of Priestley.[20] It was not simply the spiritual

64

Newton and the Prism, an engraving after George Romney. Newton is shown demonstrating the formation of the spectrum to his daughters, with blue and violet at the top of the column and the long-wave-length red at the bottom. From 1803-4, when he will have seen the original painting, Blake tended to show the spectral colours in this order even in the rainbow, where they are reversed. (**68**)

writings of the seventeenth and eighteenth centuries, but also developments in the scientific study of perception which encouraged Blake to doubt the evidence of the senses.

Given the doubts published by Priestley on the Newtonian number and order of colours in the rainbow,[21] and the traditional tri-colour bow passed on to Blake in the writings of Boehme,[22] it is perhaps surprising that Blake's solution to the problem of representing the rainbows demanded by his subject-matter is usually in Newtonian terms. As recently as 1793, Blake's friend James Barry had publicly attacked the Newtonian seven-colour conception in favour of three colours, which he supported, significantly for Blake, with quotations from Milton:

48

> our philosophers have pretended to discover in the rainbow, just seven primitive colours in that phenomenon. But if they mean by primitive colours, colours simple and uncompounded of any others, why seven, when there are but three? If they mean only to enumerate the differences, without regarding the actual fact of the procreation of the compounds from the primitives, why more

than six? or, why not double that number, or even more, if all the intermediaries are attended to? It may be worth remarking that Milton has, in a few words, described this appearance with a much more accurate and happy propriety:

> *and in a cloud, a bow*
> *Conspicuous, with* three *listed colours gay*

and in another place:

> *His* triple-*coloured bow, whereon to look ...*

But lest any one should think that our poet had from defect of sight over-looked the four other colours, we may quote the testimony of Aristotle, who has with his usual accuracy fallen upon the same tri-partite division.[23]

Certainly Dante may have presented Blake with the idea of a seven-colour bow, but Dante specified neither the colours nor their order, which in Blake's usage are always Newtonian.[24] One curious circumstance, indeed, reinforces the impression that in the construction of his rainbows, Blake was making a specifically and self-consciously Newtonian reference. In the known coloured bows before 1804 the order of the colours runs, from top to bottom, as in a perfect natural bow: red, orange, yellow, green, blue [indigo], violet.[25] Rainbows painted after 1804, on the other hand, show this order of colours in reverse, and run, top to bottom, from violet to red.[26] The crucial moment seems to be the winter of 1803-4, a time when Blake was helping William Hayley collect material for his *Life of Romney*. Hayley's *Life* published an aquatint after Romney's *Newton and the Prism*, a painting which remained in the painter's studio with his posthumous collection until 1807.[27] Blake saw this collection in October 1803, and remarked on a companion-picture to the *Newton* there, *Milton and his Daughters*, in a letter to Hayley (p. 878). We may assume that he also saw the *Newton* on this occasion, and in it, owing to the relative positions of the light-source and the prism (which seems to be held as in *Opticks*, I, ii, prop. viii, prob. iii; fig. 12), the projected spectrum runs, from top to bottom, through violet to red. Romney has even added a band of indigo below the red, which seems to correspond to a thin band of violet in Blake's *Noah*.

The material bow

If Blake's rainbow was essentially Newtonian it would be surprising to find it embodying the traditionally optimistic connotation of the Old Testament story of Noah's Flood, and its climax in the Covenant between God and man. Nor does it. Noah himself Blake pictured as shrinking 'beneath the waters' in *The Song of Los* (1795, p. 247), and from his use of it in other contexts, Blake clearly saw the rainbow rather as an emanation of water (i.e. materialism) than of light. In Jacob Bryant's *New System; or, An Analysis of Ancient Mythology*, Blake will have read that for the Greeks the sea-god Thaumas was the father of Iris, and that for the Egyptians *Thamus* was the bow itself.[28] In Blake's own mythology Tharmas personified the

element of water; and in *Vala* (p. 256) he presented Enion (earth) and her spectre in these terms:

> *Thus they contended all the day among the Caves of Tharmas,*
> *Twisting in fearful forms & howling, howling, harsh shrieking,*
> *Howling, harsh shrieking: mingling, their bodies in burning anguish.*
> *Mingling his brightness with her tender limbs, then*
> *Above the ocean; a bright wonder, Nature,*
> *Half Woman & half Spectre; all his lovely changing colours mix*
> *With her fair crystal clearness...*

Bryant had indeed suggested that the Egyptian *Thamus* signified *the wonder;* and in his final vignette to *A New System* (vol. iii), which may have been engraved by Blake, the Genesis story has been compressed to show the Rainbow of the Covenant 69 rising directly out of the Flood. Similarly, in a monochrome wash-drawing in the Abbot Hall Art Gallery, Kendal (Butlin no. 690), variously entitled *The Rainbow over the Flood* and *God moving on the Face of the Waters*, but which might perhaps more appropriately be called *Thaumas and Iris*, Blake has shown again this close relationship of bow and sea.

Both in illustrating other poets' verses and in illuminating his own, Blake used the rainbow as an emblem of materialism. In a watercolour for Night Eight of Edward Young's *Night Thoughts*, the image precisely interpreted a passage (II, 138– 48 42) on the transience of the sublunary world:

> *What is this sublunary world? A vapour;*
> *A vapour all it holds; itself a vapour;*
> *From the damp bed of chaos, by Thy beam*
> *Exhaled, ordain'd to swim its destined hour*
> *In ambient air, then melt, and disappear.*

In *Jerusalem* (ii, 48, p. 493) Blake described the creation of a bow by the emanation of the Friends of Albion:

> *With awful hands she took*
> *A Moment of Time, drawing it out with many tears and afflictions*
> *And many sorrows, oblique across the Atlantic Vale,*
> *Which is the Vale of Rephaim dreadful from East to West*
> *Where the Human Harvest waves abundant in the beams of Eden.*
> *Into a Rainbow of Jewels and gold, a mild Reflection from*
> *Albion's dread Tomb...*

The rainbow is a reflection of death, too, in the watercolours of Mary and Joseph on their biers. Blake saw Mary, like Beatrice, as a daughter of Vala, or Nature, 'Mother of the Body of Death' (p. 152), and Joseph, as her spouse, clearly belongs to the same cycle of generation. It is he who, in a drawing in Walsall Museum and Art Gallery, appears to have given the young Christ a pair of compasses in the carpenter's shop.[29]

It is, indeed, the compasses – which Blake may well have thought of as dividers – that Christ holds in common with the Newton of Blake's print; and the man Jesus

Vignette of *The End of the Deluge*, 1774, probably a design by Blake for Bryant. The Rainbow of the Covenant is shown rising directly out of the waters. (**69**)

recurs often in his prophecies as a symbol of division, and hence, according to Blake's doctrine of generation, of the material world.[30] Newton's gesture and his instrument have long been related to those in the frontispiece to *Europe* which shows the Ancient of Days holding a pair of compasses in the Heavens,[31] creating the Universe, an activity which, as Genesis has it, was conducted in a series of divisions. Blake was not only aware of the multiplicity of the Newtonian corpuscles of light, but also that the scientist's chief contribution to the understanding of colours had been to derive them from white light by a process of division through the prism. The divided light of the rainbow was thus for him a perfect image of the divided and fallen material world; and in portraying Newton in the act of creating this division – plotting perhaps the arc of the rainbow in the prism – Blake invented one of the richest images of materialism in his art.[32]

11 · Magilphs and Mysteries

…such people as ours who are floating about after Magilphs and mysteries and are very little likely to satisfy themselves with that saying of Annibal's, '*Buon disegno e colorito di fango* [good drawing and muddy colouring].'

(James Barry RA, 1769[1])

WHEN WILLIAM SANDBY PUBLISHED the first history of the Royal Academy in 1862 he made a special plea for instruction in the chemistry of colours, citing the physical decay of many pictures by Reynolds, Turner and Etty, and the late works of Wilkie.[2] The professorship of Chemistry at the Academy was not established until 1871, but already, by mid-century, the work of testing-bodies such as the Society of Arts, and of individual colourmen like George Field, had made available to artists proven methods and materials which have lasted extremely well, as for instance in the paintings of the Pre-Raphaelites.[3]

Earlier students and academicians were not so fortunate. None of the later eighteenth-century academies seems to have concerned itself with the teaching of technique, which was left to private masters,[4] and in England these masters were often unable or unwilling to provide instruction.[5] The technical manuals complained of secretiveness,[6] and recipes were spread by rumour and hint, rather than by any systematic teaching.[7] This atmosphere of uncertainty and speculation was naturally fertile in quack formulae, the grossest of which, the 'Venetian Secret' which was brought to general notice at the Royal Academy Exhibition of 1797, retained its echo of derision well into the following century.

The lure of Venetian colour

A preoccupation with sixteenth-century Venetian methods of painting was, perhaps rather surprisingly, as common among British history-painters as it was among portraitists, from Reynolds to Haydon,[8] and the tone was generally one of fascinated bafflement. When, therefore, in the 1790s, a copy of an apparently authentic early Venetian manual was produced, the enthusiasm of the President and other Royal Academicians is less surprising than their continued interest once the recipes had been tried. Ann Jemima Provis, who seems to have brought this document to the notice of the President, Benjamin West, in December 1795,[9] claimed that the original manuscript had been given to her grandfather in Italy by a Signor Barri, but had been destroyed in a fire some time after the copy had been made.[10] Little is known

about Miss Provis[11] except that she was a miniaturist who had been at some time in the care of the alienist and patron Dr Thomas Monro.[12]

Her secret, of which the diarist Farington's copy is preserved in the library of the Royal Academy, was by no means exclusively Venetian. It offered, indeed, a 'System of Painting according to the Several Great Italian Schools', and among the recipes for painting draperies is a 'Raphael Green', mixed from indigo, yellow ochre and orpiment, with powdered glass as a dryer.[13] Farington's *Diary* also tells us that Miss Provis was prepared to teach Roman practice,[14] and the manuscript even has some notes on the procedures of the Dutch painters Ruisdael and Wynants.[15] Her advice on method was also generously vague:

> Be particular to remember that all the before-mentioned Carnations may either be finished at one painting so as to deceive the eye as if they were Glazed, or heightened lastly by various Glazings of Transparent Carnations, Shades &c. mixed only in Linseed Oil very sparingly.[16]

Nearly half, however, of the Academy manuscript is in Farington's hand, which suggests that much was communicated by word of mouth, and there may have been more detail which has not survived. Stephen Rigaud, who records in a memoir the copy sold by Miss Provis to his father, the Royal Academician John Francis Rigaud, recalled that she

> committed very little of [the secret] to writing, but explained it principally by exhibiting [to a Royal Academy committee] several little pictures painted in that manner, from the first sketch to the finished work; as also by herself painting in their presence some specimens of the different processes through which the picture had to pass in order to its completion, according to the Venetian system.

This sounds remarkably like the then-current method of teaching watercolour painting to amateurs in a series of graded lessons.[17]

The three key elements of the Secret seem to have been the use of pure linseed oil, dark absorbent grounds,[18] and the 'Titian Shade', made up of equal quantities of lake, indigo, and Hungarian (Prussian) or Antwerp blue, plus rather more ivory black. This was the universal shadow-colour for flesh, drapery and clouds,[19] and it has been pointed out that the blues in this recipe were first developed in the eighteenth, not the sixteenth century.[20]

Examples of Miss Provis's paintings according to this system had been known for some years, and she had apparently worked on West's *Venus Comforting Cupid* (*Cupid stung by a Bee*).[21] But it was not until January 1797, when it seemed that the President might buy the monopoly of the secret, that interest began to spread widely in the Academy.[22] West asserted that 'A new Epocha in the Art…would be formed by the discovery'; and Alderman Boydell had already dismissed a number of painters from his Shakespeare Gallery project, and refused to engage others until the process had been tested more fully.[23] In Gillray's satire *Titianus Redivivus* Boydell is seen slinking off with West and clutching a volume of *Shakespeare*, with the complaint that the Secret might spawn 'another Gallery'. Even before they had been convinced of the improvement in the President's 'Venetian' pictures, Farington and

70

72

This typically 'Venetian' mytho-logical scene, *Venus Comforting Cupid*, *c.* 1796–1802, was apparently started by Benjamin West, the President of the Royal Academy, in collaboration with the miniature-painter Ann Jemima Provis, the chief author of the 'Venetian Secret'. (**70**)

Robert Smirke and half-a-dozen other Academicians suggested that the Provises should be offered an annuity; but West proposed private subscriptions and the establishment of Ann's father, Thomas, as an artists' colourman.[24] According to Farington (25 January) Thomas Provis would have been satisfied originally with fifty guineas for the process, but when the copyright agreement was drawn up with Farington's help,[25] six hundred guineas was the sum which the two partners were to be allowed to collect, before subscribers were free to divulge the Secret, for which they had paid ten guineas apiece. Until then, it was reported, the fine for a breach of secrecy would be £2,000, and the buyers undertook never to divulge it to any foreigner, 'thereby to preserve the advantage to their own country'.[26] J. F. Rigaud proposed that Academy students competing for medals should not use the Secret, as this would discriminate against the poorest.[27]

Almost as soon as rumours of the Secret reached the outside world they met with ridicule as well as with rivalry and support. By March 1797 the watercolourist Paul Sandby RA had composed what he later described as a 'doodle-do song' on the affair; and he declared that he and the portraitist Sir William Beechey had quickly discovered the process for themselves 'without subscribing a shilling'.[28]

Reynolds's former colourman, Sebastian Grandi, later described by Field as 'a most ignorant Italian quack in Colours', was found successfully passing off a picture

redeunt Titiamea regna, jam nova progenies coelo demittitur alto

James Gillray, *Titianus Redivivus; or The Seven Wise-Men consulting the new Venetian Oracle*, 1797, the most important visual document of the Venetian Secret scandal. (**71**)

painted by Henry Tresham RA to the Provis formula as a product of his own 'Venetian' system.[29] At the Society of Arts, another and more modest 'Venetian' expert, Timothy Sheldrake, gave a tentative recognition to the Provis method, which he imagined was similar to his own.[30]

Edmond Malone, in the first edition of his *Works of Sir Joshua Reynolds* (1797), welcomed the advantages of the Secret, which his subject had unhappily not lived to see; and, although he alluded to the Ireland Shakespeare forgeries of a few years earlier, he declared confidently that the authenticity of the process could easily be established by experiment.[31] Malone predicted with some confidence the appearance of several 'Venetian' pictures at the coming Royal Academy Exhibition; but those that were exhibited – by West, Tresham, Smirke, Thomas Stothard and

Richard Westall – generally met with a poor reception. *The True Briton* approved of Westall's *Infant Bacchus* (a thoroughly 'Venetian' subject),[32] but other critics found that the effect of the 'Titian Shade' varied from a 'dark and purpurine hue' to 'the chalky and cold tints of fresco and that gaudy glare and flimsy nothingness of fan painting'.[33] Even West was becoming increasingly dissatisfied with the process, and complained to Provis of his lack of success.[34]

The Secret exposed

In the winter of 1797 the whole affair was publicized as a major Academic scandal by James Gillray, in his print, *Titianus Redivivus; or The Seven Wise-Men consulting the new Venetian Oracle – a Scene in ye Academic Grove*.[35] The print is both the most 71 brilliant and the fullest document of the scandal, and Gillray shows himself to have been very well informed. West and Boydell creep away with another leading print-entrepreneur, Thomas Macklin, as the villains who had hoped to make money from the Secret, just as Farington had hinted. The Seven Wise Men are Farington

Gillray's satire may have been sparked by his ongoing feud with the print-entrepreneur Josiah Boydell (centre), shown creeping away with West and the print-publisher Thomas Macklin. Two of the Wise Men, above, are the landscapist Joseph Farington and the history- and portrait-painter John Opie. (**72**)

Miss Provis demonstrating her technique of portraiture on a dark ground. The ass Pegasus's wings display the names of the newspapers who supported the Secret. (**73**)

himself, John Opie, Stothard, John Hoppner, Smirke, Rigaud and Westall, each neatly characterized on their canvases or in their speech-bubbles by some telling weakness, such as Farington's 'Filchings from Wilson', Opie's thick impasto and Stothard's obsession with white grounds. Among the swarm of increasingly ape-like painters clamouring for the Secret are James Northcote, Tresham, Thomas Lawrence and Ozias Humphry, most of whom are well known for their technical curiosity. Two of the *putti* of puffing patronage above the artists represent Sir George Beaumont, one of the first amateur painters to buy the Secret,[36] and Edmond Malone; and the painters whose work is suffering defilement to the left include Sandby and Beechey, whose scepticism about the Secret we have seen, Gillray's friend and collaborator Phillip Jacques de Loutherbourg, one of the soundest technicians of the period, Henry Fuseli who was a lifelong opponent of the Venetian School, and the rising Academy star Turner, who was to be praised in a review

74

Above: the puffing patronage of the critics, including Reynolds's biographer Malone and the amateur painter Sir George Beaumont. (**74**)

Below: Sir Joshua Reynolds rises from the grave, while nearby, an ape-like painter defiles the works of the sceptics, among them Fuseli and Turner. (**75**)

of the Exhibition of 1798 for keeping aloof from 'these ridiculous superficial expedients'.[37]

The effect of Gillray's satire, or the disillusionment of which it was a symptom, was soon clear. Malone's second edition of Reynolds's *Works* (1798) carried an embarrassed recantation of his earlier enthusiasm, which concluded that, 'however ancient...these documents may be, they hitherto appear to be of little value'.[38] The editor himself was attacked, and Reynolds defended as a naturally 'Venetian' colourist, in the bitterest criticism to arise from the affair, James Barry's *Letter to the Dilettanti Society*, which included the splenetic protest that

> such a concurrence of ridiculous circumstances, of so many, such gross absur-
> dities, and such busy industrious folly, in contriving for the publicity, and
> exposure of a quacking disgraceful imposture is, I believe, unparalleled in the
> history of the art.

As the epigraph to this chapter shows, Barry had long been an opponent of techni-
cal nostrums, but the tone of his vituperation on this occasion may well have contributed a good deal to his expulsion from the Academy in the following year. A critic noted that there were no 'Venetian' pictures to be seen at the Exhibition of 1798.[39]

The aftermath

But the matter was not entirely closed: critics of the Academy continued to use it as ammunition, and the acute anxieties about technique, together with a belief in the essentially painterly qualities of British painting, did not go away. In 1802 John Singleton Copley claimed to have found the 'vehicle' which was the key to the Secret, and, about the same time, the new exhibiting society, The British School, which introduced George Field into the world of art, showed 'a specimen of the Venetian process of Painting' by the Irish artist Solomon Williams, who was touting his own 'Venetian' vehicle among the Royal Academicians, including, notably, Farington.[40] In 1806 it is curious to see the duped of 1797 – Farington, West, Opie – joining with the sceptical – Loutherbourg, Richard Cosway, Beechey – in endors-
ing Sebastian Grandi's absorbent grounds, 'in the old Venetian stile', before the Society of Arts, which awarded him a silver medal and a bounty of twenty pounds.[41]

Miss Provis was lost to view, together with her process; but the continued attrac-
tion of Venetian secrets for lady amateurs is shown by the *Account of a New Process in Painting by means of Glazed Crayons; with Remarks on its General Correspondence with the Peculiarities of the Venetian School*, which was published anonymously at Brighton in 1815. The author was the daughter of William Cleaver, Bishop of Bangor and later of St Asaph, and she claimed to have discovered her process by accident in 1807.[42] The quality of this strange pamphlet on 'dry colouring' may perhaps be judged from its assertion that 'oil colour is...incompatible with the essential characteristics of flesh, suppleness and transparency...',[43] and from the introduction of only a single Venetian painting (Bassano) among the twelve visual

examples to which the pamphlet was to serve as text. The specimen thought to be closest to Venetian effects was after an etching by the Bolognese painter Guercino.[44]

Miss Cleaver's work, which was re-issued in an expanded London edition in 1821, would hardly merit attention in this context had she not made repeated applications for support to the British Institution, and been taken up by Sir George Beaumont, who approached Constable to make trials of her process in 1824. Constable's deep sympathy for Titian, and probably his closeness to George Field, which developed at this time, inclined him to be suspicious of all formulae; and although he heard that Miss Cleaver 'had been boring at [it] these twenty years', he concluded that he did not much like it. Cleaver hoped the Institution would send several artists to test her process at her home in Brighton 'and offer very high premiums for their success', but it is not known whether anything further was done.[45]

Miss Cleaver claimed that she had never had the opportunity of consulting original Venetian manuals;[46] but soon, with the publication of the historical researches into technique by Charles Lock Eastlake and Mary Merrifield, there could be very little possibility of further impostures of the 'Venetian Secret' type. Both historians and chemists were making artists and their public more aware of the limitations and legitimate uses of materials; possibly they were also changing an attitude of mind which looked for art in easy recipes. 'It will soon be discovered,' wrote a critic of the eighteenth-century Venetian scandal, 'that the colour-shops of ancient as well as of modern times have not dealt in the ingredients of genius.'[47]

12 · Turner as a Colourist

'AS FOR TURNER, AT FIRST HE STUNS YOU. You find yourself facing a confusion of pink and burnt siena, of blue and white, rubbed on with a rag, sometimes round and round, sometimes in lines, or in zig-zags in several directions. You might say that it was done with a rubber-stamp brushed over with breadcrumbs, or with a pile of soft paints diluted with water and spread on to a sheet of paper, which is folded and then scraped violently with a stiff brush. This gives rise to an astonishing play of mixtures, especially if you scatter a few flecks of white gouache on it before folding the paper.

'That is what you see from close to, and from a distance…everything balances itself out. Before your incredulous eyes a marvellous landscape rises, a fairy place, a radiant river flowing beneath a sun's prismatic rays. A pale sky vanished into the distance, engulfed in a horizon of mother-of-pearl, reflecting and moving in water that is iridescent like a film of soap, and the spectrum of soap-bubbles. What land, what Eldorado, what Eden flames with this wild brilliance, these floods of light refracted by milky clouds, flecked with fiery red and slashed with violet, like the precious depths of opal? And yet these are real places; they are autumn landscapes with russet trees, running water, forests shedding their foliage; but they are also landscapes that have been vapourized, where dawn fills the whole sky; they are jubilant skies and rivers of a nature sublimated, husked, and rendered completely fluid by a great poet' (J. K. Huysmans, 'Turner et Goya', *Certains*, 1889[1]).

Huysmans' vivid characterization of Turner as a colourist places the painter firmly in the Elysium of Symbolist heroes; and it is no surprise that Gustave Moreau and Edmond de Goncourt found him to be something of a 'jeweler' when they went to look at his work in the Groult collection in 1891, and may have seen there the *Landscape with a River and a Bay in the Distance* – possibly also the work, exhibited at the quai Malaquais, which had aroused such an enthusiastic response in Huysmans. Goncourt wrote of one Turner Venetian scene there – alas, likely to have been a fake – that it was 'liquid gold, and within it an infusion of purple…it has the air of a painting done by a Rembrandt born in India'.

But for the Impressionists in these years it was a very different story. In a conversation with the dealer René Gimpel in 1918, Claude Monet explained that '*Dans le temps j'ai beaucoup aimé Turner, aujourd'hui je l'aime beaucoup moins. – Pourquoi? – Il n'a pas assez dessiné la couleur et il en a trop mis* [Over the years I have liked Turner a great deal, but now I like him far less. He has given too little attention to the arrangement of colour, and he has used too much of it].'[2]

Local colour

Of course Monet was right. If we place one of his *Rouen Cathedral* paintings beside 83
Turner's small gouache of the same subject,[3] or one of his or Renoir's Venetian 82
subjects beside one of Turner's, we see that even the late Impressionist approach to
colour is very different from that of the late Turner. In Monet and Renoir colour is
a function of the light which floods into the picture, animating the complex sur-
faces of objects, but also bringing them into unison by the homogeneity which it
confers on the whole. However strange or 'recherché', the colours in Impressionist
paintings are always echoed in every part of the canvas; like the unified brushstroke,
light and colour weld the surface into a unity. Turner handled his colour in quite a
different way. Just as his brushstroke varies from object to object and from area to
area on canvas or paper, now broad and fluid, now crisp and impastoed, now swift
and calligraphic, so Turner's colour is used, for the most part, to discriminate
between objects, not to unify them. The strong red and green costumes of the
figures in the foreground of his *Rouen Cathedral* – a colour-combination so charac-
teristic of his work in the early 1830s – are used as maximal contrasts of local colour,
not, as they might be in Monet, as complementary colours of light: they give us
neither the appearance nor the conception of figures in full sunlight.

During the second half of his career Turner was always searching for ways of
introducing local colour into the various areas of his works. A Venetian subject,
painted for the sculptor Sir Francis Chantrey, was the subject of a conversation at
some reception, where a discussion ensued among a number of spectators about the
identity of a large orange object floating in the water, which some considered
might be a gorgeous turban. Then Turner came up, and 'after two or three twitches
of his lips, and as many little half h-ms, he replied, "Orange-orange." '[4]

Turner's liking for fruit and vegetables in his pictures, which Ruskin attributed to
tastes developed during his boyhood near Covent Garden market, served in the
event a much more purely formal purpose. They were the landscape-painter's sur-
rogates for the coloured draperies of the history-painter or the bric-à-brac of the
still-life artist, to be manipulated at will, according to the exigencies of a pictorial
idea. But they must not be wholly arbitrary: Turner's resistance to abstraction is
nowhere more evident than in his urge to give these patches of brilliant local
colour a recognizable – and more or less reasonable – physical form. The need for
reason is emphasized in a story circulating in the 1850s at Petworth House in
Sussex, the home of Turner's most important later patron, Lord Egremont, about
Brighton from the Sea, one of the painter's florid footnotes to the family portraits by
Van Dyck. As one visitor wrote: '[Turner] introduced in the foreground of it a
broken basket with some floating turnips, carrots, etc., and, as the old butler told
me . . ., was savage when, at Lord Egremont's suggestion as to their specific gravity,
he asked for a tub of water and some of the identical vegetables, and found the latter
all sank. They were evidently too useful in his picture to be removed.'[5]

They were indeed extremely useful, and as late as 1847, when Turner had taken
to repainting some of his early canvases, he introduced into *Tapping the Furnace* (a
work originally produced nearly half a century earlier) a strikingly characteristic

device to accentuate the flames of the furnace. 'Turner, not satisfied with the daz-zling effect obtained by surrounding the blazing fire with broad masses of shadow on the walls and roof of the foundry,' recalled a contemporary, 'had determined to make the glow and glare still more effective by opposition of colour. He could conceive of nothing that would naturally be seen in the place to answer the desired purpose; and so he introduced, in the immediate front of his picture, stretching from side to side, a row of cut cabbages of the greenest possible hue. These cabbages were a great puzzle to many visitors to the exhibition.'[6]

The public certainly saw the work primarily as a matter of colour: as the critic of the *Atheneum* put it, it was 'full of fine passages of chromatic arrangement; it has so little foundation in fact that the sense is merely bewildered at the unsparing hand with which the painter has spread forth the glories of his palette'. Turner's inten-tions were essentially colouristic, but he was not prepared to allow colour to stand by itself. By an irony of history, the cabbages in *Tapping the Furnace* are still some-thing of a puzzle, and their presence has barely been noticed by modern commen-tators on the picture, for the hasty methods used by Turner to improvise his repainting in time for the Exhibition have meant that they have now darkened and cracked to the point of being virtually invisible.

Thus, if Turner's later treatment of colour was not abstract, seen from the point of view of 'realism' or 'naturalism' it could none the less be thoroughly wilful, and Monet's strictures in 1918 are entirely in order. Yet it had not always been so, and if Monet saw Turner's early work, like the *Cilgerran Castle* (Leicester) which passed through the Paris saleroom in 1874, at a time when the English painter was still something of a hero to the Impressionists, he will surely have recognized a kindred spirit.[7] For between about 1800 and 1812 Turner's art saw a naturalistic phase which is precisely parallel to the 'high' period of Impressionism in the 1870s. He developed an interest in more informal pastoral subjects, and he took to the practice of working directly from nature in the open air, both on small oil-sketches and on the earlier stages of canvases destined for the Exhibition. This was the time when he believed, as he told a travelling-companion in 1813, that 'we can paint only what we see'.[8]

Primaries – the 'colour-beginning'

But it was only a phase, and already by 1820 Turner had begun to organize his work colouristically on the basis of the 'colour-beginning',[9] a method which began with watercolours, but which by the early 1830s had also become his standard procedure in oil. It is a procedure closely associated with Turner's work in series, of which the *French Rivers* is one of the finest, and certainly one of the most sustained examples, where the painter worked simultaneously on many separate images, taking each of them to completion through a series of stages; and this serial process was also applied increasingly to oils in the 1830s.

The 'colour-beginning' divided canvas or paper into large areas of distinct colour, sometimes pure and sometimes surprisingly bright, and these areas had little direct connection with the nature of the objects which were to be represented. The

colours which came to be chosen were for the most part the three subtractive primary colours, yellow, red and blue, which Turner felt were an epitome of the whole of visible creation. As he wrote in a lecture of 1818, yellow represented the medium (i.e. light), red the material objects, and blue, distance (i.e. air) in landscape, and in terms of natural time, morning, evening, and dawn.[10] In common with many artists of his generation Turner was fascinated by the idea of discovering an irreducible number of elements in nature and art; his interest in primary colours is matched by a belief in the underlying geometrical simplicity of forms.

Light and colour

That tradition in the understanding of colour in France which runs from Chevreul (Chapter 15) to the Neo-Impressionists was essentially perceptual; it concerned itself chiefly with optical functions. Complementary colours acquired a special status because they are 'objectively' the colours of light and of the shadows cast by objects placed in that light, and because they are 'subjectively' the colours of after-images, of those pairs of colours which seem to be demanded by the natural functioning of the eye. Nothing is more indicative of Turner's lack of concern with this aspect of colour in nature and in perception than his adaptation of one of the earliest colour-circles to arrange the 'prismatic' colours in a complementary sequence: the circle devised by the entomologist Moses Harris about 1776. Turner used this circle as the basis for one of his lecture diagrams in 1827, but he denied precisely these complementary functions of colour in favour of those traditional functions of value: light and dark, day and night.[11] Turner's abiding interest in the symbolic attributes of colour is clear from the series of small paintings, conceived in pairs, which he produced in the early 1840s, and of which the best known is *Shade and Darkness: the Evening of the Deluge,* and *Light and Colour (Goethe's Theory): the Morning after the Deluge – Moses writing the Book of Genesis.*[12] In these two paintings, with their convoluted iconography, Turner was concerned first of all with the capacity of colour to convey an idea, rather than with the sensations of darkness and light.

Turner's insistence on the essentially symbolic value of colour in nature is bound up with his belief that colour and light are substances, a view which was presented to him in a number of literary sources from the Renaissance and the late eighteenth century. It must have been a particularly attractive notion to a painter whose handling of his materials, whether in watercolour or in oil, showed such a delight in their substantiality. Light in his paintings, and particularly the disc of the sun in, for example, *The Festival of the Vintage at Maçon* and *Calais Sands,*[13] is rendered by a thick impasto of white or vermilion, 'standing out', as one commentator on the *Regulus* of 1837 put it, 'like the boss of a shield'.[14] One of Turner's sources, Edward Hussey Delaval, also suggested that the production of colours in animals, plants and minerals was analogous to the procedure of the watercolourist (extended to oils in Turner's latest practice), which functioned 'by the transmission of light from a white ground through a transparent coloured medium'.[15] The idea that all the colours of the visible world could be subsumed under the three primaries, red, yellow and

13

59
81

76-7

J. M. W. Turner, *Shade and Darkness: the Evening of the Deluge* (above), and *Light and Colour* (*Goethe's Theory*): *the Morning after the Deluge – Moses writing the Book of Genesis* (right), both of 1843. Turner contrasts the dark prelude to the biblical Deluge and its brilliant aftermath, when the sun brought prismatic bubbles to the surface of the Flood. The Goethe reference is probably to the poet's table of polarities – blue and yellow, dark and light, and so on – in *The Theory of Colours*, of which Turner annotated his own copy at this time. But Turner felt that even Goethe had not sufficiently stressed the constructive role of darkness in the generation of colour. (**76**, **77**)

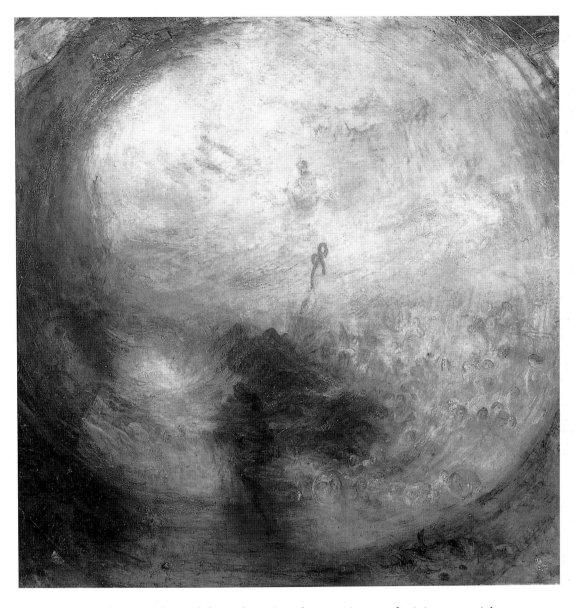

blue, was also of course derived from the painterly experience of mixing material pigments, rather than from an analysis of the prismatic spectrum, and all these notions allowed Turner to resist the conclusion that colour, even as it is perceived, is simply a function of the action of light on surfaces.

The relativity of colour

But this is to concern ourselves only with the 'objective' status of colour; and Turner's colourism is also a result of those aspects of colour which occupied the researches of Chevreul and of the Impressionists, namely colour as a relative value,

and the notion that contrasts and juxtapositions may work miracles with perception. 'Stay there', Turner is reputed to have muttered to a patch of yellow pigment on his canvas, 'until I make you white.'[16] And he was prepared to turn the accidents of perception into a painterly method during those 'Varnishing Days' at the Royal Academy and British Institution exhibitions. A younger contemporary recalled how, when Turner arrived to hang his work at the Royal Academy exhibition in 1846, 'some of his work was, as usual, only rubbed in, and it was common practice of his, when he saw how his pictures were placed, to paint first a little on one, then on another, and so on till all were finished to his satisfaction'.[17]

This procedure was very much a method of self-defence, as the critic of *L'Artiste* had noted, with pardonable exaggeration, as early as 1836:

> There is no doubt that the chief reason for the great change which has crept into his style derives from the rivalries occasioned by the annual exhibition of paintings at Somerset House, where the paintings are so crowded together, that the artist most ambitious for reputation tries to attract attention by the use of bright colour and the most dazzling effects of light. When a man of genius like Turner makes this effort, the result is overwhelming for artists with less imagination.[18]

And not for these nameless artists of lesser imagination alone, for in 1832 John Constable himself was to find the red robes of the dignitaries in his picture of the *Opening of Waterloo Bridge* (London, National Gallery) cast into obscurity by the wafer of red sealing-wax which Turner applied to the water of his cool green seapiece next to it, *Helvoetsluys*, and later painted into the form of a buoy. 'He has been here', said Constable when he saw it, 'and fired a gun.'[19]

As he grew older, Turner paid more and more attention to these subjective effects of colour; in 1845 a group of visitors to the private gallery he had designed and built to provide the best lighting and coloured background for his paintings was told to wait for some time in a totally darkened anteroom before they were allowed to see the pictures themselves, since 'the bright light outside would have spoilt their eyes for properly appreciating the pictures, and that to see them to advantage an interval of darkness was necessary'.[20]

We return here to where we started, to the world of late Monet, for it was Monet who proclaimed, just before he died, that he would have liked to have been born blind and to have had his sight suddenly restored, so that he could see the world afresh as nothing but an arrangement of coloured patches, without reference to any knowledge of objects. It is fitting that Monet should here have been echoing a notion he had found in that most admired of Ruskin's works in late nineteenth-century France, *The Elements of Drawing*, translated as it was by the Neo-Impressionists Henri-Edmond Cross and Paul Signac,[21] and that Ruskin himself should have come to recognize these principles of colour-relativity above all from his experience of late Turner.

13 · 'Two Different Worlds' – Runge, Goethe and the Sphere of Colour

IN THE HISTORY OF COLOUR-IDEAS 1810 was something of an *annus mirabilis*, for in that year two books appeared almost simultaneously in Germany which, after Newton's *Opticks*, have some claim to being the most important early modern classics of colour. Unlike the *Opticks*, however, they were neither of them the work of a professional scientist, let alone a significant one. The first was the poet Goethe's 78
Die Farbenlehre (Theory of Colours) and the second was *Die Farben-Kugel* (Colour-Sphere) by the Hamburg painter Philipp Otto Runge.

Goethe's *Farbenlehre* is still the most comprehensive study of colour from every point of view, including the historical, and although its 'Historical Part', like its detailed polemical critique of Newton's theory of colours, has not often been reprinted, the 'Didactic Part', laying out Goethe's own theory, has been much re-edited and translated, and is still in print in several languages, including English. Goethe's theory of the origin of colours in the polar interaction of light and darkness, and the exemplification of this action in many familiar experiences of colour, have become in recent years of increasing interest to historians of science, and Goethe's work is now routinely included in scientific, as well as philosophical discussions of colour.[1]

Runge's *Farben-Kugel*, a far slimmer text, is essentially an exposition of his three-dimensional arrangement of colour-space, co-ordinating the six primary and sec- 79
ondary hues with the value-scale of light and dark. It included an introduction on the place of colour in nature, not by Runge himself, and a brief appendix on the use of the sphere to derive principles of colour-harmony by complementary contrasts. The colour-sphere is the ancestor of most modern systems of surface-colour, and it has often been cited in the literature of colour-measurement, although its ideal symmetry has not proved adequate to modern conceptions of colour-spacing. The text of the *Farben-Kugel* is concise and factual; only the appendix introduces a note of personal interpretation, although this interpretation was hardly unique to Runge. The Romantic character of the painter's enterprise emerges only from the thoroughly speculative introduction by the Danish nature-philosopher Henrik Steffens which has not always been reprinted in modern editions.[2]

Goethe and Runge

However disparate these two contemporary treatises may seem, they have usually been considered together because Goethe and Runge were, in fact, closely involved

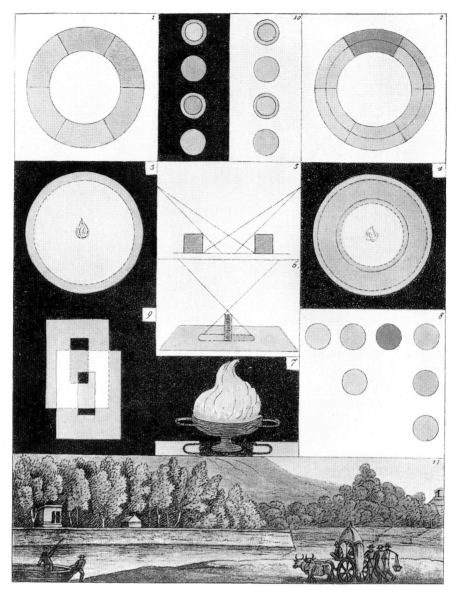

J. W. von Goethe, frontispiece to *Die Farbenlehre* (Theory of Colours), 1810. Nos 3 and 7 show the basic colours of light (or flame) as yellow and blue, while circles 1 and 2 have at the top Goethe's most important colour: *Purpur* (red), produced by the 'augmentation' of polar yellow (light) and blue (darkness). The landscape below contains no blue – a precocious investigation of colour-blindness. (**78**)

in each other's developing interest in colour over a period of nearly ten years; and theirs is an exceptionally well-documented relationship which promises many insights into the interaction of practice and theory in the visual arts. And yet the completeness and intelligibility of this record is more apparent than real, and I hope in this chapter to suggest that we are still faced with as many questions as answers, to point out what these questions are, and to go some way towards answering some of them.

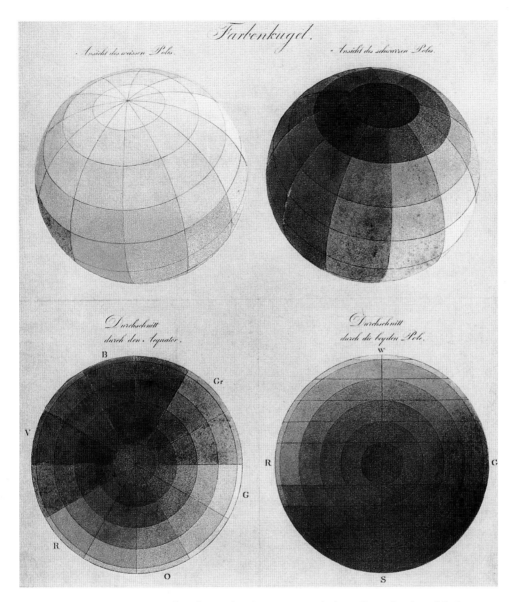

Philipp Otto Runge, *Farben-Kugel* (Colour-Sphere), 1810. Runge's three-dimensional model of colour-space co-ordinates hues with values (light and dark). A set of three primaries – red, yellow and blue – is arranged in a complementary scheme around the equator, with black and white at the respective poles. (**79**)

To the central, 'Didactic Part' of his *Farbenlehre* Goethe appended a letter which he had received from Runge in 1806: a letter, as the poet wrote in a prefatory note, which showed 'that artists have already opened up the path which we see as the correct one…', so that:

> without being informed of my efforts, through his own inclinations, his own practice and his own thought, [Runge] has found himself on the same path.

A careful comparison of this letter and my sketch will reveal that in several places they agree precisely, and that others may be interpreted and illuminated by my work, so that the writer has anticipated me in several points by his lively conviction and true feeling.[3]

A 'careful comparison' of the two texts will, however, show us that there are remarkably few points of comparability between them: Runge, for example, is not at all concerned with the origin of colours in the interplay of light and dark, which is the keystone of Goethe's theory; and Goethe, for his part, shows no special interest in the distinction between transparent and opaque colours, which is Runge's chief preoccupation in this letter. But by the time the *Farbenlehre* appeared in print Goethe had received a further sample of Runge's colour-ideas in the form of the *Farben-Kugel*, which the poet read in manuscript during 1809 and in its printed version early the following year. This text he also welcomed as being close to his own views,[4] although again, with the exception of the appendix on harmony (which recommended complementary contrasts), it had little to do with the leading arguments in Goethe's book, and was indeed even further in general terms from Goethe's approach and tone than the 1806 letter had been. In particular, Runge had now abandoned that arrangement of the colour-circle with red at the top, which had a crucial significance for Goethe, but none for Runge, who tried many orientations quite indifferently during the preparation of his treatise.[5]

78 Goethe's concept of *Steigerung* (augmentation) by means of the semi-opaque medium, by which the two basic colours, yellow representing light and blue representing darkness, are acted upon to produce the highest, noblest colour, red (*Purpur*), was the driving force behind the poet's attack on the Newtonian doctrine that all colours inhere in white light alone, without the intervention of darkness. But Runge came late to Newton – as late as September 1806 he was asking Goethe where he could find a good account of Newton's theory[6] – and opposition to Newton was never a central issue with him, since he avoided any engagement with the crucial matter of the origin of colours (*Farben-Kugel*, §4). The *Farben-Kugel* was at once recognized as in no way an anti-Newtonian treatise,[7] and Runge, like Blake, continued, for example, to use the Newtonian seven-colour schema of the rainbow-colours.[8]

When in the summer of 1810, and shortly before his death, Runge came to read Goethe's *Farbenlehre* itself, he found

that there is much that I have not understood or see differently, and since several errors have slipped into [my] book, [Goethe] will have something to forgive: my goal is really a different one...[9]

And the only recorded note which the painter made in the course of his reading of the poet's text was to counter one of Goethe's arguments about subjective, physiological colour-phenomena by an appeal to the effects of objective transparency.[10] At no stage in the interchanges between Goethe and Runge between 1806 and 1810 do we have a sense of the unity of minds.

Why then did Goethe claim so vigorously that there was a close similarity between

his and Runge's views on colour? Certainly we know from their correspondence that he was aware of a far greater range of Runge's thoughts and experiments than was ever published in either of their books; but that is hardly the point, and there was, in any case, little in these further thoughts and experiments which came close to Goethe's central concerns. Some indication of what was in Goethe's mind emerges from a letter to the composer and musical-theorist Zelter in August 1806, and from a remark made both to Runge and to Steffens in 1809:

> It would be very congenial to me if, on the completion of my work, I can appeal to sympathisers among my contemporaries, since so far I have been able to find support only among the dead.[11]

Goethe was above all anxious to find support among the living, for he had already enrolled the dead in the 'Historical Part' of the *Farbenlehre*, and if there was nothing in Runge's work that was specifically anti-Newtonian, nor was there anything there which clashed directly with his own views.

Steffens, Schiffermüller and the Farben-Kugel

In the letter to Zelter as well as in the published note on Runge's letter of 1806, Goethe claimed that Runge had known nothing of his (Goethe's) colour-studies before that date, and if this is so, then the mysterious conversation between them which took place at Weimar in 1803 can hardly, as has sometimes been assumed, have touched on that subject.[12] But in April 1808 Runge referred approvingly to an idea in Goethe's *Beiträge zur Optik* (*Contributions to Optics*), which had been published fifteen years earlier.[13] During the winter of 1807-8 Runge had renewed his acquaintance with Steffens, who had long been familiar with Goethe's early optical work and was to cite it repeatedly in his own contribution to the *Farben-Kugel* in 1809.[14] Runge's brother Daniel recalled that it had been discussions with Steffens which had first led the painter to formulate the idea of the *Kugel* itself.[15] The *Kugel* is first mentioned in a letter to Goethe of November 1807, and is described as 'ready' (presumably referring to the three-dimensional model, rather than to the book) by April of the following year, in a letter which also acknowledged Runge's indebtedness to Steffens at this time.[16] Clearly Steffens was a figure of the greatest importance for the direction taken by Runge's study of colour.

Steffens's essay, 'On the meaning of colours in nature', unlike Runge's own part of the *Farben-Kugel*, has attracted very little attention.[17] Certainly it came very much as an afterthought, and does not seem to have been written in direct consultation with the painter, who read it with some curiosity and even surprise when his book was published in 1810.[18] It does nevertheless throw light on a number of problems connected with Runge's own work. In a list of earlier authorities on colour, introduced to point up the originality of Runge's contribution to the subject, Steffens mentioned not only the Goethe of the *Contributions to Optics*, but also the Viennese entomologist Ignaz Schiffermüller, whose *Versuch eines Farbensystems* (Essay on a System of Colours) had appeared in 1771 (see pp. 24-5).[19]

6 Schiffermüller presented his colour-circle in a thoroughly Rococo format – he himself admitted that the diagram had an element of pure decoration – and this is perhaps one reason for his rather poor press among some modern students of colour.[20] But the book is nevertheless of the greatest interest as perhaps the earliest attempt to base a theory of harmony on the arrangement of colours in a circle. Like Runge, Schiffermüller found that colours close to each other on the twelve-part circle are discordant; unlike him, he agreed with those critics of complementary juxtapositions who called them 'poisonous and merely box-painting' (*giftig und eine Schachtelmalerei*), although he added that they might be manipulated into harmony by modifying the values of light and dark in each hue.[21] Also like Runge in the *Farben-Kugel*, Schiffermüller, following Louis-Bertrand Castel, placed blue at the apex of his schema as the most important colour, by virtue of its keeping its identity as blue throughout the whole range of values from light to dark.[22]

The *Essay* was noticed briefly in the 1792 edition of J. G. Sulzer's *Allgemeine Theorie der Schönen Künste* (General Theory of the Fine Arts), with which Runge appears to have been long familiar,[23] but that the painter turned to it at this particular moment in 1807 is suggested by his new interest in testing pigment- and light-mixtures on a spinning disc; for this experimental method, and the marked differences between pigment-mixtures on a disc and those mechanically achieved on the palette, had also been discussed in some detail by Schiffermüller.[24] It remains, however, that Runge's far more comprehensive treatment of harmony in the appendix to the *Farben-Kugel* is closest to Goethe's formulations of 1798, and the likeness cannot be simply coincidental.[25]

The suppression of symbolism

Steffens in his essay also suggested that the *Farben-Kugel* was far from representing the whole of Runge's views on colour: 'do not imagine that he has given all that he was capable of giving'.[26] The treatise is indeed a surprisingly dry and old-fashioned affair, especially if we recall that a three-dimensional model of a colour-system had

59 been implicit, if not quite explicit, in Moses Harris's *The Natural System of Colours* which had been published in the 1770s, and that the unpublished idea goes back to the early seventeenth century.[27] What had become of Runge's intense involvement with colour as 'the ultimate art', as religious expression, as universal symbol, which had obsessed him as a painter as well as a theorist since his first encounter with the colour-ideas of the poet and novelist Ludwig Tieck in 1801? In recommending the *Kugel* to Goethe in 1809, Steffens stressed

> the great clarity, the spontaneous simplicity and the well-organized, poetic geometry, if I may so call it, of his vision, by which this exposition...so fortunately distinguishes itself from the wild fantasists of the day.[28]

And Runge himself explained to Goethe that he would be able to gain a clearer view of his own work 'when something has been established which we can all agree with...and which can provide a point of reference to us all'.[29] He wanted the sim-

plest common denominator of a systematic conception of colour which would, in itself, be quite uncontroversial. Could both he and his collaborator Steffens have been thinking, in the first instance, of Goethe the 'classicist' as their audience, and remembering how much both of them had already suffered from the poet's attacks on the wilder aspects of their thought and style? The more symbolic element of Goethe's thought, his psychological theory (see p. 187), was not to be published until the following year. If so, we shall be surprised when we turn to Steffens's essay to find that he is clearly aligned with the 'wild fantasists', both in the content and in the manner of his wide-ranging speculations, which were attacked precisely on these grounds by the reviewer in the *Göttingsche gelehrte Anzeigen* in 1810.[30]

Steffens's introduction to the *Farben-Kugel* was written independently of Runge, but does it reflect some unrecorded discussions with the painter, and especially, since it was composed in the winter of 1809-10, does it represent Runge's last views on the status of colour in nature? There is some reason to think this may indeed be so. Steffens, for example, like Runge, linked colours with the four times of day:

> Is not the dawn to be seen as the red side of the great colour-structure [*Farben-bild*] which is every day in motion, which projects itself into the brightness of day? And noon as the dominant yellow, and evening the violet, which loses itself in the darkness of night?[31]

These equivalents, which seem to be related to Steffens's unusual idea that red and blue are the most basic primaries,[32] do not agree with Runge's earliest (1802) formulation of the relationships between colours and the Christian Trinity and three times of day where, in a thoroughly idiosyncratic way, blue was held to characterize the Father (morning), red the Son (noon) and yellow the Holy Ghost (night).[33] But morning, for example, soon became red in Runge's system, and in the 1808 *Small Morning* the central focus in the frame is on the red lily, *Amaryllis formosissima*, which thus comes to embody the dawn or *Morgenroth*, and, together with the abandonment of the name of God, *Jaweh*, which appeared in earlier versions of this frame, to throw the emphasis of the *Morning* entirely on to red. It is clear, too, from the way in which the *Times of Day* series developed, that Runge was increasingly anxious to move away from more conventional Christian or Classical imagery and towards something more 'abstract'; in describing a preparatory study for the *Small Morning* in April 1808 he avoided any specific mythological reference to the figures: they are simply general embodiments of the forces of nature.[34]

And yet Runge was still uncertain of the precise relationship of theory to practice. Writing to his brother Gustav in November 1808 he characterized the *Farben-Kugel* as:

> not a product of art, but a mathematical figure based on some philosophical considerations...

And he concluded:

> that it is necessary for me, when I am working as an artist, not to know anything about it, since these are two different worlds which intersect in me...[35]

84

But in a letter to the philosopher F. W. J. von Schelling, early in 1810, in which he expressed the hope that he might be able to extend the discoveries of the *Kugel* into a more wide-ranging study of the colour-phenomena of nature, Runge was still able to suggest that what his contemporaries needed most was for 'scientific discoveries in the practice of art to be related more to general scientific ideas, and to be raised to their level'.[36] It is clear that he was deeply concerned that his early engagement with colour should be intensified, but equally clear that he did not yet know how in detail this was to be achieved. His involvement with precise and original experiments since 1806 had made him less, rather than more sure of his fundamental ideas, and it was perhaps for this reason that he welcomed the intervention of the scientist Steffens in the *Farben-Kugel* project, especially since Goethe had been so uncommunicative about his own work. Runge's thought, like his practice, was in a continual state of evolution, and the *Farben-Kugel* represents only one aspect of one or two moments in that evolution: in 1807-8 for the principal text, and 1809 for the appendix on harmony. We are mistaken if we interpret it as the statement of a mature and coherent doctrine.

Despite what seems on the face of it to be an ideally complete record of the relationship between Goethe and Runge in respect to colour, it would appear that many questions cannot be answered simply by reference to this record. Runge's art and theory presents us with a mind in a constant state of flux, the work of a life tragically truncated at the age of thirty-three, before it could formulate any very compelling statements. We should perhaps try to understand Runge's thought on colour by appealing to the shape of that life, rather than by extrapolating backwards from the simplified interpretation of his Romanticism which has been common in our own century.

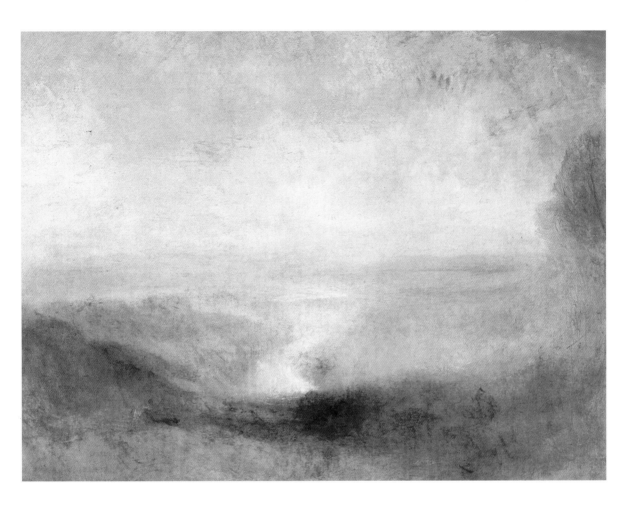

Turner's light and darkness

The first painting by Turner to make a major impact in France: his late, and probably unfinished *Landscape with a River and a Bay in the Distance* of *c.* 1845 – perhaps the poet Huysmans' 'radiant river flowing beneath a sun's prismatic rays'. In the France of the 1880s and 1890s this canvas was regarded as characteristic of Turner's style towards the end of his life. (**80**)

A lecture diagram of *c.* 1825 (right) illustrating Turner's interest in darkness as well as light. It was based on the circle devised by the entomologist Moses Harris about 1776 (59), but Turner ignores Harris's complementary functions of colour in favour of value, with light at the top of the circle and central triangle, dark below. (**81**)

Colour in Turner and in Impressionism

Turner's small gouache of *Rouen Cathedral*, *c.* 1832, uses colour chiefly to discriminate between objects, not to unify them (above), whereas in Monet's painting of the same subject in 1892–4 (right), colour is a function of the light which floods into the picture, animating complex surfaces, but also bringing them into homogeneity. Turner's handling of the bustling street-scene shows a far greater preoccupation with local colour. (**82**, **83**)

Red and the feminine

A systematic conception of colour, as espoused by Goethe in the *Theory of Colours* (78), and colour as 'the ultimate art' – were represented respectively in the Hamburg painter Philipp Otto Runge's *Colour-Sphere* (79) and his paintings of the three *Times of Day*. Morning was seen as red in Runge's system (left: *The Small 'Morning'*, 1808). In the gendering of colour, red is here linked to the female figure of Aurora, flanked by the red lilies in the frame. (**84**)

In anthropological vein, the German Romantic painter Franz Pforr believed colour to be expressive of character (above). His *Sulamith and Maria* of 1811 clothes the allegorical figure of the South, brown-haired Sulamith, in white, red and green, and the blonde northerner Maria in a bright-red dress and white apron. (**85**)

German Modernism and Goethe's theory

Both Franz Marc (above: *Blue Horse I,* 1911) and Kandinsky were persuaded of the masculine spirituality of blue – the Romantic colour *par excellence.* 'We both loved blue,' Kandinsky mentioned *a propos* the name of the almanac *Der Blaue Reiter* – 'Marc horses; I riders'. (**86**)

Perhaps under the stimulus of Goethe in 1910-11 Marc painted his dog Russi as seen through a prism, recording the coloured fringes at the junction of light and dark (above right), and also, as he explained, to study the contrasts between yellow, white and blue. (**87**)

In *Yellow-Red-Blue* of 1925 (right), Wassily Kandinsky, then a teacher at the Bauhaus, exemplifies a further aspect of Goethe's theory – the creation of red from the 'augmentation' (*Steigerung*) of yellow (light) and blue (dark) as described in Goethe's *Theory of Colours.* (**88**)

The polar interaction of light and darkness made visible – the most striking instance of the application of Goethe's theory of colour to painting. The German artist Arthur Segal's *Fisherman's House on Sylt I* (1926) portrays the spectral edges engendered at the meeting of light and dark. In this same series of paintings the artist hoped to find a way of reconciling the equal demands of colour and form. (**89**)

14 · Mood Indigo – From the Blue Flower to the Blue Rider

Price question:
1. Anna Blossom has wheels.
2. Anna Blossom is red.
3. what colour are the wheels?
Blue is the colour of thy yellow hair.
Red is the whirl of thy green wheels.
Thou simple maiden in everyday-dress,
Thou dear green animal,
I love Thine! -
(Kurt Schwitters, *Anna Blossom has Wheels*, 1942[1])

KURT SCHWITTERS'S PARADOXICAL HANDLING of colour in his best-known poem, originally published in German in 1922, where the contraries are elided into a syncretic conception of love, may stand as a sign of one of the most durable features of German attitudes to colour, from the Romantics to the Modern movement - the structuring of colour as a set of polarities.

Despite the central importance of that most concrete, as well as most compre-hensive of colour-handbooks, Goethe's *Farbenlehre* (1810), German approaches to colour continued to be far more abstract and symbolic than perceptual. Where French theorists, from Philippe de la Hire (*Dissertation on Various Occurrences in Vision*, 1685) to Auguste Rosenstiehl (*Treatise on the Physical, Physiological and Aesthetic Aspects of Colour*, 1913), and French painters from Chardin to Matisse, wrestled with colour-relationships as presented to and processed by human vision, Germans were more concerned with the ideal relationships articulated by the burgeoning colour-order systems of the eighteenth and nineteenth centuries. It was the schematic logic rather than the empirical richness of Goethe's theory that most impressed his sympathetic contemporaries, and it was the German physicist and physiologist Hermann von Helmholtz who persuaded the French most decisively in the second half of the nineteenth century that to opt for a radical perceptual realism was to misunderstand the nature of visual experience (see p. 221 below).[2]

Schwitters showed himself to be sufficiently up-to-date in his knowledge of colour-systems to make blue the contrary of its complementary, yellow (in Goethe's day the complementary of blue had usually been seen as orange, the product of the mixture of the two remaining primaries, yellow and red); but it seems clear that his oxymoronic play with colours was simply a play with opposites: we need look no further than the words on the page. Indeed, his idea may have a literary rather than

78

109

a scientific background, and in this chapter I want to look at the way in which some of his Expressionist contemporaries took up and revalued the approaches to colour first articulated so vividly in German Romanticism. To do so I shall focus on that supremely Romantic colour, blue.

The blue flower

Blue established its central place in the Romantic imagination chiefly through the work of the geologist, poet and novelist Friedrich von Hardenberg, who wrote under the name of Novalis. Novalis's novel *Heinrich von Ofterdingen* (1800) opens with the hero sleepless with yearning to see the blue flower of which he has heard from a stranger. He falls asleep and dreams of setting out on a quest for the flower, which takes him to a remote cave in a wild country, filled with bluish light reflected from a fountain. Later, he finds himself in a meadow surrounded by dark-blue rocks under a dark-blue sky, where he discovers the tall light-blue flower in whose centre he sees a face.[3] The face turns out to be that of his beloved, who when Heinrich meets and dances with her is revealed to have light sky-blue eyes and blue veins on her neck. One of Heinrich's chief helpers in this quest is the shepherd-girl Cyane, whose name derives from the Greek term for 'blue', and who, in the uncompleted continuation of the novel, picks the blue flower for him. Cyane claims to be the daughter of Mary, Mother of God.

The identification of colours and flowers was a central theme of German Romanticism. The Hamburg painter Philipp Otto Runge used the expressive imagery of flowers in all his *Times of Day*, which themselves had their own characteristic colours (p. 175 above); and the theorist of Romanticism Wilhelm Heinrich Wackenroder wrote in an essay on colours edited by Runge's friend Ludwig Tieck (who was also close to Novalis) that:

84

> In nature, even a single flower, a single isolated petal, can enchant us. It is no surprise that we express our pleasure simply in its colour. The various spirits of nature speak to us through the individual colours, just as the spirits of the heavens speak through the various sounds of musical instruments. We can hardly express how moved and touched we are by every colour, for the colours themselves speak to us in a gentler accent...[4]

Similarly, in the essay on the meaning of colour in nature appended to Runge's *Farben-Kugel* of 1810, the Danish scientist Henrik Steffens (who like Novalis was interested in minerals) speculated that the colour of flowers was, like their perfume, a function of their powers of attraction - an idea he may well have drawn from that early botanical classic, C. K. Sprengel's *The Secret of Nature revealed in the structure and fertilization of flowers*, 1793, which argued for the importance of colour in attracting pollinating insects, and pointed, for example, to the powerful yellow-blue contrast of the forget-me-not (*Myosotis palustris*) and the blue iris.[5] Goethe, too, drew particular attention to blue and yellow among the flora, although he also noted that blue, as opposed to yellow, was relatively rare.[6]

Modern commentators on *Heinrich von Ofterdingen* have debated the identity of the blue flower with little agreement; some have concluded that Novalis had no specific flower in mind. One suggestion has been that since, like Ludwig Tieck, Johann Gottfried Herder and Jean-Paul Richter, he showed some interest in the newly available literature of India, the very exotic name 'indigo' (i.e. *Indigblau*, 'Indian') may have been uppermost in his mind.[7] But certainly the colour seems to have come before the flower: as Novalis wrote in a notebook,[8] 'The character of colours: everything is blue in my book.'

Gendering of blue

Novalis was probably introduced to colour-systems by his teacher and friend the geologist A. G. Werner, who like many natural scientists in the eighteenth century had introduced colour into his own taxonomical scheme (see p. 26 above).[9] Novalis was probably also familiar with the early theory of Goethe, whom he had met in 1798. A note on coloured shadows in blue and yellow[10] seems to point to the older poet,[11] and it is likely to have been important for the scheme of polarities, blue-yellow and red-green, which interested Novalis as it interested so many exponents of *Naturphilosophie* in his day.[12] The polarity of colour was one of its characteristics which, as we shall see, continued to fascinate German artists and theorists well into the twentieth century, for it could readily be understood in terms of either a physiological or a psychic dynamism.

The contrasting dynamics of blue and yellow seem hardly to have concerned Novalis, but in a dream-sequence in a novel by his contemporary Jean-Paul Richter, which may well have given some stimulus to the introduction of the central motif in *Heinrich von Ofterdingen*, the hero is sucked like a dewdrop into a blue flower and lifted up into a lofty room within reach of the mysterious sister of his own genius-figure. As in Novalis's novel, the blue and the feminine share an active power of attraction.[13] Goethe was soon to write in his *Farbenlehre* ('Didactic Part', §781): 'As we readily follow an agreeable object that flies from us, so we love to contemplate blue, not because it advances to us, but because it draws us after it.'[14]

This gendering of blue was also felt by Runge, who in a diagram of about 1809 90 conceived of the warm, yellow-orange side of the colour-circle as male, and the cool, blue-violet side as female. Runge may have been responding to the chemical ideas of Steffens, who in his essay of 1810 argued for red as a sign of the contractive, oxygenizing effect in metals, and blue of the more expansive effect of hydrogen on them.[15] Goethe, in a similar vein, included the affinity with acid and affinity with alkalis among the characteristics of his polar blue and yellow.[16] But in a much earlier statement about the natural meaning of the primary colours, which may be linked to the first versions of the *Times of Day*, Runge had characterized blue as emblematic of God the Father and red of God the Son; we saw that in the painted *Morning* (small version of 1808), red is clearly linked to the female figure of Aurora as well as 84 to the small baby beneath her. Here Runge may have taken his cue from J. G. Herder's aesthetic treatise *Kalligone*, in which that precocious anthropologist

The German Romantic painter Philipp Otto Runge's circle of Ideal and Real colours, *c.* 1809. The warm, orange-red side of the circle is given to the male and the cool, blue-violet side to the female. (**90**)

argued, unfortunately without giving details, that because of the colours' supreme beauty (after white), 'several nations' called blue and red the 'beautiful colours', attributing them to man and woman: 'firm blue to the man, soft red to the woman'.[17] Although this common belief in the polar structure of colour-space was to be characteristic of German thought throughout our period, here as usual there was no consensus about the meaning of specific colours.

An anthropology of colour

Herder's appeal to popular 'national' usage proved very congenial to German artists in the Romantic period, and especially to painters of the figure. The two young painters Friedrich Overbeck and Franz Pforr, who moved from Vienna to Rome in 1810 to found the *Lukasbund*, had already shared a belief that the colours of dress were, and should be, represented in pictures as expressive of character. These notions would be most appropriate for depicting women, since men's clothing, they thought, was largely determined by profession; and yet there was a remarkable uniformity in female dress. Black hair, said Pforr, went best with combinations of black and violet, black and blue, or white and violet; brown hair with green and violet, white and blue, yellow-green and violet, and so on; blonde hair suited quiet colours, such as blue and grey, grey and crimson, reddish-brown with a crimson cast, violet-grey and black. Black hair, he thought, was expressive of a proud and cool personality or, on the other hand, of cheerfulness and happiness; brown hair of happiness and good temper, innocent roguishness, naiveté and cheerfulness; blonde of solitariness, modesty, good-heartedness and calm, more passive than active. Pforr added that he did not need to spell out the meaning of red hair, 'with an appropriate face', probably an allusion to the legendary red hair of Judas and the Jews.[18] Yet in Pforr's *Sulamith and Maria* of 1811, the allegorical figure of the South, the brown-haired Sulamith, wears white, green and red, and the blonde northerner Maria wears a bright red dress with a white apron.[19] Overbeck, who dressed his later *Italia and Germania* (1828) respectively in red, dark blue and white for the dark-haired Italia, and salmon pink, green, pale blue and yellow (a touch in a lining) for the

85

91

Friedrich Overbeck's *Italia and Germania*, 1828, an allegory of the friendship of southern and northern Europe in which contrasts of hair-colour match contrasts of dress. (**91**)

blonde Germania, had argued to his father in 1808 precisely that blonde hair with grey and crimson was expressive of 'feminine gentleness and amiability, or rather, true femininity'.[20] The move to Rome may well have worked a powerful change in the Nazarene's colour-perceptions. As that veteran grand tourist Goethe wrote in these years, when he was in touch with if not entirely sympathetically disposed towards their art: 'the inhabitants of the south of Europe make use of very brilliant colours for their dresses. The circumstances of their procuring silk stuffs at a cheap rate is favourable to this propensity. The women, especially, with their bright-coloured bodices and ribbons, are always in harmony with the scenery, since they cannot possibly surpass the splendour of the sky and landscape.'[21]

Perhaps, too, for Pforr and Overbeck this iconography of colour had to yield in practice to more private aesthetic considerations: Pforr's detailed account of his *Sulamith and Maria* mentioned Maria's red dress, 'just as we have so often spoken about it', and even then not all his details of the colouring were followed exactly in the painting.[22]

85

Goethe was also happy to muse, in anthropological vein, on colour-preferences in clothing in Europe and beyond, in north and south, male and female: 'The female sex in youth is attached to rose-colour and sea-green, in age to violet and dark green. The fair-haired prefer violet, as opposed to light yellow, the brunettes blue, as opposed to yellow-red, and all on good grounds...'[23]

Goethe's following: symbol versus substance

78 It might well have been expected that Goethe's *Farbenlehre*, shaped as it was by the poet's experience of art, and bearing his vast international reputation with it, would have been taken up at once by painters as it was by philosophers such as Hegel and Schopenhauer.[24] Yet this was hardly the case. The Frankfurt painter and art historian Johann David Passavant, to whom Pforr had confided his views on colour in 1808, studied Goethe's treatise while he was a pupil of David's in Paris somewhat later; and the book seems to have been in great demand among German artists in Rome as early as 1811.[25] But there is little sign that they were prepared to make use of its somewhat hermetic principles, and indeed, Wilhelm Schadow, a collaborator with Overbeck and one of the several Nazarenes to leave Rome and take up academic positions in Germany, was still maintaining, in an essay on the training of artists in the late 1820s, the traditional view that colour was essentially unteachable.[26] By the middle of the century, however, teachers at the academies of Berlin and Dresden as well as German artists in Rome were looking more closely at Goethe's *Farbenlehre*, and supporting a new wave of attempts to vindicate its arguments against Newtonian optics, which excluded the idea of active darkness.[27]

As we might expect, however, German painting in the nineteenth century was not entirely immune from the perceptualism and the emphasis on the material qualities of pigments which were so highly developed in France. If German Romantic painting, with its particular closeness to watercolour, often presented rather abstract painterly surfaces, so that even Schadow, the most 'painterly' of the Nazarenes, could argue that it was immaterial from the point of view of colour what support or medium, fresco, oil, wax or watercolour, was used,[28] Germany was also the home of a school of *plein-air* painters which, there as elsewhere, gave a good deal of attention to vigorous impasto and brushwork. This was a tendency which was sometimes hostile to theory; Max Liebermann, for example, deliberately rejected the Neo-Impressionist divided touch in the interest of his 'simple' browns and greys.[29]

The increasing attention to qualities of materials and surface, so familiar in French painting, was also marked among German artists in the later nineteenth century. The Basel Symbolist Arnold Böcklin made a profound and practical study of the history of techniques, and it was in Munich that one of the earliest painters' groups to test the properties of the proliferating new synthetic materials, the German Society for the Promotion of Rational Methods of Painting, was established in 1886.[30] This was an emphasis on the materiality of materials which was to pass, via Henry van de Velde, to the Bauhaus, and beyond, to Joseph Beuys and Anselm Kiefer.

Böcklin and Bezold

Böcklin was also engaged in a detailed examination of the perceptual qualities of colour-contrast, which had been put high on the nineteenth-century painterly agenda by M.-E. Chevreul (see Chapter 15). This was now, in the 1870s, given a far more extensive and nuanced treatment by Wilhelm von Bezold, a Munich meteorologist who frequented a circle of artists in that city and was personally known to Böcklin. Some of Böcklin's particular colour-interests, such as his wide-ranging concern for simultaneous and complementary contrasts, and his close attention to controlling the colour-effects of his paintings by working on them in their frames, can be related to Bezold's ideas.[31] Bezold's treatise of 1874 on colour-theory seems to have been closely studied in Munich: his unusually extended discussion of the spatial effect of 'warm' and 'cool' colours became a central interest for Böcklin's younger Symbolist contemporary Franz von Stück, among whose pupils in Munich were not only Wassily Kandinsky and Paul Klee, but also Josef Albers, 92 whose *Interaction of Color* (1963) cites Bezold on colour-spread ('the Bezold Effect') and also uses Bezold's striking device of overlaid cut-out planes to demonstrate vividly the contrast and relativity of colours.[32]

Yet these more perceptually-oriented tendencies remained the exception in German colour-theory for artists, who, in the tradition of Goethe's moral and symbolic values for colours, developed elaborate schemes of symbolic correspondences during the nineteenth century and early modern period. Böcklin himself had studied Goethe's *Farbenlehre* in depth, but he devised his own set of moral associations: to him black, green and white in combination suggested seriousness, red, yellow and blue cheerfulness, blue restfulness, and so on.[33] Stück similarly exploited the connotations of his colours in painting: red for passion, sulphur-yellow for danger, green for hope and blue for mystery, eternity, intellectuality and poetic worth.[34]

Experimental psychology: Fechner and Wundt

Such subjective attitudes to colour were much stimulated during the second half of the century by the developing – and largely German – science of experimental psychology, from G. T. Fechner's *Vorschule der Aesthetik* (Primer of Aesthetics) of 1876, to the important work on colour-affects and preferences emanating chiefly from the Leipzig laboratory of Wilhelm Wundt around 1900. Thus the great interest in the dynamics of colour, which with the late-Romantic Bähr (*Der dynamische Kreis* – The Dynamic Circle) had been expressed in terms of light and chemistry – so that Bähr's blue, for example (in contrast to Steffens's), represented oxygen – was now directed inwards, and was nourished by experimental work with many human subjects. Colour was now largely a concern of psychology.

Before the prestige of the Vienna school focused attention on psychiatry and psycho-analysis it was experimental psychology which provided the concepts shaping public awareness of the problems of mind. Thus in a periodical review of a

Munch exhibition in Berlin in 1906, the politician and critic Friedrich Naumann could appeal quite naturally to the psychologist Wundt for an explanation of the Norwegian painter's divided touch.[35] It was in Wundt's laboratory that the most sustained experimentation on the non-associative effects of colour was carried out in the twenty years up to the First World War. In a study of fourteen young, professional and mainly German subjects in the early 1890s, Jonas Cohn found a surprising love of contrasts of highly saturated colours, and he concluded that there was a common, basic, sensual instinct for strong colour which was only later modified by culture.[36] A later researcher in the same laboratory, F. Stefănescu-Goangă, reinforced Cohn's conclusions, emphasizing 'the individual consciousness and above all individual experience'.[37]

Stefănescu-Goangă found that blue was experienced as calming, depressing, peaceful, quiet and serious, nostalgic (*sehnsuchtig*), melancholy, cool and calm, or dreamy. Several of his subjects followed Goethe in feeling that this colour drew them after it, and others described it as a 'mysterious' colour.[38] All this seemed to reinforce the attitudes of recent researchers into synaesthesia and chromotherapy, that colour was primarily a question of immediate feeling rather than of intellectual judgment, and it was thus of the greatest importance to artists engaged in developing a non-representational art. As the critic Karl Scheffler wrote in an article which may have introduced Kandinsky to both synaesthesia and chromotherapy (see Chapter 21), 'never before was the sense of colour such a matter of nerves'.[39]

Kandinsky and blue

Kandinsky had a particular liking for blue. 'The inclination of blue towards depth', he wrote in *On the Spiritual in Art* (1911-12):

> is so great that it becomes more intense the darker the tone, and has a more characteristic inner effect. The deeper the blue becomes, the more strongly it calls man towards the infinite, awakening in him a desire for the pure and, finally, for the supernatural...Blue is the typical heavenly colour. Blue unfolds in its lowest depths the element of tranquility. As it deepens towards black, it assumes overtones of a superhuman sorrow. It becomes like an infinite self-absorption into that profound state of seriousness which has, and can have, no end. As it tends towards the bright [tones], to which blue is, however, less suited, it takes on a more indifferent character and appears to the spectator remote and impersonal, like the high, pale-blue sky. The brighter it becomes, the more it loses its sound, until it turns into silent stillness and becomes white. Represented in musical terms, light blue resembles the flute, dark blue the 'cello, darker still the wonderful sounds of the double bass; while in a deep, solemn form the sound of blue can be compared to that of the deep tones of the organ.[40]

This passage is crucial to understanding Kandinsky's approach to colour because it is informed by a whole range of reading which the painter had made his own. The traditional ascription of spirituality to blue had been intensified at the beginning

of the century by the Theosophical movement, to which Kandinsky was sympathetic although he was never a member. In *Thought-Forms* (1901), which had been translated into German in 1908, Annie Besant had argued that 'The different shades of blue all indicate religious feeling, and range through all hues from the dark brown-blue of selfish devotion, or the pallid grey-blue of fetish-worship tinged with fear, up to the rich deep clear colour of heartfelt adoration, and the beautiful pale azure of that highest form which implies self-renunciation and union with the divine...'[41]

Kandinsky's musical analogies are particularly striking, since the 'cello was his own instrument, whereas the flute, on the other hand, had been widely characterized as light blue in the technical literature of synaesthesia from the 1870s onwards.[42] So his responses to blue were both personal and potentially universal. Certainly we should not take as exhaustive Kandinsky's late and rather off-hand story of the origins of the title *The Blue Rider* for the almanac which he and Franz Marc decided to edit in 1911, and which was to gather together examples of artistic creativity widely separated in time and space. 'We both loved blue, Marc horses; I riders. So the name invented itself.'[43]

Marc was indeed enthusiastic about blue horses (see his 1911 painting), but he 86
was no less convinced than Kandinsky of the masculine spirituality of blue. In a letter of 1910 to his friend the painter August Macke he had revived the Romantic aspiration of Runge to divide the colour-circle according to gender: '*Blue* is the *male* principle, sharp and spiritual, *yellow*, the female principle, soft cheerful and sensual, *red*, the *material*, and ever the colour which must be resisted and overcome by the other two!'[44]

Here too, although the agenda may seem to have been a specifically Romantic one, contemporary psychology was uncovering similar attitudes among a range of subjects; Stefănescu-Goangă, for example, reported that among those he interviewed in 1910-11, 'some characterized [yellow] as feminine and soft, in contradistinction to red, which had a masculine, serious cast'.[45]

Goethe in the twentieth century

What links the Blue Rider group most clearly to the Romantic tradition of colour-theory is the belief in polarity, in contrast, which informs all their thinking, and which often seems to be related specifically to Goethe. Kandinsky's table of polarity 92
between blue and yellow is perhaps the most succinct illustration of this, but Macke, too, in response to a questionnaire from the art magazine *Kunst und Kunstler* 101
in 1914, also argued that the supremely modern means of pictorial organization was the strong overall effect created by individual areas of contrast in the painting; and he cited especially the work of Robert Delaunay.[46] In the early years of the century Goethe's *Farbenlehre* underwent a wide-ranging revaluation among German artists, from the apparently academic circle around the scientist Arnold Brass in Munich to the Expressionist E. L. Kirchner in Dresden, who was anxious to move on from Neo-Impressionism.[47]

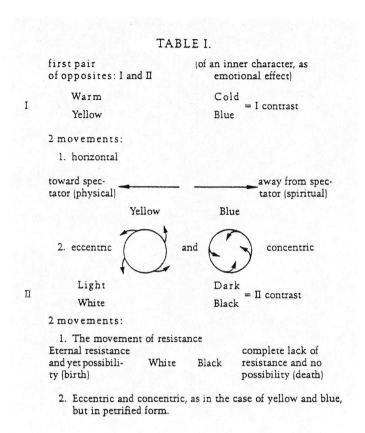

Wassily Kandinsky's table of polarities from *On the Spiritual in Art*, 1911-12. This table was probably developed from Goethe's polarities of yellow and blue in the *Theory of Colours*, but Kandinsky gives the opposites a particularly dynamic twist. (**92**)

87 It was probably under the stimulus of Goethe that Marc in the winter of 1910-11 began to look through a prism at the snowy landscape and his dog Russi, and to attempt to match on the canvas the brilliance of the coloured fringes he saw at the junctions of light and dark. Goethe had described his own experience of brilliant and delicate-coloured shadows on the snow during a journey in the Harz mountains, although on that occasion he had not used a prism.[48] Marc told Macke of the 'amazing coloured fringes' he saw around his dog, a Siberian Shepherd, and of how he completed the painting as a study of the contrasts between yellow, white and blue.[49]

This fascination with the prism, and enthusiasm for the powerful effects of colour-contrast it revealed, was shared by a number of artists and critics close to Herwarth Walden's Sturm Gallery in Berlin during and after the war. In 1916 S. Friedländer (later Friedländer-Mynona) published in the gallery's journal *Der Sturm* an article in which he argued that colour-polarity was Goethe's distinctive discovery, and in the following year he amplified this view in a discussion of Goethe's prismatic

experiments (p. 132 above).[50] Arthur Segal, a painter who had exhibited with *Der* 89
Sturm during the war, began to experiment with Goethe's prismatic fringes in
paintings of the early 1920s in order to find a way of reconciling the equal demands
of colour and form: 'The polar interaction of light and darkness', he wrote, 'is
manifested in the optical effect of things, thus in forms and colours.'[51]

Goethe's theory was an abiding presence among German modernist painters;
Kandinsky began to engage with it in a more thoroughgoing way as a teacher at the
Bauhaus in the 1920s, and in *Yellow-Red-Blue* of 1925 he developed an unusually 88
sophisticated visualization of the creation of red from the augmentation (*Steigerung*)
of yellow and blue, as described in Goethe's *Farbenlehre*.[52] Extracts from a later
section of the book which also treats of this process appear among the lecture-notes
for Kandinsky's Bauhaus courses, but he amplifies them with his own myth of the
sun (yellow) and the moon (blue), which link on the edges of night and day as red
sunrise or sunset.[53] It was perhaps in the context of this new agenda that Kandinsky
reversed the Theosophical and Blue Rider concept of the masculine spirituality of
blue, and suggested again that blue represented the feminine, for in many cultures
the moon was conceived of as female – although not, of course in Germany (*der*
Mond), so that Kandinsky was drawn to its Latin and feminine title, 'Luna'.[54] At the
Dessau Bauhaus, with its decisively modern and technological orientation, he was
now taking a more detached view of 'the Theosophists', and made much more
reference to the ideas of Wilhelm Ostwald (pp. 257–8), the best-known of German
scientific colour-theorists, to Wundt and to the recent German school of Gestalt
psychology. But in an institution where the systems of Runge and Ostwald were
given equal attention, Kandinsky was also investing the abstract categories of
German Romantic colour with a new vitality.[55]

15 · Chevreul between Classicism and Romanticism

FIVE YEARS BEFORE the death of the French chemist Michel-Eugène Chevreul at the age of one hundred and three, the up-coming Neo-Impressionist Paul Signac visited him in the company of another painter, Charles Angrand, with the intention of discussing some problems about the division of light. When he heard that they were concerned with painting, Chevreul advised them to call on his colleague at the Institut, Monsieur Ingres, who would be able to tell them all they needed to know.[1] This advice has puzzled historians of art, who, following the hints of the critic Charles Blanc, have generally believed that Chevreul's influential ideas on colour were transmitted to French artists in the nineteenth century through the agency of Ingres's great rival, Delacroix. This is a view which has something to recommend it, but I want in this chapter to suggest that the great chemist's suggestion was perfectly correct – apart from the fact that Ingres had been dead for eighteen years – and that it was among painters of a classicizing tendency, such as Ingres, that we may find the most immediate heirs of Chevreul's principles. We may well recall, as Meyer Schapiro noted many years ago, that Chevreul had been appointed to the Gobelins tapestry works in the 1820s, not simply to regulate the dyes, but also to banish unforeseen and unwanted colour from the woollen threads and produce pure blacks by the removal of the subjective effects of simultaneous contrast.[2] If Romanticism meant colour, then the mere removal of it could align Chevreul immediately with the rival school of the classicists.

In 1828 Chevreul published his first discussion of colour: 'Memoir on the influence that two colours may have on each other when they are seen simultaneously',[3] in which he announced the laws of simultaneous and successive contrast; but it was largely through the biennial courses of public lectures that he gave at the Gobelins from this date until the 1850s that his ideas passed into the orbit of painters, who began to take notice of these 'laws' in the 1830s, and to heighten their contrasts by juxtaposing complementary colours.[4] A decade later, when Chevreul's monumental study, *On the Law of Simultaneous Contrast of Colours*, was finally published, not only were his principles taken up in a number of professional journals, such as *L'Artiste*, but his lectures were also advertised at the Paris Salon exhibition as 'a course which all artists may follow with profit'.[5]

Chevreul was increasingly consulted by painters. One was Louis Hersent, a pupil of the Neo-Classical painter Regnault and a long-time professor at the École des

Beaux-Arts; another was Louis Daguerre, who before turning to photography was the best-known painter of that popular spectacle, the Diorama, both in France and in England. Chevreul had been able to show Daguerre how the effects of successive contrast would enable him to rest his eyes during prolonged work on the large-scale Diorama, if he turned to look at sheets of paper painted with colours complementary to those on his canvas.[6]

Chevreul and Vernet

Chevreul's most important contact among painters, however, was certainly Horace Vernet, who soon became a friend.[7] As a specialist in battle-painting, Vernet shared with the chemist a particular interest in military uniforms; Chevreul argued that strong combinations of colours would allow simultaneous contrast to counteract the effects of fading and wear, and thus prove to be more economical than more closely-related tones.[8] But, of course, the development of more effective artillery and rifles meant that the tradition of hand-to-hand fighting was increasingly irrelevant, and camouflage became more important than impressive display. As Chevreul himself recognized:

> If uniforms which present contrasts of colour are advantageous in an economical point of view, if uniforms of light colours are advantageous when we wish to impress an enemy by the number of combatants opposed to him, there are cases where, far from deploying battalions and squadrons, with the intention

93
94

M.-E. Chevreul by his friend, the painter Horace Vernet, around 1850. (**93**)

197

of rendering extended lines visible, we seek, on the contrary, to conceal the presence of riflemen or sharpshooters. For the latter, and also if we wish to establish a kind of hierarchy between different corps by means of dress, we may have recourse to a monochrome uniform of a sombre colour.

(*On the Law of Simultaneous Contrast*, 1839, §674)

In spite of his links with the French Romantic school in his youth, Vernet became an establishment figure, member of the Institut, professor at the École and the predecessor of Ingres as director of the French Academy in Rome (1829-34), loaded with honours both in France and abroad, and perhaps the French painter best known to the general public of his day. But did Vernet learn something about colour from the theorist? Not perhaps very much.

Chevreul's 'laws' were promoted largely as a key to colour-harmony – the first English translation of his book was entitled *The Principles of Harmony and Contrast of Colours* (1854); and in a subsequent revision Chevreul had hoped to include a section specifically on aesthetics.[9] But Vernet had the reputation of being a poor harmonizer; as one of his bitterest critics, Théophile Silvestre, put it in 1856:

He lacks character in his drawing and at the same time unity in his composition, magic in his chiaroscuro, concentration of effect, and harmony of colour. Particularly in recent years his work has displayed a harsh crudity, and I believe it was according to the formula of some [paint] merchant from Saint-Germain that he sang his last clashing scale:

PURE BLUE, PURE RED, PURE GREEN, PURE
YELLOW, PURE VIOLET, PURE WHITE.

The shrill harmonies of these words will perhaps give you some idea of the arrangement of his hues.[10]

Painting in flat tints

It was nevertheless precisely here that Vernet owed something to Chevreul, for the chemist's privileging of the harmony of complementaries was essentially in the context of 'painting in flat tints', a method developed largely in the decorative arts, but which was increasingly integrated into many branches of French painting in the second half of the nineteenth century (*Law*, §237). Chevreul distinguished between the 'chiaroscuro painting' of the European tradition, and the 'flat tints' which he identified with applied art, and especially with Oriental styles; but although he thought the latter method of painting more primitive, it was still important in modern Western practice:

for in every instance where painting is an accessory and not a principal feature, painting in flat tints is in every respect preferable to the other.

(*Law*, §302)

And he instanced the remote distance of represented objects which would make the finish of 'an elaborate picture' disappear, so that the economy of means of decorative painting would make it far clearer. Simultaneous contrast was to play a major role in this style of painting, and in the harmony of contrast, as opposed to the harmony of close tones, the complementaries provided the best combination of colours (§237).

Chevreul's reference to Oriental painting was very much in tune with the interests of both classicists and Romantics in France from the 1820s onwards; Vernet for example had a room at the Villa Medici, the seat of the French Academy in Rome, decorated for himself in the Turkish style while he was director there. Delacroix's *Algerian Women in their Apartment* of 1834, a painting used by the mid-century critic 95 Charles Blanc to illustrate Chevreul's principles of contrast in its handling of textiles,[11] was matched by Ingres's *Odalisque* of 1814 (Louvre) and his *Odalisque with a Slave* of 1839-40, and Delacroix remarked to George Sand particularly about the 96 'flat' decorative emphasis in Ingres's painting, complaining:

> he puts a bit of red on a cloak, some lilac on a cushion, some green here, some blue there, a vivid red, a spring green, a sky-blue. He has a taste for dress and a knowledge of costume. He has interspersed in his coiffures, in his fabrics, in his ribbons, a lilac of exquisite freshness, coloured borders and the attractiveness of a thousand pretty ornaments, but they do nothing at all to create colour.[12]

But for Ingres himself this was a matter of principle; as he wrote:

> the essential qualities of colour are... in the brightness and individuality of the colours of objects. For example, put a beautiful and brilliant white drapery against an olive-dark body, and above all distinguish a pale *blonde* colour from a cold colour, and a transient colour from the colours of figures in their local tints. This observation was provoked by the chance sight of a brilliant and beautiful white drapery against the thigh of my *Oedipus* reflected in a mirror beside the warm and glowing colour of the flesh.[13]

It is thus no surprise that one of the earliest discussions of Chevreul's ideas in the context of art was that of the decorative painter Clerget, in the *Bulletin de l'Ami des Arts* in 1844; nor that it was a pupil of Ingres also concerned with applied art, Jules-Claude Ziegler, who six years later published the first extended, if not entirely favourable account of Chevreul's principles in *Études Céramiques*, perhaps the earliest treatment in a French book.[14]

There is a certain irony in Charles Blanc's determination to treat Delacroix's *Algerian Women* as if it were based on complementary contrasts, since there are very few Chevreulian complementaries in this painting, and the painter's theoretical interests at this time seem to have been informed rather by a colleague, the painter and colour-technologist J. F. L. Mérimée.[15] When Blanc met Delacroix, perhaps for the first time, around 1850, the painter was certainly very interested in Chevreul's ideas and hoped to visit the chemist, but was prevented from doing so by a throat infection. It was about this time that Delacroix must have acquired a notebook summarizing a course of lectures given by Chevreul during the winter of 1847-8

which included a discussion of 'painting in flat tints'.[16] Delacroix's increasing involvement with large-scale mural and ceiling painting at the Palais Bourbon and in the Palais du Luxembourg in the 1830s and 1840s, and his work from 1850 on the ceiling of the Salle d'Apollon in the Louvre, demanded just the strong contrasting tones for distant viewing which the chemist had explored so thoroughly.[17]

Shades of grey

Thus artists learned much from Chevreul during his own lifetime; but it seems to have been largely for the purposes of structuring their paintings, rather than for the creation of colour-harmonies, or to understand more clearly the manifestations of colour in nature. French painters looked to Chevreul for essentially formalist reasons, and formalism was already a major concern of academic art. It will be recalled that at the beginning of his work on colour, Chevreul had been concerned to remove all unforeseen colours from the Gobelins tapestries and, like a true classicist, he loved greys, especially in female dress.[18] For, as he had established in his *On the Law of Simultaneous Contrast of Colours*, it was contrasts of value, not of hue, that offered the most powerful effects of simultaneous contrast (§339). Both the brilliant lithographer Delacroix and the *grisaille*-painter Ingres would probably have agreed with him on this; and among artists of the next generation, the etcher and former pupil of Ingres, Félix Bracquemond, an associate of the Impressionists as well as an orientalizing designer, made a similar point in his *Du Dessin et de la Couleur* of 1885, where he argued that even Chevreul had been rather casual about establishing a comprehensive grey-scale.[19] In the notes which Georges Seurat made from Chevreul's treatise it is clear that he was also much impressed by the idea of the dominant role of black and white; and all Seurat's major compositions until 1890 are based on an underlying tonal structure (see the following chapter). The notorious greying, the suppression of colour, for which so many artists and critics attacked Seurat's paintings, may well turn out to be the most sincere of the tributes paid by nineteenth-century painters to the work of Chevreul.[20]

The bright military uniforms of the French battle-painter Horace Vernet (1824). Vernet's colourful painting links his interests to those of his friend, the chemist Michel-Eugène Chevreul, who advocated the use of strong complementary colours for military wear for the very practical reason that they would offset the effects of fading. (**94**)

Chevreul and contrast

Both Delacroix and Ingres, in their many oriental subjects, used juxtaposed complementaries and near-complementaries to create a sense of harmony in variety. Eugène Delacroix's *Algerian Women in their Apartment* of 1834 (below) heightens the tonal contrast in patterned silks by juxtaposing orange and blue, violet and blue-green. The later nineteenth-century critic Charles Blanc went so far as to suggest that Delacroix was a conscious follower of Chevreul, who had elevated the idea of contrast into a law. (**95**)

The harmonious interior of J. A. D. Ingres' *Odalisque with a Slave* of 1839-40 (right) strengthens red by the contrast of pale green. (**96**)

Indefinable colour

With fluid, shimmering, subtly dissolving areas of pinks, blues, greens and oranges, Georges Seurat's *Evening, Honfleur* of 1886 gives a particularly vivid sense of the shifting colours of nature – indefinable, and hence resistant to analysis. (**97**)

Black is offered as a subject in this canvas (right) more radically than in any other work by Matisse. *French Window – Collioure* (1914) relates closely to Manet's *The Balcony* (20). The window, opening not out on to a landscape, but in to a dark room, presents a quality of luminous blackness as the main theme of the painting. It was first exhibited in 1966, in the United States. (**98**)

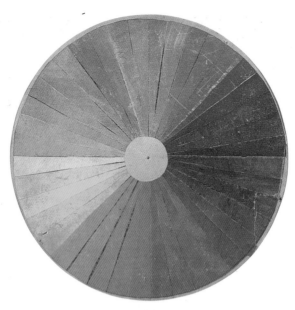

The theoretically oriented artist Louis Hayet devised ten different colour-circles incorporating the newest conceptions of complementarity, such as Helmholtz's pair of yellow and blue that mix to white. One (above) he sent to Pissarro, another to the younger painter Seurat, whom he met in 1885. The circles' very fine divisions made them frustratingly impractical for artists. (**99**)

The rainbow-like gradations of M.-E. Chevreul's 1864 colour-circle (below) suggest how hard it was for Hayet to define the edges of his many segments in colour-space. (**100**)

Shaping colour

Stimulated by Delaunay's *Windows* (p. 255–6), in 1912 August Macke adopted a similar technique for *Large, Bright Shop Window*. Transparency is rendered with facetted planes of colour, lustre with dots of the complementaries. (**101**)

A rare vizualization of the colours of spoken words: 'Lawyer Spoke Stith's address to the jury', 1900, from *The Music of Color and the Number Seven* by the American architect and designer E. J. Lind. (**102**)

The physiological effects of exposure to colours attracted general attention around the time of the First World War. Here a paint-manufacturer advertises a 'therapeutic' colour for use in a 'shell-shock ward'. The medical establishment remained sceptical, and modern research into the area has been limited. (**103**)

16 · The Technique of Seurat – A Reappraisal

RECENT STUDIES of Seurat have usually focused on his subject matter, but there can be little doubt that the painter himself nailed his flag firmly to the mast of technical innovation. '*Technique*', as he wrote to his friend, the critic Félix Fénéon, was 'the soul and the body of the art';[1] and he complained that it was a mistake to see poetry in his work, which was simply a matter of method.[2] Seurat's working methods have been treated in some detail, and the full-length monograph by W. I. Homer, *Seurat and the Science of Painting*, which has been reprinted several times since it was first published in 1964, has seemed to most commentators to be exhaustive,[3] which is one reason, perhaps, why the subject now attracts relatively little attention. In his book Homer wrote of *La Grande Jatte*, the key painting in the development of Neo-Impressionism:

104

> First, [Seurat] discovered and applied physical laws governing the behaviour of light and color in nature, rather than merely relying on his sensations; by doing so, he was literally able to make his picture duplicate nature's mode of operation, thus obtaining a degree of luminosity far greater than that achieved by the Impressionists. Second, Seurat successfully integrated a carefully thought-out, wide-range value-scheme with a color system that could accurately represent nature's hues and values. In other words, he united the traditional elements of chiaroscuro, both in modeling and pictorial planning, with colors that, like those of the Impressionists, were extremely accurate in representing the actual hues present in the subject – local colors, the tone of the illuminating light, and diverse reflections. Third, he harmonized the colors of *La Grande Jatte* according to the principles of contrast and analogy drawn largely from the writings of Chevreul and Rood, rather than relying on instinct or rule of thumb.[4]

This thesis, which is essentially the theme of Homer's book as a whole, rests on a number of misunderstandings of Seurat's ideas and practice; and these have tended to suggest that the painter's approach to 'scientific' theory was unproblematic. Even Meyer Schapiro, whose healthy scepticism about the scientific credentials of Neo-Impressionism has been too little heeded by later commentators, was content to argue that they simply do not matter for the aesthetic understanding of Seurat's art: 'Too much has been written, and often incorrectly, about the scientific nature of the dots. The question whether they make a picture more or less luminous hardly matters. A painting can be luminous and artistically dull, or low-keyed in color and radiant to the mind.'[5] Indeed it can; but if Seurat, who identified himself as an '*impressioniste-luministe*',[6] adopted the dotted technique in the expectation of

achieving a heightened luminosity — as Fénéon suggested that he did — and if this were an expectation that could not, for theoretical and practical reasons, be sustained, it is surely in order to inquire further into the mechanisms of experimentation that encouraged the painter to persist in this method through the major paintings of several years.

Here I shall discuss a few of the factors that suggest that Seurat was not especially anxious to ground his practice in a thorough understanding of the colour-theory of his day. I shall try to throw more light on his piecemeal reading of that theory, and suggest that the aspects of the theory with which he felt most affinity were not always those which reflected most closely the 'scientific aesthetics' of the 1880s.

Seurat's reading

It is not at all surprising that Homer should have developed the thesis implicit in the statement quoted above, for it derives essentially from the criticism of Fénéon, which, in its turn, had received the sanction of Seurat himself.[7] Fénéon's first and most substantial analysis of the painter's work appeared in *La Vogue* for June 1886:

> If you consider a few square inches of uniform tone in Monsieur Seurat's *Grande Jatte*, you will find on each inch of its surface, in a whirling host of tiny spots, all the elements which make up the tone. Take this grass plot in the shadow: most of the strokes render the local value of the grass; others, orange-tinted and thinly scattered, express the scarcely felt action of the sun; bits of purple introduce the complement to green; a cyanic blue, provoked by the proximity of a plot of grass in the sunlight, accumulates its siftings towards the line of demarcation, and beyond that point progressively rarifies them. Only two elements come together to produce the grass in the sun; green and orange-tinted light, any interaction being impossible under the furious beating of the sun's rays...[8]

This formulation was very similar to Seurat's own summary characterization of his technique in a letter to the journalist Maurice Beaubourg of 28 August 1890:

> The means of expression is the optical mixture of tonal values and colors (both local color and the color of the light source, be it sun, oil lamps, gas, etc.), that is to say, the optical mixture of lights and their reactions (shadows) in accordance with the laws of *contrast*, gradation, and irradiation.[9]

Yet there are several anomalies in these accounts. One is the notion of 'local' colour (i.e., the colour conceived as a constant attribute of the object) in a context so evidently flooded with 'the furious beating of the sun's rays', for there is, strictly speaking, no colour *except* that inherent in the rays of light reflected back into the eyes of the spectator. Fénéon's remarks have been appropriately traced back to a passage in the American physicist Ogden Rood's *Modern Chromatics*, a work he cites in his review of 1886, and which Seurat implies he had himself seen as early as 1881, the year of the French translation.[10] Rood, however, was considering a laboratory situation in which surfaces are lit simultaneously by white and coloured light; he was

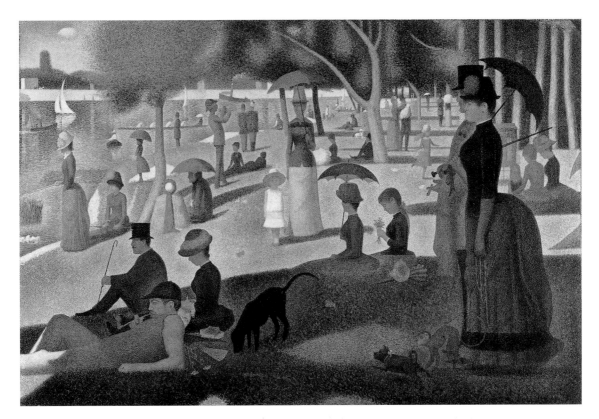

Georges Seurat, *Sunday Afternoon on the Island of La Grande Jatte*, 1884–6. The pointillist technique is here applied to a major subject for the first time, although not introduced until the later stages of the execution, in 1886. (**104**)

careful to explain that the 'natural' colour of surfaces, which, he says, artists call 'local colour', is their colour in white light, and he allows his objects no inherent colour, irrespective of their lighting.[11]

Seurat's endorsement of the conventional notion of local colour is the more surprising in that, in his letter of 1890 to Fénéon, he also listed in his early reading Charles Blanc's essay on Delacroix of 1864.[12] Blanc had begun his account by recalling a conversation among Delacroix, the painter Chenavard and himself, in the course of which the aged master had asserted that the great colourists had always perceived the essential relativity of colour: they had never sought to establish '*le ton local*', but had always worked through the manipulation of optical contrasts. It was this very passage in Blanc which, also in the early 1880s, had especially intrigued and puzzled van Gogh, and had led him at Neunen specifically to reject the idea of 'local colour' with which he had been brought up.[13] Not so Seurat, and his practical exemplification of the idea is well illustrated in *La Grande Jatte*, where, as Fénéon observed, the more transient effects of light are scattered over much more broadly and solidly established areas of 'local' tone and hue. But this was a procedure that he progressively eliminated in favour of a more uniform overall structure of dots, expressive entirely of the action of light.[14]

104

Another curiosity in Fénéon's *La Vogue* analysis is his introduction of the notion of 'solar orange'. Rood, and I suppose every other theorist of the 1870s, had explained sunlight as a white aggregate of all the colours of the spectrum, in which orange played a very minor role. Some of Seurat's earliest colour-sketches for *La Grande Jatte* suggest that he, too, had felt that sunlight, as it is reflected from water or grass, is essentially achromatic, for they are vigorously flecked with strokes of white paint.[15] As the lover of 'striped' lawns or the observer of a hayfield ruffled by the wind may easily see, much of this whiteness is due to the glossy, highly reflective surface of the individual blades of grass. Certainly Blanc, as well as his hero Delacroix, had written of sunlight as 'orange' or 'golden,' in texts that were familiar to Seurat;[16] and in a passage on the modifying effects of environmental reflections, Rood himself had almost described the rationale of the painter's touches of orange-yellow and sky-blue in *La Grande Jatte*:

> The grandest illustration of these changes we find in those cases where objects are illuminated simultaneously by the yellow rays of the sun and the blue light of the clear sky: here, by this cause alone, the natural colors of objects are modified to a wonderful extent, and effects of magical beauty produced, which by their intricacy almost defy analysis.[17]

Working from nature, too, Seurat may have come to feel that the warmth of afternoon sunlight might best be expressed chromatically as orange. In his diary for 3 December 1894, the painter's friend and interpreter Paul Signac identified the colour of light at noon as 'yellow white' or 'orange yellow', and at five in the afternoon as 'orange' or 'orange and red';[18] and Fénéon had firmly placed *La Grande Jatte* at four o'clock, which, from the length of the shadows, seems plausible enough for late May or early June.[19] One factor, however, and perhaps the most important, which may have decided Seurat to interpret sunlight as orange during the course of his work on this picture, and to confine white to the 'local' colour of many objects in it, was that white stood outside the circle of hues, and its opposite or 'complement', black, was banished from the palette as a 'non-light' (in Fénéon's words), so that white could necessarily play no part in a style whose structural principle was complementarity.

It is perhaps in his treatment of complementarity that Seurat's attitude to contemporary theory shows itself to be most ambivalent. The pioneering work on additive and subtractive mixture by Hermann von Helmholtz and Clerk Maxwell in the 1850s and 1860s had modified the traditional view (repeated by Chevreul and Blanc) that the pairs of colours complementary to each other were red-green, orange-blue, and yellow-violet, and had given much more precise chromatic definitions of these pairs. Helmholtz's conclusions had been popularized in a number of French manuals in the 1870s, as well as in the French translations of books by Ernst Brücke and Rood, whose chapter on colour-mixing included very precise tables of the results achieved by rotating discs painted with areas of named pigments. Rood's book is especially important because it presented these findings specifically to painters, who were instructed how to make use of additive mixtures based on the primaries red, blue-green and violet by means of a dotted technique (where the

109

more traditional methods of mixing on the palette or by means of glazing were, of course, subtractive, and employed a primary set of red, yellow, and blue).

These details would have been of the first importance for painters anxious, like Seurat, to reconstitute light by the optical mixture of its components. Seurat never claimed to have *read* Rood (see n. 10), but he certainly made notes from him,[20] and, most important, he seems to have copied Rood's circular contrast-diagram arranged according to Helmholtz's new scheme, with blue opposite orange-yellow, green opposite red-purple, and so on.[21] We do not, however, know the date of this copy, or even whether it is certainly by Seurat, for it seems to be a tracing; and a sketch of a colour-circle about 1887-8, recently published by Herbert, shows the painter still thinking in terms of the traditional sets.[22] The latter diagram seems to have been made from memory, perhaps to demonstrate a point to another person. As Herbert shows, Seurat's starting point was the circle of Charles Henry, whose *Introduction à une esthétique scientifique* (1885) is the source of other notes on this sheet; but Henry's eight-part circle was based on Helmholtz's complementaries, and Seurat clearly had

Charles Henry's colour-circle showing the movement of colours, from *Cercle Chromatique*, 1889. Henry was one of the earliest French exponents of experimental psychology as applied to aesthetics. In his circle, colours moving from low to high, e.g. blue-green to red, or from left to right, were 'dynamogenous' and pleasing, while those moving in the opposite direction were inhibitory or sad. Seurat became interested in using some of Henry's ideas in his later work. (**105**)

Seurat's colour-diagram sketched at the bottom of a sheet of *Parade* studies, 1887-8. The changes of mind about the positions of contrasting colours suggest a confusion in Seurat's mind between the systems of Chevreul and Helmholtz. (**106**)

difficulty fitting his own sexpartite Chevreulian scheme (also discussed by Henry in this book) into this format, hence the indecision about the position of yellow.[23] Robert Herbert has pointed out to me the co-existence of Chevreul's *and* Helmholtz's pairs in the painted complementary frame of the small ensemble study of *Les Poseuses* in the Berggruen Collection;[24] but the Chevreulian set was what Seurat recalled in his unpublished letter to Beaubourg (cited p. 210 above), as well as in his published statement to Jules Christophe, as late as 1890.[25]

I have suggested that one of the great virtues of Rood's handbook was its practicality: it discussed colour-effects not simply in terms of abstract hues, but also in terms of pigments available to artists. Homer's important article on a (late?) palette in the *Nachlass* does not go into details about the pigments on it,[26] but although Seurat's arrangement of hues does not seem to be quite that recalled by Signac for his own practice after 1883, it is reasonable to assume that their pigments were very similar, and that Seurat's were arranged, from the thumbhole, in this order: cadmium yellow, orange(?), orange(?), vermilion, cobalt violet, artificial ultramarine, cerulean or cobalt blue, viridian (emerald) green, chrome green.[27] This palette was described by Fénéon as organized along prismatic lines, but it is not strictly the case, and the arrangement can be contrasted with the truly spectral palette published in these years by the teacher of technique at the École des Beaux-Arts, the genre-painter J.-G. Vibert, in his *Science of Painting*.[28] What seems chiefly to concern Seurat is to reconcile as far as possible the traditional, tonally arranged academic palette, running from white to black through yellow, red, and blue, with the order of hues in the solar spectrum; and this is of some importance for the assessment of the role of tonal values in Seurat's painting.

Rood, whose experiments with disc-mixtures were conducted in watercolours, listed a palette of gamboge, Indian yellow, chrome yellow, vermilion, red lead, carmine, Hoffmann's violet, cobalt blue, cyan blue, Prussian blue, and emerald green, many of which had to be mixed on the palette to achieve the appropriate effect on the discs.[29] It is a palette similar in character to the one reconstructed for Seurat above, and although it is more traditional than that of the French painter, it also excludes earth-colours. That Seurat continued to use earths at least until 1884[30] suggests either that he had not read (or had not understood) Rood by that date, or that he was not yet interested in the method of optical mixing for which Rood's suggestions about pigments would have been especially helpful. The emergence of a regularly dotted technique only in the later stages of painting *La Grande Jatte* suggests that the latter hypothesis is the case.

Painterly experiment

Seurat styled his new method of working '*peinture optique*'.[31] It was based on a specific philosophy of perception; and it might well be that the painter's evident disregard of current theory had no damaging consequences for his work, which could have started with a few simple notions, for example of optical mixture, and then developed under the independent momentum of his practice. He did, after all,

claim that he had 'discovered scientifically the law of pictorial colour...with the experience of art'.[32] It is one of the strengths of Homer's study that he shows how Seurat's technical strategies were modified with each of the major compositions of the 1880s as a result of a continuous programme of experimentation. Here I shall look at three aspects of the method that might be expected to depend essentially on this programme: viewing distance, the relationship of contrasts to mixtures in the structure of the surface, and the relationship of hues to values.

Homer, following Fénéon, has opted for a relatively fixed viewing distance, at the point where the eye has difficulty in resolving the discrete marks into a single tone, and in the effort to do so continually changes its focus, producing that rich shimmering effect which Rood characterized as 'lustre'.[33] Homer cites Pissarro's dictum, that a picture should be seen at a distance 'which allows its colors to blend', which that painter thought was usually three times the diagonal of the canvas.[34] Signac, too, seems to have felt that the colours should fuse, and sought to devise a technique of blending the brushstrokes where this did not happen at the appropriate distance.[35] But what is very striking in *La Grande Jatte* and *Les Poseuses*, as well as in several late works like *La Poudreuse* in London, is the great variety in size and shape of Seurat's brushstrokes; and we know from Signac that at least the two earlier pictures were painted in a studio too confined to allow the artist to stand back very far, with the result that he found the dots too small for the large size of the canvas.[36] Seurat must clearly have had his reasons for the variety in his touch, and in some cases they are very obvious: sometimes, for example, he wanted to firm up the contours of his shapes by making the dots along them much smaller than average, and hence fusible by the spectator closer to the surface of the picture.[37] But this cannot be the only reason.

104, 29

27

In his classic study of the technique of Impressionism, J. Carson Webster showed that optical mixtures in *La Grande Jatte* seem in some cases to offer no advantages over ordinary palette-mixtures;[38] and this can be demonstrated even more effectively in the case of the recently cleaned *Bathers at Asnières*, a pre-Divisionist work of 1883-4 that received a few local revisions in the later technique in 1887. The retouchings in bright blue and orange on the back of the central bather fuse at a distance to a warm bluish-pink, which is very close to the original palette-mixed shadows under his arm. It seems clear that Seurat was not so much interested in the optically-mixed tone as in the lively texture created by the separated dots themselves. In the area around the hat on the grass in this picture, the darkened yellow revisions — due, according to Signac, to inferior paints and already apparent very soon after Seurat's death[39] — can still be seen clearly at the far end of the gallery, long after the other retouchings have disappeared.

107

Seurat must have realized after only a few experiments with optical mixture that there is, indeed, no constant viewing-distance for fusing the various separate colours. In particular, he must have noticed that contrasting values resist fusion far longer than even complementary hues,[40] and this is surely of the greatest consequence to our understanding of his use of values in the structure of his major paintings. Yet there is no indication in Seurat's work that he sought to vary the size of dot for specific *hues*, to achieve fusion at a constant distance, and it is difficult to resist the

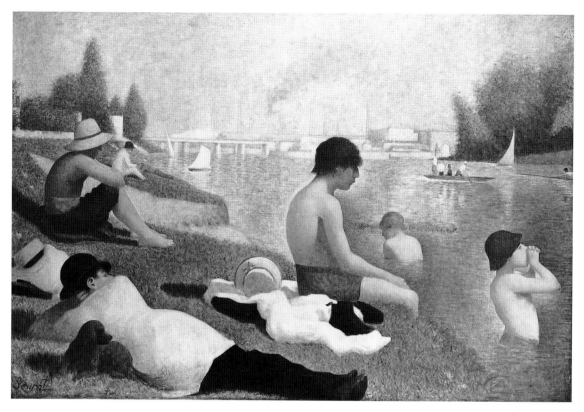

Georges Seurat, *Bathers at Asnières*, 1883-4. That Seurat repainted only parts of his *Bathers* in a dotted technique in 1887 suggests that even at this late date he did not insist upon a unified surface nor a fixed viewing distance. (**107**)

conclusion that, as Meyer Schapiro noticed long ago, the dotting has itself an important aesthetic, and even a political resonance, in that it draws attention to its own mode of operation, and makes itself accessible to every spectator.[41]

Seurat's major compositions, up to *Le Cirque* of 1890, rest on a magnificent series of charcoal and conté drawings, and it was the secure knowledge of tonal structure that these studies provided that made the painter feel free to ignore some of the more problematic aspects of the theory of colour. In an article on Signac, Fénéon noted that contrasts of value 'regulate' contrasts of hue;[42] and Seurat himself copied from Chevreul a passage that includes substantially the same point: 'To put a dark colour near a different but lighter colour is to heighten the tone of the first and to lower that of the second, independently of the modification resulting from the mixture of the complementaries.'[43] As Seurat told his fellow Neo-Impressionist H. E. Cross, the 'ensemble' first presented itself to his imagination 'by the masses, and by the interplay of values';[44] and Signac told Daniel Catton Rich that even during the course of working on the final canvas of *La Grande Jatte* the painter would fix the large conté studies of figures against the appropriate part of the picture to assess the effect.[45]

108, 111

216

It was probably this tonal anchor that allowed Seurat to overcome the contradictions inherent in a method that sought to combine optical mixture which creates soft contours with complementary contrast which requires hard ones.

As Signac wrote in his attack on mindless 'pointillism' in his pamphlet *From Delacroix to Neo-Impressionism*:

> The role of dotting [*Pointillage*] is more humble: it simply makes the surface of the paintings more lively, but it does not guarantee luminosity, intensity of colour, or harmony. For the complementary colours, which are allies and enhance each other when juxtaposed, are enemies and destroy each other if mixed, even optically. A red and a green surface, if juxtaposed, enliven each other, but red dots mingled with green dots make an aggregation which is grey and colourless.[46]

It was probably for this reason, too, that Seurat, finding that his optical mixtures would not provide surfaces so intensely coloured that they could, when juxtaposed, create of their own accord the contrast effects described by Chevreul, painted these effects into his pictures, darkening edges where they met the light, and lightening them where they met the dark, as well as tingeing the coloured boundaries with their complementaries.[47] His 'optical painting', deprived of the powers of nature itself, could be truly optical only in one dimension.

27-8

Georges Seurat, *The Nurse*, 1884. The large number of conté crayon drawings prepared for each of Seurat's major compositions — here for *La Grande Jatte* — show how firmly the paintings were based on a tonal rather than chromatic structure. (**108**)

The primacy of Chevreul

Seurat emerges as a painter who, unlike some of the critics of Impressionism such as Duranty and Huysmans, was not really abreast of the colour-science of his period, even though it had been specifically popularized for the use of artists.[48] But his painterly sensitivity and technical ingenuity nevertheless enabled him to extract from the theoretical literature a number of simple concepts and put them to work in the formation of a new style, avoiding many of the pitfalls that situations of such enormous complexity were bound to present. What is most surprising is that Fénéon's ill-informed resumé of some of the principles he found in Rood's textbook should for so long have passed muster, not simply with painters like Signac or Pissarro, to whom, when Seurat himself was not forthcoming, he turned for the checking of his texts,[49] but also with a polymath trained in the natural sciences like Charles Henry.[50] Perhaps the separation of the spheres of art and science at this time was rather more complete than we have been led to expect.

What, then, was Seurat after in his theoretical reading, and in particular, why did he remain attached to the superannuated Chevreul in the face of the more recent work of Helmholtz, which was readily available to him in Rood and in many other French sources? It was I think chiefly because of his overriding preoccupation with harmony: 'Art is Harmony,' as he put it at the head of his statement in the 1890 letter to Beaubourg; and Chevreul had far more, and far simpler things to say about harmony than any of his successors. Most important, Chevreul had equated the maximal contrast of the complementaries with maximum harmony.[51] Rood, in the chapter of his treatise on 'Combinations of colors in pairs and triads', in which he chiefly discussed harmony, was content essentially to follow Chevreul; but it is clear that his own preferences as a painter and a theorist were rather for 'the small interval' (that is, juxtapositions of colours close to each other on the circle) than for maximal contrasts.[52] Seurat's aesthetic credo of 1890, although it begins by stating that harmony is the analogy of similar elements as well as of opposites, gives no further attention to the former; and it has frequently been observed that his style of Neo-Impressionism differs from that of, say, Signac or Pissarro precisely in a liking for sharp contrasts, especially in the period 1886-7.

Can Seurat's technique, therefore, be understood as 'scientific', and if so, in what sense? I think it can, and most of all in its experimentalism, which provided an unusually precise focus for the assessment of visual effects, and allowed Seurat, as well as his many successors in the years up to the First World War, to test the effectiveness of their methods, and, of course, ultimately to reject them. Seurat's programme of experimentation is also seen in a negative light in his obsessive concern with the chronology of his researches, and in his wish, expressed in his letter to Fénéon of June 1890, to set the record of his own priority straight.[53] The idea of painting as a progressive series of visual discoveries is, of course, as old as art historiography itself, but with Seurat it took on a particular urgency, and has become part of the mythology of specifically modernist art.

17 · Seurat's Silence

Given the notably synaesthetic effect of many of Seurat's major paintings: the shouting boy in *Bathers at Asnières*, or the razzmatazz of the *Grande Jatte, Parade, Chahut* and *Cirque*,[1] my title may seem to be something of a misnomer; one recent commentator has reminded us that Seurat's art was seen by at least one of his contemporaries, Paul Alexis, as positively Wagnerian.[2] In this chapter I am concerned with Seurat's science, but I am equally concerned with his unusual silence about it: as he wrote in 1888 to Paul Signac, 'I don't talk much.'[3]

That Seurat opened himself to some people and not to others is no more than we should expect; but it has been particularly unfortunate for his posterity that he was not very forthcoming to the critic Félix Fénéon, who passed on the most extensive and circumstantial account of Seurat's theories but had to rely on another Neo-Impressionist, Camille Pissarro, for the details.[4] It was not until 1890, four years after the advent of Neo-Impressionism at the last Impressionist exhibition in Paris, that Seurat himself supplied Fénéon with a defensive and somewhat tendentious account of his own part in the movement. And what did Pissarro really understand of Seurat's principles, if his own approach to the dotted technique was so divergent from that of the painter he acknowledged as the movement's leader?

Much has been said and written about these principles and their limitations; here I want simply to point out that the demands placed on an aspiring 'scientific' painter in late nineteenth-century France were very considerable, and that even in the several handbooks of popular science for artists which may have come Seurat's way, and which help to define the French aesthetic of the day as indeed 'scientific', these demands were sometimes seen to be too great.

Helmholtzian chromatics

The key theorist of the period was the German physicist and physiologist Hermann von Helmholtz, who in the 1850s and 1860s had effectively displaced the French chemist Chevreul as the leading scientific interpreter of colour for painters. Although the distinction between additive light- and subtractive pigment-mixture had been explored by a number of scientists earlier in the century, it was Helmholtz who made it widely known. His fundamental article on colour-mixing had been published in Germany in 1852, and was almost immediately translated into French.[5] In it, Helmholtz showed that the mixture of lights yielded only two complementary colours (i.e. colours mixing to white), spectral yellow and indigo, which in

	Violet.	Bleu indigo.	Bleu cyanique.	Vert bleu.	Vert.	Jaune vert.	Jaune.
Rouge.	Pourpre.	Rose foncé.	Rose blanchâtre.	Blanc.	Jaune blanchâtre.	Jaune d'or.	Orangé.
Orangé.	Rose foncé.	Rose blanchâtre.	Blanc.	Jaune blanchâtre.	Jaune.	Jaune.	
Jaune.	Rose blanchâtre.	Blanc.	Vert blanchâtre.	Vert blanchâtre.	Jaune vert.		
Jaune vert.	Blanc.	Vert blanchâtre.	Vert blanchâtre.	Vert.			
Vert.	Bleu blanchâtre.	Bleu d'eau.	Vert bleu.				
Vert bleu.	Bleu d'eau.	Bleu d'eau.					
Bleu cyanique.	Bleu indigo.						

Hermann von Helmholtz's table of colour-mixtures, based on experiments with spinning discs – the first sign that painters' traditional assumptions about the mechanics of mixture were no longer valid. Colours are given along the top and left, their product at the intersection. The table was reproduced in a number of French artists' handbooks of the 1860s and 1870s. (**109**)

pigment-terms could be matched, he said, by chrome yellow and dark ultramarine. In disc-mixtures the same effects would be achieved by using gamboge and azurite, and in this technique of mixing, red and green produced yellow. Helmholtz pointed out that these results conflicted with the experience of painters; yet he devised a
109 table of mixtures which became part of the diagrammatic component of several French handbooks on painting in the 1860s and 1870s, after it had been republished in Helmholtz's monumental *Treatise on Optics* of 1867.[6]

One of the first French aesthetic writers to acknowledge Helmholtz was Auguste Laugel, who in a handbook of 1869, *Optics and the Arts*, published a colour-circle
110 based on his scheme of complementary colours adding up to white, but at the same time acknowledged that the complications of this scheme might make the 'cruder' Chevreulean colour-star devised by Delacroix more useful to painters.[7] Seurat also had a copy of a Helmholtzian scheme taken from Rood; but as we saw, at the
106 foot of studies for *Parade* of c. 1887-8 he drew a diagram similar to the Delacroix star, and, of course, Delacroix was an artist he especially admired as a 'scientific' painter. He continued to refer to this simpler arrangement until the end of his life .

Another important French handbook of a decade later, *The Scientific Principles of the Fine Arts* (1878) by the Viennese physiologist Ernst Brücke, went so far as to argue that, in the face of the complexities of recent scientific research, it was quite impossible for a late nineteenth-century painter to appropriate modern theory in the way that Leonardo da Vinci had been able to do – Leonardo, whose scientific writings were being closely studied by the mathematician and aesthetician Charles
105 Henry at the time he met Seurat in 1885. 'Today', as Brücke wrote,

Helmholtz's complementaries in August Laugel's colour-circle, from *L'Optique et les Arts*, 1869. Laugel's was perhaps the first attempt, in a painters' handbook, to incorporate the Helmholtzian complementaries in a traditional format. But he warned that artists might find them too nuanced to remember. (**110**)

> it is difficult for the artist to be taught the theoretical science he needs, and even more difficult for him to learn it. Leonardo da Vinci was thoroughly familiar with all the knowledge of his day; he knew geometry, mechanics, physics, physiology, anatomy, all that was known of them in his time. That is impossible now because of the developments which all the sciences have undergone.[8]

As an appendix to Brücke's book, Helmholtz's important lecture 'On the relation of optics to painting' was printed in a French version. In the late 1860s this had been one of the first arguments by a scientist against the possibility of replicating the visible world in painting. In a discussion of colour-contrast, for example, Helmholtz argued that the limitations of pigments and of environmental lighting made it impossible for pictures to reproduce the effects of natural light and colour:

> If, therefore, with the pigments at his command, the artist wishes to reproduce the impression which objects give, as strikingly as possible, he must paint the contrasts which they produce.[9]

One of the phenomena which Helmholtz cited in this instance was *irradiation*, by the action of which the colour of a bright object spread to the surrounding space in the visual field; and this was taken up in a series of articles on *The Phenomena of Vision* (1880) by the Swiss aesthetician David Sutter, which Seurat certainly read.[10] It is particularly in the cunningly managed contrasts of Seurat's conté crayon draw- 111 ings that we sense a familiarity with these scientific arguments.

Georges Seurat, *Seated Nude Boy*, 1883, a conté crayon study for *Bathers* (107), illustrating Helmholtz's dictum that 'the impression which objects give' must be rendered by 'the contrasts they produce'. (**111**)

Whether or not Seurat knew much of Brücke's and Helmholtz's ideas, he certainly knew Helmholtz's name,[11] and could have read about some of his optical experiments in *Théorie Scientifique des Couleurs* of 1881 (the French version of *Modern Chromatics* by Ogden Rood of Columbia College, New York), which we

know the painter consulted.[12] But a rather sceptical attitude to the applicability of the most up-to-date theory might well have been fostered in Seurat by his contact with the two most theoretically oriented of the Neo-Impressionists, Albert Dubois-Pillet and Louis Hayet.

Dubois-Pillet and Hayet

Dubois-Pillet, an army officer and amateur painter, was much older than Seurat, and was the chief organizer of the group of Indépendants to which the Neo-Impressionists belonged. Although he was devoted to Seurat's example, he sought from about 1887 to develop the theory of pointillism by turning to Thomas Young, the English polymath whose early nineteenth-century work on colour-vision was first given international prominence by Helmholtz, and whose fundamental doctrine of the three colour-receptors in the eye was summarized in Rood's book.[13] According to Dubois-Pillet's early biographer Jules Christophe, whose account of Young's theory comes straight from Rood, the painter hoped to apply the English scientist's conclusion that each receptor is variably sensitive to each of the three primary colours of light – red, green and violet – by including traces of these three primaries in the *passage* from tone to tone and from light to shade.[14] The exact method of proceeding is far from being clear, and Christophe remarked that Dubois-Pillet's reasoning had 'failed to convince all his colleagues'.

Louis Hayet, five years younger than Seurat, whom he met in 1885, was not at all inclined to be reticent about his extensive programme of investigation into colour-relationships. Like Dubois-Pillet, he developed an interest in colour while on military service; and in 1886 and 1887 he devoted much time and thought to the construction of ten colour-circles incorporating the newest conceptions of complementarity, one of which he sent to Seurat, and three others to other painters in the Neo-Impressionist group. Pissarro's version appears to be the only one of these circles to have survived, and Pissarro commented that Hayet 'had not taken account of the large or small intervals [*des grandes et des petites distances*] between the hues, so that they are no use to us'.[15] Hayet was able to construct only a forty-division circle on the Chevreulean model, but, as he wrote to Pissarro in December 1886, he hoped to be able to quadruple this number,[16] and we know from other experiments that he was also much concerned to bring precision to a three-dimensional colour-solid, co-ordinating hues and values, and to the phenomenology of optical mixture.[17] In spite of Pissarro's reservations about Hayet's methods, the younger painter's conception of mixture was, in its emphasis on close tones, closer to Pissarro's and Signac's approaches than to Seurat's. Hayet called Seurat's use of complementary dots the 'unified mode' because of its neutralizing effect (juxtaposed complementaries mix to grey), and opposed it to his own 'pluralist' mode. In his notes he took a stand against Seurat's practice:

> Example of unity and plurality: if I have to represent a pure scarlet, I cannot render it in either of these modes except with scarlet; but what if, instead of

113

112

99

100

223

Louis Hayet, *Banks of the Oise*, 1888. Hayet, the most theoretically oriented of the Neo-Impressionists, used soft optical mixtures and attacked Seurat for his crude contrasts. (**112**)

pure scarlet, it is sort of brick-red or a muted scarlet? Seurat represents that sort of colour by scarlet desaturated with the help of its complementary. In the pluralist mode, on the other hand, it could be obtained by the optical mixture of various oranges, of various carmines, of various violets; there are nuances which have still to be precisely established. It is easy to understand that the pluralist mode will give more flexible and harmonious hues because it offers a larger choice of forms of expression. It is immediately apparent that we need a colour-circle to attain this; and it was that which, later on, I set out to construct.[18]

99

Hayet also claimed to have discussed these ideas with Seurat and Pissarro in 1887; and he went so far as to propose that the Neo-Impressionists should set up what he called 'an Institute for experimental research into the laws of optics as they relate to painting', a proposal remarkably close to one mooted forty years later by the Russian Suprematist Malevich, and again with pointillism in mind.[19] Hayet complained that on this occasion he had met with a rebuff, since the group thought that their theories stood in no need of improvement.

Whatever credence we may give to Hayet's recollections, written down a quarter of a century after the event, it seems clear that he was an obsessive who was likely

Albert Dubois-Pillet, *Saint-Michelle d'Aguille in Snow*, 1889-90. The artist attempted to apply the theory of the English scientist Thomas Young concerning the perception of red, green and violet as the primary colours of light, but fellow-Neo-Impressionists were little able to grasp his system. (**113**)

sooner or later to become a bore. Even Camille Pissarro, the least contentious of all the members of the Neo-Impressionist group, when Hayet criticized the work of his son, Lucien, could not refrain from complaining about Hayet's scathing attitude to the world, and also about his superficiality: 'in spite of all his grand airs, Hayet only understands the surface of things'.[20]

It is also clear that Seurat, for his part, was a highly experimental artist who modified his methods from picture to picture. But it is one thing to experiment and quite another to be able to give a coherent account of the underlying principles of this experimentation. Seurat's silence reminds us of Pissarro's reaction to the critic Fénéon's constant requests for more technical information. In a letter of February 1889 in response to the critic's queries about his own conception of *passage*, or tonal liaison, Pissarro wrote:

> It would be difficult to say anything about this; I am trying at this very moment to master the technique which ties me down and stifles the spontaneity of impressions on the canvas. It would be better to say nothing about it, nothing definite yet.[21]

This was, like Seurat's, the wise silence of someone still working on the problem.

Vibert and science

The ambivalent attitude of the Neo-Impressionists to the details of theory is also illuminated by the amusing attack on 'scientific' theories of colour for painters by the teacher of painterly technique at the École des Beaux-Arts in the year of Seurat's death, J.-G. Vibert. Vibert was a painter of genre and also a gifted short-story writer, who in his handbook *The Science of Painting*, first published in 1891, presented a vivid tableau of a young artist on a visit to the labyrinth of the scientists, where he finds Chevreul, Thomas Young and Helmholtz, all of whom claim to have discovered the truth about colour. Chevreul tells the painter that there is no room for ultramarine in the colour-circle; and Young and Helmholtz present him with their bewildering triad of light-primaries (which had also been dismissed as irrelevant to painters by Pissarro's friend Félix Bracquemond). After wandering helplessly among other divergent opinions, the artist emerges, grey and in his fifties, to be greeted at the entrance by Common Sense, who tells him that there have been magicians of colour called Veronese, Rubens and Delacroix who knew more about colour than any scientist, 'for with their colours they created a language which speaks to the soul, which communicates emotion and life, before science came to doubt even that coloured rays influence the brain'.[22]

After this vigorous attack on the pretensions of science, it may be surprising to find that Vibert, like Seurat and other Neo-Impressionists, had developed a spectral palette.

A well-known remark of Seurat's to Gustave Kahn might suggest that the painter felt that, 'with the help of art', he had mastered scientific colour before he mastered line;[23] but the chronology of his works indicates that the move towards an ever more homogeneous colouristic surface was anticipated in his drawings, which, from round 1881, made a skilful use of rough paper to create in conté crayon optical greys of extraordinary refinement. Yet, as Herbert has demonstrated, it is these drawings which link Seurat most clearly with Symbolism, with Redon and with the most Wagnerian of French painters, Fantin-Latour.[24] Seurat was Wagnerian, too, in his search for the ultimate division of tone; but he also came close to Symbolist attitudes in his colour.[25]

108, 111
119 (margin references)

Indefinable colour

97 (margin reference)

In a letter to Signac from Honfleur in June 1886 Seurat spoke of the sea as of 'an almost indefinable grey'.[26] We too would, I think, be hard put to find colour-terms for the subtly dissolving areas of pinks, blues, greens and oranges which are, miraculously, common to Seurat's marines and his figure-subjects at this time. Here surely is a democracy of style. But in Seurat's day the language of colour was no less contentious an issue than its physics. Synthetic dyes and their marketing had led to a plethora of fashionable terms which could only confuse. Vibert had his Chevreul in *The Science of Painting* tell the young artist that his numbered colour-system had enabled him to replace uncertain and ephemeral terms such as 'dove-grey', 'dead

leaves', 'thigh-of-excited-nymph pink' or 'Dauphin's-poo' (*caca-Dauphin*); and these were the sort of names which had also been condemned by Bracquemond.[27] The instability of the intermediate tones, as opposed to the primaries and secondaries, must have been brought home to Seurat from the time of his schooldays, in the colour-star published in Charles Blanc's *Grammar of the Arts of Design* (1867), which changed some of the terms for the intermediates from its source, the treatises of J.-C. Ziegler: *cadmium* to *saffron*, *indigo* to *campanule* (bell-flower), and demonstrated how non-standard these terms still were. It also suggests the potential for poetic associations among these terms, where the primaries and secondaries retained their by-now prosaic labels red, green, orange and so on.[28]

Seurat was reluctant to talk in more than the most general terms about the colour he was creating because it was impossible to talk of these colours at all; even mathematical labels were out of court because of the perceptual variables among spectators. It was the old problem, that we may quantify the stimuli but not the perception, a problem which had been re-stated very forcefully in Seurat's lifetime by the German psychologist Gustav Fechner, at the very moment that he was proposing a means of quantifying sensation.[29] One of the many paradoxes in Seurat's method is that the technique of dotting, which allowed him to analyse light in painting to an unprecedented degree – as he told Fénéon, 'the purity of the spectral element' was the keystone of his technique[30] – should have produced many 'colours' which because of their fluid, shimmering character, defy analysis.

18 · Matisse's Black Light

IN THE THIRTEENTH number of the arts review *Verve* (1945), which its editor, Matisse's friend Tériade, devoted to the painter's recent work under the title *De la Couleur*, the elderly artist gave a new twist to his life-long preoccupation with art as process by setting beside each of the sixteen colour-reproductions a diagram of the precise palette he had used for the painting, even to the extent of giving, in some cases, the name of the colour-supplier, Lefranc.[1] These 'palettes' were surely made to satisfy a public curiosity, rather than as an *aide-memoire* for the artist himself,[2] and one of the colours listed on them most intriguingly is 'black'. Thus the door of *La Porte Noire* of 1942 was painted with 'pure Prussian blue' (*bleu de prusse pur*), but the darkest blues in *Le Tabac Royal* of 1943 were made with 'pure black on blue' (*noir pur sur bleu*). The background darks of *La Robe Jaune et la Robe Écossaise* (*Les Deux Amies*) of 1941 were 'black on red'; and the black of *Danseuse, fond noir, fauteille rocaille* of 1942 was specified as 'ivory black' (*noir d'ivoire*). Other blacks in the series were simply described as *noir*, but in a striking paradox, the grey dress in *L'Idole* of 1942 is characterized as 'black white' (*blanc noir*). An even greater paradox, perhaps, is the original stencilled print of 1943 which served as the title-page to the album, where, above the title *De la Couleur* initialled by Matisse, and above two landscape-like strips of yellow and brown, rises a multi-rayed sun which is entirely black.

On Colour included a short untitled essay by Matisse on the relationships of modern painters to tradition, which barely mentions colour. It has been suggested

Matisse's colour-diagram for the painting *Danseuses, fond noir, fauteille rocaille* of 1942, including (as no. 1) *noir d'ivoire*. (**114**)

Matisse's black sun, 1943, used as the title-page of *De la Couleur* in the review *Verve*, 1945. (**115**)

that, as Matisse wrote to Tériade in 1944, he was too exhausted to write on a subject which 'disgusted' him.[3] But a year after the *Verve* article, Matisse wrote in another review a short note on black as a colour in its own right in which he appealed to the example of Japanese prints, of Manet, and of a painting of his own, *The Moroccans*, painted more than thirty years earlier.[4] 117

A remark in a treatise on colour by the nineteenth-century Japanese draughts-man, painter and printmaker Hokusai – which could well have been familiar to Matisse, since it had been published in a French translation in an 1895 article on Hokusai's technical treatises – also listed a whole range of blacks:

> There is a black which is old and a black which is fresh. Lustrous [*brillant*] black and matt black, black in sunlight and black in shadow. For the old black one must use an admixture of blue, for the matt black an admixture of white; for the lustrous black gum [*colle*] must be added. Black in sunlight must have grey reflections.[5]

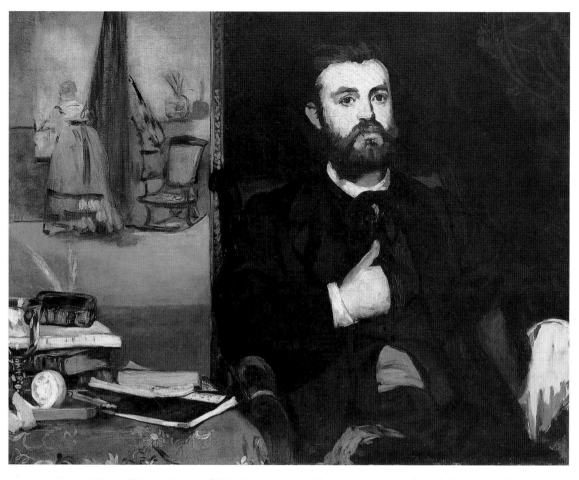

Edouard Manet, *Portrait of Zacharie Astruc*, 1866. Matisse particularly admired this painting for its 'luminous black'. (**116**)

Here, with the addition of a highly reflective medium, black may have lustre or brilliance; but it was in modern French painting that Matisse detected that even matt black, as in his black sun in *Verve*, was not simply used as a colour, but specifically as a colour of light.

Matisse's Manet

In his note on black as a colour, Matisse mentioned two Manets, *Breakfast in the Studio* of 1868, in which the velvet jacket of the young boy in the centre (Leon Leenhoff) was of a 'frank and luminous black' (*un noir franc et lumineux*), and the 116 *Portrait of Zacharie Astruc* of 1866, where the black-velvet suit worn by Astruc had the same luminous quality. The portrait was perhaps the more significant picture for Matisse, not simply because Manet showed Astruc as a connoisseur of the Japanese prints to which Matisse referred later in his note, and which appear as an album on

the writer's table, but also because Manet had divided his composition boldly into two tonal areas, light on the left, dark on the right, and furnished the right-hand portion with a whole gamut of blacks. The black-haired Astruc in his black suit and black silk cravat is set against a flat black ground. It was relatively simple to argue for the luminosity of a lustrous material such as velvet, especially when it clothed a three-dimensional form, but to set black against black required extraordinary perceptual virtuosity, especially in the handling of a uniform background which, from the 1910s, became a special area of experiment for Matisse, and conspicuously in the great *Moroccans* of 1915-16.

117

Matisse may have been able to examine both the *Portrait of Astruc* and *Breakfast in the Studio* in the gallery of the Impressionist dealer Durand-Ruel in the late 1890s, before they were sold on;[6] he was himself introduced to Durand-Ruel about this time by his friend Simon Bussy.[7] But in an interview with André Marchand in 1947, Matisse stated that it had been the veteran Impressionist Camille Pissarro who had observed to him one day that Manet 'made light with black'.[8] Matisse had also been introduced to Pissarro by Bussy in the spring of 1897, and he went with the old painter to see the newly displayed Caillebotte Bequest of Impressionist works at the Luxembourg Museum soon after the exhibition opened that year. It is tempting to think that the remark about Manet's black was made on that occasion, and that it

Henri Matisse's *The Moroccans*, 1915-16, where the praying figures are set against a flat black background. (**117**)

was linked to Pissarro's observation on Matisse's major painting of that same year, *The Dinner Table*, that 'it is impossible to create light with white'.[9] For the more
20 important of the two Manets in the Bequest was *The Balcony* (1868-9), which sets the landscape-painter Antoine Guillemet, in a black coat, against the deep luminous darkness of a room in Manet's studio on the rue Guyot in Paris, in which can just be discerned the figure of the youth, Leon Leenhoff, who also posed for the *Breakfast*.[10] The austere, symmetrical format of a dark space between shutters recalls one of Matisse's first paintings in the period when he first became so pre-occupied with
98 black: the large *French Window – Collioure* (1914), in which it is still just possible to detect a balcony grille and the shapes of landscape or figure, which were then blacked-out in such an unrelenting way.[11] When this painting was exhibited for the first time, in the United States in 1966, that modern American master of black, Ad Reinhardt, identified it as one of the most significant European paintings of 1914.[12] In its original form the *French Window* had reversed Manet's viewpoint to present, albeit in an unprecedentedly reduced format, the motif which had occupied Matisse for a number of years, that of a window opening on to landscape or sea. In reverting to Manet's own subject of an opening into a dark room, Matisse seems to be presenting a quality of luminous blackness as the main subject of the painting. I say 'seems', because the lack of a signature and date has already suggested that Matisse regarded the work as unfinished; but in a number of signed and dated paintings of the following years, such as *The Moroccans*, black fulfills no less significant a role, and there is good reason to believe that in them Matisse saw himself as striking out in an important new and experimental direction.

Half a scientist

When in the 1940s Matisse reconstructed the outline of his 'black' period during the First World War, he dated his discovery of black light, not from the *French Window* of 1914, and still less from the highly original series of black-ground monotypes which he began in the winter of that year,[13] but rather from a smaller
118 painting of a year or so later, the *Gourds*, of which Matisse claimed, in an answer to a questionnaire sent to him by Alfred Barr in 1945: 'in this work I began to use pure black as a colour of light and not as a colour of darkness'.[14] Gourds were also the subject of a black-ground monotype in 1916, but there the white-line image was presented three-dimensionally in a sharply receding space. In the painting all the objects are seen flattened against a two-dimensional ground which is bisected emphatically into areas of black and grey-blue.

In a letter of late 1914 Matisse had told his close friend the painter Charles Camoin how he had borrowed from Félix Fénéon, now of the Bernheim-Jeune Gallery, two small Seurat panels, one of them highly coloured, which set him thinking about Seurat's composition in relation to that of Delacroix's mural of *Jacob Wrestling with the Angel* in the church of Saint-Sulpice in Paris. The Delacroix was rather cobbled-together, whereas Seurat had organized his material 'more scientifically',

In *Gourds* of 1915-16 Matisse lays out his objects like a set of scientific specimens, flat against a black and grey-blue ground. It was in this work, he wrote, that he 'began to use pure black as a colour of light and not as a colour of darkness'. (**118**)

offering our eyes objects constructed by scientific means, rather than with the images [*signes*] which arise from feeling. This lends his works a positive quality, a rather inert stability arising from his composition, which is not the result of a mental act [*une creation d'esprit*], but of a juxtaposition of objects.[15]

This sounds remarkably like the method of *Gourds*, of which Matisse also said to Barr in 1945 that it was 'a composition of objects which do not touch – but which all the same participate in the same *intimité*'.

But Fénéon also owned a number of strikingly flat and sparsely constructed black conté crayon drawings by Seurat, including *The Balcony* (1883-4), *The Gateway* (1882-4), and probably *The Nurse* (1884), whose radically stylized back seems to be behind both the right-hand figure in *The Moroccans* and the third of the series of *Backs* sculpted by Matisse in 1916.[16]

119
108
117

Georges Seurat, *The Balcony*, 1883-4, a conté crayon drawing owned by the critic Fénéon and possibly shown to Matisse. (**119**)

Modern commentators have also pointed to the black ground of Picasso's 1915 *Harlequin*, also in the Museum of Modern Art in New York, a painting which Matisse noted in a letter to Derain early the following year, but without alluding to the colour.[17] All these could plausibly have offered very striking visual stimuli to the painter; but what made Matisse respond in *Gourds* to the *idea* of black as light in such a dramatic way?

The concept of black as a colour (not simply as a darkener) had been much debated in painterly circles since the Renaissance, and had been more or less generally accepted by the close of the nineteenth century.[18] Among Matisse's contemporaries, a painter well-read in theory, such as Malevich, might even interpret the Fraunhofer absorption lines (lines at certain wavelengths where radiation – light – is absorbed by elements in the atmosphere) as evidence that there was black (as well as white, the sum of all the colours of light) in the spectrum itself.[19] But the notion of black as a *light* is so novel, so paradoxical and so radical, that it invites a more thorough circumstantial examination. A recent perceptualist analysis links the development of the idea to Matisse's move from a well-lit to a dark studio in the autumn of 1913, and appeals to the laws of simultaneous and value contrast which make the lights look lighter as they abut on the areas of dark.[20] Such effects were

118

indeed abundantly present in Seurat's drawings, although, because he did not use absolutely flat, dense tones, he was obliged to represent, and not simply to create them. Certainly Matisse recalled that 'blacks and their contrasts' first came to be exploited in *The Moroccans*;[21] and in addition, a prolonged inspection of Matisse's 117 sizeable paintings will induce a strong, luminous after-image of the blacks. But quite apart from the question of whether Matisse's work, with its complex rhythmic surfaces, invited this sort of inspection, there was another approach to black which seems to have been crucial to this period of experimentation, and that was the idea of black light as a physical phenomenon, which was then a fashionable topic in French science.

In his 1914 letter to Camoin, Matisse followed his mention of Seurat with the confession that:

> I am a romantic, but with a good half of the scientist, the rationalist, in me, which makes for a struggle from which I emerge sometimes triumphant, but breathless.[22]

Already in his 1908 *Notes of a Painter*, where he had expressed dissatisfaction with the limitations of Neo-Impressionist technique, Matisse had looked forward to defining 'certain laws of colour' by studying the colour-handling of many intuitive artists:[23] an aspiration which was very far from being purely intuitive itself. Matisse's interest in Bergson's philosophy of duration has long been appreciated;[24] but his knowledge of contemporary scientific ideas has been less examined. In the letter to Derain early in 1916, Matisse drew that painter's attention to some 'dizzying' hypotheses he had found in the book *Science and Hypothesis* (1902) by the distinguished mathematician Henri Poincaré, and said that he had been particularly impressed by the notion that:

> Movement exists only by means of the destruction and reconstruction of matter.[25]

Poincaré's account in this book of one of the leading tendencies of modern physics also sounds remarkably like Matisse's characterization, in his response to Barr, of the *intimité* of objects in *Gourds*: 118

> new relations are continually being discovered between objects which seemed destined to remain for ever unconnected; scattered facts cease to be strangers to each other and tend to be marshalled into an imposing synthesis. The march of science is towards unity and simplicity.[26]

His book had been commissioned by the editor of the series *Bibliothèque de Philosophie Scientifique*, Gustave Le Bon, who was also much concerned with the instability of matter, and who quoted Poincaré enthusiastically in his own *L'Évolution des Forces* of 1907. And it was Le Bon who, from 1896, began to develop the theory of Black Light.[27]

The 1890s was a decade in which interest in all forms of radiation, which had begun to occupy scientists since the Romantic period, took on a more precisely phenomenological form. It was the period of the discovery of X-rays by Röntgen,

and of radium and uranium by Marie and Pierre Curie, who, with Henri Bequerel, won the Nobel Prize for their work on radioactivity in 1903. Le Bon, who had made his reputation earlier in the century with a study of the psychology of crowds, gave a candid account in one of his most popular books of how he came to publicize his own work on radiation:

> The appearance in 1896 of the work of Röntgen on the X-rays determined me to publish immediately, in order to settle the order of dates, a note on some particular radiations capable of passing through bodies... I called them by the name of Black Light by reason of their sometimes acting like light while remaining invisible.[28]

The rays in question were radioactive particles such as cathode rays (later removed by Le Bon from the category of Black Light), the long-wavelength radiations in the infra-red of the spectrum and beyond, and radiation due to invisible phosphorescences. Although the term Black Light was not generally accepted, Le Bon's work was widely regarded by 1900 as having demonstrated that invisible radiation was a universal property of matter: the physiologist Albert Dastre of the Sorbonne told readers of the non-specialist *Revue des Deux Mondes* in 1901:

> Not a sunbeam falls on a metallic surface, not an electric spark flashes, not a discharge takes place, not a single body becomes incandescent, without the appearance of a pure or transformed cathode ray. To Gustave Le Bon must be ascribed the merit of having perceived from the first the great generality of this phenomenon. Even though he had used the erroneous term of *lumière noire*, he has none the less grasped the universality and the principal features of this product. He has above all set the phenomenon in its proper place by transferring it from the physicist's cabinet to the great laboratory of nature.[29]

The fundamental premise of Le Bon's theory was the recognition that in the continuous spectrum of radiation the visible spectrum, that is, visible light, formed less than a tenth of the whole. Thus 'the invisible region of the spectrum constitutes... the most important portion of the light. It is only the sensitiveness of the human eye which creates the division between the visible and invisible parts of the spectrum.'[30]

It might be that there were animals able to see into those parts of the spectrum invisible to the human eye, but it was certainly the case that Black Light could be registered on photographic plates. Le Bon published a number of experiments using statuettes to demonstrate that photographs could be made in total darkness by Black Light, which, since it had the same properties of rectilinear propagation and refraction as visible light, produced perfectly sharp images. In one experiment, a replica of the Venus de Milo was coated with photo-sensitive sulphide of calcium and exposed to light for three or four days until it had become 'entirely dark' by

Gustave Le Bon, The 'black spectrum', 1908, from *L'Évolution des Forces*, showing how little of the spectrum of radiation is composed of visible light. (**120**)

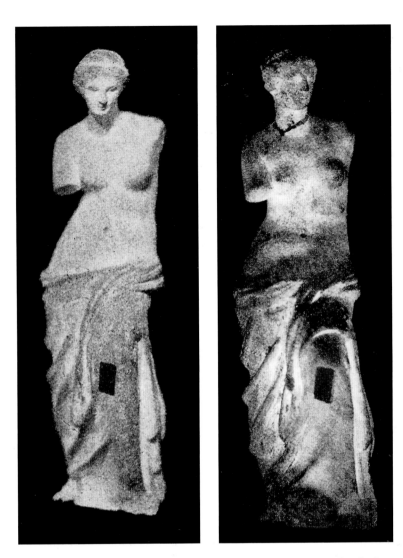

Gustave Le Bon's 'black light' experiment with Venus de Milo statuettes. Coated with photo-sensitive sulphide of calcium and exposed to light until they blackened, they were then photographed in darkness by the 'invisible rays emitted by them eighteen months after having been struck by light' (as the original caption has it). The black patches are uncoated areas. (**121**)

photo-chemical action. It was then placed in complete darkness and photographed with a Black Light camera for from eight to fifteen days, until a perfect image was obtained.[31] In another, using statuettes of the Buddha or Baccantes, the invisible rays emitted from the coated surfaces in a completely blacked-out room were joined to the rays from a special 'dark lantern' which itself emitted only Black Light, with the result, reported Le Bon, that

> the observer sees, at the end of one or two minutes, the statue light up and come forth from the darkness. The experiment is a very curious one, and has always vividly impressed the spectator. It is, in fact, very strange to see the dark

Henri Matisse, *Portrait of Mlle Yvonne Landsberg*, 1914. (**122**)

radiations of the lamp, added to the dark radiations of the sulphide, produce visible light. It is almost the converse of the celebrated interference experiments of Fresnel, in which light added to light produced darkness. In my experiment, it is darkness added to darkness which gives birth to light.[32]

Le Bon might almost be describing the coming into light of the variegated silver jug in Matisse's *Gourds* – the highest contrast with the black in the picture – and the 118 mysteriously flat grey gourd, which speaks across the composition to the grey of the casserole and the blue-grey of the lighter ground itself. Certainly the slanting edge of the black suggests that these objects are caught in a shaft of Black Light.

Dark light

Le Bon's experiments were published in a popular book: his *L'Évolution des Forces* sold twenty-six thousand copies and was in print until at least 1917; and his concept of universal radiation remained interesting, at least to newspaper journalists, for many years. It has been suggested that Matisse read an article published in *L'Intransigéant* in 1913 which claimed that the rays emanating from human bodies, as well as from plants and minerals, could be photographed, and that this reading relates to the extraordinary *Portrait of Mlle Yvonne Landsberg* (1914), on which, after many sittings 122 and repaintings, Matisse finally scratched arching lines of force around the young body.[33] Emanations have rarely been so graphic; but in the present context what is perhaps even more striking is that here, as in Matisse's portrait of his wife painted the previous year, the large eyes, those windows of the soul, have been completely blacked out.

So far as I know, the name of Gustave Le Bon appears nowhere in Matisse's writings, but there is at least one slight indication that he might have looked at the long Black Light section in *L'Évolution des Forces*. Another experiment published there 123 illustrated an apparatus designed by the scientist to demonstrate the transparency of

Matisse will have seen this ilustration of Gustave Le Bon's experiment to prove that invisible light can penetrate an opaque substance, from *L'Évolution des Forces*, 1908. (**123**)

Matisse's design for a black chasuble, 1950-2, inscribed with the Provençal word *esperluçat,* meaning 'to open the eyes'. (**124**)

opaque bodies to invisible light. It consisted of an ebonite plate to which metal stars had been glued, placed beneath a photographic plate of which the upper half had been exposed to candlelight. When exposed to full sunlight and developed, the lower half of the plate was black, while the upper half showed the image of the half-stars. Their metal had protected the plate from infra-red rays passing through the ebonite. The resulting image is strikingly close to Matisse's design for the title-page of *Verve* in 1945, and would have been even more so in the negative, where, as Le Bon points out in his caption, the half-star shape rising above the 'horizon' would have been black.

In spite of the great interest shown in his work in the 1890s, especially in France, and in spite of the popularity of his later books, Le Bon's reputation as a physicist scarcely survived the turn of the century. It was argued that his essentially qualitative experimental procedures were faulty, and – in England – that his results had for the most part been anticipated at Cambridge.[34] Black Light was not a concept which had any lasting impact on the study of radiation. Matisse's 'black light', on the other hand, propelled partly by the inner turmoil brought about by illness and war, had a long life ahead of it. The 'black' paintings of 1914-16 were joined by a cluster of predominantly black subjects around 1940;[35] and at the close of Matisse's life, by cut-paper designs such as *The Sorrows of the King* (1952) and the series of maquettes for black chasubles for the Chapel of the Rosary at Vence (1950-2), most of which are now in the Matisse Museum at Nice.[36] One of these, bearing the inscription *esperluçat,* a Provençal word meaning 'to open the eyes' or 'to perceive', may serve as a summary of the painter's fifty-year meditation on 'black light'. What proved to be contingent and provisional in science has revealed itself as enduring in art.

19 · Colour as Language in Early Abstract Painting

THE HISTORY OF ABSTRACT PAINTING is only beginning to be written, and it seems clear that, appropriately enough in a period of post-modernism, philosophers of art are generally more concerned with problems of abstracting, and of its concomitant, representing, than with the essential issues in the history of abstraction itself. It has not proved difficult with hindsight to trace continuities between representational and non-representational art; and the long careers of several of the key figures, like Kandinsky, Malevich and Mondrian, who began with representation, have seemed to give the plotting of these continuities some sort of validity. Kandinsky, however, in an unusually candid autobiographical essay, gave a rather different account of his feelings when he at last realized that his pictures were harmed by the presence of a recognizable subject:

> A terrifying abyss of all kinds of questions, a wealth of responsibilities stretched before me. And most important of all: What is to replace the missing object?[1]

Kandinsky's dilemma points to the importance of content in early abstraction; but the criticism of abstract art, as it developed from the earliest years, about the time of the First World War, has been very little concerned with content. The primary as well as the secondary sources tell, for the most part, a story of abstraction as essentially an autonomous, even hermetic, non-representational activity; and this has enabled opponents like the anthropologist Claude Lévi-Strauss or the art-historian Ernst Gombrich to suppose that what they see as the failure of abstraction is due to its very impoverished semantic credentials.[2] As I shall show at the close of this chapter, there is a very direct way in which one branch of early abstraction, Russian Suprematism, owed its force to a context of debate on the fundamentals of language; but for the moment I want to look chiefly at the question of colour in early abstraction, for colour was an area of especial semantic richness at the beginning of this century, and it offers an aspect of content in early abstract painting which is as complex and as resonant as, say, the iconography of the Madonna in the Italian Quattrocento.

A good starting-point is, again, Kandinsky, whose discussion of colour in his first major publication, *On the Spiritual in Art* (1911-12), has come in for a good deal of attack, even from supporters of abstraction like Stephen Bann, who has written: 'I would reject as utterly implausible the specific equations of form, colour and meaning propagated by Kandinsky.'[3]

Colour in Theosophy and in Kandinsky

Kandinsky was not alone in proposing that colour and form constitute a language of affects. Yet if we compare Kandinsky's treatment of colour with that of one of his sources in the literature of the Theosophical movement, we shall see how much more rigorous the painter is. The Theosophical system in Besant and Leadbeater's *Thought-Forms* (1901), although it incorporates notions of a moral colour-space – lightness and purity as opposed to darkness and corruption – seems to be a quite arbitrary arrangement: two widely separated classes of red, for example, are given quite antithetical connotations of 'Pure affection' and 'Avarice'. The Theosophical texts are concerned to interpret colours as they are experienced by the adept in auras, or 'thought-forms' (see p. 267 below); Kandinsky on the other hand starts from what he considers to be the properties of colours themselves: their polar con-

92, 125 trasts of warm and cool, light and dark, or complementarity; and he articulates these into a set of antitheses which provide a tightly interlocking armature for his meanings. The respective treatments of green are instructive: in *Thought-Forms* Besant and Leadbeater write:

> Green seems always to denote adaptability; in the lowest case, when mingled with selfishness, this adaptability becomes deceit; at a later stage, when the colour becomes purer, it means rather a wish to be all things to all men, even though it may be chiefly for the sake of becoming popular and bearing a good reputation with them; in its still higher, more delicate and more luminous aspect, it shows the divine power of sympathy.[4]

For Kandinsky, however, who had been especially attracted to green in his earlier, representational phase as a painter, it was now a product of the coming-together of

92 the eccentric yellow and the centripetal blue, and it was thus expressive of calm, but also of boredom:

> Thus pure green is to the realm of colour what the so-called bourgeoisie is to human society: it is an immobile, complacent element, limited in every respect. This green is like a fat, extremely healthy cow, lying motionless, fit only for chewing the cud, regarding the world with stupid, lacklustre eyes.[5]

The values attributed to specific colours are often very similar in the Theosophists and in Kandinsky – the spiritual blue and the earthly or intellectual yellow, for example – but only Kandinsky is prepared to argue for them according to a publicly recognizable set of principles.

125 Kandinsky's arrangement of colours into a polar scheme shows clearly that
78 he was heir to earlier colour-systems, and especially to those of Goethe and the Viennese psychologist Ewald Hering, whose theory of colour-perception was based on the three oppositions (opponent-colours), black-white, red-green, and blue-yellow. The painter probably found Hering's ideas in the well-known standard psychological textbook of Wilhelm Wundt.[6] His views are thus far from arcane, 'implausible' or even very individual, for they rest in principle, if not always in detail, on a widely debated body of psychological doctrine which included effects

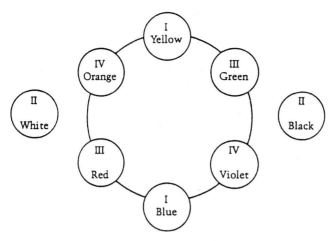

Kandinsky's pairs of opposites, from *On the Spiritual in Art*, 1911-12. His scheme is close to the Viennese psychologist Ewald Hering's 'opponent colours', although his orange-violet opposition and his characterization of black and white as 'death' and 'birth' are both unusual. (**125**)

of synaesthesia very familiar to the painter: Kandinsky's understanding of the timbre of the flute as light blue, for example, followed a theory that had been mooted in the 1870s by several psychologists and aestheticians, and was appropriated by Wundt.[7]

Nature and system

In *The Raw and the Cooked* Lévi-Strauss argues that painting can never constitute an abstract system on a par with music, since its forms and colours are necessarily rooted in nature.[8] He has clearly overlooked the developments in chromatics and psychology to which I have just referred; but he has also, and perhaps more surprisingly, neglected the Enlightenment prototypes of these late nineteenth-century schemata, notably the circular systems of the entomologists Moses Harris and Ignaz Schiffermüller, whose dual reference to nature and to system is immediately clear. As part of the great eighteenth-century enterprise of cataloguing the whole of the natural world, Schiffermüller's and Harris's scales epitomise what Foucault has termed the *method* of Enlightenment taxonomies; but, as their titles, respectively *Versuch eines Farbensystems* and *The Natural System of Colours*, make clear, they also represent aspects of Foucault's *system*: self-contained and internally coherent schemes of colour-articulation, based upon the notion of primary and secondary characteristics, and of contrast or harmony.[9] Although the modern Munsell and CIE (Commission Internationale d'Éclairage) systems have become more complex and more open-ended, they are no less systematic, and as early as the second half of the nineteenth century it had become quite in order for the popularizers of colour-theory to refer to it in terms of a 'grammar'.[10]

I do not propose to examine here the many problems facing the users of these very simple early schemata, problems which the later developments were designed

59
6

to reduce. But there is one factor which I think has an important bearing on the role of colour as system in early abstract painting. As Harris had already shown, the painter's application of the principles of contrast, as presented in his *Natural System of Colours* (*c.* 1776), was made very difficult by his inability to find colorants which would exactly match ideal colours. The developing paint-industry of the nineteenth century addressed this problem: the Englishman George Field, for example, 134 who was both a theorist and a manufacturer, was careful to specify the pigments he used in his diagrams; and by the 1880s the influential circle of contrasts published by Ogden Rood was able to give precise pigment-equivalents for complementaries, and Seurat was able to set his palette with a series of paints approximating to the colours of the solar spectrum, at least in hue.[11]

This increasing range of colorants was of great importance in the practical application of theory, and in particular for theories of the affects of colours on spectators, who could now be presented with standard, measured hues, so that dependence on language, and hence on associations, could be reduced to a minimum. Not that technology had yet succeeded in providing a categorically 'pure' primary colour: it is no surprise that early abstraction, especially in Russia and Germany, sought to exert its influence on paint-manufacture, or that the most influential colour-132 theorist of these years, the chemist Wilhelm Ostwald, was in the 1920s and 1930s an important consultant to the paint-industries of several countries. The Hungarian painter Vilmos Huszár, who introduced Ostwald's system into the Dutch De Stijl group in 1917, noted once again that the aspiration for 'pure' colours was still frustrated by imperfect materials.[12] Of this group Mondrian, who perhaps more than any of its other artists had the capacity to produce work of great formal and colouristic sensitivity, continued to be vexed by the problem of finding a perfect red, and his reds even more than his other 'primary' colours continued to be structurally complex well into the 1920s.[13] Mondrian, too, was an admirer of Ostwald's principles (see the following chapter), and as late as 1920 he was still using the fourth 'primary' colour, green, which Ostwald had adopted from Hering, as were Huszár, and the founding father of the De Stijl group, Theo van Doesburg.[14]

The significance of primaries

The scheme of 'primary' colours was the most resonant aspect of the colour-debate among painters in these years, and the apparently straightforward adoption of three: red, yellow and blue, plus the three 'non-colours', black, white and grey, within De Stijl was far more complex than it seems. Van Doesburg came to take a broadly phenomenological position, treating these colours as energies to be used in the dynamic articulation of two- or three-dimensional space.[15] Bart van der Leck, the painter to whom may belong the credit for having impressed the privileged status of red, yellow and blue on the other members of the group, thought of these colours as the direct embodiment of light.[16] The architect and designer Gerrit Rietveld, whose red-blue chair of the early 1920s came to symbolize the movement as a whole, held the mistaken view that red, yellow and blue are the 'primaries' of

The Last Futurist Exhibition, o.10, Petrograd, 1915. Malevich has placed his *Black Square* (on a white ground) in the traditional position of the most important icon in the Russian house – in the 'red' corner of the room, so making this corner of the exhibition-space symbolically black, white and red. (**126**)

colour-vision;[17] and the painter and sculptor Georges Vantongerloo, although he had been briefly a follower of Ostwald, developed about 1920 a wide-ranging spiritual interpretation of colour-harmony using a mathematical analysis of wavelength in the spectrum.[18] Even Mondrian, as late as 1929, was still thinking of his colours in symbolic terms: red was more 'outward' or 'real' and blue and yellow were more 'inward' or 'spiritual', in a way which relates to his early interest in Theosophy and in the theory of Goethe, which had been re-stated by Mondrian's friend, the Dutch Theosophist Schoenmaekers in 1916.[19] (Goethe had posited two primaries, yellow and blue, but the red, *Purpur*, which was derived from them by a process of 'augmentation' was for him the noblest and the highest colour.) What unites the De Stijl artists beyond all these distinctions is a belief in the importance of primariness as such, and this was clearly the legacy of the reductive and symmetrical colour-systems of the nineteenth century.

Red, yellow and blue are not, of course, the only 'primary' triad, or even the most privileged one. The much older and more universal set, black, white and red, has recently come into prominence again in anthropological studies of language, chiefly in connection with the evolution of non-European cultures, where the earliest colour-categories were those of light and dark, followed almost universally by a term for 'red'.[20] But this triad also has a long history in the Indo-Germanic languages and their cultures (as readers of Grimm's fairy-tale *Snow White* will recall, the heroine was compounded of these three colours).[21] In early abstract painting this

Kasimir Malevich's *Suprematist Painting*, 1917–18, an example from his great 'white on white' series. (**127**)

126

127

set had an especially prominent place in Russia in the first school of geometric abstraction, the Suprematism of Malevich. In an essay of 1920 Malevich divided his movement into three phases, according to the proportion of black, red and white squares introduced into its pictures. Black represented a worldly view of economy, red revolution, and white pure action; and of these, white and black were more important than red, and white the culmination of all.[22] Although Malevich paid a rather ambivalent tribute to colour-science, considering black and white 'to be deduced from the colour spectra',[23] and although the command of many nuances of white which informs his great series of 'white on white' paintings may have been stimulated by the revival of interest in early Russian icons, with their creams and off-whites which often served as a surrogate for gold,[24] there can be little doubt that the place of white in the Suprematist colour-system was essentially associative and literary. Malevich's best-known statement,

the blue of the sky has been defeated by the suprematist system, has been broken through, and entered white, as the true, real conception of infinity, and thus liberated from the colour background of the sky... Sail forth! The white, free chasm, infinity, is before us...[25]

echoes the transcendent interpretation of white as it appears in the poetry of the Russian Symbolists Belyi (whose name of course means 'white') and Blok.[26]

A language of colour

Malevich was also a friend of the poet and theorist Velimir Khlebnikov and of the linguistic scholar Roman Jakobson, through whom the work of the burgeoning Moscow Linguistic Circle on basic phonetics must have become very familiar to him. Khlebnikov had indeed collaborated with Malevich in 1913 on the opera *Victory over the Sun*, in which one aria was composed entirely of vowels and another entirely of consonants; and the painter's austere geometric designs for the sets and costumes of this production have rightly been seen as embodying the seeds of the Suprematism which emerged two years later.[27] Both Khlebnikov and Jakobson were interested in that aspect of synaesthesia known as *audition colorée*, in which spoken sounds, particularly vowel-sounds, were involuntarily associated with colours; and Jakobson indeed seems to be one of the very few students of languages to have maintained an interest in the phenomenon (see Chapter 21). The sound-colour association is probably best known from one of the earliest recorded examples, Rimbaud's *Sonnet des Voyelles* (p. 263 below), but by the time of the First World War it had become a major preoccupation of experimental psychologists. In 1890 the Congrès Internationale de Psychologie Physiologique set up a committee to investigate the phenomenon, and this was productive of a spate of publications, but even before that, *audition colorée* had been investigated on a statistical basis in the influential aesthetic publications of G.T. Fechner.[28]

Jakobson, who had become friendly with Malevich by 1916, may have already begun to relate infant preferences for black, white and red to the early development of speech-sounds, in which 'a' (which was often associated with red in these psychological experiments) provided the basic phonetic contrast to 'w', which according to several authorities was associated with black.[29] In a manifesto of 1919, Khlebnikov appealed to the painters of the world to help in the establishment of a universal language, for

the task of the colour-painter is to give geometrical signs to the basic units of understanding... It would be possible to have recourse to colour and express M with dark blue, W with green, B with red, E with grey, L with white...[30]

Painterly and linguistic research in Russia was thus directed to the identification and expression of fundamentals, and this area of enquiry became part of the curriculum of the Soviet State Art Schools in the 1920s, a period which saw perhaps the last major flowering of interest in *audition colorée* until very recent times.

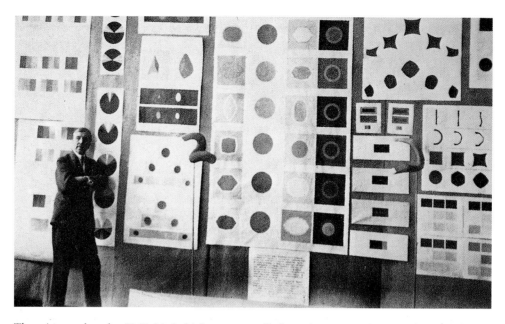

The painter and teacher K. V. Matiushin's vast array of colour-charts, Moscow, 1924, suggesting the laboratory rather than the studio. (**128**)

Kandinsky, who had been engaged on drawing up some of the teaching programmes there immediately after the Revolution, took with him an interest in this sort of research when he returned to Germany and the Bauhaus later in the decade.[31] In Russia, indeed, where Ostwald's colour-theories were widely adopted, it was the psychological laboratories of late nineteenth-century Germany which provided the models for the art institutions of the Revolutionary and immediately post-Revolutionary periods.[32]

128

 We are now, I think, in a better position to interpret an extravagant remark by the Suprematist Ivan Klyun, who in a manifesto of 1919, summarized the theme of the present chapter in claiming:

> our colour-compositions are subject only to the laws of colour and not to the laws of nature.[33]

Early abstract artists were thus presented with a number of well-articulated colour-systems which allowed them to consider colour as in the nature of a language. But it is not surprising that their use of this language should have depended upon principles of salience and symbolism, rather than on notions of mere perceptibility. Nor is it altogether surprising – although it may be a matter of regret – that this language of colour, which seemed around 1900 to offer the prospect of universality, should have turned out to be so thoroughly hermetic.

20 · A Psychological Background for Early Modern Colour

'PEOPLE TODAY HAVE A REMARKABLE relationship with colour. Our time, which depends on the past more than any other for its forms, has produced a kind of painting in which colour is independent.' Thus claimed the critic Karl Scheffler in an essay, 'Notizen über die Farbe', in the journal *Dekorative Kunst* in 1901. Scheffler's view of the centrality of colour in modern painting was reinforced by many critics and artists in France and Germany before the First World War, and if colour came to play a leading role in early abstraction, this was not so much because it had lost its traditional mystery, but rather that this mystery had been deepened and ramified by developments in colour-study during the second half of the nineteenth century, to the point where it could become a central preoccupation of painters seeking new means of expression.

The aims of abstraction were spiritual, but to realize those aims, painters were ready and able to use the very substantial body of colour-theory which had been published by 1900. The classic studies of Goethe (1810) and M.-E. Chevreul (1839) had established the study of colour firmly on a subjective basis, and the developing science of experimental psychology, and later of phenomenology, gave a good deal of attention to the perception of colour. Experimental psychologists frequently drew on their experience of painting: several, like David Katz, were themselves painters, and others, like Müller-Freienfels, were also historians of art. Their tastes were usually conservative, but this was not always so.

In 1913 a painter from the Cleveland School of Art and a physiologist from the Western Reserve Medical School published a study which examined, not simply the physiological basis of Neo-Impressionism, but also the reaction against Neo-Impressionism in the work of the Fauves, who had found, like many other artists around 1906, that the pointillist technique produced a decidedly achromatic, greyed effect, and who sought to base a new colouristic style on the contrast of large areas of flat tint.[1] Matisse's thoroughly phenomenological 'Notes of a Painter', in which he described his painting procedure as starting from the immediate, naive sensation of a colour-patch set down on the canvas, was published in the same year, 1908, as E. Utitz's *Principles of the Aesthetic Theory of Colours* (*Grundzüge der aesthetischen Farbenlehre*), which claimed that the painter 'does not take his habitual colours [i.e. the colours expected in objects, and hence perceived in them] to his subject, but gives himself up naively to the immediate impression'. This view was quoted approvingly by David Katz in an early classic of phenomenology, *The Modes of Appearance of Colours and their Conditioning by Individual Experience* (*Die Erscheinungsweise der Farben und Ihre Beeinflussung durch die Individuelle Erfahrung*, 1911). The interests and

even the methods adopted by painters and psychologists were very much in tune. A series of studies carried out in the Leipzig psychological laboratory of Wilhelm Wundt in the 1890s and early years of this century was directed towards establishing colour-aesthetics on an empirical basis by means of controlled experiments with many subjects. In an early study of 1894, Jonas Cohn had already discovered that most of his subjects (who were all educated men) preferred combinations of highly saturated colours, and particularly saturated complementaries, and he noted that this preference had hitherto been regarded as peculiar to primitives and the uncultivated. In a series of experiments of 1910-11, F. Stefănescu-Goangă came to the conclusion that the feelings produced in his subjects by colours were the direct effect of sensory perception, rather than the result of associations, which were secondary phenomena.[2] This work tended towards the view that colour-sensations themselves could be free of associative elements – could be more abstract.

It is not at all certain how far these studies were accessible to painters in the way in which the earlier, simpler and more comprehensive manuals of Goethe, Chevreul and Ogden Rood had been; but what is clear is that, in the early development of abstraction, painters interested in colour were experimenting in very much the same way as the psychologists; that they used analogous experimental procedures, and sometimes came to very similar conclusions. Painting had been established as an experimental activity in the 1880s by Seurat: after the death of Cézanne in 1906 it became more insistently so; and if we examine painterly practice and theory in the years around 1912 with a view to discovering its preoccupations and motivating forces, we may go far towards reconstructing the processes of trial and error which more than ever shaped the non-representational painting of that time.

Kandinsky's grammar of colour

The first colours that made a strong impression on me were bright, juicy green, white, carmine red, black, and yellow ochre. These memories go back to the third year of my life. I saw these colours on various objects which are no longer as clear in my mind as the colours themselves.

(W. Kandinsky, *Reminiscences*, 1913, trans. Herbert)

In this opening passage of his essay in autobiography Kandinsky presents himself not simply as an instinctive, inveterate colourist, but also as an introspector who seems to be describing the experience of what Katz in 1911 had characterized as *film* colours: colours which are perceived as only loosely attached to objects.

Commentators on Kandinsky's theory of colour, as set out in *On the Spiritual in Art* (1911-12), have emphasized its links with Theosophy, in particular with the writings of Rudolph Steiner with which the painter had become very familiar in the years after 1908. It has been suggested that Kandinsky became interested in modern psychology only after the war, at the Bauhaus, where the experimental method was very much part of his teaching. But this is to underestimate the extent to which Theosophical writers were themselves indebted to recent discoveries in experimental psychology; and the colour-formulations of Kandinsky's treatise

Kandinsky's early abstraction still draws substantially on the imagery of his earlier paintings. Here in the decorative mural for Edwin Campbell of 1914, the middle section includes a sweeping yellow and scarlet form close to the trumpets played by angels in some of his Apocalyptic subjects, for example the 1911 *Resurrection* in Munich. Kandinsky's synaesthetic instincts – and perhaps also his reading – associated scarlet and the sound of the trumpet. (**129**)

suggest a far earlier interest than that. One of his preoccupations at this time was the establishment of a 'grammar' of painting on a level with what he saw as the 'grammar' of music: again and again he quoted a remark of Goethe's, that painting needed a thorough-bass – the eighteenth-century method of establishing a base-line in a score which predetermined the subsequent elaboration of the other parts – and this is a quotation not without its irony in the context of 1912, since at this time Kandinsky's friend and collaborator Arnold Schoenberg was asserting that the method was entirely outmoded (*Theory of Harmony*, 1911).

Kandinsky had been concerned with the theory of colour at least since 1903, the year of the German translation of Signac's manifesto *From Delacroix to Neo-Impressionism*, and it is very likely that he had already read Scheffler's article of 1901 on colour, cited above, for he referred to it in *On the Spiritual in Art*, where the treatment of mental disturbances by chromotherapy was one of the subjects under

92 discussion. Some aspects of the dynamic of colour which Kandinsky made the basis of his colour-system have rightly been traced to a pamphlet on chromotherapy by A. Osborne Eaves, *Die Kräfte der Farben* (The Powers of Colours) of 1906, where red and blue were characterized as the most contrasting and the most therapeutically effective colours, and where Kandinsky made his characteristic diagrams of expansion and contraction in the margin of his own copy. But Kandinsky's system was based upon the primary polarity of yellow and blue which goes back ultimately to Goethe's table of plus and minus, active and passive colour-sensations (*Theory of Colours*, § 696), albeit much amplified by Wundt in his *Principles of Physiological Psychology* (1874, 5th edn 1902) into what he called the 'unique contrast of feeling [*Stimmung*] in colour': the lively yellow and the calm blue. Wundt had described a two-fold movement from yellow to blue – an unstable, labile progression through red, and a stable, balanced, restful progression through green – which colour, according to Kandinsky, also represented 'the passive principle'.

129 In his discussion of synaesthesia (the simultaneous response of two or more senses to a single stimulus) Wundt introduced some musical-chromatic examples which are close to Kandinsky's: their scarlet trumpet was a very traditional equivalent which goes back to the eighteenth century, but the light blue of the flute is a more recently experienced correspondence, noted in the psychological literature of the late nineteenth century. And like Wundt's pupil Stefănescu-Goangă, Kandinsky felt that 'the theory of association is no longer satisfactory in the psychological sphere. Generally speaking, colour directly influences the soul.'

But the detailed correspondences between the ideas of Kandinsky and those of Wundt and his school are only occasional, and rather unimportant: what is more interesting is the painter's method of proceeding in his enquiry, whose conclusions were, as he said, the result of 'empirical feeling', 'not based on any exact science', but which could be substantiated by 'proceeding experimentally in having colours act upon us'. Kandinsky, who had been trained in law and ethnology before he turned to painting, was no stranger to the experimental method. It was not until after the publication of *On the Spiritual in Art* early in 1912, under the influence of the American printer Edward Harms, that he subjected Goethe's *Theory* to experimental testing with the prism, hoping in vain to substantiate Steiner's Theosophical interpretation of that work: but that he should have felt such experimentation to be appropriate at all is witness to a remarkably positivist element in his mind.[3]

After the war Kandinsky introduced the study of the medical and physiological, as well as the occult aspects of colour into his proposals for the curriculum of the Moscow Institute of Art Culture; and three years later, at the Bauhaus, he dropped the occult, and added psychology, stressing that all these studies should be carried out by means of exact measurements and experiments. His most notorious excursion was the test with a thousand postcards sent out to a sample of the Weimar community, asking that the three 'primary' colours, red, yellow and blue, should be allotted to the three 'primary' shapes, the triangle, circle and square. The questionnaire produced an 'overwhelming majority' in favour of the yellow triangle, the red square, and the blue circle. But like its results, the psychological presuppositions of this survey had already been suggested in Kandinsky's *On the Spiritual in Art* in 1912,

August Macke, *Colour Circle II (Large)*, 1913.
The young Westphalian painter's circle is close
to Delaunay's experiments with *Circular Forms* of
the same year, but Macke adds dynamism to his
version with a spiralling shape and contrasts of
blue and red, yellow and green. (**130**)

where he proposed that 'sharp colours have a stronger sound in sharp forms (e.g.
yellow in a triangle). The effect of deeper colours is emphasized by rounded forms
(e.g. blue in a circle).' Introspection needed only the authority of a statistical survey
to become the compelling basis of a universal pictorial language.

Kandinsky's interest in a universal language of colour is nowhere more apparent
than in the almanac of the Munich Blue Rider group (p. 193 above). His stage-piece
The Yellow Sound, published there, is one of the earliest manifestations of synaesthe-
sia as an aesthetic principle. But more important, the almanac brought together for
the first time high art and popular art, the art of children and amateurs, art from
Africa, Asia, Polynesia and the Americas. The group's leading enthusiast for non-
European art was August Macke, who wrote for it an essay on masks. But Macke 101, 130
also found himself increasingly unhappy with the introspective emphasis of
Kandinsky, and looked for a more objective handling of colour. This he found in the
work of the French painter Robert Delaunay, whose Paris studio he visited in 1912.

Delaunay's practical theory

In these years [about 1912] whole treasures of patience, analysis, research and
learning were devoured in the studios of the young painters in Paris, and sheer
intelligence welled up more intensely than ever before. The painters looked at
everything: contemporary art, and art in every historical style, the expressive
means of all peoples, the theories of all periods. Never before had so many
young painters been seen in the museums, studying and comparing the tech-
niques of the Old Masters. They looked at the artistic productions of savages,
of primitive peoples, and the evidence of prehistoric art. At the same time they
were much occupied with the latest theories of electro-chemistry, biology,
experimental psychology and applied physics....

The poet Blaise Cendrars, writing in *Aujourd'hui* in 1931 (138f), is describing here the Paris circle of artists which included Robert Delaunay, whom he had met at the end of 1912. Delaunay was still working on a series of paintings of *Windows* which he had begun a year earlier, but probably in 1913 he began painting the *Sun* and *Moon* series which was to mark an entirely new direction in his work, and was effectively to form its basis until his death in 1941. The painter and his critics have seen the work of this period as the first non-representational art in France, and it is worth examining the painting of this seminal year 1912 in the light of the theory of art that Delaunay began to elaborate at the same time, for the comparison will show how close he was also to developing an experimental method.

Delaunay called this style of painting *Simultané*, taking up the term applied by Chevreul to a particular kind of colour-contrast which he had made the focus of his 1839 treatise, *On the Law of Simultaneous Contrast of Colours*, declaring that,

> in the case where the eye sees at the same time two contiguous colours, they will appear as dissimilar as possible, both in their optical composition and in the height of their tone. (§16)

Delaunay may have studied Chevreul as early as 1906, when his painting and that of his friend Jean Metzinger passed through a Neo-Impressionist phase. The large, square brushstrokes which characterize the work of this period were a reaction against the greying effect of Seurat's smaller dots, and, in Delaunay's *Landscape with Disc* of 1906/7 (Paris, Musée d'Art Moderne), were also used as an expressive means: the vibration created by the refusal of the large colour-patches to mix optically has a direct relation to the dynamic subject of the painting, the sun. This picture also makes some play with complementary after-images (red-green), but there is no reason to suppose that it represents any sustained study of Chevreul.

When, probably early in 1912, Delaunay wrote to Kandinsky outlining his theories, he had shifted to a rather different approach, claiming:

> the laws I discovered...are based on researches into the transparency of colour, that can be compared with musical tones. This has obliged me to discover the *movement of colours*.

In France colour-dynamics had been the particular concern of Charles Henry, who in his *Cercle Chromatique* (1889) had presented red as moving vertically upwards, blue as moving horizontally from right to left, and yellow as moving from left to right. Delaunay also shared the preoccupation with colour-movement with Kandinsky, whose *On the Spiritual in Art* he had just received from the artist, but could not read. But that the movement could be achieved through the means of transparency was very much Delaunay's own conception, and like colour-movement itself, had very little to do with Chevreul. Chevreul had, however, introduced a discussion of stained-glass windows, and especially rose-windows, as a brilliant example of simultaneous contrast, and he attributed their beauty

> 1 To their presenting a very simple design, the different, well-defined parts of which may be seen without confusion at a great distance.

Jean Metzinger like Delaunay turned the pointillist 'dot' into a mosaic of close-packed 'cubes'. This more abstract method, as he explained in 1907, was not intended for 'the objective rendering of light', but to capture 'iridescences and certain aspects of colour still foreign to painting'. The handling of the sun of *Landscape* (*Coucher de Soleil*) of 1906/7 is close to Delaunay's in *Landscape with Disc*. (**131**)

2 To their offering a union of coloured parts distributed with a kind of symmetry, which are at the same time vividly contrasted, not only among themselves, but also with the opaque parts which circumscribe them. (§ 435)

Both these features were to be applied by Delaunay in his *Windows*, which make substantial use of contrast and symmetry. Delaunay's interest in transparency was also stimulated by his study of stained glass at Laon, where he worked in 1907 and again early in 1912, and in the Paris church of Saint-Severin, the subject of a series of paintings in 1909 and 1910. Perhaps, too, it was the experience of these windows which led him to the *Windows* series of 1909-12, where the technical problems of conveying transparency were addressed for the first time.[4] In the earliest of the series, *The City II* (1910-11, New York, Guggenheim Museum), the upper part of the window has been treated in a pointillist technique while the lower parts are largely handled in flat tones, so as to convey the varying qualities of reflected (iridescent) and transmitted light. Later, as in *Window on the City No. 3* (1911-12, Guggenheim), the whole surface has been treated in the chequerboard manner, and there is little doubt that Delaunay was concerned to render an all-over transparency by means of the phenomenon of *lustre*. This effect had been well described by the theorist most used by the Neo-Impressionists, Ogden Rood, in *Modern Chromatics*:

> If the coloured lines or dots are quite distant from the eye, the mixture is of course perfect…but before this distance is reached there is a stage in which the colours are blended, though somewhat imperfectly so that the surface seems to flicker or glimmer – an effect that no doubt arises from a faint perception from time to time of its constituents. This communicates a soft and peculiar brilliancy to the surface, and gives it a certain appearance of transparency: we seem to see into it and below it.

And Rood continues:

> With bright complementary colours the maximum degree of lustre is obtained: when the colours are near each other in the chromatic circle, or dull or pale, the effect is not marked, but exists to the extent of making the surface appear somewhat transparent.

101

The palette of the first of the pictures of the *Windows* series is indeed dull or pale, and it was not until *Simultaneous Windows* early in 1912 that Delaunay began to work out his composition in strong simultaneous complementary or near-complementary contrasts of orange and green, yellow and purple, and to abandon the use of a dotted technique (which survives only in a few residual touches on the painted frame) in favour of angular planes of colour, derived from a study of Picasso's Cubist work of 1910-11, and more interestingly, from the late works of Cézanne. Now the colour-patches are bounded, sometimes by hard edges, sometimes by soft gradations made by glazing or scumbling the colours over one another: transparency is achieved by the most direct of painterly means.

Delaunay continued to work on the *Windows* series throughout 1912, but in his statements of intention made later that year the emphasis on transparency has gone. The *Essay on Light*, which was composed during the summer of 1912, attributed the movement of colours less to transparency than to the qualities of hue:

> Movement is given by the relationship of *unequal measures*, of contrasts of colours among themselves which constitute *Reality*. This reality has *depth* (we see as far as the stars), and thus becomes *rhythmic Simultaneity*.

That summer Delaunay was staying outside Paris, and according to his wife Sonia he was much occupied with the clouds and the heavenly bodies by day and night: the material of his new repertory of *Disc* subjects in 1913 (for example *Sun, Moon, Simultané I*: see *Colour and Culture*, pl. 208).[5] The use of the term *simultaneity* suggests a renewed interest in Chevreul, and by August 1912 Delaunay was no longer speaking in terms of depth: he was now focusing solely on the complementary contrast of colours as pictorial means. Of Seurat he wrote:

> *His creation remains the contrast of complementary colours* (optical mixture by means of dots…since it is nothing but a technique, does not have the same importance as contrast. THE MEANS OF CONSTRUCTION FOR PURE EXPRESSION).

The aspect of Chevreul's work which now absorbed Delaunay was painting in flat tints, whose characteristics, according to Chevreul, 'necessarily consist in the per-

fection of the outlines and colours. These outlines contribute to render the impression of colours stronger and more agreeable...' (§303). For Chevreul in 1839 such painting had only a decorative, accessory function, but the Delaunays did not feel the distinction, and Sonia had recently been experimenting with flat colours in appliqué textiles and in bookbindings decorated with collage.[6] This new experience culminated in Robert's *Disc* of 1914, an experiment designed to test the psycho-physiological effects of certain colour-combinations, and painted in bands of flat colour with hard contours. As Delaunay wrote to Mlle de Bonin, the near-complementaries of blue and red at the centre of the circle produced a slow-moving contrast, and the dissonances towards the edges moved rather faster.[7]

The summer sky gave Delaunay the experience necessary to create a number of pictures of 1912-13: the *Circular Forms*, with references to sun and moon, several of which, like the *Sun No. 1*, are painted in largely flat tints, and have very pronounced and regular contours. It was perhaps this picture to which Delaunay referred in a letter of 2 June 1913 to August Macke:

> My last picture is the 'Sun': it shines more and more strongly the more I work on it: it is from this movement that from now on all my new Synchromies will be born. The 'Windows' saw the opening of them.

The place of Delaunay's *Disc* of 1914 in his experimental approach to painting cannot be overestimated. The *Circular Forms*, like Kupka's *Discs of Newton* of 1912, 47 are still subject-pictures, and it is arguable that Delaunay, unlike his German admirers Klee and Marc, had no conception of a non-objective art before the First World War: but the *Disc* and its antecedents show clearly that Delaunay conceived of the role of the painter in relation to his expressive means as akin to the role of the experimental psychologist.

Mondrian's primary order, Ostwald's theory of harmony

The colour-interests of painters before the First World War had been nourished by rather traditional sources of theory: the texts to which they referred had for the most part been published in the 1870s, and some of the most important go back to the early years of the nineteenth century. But during the war a new body of colour-theory was published in Germany which came to dominate the field of colour-studies for the next decade. It was the work of the veteran chemist Wilhelm Ostwald, who had occupied himself in his retirement with problems of colour-measurement. Ostwald felt that there could be no certainty in colour-studies until colour was quantified, from the psychological as well as from the physical point of view. He drew particularly on the work of G. T. Fechner (*Elemente der Psychophysik*, 1860), who had shown that stimuli relate to sensations, not in a direct but in a proportional way: a simple arithmetical progression in sensations must be based on a geometrical progression in the stimuli.

Ostwald applied these findings to colour first of all by establishing a scale of greys between white and black, in which each perceptual step was made by increasing the

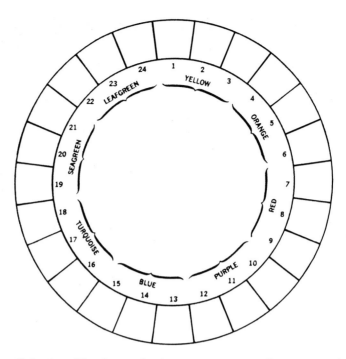

The chemist Wilhelm Ostwald's colour-circle of 1916, giving an unusually prominent place to green. (**132**)

proportion of black to white geometrically (i.e. by squaring the quantity of black). This grey-scale he then applied to scales of each of the hues on his colour-circle, which at first had one hundred hue-divisions, but was then simplified to twenty-four. These twenty-four hues were based on the system of four psychological primaries, red, yellow, blue and green, which Ostwald derived from Ewald Hering (*Lehre vom Lichtsinne*, 1878) who had divided colour-sensations into 'complementary' pairs: black and white, blue and yellow, green and red. Although green had traditionally been regarded as a mixed colour, Hering had claimed that perceptually it was autonomous, and it can be seen to play a large part in Ostwald's circle, which includes nine greens. Ostwald was well aware of the novelty of this arrangement, and explained that 'the beginner' would probably have difficulty in distinguishing so many: 'this is due to the fact that this area of the colour-circle is very little known to us, since the colours hardly occur in nature'.

During the preparation of a colour-atlas to demonstrate the colour-solid based on these principles, Ostwald had noticed that individual sections of the solid, which showed complementary hues with equal degrees of value on the grey scale, were particularly pleasing, and he concluded that the principles of colour-harmony depended on the balance of values (the black and white content of each hue), and, among the hues round the colour circle, on the juxtaposition of those which are found at intervals of 3, 4, 6, 8 or 12. Harmony, he said, is order, and it was this order in colour which he felt he had finally established.

Ostwald's theory was first published in 1916 in a short book, *Die Farbenfibel* (*The Color Primer*), and was immediately taken up by the Dutch movement De Stijl,

132

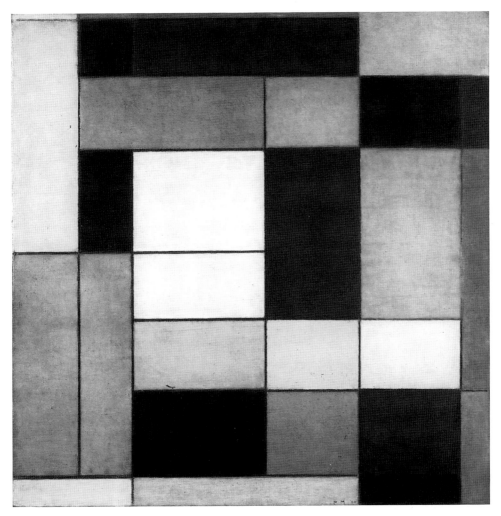

In the *Composition with Grey, Red, Yellow and Blue* of 1920 the De Stijl artist Piet Mondrian uses the red that he regarded as an 'outward' colour together with the more 'inward' blue and yellow – but combined with greys, to which he gives the unusual role of 'primary non-colours' – suggesting the continuing influence of Ostwald, for whom grey was the chief controller of harmony. (**133**)

founded in 1917 by Theo van Doesburg, Piet Mondrian, Bart van der Leck and Vilmos Huszár, who published an article on Ostwald's system in the first volume of the group's magazine.[8] Huszár stressed that Ostwald, who as a chemist had given particular attention to the properties of available pigments, was far more useful to artists than earlier theorists, and that his system was the first to be based on geometry, a feature which would especially appeal to the De Stijl group members who were establishing a geometrical aesthetic. He was, however, quick to warn of the subjectivity of colour-sensations, and to insist that Ostwald's circle of hues had no compelling aesthetic validity – and it is true that Ostwald's four primaries had a limited interest for the group apart from Mondrian and van Doesburg, who continued to make use of green.[9] Far more important to De Stijl was the concept of

harmonizing colours by balancing their white and black content: and the first painter to show a close interest in this aspect of Ostwald's ideas was Mondrian.

Mondrian had been painting in a brilliant, Fauve-like palette since about 1908, and about the same time a brief involvement with Neo-Impressionism had led him to formulate a simple doctrine of pure colours laid side by side 'in a pointillist or diffuse manner'. But the impact of Cubism from 1911 to 1912 directed his attention away from questions of colour, and it is only in the 1914 sketchbook that we find hints that he had come across Kandinsky's *On the Spiritual in Art*, and had been pondering the complementary relationship of red and green as female and male, external and internal colours.[10] Mondrian's characterization of red and green as respectively external and internal might simply refer to their role in the modelling of flesh, but the context suggests that they were far more than this, and, although they are not Kandinsky's values for these colours (p. 242), they are very close to those of the Theosophists, to whom Mondrian had been attached since 1909. In Besant and Leadbeater's *Thought-Forms* (1901) red, Mondrian's female, material colour, is characteristic of pride, avarice, anger and sensuality, and green, his male, spiritual value, of sympathy and adaptability.[11] By 1917, perhaps following the lead of Huszár,[12] Mondrian had adopted a basic palette of white, black and grey, plus three primaries, red, yellow and blue. He still regarded red as essentially an 'outward' colour, and, following Goethe, Kandinsky and the Dutch Theosophist H. Schoenmaekers, he claimed that yellow and blue were more 'inward', but that, for the moment, the three primaries together could not be dispensed with in painting.[13]

Mondrian's earlier interest in green as a male and internal colour may have been reinforced about 1920 by his knowledge of Ostwald's emphasis on unnatural greens, for in a number of Neo-Plastic paintings of that year he experimented with a distinctly greenish yellow or yellow green. Yet, unlike van Doesburg or Vantongerloo among De Stijl artists, he never used green as a fourth Ostwaldian primary.[14] On the other hand, he was certainly very much affected by Ostwald's views on grey.

In a footnote to an article dealing with colour in the journal *De Stijl*, Mondrian wrote that black and white might be mixed with yellow, red and blue and yet these would still remain primary colours.[15] In his painting of the period he used planes of very desaturated primaries which may be clearly related to Ostwald's view that colour-harmony was to be achieved chiefly by regulating *value*. The earliest composition to make use of this principle seems to be *Composition – 1916* in the Guggenheim Museum in New York, but the idea was explored far more systematically in 1917 and 1918, for example in *Composition with Colour-Planes No. 3*, *Composition: Colour-Planes with Grey Contours* and *Composition with Grey, Red, Yellow and Blue* of 1920; and well into the 1920s Mondrian was mixing a good deal of grey into his primary colours.[16]

During that decade he moved away from this interest in desaturation and in grey, but the colouristic element in his Neo-Plasticism, his first thoroughly non-representational style, during and immediately after the war, had been given a powerful impetus by Ostwald's promise that it was possible to quantify the psychological response to colour, and thus to make it into a mathematical study.

133

21 · Making Sense of Colour – The Synaesthetic Dimension

Perception and deception

VISITORS TO ST PETER'S in Rome have often marvelled at the full-size mosaic reproductions of Renaissance and Baroque altarpieces in many of the chapels there. These copies of oil paintings were made, largely in the seventeenth and eighteenth centuries, in the Vatican workshops set up by Pope Gregory XIII in the late sixteenth century to reproduce specially designed cartoons. In the 1620s the mosaic craftsmen began to reproduce oil paintings, and in due course copied in this more or less permanent form the works of several old masters such as Raphael.[1] These deceptive productions were not only impressive to worshippers or tourists, they had much to interest the colour-scientist and psychologist as well. When the Scottish optical physicist J. F. Forbes visited Rome in the 1840s he remarked that:

> the immense collection of artificial enamels employed in the Vatican fabric of mosaic pictures seems to offer an unrivalled opportunity of forming…a classification [of colours]….The material is a soft and fusible enamel, and the formation of 18,000 tints was effected by an ingenious artist named Matteoli…The rough cakes of enamel are preserved in separate cupboards or pigeon-holes, surrounding a hall of great length appropriated to this purpose by Pope Pius VI. But the main intention of the work being completed within St Peter's, it has not been thought worthwhile to preserve the integrity of the collection…and it is certain that though still reputed to contain 18,000 modified colours, the effective number is vastly smaller.

Forbes was able to secure a sample of 941 pieces with 'a great preponderance of indefinite colours', but particularly, whole packets were composed of 'specimens scarcely sensibly differing from each other'. This, he thought, was only natural in sets designed to imitate oil paintings; and he also noted, 'many of the suites of indefinite colours are exquisitely beautiful'. The accompanying list of Italian colour-names for these samples gave 142 under blue-grey-greens (*veroli*), 100 under greys, 100 under flesh-pinks (*carnagioni*), 91 under blues (*turchini*), 60 under yellows, and so on.[2]

Twenty years later the English psychologist Francis Galton found that, so far from decreasing, the range of the coloured cubes used in the Vatican *fabbrica* had increased to 25,000, and that they were kept in numbered trays or bins, so that the mosaic workers could simply call for them by number; and on a return visit to the Vatican, twenty years after this, he discovered that the number of bins had

increased to 40,000, although only 10,752 (!) were classified. Like Forbes, Galton hoped to acquire a set of standard cubes to be supplied to art schools by the South Kensington Museum, but the Vatican asked too high a price.[3]

The Vatican practice of numbering nuances of hue has been adopted by most modern colour-systems, although the range of nuances has been substantially reduced: the American Munsell system, which is very generally used as a standard for surface colours, comprises somewhat over fifteen hundred plastic chips. And although a modern dictionary of European colour-names lists about five thousand, many of these are short-lived fashion names, and only around a dozen are in common use.[4] There is thus a marked discrepancy between the large number – some psychologists say millions – of perceivable colours and the handful of names we use to identify them. Language labels only those few segments of the continuous colour-space which are important to us, and thus the study of colour as we understand it becomes very much the study of colour-language.

This radical imbalance between sensation and language means that the experience of colour will be very largely associational. Colour has always lent itself very readily to association and symbolizing, whether on the general level of identifying the sensuous, unstable, indeterminate characteristics of colour as such with the female, as opposed to the determinate, stable, male element of line or form;[5] or grouping individual colours into categories such as 'warm' and 'cool';[6] or characterizing colours as, for example, 'cheerful' or 'sad'.[7] But the course of the nineteenth-century developments in the physiology of the nervous system, in experimental aesthetics, as well as in the understanding of painting as less and less related to direct representation, increased the tendency to detach colour-expression from association, and to see colour as evoking immediate physical and mental responses.

The unity of the senses

One of the most interesting and still one of the most problematic of the links between colour-concepts and colour-perceptions is synaesthesia, the involuntary psychological mechanism by which two sensations are simultaneously triggered by the same stimulus. Synaesthesia conflicts with the classical doctrine, first articulated by Aristotle (*De Anima*, II, 6, 418a; III, 1, 425a-b), that each of the five senses has its own discrete area of operation;[8] and it may have been investigated more widely in the late nineteenth century because it also conflicted with Johannes Müller's modern, and still widely influential, version of this idea in the principle of the 'specific nerve energies'. Müller's agument that sensation was dependent upon the internal character of the five senses, rather than on the nature of the external stimulus, so that the same stimulus acting on different nerves gave rise to different sensations, and vice-versa, had been anticipated in the late eighteenth century by the English doctor John Elliot, whose work on the senses had been translated into German in 1785 and was known to Müller. But it was the comprehensive handbook of physiology (1838) by Müller, the teacher of Helmholtz, which brought the question into the centre of psycho-physiological debate, and so came to have a

long-standing effect on the general understanding of the subjective representation of the world.[9]

During Müller's lifetime several cases of synaesthesia were reported in the medical, as well as in imaginative literature, and began to attract the attention of psychologists, especially in Germany, Switzerland and England. G. T. Fechner studied a number of cases of colour-synaesthesia in his *Primer of Aesthetics* of 1876-7,[10] and by 1890 the number of reported cases had become so numerous that the Congrès Internationale de Psychologie Physiologique set up a committee to make systematic investigations.

The most familiar branch of synaesthesia is colour-hearing (*audition colorée*), and the best-known type of colour-hearing is musical.[11] It is easy to see how attractive it has seemed to find points in the continuum of spectral colour analogous to discrete pitches in the continuum of sound whose relationships have been regarded as harmonious in the Western tradition; and Newton gave great authority to this sort of enquiry.[12] I do not propose here to look again at this much-studied area of synaesthetic experience, but rather to consider another very common type: the involuntary association of verbal sounds, especially vowel-sounds, with colours. This was a frequently-reported synaesthetic phenomenon in the late nineteenth century, and it still accounts for a good deal of psychological research.[13] But it was given a particular impetus, not in psychology but in literature, by Rimbaud's sonnet, *Voyelles* (Vowels), of 1871, with the opening line:

A noir, E blanc, I rouge, U vert, O bleu, voyelles...

which must remain untranslated, because it was the sounds and not the visible letters that were generally thought to evoke the synaesthetic effect. Although the poet soon disclaimed any involuntariness for the colour-vowel correspondences in his poem, which he had invented, he said, specifically to open it up to all the senses (and it does indeed introduce analogies of touch and smell as well as of colour), the work was very quickly adopted by the scientists.[14] But it was almost certainly Rimbaud's poetic reputation and the growing Symbolist movement which made the phenomenon of particular interest to artists and writers. As the distinguished French psychologist Alfred Binet wrote in 1892, *audition colorée* had become a vogue in science, literature, poetry, and the theatre:

While medical doctors have preferred to see in *audition colorée* nothing but a disturbance in sensory perception, literary people believe that they have found in it a new form of art.[15]

Perhaps one of the very few visualizations of coloured words from this period is by the American architect and designer E. J. Lind, who put together his ideas on this subject in the 1880s, although he traces them back to 1850 when he was a student at the School of Design in Somerset House in London. There, one or other of the then very common analogies between music and colour may have been on the agenda:[16] two of the extensive treatments of colour, those by George Field and David Hay, recommended in the 1853 *Manual of Colour* by the Art Superintendent of the School of Design from 1852, Richard Redgrave, included highly specific

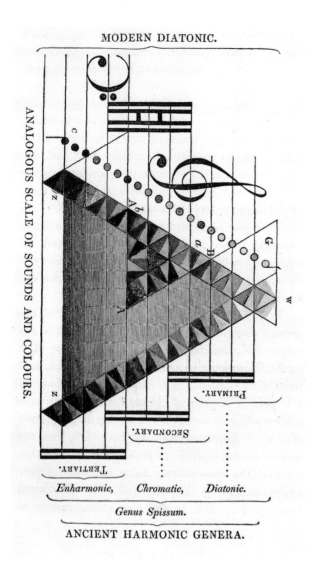

MODERN DIATONIC.

ANALOGOUS SCALE OF SOUNDS AND COLOURS.

PRIMARY.

SECONDARY.

TERTIARY.

Enharmonic, Chromatic, Diatonic.

Genus Spissum.

ANCIENT HARMONIC GENERA.

AEIOU
red, blue, green,
yellow, purple, brown,
golden, silver, black,
white, violet, orange.

Left: George Field's 'Colours and Sounds' from *Chromatics*, 1845, one of many diagrams of the Romantic period to link the scale of colour and the diatonic musical scale. (**134**)

Above: Francis Galton's coloured vowels, from *Inquiries into Human Faculty*, 1883. Here, for example, A is yellow, E is green, O is red. Galton was perhaps the first psychologist to illustrate the phenomenon of colour-hearing. (**135**)

treatments of the analogy with music. Field's *Chromatography* (1835) argued that the painter should follow the musician in matters of harmony, identifying blue specifically with C; and Hay's *Laws of Harmonious Colouring* (4th ed., 1838) include a scale linking music and colour in the most direct way.[17]

102 But Lind's interest in the colour of words probably developed out of the growing literature of the 1880s, and perhaps from the discussion in Francis Galton's important

135 book, *Inquiries into Human Faculty and its Development*, which was first published in 1883 and included a diagram of a coloured alphabet. Galton discussed colour-hearing in the context of many varieties of visionary experience and colour-association, and he summarized its characteristics as follows:

> the vowel sounds chiefly evoke [colour-associations]...the seers are invariably most minute in their description of the precise tint and hue of the colour. They are never satisfied, for instance, with saying 'blue', but will take a great

deal of trouble to express or to match the particular blue they mean…no two people agree, or hardly ever do so, as to the colour they associate with the same sound.

Lastly, and perhaps most importantly, Galton found that the tendency to colour-hearing was hereditary.[18] Thus his emphasis was both on the involuntary character and on the extraordinary concreteness of the phenomenon.

Colour and physiology

In the course of his discussion of colour-hearing Lind mentioned a recent discovery, that:

> when the colored light of the solar spectrum is cast on colored worsteds placed in a vessel convenient to receive the rays, sounds will be emitted, louder or fainter according to the colors of the rays directed upon them, the green ray upon the red worsted or the red ray upon the green worsted, giving out the most powerful sounds, thus demonstrating that colored sounds are not so speculative after all.[19]

This disturbing positivism is characteristic of the period: it was also the *physiological* psychologists who decided to investigate colour-hearing in 1890; and the period saw the development of techniques to investigate the general effects of colour on the human organism. This was the era of chromotherapy, and in a letter of 1880 Galton observed:

> there is no doubt that blue has a calming effect and red an irritating one, for the Italian mad-doctors find an advantage in putting their irritable patients in a room lighted with blue light, and their apathetic ones under red light.[20]

One of these 'mad-doctors' might well have been the psychologist later famous for his positivist criminology, Cesare Lombroso, who was said on one occasion to have treated an 'hysterical' patient who had lost her sight, but was able to read with the tip of her ear:

> As a test, the rays of the sun were focused upon her ear through a lense, and they dazzled her as if turned upon normal eyes, causing a sensation of being blinded by unbearable light. Still more puzzling to Prof. Lombroso was the fact that her sense of taste was transferred to her knees and that of smell to her toes.[21]

Interest in the variable effects of different coloured lights on plants, animals and human beings had been growing throughout the nineteenth century,[22] and had attracted the attention of, for instance, Galton's cousin, Charles Darwin. As Binet suggested in 1892, these early experiments in synaesthesia were posited on the belief in some anomaly in the nervous system which might be understood and treated in purely physiological terms. About the time of the First World War a good deal of work was being done to give a specifically therapeutic function to the decoration of hospital wards, although in Britain at least, the medical establishment

136

103

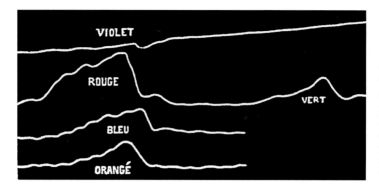

Charles Féré's graph of the greater and lesser effects of colours on muscular activity, 1887. His was one of the first attempts to tabulate the physiological action of colour on the human organism. (**136**)

remained sceptical, and this scepticism has accounted, perhaps, for the very limited modern research into the physiological effects of exposure to colours.[23]

Most recent work on colour-word synaesthesia has been conducted by neurologists, who are largely concerned to understand the *mechanisms* of transference from one mode of brain activity to another, and they have emphasized the absolute normality of the experience.[24]

During the high period of colour-hearing, however, this faculty was seen as a symptom of abnormality, of heightened sensibility, and the belief that colour could exert an immediate, non-associative effect on the human organism became crucial to avant-garde artists such as Kandinsky who were concerned to develop a non-representational art in the early years of this century.

In his 1912 book, *On the Spiritual in Art*, Kandinsky concluded a review of some of these synaesthetic experiments with the thought that their effects

> would seem to be a sort of echo or resonance, as in the case of musical instruments, which without themselves being touched, vibrate in sympathy with another instrument being played. Such highly sensitive people are like good, much played violins, which vibrate in all their parts and fibres at every touch of the bow.[25]

Here Kandinsky, who as we have seen was not only a string-player but also seems to have possessed a synaesthetic gift himself, was writing in a remarkably positivist vein; but we must remember that neither in his writings nor in his paintings of these years did he abandon associations. Nor did he engage with the specific topic of colour-vowel synaesthesia until he was teaching at the Bauhaus in the 1920s, and possibly then only as a result of his teaching experiences in Moscow just after the war.[26]

Synaesthesia and aesthetics

I am of course unable to enter into the neurological arguments in any detail, but it seems likely that one of the most serious obstacles to a neuro-physiological interpretation of colour-hearing has been the almost complete lack of unanimity about the colours attached to particular vowels. As Galton wrote in 1883:

129

Persons who have colour associations are unsparingly critical. To ordinary individuals one of these accounts seems just as wild and lunatic as another, but when the account of one seer is submitted to another seer, who is sure to see the colours in a different way, the latter is scandalised and almost angry at the heresy of the former.[27]

The Theosophist Cyril Scott, who re-told in his *Philosophy of Modernism* the experiences of Professor Lombroso, cited above, was nonplussed at these disagreements, and argued that

we must only expect anything like accuracy from persons who have gone through the necessary occult training.

Galton's subjects had clearly not experienced 'with the pineal gland [the organ of psychic perception]', thought Scott, 'but merely by a process of imaginative association'.[28] It is true that several of the best-known synaesthetes, the Russian composer Scriabin, the Russian Symbolist poet Andrei Belyi and the Russian painter Kandinsky, were sympathetic to Theosophy or clairvoyance; but even direct contact with spiritual correspondences did not guarantee uniformity of experience. Annie Besant, co-author of that most influential Theosophical handbook of colour, *Thought-Forms*, first published in 1901, explained her methods in an early article:

Two clairvoyant Theosophists observed the forms caused by definite thoughts thrown out by one of them, and also watched the forms projected by other persons under the influence of various emotions. They described these as fully and accurately as they could to an artist who sat with them, and he made sketches and mixed colours, till some approximation to the objects was made. Unfortunately the clairvoyants could not draw and the artist could not see, so the arrangement was a little like that of the blind and lame men – the blind men having good legs carried the lame ones, and the lame men having good eyes guided the blind. The artist at his leisure painted the forms, and then another committee was held and sat upon the paintings, and in the light of the criticisms then made our long-suffering brother painted an almost entirely new set – the most successful attempt that has hitherto been made to present these elusive shapes in the dull pigments of earth.[29]

So, although a recently reported case study of nine female students has found a very high degree of consistency in the attribution of white to O, white or pale grey to I and yellow or light brown to U,[30] and a remarkable study carried out half a century ago by the structural linguist Roman Jakobson found that in several cases, Czech, German, Serbian and Russian speakers found E was always either yellow or bright green,[31] regularities have in fact been very hard to identify; and it has come to be argued in some quarters that the discrepancies may be reconciled by assuming that the synaesthetic process lies in a pre-perceptual stage of neural activity.[32] But if, at the level of perception, synaesthetic correspondences are no more universal than the symbolic attributes of colour have proved to be, this must have serious

consequences for the place of synaesthesia in the experimental aesthetics which Fechner had sought to introduce. As an early twentieth-century commentator on a French *Gesamtkunstwerk* based on *The Song of Solomon* put it: 'to the man who has no such turn of his thought, the whole experiment must seem futile to a high degree'.[33]

Perhaps it is not surprising that the non-associative interpretation of colours with verbal sounds should have reached its apogee in a period when linguistics itself, in the tradition of the Symbolist René Ghil, was increasingly concerned with the structural, non-representational elements of language. The Moscow Linguistic Circle, of which Jacobson was a member, was much concerned with phonetics, and also took *audition colorée* on board.[34] Jakobson, indeed, was still investigating the phenomenon well after the Second World War. It had long been felt that the Russian language lent itself especially to *audition colorée*,[35] and one of the most remarkable instances of this was that of a young woman, E. Werth, studied by Jacobson in the United States in the 1940s, two of whose half-dozen languages were Serbian and Russian. Werth had spoken Serbian and Hungarian since infancy, and to these added French, German, English and Russian, in that order. She was able to make clear distinctions between the colour-characteristics of each of her languages:

> As time went on words became simply sounds differently colored, and the more outstanding one color was the better it remained in my memory. That is why, on the other hand, I have great difficulty with short English words like *just, jot, jug, lie, lag*, etc. Their colors simply run together and are obscured by the longer words that stand near them.
>
> I like to play with words. I like to listen to new sound-combinations and to arrange them in color-patterns. For example, Russian has a lot of long, black and brown words, like Serbian words; in both these languages the combinations of *ya* or *yu* are little sparkling stars. The German scientific expressions are accompanied by a strange, dull yellowish glimmer, the word *English* and many English words are steel blue to my mind. Hungarian with its frequent *cs, zs, cz, sz* twinkles in violet and dark green, while French, the language I love most, is richest in colors, colors that at the same time carry a tone; hence a vivid mental picture when I listen to French.[36]

Werth's gender may have been of some significance. As in other areas of sensibility to colour, colour-synaesthetes have in modern studies been predominantly female, and a questionnaire launched in England in 1992 elicited 210 responses from women claiming to be colour-sound synaesthetes, but only two from men.[37] If this gender bias turns out to be an intrinsic characteristic of the phenomenon it must further compromise the aspiration to integrate synaesthesia into a modernist-inspired universal language of the sort proposed by Khlebnikov in 1919 (p. 247).

The history of synaesthesia suggests that the very senses themselves, which have generally been thought of as bodily functions, are not exempt from, or are by and large the products of cultural conditioning.

Acknowledgments
Notes to the Text
Select Bibliography
List of Illustrations
Index

Acknowledgments

Many of the chapters have their origin in articles and conference papers written and published over the last thirty years, while others are previously unpublished or are written specifically for this book.

Chapter 1 stems from an article of 1984 in *Interdisciplinary Science Reviews*, IX; Chapter 2 from part of the 1993 Darwin Lecture Series on *Colour* at Cambridge University, first published in T. Lamb and J. Bourriau (eds) 1995, *Colour: Art and Science*. Chapter 3 is a revised version of 'Colour in Western Art: An Issue?' *Art Bulletin*, LXXII, 1990.

Chapter 4 arose from a research seminar at the University of East Anglia and lectures given in 1977 at the University of East Anglia, the Colour Group Symposium, and in 1978 at the Centre for Byzantine Studies at the University of Birmingham. It was published in 1978 in *Art History*, I. My colleagues at the University of East Anglia gave generous leave of absence to pursue these enquiries, and I am particularly indebted for help and advice to David Chadd, Robin Cormack, Richard Gordon, Paul Hetherington, John Mitchell and Paolo Vivante. Chapter 5 is an expanded version of a paper given in 1995 at a Manuscript Workshop: *Colour and Pigments in Manuscript Illumination*, arranged by the Parker Library at Corpus Christi College, Cambridge. Another version was published in 1998 in *Leids Kunsthistorisch Jaarboek* XI. Chapter 6, on the background to Ghiberti's *Third Commentary*, was first published in 1972 in *Apollo*, XCV. I am grateful for the generous advice of the late Andrew Martindale during its preparation.

Chapter 7 is a modified version of a paper given in 1994 at the conference *El Color en el Arte Mexicano* arranged by the Universidad Nacional Autónoma de Mexico, published in a Spanish version with the other papers. I am particularly grateful to Georges Roque for giving me the occasion to investigate the subject of this paper, and to Danièle Dehouve for her advice on Nahuatl colour-terms.

Chapter 8 derives from a paper on 'Rainbow and Prism' given in Edinburgh in 1994 at the Interalia Conference *Visions of Light*, and another, 'The *De Coloribus* of V. Scarmilionius', presented to the 1995 Symposium of the Leonardo da Vinci Society and the Society for Renaissance Studies: Art and Science in the Italian Renaissance: Light. I am grateful to Richard Bright and Martin Kemp for their invitations to contribute to these events. Chapter 9 originates in a paper given in at a conference arranged by the School of Epistemics at Edinburgh University in 1981, first published in M. Pollock (ed.) 1983, *Common Denominators in Art and Science*; Chapter 10 appeared in 1971 in the *Journal of the Warburg and Courtauld Institutes*, XXXI; Chapter 11 is an expanded version of a study in *Apollo*, LXXX, 1964; 12 appeared in the exhibition catalogue *Turner en France*, Paris, 1981, Centre Cultural du Marais.

Chapter 13 is a revised version of a paper presented at the symposium *Runge Fragen und Antworten* arranged by the Hamburg Kunsthalle in 1977, and published with the other papers in 1979 under the editorship of Hanna Hohl; Chapter 14 appeared in the catalogue of the exhibition *The Romantic Spirit in German Art, 1790-1990*, Edinburgh, London, Munich, 1994-5. Chapter 15 is an expanded version of a paper given at the *Journée Chevreul* arranged by the Musée National d'Histoire Naturelle in Paris in 1989, published in French in F. Viénot and G. Roque (eds), *Michel-Eugène Chevreul: un Savant, Des Couleurs!*, 1997. Chapter 16 was first published in 1987 in *Art Bulletin*, LXIX and is reprinted here with revisions to the notes. I am especially grateful to Bob Herbert for having read my original typescript and making several suggestions about the argument. Chapter 17 is an expansion of a paper given in 1991 at the Seurat Symposium at the Metropolitan Museum of Art in New York. I am particularly grateful to Bob Herbert for inviting me to contribute. Chapter 18 is written specifically for the present book

Chapter 19 is a revised version of paper given at the 1985 Royal Institute of Philosophy conference at Bristol, published in A. Harrison (ed.), *Philosophy and the Visual Arts: Seeing and Abstracting*, 1987. Chapter 20 originated as an essay first published in M. Compton (ed.), *Towards a New Art: Essays on the Background to Abstract Art, 1910-20*, Tate Gallery 1980. Chapter 21 was first presented in 1994 as a paper at the conference *Son et Lumière* held at Sussex University. I am indebted to Nigel Llewellyn for inviting me to contribute.

For permission to reproduce material am indebted to the editors of *Art Bulletin*; *Apollo*; *Interdisciplinary Science Reviews*; *Art History*; the *Journal of the Warburg and Courtauld Institutes*; the former Centre Culturel du Marais, the University Presses of Cambridge and Aberdeen, to Prestel Verlag, D. Riedel Publishing Company and the Tate Gallery.

My great indebtedness to individuals is expressed above and in the Notes to the Text below, but my greatest thanks go, as always, to my family for their patience and support.

J. G.

Notes to the Text

Introduction

1 P. Brunette and D. Wills (eds) 1994. *Deconstruction and the Visual Arts, Art Media, Architecture.*

2 Brunette and Wills (op. cit.) 19: 'The spatial arts: an interview with Jacques Derrida'.

3 J. Derrida 1987, 'R' in *The Truth in Painting*, trans. G. Bennington and I. McLeod, 169.

4 V. Adami 1976, 'Les règles du montage', trans. G. Joppolo in *Derrière le Miroir* 220, Oct., 23, cit. J. P. Leavey Jr, 'Sketch: counterpoints of the eye' in Brunette and Wills (eds) op. cit. 193.

5 S. Melville, 'Color has not yet been named: objectivity in deconstruction' in Brunette and Wills (eds), op. cit. 45.

6 I. Kant (1790), *Critique of Judgement*, trans. J. C. Meredith 1952, 14, cit. Derrida, op. cit. 77. Euler's discussion is in *Nova Theoria Lucis et Colorum*,1746, for which see R. W. Home 1988, 'Leonhard Euler's "Anti-Newtonian" theory of light', *Annals of Science* 45, 521-33. It is striking that Kant (§42) adopts a 7-colour Newtonian spectrum for his neo-baroque scheme of colour-meanings in which, for example, red connotes sublimity and violet tenderness. For Kant's lack of interest in the visual, J. Ward 1922, *A Study of Kant*, 237.

7 L. Wittgenstein (1950), *Remarks on Colour* 1978, 20, 27, 34.

8 See espec. A. Morton, 'Colour appearances and the colour solid' in A. Harrison (ed.) 1987, *Philosophy and the Visual Arts: Seeing and Abstracting*, 35-52; C. L. Hardin, *Color for Philosophers*, 2nd ed. 1988; J. Westphal, *Colour: a Philosophical Introduction*, 2nd ed. 1991. B. Maund 1995, *Colours: their Nature and Representation*, offers a useful survey of recent studies, while at the same time attempting to address more traditional philosophical issues.

1 The Contexts of Colour

1 R. W. Burnham, R. M. Haines and C. J. Bartleson 1963, *Color: A Guide to Basic Facts and Concepts*, 11.

2 D. B. Judd and G. Wyszecki, *Color in Business, Science and Industry*, 3rd ed. 1975.

3 The exceptions are popular coffee-table treatments such as H. Varley (ed.) 1980, *Colour*, and H. Kramer and O. Matschoss (eds) 1963, *Farben in Kultur und Leben*; collections of rather heterogeneous essays, such as I. Meyerson (ed.) 1957, *Problèmes de la Couleur*; *Studium Generale*, XIII, 1960, T. B. Hess and J. Ashbery (eds) 1969, *Light: From Aten to Laser* (Art News Annual, XXXV), *Eranos Yearbook* 41, 1972, M. Hering Mitgau, B. Sigel, J. Ganz and A. Morel (eds) 1980, *Von Farbe und Farben: Albert Knoepfl zum 70. Geburtstag*, Zurich; and M. Minnaert's excellent handbook for the ordinary observer of the outdoor scene, *Light and Colour in the Open Air*, 3rd ed. 1959.

4 Here, too, the few historical treatments of colour have tended to reflect the physical or psycho-physical biases of their authors. K. T. A. Halbertsma's brief study, *A History of the Theory of Colour*, 1949, is the fullest treatment to date, but its 19th- and 20th-century sections are almost exclusively concerned with physical and ophthalmic questions, and its earlier chapters depend almost entirely on material gathered by Goethe and first published in 1810; J. W. von Goethe, *Zur Farbenlehre: Historischer Teil,* in Goethe, *Die Schriften zur Naturwissenschaft*, ed. Matthaei, Troll, Wolf 1957, Weimar, I, vi (text); 1959, II, vi (*Ergänzungen und Erläuterungen*). The earlier history of the theory of colour was later amplified in a rather inaccessible series of articles by J. MacLean, 'De Kleurentheorie van Aristoteles', *Scientiarum Historia*, VII, 109-16 (1965); 'De Kleurentheorie der Arabieren', ibid.,

143-55; 'De Kleurentheorie in West-Europa van ca. 600-1200', ibid., VII, 30-50 (1966); 'Geschiedenis van de kleurentheorie in de zestiende Eeuw', ibid., IX, 23-39 (1967); and a short anthology of source-materials has been published by D. L. MacAdam 1970, *Sources of Color Science*. None of these studies gives any attention to the question of colour-terminology.

5 S. Skard, 'The use of color in literature: a survey of research', *Proceedings of the American Philosophical Society*, XC (1949); H. Dürbeck 1977, *Zur Charakteristik der griechischen Farbenbezeichnungen*; J. André 1949, *Étude sur les termes de couleur dans la langue latine*; N. F. Barley 1974, 'Old English colour classification: where do matters stand?', *Anglo-Saxon England*, III.

6 B. Berlin and P. Kay 1969, *Basic Color Terms*, 2nd ed. 1991.

7 H. Zollinger 1979, 'Correlations between the neurobiology of colour vision and the psycho-linguistics of colour naming', *Experientia*, 35, 1-8.

8 There have been nods in the direction of the visual arts at symposia, for example, I. Meyerson, op. cit. n. 3 above; International Colour Association, *Colour 73*, London, 1973; F. W. Billmeyer and G. Wyszecki (eds), *Color 77: Proceedings of the Third Congress of the International Colour Association*, Bristol 1978.

9 R. M. Evans 1948, *An Introduction to Color*; Judd and Wyszecki, op. cit. n. 2 above.

10 It may be hoped that with the recent foundation of substantial and wide-ranging colour libraries like the Birren collection at Yale (see R. L. Herbert, 'A Color Bibliography', *Yale University Library Gazette*, 49 [1974], 3-49; 52 [1978], 127-65), the Colour Reference Library at the Royal College of Art in London, and, on a lesser scale, the still-excellent collection of colour-literature at the Zentralinstitut für Kunstgeschichte in Munich (see the extensive treatment of the subject by its librarian: T. Lersch, 'Farbenlehre', *Reallexikon zur deutschen Kunstgeschichte*, VII [1974], cols 157-274), renewed attempts will be made to approach the subject from a broader perspective.

11 W. Schöne, *Über das Licht in der Malerei*, 3rd ed. 1979.

12 N. Bromelle 1955, 'Colour and Conservation', *Studies in Conservation II*, 764.

13 Gage 1993, *Colour and Culture*, ch. 1.

14 R. W. G. Hunt, 'Problems in Colour Reproduction', *Colour 73*, espec. 7ff; idem, *The Reproduction of Colour*, 3rd ed. 1975.

15 M. Baxandall 1972, *Painting and Experience in Fifteenth Century Italy*, 3-11.

16 M. Merrifield, *Original Treatises on the Arts of Painting*, 2nd ed. 1967, vol. II, 384-405.

17 E. van Even, 'Le contrat pour l'éxécution du triptique de Thierry Bouts de la Collégiale Saint-Pierre à Louvain (1464)', *Bulletin de l'Academie Royale des Sciences, des Lettres et des Beaux-Arts de Belgique*, 2nd series, XXXV, 474f (1898); P. Coremans, R. J. Gettens, J. Thissen, 'La technique des Primitifs Flamands, II, T. H. Bouts: Le Retable du Saint Sacrement', *Studies in Conservation I* (1952), 15ff. See now M. Comblen-Sonkes 1996, *The Collegiate Church of Saint Peter, Louvain*.

18 P. Coremans 1953, *L'Agneau Mystique au Laboratoire* (Les Primitifs Flamands III, Contributions à l'étude des Primitifs Flamands), 70ff.

19 Gage 1993, *Colour and Culture*, 34-6.

20 For a recent assessment of the theoretical basis for the analogy colour-scale–musical octave, see C. Loef, 'Die Bedeutung der Musik-Oktave im optisch-visuellen Bereich der Farbe', *Von Farbe und Farben* (cit. n. 3 above) 227-36.

21 R. Waller, 'A Catalogue of Simple and Mixt Colours', *Philosophical Transactions of the Royal Society of London*, XVI, 24ff (1686). See also Judd and Wyszecki (op. cit. n. 2 above) 373ff.

22 Burnham, Haines and Bartleson (op. cit. n. 1 above) 209-10.

23 G. Bierson, 'Why did Newton see indigo in the spectrum?', *American Journal of Physics*, 40, 526 (1972).

24 E. Fletcher (ed.) 1901, *Conversations of James Northcote with James Ward*, 217-18. Cf. J. Burnet 1822, *Practical Hints on Composition in Painting*, 23. Purkinje's observations were stimulated by Goethe's *Theory of Colours*, espec. §54, and first publ. in J. E. Purkinje, *Beobachtungen und Versuche zur Physiologie der Sinne II, 1825* (*Opera Omnia*, vol. 1, 1918), 118f.

25 J. Gage, 'Colour at the Bauhaus', *AA Files*, 1, 51 (1982), 1993, 259-63.

26 Theophilus, *On Divers Arts*, trans. J. G. Hawthorne and C. S. Smith, 2nd ed. 1979, 24f.

27 *Corot raconté par lui-même*, 1946, 83; for the Villalobos system see Burnham, Haines and Bartleson (op. cit. n. 1 above) 172.

28 Burnham, Haines and Bartleson (op. cit.) 91-2.

29 See the technical notes in *Rembrandt in the Mauritshuis*, 1978.

30 C. Hope 1980, *Titian*, 161-3.

31 Gage 1993, *Colour and Culture*, 168.

32 R. Liebreich, 'Turner and Mulready – On the effect of certain faults of vision on painting', *Notices of the Proceedings of the Royal Institution*, VI, 450-63 (1872). The argument was countered by W. M. Williams 1872, *Nature*, 500, and especially in an anonymous review of Liebreich, 'Painters and the Accidents of Sight' in *The British and Foreign Medico-Chirurgical Review*, 50, Oct. 1872, 284-306. Cf. P. D. Trevor-Roper, *The World Through Blunted Sight*, 2nd ed. 1988, 2-3. See also below, ch. 3.

33 J. Cowart, J. D. Flam, D. Fourcade and J. H. Neff 1977, *Henri Matisse: Paper Cut-Outs*, 28-30. *British Journal of Aesthetics*, XVIII, 1978; G. W. Granger, 'Colour Harmony in Science and Art', *Colour 73* (cit. n. 8 above) 502-5.

34 M. Sahlins, 'Colours and Cultures', *Semiotica* (1976), 16, 12.

2 Colour and Culture

1 J. M. Oxbury, S. M. Oxbury, N. K. Humphrey 1969, 'Varieties of colour anomia', *Brain* 92, 847-60; A. Damasio, 'Disorders of complex visual processing: Agnosiasis, Achromatopsis, Balint's syndrome and related difficulties of orientation and construction' in M.-N. Mesulam (ed.) 1985, *Principles of Behavioural Neurology*, 259-88. See also M. H. Bornstein 1985, 'On the development of color naming in children: data and theory', *Brain and Language*, 26, 85-6.

2 U. Eco, 'How culture conditions the colors we see' in M. Blonsky (ed.) 1985, *On Signs*, 157-75.

3 M. Kemp, *The Science of Art*, 2nd ed. 1991, Part III.

4 R. W. Darwin 1786, 'On the ocular spectra of light and colours', *Philosophical Transactions of the Royal Society*, LXXVI, ii, espec. 328.

5 See G. Roque 1994, 'Les couleurs complémentaires: un nouveau paradigme', *Revue d'Histoire des Sciences*, XLVII, 405-33, espec. 414, 423. This is the fullest historical study of complementary colours, but for Newton see above, 142-3.

6 J. Albers, *Interaction of Color* (1963), rev. ed. 1971, VIII, 22: 'green or blue-green'. 'This green is the complementary color of red or red-orange.'

7 C. Hayter 1813, *An Introduction to Perspective adapted to the capacities of youth...*, pl. XIV, fig. 4. The earliest record I have found of a perceptual classification of colours as 'warm' or 'cool' is in Johannes Hübner's *Curieuses Natur-Kunst-Berg-Gewerck und Handlungs-Lexicon*, Leipzig 1727, col. 1019: 'dasz die maler die blauen farben Kalte farben nennen, engl. *cold*, die gelben *warme*' (cited in Grimm, *Deutsches Wörterbuch*, sv. *kalt*, col. 80). Earlier notions of colour-temperature had depended on the doctrine of the mixture of the four temperaments, e.g. B. Telesius, *Liber de Coloribus* in *Bernardini Telesii Varii de Naturalibus*, Venice 1590, where white was the warmest colour.

8 See the cautious scepticism of P. O. Fanger, N. O. Breum, E. Jerking 1977, 'Can color and noise influence man's thermal comfort?', *Ergonomics* 20, 11-18; T. C. Greene, P. A. Bell 1980, 'Additional

considerations concerning the effects of 'warm' and 'cool' colors on energy conservation', ibid. 23, 949-54.

9 A. Wierzbicka 1990, 'The meaning of color terms: semantics, cultures and cognition', *Cognitive Linguistics*, I, 99-150. See also the more cautious remarks in H. B. Nicholson, 'Polychrome on Aztec sculpture' in E. H. Boone (ed.) 1986, *Painted Architecture and Polychrome Monumental Sculpture in Mesoamerica*, 147: 'Certain associations seem reasonably obvious and 'natural', such as black with night and darkness and the sub-terrestrial realm, blue with the diurnal celestial sphere and aquatic phenomena, green with vegetation and preciousness in general, red with sacrificial blood, and red and yellow in combination with fire and solar heat. However, more subtle and complex connotations were probably also involved...'.

10 J. G. Millais 1899, *Life and Letters of Sir J. E. Millais*, I, 240 and the letter from 'Chromos' to Millais, publ. by P. Fagot, 'Témoignages synoptiques de William Blake et d'Emmanuel Swedenborge sur l'arc-en-ciel' in P. Junod and M. Pastereau (eds) 1994, *La couleur: regards croisés sur la couleur*, 93. Millais was, however, still having trouble with the order of the rainbow colours in what seems to be a later picture: see J. Larmor (ed.) 1907, *Memoir and Scientific Correspondence of the late Sir George Gabriel Stokes, Bt.*, I, 20 (I owe this reference to Joanie Kennedy). On the perception and representation of the rainbow, Gage 1993, *Colour and Culture*, ch. 6.

11 P. Syme, *Werner's Nomenclature of Colours adapted to Zoology, Botany, Chemistry, Mineralogy, Anatomy and the Arts*, 2nd ed. 1821, 11. For Darwin's use of Syme/Werner in 1832 and 1833, F. Burkhardt and S. Smith (eds) 1985, *The Correspondence of Charles Darwin*, I, 280, 353.

12 For Darwin's few marginal notes in his copy of Syme, M. A. Di Gregorio 1990, *Charles Darwin's Marginalia*, I, col. 797. Some 1,868 colour-notes on the feathers of *Polypection Napoleonis* use very general terms and include a correction from 'ashy brown' to 'blackish' (Cambridge University Library, Darwin Papers 84.2, ff 63-4).

13 W. Dacre (Nicholson), 'Liberation of Colour' (1944) in W. Nicholson 1987, *Unknown Colour: Paintings, Letters, Writings*, 125.

14 For *faktura*, Gage 1993, *Colour and Culture*, 225.

15 D. Katz 1935, *The World of Colour* (repr. 1970).

16 See H. P. Barlow and J. D. Mollon (eds) 1982, *The Senses*, 112-13.

17 M. Sahlins 1976, 'Colors and Cultures', *Semiotica*, 16, 8.

18 T. D. Crawford 1982, 'Defining "Basic color terms"', *Anthropological Linguistics* 24, 338-43; B. Saunders 1995, 'Disinterring *Basic Color Terms*: a study in the mystique of cognitivism', *History of the Human Sciences* 8, 19-38.

19 Gage 1993, *Colour and Culture*, espec. 32-3.

20 R. Arnheim, *Art and Visual Perception: a Psychology of the Creative Eye*, 2nd ed. 1974, 340.

21 Sahlins 1976, 16. L. Wittgenstein 1978, *Remarks on Colour*, speaks casually of *the* colour circle (III, 80) and *the* 'colour-octagon' (III, 197).

22 For *sinople* and *bloi*, Gage 1993, *Colour and Culture*, 81-2, 90.

23 Wittgenstein (op cit. n. 21 above) I, 9-14. For Japan, N. B. McNeill 1972, 'Colour and Colour Terminology', *Journal of Linguistics*, VIII, 21; for Slav terms covering yellow and blue, G. Herne 1954, *Die slavischen Farbenbenennungen* (Publications de l'Institut Slave d'Upsal, 9) 73. P. Klee, *Beiträge zur bildnerische Formlehre*, ed. J. Glaesemer 1974, facs. 159. C. L. Hardin has pointed to some laboratory experiments which suggest that subjects *may* read a surface as simultaneously red and green all over (*Color for Philosophers*, 2nd edn. 1988, 124f).

24 R. E. MacLaury *et al.* 1992, 'From brightness to hue: an explanatory model of color-category evolution', *Current Anthropology* 33, 137-86. For Judaism and Pseudo-Dionysius, Gage 1993, *Colour and Culture*, 60, 71.

25 R. Kuschel and T. Monberg 1974, '"We don't talk much about colour here": a study of colour semantics on Bellona Island', *Man* 9, 213-42; for a further critique of the social attitudes implicit in colour-tests in anthropology, Saunders (op. cit. n. 18) 35 n. 17.

26 T. Izutsu, 'The elimination of colour in Far Eastern art and philosophy' in S. Haule (ed.) 1977, *Color Symbolism: Six Excerpts from the Eranos Yearbook 1972*, 167-95.

27 J. Harvey 1995, *Men in Black*.

28 C. Féré 1887, *Sensation et Mouvement*, 41-6.

29 P. K. Kaiser 1984, 'Physiological response to color: a critical review', *Color Research and Application* 9, 29-36.

30 I. Scott (ed. and trans.) 1971, *The Lüscher Colour Test*, 68; cf. H. Eysenck 1941, 'A critical and experimental study of colour preferences', *American Journal of Psychology* 54, 386.

31 M. Lüscher, *Psychologie der Farben*, Basel, n.d. (1949), 32-3 for Goethe and Kandinsky, 59 for the four humours. For Goethe and Schiller, Gage 1993, *Colour and Culture*, 204.

32 For a review of the extensive literature on children, Bornstein (op. cit. n. 1 above) 72-93; for animals, A. Portmann, 'Colour sense and the meaning of colour from a biologist's point of view' in Haule, ed. (op. cit. n. 26 above) 977, 1-22.

33 MacLaury, op. cit. n. 24 above.

34 N. A. Stekler and W. E. Cooper 1980, 'Sex differences in color naming of unisex apparel', *Anthropological Linguistics* 22, 373-81; J. D. Mollon, 'Colour vision and colour blindness' in Barlow and Mollon (op. cit. n. 16 above) 187-9; Bornstein, op. cit. n. 1 above; J. Mollon, 'Seeing colour' in T. Lamb and J. Bourriau 1995, *Colour: Art and Science*, espec. 139-40.

3 Colour in Art and its Literature

1 See below p. 67.

2 See particularly the remarks by J. Shearman on the distinction between historiography and science in 'The Historian and the Conservator', J. Shearman and M. B. Hall (eds) 1990, *The Princeton Raphael Symposium. Science in the Service of Art History*, 7-8.

3 W. Menzel 1842, 'Die Mythen des Regenbogens' in *Mythologische Forschungen und Sammlungen,* Stuttgart and Tübingen, 241.

4 For example, G. Dumézil 1946, '"Tripertia" fonctionnels chez divers peuples indo-européens', *Revue d'histoire des religions*, CXXXI, 54ff. For a critique, see C. Renfrew 1987, *Archaelogy and Language: The Puzzle of Indo-European Origins*, 251ff.

5 See particularly M. Bernal 1987, *Black Athena: The Afro-Asian Roots of Classical Civilization*, I, 240ff. Bernal documents the long-standing European doubts about whether the ancient Egyptians were black or light-skinned. The transmission of the negative connotations of black Egyptians to the Christian tradition of the Devil has been studied by P. du Bourguet 1972, 'La Couleur noire de la peau du démon dans l'iconographie chrétienne: A-t'elle une origine précise?', *Actas del VIII Congreso Internacional de Arquelogia Cristiana* (1969), Città del Vaticano and Barcelona, 271-2. For Iconoclasts as blacks in Byzantium, see R. Cormack 1985, *Writing in Gold: Byzantine Society and Its Icons*, 136f. White and racialism has now been studied by Richard Dyer 1997, *White*. For another racially-linked colour prejudice, see R. Mellinkoff 1983, 'Judas' Red Hair and the Jews', *Journal of Jewish Art*, IX, 31-46; and M. Pastoureau (1989), 'Rouge, jaune et gaucher: Notes sur l'iconographie médiévale de Judas' in *Couleurs, images, symboles*, n.d., 69-83.

6 Victor Turner's classic study, 'Colour Classifications in Ndembu Ritual: A Problem in Primitive Classification' (1966) in *The Forest of Symbols: Aspects of Ndembu Ritual*, 2nd ed. 1970, 59f, should now be supplemented by R. Willis, 'Do the Fipa have a word for it?' in D. Parkin (ed.) 1985, *The Anthropology of Evil*, espec. 217ff. For a rather slight modification of the traditionally negative interpretaion of 'black' among Afro-Americans, see J. E. Williams 1964, 'Connotations of Color Names among Negroes and Caucasians', *Perceptual and Motor Skills*, XVIII, 729; and J. E. Williams, R. D. Tucker, F. Dunham 1971, 'Changes in the Connotations of Color Names among Negroes and Caucasians, 1963-1969', *Journal of Personality and Social Psychology*, XIX, 228.

7 A. L. Plehn 1911, *Farbensymmetrie und Farbenwechsel. Prinzipien der deutschen und italienischen Farbenverteilung (Studien zur deutschen Kunstgeschichte*, CXLIII); E. von den Berken 1930, 'Forschungen über die Farbe in der Malerei', *Forschungen und Fortschritte*, VI, 262-3; and E. Souriau 1962, 'Y-a-t-il une palette

française?, *Art de France*, II, 23-42. Souriau's answer was yes: it is red, white, and blue.

8 S. R. Weitman 1973, 'National Flags: A Sociological Overview', *Semiotica*, VIII, 328-67. See also H. Fischer 1963, 'Rot and Weiss als Fahnenfarben', *Antaios*, IV, 136ff; L. Schmidt, 'Rot und Blau. Zur Symbolik eines Farbenpaares' in ibid. 168ff; and R. Girardet 1984, 'Les Trois Couleurs, ni blanc ni rouge' in P. Nova (ed.), *Les Lieux de mémoire*, I, *La République*, 5ff.

9 For the ancient practice, see Vitruvius, *Ten Books on Architecture*, VII, 7-8; and Pliny, *Natural History*, XXXV, 30. For an instance in 15th-century Siena, see G. Milanesi, *Documenti per la storia dell'arte senese*, 1854, II, 307, no. 215; and for another in Baroque Rome, see D. Mahon 1947, *Studies in Seicento Art and Theory*, 92. For 18th-century Spain see Z. Veliz 1986, *Artists' Techniques in Golden Age Spain*, 154.

10 G. Vasari, *Le vite…*, ed. G. Milanesi, 1878-81, II, 187-9. For a Baroque retelling of the story that stressed the Pope's 'eye' over his 'reason', see G. D. Ottonelli and P. Berrettini, *Trattato della pittura e scultura: Uso et abuso loro* (Florence, 1652), ed. V. Casale 1973, 58f.

11 Bernal (op. cit. n. 5 above) 343.

12 C. A. du Fresnoy (1667), *The Art of Painting*, trans. W. Mason in *The Literary Works of Sir Joshua Reynolds*, ed. H. W. Beechey 1852, II, 274; see also E. Cropper 1984, *The Ideal of Painting: Pietro Testa's Düsseldorf Notebook*, 252.

13 C. Blanc 1867, *Grammaire des arts du dessin*, 22.

14 H. Matisse, *Écrits et propos sur l'art*, ed. D. Fourcade 1972, 201.

15 P. O. Runge (1840), *Hinterlassene Schriften*, repr. 1965, I, 164; Marc to August Macke, 12 Dec. 1910 in W. Macke, ed. 1964, *August Macke – Franz Marc Briefwechsel*, 28.

16 R. Matthäi 1928, 'Experimentelle Studien über die Attribute der Farbe', *Zeitschrift für Sinnesphysiologie*, LIX, 354; see also A. Lichtwark (1891), *Die Erziehung des Farbsinnes*, 3rd ed. 1905, 5, 23.

17 H. B. Barlow and J. D. Mollon (eds) 1982, *The Senses*, 187. Possibly the only scholar to contest these figures is G. S. Wasserman 1978, *Color Vision: An Historical Introduction*, 69ff.

18 One of the few studies of costume to address itself specifically to historians of art is by a pupil of Newton: E. Birbari 1975, *Dress in Italian Painting 1460-1500*. F. Brunello's most important study is *L'Arte della tintura nella storia dell' umanità*, 1968 (also publ. in English, Vicenza 1968).

19 A. Hollander 1978, *Seeing through Clothes*; and R. Parker 1984, *The Subversive Stitch: Embroidery and the Making of Femininity*.

20 G. Berkeley (1709), *An Essay towards a New Theory of Vision*, XLIII, CIII, CLVI, CLVIII; J. W. von Goethe (1810), *Theory of Colours*, trans. C. L. Eastlake (London, 1840), repr. 1970, xxxviii-xxxix. For the Sceptics, see J. Annas and J. Barnes 1985, *The Modes of Scepticism*, espec. 38-9; and J. Locke, *An Essay on Human Understanding*, 4th ed. 1700, II, xxii, vv. 2, 8, 10-11. See also M. Baxandall 1985, *Patterns of Intention: On the Historical Explanation of Pictures*, 76-80.

21 J. D. Mollon 1989, '"Tho' she kneeled in that place where they grew…". The Uses and Origins of Primate Colour Vision', *Journal of Experimental Biology*, CXLVI, 21-38. See also the discussion of infants' observation of contour, as opposed to colour at the centre of forms, in M. H. Bornstein 1975, 'Qualities of Colour Vision in Infancy', *Journal of Experimental Child Psychology*, XIX, 415-16.

22 See, for example, G. Mancini 1956, *Considerazioni sulla pittura*, ed. A. Marucchi, I, 162; Domenichino to Angeloni (1632) in Mahon (op. cit. n. 9 above) 120; and G. P. Bellori (1732), *Vita di Carlo Maratti* in *Le Vite…*, ed. E. Borea 1976, 632. A critique of the later development of this view has been offered by L. Venturi 1933, 'Sul 'colore' nella storia della critica', *L'Arte*, IV, 228-33 (repr. in *Saggi di critica*, 1956, 159-69).

23 For a brief survey of this tradition, see E. Strauss, 'Zur Entwicklung der Koloritforschung' in Strauss, *Koloritgeschichtliche Untersuchungen zur Malerei seit Giotto und andere Studien*, 2nd ed., ed. L. Dittmann 1983, 331-41.

24 L. Dittmann (1959), 'Bemerkungen zur Farbenlehre von Hedwig Conrad-Martius', *Hefte des Kunsthistorischen Seminars der Universität*

München, v, 1963, 22ff. Conrad-Martius's most important text in this regard is H. Conrad Martius 1929, 'Farben: Ein Kapitel aus der Realontologie', *Festschrift Edmund Husserl*, 339-70. For an exceptionally vital and far from formalist analysis in the spirit of Conrad-Martius, see L. Dittmann 1961, 'Zur Kunst Cézannes' in M. Gosebruch (ed.), *Festschrift Kurt Badt*, 190-212.

25 W. Schöne (1954), *Über das Licht in der Malerei*, 5th ed. 1979. For an English summary, see A. Neumayer's review in *Art Bulletin*, XXXVII, 1955, 301ff. Some extracts appear in English in W. Sypher (ed.) 1963, *Art History: An Anthology of Modern Criticism*, 132-52. See also the only English published study to draw on Schöne's approach: P. Hills 1987, *The Light of Early Italian Painting*. Among the several studies of light in European culture are V. Nieto Alcaide 1978, *La Luz, Simbolo y sistema visual (El espacio y la luz en el arte gotico y del renacimiento)*; C. R. Dodwell 1982, *Anglo-Saxon Art: A New Perspective*; D. Bremer 1974, 'Licht als universales Darstellungsmedium', *Archiv für Begriffsgeschichte*, XVIII, 185-206 (with extensive bibliography); K. Hedwig 1977, 'Forschungsübersicht: Arbeiten zur scholastischen Lichtspekulation. Allegorie-Metaphysik-Optik', *Philosophisches Jahrbuch*, LXXXIV, 102-26; idem 1979, 'Neuere Arbeiten zur mittelalterlichen Lichttheorie', *Zeitschrift für philosophische Forschung*, XXXIII, 602-15; Gage 1993, *Colour and Culture*, ch. 4.

26 Dittmann 1987, *Farbgestaltung und Farbtheorie in der abendländischen Malerei*, XI, n. I. The reference is to M. Rzepińska, *Historia Koloru w dziejach malarstwa europejskiego*, 3rd ed. 1989. Since I am not familiar with Polish I have relied for my assessment of Dittmann's remark on I. M. Neugebauer 1979, 'Die Farbe in der Kunst, Bemerkungen zu einem Buch von Maria Rzepińska', *Zeitschrift für Ästhetik und allgemeine Kunstwissenschaft*, XXIV, espec. 228, and B. Zelinsky 1986, 'Maria Rzepińska über die Farbe' in ibid., XXXI, espec. 182. Useful discussions of Rzepińska's book have appeared in English in *Polish Perspectives*, XII, 1970, 91-2 (by J. Przybos), and the *Journal of Aesthetics and Art Criticism*, XXXII, 1973, 555-6 (by M. Rieser).

27 Dittmann (op. cit.) 290.

28 A good example is the contradictory characterizations of the colour of Delacroix's *Liberty Leading the People* (Louvre) by Lee Johnson 1963, who notices a return to the early palette of Géricault (L. Johnson, *Delacroix*, p. 38), and Jutta Held 1964, who saw in Delacroix's 'complementaries' a contrast to Géricault's emphasis on chiaroscuro (*Farbe und Licht in Goyas Malerei*, 152-3).

29 Dittmann (op. cit) 39-40, 68-9.

30 Schöne (op. cit. n. 25 above) 32-6, 256-65. For the marked effect of the glass on the mural of the Baroncelli Chapel, see Hills (op. cit. n. 25 above) 83.

31 Strauss (op. cit. n. 23), 340f. Cf. also his essay, 'Zur Frage des Helldunkels bei Delacroix' in ibid., 135-51; K. Badt 1965, *Eugène Delacroix: Werke und Ideale*, 46-74; and idem, *Die Farbenlehre Van Goghs*, 2nd ed. 1981. See also W. Hess, *Das Problem der Farbe in den Selbstzeugnissen der Maler von Cézanne bis Mondrian*, 2nd ed. 1981.

32 E. Walter-Karydi 1986, 'Principien der archaischen Farbengebung', *Studien zur klassischen Archäologie. Festschrift Friedrich Hiller*, ed. K. Braun and A. Furtwängler, espec. 31. See also idem, 'Ernst Strauss' Koloritforschuhng und die Antike' in Munich, Galerie Arnoldi-Livie, *Ernst Strauss zum 80. Geburtstag 30 Juni 1981*, n.d. A rather loose but well-documented overview of ancient symbolism has now been given by L. Luzzato and R. Pompas 1988, *ll significato dei colori nelle civiltà antiche*.

33 U. M. Rüth 1977, *Die Farbegebung in der byzantinischen Wandmalerei der spät-paleologischen Epoche (1346-1453)*, diss., Bonn, 644, 757, 801f and passim.

34 G. Hopp 1968, *Edouard Manet: Farbe und Bildgestalt*, 54. Hopp notes (p.100) that this green has not been noticed by later commentators, but more recently, Françoise Cachin, in the catalogue of the Manet exhibition in New York and Paris of 1983, talks of its 'violence' (Paris, Grand Palais, *Manet 1832-1883*, 1983, 306-7).

35 Hopp (op. cit. n. 34 above) 85ff; Cachin (op. cit. n. 34 above) 478.

36 Schöne (op. cit. n. 25 above) 5.

37 Dittmann (op. cit. n. 26 above) 195; he draws here on the obses-

sive but very well-documented discussion by R. Verbraeken 1979, *Clair Obscur – histoire d'un mot*.

38 Dittmann (op. cit. n. 26 above) 346; cf. also Strauss (op. cit. n. 23 above) 12.

39 J. Westphal, *Colour: A Philosophical Introduction*, 2nd ed. 1991, ch. 3. Westphal is mistaken in thinking that pigment-mixtures of yellow and black yield brown (44, n. 7); the product here is green (F. Kiesow 1930, 'Über die Entstehung der Braunempfindung', *Neue Psychologische Studien*, VI, 121ff); and idem 1982, 'Brown', *Inquiry*, xxv, 1982, espec. 420. In note 32 here Westphal suggests circumstances in which brown might be seen to be a spectral colour. See also K. Fuld, J. S. Werner, B. R. Wooten 1983, 'The possible elemental nature of brown', *Vision Research*, 23, 631-7; P. C. Quinn, J. L. Rosano, B. R. Wooten 1988, 'Evidence that brown is not an elemental color', *Perception and Psychophysics*, 43, 156-64.

40 C. J. Bartleson 1976, 'Brown', *Color Research and Application*, I, 188; M. Sahlins, 'Colors and Cultures' in J. L. Dolgin, D. S. Kemnitzer, D. M. Schneider, eds 1977, *Symbolic Anthropology: A Reader in the Study of Symbols and Meanings*, 170.

41 Bartleson (op. cit. n. 40 above); B. Harrison 1973, *Form and Content*, 108-11.

42 Verbraeken (op. cit. n. 37 above) 59, 102; A. M. Kristol 1978, *Color: Les Langues romanes devant le phénomène de la couleur*, 103, 323, n. 41; K. Borinski 1918, 'Braun als Trauerfarbe', *Sitzungsberichte der bayerischen Akad. der Wissenschaften: Philosophische-Philologische Klasse, Abhandl.* x, 1-18; idem, 'Nochmals die Farbe Braun' in ibid. (1918), 1920, *Abhandl.* I, 3-20.

43 Conrad-Martius (op. cit. n. 24 above) 365, para. 283; Schöne (op. cit. n. 25 above) 229-30; E. Heimendahl 1961, *Licht und Farbe: Ordnung und Funktion der Farben*, espec. 69; E. Strauss 1969, 'Zur Wesensbestimmung der Bildfarbe' (op.cit. n. 23 above), 18.

44 Dittmann (op. cit. n. 26 above) 70.

45 H. Soehner 1955, 'Velàzquez und Italien', *Zeitschrift für Kunstgeschichte*, xviii, 22-7; K. H. Spinner 1971, 'Helldunkel und Zeitlichkeit. Caravaggio, Ribera, Zurbaràn, Georges de la Tour, Rembrandt' in ibid., xxxiv, 174. See also Dittmann (op. cit. n. 26 above) 231.

46 Veliz (op. cit. n. 9 above) 3, 109, 154. For Spain as an important source for red earths ('Spanish brown') in the 17th century, see R. D. Harley, *Artists' Pigments, c. 1600-1835: A Study in English Documentary Sources*, 2nd ed. 1982, 120.

47 See H. Jantzen's remarks on Hetzer's neglect of such considerations in his review of *Tizian: Geschichte seiner Farbe* in *Deutsche Literaturzeitung*, XLII, 1937. Cf. also Strauss (op. cit. n. 23 above) 9-19. Schöne (op. cit. n. 25 above) was certainly less happy about the problems he faced: see e.g. his remarks on Romanesque wallpainting, p. 31; and Dittmann (op. cit. n. 26 above, 47) expressed reservations about the condition of Masaccio's frescoes in the Brancacci Chapel in Florence, but not, for example, about Titian's *Bacchus and Ariadne* in London (p. 174) or Seurat's *Grande Jatte* in Chicago (pp. 307-8). From time to time Dittmann cites the work of the conservator Hubert von Sonnenburg in his notes, but none of his work appears in the text.

48 See e.g. *Capolavori e restauri*, Florence, Palazzo Vecchio, 1986-7; *Venezia restaurata 1966-1986*, Milan, 1986; *The Hamilton Kerr Institute: The First Ten Years*, Cambridge, Fitzwilliam Museum, 1988; *Art in the Making: Rembrandt*, London, National Gallery, 1988-9, and *Impressionism*, London, National Gallery, 1990-1.

49 Among them are the National Gallery of Art, Washington, DC, *Report and Studies in the History of Art* (1967-); National Gallery, London, *Technical Bulletin* (1977-); *Gli Uffizi: Studi e ricerche* (1984-); *OPD Restauro: Quaderni dell'opificio delle pietre dure e laboratorio di restauro di Firenze* (1986-) and *Science et technologie de la conservation et de la restauration des oeuvres d'art et du patrimoine* (1988-). See also the article by J. Plesters, '"Scienza e Restauro": Recent Italian Publications on Conservation', *Burlington Magazine*, CXXIX, 1987, 172-7.

50 E.g. J. Bruyn et al., *Corpus of Rembrandt Paintings*, I, 1625-31, 1982; J. O. Hand and M. Wolff, *National Gallery of Art, Washington: Early Netherlandish Painting*, 1986; H. W. van Os et al.., *The Early Venetian Paintings in Holland*, 1978.

51 See particularly the series of articles generated by the 'cleaning controversy' at the National Gallery, London, in the *Burlington Magazine*, CIV, 1962, 51-62, 452-7, and CV, 1963, 90ff. The Gallery's case was put in *The National Gallery, January 1960-May 1962*, 67-89. See also the general surveys by S. Keck, 'Some Picture Cleaning Controversies, Past and Present', *Journal of the American Institute for Conservation*, XXIII, 1984, 73-87; and A. Conti, *Storia del restauro*, 1988.

52 'La Restauration des vitraux anciens' (editorial), *Revue de l'art*, XXXI, 1976, 6ff; and L. Grodecki, 'Esthétique ancienne et moderne du vitrail roman', *Les Monuments historiques de la France*, 1977, 17-30.

53 The chief studies so far are A. Chastel *et al.* 1986, *La Capella Sistina, I Prima restauri: La Scoperta del colore*; A. Conti 1986, *Michelangelo e la pittura a fresco. Tecnica e conservazione della Volta Sistina* (a radical critique of the restoration); G. Colalucci, 'Le Lunette di Michelangelo nella Capella Sistina (1508-12)' in E. Borsook and F. Superbi Gioffredi 1986, *Tecnica e stile*, 76ff; F. Mancinelli 1988, 'La Technique de Michel-Ange et les problèmes de la Chapelle Sixtine: *La Création d'Eve et le Péché Originel*', *Revue de l'art*, LXXXI, 9-19; J. Beck 1988, 'The Final Layers, "L'ultima mano" on Michelangelo's Sistine Ceiling', *Art Bulletin*, LXXX, 502-3, and F. Mancinelli (ed.) 1994, *Michelangelo: La Capella Sistina. Rapporto sul Restauro degli affreschi della volta*, espec. III, 159-94.

54 M. B. Cohn, *Wash and Gouache: A Study of the Development of the Materials of Watercolor*, Cambridge, Mass., Fogg Art Museum, 1977; London, Tate Gallery, *Paint and Painting*, 1982; Marseilles, Centre de la Vieille Charité, *Sublime Indigo*, 1987; J. Krill, *English Artists' Paper: Renaissance to Regency*, London, Victoria and Albert Museum, 1987; J. Gage, *George Field and his Circle from Romanticism to the Pre-Raphelite Brotherhood*, Cambridge, Fitzwilliam Museum, 1989.

55 J. W. Lane and K. Steinitz, 'Palette Index', *Art News*, Dec. 1942, 23-35, espec. 32; F. Schmid 1948, *The Practice of Painting*; idem 1958, 'Some Observations on Artists' Palettes', *Art Bulletin*, XL, 334-46; idem 1966, 'The Painter's Implements in Eighteenth-Century Art', *Burlington Magazine*, CVIII, 519-21. A useful checklist of 282 artists' portraits including palettes, collected by Faber Birren and now at Yale, is given in R. C. Kaufmann 1974, 'The Photo-Archive of Color Palettes', *The Yale University Library Gazette*, XLIX, 51-72. Ernst Strauss (op. cit. n. 23 above, 13) has underlined the conceptual importance of the palette in the 20th century, See also Gage 1993, *Colour and Culture*, ch. 10.

56 M. Baxandall, *Painting and Experience in Fifteenth-century Italy*, 2nd ed. 1988, 6, 11. For Spain see Veliz (op. cit. n. 9 above) 118.

57 M. Merrifield, *Original Treatises on the Arts of Painting*, 2nd ed. 1967, II, 384-405. On pp. 388-9 of this edition of the Bolognese MS, a complex recipe for a blue made from, among other colours, cinnabar, Roman vitriol, orpiment, and verdigris is claimed to be 'an azure better than German azure, and in appearance and colour... equal to ultramarine'. For some of these artificial blues, see M. V. Orna *et al.* 1980, 'Synthetic Blue Pigments: Ninth to Sixteenth Centuries. I, Literature', *Studies in Conservation*, XXV, 53-63; idem 1985, 'II, Silver Blue', ibid. XXX, 155-6.

58 The fundamental study of Italian artists' contracts is H. Glasser 1977, *Artists' Contracts of the Early Renaissance*. There is no comparable study of Northern contracts, but see above p. 14. For guild regulations, see L. Manzoni 1904, *Statuti e matricole dell'arte dei pittori della città di Firenze, Perugia, Siena*, 32f, 87f; and C. Fiorilli 1920, 'I Dipintori a Firenze nell' arte dei medici, speciali e merciai', *Archivio storico italiano*, LXXVIII, II, 48.

59 For the historian of colour in art, the most important publications to come from conservation studies concern the history of pigments, for example, Harley, op. cit. n. 46 above; and R. L. Feller, ed., *Artists' Pigments: A Handbook of Their History and Characteristics*, I 1986; II, ed. A. Roy, 1993. For the late 19th century a key text is still J.-G. Vibert (1891), *La Science de la Peinture*, repr. 1981.

60 On media, e.g., see M. Johnson and E. Packard 1971, 'Methods Used for the Identification of Binding Media in Italian Paintings of the Fifteenth and Sixteenth Centuries', *Studies in Conservation*, XVI,

145ff; and E. Bowron, 'Oil and Tempera Mediums in Early Paintings: A View from the Laboratory', *Apollo*, c. 1974, 380-7.

61 H. Roosen-Runge 1967, *Farbgebung und Technik frühmittelalterlicher Buchmalerei: Studien zu den Traktaten 'Mappae Clavicula' und 'Heraclius'*; D. Winfield 1968, 'Middle and Later Byzantine Wall-painting Methods', *Dumbarton Oaks Papers*, XXII,136ff; and M. Kirby Talley and K. Groen 1975, 'Thomas Bardwell and His Practice of Painting: A Comparative Investigation between Described and Actual Painting Technique', *Studies in Conservation*, XX, 44-108. See also M. Kirby Talley 1981, *Portrait Painting in England: Studies in the Technical Literature before 1700*, and the collection, H. Althöfer (ed.), *Das 19 Jahrhundert in der Restaurierung*, 1987.

62 The medieval compilation of 'Heraclius', *De Coloribus et Artibus Romanorum* has been re-edited by C. G. Romano, *I Colori e le Arti dei Romani e la compilazione Pseudo-Eracliana*, Instituto Italiano per gli Studi Storici di Napoli, 1996. C. R. Dodwell's standard edition of Theophilus's *De diversis artibus* has now been reprinted (1986), but the best translation and commentary is still that by J. G. Hawthorne and C. S. Smith (1963). Franco Brunello's editions of Cennino Cennini, *Il libro dell'arte*, 1971, and the anonymous *De arte illuminandi*, 1975, have valuable notes. The important *De Clarea*, an 11th- or 12th-century MS in Bern, has been re-edited by R. Straub 1965, *Jahresbericht der Schweizerisches Institut für Kunstwissenschaft,1964*, 81-114. See also S. Pezzella 1976, *Il Trattato di Antonio da Pisa sulla fabricazione delle vetrate artistiche*; Karel van Mander's *Den grondt der Edel vry Schilder-Const* (1604) has been edited with a modern Dutch translation by H. Miedema, 1973; P. Hetherington 1974, *The 'Painters' Manual' of Dionysius of Fourna*; P. Signac, *De Delacroix au Néo-Impressionisme*, ed. F. Cachin, 1978 (English trans. F. Ratliff, *Paul Signac and Color in Neo-Impressionism*, 1990).

63 Bernard Bischoff 1984 published newly discovered Carolingian or Ottonian texts on the manufacture of glass and the setting of mosaics: *Anecdota Novissima: Texte des vierten bis sechzehnten Jahrhunderts*, 221-3; a number of early recipes for MS illumination that have not generally been noticed are in a medical MS at Ivrea: P. Giacosa, 'Un recettario del secolo XI esistente nell'archivio capitolare d'Ivrea', *Memorie della Reale Accademia delle Scienze di Torino*, ser. II, XXXVII, 1886, 651ff. For England: T. Hunt 1995, 'Early Anglo-Norman receipts for colours', *Journal of the Warburg and Courtauld Institutes*, LVIII, 203-9; A. Petzold, 'De coloribus et mixtionibus: the earliest MSS of a Romanesque illuminators' handbook' in L. Brownrigg (ed.) 1995, *Making the Medieval Book*, 59-65. For Italy, see now R. Silva 1978, 'Chimica tecnica e formole dei colori nel manoscritto lucchese 1939 del secolo XIV', *Critica d'Arte*, XLIII, fasc. 160-2, 27-43; D. Bommarito 1985/1, 'Il MS 25 della Newberry Library: la tradizione dei ricettarii e trattati sui colori nel Medioevo e Rinascimento veneto e toscano', *La Bibliofilia*, LXXXVIII, 1-38; L. Miglio 1977-8, 'Tra chimica e colori alla metà del Cinquecento; le ricette del MS 232 della biblioteca della città di Arezzo', *Annali della Scuola Speciale per Archivisti e Bibliotecari dell'Università di Roma*, XVII-XVIII, 194-213; A. Wallert, '*Libro Secondo di Diversi Colori e Sise da Mettere a Oro*, a 15th-century technical treatise on manuscript illumination' in A. Wallert, E. Hermens, M. Peek (eds) 1995, *Historical Painting Techniques; Materials and Studio Practice*, 38-47; E. Hermens, 'A seventeenth-century Italian treatise on miniature painting and its author(s)', ibid., 48-57; F. Tolaini 1996, 'Proposte per una metodologia di analisi di un ricettario di colori medievali' in *Il Colore nel Medioevo: Arte, Simbolo, Tecnica*, Lucca, Istituto Storico Lucchese, 91-116; S.Baroni, 'I ricettari medievali per la preparazione dei colori e la loro trasmissione', ibid., 117-44; B. Tosatti Soldano 1978, *Miniatura e Vetrate Senesi del Secolo XIII* (Collana Storica di Fonti e Studi, 25). On some Dutch 17th-century pigment-terms, T. Goedings and K. Groen 1994 in *Hamilton Kerr Institute Bulletin*, 2, 84-8. For French printed sources, A. Massing 1990, 'Painting materials and techniques: towards a bibliography of the French literature before 1800' in *Die Kunst und ihre Erhaltung: Rolf E. Straub zum 70. Geburtstag*, 57-96; for German sources, U. Schiessl 1989, *Die Deutsch-sprachige Literatur zu Werkstoffen und Techniken der Malerei von 1530 bis. ca. 1950*. See also H. J. Abrahams 1979, 'A Thirteenth-

Century Portuguese Work on Manuscript Illumination', *Ambix*, XXVI, 97ff. E. Vandamme has published a 16th-century MS recipe book from the Netherlands, together with a useful bibliography of contemporary printed sources: 'Een 16e -eeuws zuidnederlands receptenboek', *Jaarboek van het Koninklijk Museum voor Schone Kunsten Antwerpen*, 1974, 101-37; M. Sanz has published an anonymous mid-17th-century Spanish painter's manual, now translated into English by Veliz (op. cit. n. 9 above) 107-27; and E. A. de Klerk a treatise by Cornelis Pieterz. Biens, published in Amsterdam in 1639, but now known only in a single copy: 'De Teecken-Const, een 17de eeuws Nederlands Traktaatje', *Oud Holland*, XCVI, 1982, 16ff (with English summary).

64 Urso von Salerno, *De Commixtionibus elementorum libellus*, ed. A. Stürner, 1976, 111-16. There is also a reference to painting in the *De coloribus* by a follower of Urso (ed. L. Thorndike, 'Medieval Texts on Colors', *Ambix*, VII, 1959, 7). For the earliest extant oil painting on panel, from late 13th-century Scandinavia, see C. Périer-D'Ieteren 1985, *Colyn de Coter et la technique picturale des peintres flamands du XV^e siècle*, 14; and for early oil painting on walls, to which Urso seems to refer, see H. Travers Newton 1983, 'Leonardo de Vinci as a Mural Painter: Some Observations on His Materials and Working Methods', *Arte lombarda*, LXVI, 72.

65 A. Callen 1982, *Techniques of the Impressionists*, espec. 18-27. This study draws on the far richer documentation of Callen's 1980 dissertation, 'Artists Materials and Techniques in Nineteenth-Century France', PhD diss., London.

66 A notable exception is D. Cranmer. 'Painting Materials and Techniques of Mark Rothko: Consequences of an Unorthodox Approach' in *Mark Rothko 1903-1970*, London, Tate Gallery, 1987, 189-97.

67 The post-Antique history of colour as it relates to theories of perception has now been well covered in two studies in English: D. C. Lindberg 1976, *Theories of Vision from Alkindi to Kepler*; and N. Pastore 1971, *Selective History of Theories of Visual Perception, 1650-1950*. A still-useful general history of colour-theories is K. T. A. Halbertsma 1949, *A History of the Theory of Colour*, although its early chapters are based almost entirely on material gathered by Goethe: J. W. von Goethe, *Zur Farbenlehre: Historischer Teil*, in Goethe, *Die Schriften zur Naturwissenschaft*, ed. R. Matthaei, W. Troll, K. L. Wolf, Weimar, I, no.6, 1957 (text); II, no. 6, 1959 (*Ergänzungen und Erläurungen*).

68 Recent studies of Theophilus have stressed the intellectual background of his writing: W. Hanke 1962, *Kunst und Geist: Das philosophischen Gedankengut der Schrift, 'De Diversis Artibus' des Preisters und Monachus Theophilus*; L. White, Jr 1964, 'Theophilus Redivivus', *Technology and Culture*, v, 226ff; J. van Engen 1980, 'Theophilus Presbyter and Rupert of Deutz: The Manual Arts and Benedictine Theology in the Early Twelfth Century', *Viator*, XI, 150ff.

69 V. J. Bruno 1977, *Form and Color in Greek Painting*, esp. 53ff. J. J. Pollitt has criticized the version of the four-colour story given by Cicero, and regarded as plausible by Bruno (J. J. Pollitt 1974, *The Ancient View of Greek Art*, 111). See also Gage 1993, *Colour and Culture*, ch. 2. The fullest discussion of the context of Pliny's and Cicero's account is H. Jücker 1950, *Vom Verhältnis der Römer zur bildenden Kunst der Griechen*, espec. 140-57.

70 D. R. Edward Wright 1984, 'Alberti's *De Pictura*', *Journal of the Warburg and Courtauld Institutes*, XLVII, 52-71. Alberti's Italian and Latin texts have now been brought together by C. Grayson, ed. 1973, *Alberti, Opere Volgari*, III, although Grayson has not accepted the convincing arguments of Simonelli for placing the Italian before the Latin version (M. P. Simonelli 1972, 'On Alberti's Treatises and Their Chronological Relationship', *Yearbook of Italian Studies, 1971*, 75-102).

71 S. Y. Edgerton 1969, 'Alberti's Colour Theory: A Mediaeval Bottle without Renaissance Wine', *Journal of the Warburg and Courtauld Institutes*, XXXII, 112ff. C. Maltese 1976, 'Colore, luce e movimento nello spazio Albertiano', *Commentari*, XXVII, 238-46, has contested Edgerton's view of Alberti's traditionalism, but has replaced it with an equally implausible notion that Alberti was

groping towards a modern conception of three-dimensional colour-space. C. Parkhurst, 'Leon Battista Alberti's Place in the History of Color Theories' in M. B. Hall, ed. 1987, *Color and technique in Renaissance Painting, Italy and the North*, 161-204, presents some valuable new material on Alberti's Antique sources, but also includes a quite unrealistic account of his medieval background. M. Barasch 1978, *Light and Color in the Italian Renaissance Theory of Art*, 27-31, confuses the relationship of the Latin and Italian versions of Alberti's text on white, black, and the hues. Certainly in the Latin version Alberti shows himself anxious to distance himself from 'the philosophers' and to speak 'as a painter', which suggests that he anticipated the objections of a learned audience. On the two versions, see also N. Maraschio 1972, 'Aspetti del bilingualismo albertiano nel 'De Pictura', *Rinascimento*, 2nd ser., XII, 183-228, espec. 208-14 on colour-terms. See also L. Gérard-Merchaut 1991, 'Les indications chromatiques dans le *De Pictura* et le *Della Pittura* d'Alberti', *Histoire de l'Art*, XI, 23-36.

72 Alberti, *De Pictura*, I, 10, II, 47, and for the contemporary discussions of Sendivogius at Cracow and Hamerlin in Vienna, G. Rosinska 1986, 'Fifteenth Century Optics between Medieval and Modern Science', *Studia Copernicana*, XXIV, 127, 152ff (Polish with English summary). See also J. S. Ackerman 1980, 'On Early Renaissance Color Theory and Practice', *Studies in Italian Art and Architecture, Fifteenth through Eighteenth Centuries* (*Memoirs of the American Academy in Rome, XXXV*), 3.

73 *De Pictura*, II, 48; cf. S. Pezzella (op. cit. n. 62 above). Both Alberti and Antonio da Pisa describe the way that the interposition of white makes the other colours 'joyful', and Alberti uses the same idea when he recommends colours for dress in *I libri della famiglia* (*Opere volgari*, ed. C. Grayson 1960, I, 202).

74 The best edition is K. Bergdolt 1988, *Der Dritte Kommentar Lorenzo Ghibertis: Naturwissenschaften und Medezin in der Kunsttheorie der Frührenaissance*. Ghiberti's sources have been listed most accessibly by G. ten Doesschate 1932, 'Over de Bronnen van de 3de Commentaar van Lorenzo Ghiberti', *Tijdschrift voor Geschiednis*, 432-7. Also G. F. Vescovini 1965, 'Contributo per la storia della fortuna di Alhazen in Italia: Il volgarizzamento del MS Vaticano 4595 ed il 'Commento Terzo' del Ghiberti', *Rinascimento*, 2nd ser., v, 18-41.

75 C. Maltese, 'Il colore per Leonardo dalla pittura alla scienza' in P. Rossi and E. Bellone, eds 1981, *Leonardo e l'età della ragione*, 171-84; idem, 'Leonardo e la teoria dei colori', *Römisches Jahrbuch für Kunstgeschichte*, xx, 1983, 211-19.

76 M. Kemp 1990, *The Science of Art*, 268f.

77 Maltese, 'Leonardo e la teoria…' (cit. n. 75 above) 218; J. Gantner 1969, 'Colour in the Work of Leonardo', *Palette*, XXXII, 8-26.

78 M. Barasch 1978, *Light and Color in the Italian Renaissance Theory of Art*, 64f; J. Gavel 1979, *Colour: A Study of Its Position in the Art Theory of the Quattro- and Cinquecento*, 111f; J. Bell 1993, 'Aristotle as a source for Leonardo's theory of colour perspective after 1500', *Journal of the Warburg and Courtauld Institutes*, LVI, 100-18. A useful collection of Leonardo's notes on colour is in M. Kemp and M. Walker, eds 1988, *Leonardo on Painting. An Anthology of Writings by Leonardo daVinci with a Selection of Documents Relating to His Career as an Artist*, Pt II.

79 Barasch, 53f; M. Kemp 1981, *Leonardo daVinci: The Marvellous Works of Nature and Man*, 97; and idem, 267f.

80 Verbraeken (op. cit. n. 37 above) 91ff; G. F. Folena 1951, 'Chiaroscuro Leonardesco', *Lingua nostra*, XII, 56-62; Z. Z. Filipczak 1977, 'New Light on Mona Lisa: Leonardo's Optical Knowledge and His Choice of Lighting', *Art Bulletin*, LIX, 518-22. C. J. Farago 1991, 'Leonardo's color and chiaroscuro reconsidered: the visual force of painted images', *Art Bulletin*, LXXIII, 63-88.

81 J. Shearman, 1962, 'Leonardo's Colour and Chiaroscuro', *Zeitschrift für Kunstgeschichte*, XXV, 30.

82 J. Meder, *Die Handzeichnung*, 2nd ed. 1923, 116,136.

83 T. Brachert 1970, 'A Distinctive Aspect of the Painting Technique of the *Ginevra de'Benci* and of Leonardo's Early Works' in Washington, DC, National Gallery of Art, *Report and Studies in the*

History of Art 1969, 84ff; idem 1974, 'Radiographische Untersuchungen am Verkündigungsbild von Monte Oliveto', *Maltechnik/Restauro*, LXXX, 180; and idem 1977, 'Die beiden Felsgrottenmadonnen von Leonardo da Vinci' in ibid., LXXXIII, 11.

84 Dittmann (op. cit. n. 26 above) 119; cf. W.J. Hofmann 1971, *Über Dürers Farbe*.

85 B. Saran 1972, 'Der Technologe und Farbchemiker "Matthias Grünewald"', *Maltechnik*, IV, 228ff.

86 Apart from the works by Barasch and Gavel (op. cit. n. 78 above), the chief studies have been J. A. Thornton 1979, 'Renaissance Color Theory and Some Paintings by Veronese', PhD diss., University of Pittsburgh; idem, 'Paolo Veronese and the choice of colors for a painting' in M. Gemin (ed.) 1990, *Nuovi Studi su Paolo Veronese*, 149-65; P. Rubin 1991, 'The art of colour in Florentine painting of the early sixteenth century: Rosso Fiorentino and Jacopo Pontormo', *Art History*, XIV, 175-91; M. Hall 1992, *Color and Meaning: Practice and Theory in Renaissance Painting*; C. Wagner 1996, *Farbe und Mataphor: Die Entstehung einer neuzeitlichen Bildmetaphorik in der vorrömischen Malerei Raphaels*. L. K. Caron 1985, 'Choices Concerning Modes of Modeling during the High Renaissance and After', *Zeitschrift für Kunstgeschichte*, XLVIII, 476-89; idem 1988, 'The Use of Color by Rosso Fiorentino', *Sixteenth-Century Journal*, XIX, 355-78. I have tried to detach Giorgione and Titian from colour-theory in Gage 1993, *Colour and Culture*, 34, but see D. Gioseffi 1979, 'Giorgione e la pittura tonale' in *Giorgione: Atti del Convegno Internazionale di Studio per il 50 Centenario della Nascita 1978*, 95, for an attempt to link Giorgione's practice with the 'four-colour theorem' of mathematics.

87 For Arcimboldo, see T. D. Kaufmann 1989, *The School of Prague. Painting at the Court of Rudolph II*; for Kepler, *Opera Omnia*, ed. C. Frisch 1858, I, 200; and for de Boodt, C. Parkhurst 1971, 'A Color Theory from Prague: Anselm de Boodt', *Allen Memorial Art Museum Bulletin*, XXIX, 3-10. Scarmilionius's *De Coloribus* was published at Marburg in 1601. For the general cultural milieu of Prague, see R. J. W. Evans 1973, *Rudolf II and His World*; and Essen, Villa Hügel, and Vienna, Kunsthistorisches Museum, *Prag um 1600: Kunst und Kultur am Hofe Rudolphs II*, 1988.

88 See Kemp (op. cit. n. 76) 275-82, for a summary of this literature. For Testa, see Cropper (op. cit. n. 12 above).

89 J. C. Bell 1985, 'The Life and Works of Matteo Zaccolini (1574-1630)', *Regnum Dei*, XLI, 227-58; idem 1993, 'Zaccolini's theory of color perspective', *Art Bulletin*, LXXV, 91-112. Janis Bell is preparing an edition of Zaccolini's writings on colour, part of which appeared in her dissertation, 'Color and Theory in Seicento Art. Zaccolini's 'Prospettiva del Colore' and the Heritage of Leonardo', PhD diss., Brown University 1983.

90 B. Teyssèdre 1965, *Roger de Piles et les débats sur le coloris au siècle de Louis XIV*. For a brief English summary, see A. Soreil 1963, 'Poussin versus Rubens: The Conflict between Design and Colour in France', *Palette*, XII, 3-12; and for some Roman antecedents to this debate, see M. Poirier 1979, 'Pietro da Cortona e il dibattito disegno-colore', *Prospettiva*, XVI, 23-30.

91 M. Rzepińska 1986, 'Tenebrism in Baroque Painting and Its Ideological Background', *Artibus et Historiae*, XIII, 91-112.

92 Kemp (op. cit. n. 76 above) 286-90.

93 Colour-systems have been investigated by F. Gerritsen 1979, 'Evolution of the Color Diagram', *Color Research and Application*, IV, 33ff; C. Parkhurst and R. L. Feller 1982, 'Who Invented the Color Wheel?', ibid., VII, 219ff; M. Richter 1984, 'The Development of Color Metrics', ibid., IX, 69-83; S. Hesselgren, 'Why Color-Order Systems?' ibid., 220-28; H. Matile, *Die Farbenlehre Phillipp Otto Runges*, 2nd ed. 1979, 58-83; and Kemp (op. cit. n. 76 above) 289-92.

94 J. E. Purkinje 1918, *Beobachtungen und Versuche zur Physiologie der Sinne*, II (1825), *Opera omnia*, Prague, I, 118f; and P. de la Hire (1685), *Dissertations sur les differens accidens de la Vüe* I, V, in Baxandall (op. cit. n. 20 above) 90. For some later painterly examples, see above, ch. 1.

95 On Meyer's contribution, see Strauss (op. cit. n. 23 above) 335.

96 For the earlier literature, see F. Amrine, 'Goethe and the Sciences: An Annotated Bibliography, VII, Color Theory and Optics' in F. Amrine, F. J. Zucker and H. Wheeler 1987, *Goethe and the Sciences: A Reappraisal* (Boston Studies in the Philosophy of Science, XCVII), 419-23; S. M. Gruner 1974, 'Goethe's Criticisms of Newton's Optics', *Physis*, XVI, 66-82; N. B. Ribe 1985, 'Goethe's Critique of Newton: A Reconsideration', *Studies in the History and Philosophy of Science*, XVI, 315-35; F. Burwick 1986, *The Damnation of Newton: Goethe's Color Theory and Romantic Perception* (chap. II of this study is the best English account of Goethe's theory and its reception); G. Böhme, 'Is Goethe's Theory of Color Science?' in F. Amrine *et al.*, *Goethe and the Sciences*..., 147-73; H. O. Proskauer 1986, *The Rediscovery of Color: Goethe versus Newton Today* (a trans. of *Zum Studium von Goethes Farbenlehre*, 1951); D. L. Sepper, 'Goethe against Newton: Towards Saving the Phenomenon', in Amrine *et al.*, 175-93; idem, *Goethe contra Newton. Polemics and the Project for a New Science of Color*, 1988 (the most useful history of Goethe's researches for readers without German); and M. J. Duck 1988, 'Newton and Goethe on Colour: Physical and Physiological Considerations', *Annals of Science*, XLV, 507-19.

97 D. Gray 1952, *Goethe the Alchemist*; and B. J. T. Dobbs 1975, *The Foundations of Newton's Alchemy*. See now the remarks of A. E. Shapiro 1993, *Fits, Passions and Paroxysms: Physics, Method and Chemistry and Newton's Theories of Coloured Bodies and Fits of Easy Reflection*, 74-6, 116 n.

98 See, however, the over-pessimistic discussion by M. K. Torbruegge 1974, 'Goethe's Theory of Color and Practicing Artists', *Germanic Review*, XLIX, 189-99. Torbruegge finds little evidence of Goethe's effect on artists in any period, although his impact on the early 20th century, on the avant-garde, and on other artists is well documented: A. Brass 1906, *Untersuchungen über das Licht und die Farben*, I, Teil. Brass was close to an unspecified group of artists in Munich (M. Richter, *Das Schrifttum über Goethes Farbenlehre*, 1938, no. 41). For the revival of interest in Goethe's work in Kandinsky and Mondrian, see below pp.195, 252, 260. The use of Goethe's *Theory* by E. L. Kirchner and the Dutch painter Jan Wiegers was the subject of the exhibition, *Goethe, Kirchner, Wiegers. De Invloed van Goethe's Kleurenleer*, Groningen Museum, 1982.

99 Most recently Heinz Matile has represented the view that Runge's and Goethe's views on colour were closely related: P. O. Runge, *Farben-kugel, Neudruck der Ausgabe Hamburg 1810 mit einem Nachwort von Heinz Matile*, 1977, *Nachwort* II-III; Matile (op. cit. n. 93 above) 148, and espec. 224-7 on Runge's links with Goethe's earlier *Beiträge zur Optik*; on p. 231 Matile points to some important differences between Goethe's and Runge's views, and on pp. 235-41 to their very similar approach to harmony. For a more sceptical treatment, see below Chapter 13.

100 This was, however, only published in recent times: S. A. Forsius, *Physica*, ed. J. Nordström 1952, *Uppsala Universitets Årsskrift*, X, 316-19. Forsius's colour-space is not three-dimensional in the modern sense, as Runge's is, since the Swede sought to incorporate black and white into the two-dimensional section of the sphere. On Forsius, see R. L. Feller and A. S. Stenius 1970, 'On the Color-Space of Sigfrid Forsius', *Color Engineering*, VIII, 48-51.

101 H. Matile (op. cit. n. 93 above) has related Runge's metaphysics to Jacob Boehme's colour-theory, 130-42; and to German Romantic thought, 'Runges Farbenordnung und die "unendliche Kugel"' in H. Hohl (ed.) 1979, *Runge Fragen und Antworten*, 269-72. The most coherent account of Lomazzo's colour-theory is now Kemp (op. cit. n. 76 above) 66-77.

102 Matile (op. cit. n. 93 above) 202-3.

103 See M. Kemp, 'Yellow, Red and Blue. The Limits of Colour Science in Painting, 1400-1730' in A. Ellenius (ed.) 1985, *The Natural Sciences and the Arts (Actua Universitatis Upsaliensis*, XXII), 98-105.

104 The German context has been outlined by B. Rehfus-Dechêne 1982, *Farbengebung und Farbenlehre in der deutsche Malerei um 1800*. For England, see G. Finley 1967, 'Turner: An Early Experiment with Colour Theory', *Journal of the Warburg and Courtauld Institutes*, XXX, 357-66; P. D. Schweitzer 1982, 'John Constable, Rainbow

Science, and English Color Theory', *Art Bulletin*, XLIV, 424-45; and Gage (op. cit. n. 54 above), 12-28. A study of the French literature is one of the most urgent tasks of the colour historian. See now B. Howells, 'The problem with colour: three theorists, Goethe, Schopenhauer, Chevreul' in P. Collier and R. Lethbridge (eds) 1994, *Artistic Relations: Literature and Visual Arts in Nineteenth Century France*, 76-93.

105 Matile (op. cit. n. 93 above) 185-91.

106 J. Gage 1969, *Colour in Turner: Poetry and Truth*, espec. chap. 11; and idem 1984, 'Turner's Annotated Books: Goethe's *Theory of Colours*', *Turner Studies*, IV, 2, 34-52. G. Finley 1973 has pointed to Turner's positive evaluation of Newton about 1818: 'A "New Route" in 1822: Turner's Colour and Optics', *Journal of the Warburg and Courtauld Institutes*, XXXVI, 389, n. 33. See also U. Seibold 1987, *Zum Verständis des Lichts in der Malerei J. M. W. Turners*, PhD diss., Heidelberg, 101-11, and G. Finley, 'Pigment into Light': Turner and Goethe's "Theory of Colours"' in F. Burwick and J. Klein (eds) 1996, *The Romantic Imagination: Literature and Art in England and Germany*, 357-76.

107 L. Johnson 1963, *Delacroix*, 63-72, based on idem 1958, 'Colour in Delacroix: Theory and Practice', PhD diss., Cambridge University. See also J. B. Howell 1982, 'Eugène Delacroix and Color: Practice, Theory and Legend', *Athanor*, II, 37-43.

108 For the note and the triangle, see Kemp (op. cit. n. 76 above) 308; J. F .L. Mérimée (1830), *De la Peinture à l'huile*, 1981, ill. facing 272 and 274-5. For the date of the note, see below p. 297, col. 2, n. 15. Delacroix and Mérimée were both members of a government committee on the arts in 1831 (L. Rosenthal 1914, *Du Romantisme au réalisme*, 5). For Mérimée's career, Gage 1993, *Colour and Culture*, 214-15.

109 For the lecture notes, now in the Cabinet de Dessins of the Louvre, see Kemp (op. cit. n. 76 above) 310, and for Delacroix's proposed visit to the chemist, see Signac (op. cit. n. 62 above) 76.

110 For Blanc's interpretation of Delacroix, see Johnson (op. cit. n. 28 above) 63-72; G. Roque 1996, 'Chevreul and Impressionism: a reappraisal', *Art Bulletin*, LXXVIII, 26-39.

111 M. Song, 1984, *Art Theories of Charles Blanc, 1813-1882*.

112 The colour-star in *Grammaire des arts du dessin* (1867), 599, derives from J. Ziegler 1850, *Études céramiques*, 199, repr. in idem 1852, *Traité de la couleur et de la lumière*, 16.

113 R. L. Herbert et al., 1991, *Georges Seurat 1859-1891*, 397-8. The fullest account of the *papier de Gauguin* is in M. Roskill 1969, *Van Gogh, Gauguin and the Impressionist Circle*, 267-8. Roskill inclined to think that the text, printed conveniently in L. Nochlin (ed.) 1966, *Impressionism and Post-Impressionism, 1874-1904*, 166-7, was authentically Turkish, but parts of it seem too close, e.g., to Blanc, *Grammaire*, 606, not to arouse our suspicions.

114 R. A. Weale 1972, 'The Tragedy of Pointillisme', *Palette*, XL, 16ff; A. Lee 1987, 'Seurat and Science', *Art History*, X, 203-26. See also below Ch. 16.

115 A. Laugel 1869, *L'Optique et les arts*, 151. For Delacroix's circle, see Johnson (op. cit. n. 28 above), 56, pl. 34. For Seurat's, see below, pl. 106.

116 Herbert (op. cit. n. 115 above); J. Arguëlles 1972, *Charles Henry and the Formation of a Psychophysical Aesthetic*.

117 Badt (op. cit. n. 31 above).

118 E. van Uitert, 'De toon van Vincent van Gogh: Opvattingen over Kleur en zijn hollandse Periode', *Simiolus*, II, 1966-7, 106, 108-9 (with English summary), has made a careful study of Vincent's early use of Fromentin and Blanc. See B. Welsh-Ovcharov 1976, *Vincent van Gogh; His Paris Period, 1886-1888*, 65-6; J. A. Walker 1981, 'Van Gogh's Colour Theories and Their Relevance to the Paintings of the Arles Period' in *Van Gogh Studies: Five Critical Essays*, 7, n. 6. I have touched on Vincent's use of A. Cassagne, *Traité d'aquarelle* (1875) in 'Constancy and Change in Late Nineteenth-Century French Painting' in United Kingdom Instititute for Conservation Reprints, *Appearance, Opinion, Change: Evaluating the Look of Paintings*, 1990, 32-5.

119 P. Sérusier (1921), *ABC de la peinture*, 3rd ed. 1950, 29, 94-5;

also in Hess (op. cit. n. 31 above), 64-9. See also C. Boyle-Turner 1983, *Paul Sérusier*, espec. 84.

120 R. Shiff 1978, 'Seeing Cézanne', *Critical Inquiry*, IV, 786ff; and idem 1978, 'The End of Impressionism: A Study in Theories of Artistic Expression', *Art Quarterly*, new ser. I, 347ff.

121 For extreme perceptualist views see G. J. R. Frankl (1951), 'How Cézanne Saw and Used Colour' in J. Wechsler (ed.) 1975, *Cézanne in Perspective*, 125-30; H. Damisch, 'La Géometrie de la couleur' in C. de Peretti (ed.) 1982, *Cézanne, ou la peinture en jeu*, 42.

122 L. Gowing, 'The Logic of Organized Sensations' in W. Rubin (ed.) 1977, *Cézanne: The Late Work*, 55-71; E. Strauss (1980), 'Nachbetrachtungen zur Pariser Cézanne-Retrospective 1978' in Strauss (op. cit. n. 23 above) 164, 183. Both Gowing and Strauss seek to analyse the painter's idiosyncratic terminology, but neither of them looks at its immediate context in French philosophy and psychology. I have tried to make a start in 'Constancy and Change...' (cit. n. 118 above).

123 Matisse (op. cit. n. 14 above) notable for its detailed index; D. Fourcade 1976, 'Autres Propos de Henri Matisse', *Macula*, I; J. Flam (ed.) 1973, *Matisse on Art* (a shorter selection than the French, but with some pieces not in Fourcade); H. Roethel and H. Hahl-Koch 1980, *Kandinsky: Die Gesammelte Schriften*, I; W. Kandinsky, *Complete Writings on Art*, ed. K. Lindsay and P. Vergo 1982; idem, *Écrits*, ed. P. Sers 1975 (Vol. III of this edition includes the unpublished notes for his Bauhaus lectures); F. Marc, *Schriften*, ed. K. Lankheit 1978; F. Kupka, *La Création dans les arts plastiques*, ed. and trans. E. Abrams 1989; R. Delaunay, *Du Cubisme à l'art abstrait*, ed. P. Francastel 1957; R. and S. Delauney, *The New Art of Color*, ed. and trans. A. A. Cohen 1978; P. Klee, *Schriften Rezenzionen und Aufsäze*, ed. C. Geelhaar 1976; idem, *The Diaries*, ed. F. Klee 1965; J. Spiller, ed. 1964, *Paul Klee: The Thinking Eye*; idem 1973, *Paul Klee, The Nature of Nature* (both extracts from Klee's Bauhaus lectures); P. Mondrian, *The New Art -The New Life: The Collected Writings*, ed. and trans. H. Holzmann and M. S. James 1986; T. van Doesburg, *Scritti di arte di architettura*, ed. S. Polano 1979; J. Baljeu 1977, *Theo van Doesburg*; W. Nicholson 1987, *Unknown Colour*; H. Hofmann, *The Search for the Real*, 2nd ed. 1967; K. Malevich, *Essays on Art*, ed. and trans. T. Andersen 1969-78; idem, *Écrits*, ed. A. Nakov, 2nd ed., 1986; and V. Knight (ed.) 1988, *Patrick Heron*.

124 J. E. Bowlt 1976, *Russian Art of the Avant-Garde: Theory and Criticism, 1902-1934*; N. Watkins 1984, *Matisse*, drawing on his 1979 dissertation, 'A History and Analysis of the Use of Colour in the Work of Matisse', M.Phil. thesis, London, Courtauld Institute; V. Spate 1979, *Orphism*; W. Rotzler, *Johannes Itten: Werke und Schriften*, 2nd ed. 1978; C. Lodder 1983, *Russian Constructivism*. A. Doig 1986, *Theo van Doesburg: Painting into Architecture, Theory into Practice*. C. Blotkamp et al. 1986, *De Stijl: The Formative Years*. W. Venzmer 1982, *Adolf Hoelzel: Leben und Werk*.

125 H. B. Chipp 1958, 'Orphism and Color Theory', *Art Bulletin*, XL, 55-63; J. E. Bowlt 1973-4, 'Concepts of Color and the Soviet Avant-Garde', *The Structurist*, XIII/XIV, 20-9; C. Douglas, 'Colors without Objects: Russian Color-Theories (1908-1932)' in ibid., 30-41; J. F. Moffitt, 'Fighting Forms: The Fate of the Animals: The Occultist Origins of Franz Marc's "Farbentheorie"', *Artibus et Historiae*, XII, 1985, 107ff; R. Wankmüller 1960, 'Zur Farbe bei Paul Klee', *Studium generale*, XIII, 427-35; M. Huggler 1967, 'Die Farbe bei Paul Klee', *Palette*, XXII, 13-22; E. Strauss (1970), 'Paul Klee: *Das Licht und Etliches*' (op. cit. n. 33 above) 219-26; idem, 'Zur Helldunkellehre Klees', ibid. 227-39; L. Nochlin, 'Picasso's Color: Schemes and Gambits', *Arts in America*, Dec. 1980, 105-23, 177-83; R. Bothner 1987, 'Mark Rothkos Modulationen', *Pantheon*, XLV, 172ff. I have taken the discussion of Rothko rather further in 'Rothko: Color as Subject', an essay for the catalogue of the Rothko exhibition, Washington, DC, National Gallery of Art, 1998.

126 For example, C. C. Bock 1981, *Henri Matisse and Neo-Impressionism, 1898-1908*; S. Buckberrough 1982, *Robert Delaunay: The Discovery of Simultaneity*; G. Levin 1978, *Synchromism and American Color Abstraction, 1910-1925*; N. G. Parris 1979, 'Adolf Hoelzel's

Structural and Color Theory and Its Relationship to the Development of the Basic Course at the Bauhaus', PhD diss., University of Pennsylvania; C. V. Poling 1973, 'Color Theories of the Bauhaus Artists', PhD diss., Columbia University; idem 1982, *Kandinsky-Unterricht am Bauhaus: Farbseminar und Analytisches Zeichnen* (English version: *Kandinsky Teaching at the Bauhaus: Color Theory and Analytical Drawing*, 1987).

127 H. Weitemeier, *Schwartz*, Düsseldorf, Kunsthalle, 1981; M. Besset *et al.*, *La Couleur seule: L'Expérience du monochrome*, Lyon, Musée des Beaux-Arts, 1988; P. Colt, intro., *Color and Field 1890-1970*, exhib. cat., Buffalo, 1970; M. Tucker, *The Structure of Color*, New York, Whitney Museum of American Art, 1971; M. Tuchman, ed., *The Spiritual in Art 1890-1985*, Los Angeles, 1986.

128 J. Gage 1982, 'Colour at the Bauhaus', *AA Files*, I. A good deal of attention has been given recently to the history of colour-systems: see n. 94 above and S. Wurmfeld 1985, *Color Documents: A Presentative Theory*, New York, Hunter College; F. Birren 1979, 'Color Identification and Nomenclature: A History', *Color Research and Application*, IV, 14ff; R. S. Berns and F. W. Billmeyer, Jr 1985, 'Development of the 1929 Munsell Book of Color: A Historical Review' in ibid., X, 246-50; M. Richter and K. Witt 1986, 'The Story of the DIN Color Systems' in ibid., XI, 138ff; F. W. Billmeyer, Jr 1987, 'Survey of Colour Order Systems' in ibid., XII, 173ff; W. D. Wright, 'The Historical and Experimental Background to the 1931 CIE System of Colorimetry' in Society of Dyers and Colorists, *Golden Jubilee of Colour in the CIE*, London, 1981, 3-18.

129 G. J. von Allesch 1925, 'Die aesthetische Erscheinungsweise der Farben', *Psychologische Forschung*, VI, 1-91, 215-81. Allesch's report was based on work with largely professional people in the early 1900s (p.18); his results were reviewed in English by A. R. Chandler 1934, *Beauty and Human Nature*.

130 I owe this information to the kindness of Dr Anna Rowlands. For the prospectus, see H. M. Wingler, *The Bauhaus*, 3rd ed. 1976, 31-3. 'The physical and chemical theory of color' and 'rational painting methods' were included under the general rubric of 'Training in Science and Theory'. The Statutes of the Bauhaus of January 1921 (Wingler, 44-8) include the 'Preliminary Course', but mention colour only under 'supplementary subjects of instruction'.

131 See the timetable of *c.* 1924 published by F. Whitford 1984, *Bauhaus*, 102.

132 P. Klee, *Beiträge zur bildnerischen Formlehre*, ed. J. Glaesemer 1979. For the dating, see Matile (op. cit. n. 93 above) 373-4, n. 611.

133 T. Lux Feininger in J. D. Farmer and G. Weiss 1971, *Concepts of the Bauhaus: The Busch-Reisinger Museum Collection*, 47. A plan for the preliminary Course at Dessau, however (Wingler, 109), includes colour under form. See also H. Düchting 1996, *Farbe am Bauhaus; Synthese und Synästhesie*.

134 A. Lee 1981, 'A Critical Account of Some of Josef Albers' Concepts of Color', *Leonardo*, XIV 99-105; see also letters from R. Arnheim and Lee in ibid., XV, 1982, 174-5. On Albers' appropriation of Goethe's name, but not his concepts, for his colour triangle, see also Torbruegge (op. cit n. 98 above) 198. For a general survey of 20th-century theories of colour in relation to painting, see E. C. Elliott 1960, 'Some Recent Conceptions of Color Theory', *Journal of Aesthetics and Art Criticism*, XVIII, 494-503; C. A. Riley 1995, *Color Codes: Modern Theories of Color in Philosophy Painting and Architecture, Literature, Music and Psychology*.

135 O. Wulff 1941, 'Farbe, Licht und Schatten in Tizians Bildgestaltung', *Jahrbuch der preussischen Kunstsammlungen*, LXII, 108.

136 H. Jantzen 1951, 'Über Prinzipien der Farbengebung in der Malerei' in *Über den gotischen Kirchenraum*, 61-7.

137 T. Hetzer, *Tizian. Die Geschichte seiner Farbe*, 3rd ed. 1969, 116. See also R. Kudielka, 'Zum Versuch, von Tizians Farbkunst ein auschaulichen Begriff durch Farbabbildungen zu geben' in G. Berthold (ed.) 1992, *Schriften Theodor Hetzers*, VII, 15-35.

138 Wulff (op. cit. n. 135 above) 120; cf. also Lichtwark (op. cit. n. 16 above) 13.

139 Cennini, chap. CLXXIII. An extended study of northern

Gothic panel- and glass-painting has led Eva Frodl-Kraft to date an interest in absolute rather than representational colour (chiefly in drapery) from this period: E. Frodl-Kraft, 'Farbendualitäten, Gegenfarben, Grundfarben in der gotischen Malerei' in M. Hering-Mitgau et al. (eds) 1980, *Von Farbe und Farben: Albert Knoepfli zum 70. Geburtstag*, 298; idem 1977-8, 'Die Farbsprache der gotischen Malerei', *Wiener Jahrbuch für Kunstgeschichte*, XXX/XXXI, 89-178. See also above, n. 73.

140 An exception is the remarkable exhibition held in 1983 in the Volkerkunde-Museum in Berlin: H. Nixdorff and H. Müller, *Weisse Westen – Rote Roben: Von den Farbordnungen des Mittelalters zum individuellen Farbgeschmack*, Berlin, Staatliche Museen preussischer Kulturbesitz, 1983. See also the brief discussion by W. Brüchner 1982, 'Farbe als Zeichen: Kulturtradition im Alltag', *Zeitschrift für Volkskunde*, LXXVIII, 14-27. There is much important material in English in J. Sekora 1977, *Luxury: The Concept in Western Thought, Eden to Smollett*. See also M. Pastoureau, 'Vers une Histoire sociale des couleurs' (cit. n. 5 above), espec. 31-40. The otherwise rather sketchy study by M. Brusatin, *Storia dei colori*, 2nd ed. 1983 (French version, 1986, English version, 1991) has some excellent material on colour in dress.

141 H. Siebenhühner 1935, *Über den Kolorismus der Frührenaissance, vornehmlich dargestellt an dem Trattato della Pittura des L.B. Alberti*, PhD diss., Leipzig.

142 J. Shearman 1965, *Andrea del Sarto*, I, 135; the whole of the account of Sarto's colour in chap. VIII is masterly; idem (op. cit. n. 81 above),14ff; and M. B. Hall, 'From Modeling Techniques to Color Modes' in Hall (op. cit. n. 71 above) 3 and n. 9.

143 K. H. Tachau 1988, *Vision and Certitude in the Age of Occam*, 96, n. 34; cf. also 327, n. 36 and 329, n. 43. The discussion of the fall of light on a dove's neck or a peacock's tail is here supplemented by refence to the new (shot?) textiles. The 'birds' feathers' tradition has been surveyed from the Peripatetic *De coloribus* to Newton by H. Guerlac 1986, 'Can There Be Colors in the Dark? Physical Color Theory before Newton', *Journal of the History of Ideas*, XLVII, 3-20.

144 *Archivum franciscanum historicum*, VII, 1914, nos 207, 208, 227, and espec. 239 (*cagnacolore*). Donald King has kindly informed me of a Pisan brokerage list of 1323 referring to *tartarini dicti cangia colore*, which suggests a Central Asian origin. See R. Kuehni 1996, 'Cangiante: a fabric and a coloristic device in the Art of the Renaissance', *Color Research and Application*, 21, 326-30.

145 The most useful survey is still E. W. Bulatkin 1954, 'The Spanish word 'Matiz': Its Origin and Semantic Evolution in the Technical Vocabulary of Medieval Painters', *Traditio*, X, 461ff.

146 As late as 1436 an inventory of St Peter's in Rome described a dalmatic and tunicle as 'viridia sive crocea' (E. Müntz and A. L. Frothingham 1883, *Il Tesoro della Basilica di S. Pietro*, 65).

147 Gavel (op. cit. n. 78 above), 115, n. 15, distinguishes between 'colour-change', which he sees as a modelling technique only, and *cangianti*, which is related to specific textiles.

148 The best survey is still B. J. Kouwer 1949, *Colours and Their Character: A Psychological Study*. Several important essays on Western colour-symbolism from Antiquity until the 19th century were included in *The Realms of Colour* (*Eranos Yearbook*, 1972), 1974, and three of them were reprinted in S. Haule (ed.) 1977, *Color Symbolism*. See also G. Ortiz 1992, *El Significado de los Colores*.

149 G. Haupt 1941, *Die Farbensymbolik in der sakralen Kunst des abendländischen Mittelalters: Ein Beitrag zur mittelalterlichen Form-und Geistesgeschichte*.

150 P. Dronke, 'Tradition and Innovation in Mediaeval Western Colour-Imagery', *Eranos Yearbook* (cit n. 148 above), 51-107, repr. in *The Mediaeval Poet and His World*, 1984. F. Haeberlein 1932-3, 'Zur Farbenikonographie des Mittelalters', *Annales instititorum*, Rome, V; idem 1939, 'Grundzüge einer nachantiken Farbikonographie', *Römisches Jahrbuch für Kunstgeschichte*, III, 75-126, also remain, despite some attempts at visual colour reconstructions, closely based on written texts.

151 See, for example, Haupt's remarks on red and purple and yellow and gold, *c.* 46f; also C. Meier 1977, *Gemma Spiritualis: Methode und*

Gebrauch der Edelsteinallegorese vom frühen Christentum bis ins 18 Jahrhundert, Bk I, 152.

152 For example, see Meier (op. cit.) 147ff, on the sard. See also her general discussion of the problems of symbolic interpretation (1974) in 'Das Problem der Qualitätenallegorese', *Frühmittelalterliche Studien,* VIII, espec. 387ff on colour; also F. Ohly 1977, *Schriften zur mittelalterlichen Bedeutungsforschung,* XVI-XXI. For the ill-fated dictionary of medieval colour symbolism, C. Meier and R. Suntrup 1987, 'Zum Lexikon der Farbenbedeutungen im Mittelalter', *Frühmittelalterlichen Studien,* XXI, 390-478 (including a sample entry on 'red').

153 See, for example, M. Bornstein 1976, 'Name Codes and Color Memory', *American Journal of Psychology,* LXXXIX, espec. 274.

154 The classic treatment of J. B. Weckerlin 1905, *Le Drap 'escarlate' au Moyen Age,* has now been subject to revision by J. H. Munro, 'The Mediaeval Scarlet and the Economics of Sartorial Splendour' in N. B. Harte and K. G. Ponting (eds) 1983, *Cloth and Clothing in Mediaeval Europe,* 13ff; but there is no doubt that the documents record 'scarlets' of many hues. A similar case is the obsolete colour term *perse,* which comprised many colours, and may also refer to a quality of cloth (below p. 68).

155 M. Pastoureau 1979, *Traité d'héraldique;* and idem 1983, *Armorial des chevaliers de la Table Ronde.* Arthurian heraldic blazon has also been treated in detail by G. J. Brault 1972, *Early Blazon, Heraldic Terminology in the Twelfth and Thirteenth Centuries with Special Reference to Arthurian Literature.* Many of Pastoureau's essays have been gathered in *L'Hermine et le sinople,* 1982; *Figures et couleurs: Études sur la symbolique et la sensibilité médiévales,* 1986; and *Couleurs, images* (cit. n. 5 above). Pastoureau's insistence on the abstract character of heraldic colour, restated recently in 'Vers une histoire sociale des couleurs' (*Couleurs, images,* 43) seems to me to overlook the history and concrete character of heraldic language, which he has also noted in passing ('Couleurs, décors, emblèmes' in *Figures et couleurs,* 52).

156 'Farbe (Liturgisch)', *Reallexikon zur deutschen Kunstgeschichte,* VII, 1981, cols 54-139.

157 On Rubens, see C. Parkhurst 1961, 'Aguilonius' Optics and Rubens' Color', *Nederlands Kunsthistorisch Jaarboek,* XII, 35-49; M. Jaffé 1971, 'Rubens and Optics: Some Fresh Evidence', *Journal of the Warburg and Courtauld Institutes,* XXXIV, 326-66; and Kemp (op. cit. n. 76 above) 275-7. On Poussin, see O. Bätschmann, 'Farbgenese und Primärfarbentrias in Nicholas Poussins "Die Heilung der Blinden"' in M. Hering-Mitgau *et al.* (n. 139 above), 329-36; idem, *Dialektik der Malerei von Nicholas Poussin,* 1982 (English trans. 1990), chaps I, III; and Kemp (op. cit. n. 76 above) 278-81. On Turner, see J. Gage, *Colour in Turner* (cit. n. 106 above), chap. 11.

158 For a structural analysis of this series, see J. Albrecht 1974, *Farbe als Sprache: Robert Delaunay, Josef Albers, Richard Paul Lohse,* 60-113.

159 The study of frames and hanging conditions has blossomed in recent years: see J. Foucart 1987, 'Bibliographie du cadre', *Revue de l'art,* LXXVI, 60-62. This issue of the review also contains a number of important articles on framing from the Renaissance to the 19th century, including J. Foucart, 'Étude critique de l'encadrement', 7-14; C. Grimm, 'Histoire du cadre: Un Panorama', 15-20. See also the number of *The International Journal of Museum Management,* IV, 1985, devoted to framing; and the *Cahiers du Musée National d'Art Moderne,* XVII/XVIII, 1986, 'L'Oeuvre et son accrochage', which included two important essays on Matisse's frames: D. Fourcade, 'Crise du cadre: A Propos d'un tableau de Matisse, Le Peintre dans son atelier', 68-76; and J. C. Lebensztejn, 'Constat amiable', 84-91. There have also been a number of recent exhibitions on framing: *Italienische Bilderrahmen des 14-18 Jahrhunderts,* Munich, Alte Pinakothek, 1976; *La Città degli Uffizi,* Florence, Uffizi, 1983; *Prijst de Lijst,* Amsterdam, Rijksmuseum, 1984; *The Art of the Edge: European Frames 1300-1900,* Chicago Art Institute, 1986; *Or et couleur: Le Cadre dans la seconde moitié du dix-neuvième siècle,* Paris, Musée d'Orsay, 1989 (see the book of the exhibition, I. Cahn, *Cadres de peintres,* 1989); Amsterdam, Van Gogh Museum, *In Perfect Harmony: Picture and Frame, 1850-1920,* 1995. Just as exhibitions of paintings now encourage studies of problems of technique and conservation, so scholars are beginning to take more notice of frames: see, for

example, P. Mitchell 1990, 'Wright's Picture Frames' in J. Edgerton, *Wright of Derby,* London, Tate Gallery.

160 B. H. Crawford 1960, 'Colour rendition and Museum Lighting', *Studies in Conservation,* V, 41-51: H. Ruhemann 1961, 'Experiences with the Artifical lighting of Paintings' in ibid., IV, 83-85 (repr. in *The Cleaning of Paintings,* 1968, 344-8); G. Thomson 1961, 'A New Look at Colour-Rendering, Level of Illumination, and Protection from Ultraviolet Radiation in Museum Lighting:, in ibid., VI, 46-70; B. H. Crawford and D. A. Palmer, 'Further Investigations of Colour Rendering, and the Classification of Light Sources' in ibid., 71-82; R. A. Weale 1973, 'La Lumière dans les Musées', *Chronique des Arts,* suppl. to *Gazette des Beaux-arts,* July-Aug., 1-2; H. Lank 1984, 'The Function of Natural Light in Picture Galleries', *Burlington Magazine,* CXXVI, 4ff; R. S. Berns and F. Grum 1987, 'Exhibiting Art Work: Consider the Illuminating Source', *Color Research and Application,* XII, 63-72.

161 Schöne (op. cit. n. 25 above) 260, n. 448.

162 The modern literature differs considerably in estimating this figure: for 'some ten million colours', see K. Nassau 1983, *The Physics and Chemistry of Color,* 7; for seven million, C. A. Padgham and J. E. Saunders 1975, *The Perception of Light and Colour,* 104; for one million, H. Terstiege, 'The CIE Colour-Coding System' in J. D. Mollon and L. T. Sharpe (eds) 1983, *Colour-Vision: Physiology and Psychophysics,* 563.

163 The standard study is now B. Berlin and P. Kay, *Basic Color Terms,* 2nd ed. 1991, but see also n. 183 below. On trichromacy in colour vision, see J. D. Mollon, 'Colour Vision and Colour Blindness' in Barlow and Mollon (op. cit. n. 17 above), 165ff. To my knowledge, only one modern artist, Gerrit Rietveld, has related his use of 'primary' colours (implausibly) to the mechanics of vision. For the notion of 'primary colours' in aesthetics, see E. E. Gloye 1957-8, 'Why are There Primary Colours?' *Journal of Aesthetics and Art Criticism,* XVI, 128ff.

164 P. Trevor-Roper, *The World Through Blunted Sight,* 2nd ed. 1988, chaps II, III. See also R. W. Pickford 1965, 'The Influence of Colour-Vision Defects on Painting', *British Journal of Aesthetics,* LII, 211ff; idem, 'Colour Defective Students in Colleges of Art' in ibid. 1967, 132ff; 'The Artist's Eye', *British Medical Journal,* 19 Aug. 1972, 434 (cf. also correspondence in ibid., 586, 702, 826): P. Lanthony 1982, 'Daltonisme et peinture', *Journal français d'ophthalmologie,* V, 373-85, idem 1994, 'J. J. Peintre Daltonien', ibid., XVII, 596-602; R. W. Pickford and J. Bose 1987, 'Colour Vision and Aesthetic Problems in Pictures by Rabindranath Tagore', *British Journal of Aesthetics,* XXVII, 70-5; G. H. Hamilton, 'The Dying of the Light: The Late Work of Degas, Monet and Cézanne' in J. Rewald and F. Weitzenhoffer (eds) 1984, *Aspects of Monet: A Symposium on the Artist's Life and Times,* 223-37; O. Sacks 1995, 'The case of the colour-blind painter' in *An Anthropologist on Mars,* 1-38; and P. Lanthony 1989, *Les Effets de cataracte sur les oeuvres picturales.*

165 I. M. Siegel and G. B. Arden, 'The Effects of Drugs on Colour Vision' in A. Herxheimer (ed.) 1968, *A Symposium on Drugs and Sensory Functions,* 210-28, espec. 217 on alcohol and tobacco.

166 A. von Wattenwyl and H. Zollinger 1981, 'Color Naming by Art Students and Science Students', *Semiotica,* XXXV, 303-15.

167 For the early history of chromotherapy, see R. D. Howat 1938, *Elements of Chromo-Therapy,* 1ff. The classic text is C. Féré 1887, *Sensation et mouvement.* Kandinsky knew of the subject at least through the article by Karl Scheffler. 'Notizen über die Farbe', *Dekorative Kunst,* IV, 1901: see below 251. See also B. D. Prescott 1942, 'The Psychological Analysis of Light and Color', *Occupational Therapy and Rehabilitation,* XXI, 142-6; K. Goldstein, 'Some Experimental Observations Concerning the Influence of Colors on the Function of the Organism' in ibid., 147-51. The article by E. and P. Gruss 1982, 'Der Einfluss des Farbsehens auf die Motorik bei Gesunden, und Hirnkranken', *Festschrift für H. Roosen-Runge,* 277ff, is little more than a repetition of Goldstein's experiments. For a survey of the hitherto meagre results in this branch of experimental psychology, see P. K. Kaiser 1984, 'Physiological response to color: A Critical Review', *Color Research and Application,* IX, 29-36.

168 *The Lüscher Colour Test*, trans. and ed. I. Scott, 1971, 50.

169 The most extensive study seems to be H. J. Eysenck 1941, 'A Critical and Experimental Study of Color Preferences', *American Journal of Psychology*, LIV, 388: blue, red, green, violet, orange, yellow. A slightly divergent scheme, apparently based on much the same earlier literature, is R. W. Burnham, R. M. Haines, C. J. Bartleson 1963, *Color: A Guide to Basic Facts and Concepts*, 209-10. Some more recent tests, in which, for example, blue remains the preferred colour in most European countries, except Spain (and Peru), are mentioned by Pastoureau, 'Vers une Histoire sociale des couleurs' (cit. n. 5 above), 13-14, but unfortunately he gives no references. See also I. C. McManus, A. L. Jones, J. Cottrell 1981, 'The Aesthetic of Colour', *Perception*, X, 651-66.

170 For a Constructivist artist who has used the Lüscher system (as well as those of Aristotle, Goethe, and G. Wyszecki), see H. Stierlin (ed.) 1981, *The Art of Karl Gerstner*, which includes (164ff) an appreciation by Lüscher himself.

171 Heimedahl (op. cit. n. 43 above), 165ff; R. W. Pickford 1971, 'The Lüscher Test', *Occupational Psychology*, XLV, 151-4; and R. Lakowski and P. Melhuish 1973, 'Objective Analysis of the Lüscher Colour Test' in International Colour Association, *Colour 73*, 486-9.

172 For example, C. E. Osgood, G. J. Suci, P. H. Tennenbaum 1957, *The Measurement of Meaning*, Ill, 292ff; and G. Cerbus and R. C. Nichols 1963, 'Personality Variables and Response to Colour', *Psychology Bulletin*, LX, 566-75.

173 For a short critical survey of these types of theory, see R. Arnheim 1974, *Art and Visual Perception: A Psychology of the Creative Eye: The New Version*, 346ff. Carl Loef has recently sought to reconcile the value-based theory with the musical octave: 'Die Bedeutung der Musik-Oktave im optischen-visuellen Bereich der Farbe' in Hering-Mitgau *et al.*, 227-36.

174 V. K. Ball 1965, 'The Aesthetic of Color: A Review of Fifty Years' Experimentation', *Journal of Aesthetics and Art Criticism*, XXIII, 441ff.

175 T. W. A. Whitfield and P. E. Slatter 1978, 'Colour Harmony: An Evaluation', *British Journal of Aesthetics*, XVIII, 1899ff.

176 See, for example, H. Zeishold 1944, 'Philosophy of the Ostwald Color System', *Journal of the Optical Society of America*, XXXIV, 355ff; Hesselgren (op. cit. n. 94 above); and R. S. Berns and F. W. Billmeyer, Jr (op. cit n. 128 above).

177 See the extensive bibliography in F. Mahling 1926, 'Das Problem der "Audition Colorée"', *Archiv für die gesamte Psychologie*, LVII, 165ff. For some effects on painterly research and practice, see below pp. 192, 247, 251, ch. 21.

178 L. E. Marks, 1978, *The Unity of the Senses*; S. Baron-Cohen, J. E. Harison (eds) 1997, *Synaesthesia; Classic and Contemporary Readings*; M. Déribéré 1978, ' The Relationship between Perfumes and Colours', *Color Research and Application*, III, 115f; S. Baron-Cohen, M. A. Wyke, C. Binnie 1987, 'Hearing Words and Seeing Colours: An Experimental Investigation of a Case of Synaesthesia', *Perception*, XVI, 761-7. This study examines the case of an elderly female painter. See also below ch. 21.

179 G. T. Fechner, *Vorschule der Aesthetik*, 2nd ed. 1897-8, I, 176; II, 315ff.

180 Kandinsky, *Complete Writings* (cit. n. 123 above), I, 193. For Kandinsky and Schoenberg, see J. Hahl-Koch (ed.) 1984, *Arnold Schoenberg – Wassily Kandinsky: Letters, Pictures and Documents*. The more or less close interest of many 20th-century artists in musical aesthetics has been documented in a number of studies, notably Kunsthaus, Zurich, Städtische Kunsthalle, Düsseldorf, Museum des 20. Jahrhunderts, Vienna, *Der Hang zum Gesamtkunstwerk: Europäische Utopien seit 1800*, 1983; K. von Mauer (ed.) 1985, *Vom Klang der Bilder: Die Musik in der Kunst des 20. Jahrhunderts*. Paul Klee has been particularly well served by studies of his musical interests and activities: R. Verdi 1968, 'Musical Influences on the Art of Paul Klee', *Museum Studies* (Chicago), III, 81ff; A. W. Kagan 1983, *Paul Klee: Art and Music*; Paris, Centre Georges Pompidou, *Klee et la musique*, 1985-86 (German ed. 1986). But none of these studies devotes much attention to the question of colour.

181 W. Waetzoldt 1909, 'Das theoretische und praktische Problem der Farbenbenennung', *Zeitschrift für Asthetik und allgemeine Kunstwissenschaft*, IV, espec. 384ff; P. Coremans, 'La Notation des couleurs. Essai d'application aux Primitifs flamands' in M. Meiss (ed.) 1961, *De Artibus Opuscula*, XL: *Essays in Honor of Erwin Panofsky*, 76-81.

182 See the exemplary bibliography by M. Grossmann 1988, *Colori e lessico: Studi sulla struttura semantica degli aggettivi di colore in catalano, castigliano, italiano, romano, latino ed ungherese*, 320-9. Perhaps the most useful studies for the art historian are: D. G. Hays *et al.* 1972, 'Color Term Salience', *American Anthropologist*, LXXIV, 1107ff; M. Durbin 1972, 'Basic Terms – Off Color?', *Semiotica*, VI, 257-78; N. B. McNeil 1972, 'Colour and Colour Terminology', *Journal of Linguistics*, VIII, 21ff; H. C. Conklin, 'Colour Categorization', *American Anthropologist*, LXXV, 931-42; H. Zollinger, 'A Correlation between the Linguistics of Colour-naming and Colour perception', *Colour 73* (cit. n. 171 above), 389ff, R. Kuschel and T. Monberg 1974, 'We don't talk much about color here'. A Study of Colour Semantics on Bellona Island', *Man*, IX, 213-42; C. B. Merrin *et al.* 1975, 'Development of the Structure of Color Categories', *Developmental Psychology*, XI, 54-60; M. Sahlins 1976, 'Colors and Cultures,' *Semiotica*, XVI, 1ff; F. Ratliff 1976, 'On the Psycho-Physiological Bases of Universal Color Terms', *Proceedings of the American Philosophical Society*, CXX, 311-30; B. Lloyd, 'Culture and Colour Coding' in G. Vesey (ed.) 1977, *Communication and Understanding* (Royal Institute of Philosophy Lectures), 141ff; H. Zollinger 1979, 'Correlations between the Neurobiology of Colour Vision and the Psycholinguistics of Colour Naming', *Experientia*, XXV 1-8; idem, 'Farben-gesehen, erkannt und erlebt' in Hering-Mitgau *et al.* (op. cit. n. 139 above) 9-12; W. D. Wright 1984, 'The Basic Concepts and Attributes of Colour Order Systems', *Color Research and Application*, IX, 229-3; U. Eco 1985, 'How Culture Conditions the Colors We See' in M. Blonsky, *On Signs*, 157-75.

183 Several fundamental studies of colour-terminology relevant to the history of Western art are now available: for Ancient Egypt, J. Baines 1985, 'Color Terminology and Color Classification: Ancient Egyptian Color Terminology and Polychromy', *American Anthropologist*, LXXXVII, 282-97; for Hebrew, A. Brenner 1982, *Colour Terms in the Old Testament*; for Greek, C. Mugler 1964, *Dictionnaire historique de la terminologie optique des Grecs*; P. G. Maxwell-Stuart 1981, 'Studies in Greek Colour Terminology, I, Glaucos, II, Karopos, *Mnemosyne*, suppl. LXV; for Latin, J. André 1949, *Étude sur les termes de couleur dans la langue latine*; for Coptic, W. C. Till 1959, 'Die Farbenbezeichnungen im Koptischen', *Analecta biblica (Oriens antiquus)*, XII, 331-42; for Anglo-Saxon, N. Barley 1974, 'Old English Colour Classification: Where Do Matters Stand?' *Anglo Saxon England*, III, 15-28; IV, 1975, 145-54; for Old German, J. König 1927, 'Die Bezeichnung der Farben', *Archiv für die gesamte Psychologie*, LX, 145ff; for Old French, A. G. Ott 1899, *Etudes sur les couleurs en vieux français* (repr.1977); for Slavic languages, G. Herne 1954, *Die slavischen Farbenbenennungem* (Publications de l'Institut Slave d'Upsal, IX), 24ff; P. M. Hill 1972, *Die Farbwörter der russischen und bulgarischen Schriftsprache der Gegenwart*; for Catalan, Spanish, Italian, Romanian and Hungarian, see Grossmann (op. cit. n. 182 above).

184 R. Byron 1985, *First Russia, Then Tibet* (1933), 99-100.

185 For example, W. Vöge 1891, *Eine deutsche Malerschule um die Wende des ersten Jahrtausends*, 165, who found the information gathered from his 'systematisch geordneten Farbentafel' too difficult to convey in language; E. H. Zimmermann 1916, *Vorkarolingische Miniaturen*, IX, used a commercial colour-maker's chart; O. Grautoff 1914, *Nicholas Poussin: Sein Werk und sein Leben*, included his own table of 62 samples prepared by a painter.

186 H. Fuerstein, ed., *Fürstlich Fürstenbergische Sammlungen zu Donaueschingen: Verzeichnis der Gemälde*, 3rd ed. 1921, XI, and, for example, 15, no. 98. Ostwald's system was applied only in a few instances; for a later recourse to it, see H. Chorus 1933, *Gesetzmässigkeit der Farbgebung in der ottonischen Buchmalerei*, PhD diss., Cologne, 8f, 54.

187 M. Saltzman's paper, 'Color Terminology: Can We Talk with Each Other?' given at the 1980 Temple University conference,

'Color and Technique in Renaissance Painting', and advocating the Munsell system, is mentioned by Hall (op. cit. n. 71 above) XXI. One of the first scholars to use the *Munsell Book of Color* was probably Joy Thornton (diss. cit. n. 86 above); for recent examples, see M. G. Robertson 1983, *The Sculpture of Palenque*, Princeton, I, xvii, 97; 1985, II, 69-72; 1985, II, 99-103; A. W. Epstein 1986, *Tokali Kilise: Tenth-Century Metropolitan Art in Byzantine Cappadocia*, Washington, DC, 58f.

188 O. M. Lilien 1985, *Jacob Christophe Le Blon, 1667-1741, Inventor of Three and Four Colour Printing*; also see the review by J. Gage 1986 in *Print Quarterly*, III, 65-7. See also J. Friedman 1978, *Color Printing in England, 1486-1870*, Yale Center for British Art, New Haven; S. Lambert 1987, *The Image Multiplied: Five Centuries of Reproduction of Paintings and Drawings*, 87-99; F. Rodiri (ed.) 1996, *Anatomie de la Couleur: l'Invention de l'Estampe en Couleurs*.

189 For example, the processes desribed by E. Robinson and K. R. Thompson 1970, 'Matthew Boulton's Mechanical Paintings', *Burlington Magazine*, CXII, 497ff.

190 On the early lithographic facsimiles and their technical problems, see C. Nordenfalk 1976, *Color of the Middle Ages, A Survey of Book Illumination Based on Color Facsimiles of Medieval Manuscripts*, Pittsburgh, University Art Gallery; also E. Spalletti 1979, 'La documentazione figurativa dell' opera d'arte, la critica e l'editoria nell' epoca moderna (1750-1930)' in *Storia dell'arte italiana*, II, 415-484; and T. Fawcett 1986, 'Graphic versus Photographic in the Nineteenth-Century Reproduction', *Art History*, IX, 195-200.

191 B. Coe 1978, *Colour Photography. The First Hundred Years*.

192 For Warburg's use of a coloured 'Lumière-Lichtbild' at the 1912 International Congress of Art History, see T. Fawcett 1983, 'Visual Facts and the Nineteenth-Century Art Lecture', *Art History*, VI, 457. Berenson, who had, of course, pioneered the use of black-and-white photography in the 1890s, seems by 1921 to have considered coloured slides to be superior to black-and-white ones for lecturing (A. K. McComb (ed.) 1965, *The Selected Letters of Bernard Berenson*, 90).

193 *Colour*, Oct. 1920, 43.

194 E. Diez and O. Demus 1931, *Byzantine Mosaics in Greece: Hosios Lukas and Daphni*, VII-VII.

195 H. Ruhemann (1951), 'The Masters' Methods and Colour Reproduction', repr. in *The Cleaning of Paintings*, 1968, 353.

196 For example, J. Widman 1958, 'Die Colorphotographie im Dienste der Kunstpflege und Forschung', *Festschrift Johannes Jahn*, 223-4.

197 R. Longhi 1952, 'Pittura-Colore – Storia e una domanda', *Paragone*, XXXIII, 3-6. See also the editorial in the *Burlington Magazine*, CV, 1963. 47f; R. Longhi 1964, 'Il critico accanto al fotografo, al fotocolorista e al documentarista', *Paragone*, CLXIX, 29-38. See also Kudielka, op. cit. n. 137 above. Now of course computers and videos have changed the whole future picture of colour documentation.

198 P. C. Beam 1942-3, 'The Color Slide Controversy', *College Art Journal*, II, 35-8; J. M. Carpenter, 'The Limitations of Color Slides', ibid., 38-40.

199 See E. Wind 1963, *Art and Anarchy*, 165f: 'Since the ordinary photographic plate is sensitive to a larger range of shades than can be recorded in colour, the best black-and-white reproduction of a Titian, Veronese or Renoir is comparable to a conscientious piano transcription of an orchestral score, whereas the colour print, with some exceptions, is like a reduced orchestra with all the instruments out of tune.'

200 For example, R. G. W. Hunt, 'Problems in Colour Reproduction', *Colour 73* (cit. n. 171 above), 53ff.

4 Colour in History – Relative and Absolute

1 S. Skard 1946, 'The Use of Color in Literature: a Survey of Research', *Proceedings of the American Philosophical Society*, XC, 181. Skard's list could now be much expanded: see above Chapter 3. Essays on colour of special interest to historians of art have appeared frequently in the Swiss pharmaceutical journals *CIBA Review* and *Palette*.

2 Wolfgang Schöne 1961, *Über das Licht in der Malerei*, espec. 5, 68. Schöne's terms derive from the *Eigenwert* and *Darstellungswert* of colour proposed by H. Jantzen in 1913 ('Über Prinzipien der Farbengebung in der Malerei', reprinted in *Über den gothischen Kirchenraum*, 1951, 61-7). His view of the irrelevance of contemporary theory was contested by A. Neumayer 1955 in his review (*Art Bulletin*, 37, 302-3), which also provides a useful English summary of a difficult book. Something like a development from *Eigenlicht* to *Beleuchtungslicht* has indeed been traced in the medieval philosophy of light between the 13th and the 15th centuries by G. F. Vescovini 1965, *Studi sulla Prospettiva Medievale*. For *Koloritgeschichte*, see above, Chapter 3.

3 B. Berlin and P. Kay 1969, *Basic Color Terms*, 2nd ed. 1991.

4 For critiques of Berlin and Kay, see especially the survey in M. Grossmann 1988, *Color e Lessico: Studi Sulla Struttura semantica degli aggettivi di color in Catalano, Castigliano, Italiano, Romano Latino ed ungherese*, 16-17, and Chapter 2 above. E. Irwin 1974, *Colour Terms in Greek Poetry*, espec. 220ff. For Latin: J. André 1949, *Études sur les Termes de Couleur dans la langue Latin*; for Anglo-Saxon, N. F. Barley 1974, 'Old English Colour Classification: where do matters stand?', *Anglo-Saxon England*, III, espec. 17.

5 Although J. J. G. Alexander's 1975 article 'Some Aesthetic Principles in the Use of Colour in Anglo-Saxon Art', *Anglo-Saxon England*, IV, 145ff, was ostensibly linked to Barley's linguistic study (cit. n. 4 above), it did not make use of these findings, but interpreted colour-usage chiefly in terms of naturalism.

6 See espec. P. Toynbee 1902, *Dante Studies*, 307-14; also M. Mann 1923 in *Romania*, XLIX, 186ff and E. Hoepffner in ibid. 592ff.

7 The 9th-century inventory of the monastery of S. Riquier refers to *persae sericae* in a list of coloured vestments (J. Wickham Legg 1882, 'Notes on the History of the Liturgical Colours', *Transactions of the St Paul's Ecclesiological Society*, I, iii, 99), and in the 11th-century gift of Robert Guiscard to Monte Cassino was *Tunicam unam de panno perso inaurato* (O. Lehmann-Brockhaus 1938, *Schriftquellen zur Kunstgeschichte des 11 und 12 Jh. f. Deutschland, Lothringen und Italien*, I, no. 2844). For Persia as the chief intermediary of the silk trade, O. von Falke, *Kunstgeschichte der Seidenweberei* 2nd ed. 1921, 2f.

8 H. Roosen-Runge 1967, *Farbgebung und Technik Frühmittelalterlicher Buchmalerei*, II, 66ff.

9 H. B. Gottschalk 1964, 'The *De Coloribus* and its Author', *Hermes*, XCII, 59, proposes Theophrastus as the author; E. Franceschini 1955, 'Sulle versioni latine medievali del περὶ χρωμάτων, in *Autour d'Aristote: Recueil d'études offert à M. A. Mansion*, 451, reports more than eighty codices of the Latin translation attributed to Bartolomeo da Messina (1258/66).

10 R. D'Avino 1958, 'La Visione del Colore nella Terminologia Greca', *Richerche Linguistiche*, IV, espec. 101, 103ff, 108f: P. Zancani Montuoro, 'Colore', in *Encyclopedia dell'Arte Antica, Classica, e Orientale*, II, 1959, 770ff; C. Mangio 1961, 'Cenni sulle teorie cromatiche dei Greci e loro applicazioni architettoniche', *Studi Classici e Orientali*, X, espec. 214; Irwin (op. cit. n. 4 above), 213ff.

11 Johannes Philoponus 1959, *In Aristotelis Meteorologicorum librum primum commentarium*, 47, 18. Urso of Salerno, *De Coloribus*, ed. Thorndyke, *Ambix*, VII, 15.

12 The most comprehensive recent study is in Pauly-Wissowa, *Real-Enzyklopädie d. Klass. Altertumswissenschaft*, Supp. III, cols 461ff, s v 'Färbung'.

13 A. J. Hopkins 1934, *Alchemy Child of Greek Philosophy*, 117. For the medieval developments, J. Read, *Prelude to Chemistry*, 2nd ed. 1939, 145ff.

14 *Eraclius De Coloribus et Artibus Romanorum*, III, vii (13th century), ed. C. G Romano 1996. For a modern account, M. G. Chesneau 1933, 'Contribution à l'Étude de la technique des Vitraux du Moyen-Age', *Bulletin Monumental*, XCII.

15 F. Haeberlein 1932/3, 'Zur Farbenikonographie des Mittelalters', *Annales Institutorum*, V, 103-4, where it is claimed that a fixed canon of *Farbvokabeln* obtained until the period of High Scholasti-

cism; idem 1939, 'Grundzuge einer Nachantiken Farbikonographie', *Romisches Jahrbuch für Kunstgeschichte*, III, 78ff stresses the relative unimportance of precise *hue* in establishing colour iconography, and attributes hue-preferences to *style* rather than to language. The most useful study on these lines, G. Haupt 1941, *Die Farbensymbolik in der sakralen Kunst des abendländischen Mittelalters*, also points out (46ff) the vagueness of the sense of hue among the writers discussed.

16 M. Reeves and B. Hirsch-Reich 1972, *The 'Figurae' of Joachim of Fiore*, 194. Other striking examples in Haupt (op. cit. n. 15 above) 85f. For early disagreement on the subject of whether Christ's eyes were blue or brown, and his beard black, blonde or the colour of wine, E. de Bruyne 1946, *Études d'Esthétique Mediévale*, I, 286n.

17 See W. Whiteley, 'Color words and colour values: the evidence from Gusii' in R. Horton and R. Finnigen (eds) 1973, *Modes of Thought*, 156-7, and the important observations on medieval symbolism by F. Ohly 1958, 'Vom geistigen Sinn des Wortes im Mittelalter', *Zeitschrift für deutsches Altertum*, LXXXIX, espec. 6ff.

18 J. Braun, *Die Liturgische Gewandung im Occident und Orient*, 1907, 749ff. J. Wickham Legg 1917, discovered an earlier 12th-century sequence from the Crusaders' Church in Jerusalem, which also laid the main emphasis on black, white and red vestments (*Essays Liturgical and Historical*, 157ff).

19 Paul Hetherington 1974, *The 'Painter's Manual' of Dionysius of Fourna*, 35. Only the Romanian and Russian manuals (*Podlinnik*) seem to have recorded the appropriate colours of drapery (V. Grecu 1934, 'Byzantinische Handbücher der Kirchenmalerei', *Byzantion*, IX, 694, 697f). Very few of the surviving medieval model-books show any indications of colour (R. W. Scheller, *Exemplum: Model-Book Drawings and the Practice of artistic Transmission in the Middle Ages (ca. 900-ca. 1470)*, 1995, nos 2, 3, 4, 6, 7, 8, 9, 11, 13, 15, 20, 21, 22, 24, 26, 29, 30, 31, 43, 44, are the only instances I have traced).

20 Gregory the Great, *Homiliae in Hiezechihelem Prophetam*, VIII, v. 29, ed. M. Adriaen 1971 (Corpus Christianorum Series Latina, CXLII), 118-19. On the literary tradition, Haupt (op. cit. n. 15 above), 56.

21 H. B. Meyer 1961, 'Zur Symbolik frümittelalterliche Majestasbilder', *Das Munster*, XIV, espec. 83. Some 12th-century examples are in the Westminster Psalter (British Library Royal MS 2A. XXII, f. 14), and in the Ascension in a window at Le Champ (Isère) (M. Aubert *et al.* 1958, *Le Vitrail Français*, pl. XI).

22 For some inconclusive remarks on this combination in terms of light and dark, Haupt (op. cit. n. 15 above) 73, 82f. For a study of the colours of the costumes of St Peter and the other Apostles, see now M. Lisner 1990, 'Die Gewandfarben der Apostel in Giottos Arenafresken – Farbgebung und Farbikonographie – mit Notizen zu älteren Aposteldarstellungen in Florenz, Assisi und Rom', *Zeitschrift für Kunstgeschichte*, 53, 309-75.

23 C. Mango 1972, *The Art of the Byzantine Empire*, 42.

24 Innocent: Migne, *Patrologia Latina* CCXVII, col. 802. William of Auvergne, cit. De Bruyne (op. cit. n. 16 above), III, 86. A century earlier, Hugh of St Victor had also claimed that green was the most beautiful colour, but simply on the grounds that it was the colour of spring growth (*Didascalicon*, Bk VII, ch. xii: Migne, *Patrologia Latina* CLXXVI, col. 821).

25 *Suidae Lexicon*, ed. Alder 1935, IV, 709-10.

26 Aristotle, *De Sensu*, 442a; *Meteor*, 374b-375a; E. Wunderlich 1925, *Die Bedeutung der roten Farbe im Kultus der Griechen und Römer*. (Religiongeschichtliche Versuche und Vorarbeiten, XX, i), 41; André (op. cit. n. 4 above) 138; Theophilus, *De Diversis Artibus*, ed. Dodwell 1961, 96.

27 G. M. Stratton 1917, *Theophrastus and the Greek Physiological Psychology before Aristotle*, 136-7.

28 Isidore, *Etymologiae* XVI, ix; Marbod of Rennes, PL CLXXI, col. 1774; Bede, PL XCIII, col. 202; cf. also Bede's account of the whelk used in the British Isles to make purple, which stresses the redness of the dye (*History of the English Church and People*, I, i, trans. Sherley-Price 1955, 37). For Pliny in the Middle Ages, from the 8th to the 12th centuries, M. Manitius 1890 in *Philologus*, XLIX, 380ff.

29 'oxiporfiron to apo rodinis', *Compositiones ad tingenda musiva*,

ed. Hedfors, 1932, 60; *Mappae Clavicula*, ch. 128, ed. Smith and Hawthorne 1974, *Transactions of the American Philosophical Society*, LXIV, 4, 46 (English trans.).

30 E. R. Caley 1927, 'The Stockholm Papyrus', *Journal of Chemical Education* IV, 993, no. 101, also nos 103 and 153, 999. The close association of purple with gold and with light goes back at least to Pindar (6th/5th century BC), and the Golden Fleece was sometimes described as purple (J. Duchemin 1955, *Pindare, Poète et Prophète*, 196, 228).

31 'luceat claream color, et reddetur quasi purpura pretiossima', D. V. Thompson 1932, 'The "De Clarea" of the so-called "Anonymus Bernensis"', *Technical Studies*, III, 71ff.

32 Bede, loc. cit. n. 28 above. Classical uses of red and purple as heavenly colours have been gathered by K. Lehmann 1945, 'The Dome of Heaven', *Art Bulletin*, XXVII, 11.

33 E.g. Cennino Cennini, *The Craftsman's Handbook*, ch. lxii, trans. with further references by D. V. Thompson 1933, 37 and n. Several of the sources for blue as a heavenly colour cited by Haupt (op. cit. n. 15 above) 99ff are early, and ultramarine was characterized as the *optimus color* in the 12th century (J. von Schlosser 1896, *Quellenbuch zur Kunstgeschichte des abendländischen Mittelalters*, 234), but at the same time, in his *Ekphrasis* of the Church of the Holy Apostles in Constantinople, Nikolaos Mesarites specifically contrasts the humble blue of the robe of the *Pantokrator* with the luxurious colours of purple, scarlet and hyacinth (ed. Downey 1957, *Transactions of the American Philosophical Society*, XLVII, 870). The earliest reference to blue as the noblest of colours I have found is in a 13th-century *De Colorum Diversitate* (L. Thorndyke 1960, 'Other texts on Colours', *Ambix*, VIII, 58).

34 K. Badt 1965, 'Blue' in *The Art of Cézanne*, 58-72. The earliest appraisal of blue as the most beautiful colour I have found is in a Stoic doctrine, recorded by Aëtius, which held that dark blue (*kuanodei*) was more beautiful than purple both because it is darker and because it has more shine (*stilbousan*) (J. ab Arnim 1903, *Stoicorum veterum Fragmenta*, II, no. 1009). Two studies rich in documentation, if unconvincing in their conclusions, are M. Pastoureau (1983), 'Et puis vint le bleu' in *Figures et Couleurs: Études sur la Symbolique et la Sensibilité Médiévales*, 1986, 15-22; idem 1996, 'La promotion de la couleur bleue au XIIIc siècle: le témoinage de l'héraldique et de l'emblématique', in Istituto Storico Lucchese, *Il Colore nel Medioevo: Arte, Simbolo, Tecnica*, 7-16.

35 E. Kirschbaum 1940, 'L'Angelo rosso e l'angelo purchino', *Rivista di Archeologia Christiana*, XVII, 209-48.

36 J. Seznec 1953, *The Survival of the Pagan Gods*, 47. In some other late Antique schemes, air was represented by white (Tertullian, *De Spectaculis*, ed. Castorina 1961, lxxxiv f) and in the Peripatetic *De Coloribus* air, earth and water were all white, fire red, while black was the colour of the elements in the process of transformation. For the earliest views, J. Beare 1906, *Greek Theories of Elementary Cognition from Alcmaeon to Aristotle*, 21-2.

37 J. Hess and T. B. Ashbury (eds) 1969, *Light: from Aten to Laser* (Art News Annual, XXXV), 109ff.

38 M.-M. Gauthier 1972, *Émaux du Moyen-Age Occidental*, catalogue 24 and pl. 12 above.

39 See the plates of the newly-cleaned mosaics in G. H. Forsyth and K. Weitzmann 1965, *The Monastery of St Catherine at Mount Sinai*, espec. pls CIV, CSI, CXIV.

40 The more expected sequence from light at the centre is described by Plotinus (*Enneads*, IV, 3.17) and represented in the nimbed crosses at Poreč (Parenzo), Albenga, S. Sophia and the Church of the Archeiropoietos at Salonika, and in many Byzantine illuminations (e.g. K. Weitzmann, *Illustrations in Roll and Codex*, 2n ed. 1970, figs 84, 130, 164, 165, 192), as well as in the episodes of Moses receiving the Law and the Burning Bush in St Catherine's. The most recent study of the light-imagery at St Catherine's has noted the form of the mandorla, without analysing it (J. Miziolek 1990, '*Transfiguratio Domini* in the Apse at Mount Sinai and the Symbolism of Light', *Journal of the Warburg and Courtauld Institutes*, LIII, 43).

41 Mesarites (op. cit. n. 33 above) 872. Weitzmann (op. cit. n. 39 above) 14-15 accounts for the absence of Mount Tabor in the St Catherine's mosaic by referring to St John Crysostom's *Homily on the Metamorphosis*, 'not with a cloud over his head, but surrounded by Heaven', but since no earlier version of the subject including Tabor has come to light, the point does not seem to be a crucial one (see 'Verklärung Christi' in *Lexikon der Christlichen Ikonographie*, ed. Kirschbaum 1972, IV).

42 The conception of God as darkness in the earlier Old Testament tradition (until about the 6th century BC) has been examined by J. Hempel 1960, 'Die Lichtsymbolik in Alten Testament', *Studium Generale*, XIII, espec. 355-8, 367f. For the survival of some of these ideas in medieval Jewish mysticism, G. Scholem 1972, 'Farben und ihre Symbolik in der judischen Uberlieferung und Mystik', *Eranos Yearbook*, XLI, espec. 5, 23f.

43 See espec. E. von Ivanka, 'Dunkelheit, mystische', in *Reallexikon für Antike und Christentum*. It is remarkable that in the versions of the episodes of Moses and the Burning Bush and Moses receiving the Law later than the triumphal arch at Sinai, the first shows God's hand emerging from a cloud of light, the second from a cloud of darkness (H. Buchthal 1938, *The Miniatures of the Paris Psalter*, pl. X; K. Weitzmann 1973, *Illustrated Manuscripts at St Catherine's Monastery on Mount Sinai*, pl. XXIX).

44 *Celestial Hierarchy*, XV, §8, ed. Rocques 1958, 186ff, who notes that there are no blue horses in the biblical accounts of the Horses of the Apocalypse (*Zechariah* I, 8; VI, 2-3; *Revelations*. VI, 3-7). On the shift in the Greek interpretation of *kuaneos* from 'dark' to 'blue', Irwin (op. cit. n. 4 above) 108f. The place of darkness in Dionysian thought has been discussed generally by H. C. Puech 1938, 'La Ténèbre mystique chez le Pseudo-Denys', *Études Carmelitaines*, XXIII, ii.

45 The fullest account in *Dictionnaire de Spiritualité*, III, 1957, *c.* 249ff.

46 V. E. Gardthausen 1886, *Catalogus codicum graecorum siniaticorum*, nos. 319-25.

47 Some of these ideas have been conveniently summarized by E. Panofsky 1944, 'Note on a Controversial Passage in Suger's *De Consecratione*', *Gazette des Beaux-Arts*, LXXXVI. So far as I know, the only modern discussion of the 'negative aesthetic' developed from Dionysius is De Bruyne (op. cit. n. 16 above), II, 215f, 247-8.

48 E.g. Ignatius the Grammarian on the 9th-century mosaic of the subject in the Church of the Virgin of the *Pege* at Constantinople (*The Greek Anthology*, trans. Paton 1969, I, I, 112); J. Viellard, *Le Guide du Pèlerin de Saint-Jacques de Compostelle*, 3rd ed. 1963, 104: 'Est enim Dominus ibi in nube candida, facie splendens ut Sol, veste refulgens ut nix'; Alexander of Villa Dei, *Ecclesiale* (ed. and trans. Lind 1958, 34, 85): 'a shining cloud [*lucida nubes*] enveloped them'.

49 Otto Demus 1948, *Byzantine Mosaic Decoration*, 38 and fig. 29.

50 Idem 1949, *The Mosaics of Norman Sicily*, 383ff.

51 First reported by C. Angrand to H. E. Cross about 1891 (R. Rey 1931, *La Renaissance du Sentiment Classique*, 95); with slightly different wording, Angrand in G. Coquiot 1924, *Seurat*, 41.

52 Seurat himself acknowledged a debt to Blanc, Delacroix, Chevreul, Monet, Pissaro and Rood in a letter of 1890 (W. I. Homer 1964, *Seurat and the Science of Painting*, 17, with an analysis of these sources). For Lehmann, A. Boime 1970, *The Academy and French Painting in the Nineteenth Century*, 114ff; colour-photography: L. Moholy-Nagy 1947, *Vision in Motion*, 158-9; Japanese prints: H. Dorra 1970, 'Seurat's Dot and the Japanese Stippling Technique', *Art Quarterly*, XXXIII; colour-printing: N. Broude, 'New Light on Seurat's "Dot": its Relation to Photomechanical Color Printing in France in the 1880s', *Art Bulletin*, LVI, 1974.

53 R. L. Herbert 1968, *Neo-Impressionism*, New York, Guggenheim Museum, 220f.

54 Chevreul himself surprisingly took the view that mosaic was hardly more than an imitation of painting, although it should not be too refined to tell over a distance (*The Principles of Harmony and Contrast of Colours*, trans. Martel 1854, 176); Garnier, who had admired medieval mosaics in Sicily and Constantinople (M. Stein-

hauer 1969, *Die Architektur der Pariser Oper*, 168f), opposed this attitude (C. Garnier 1869, *A Travers les Arts*, 179f), as, later, did scholars like E. Didron 1875 ('La Peinture en Mosaique', *Gazette des Beaux-Arts*, ser. II, vol. XI, 449ff) and E. Gerspach 1880 ('La Mosaique Absidale de Saint-Jean de Lateran', ibid., XXI, 141ff) who discussed the rendering of Christ's hair in terms of Chevreul's law of simultaneous and successive contrast (146-7).

55 F. Cachin 1971, *Paul Signac*, 85f, 88. It must, however, be said that he did acquire some reproductions of mosaics, and that most of the important medieval mosaics in Constantinople were not uncovered until after his visit.

56 Paul Adam, cit. Herbert (op. cit. n. 53 above) 16.

57 Homer (op. cit. n. 52 above) 288, n. 22.

58 For a wide-ranging discussion of the scientific credentials of Neo-Impressionism, P. Smith 1997, *Seurat and the Avant-Garde*, ch. 2.

59 The phenomenon was stressed in the first important account of Neo-Impressionism, by Félix Fénéon 1886, *La Vogue*, 13-20 June (*Oeuvres plus que complètes*, ed. Halperin 1970, I, 36-7). In 1888 Seurat called this article 'the exposition of my ideas on painting' (Homer, op. cit. n. 52 above, 290 n. 31).

60 'Videntur autem sic propter distantiam aut velocitatem motionis, cum visus in unoquoque istorum debilis fiat aspiciendi et intelligendi singulas partes. Quoniam, si distantia rerum videndarum quantitatem habuerit ita ut et angulus qui totam rem continet, habeat ydoneam quantitatem, singuli autem anguli qui continent diversos colores, fuerint insensibiles, apparebit ex comprehensione partium que non discernuntur, cum omnium sensibilitas congregabitur, quod color totius rei sit unus, alter quam singularum partium.

'Similiter etiam accidit ex motu vehementis celeritatis, ut moto troci plures colores habentis, quia non moratur unus et idem visibilis radius super unum et eundem colorem, quoniam recedit color ab eo propter celeritatem volutionis. Et sic idem radius, cadens super omnes colores, non potest dividere iter primum et novissimum, nec inter eos qui sunt per diversa loca. Apparent enim omnes colores per totum trocum in eodem tempore quasi unus et quod sit similis coloris qui vere fieret ex commixtis coloribus…Si linee autem fuerint super trocum constitute et per axem transducte, apparebit in volutione tota superficies troci similem habere colorem…' (A. Lejeune 1956, *L'Optique de Claude Ptolémée*, II, 95, 59-61). This sometimes difficult text survives only in an early 13th-century Latin translation from an Arabic version of the original Greek. Hints of optical mixture through distance had been given tentatively by Aristotle (*De Sensu*, 439b, 23ff, an especially interesting text, since it suggests the optical derivation of all colours from mixtures of black and white) and through motion in the Peripatetic *De Audibilibus* (803b, 34ff). A 19th-century refinement of the method of disc mixture seems to lie behind Seurat's reference to 'the duration of a light-impression on the retina' in a letter of 1890 (Homer, op. cit. n. 52 above, 140f).

61 Lejeune, loc. cit. n. 60 above, 17★.

62 R. Koldewey 1884, 'Das Bad von Alexandria-Troas', *Athenische Mitteilungen*, IX, 39f. The tesserae found here were of both stone and glass. Literary references in Pliny, *Natural History*, XXXV, 64; Statius, *Silvae*, I, 5, 42-3; Seneca, *Epistolae*, LXXVI, 6f.

63 The only example known to me is the coarse, pebble-like vault of Criptoportico D in Hadrian's Villa at Tivoli, published by G. Lugli 1928, *Bulletino della Commissione Communale di Roma*, LV, 168ff.

64 One 2nd-century AD example is in the distant landscapes and water in the small inset floor mosaics from Hadrian's Villa now in the Vatican (M. Wheeler 1964, *Roman Art and Architecture*, figs 473-4).

65 Colour plate: G. Kawerau and T. Wiegand 1930, *Altertumer von Pergamon*, V, i, pl. VIII. The 'rainbow' borders found frequently in early medieval manuscript illumination, in which each colour-band has a serrated edge, like mosaic tesserae set at an angle of 45 degrees to the line, clearly derive from mosaic practice such as the interlace borders in the late-Antique vault of Sta Constanza in Rome (Comp.

X) (G. Matthiae 1967, *Mosaici Medioevali delle Chiese di Roma*, pls I, II). The earliest MS example I have found is in a 6th-century Greek Dioscurides, *Materia Medica*, (Vienna Nat. Bibl. Vindob. med. gr. I, f. 4r, repr. A. Grabar 1966, *Byzantium from the Death of Theodosius to the Rise of Islam*, fig. 215). The almost contemporary mosaic of the Virgin and Child at Lynthrankomi seems to have a similar arrangement in its 'rainbow' mandorla (just visible to the far left in pl. II of A. Stylianou 1963, *Cyprus: Byzantine Mosaics and Frescoes*). The clearest example of the painter borrowing from mosaic convention in this context is in the 14th-century decoration of the Kariye Djami in Istanbul (P. Underwood 1967, *The Kariye Djami*, II, pl. 44, III, pl. 411).

66 E.g. 4th-century Salonika, Hagios Georgios, head of St George (good pls in H. Torp, *Mosaikkene i St Georg-rotunden*, 1963); 11th-century Daphni, Head of the Virgin in Crucifixion (pl. 78); 13th-century Rome, formerly St Peter's, Giotto's *Navicella* (G. Matthiae, loc. cit., pl. LXVIII); 14th-century Istanbul, Kariye Djami (Underwood, loc. cit., II, pls 33, 34, 45, 69, 70, 263, 326).

67 E.g. 5th-century Bitola (Heraclea Lyncestis) pavement (G. C. Tomašević 1973, *Heraclea Lyncestis*, Bitola figs 16–19); ?7th-century Istanbul, Great Palace (Mosaic Museum) (Grabar, op. cit. n. 65 above, fig. 108 – not the best example from this pavement).

68 E.g. 8th-century Rome, Chapel of John VII (P. J. Nordhagen 1965, 'The Mosaics of John VII', *Acta Instituti Romani Norvegiae*, II, 151).

69 E.g. 5th-century Rome, Sta Maria Maggiore: *Abraham visited by Angels* (Grabar, op. cit. n. 65 above, fig.157); 12th-century Monreale (Kitzinger, op. cit. n. 65 above, pls 2, 47); 13th-century Rome, Sta Prassede, Chapel of S. Zeno, Tabernacle (Matthiae) (op. cit. n. 65 above, pl. LXIII). For *lustre*, which occurs when the eye is unable to decide whether to distinguish or to fuse the dots, Fénéon (op. cit. n. 59 above).

70 Some examples in Sta Maria Maggiore in Rome and S. Apollinare Nuovo in Ravenna are cited by G. Bovini, 'Origine e tecnica del mosaico parietale paleocristiana', *Felix Ravenna*, 2nd ser. 1954, 7. Instances in the 9th-century apse mosaic in Haghia Sophia in Istanbul have been noticed by C. Mango and E. J. Hawkins 1965, *Dumbarton Oaks Papers*, XI, 125.

71 E.g. the late-Antique heads of Dionysius and a Maenead, from Utica, in the British Museum (nos. 54 g, k). Striking medieval examples are in S. Apollinare Nuovo (col. pls in G. Bovini 1958, *Mosaici di S. Apollinare Nuovo di Ravenna*), and in the Chapel of S. Zeno at Sta Prassede (e.g. W. Oakeshott 1967, *The Mosaics of Rome*, pl. V).

72 For example by Demus (op. cit. n. 50 above), 135; Bovini (op. cit. n. 70 above), 12.

73 S. Lauffer 1971, *Diokletians Priesedikt*, 118–19, 234–5. F. Deichmann 1974, *Ravenna: Hauptstadt des Spätantiken Abendlandes*, II, 189, recognizes the irrelevance of this document, but proposes a single designer and many executants, on grounds of style.

74 Kitzinger (op. cit. n. 65 above), 130, n. 106.

75 F. Forlati 1949, 'La Tecnica dei Primi Mosaici Marciani', *Arte Veneta*, III, 86; Mango and Hawkins (op. cit. n. 70 above), and the summary of research by S. H. Young 1976, 'Relations between Byzantine Mosaic and Fresco Decoration', *Jahrbuch der österreichischen Byzantinistik*, XXXV.

76 The text in B. Bischoff 1984, *Anecdota Novissima: Texte des Vierten bis Sechzehnten Jahrhunderts* (Quellen und Untersuchungen zur Lateinischen Philologie des Mittelalters 7), 223. Since the rather scanty Carolingian revival of mosaic seems to have relied on spoils from Ravenna for cubes (H. E. del Medico 1943 in *Monuments Piot*, XXXIX, 85), it is not surprising that only setting is discussed here, although there are recipes for making green, gold and silver cubes in the Lucca MS (op. cit. n. 29 above), 5–6, 86–90.

77 The treatise *Sul Modo di tagliare ed applicare il musaico* (?c. 1415), ed. Reali 1858, 12f, leaves it an open question 'se tu sai desegnare'. It was written by a Venetian craftsman working outside S. Marco (cf. p. 4), but Filarete in mid-century found similar practices there (*Treatise on Architecture*, trans. Spencer 1965, 312). Some of the other

details Filarete gives (e.g. the five values of each hue, like the 6th/7th-century Byzantine mosaic palette of 4 to 8 values recorded by B. Rubin 1954, *Byzantische Zeitschrift*, XCVII, 439, and 4 or 5 values used in the Kariye Djami, Underwood, op. cit. n. 65 above, I, 181), suggest the persistence of traditional methods. Five values were also the norm in wall painting (D. Winfield 1968, 'Middle and later Byzantine wall-painting methods', *Dumbarton Oaks Papers*, XXII, 136ff).

78 Lejeune (op. cit. n. 60 above), 27★.

79 Notably C. Mango 1963, 'Antique Statuary and the Byzantine Beholder', *Dumbarton Oaks Papers*, XVII, espec. 64ff; H. Maguire 1974, 'Truth and Convention in Byzantine Descriptions of Works of Art', ibid., XXVIII, espec. 128ff; D. S. Wallace-Hadrill 1968, *The Greek Patristic View of Nature*, 97f. *Ekphrasis* has now been studied in relation to colour in L. James 1996, *Light and Colour in Byzantine Art*.

80 There is a suggestion that flesh areas were sometimes left until last, presumably to be executed by the leading master (Underwood, op. cit. n. 65 above, I, 179f).

81 A. Chastel and F. Minervino 1973, *Tout l'Oeuvre Peint de Seurat*, pl. XLIII.

82 D. C. Rich 1936, *Seurat and the Evolution of 'La Grande Jatte'*, 34–5.

83 P. Bruneau 1972, *Les Mosaïques de Délos*, no. 214, Matthiae (op. cit. n. 65 above), pls 91, 94. Matthiae argues (pp. 154ff) that these are all contemporary, and that the setter of the Apostles was in charge of the whole scheme and probably had connections with Ravenna. He also identifies a third artist, responsible for S. Hyppolitus (pl. XX).

84 Fénéon (op. cit. n. 59 above) I, 74 (1887).

85 Vasari (1568), *Le Vite*, Milan 1965, VII, 332; Reynolds (1788), *Discourse* XIV; Constable wrote of Count Forbin, the organizer of the 1824 *Salon*: 'He is no artist (I believe) and he thought "as the colours were rough, they must be seen at a distance" – they found their mistake as they then acknowledged the richness of the texture – and the attention to the surface of objects in these pictures' (*Correspondence*, ed. Beckett 1968, VI, 185).

86 C. Mango (op. cit. n. 23 above), 197; also 205 (sermon of Leo VI).

87 *Metamorphoses*, II, 5. I have discussed the medieval interpretation of this tag in *Colour and Culture*, 1993, 75–6.

88 C. Mango 1958, *The Homilies of Photius*, 187.

89 For Empedocles, K. Freeman 1966, *Ancilla to the Pre-Socratic Philosophers*, Frags. 22–3. The same conception is repeated in the *De Mundo* attributed to Aristotle, but probably composed in the second century AD (396b).

90 Freeman, loc. cit., 92–8.

91 De Mixtione, II, 214, 18, in M. C. Nahm, *Selections from Early Greek Philosophy*, 4th ed. 1964, 164. Mango (op. cit. n. 88 above) unaccountably cites Aristotle, *Metaphysics*, 985b to illustrate Photius's point.

92 *Joannis Stobaei Eclogarum Physicarum et Ethicarum Libri Duo* (Greek and Latin), I, 1792, ch. XVII, 362ff. For Photius's copy (cod. 167), R. Henry 1960, *Photius: La Bibliothèque*, II, 149ff.

93 Theophrastus, in Stratton (op. cit. n. 27 above) 132ff. Galen and Aëtius in Nahm (op. cit. n. 91 above), 160, 176.

94 The 'primary' palette is described by Angrand in Coquiot (op. cit. n. 51 above) 40, but Signac claimed that he had already introduced Seurat to the 'prismatic' arrangement in 1884 (Homer, op. cit. n. 52 above), 151). Also W. I. Homer 1959, 'Seurat's Palette', *urlington Magazine*, CI, 192–3.

95 *Moralia*, Loeb (ed.) 1961, IX, 156–7, cf. also ibid., 247; 1962, IV, 47f, and especially V, 489f. Medieval usage: H. Silvestre 1954, 'Le MS Bruxellensis 10147-58 et son Compendium artis picturae', *Bulletin de la Commission Royale d'Histoire*, CXIX, 138.

96 *Mappae Clavicula*, op. cit. n. 29 above, ch. ix, xi, 27–8. The best survey of the literature is W. W. Bulatkin 1954, 'The Spanish word 'Matiz': Its Origin and Semantic Evolution', *Traditio*, X. Roosen-Runge (op. cit. n. 8 above) and Winfield (op. cit. n. 77 above) have shown that these prescriptions were widely practised. Roosen-Runge, Vol. II for a catalogue of the colour-terms.

97 *Mappae*, loc. cit. n. 29 above. The MS of the *De Clarea* unfortu-

285

nately breaks off when it is about to discuss such mixtures: *Puris, hoc est non mixtis coloribus ut mirabiliter mixto strata inferius, superius unbrata colore pictura sit variata cum nimis…* (op. cit. n. 31 above, 81f). The only unpublished MSS to describe mixed colours (greens), listed by Thompson 1935, date from the 15th century ('Trial Index to some unpublished sources for the History of Mediaeval Craftsmanship', *Speculum*, X, 423).

98 J. Plesters in D. Talbot Rice (ed.) 1968, *The Church of Haghia Sophia at Trebizond*, 230f. Kariye Djami: R. J. Gettens and G. L. Stout, 'A Monument of Byzantine Wall-painting – the Method of Construction', *Studies in Conservation*, III, 3, 1958, 110.

99 A small selection of illustrations in V. W. Egbert 1967, *The Mediaeval Artist at Work*. The only palette shown here (Paris BN MS Fr. 12420 f.101v; 1402) seems to be used simply for mixing a flesh-pink (colour plate in R. Behrends and K. M. Kober 1973, *The Artist and his Studio*, 12). An earlier palette, illustrated in a French Bible of c. 1300, has now been published by J. G. G. Alexander 1992, *Medieval Illuminators and their Methods of Work*, 24, pl. 35, but it shows only two colours (see below, 94 and pl. 34).

100 Good col. plates in A. K. Orlandos 1963, *Paragoritissa tis Artis*.

101 P. Signac, *De Delacroix au Néo-Impressionisme*, ed. Cachin 1964, 121.

102 Many of the Latin *tituli* in E. Diehl 1925, *Inscriptiones Latinae Christianae Veteres*, nos 1752-1979; some usefully translated in Oakeshott (op. cit. n. 71 above). Some Byzantine examples in *The Greek Anthology* (op. cit. n. 48 above), I, 1-18, cf. also Mango and Ševčenko1961, in *Dumbarton Oaks Papers*, XIV, 243ff. For apses: C. Ihm 1960, *Die Programme der Christlichen Apsismalerei*, espec.125.

103 It must be stressed that the Neo-Impressionists also used much white.

104 The best account is still H. Bauer 1911, 'Die Psychologie Alhazens auf Grund von Alhazens Optik', *Beiträge zur Geschichte der Philosophie des Mittelalters*, X, 5, 44ff. The Latin translator of Alhazen's Arabic clearly had difficulties in finding equivalents. For Alhazen's own colour-terms, *The Optics of the Al-Haytham*, trans. and introd. A. I. Sabra 1989, II, 40-44, 57-9. For his influence: D. C. Lindberg 1967, 'Alhazen's Theory of Vision and its Reception in the West', *Isis*, LVIII. For the related questions of the vagueness of Arabic colour-terms, W. Fischer 1965, *Farb- und Formbezeichnungen in der Sprache der Altararabischen Dichtung*, espec. 233ff. A. Bouhdiba 1976, 'Les Arabes et la Couleur' in *L'Autre et l'Ailleurs: Hommage à Roger Bastide*, ed. J. Poirier and F. Raveau, 347-54.

105 For raking, Forsyth and Weitzmann (op. cit. n. 39 above), espec. pls CXXIV-CXXVIII; R. Cormack in *Annual of the British School in Athens*, LXIV, 1969, espec. 30; E. Hawkins 1968 in *Dumbarton Oaks Papers*, XXII, espec. 155 and fig. 11. Photographs can rarely give this sort of information; for an attempt to make them do so, H. Karpp 1966, *Die Frühchristlichen und Mittelalterlichen Mosaiken in S. Maria Maggiore zu Rom*, 20-1.

106 K. M. Philips 1960, 'Subject and Technique in Hellenistic-Roman Mosaics: A Ganymede Mosaic from Sicily', *Art Bulletin*, XLII, 244.

107 *Homilies* (cit. n. 88 above). This may be a reminiscence of the nervous excitement recorded by Procopius in his *Ekphrasis* of Haghia Sophia (Mango, op. cit. n. 23 above, 75), which appears, too, to have been the inspiration of a passage in Theophilus (op. cit. n. 26 above, 63).

108 For Seurat's cramped studio, see Chapter 16 below .

109 Fénéon (op. cit. n. 59 above), I, 55-6.

110 *Sul Modo di Tagliare…* (loc. cit. n. 77 above). For illustrations of the mosaics and a discussion of their date, M. Muraro 1961, 'The Statutes of the Venetian *Arti* and the Mosaics of the Mascoli Chapel', *Art Bulletin*, XLIII.

111 L. B. Alberti, *On Painting and On Sculpture*, ed. and trans. Grayson 1972, 92-3. The Latin version is slightly fuller than the Italian at this point. Elsewhere, however, Alberti recognizes that the effect of mosaic derives from the *irregular* reflections from the surface (*De Re Aedificatoria*, ed. Orlandi and Portoghesi 1966, vi, x, 509).

5 Colour-words and Colour-patches

1 The *De Nominibus Utensilium* has now been fully edited in T. Hunt 1991: *Teaching and Learning Latin in Thirteenth-century England*, I, 1888-9, for the chapter on the *scriptorium*. Although this vocabulary was published by T. Wright in 1857 and by A. Scheler in 1867, was cited briefly by W. Wattenbach 1896, *Das Schriftwesen im Mittelalter*, 3rd ed., 207, 275, 293, 345, and has been trans., not always reliably, in U. T. Holmes 1952, *Daily Living in the Twelfth Century, based on the Observations of Alexander Neckham in London and Paris*, 69-70, it has so far as I know been used very rarely by historians of manuscript illumination.

2 R. E. Latham (ed.), *Revised Medieval Latin Word-List from British and Irish Sources*, rev. ed. 1965. Wattenbach 1896, 275 cites the definition of *cavilla* in the Serapeum vocabulary: '*Cavilla, cavil, in proposito est instrumentum quo posito super exemplari utitur scriptor, ut visus ejus referatur certius et promptius ad exemplar, et dicitur a cavo, as, prout idem est quod perforo; as, quia perforatur est visu.*' But Wattenbach also notes that Nequam appears to identify the term with spectacles. He also gives instances in the later Middle Ages of the use of *berillus* and *spiegel* (*speculum*) in the sense of spectacles and in the singular (288-9).

3 See for example the Anglo-Norman gloss in a Cambridge MS cited by Hunt (II, 79): '*spectaculum*: espectacle sive *cavillam* vel cavillam: spectacle'. Both the British Library MS used by Wright, *A Volume of Vocabularies*, 1857, and the Bruges MS published by Scheler in 1867 identified *cavilla* with *spectaculum*. This may be the reason why Holmes (70) has translated this term vaguely as 'indicator', citing J. Destrez, 'L'outillage des copistes du XIIIe et du XIVe siècles', in A. Lang, J. Lechner, M. Schmaus 1935, *Aus der Geisteswelt des Mittelalters: Studien und Texte Martin Grabmann zur Vollendung des 60 Lebensjahres von Freunden und Schulern gewidmet*, I, 19-34. But Destrez (33-4) was somewhat nonplussed by Wattenbach's *cavilla*, and was unable to relate the term to the line-computing device he had discovered. He was also unable to identify Wattenbach's 'Serapeum' dictionary, the source of his definition; I have had no better success.

4 The fullest discussion of these optical developments is by A. C. Crombie, 'The mechanistic hypothesis and the scientific study of vision: some optical ideas as a background to the invention of the microscope' in S. Bradbury and G. L. E. Turner 1967, *Historical Aspects of Microscopy*, espec. 46-7.

5 The classic study is E. Rosen 1956, 'The invention of eyeglasses', *Journal of the History of Medicine and Allied Sciences*, XI, 13-53, 183-218.

6 J. S. Neaman 1993, 'The mystery of the Ghent bird and the invention of spectacles', *Viator*, XXIV, 189-214. Neaman has identified spectacles in a *drôlerie* in a Ghent Psalter of c. 1240, and also points to the French and English fashion for miniature Bibles from about 1230.

7 Bruges, Bibl. Communale MS 536 in A. Scheler (ed.) 1867, *Lexicographie latine du XIIe et du XIIIe Siècle: Trois Traités de Jean de Garlande, Alexandre Neckam et Adam du Petit-Pont*, 113: *spectaculum vel cavillum*.

8 R. Gibbs 1989, *Tomaso da Modena: Painting in Emilia and the March of Treviso, 1340-1380*, 83-4, 264-5 and pls 19, 27. Gibbs also notes the use of these two instruments in frescoes at Assisi by the Bolognese painter Andrea de' Bartoli, dated 1367/9.

9 J. J. G. Alexander 1992, *Medieval Illuminators and their Methods of Work*, 32-4 and fig. 51.

10 See espec. V. Illardi, 'Eyeglasses and concave lenses in fifteenth-century Florence and Milan: New Documents', *Renaissance Quarterly*, 29, 1976, 341-60; and the excellent general survey: J. Dreyfus (1988), 'The invention of spectacles and the advent of printing' in *Into Print: Selected Writings on Printing History, Typography and Book Production*, 1994, 298-310.

11 F. Brunello (ed.) 1975, *De Arte Illuminandi e Altri Trattati sulla Tecnica della Miniatura Medievale*, 201. See also the *De Coloribus Faciendis* of Peter of St Omer, now given to the 13th or 14th century, §XXIII/172: L. van Acker (ed.) 1972, *Petrus Pictoris Carmina*

nec non Petri de Sancto Audemaro Librum de Coloribus Faciendis (Corpus Christianorum Continuatio Medievalis XXV), 185.

12 Jehan Le Begue, *Tabula de Vocabulis Sinonimis et Equivocis Colorum* (1431) in M. Merrifield (1849), *Original Treatises on the Arts of Painting*, 1967, I, 34, also 27, sv '*Fenix*'.

13 For the glosses, Hunt (op. cit. n. 1 above) II, 80, 117. For the manufacture of vermilion, R. J. Gettens, R. L. Feller, W. T. Chase 1993, 'Vermilion and Cinnabar' in A. Roy (ed.), *Artists' Pigments*, II, 159-82.

14 See his *De naturis Rerum*, ed. T. Wright 1863, espec. I, xl §94 on the colours of the peacock; and for his science, R. W. Hunt, *The Schools and the Cloister: the Life and Writings of Alexander Nequam (1157-1217)*, ed. M. Gibson 1984, 67-83.

15 Ed. cit. (n. 11 above), §XXVIII/177, 186-7.

16 Ibid. §XVIII/167, 183. For *perse* see espec. H. Meier, 'Ein dunkles Farbwort', in H. M. and H. Schommodau 1963, *Wort und Text: Festschrift für Fritz Schalk*, 101-10.

17 C. H. Haskins 1960, 'A list of text-books from the close of the twelfth century' in *Studies in the History of Medieval Science* (1927), 58.

18 Alexander (op. cit. n. 9 above) 46, fig. 67.

19 P. Stirnemann, 'Nouvelles pratiques en matière d'enluminure au temps de Philippe August' in H. Bautier (ed.) 1982, *La France de Philippe Auguste*, 968-75, no. 6.

20 Ed. cit. (n. 11 above) §§XXV-XXVI (174-5) 185-6; Gage 1993, *Colour and Culture*, 139. The fullest survey of the medieval connotations of 'red' is in C. Maier and R. Suntrup 1987, 'Zum Lexikon der Farbenbedeutungen im Mittelalter. Einfuhrung zu Gegenstand und Methoden sowie Probeartikel aus dem Farbenbereich "Rot"', *Frümittelalterlichen Studien*, XXI, 390-478.

21 A. Petzold 1990, 'Colour notes in English Romanesque manuscripts', *British Library Journal*, 16/1, 20.

22 Stirnemann (op. cit. n. 19 above) 964.

23 Ibid. 965, n. 14.

24 Merrifield (op. cit. n. 12 above) I, 38; see also 37.

25 Petzold 1990, 21-3; M. Bateson (ed.), *Records of the Borough of Leicester*, I, 1899, 102 (1264). See 84 (1259).

26 Urso von Salerno, *De Commixtionibus Elementoruam Libellus*, cit. Gage 1993, *Colour and Culture*, 165.

27 Alexander (op. cit. n. 9 above) 24, fig. 35. On the history of palette arrangements, Gage (op. cit) ch. 10.

28 Alexander (op. cit. n. 9 above) 17, fig. 25.

29 British Library Royal 6E.VI, f. 329r. See L. F. Sandler 1996, *Omne Bonum: a fourteenth-century encyclopedia of universal knowledge*. British Library MSS Royal 6E. VI-6E. VII.

30 British Library Royal 6E.VI, f. 331vff. My reading differs somewhat from the list given in Alexander (op. cit. n. 9 above), 160, n. 49.

31 L. F. Sandler 1989, 'Notes for the Illuminator: the case of the *Omne Bonum*', *Art Bulletin*, 71, 551-64. Sandler shows (557, 559-60) that these later illuminators must have consulted the text to amplify their instructions.

32 M. Seymour (ed.) 1975, *On the Properties of Things: John Trevisa's Translation of Bartholomaeus Anglicus De Proprietatibus Rerum*, II, ch. XI, 1285.

33 Ch. XII, 1285; ch. XV, 1287.

34 Merrifield (op. cit. n. 12 above) 34.

35 Seymour (op. cit. n. 32 above) chs XVII, XVIII, 1289; ch. XXV, 1293. For *siricum*, Brunello (op. cit. n. 11 above) 235-6.

36 Seymour (op. cit. n. 32 above) ch. XVII, 1288. For *kermes*, below p. 111.

37 Even the most rigorously argued and comprehensive of contemporary colour-systems, in Roger Bacon's *Liber de Sensu et Sensato*, probably written in the late 1240s, is difficult to make coherent: see C. Parkhurst, 'Roger Bacon on color: sources, theories and influence' in K. L. Selig and E. Sears (eds) 1990, *The Verbal and the Visual: Essays in Honor of W. S. Heckscher*, 151-201, espec. table on 194-6. See also Gage 1993, *Colour and Culture*, 165-6, which differs somewhat from Parkhurst in its conclusions.

38 'Viridis enim color vel niger prebent solamina radiis oculorum.

albedo enim incensa visum disgre[g]at et maxime nervum obsitum [i.e. opticum] i exsensum obtenebrat'. Hunt (op. cit n. 1 above) I, 89.

39 Gage 1993, *Colour and Culture*, 61. Also Pliny, *Natural History*, XXXVII, xvi, 62-3.

40 Seymour (op. cit. n. 32 above) ch. XIX, 1290.

41 Ibid. 1291.

42 Ibid. ch. VI, 1275; ch. XIV, 1287. This view of the central place of red in the scale between white and black was shared by Bacon, who was thus unlikely to be the first to have perceived it, as Parkhurst (op. cit. n. 37 above) 170 has suggested. It may be significant that Bartholomaeus quotes extensively from Bacon's teacher, Robert Grosseteste, on colour.

43 Seymour (op. cit. n. 32 above) ch. XIV, 1287.

6 Ghiberti and Light

1 Cf. K. van Straelen 1938, *Studien zur Florentiner Glasmalerei des Trecento und Quattrocento*, 72, 84f; A. Lane 1949, 'Florentine painted glass and the practice of design', *Burlington Magazine*, XCI, 48 on the unevenness and 'mediocrity' of the designs. R. Krautheimer 1956, *Lorenzo Ghiberti*,, 203n, dismissed the designs as contributing nothing to the understanding of Ghiberti's late style. For a more favourable view, G. Marchini 1957, *Italian Stained Glass Windows*, 43-51; G. von Habsburg 1970, 'Les vitraux de Lorenzo Ghiberti', *Comptes Rendues du 7e Colloque du Corpus Vitrearum Medii Aevi*, Florence, 24-6. M. Salmi 1956, 'Lorenzo Ghiberti e la Pittura', *Scritti in Onore di Lionello Venturi*, I, 223ff, made an inconclusive attempt to use the glass designs as a basis for constructing a painted *oeuvre*. On Ghiberti's Trecento background, espec. in glass and goldsmith's work, Krautheimer, op. cit., 54, 61-7; for his metalwork, L. Vayer 1962, 'L'Imago Pietatis di Lorenzo Ghiberti', *Acta Historiae Artium*, VIII, 45-51, T. Krautheimer-Hess 1964, 'More Ghibertiana', *Art Bulletin*, XLVI, 311-20, A. Parronchi 1980, 'La croce d'argento dell'altare di San Giovanni' in *Lorenzo Ghiberti nel suo Tempo* (Atti del Convegno Internazionale di Studi, 1978), II, 195-218; G. Brunetti, 'Ghiberti orafo', ibid. 223-44, F. Gandolfo 1982, 'Firenze 1429: Adamo e le gemme', *Storia dell'Arte*, 45, 133-51.

2 As has been done by e.g. O. Morisani in his edition of L. Ghiberti, *I Commentari*, 1947, x, xvii. Krautheimer (op. cit. n. 1 above) 306-14, although he recognized that the text as we have it is 'by and large a hodge podge of reading notes gathered from ancient and medieval writers'. K. Bloom 1969, 'Lorenzo Ghiberti's space-relief: method and theory', *Art Bulletin*, LI, 164ff, has dealt with the treatise more sympathetically, while still regarding it as 'some measure of Ghiberti's failure as a theorist' (167). But see now the monumental edition of Klaus Bergdolt (1988), *Der Dritte Kommentar Lorenzo Ghibertis: Naturwissenschaften und Medezin in der Kunsttheorie der Fruhrenaissance*, 18-19, xxxviii-xxxix, on the incomplete form of the MS.

3 G. Ten Doesschate 1940, *De Derde Commentaar van Lorenzo Ghiberti in Verbaun met de Middeleeuesche Optiek*, 5; and the concordance of translated passages on 8-9, amplified and revised in Bergdolt (op. cit. n. 2 above, 570-3).

4 G. F. Vescovini has drawn attention to Ghiberti's dissatisfaction with the translations available to him, and has shown how closely dependent he was on the 14th-century Italian version of Alhazen (now Vatican MS 4595), at the same time as he modified it to suit his own purposes ('Il problema delle fonti ottiche medievali del *Commentario Terzo di Lorenzo Ghiberti*' in *Lorenzo Ghiberti nel suo Tempo*, cit. n. 1 above, II, 352, 354 n. 16, 366). Substantial extracts from this MS were first published by E. Narducci 1871, 'Nota intorno a una traduzione Italiana fatta nel secolo decimoquarto del trattato di ottica del Alhazen', *Bulletino di Bibliografia di Storia delle Scienze Matematiche e Fisiche*, IV, 1-40. Vescovini, like Bergdolt (op. cit. n. 2 above), is chiefly concerned with Ghiberti's physiology.

5 Ghiberti's more than superficial study of his sources has been stressed by A. Castiglioni 1921, 'Il trattato dell'Ottica di Lorenzo

Ghiberti', *Rivista di Storia Critica delle Scienze Medicale e Naturali*, IV, 62, although he has not taken the analysis of the contents very far. E. Panofsky 1955 noted that Ghiberti's concept of proportionality, while drawing on Alhazen, altered Alhazen's emphasis completely (*Meaning in the Visual Arts*, 89-90 n.). For a discussion of Ghiberti's choice of sources, A. Parronchi, *Studi su la Dolce Prospettiva*, 1964, 318ff; cf. also 383f.

6 *Commentari*, ed. Morisani (op. cit. n. 2 above), 41f.

7 L. B. Alberti, *Della Pittura*, ed. Mallé, 1950, 55.

8 Bergdolt (op. cit. n. 2 above) 6.

9 *Commentari*, ed. Morisani, 44.

10 E.g. where Alhazen describes (Bk I, ch. i) the after-image of a brightly-lit white object viewed for some unspecified time, Ghiberti gives precisely 'un terzo d'ora'. Bergdolt (14-16) follows Vescovini 1965 ('Contributo per la storia della fortuna di Alhazen in Italia: il volgarizzamento del MS Vat. 4595 e il "Commentario Terzo" del Ghiberti', *Rinascimento*, ser. 2, V, 32) in pointing out that this Italian version specified 'un ora', which must have seemed a good deal too long to Ghiberti. Vescovini, in *Lorenzo Ghiberti nel suo Tempo* (cit. n. 1 above, 369-73), cites parallel passages on the effect of light on vision which also show Ghiberti's freedom with his source.

11 Ghiberti's version (Bergdolt, 22) may be roughly translated:

> if the viewer looks at a polished body with carvings in low relief on its surface, and if there be various colours in these carvings, as there are in cha [lcedonies], which are composed of several colours, and if the viewer is in a moderately illuminated place facing the light or some strongly-lit wall which reflects some light into his eyes...

Bergdolt (23, n. 5) makes rather heavy weather of this passage and does not notice that, unlike Alhazen, Ghiberti is concerned with parti-coloured stones. I have discussed another passage in Ghiberti's account of looking at sculpture in *Colour and Culture*, 1993, 120.

12 Bergdolt (32-6). This chalcedony passed from the Niccoli collection through that of Pope Paul II to the Medici, whose 1492 inventory described it as 'in transparent intaglio with no foil' (*in chavo trasparente sanza fondo*: E. Müntz, *Les Collections des Medicis au XV* Siècle, 1888, 69). As well as the version from the Medici collection (pls 38, 39) there are many 15th-century copies and variants (E. Kris 1929, *Meister und Meisterwerke der Steinschneidekunst in der Italienischen Renaissance*, I, 20f, II, pl. 5).

13 B. Cellini, 'Del'Oreficeria' in *Opere*, ed. Maier 1968, 625.

14 On this relationship, J. R. Johnson 1964, *The Radiance of Chartres*, 57-66; R. Silva 1996, 'Il colore dell'inganno: gemme, perle, ambra e corallo secondo un manoscritto del XIII secolo' in *Il Colore nel Medioevo: Arte, Simbolo, Tecnica*, 27-39.

15 Except by G. Poggi 1909, *Il Duomo di Firenze*, XCI n. 2, and E. Giusto 1911, *Le Vetrate di S. Francesco in Assisi*, who suggested that he was the glass-painter Antonio di Giomeo da Leccio, recorded in Pisa in 1386-7 and 1407.

16 See Gage 1993, *Colour and Culture*, 119. S. Pezzella (ed.) 1976, *Il Trattato di Antonio da Pisa sulla Fabbricazione delle Vetrate Artistiche*, 24. Antonio shows how close the glass-painter still was to the jeweler in his short section (49) on the best gemstones and crystals for cutting glass.

17 Van Straelen (op. cit. n. 1 above) 21, 27.

18 Pezzella (op. cit. n.16 above) 25; Marchini (op. cit. n. 1 above) figs 42-6. For the date of *St. Barnabas*, Poggi (op. cit. n. 15 above) docs 657, 677.

19 Poggi (op. cit) doc. 622.

20 Pezzella (op. cit.) 25. C. Cennini, *The Craftsman's Handbook*, trans. Thompson 1933, 111f. H. Wentzel 1949, 'Glasmaler und Maler in Mittelalter', *Zeitschrift des deutschen Vereins für Kunstwissenschaft*, III, 54f, notes many 15th-century German examples of glass-painters referred to in documents simply as 'Maler'.

21 Poggi (op. cit.) doc. 480.

22 Marchini (op. cit.) 248 n. 53.

23 Poggi (op. cit.) doc. 757. Cf. J. Pope-Hennessy 1950, *Paolo Uccello*, 145; Krautheimer (op. cit. n. 1 above), 109, for Uccello's time with

Ghiberti. His window in colour in Marchini (op. cit. n. 1 above) fig.54. Both Gaddi and Uccello are cited as *pictori* in the documents, whereas Ghiberti is called sculptor (*magister intagli*).

24 Bergdolt (op. cit. n. 2 above) 178.

25 The *Opera di Prospettiva*, which exists only in an early 16th-century MS (Florence Riccardiana 2110), but was attributed to Alberti by A. Bonucci (*Opere Volgari di L. B. Alberti*, IV, 1847), includes a number of remarks on the persistence of vision and on light as at once the condition and destruction of vision (ed. cit. 104, 132) which reinforce the more recent attribution to a Ghibertian milieu (G. Nicco Fasola 1942-3, 'Lo svolgimento del pensiero prospettico nei trattati da Euclide a Pero della Francesca', *Le Arti*, V, 66). Parronchi has republished this MS with an attribution, based chiefly on language, to Paolo dal Pozzo Toscanelli (*Studi...*, cit. n. 5 above), 299.

26 As has been suggested, for example, Kris, loc. cit. (n. 12 above). For Niccoli's real concerns, Krautheimer (op. cit. n. 1 above) 301 f; E. H. Gombrich, 'From the revival of letters to the reform of the arts: Niccoló Niccoli and Filippo Brunelleschi', *Essays in the History of Art presented to Rudolph Wittkower*, 1967, espec. 78-81; P. Castelli in the exhibition catalogue, *Materia e Ragionamenti*, Florence 1978, 534-7.

27 Vespasiano da Bisticci, *Renaissance Princes, Popes and Prelates*, ed. Gilmore 1963, 402; cf. 399 on the chalcedony.

28 J. von Schlosser 1910, 'Lorenzo Ghibertis Denkwürdigkeiten', *Kunstgeschichtliches Jahrbuch der K. K. Zentral-Kommission*, I-IV, 134.

29 Ambrogio Traversari, *Latinae Epistolae...*, ed. Cannetus and Mehus 1759 (repr. 1968), II, cols 411f; Krautheimer (op. cit. n. 1 above) 301. For Ghiberti and Traversari, Castelli (op. cit. n. 26 above) 531-4.

30 Traversari's letter has been usefully reprinted in M. Baxandall 1971, *Giotto and the Orators*, 152-4, and on Traversari's humanist vocabulary, 13-14. In the shorter account of the Basilica Ursiana in his book of travels (*Hodoeopoericon*, 1681, 49) Traversari applied the mirror image to that building rather than to S. Vitale. For a reconstruction of the basilica and illustrations of some surviving capitals in the Museo Archivescovile at Ravenna, G. Bovini 1964, *Storia e Architettura degli Edifici Paleocristiani di Culto di Ravenna*, 101-25.

31 On the aesthetic of light, Gage 1993, *Colour and Culture*, ch. 3.

32 For Niccoli's approval, Traversari to Niccoli, July 1433 in *Latinae Epistolae* (cit. n. 29 above), col. 414; for Pope Nicholas V's view that 'he understood it better in his simple text than in the others with the numerous comments and notes they contained', Vespasiano da Bisticci (op. cit. n. 27 above) 50. For the earlier translations, M. de Gandillac (ed.) 1943, *Oeuvres Complètes du Pseudo-Denys l'Aréopagite*, 12f.

33 Traversari began his translations in 1431 and had completed the task by 1437 (A. Dini-Traversari, *Ambrogio Traversari e i suoi Tempi*, n.d. 135 ff).

34 *De Divinis Nominibus*, ch. IV, lect. v. A useful English trans. and commentary (based on the Latin of Johannes Saracenus) by A. Coomaraswamy, 'Medieval Aesthetic: I. Dionysius the Pseudo-Areopagite and Ulrich of Strasburg', *Art Bulletin*, XVII, 1935, 31ff.

35 For Suger and Pseudo-Dionysius, Gage 1993, *Colour and Culture*, ch. 4.

36 Krautheimer (op. cit. n. 1 above) 311f.

7 Color Colorado

1 See espec. the bibliography in M. Grossmann 1988, *Colori e Lessico: Studi sulla Struttura Semantica degli Aggettivi di Colore in Catalano, Castigliano, Italiano, Romeno, Latino e Ungherese*; and L. Maffi, 'A Bibliography of Color Categorization Research, 1970-1990' in B. Berlin and P. Kay, *Basic Color Terms: their Universality and Evolution*, 2nd ed. 1991.

2 See, for example, the discussion in B. A. C. Saunders and J. van Brakel, 'Re-evaluating Basic Color Terms', *Cultural Dynamics*, I, 3, 1988, 359-78.

3 Berlin and Kay, loc. cit., 6-7. In publications since 1969 Berlin and Kay have modified some of these criteria: see, for example, B. Kay and C. K. McDaniel, 'The linguistic significance of the meaning of basic color terms', *Language*, 54, 1978, 610-46.

4 For *azul*, see R. M. Duncan 1968, 'Adjetivos de color en el Español medieval', *Anuario de Estudios medievales*, V, 463, 466; also the revisions in idem 1975, 'Color words in medieval Spanish', *Studies in Honor of L. A. Kasten*, 62. For *gris*, a term for fur, J. Corominas and J. A. Pascual, *Diccionario Critico Etimologico Castellano e Hispanico*, 1980- . The origin of *anaranjado* remains obscure: whether, like so many medieval 'colour' terms (e.g. *purpura, escarlata*) it referred primarily to a type of cloth, or whether it took its name from a fruit (English: *orange*) is still uncertain: see the discussion of *Naranje* in J. Alfau de Solalinde 1969, *Nomenclatura de los Tejidos Españoles del Siglo XIII*, 135-7.

5 Berlin and Kay, loc. cit., 7. Danièle Dehouve has found rather more evidence of the influence of bilingualism in modern Nahuatl: see 'Nombrar los colores en Nahuatl (Siglos XVI-XX)', to be published in the papers of the 1994 *El Color en el Arte Mexicano* conference.

6 Berlin and Kay, loc. cit., 12, 32.

7 See the Mixtec mask in Rome in J. A. Levenson (ed.) 1991, *Circa 1492: Art in the Age of Exploration*, no. 377; and the Aztec Tlaltoc vase (*c.* 1470) from the Museo de Sitio del Templo Mayor in Mexico City: ibid. no. 368.

8 Fray Bernardino de Sahagún, *Florentine Codex: General History of the Things of New Spain*, ed. and trans. C. E. Dibble and A. J. O. Anderson 1961, Bk X, ch. 16, 60. This passage is not in Sahagún's own Spanish translation. *Chalchiuhnamac* relates to *chalchiuitl*, 'emerald', but, according to A. de Molina, *Vocabulario en Lengua Castellana y Mexicana, y Mexicana y Castellana*, Mexico 1571 (repr. 1970), in the form of *chalchiuhiximatqui* ('knowledge of stones') it has the connotation of *any* stone. It is notable that the earliest known reference to the colour of the turquoise in Europe, in the mid-13th-century lapidary of Albertus Magnus, it is described as *blavus* (blue): Albertus Magnus, *The Book of Minerals*, trans. D. Wyckoff 1967, 123. See also A. Pagliaro, 'Il nome della turchese', *Archivio glottologico italiano*, 39, 1954, 142-65. Pagliaro's 16th-century edition of Albertus Magnus, interestingly, reads *blavus* as *flavus* (yellow). The Nahuatl term for obsidian in this passage in Sahagún is *matlalitzli*, which is used for the term for 'fine blue' and 'dark green', *matlalin*. The more usual term for blue is *texotli*. See also Sahagún's Bk XI, ch. 8, 1963, 222-4, on the many green stones.

9 *Itzac* (white object, from 'salt'); *yapalli* (black); *chichiltic* (red object, from 'chili-pepper'); *quilpalli* (blue or green or 'verdigris'); *cuztic* (yellow, gold); *texotli* (blue); *quauhpachtli* (brown); *camopalli* (purple); *tlaztaleualli* (flesh-pink); *xuchipalli* (orange); *nextic* (grey, from 'ashes'). These terms are taken from Molina (loc. cit. n. 8 above). For Sahagún's use of this source, R. J. Campbell and M. L. Clayton, 'Bernardino de Sahagún's contribution to the lexicon of Classical Nahuatl' in J. J. Klor de Alva, H. B. Nicholson, E. Q. Keber (eds) 1988, *The Work of Bernardino de Sahagún*, 297. For a general study of some aspects of this colour-vocabulary, J. H. and K. C. Hill, 'A note on Uto-Aztecan color terminologies', *Anthropological Linguistics*, 12, 1970, 235. Molina and Sahagún list many other nuances besides those given above.

10 Berlin and Kay (loc. cit. n.1 above) 13.

11 For a discussion of the history of the idea of 'primary colours' and their largely 19th-century interpretation as intrinsic to colour-science, Gage 1993, *Colour and Culture*, 34-6, 258-9.

12 Georges Roque has drawn my attention to the reconstructed headdress, largely of quetzal feathers, known as the *Penacho de Moctezuma* in the Museo Nacional de Antropologia in Mexico City. The colours veer from blue-green to green as the feathers move. The blue feathers at the base were originally from the *Cotinga amabilis Gould*, known to the Nahua as *xiuhtototl* ('turquoise bird'): see K. A. Nowotny 1960, *Mexikanische Kostbarkeiten aus Kunstkammern der Renaissance im Museum fur Volkerkunde, Wien und in der Nationalbibliothek Wein*, no. 3, 44. The much-damaged original is still in Vienna.

13 See D. Gonzales Holguin 1608, *Vocabulario de la lengua general de todo el Peru* (repr. 1952), under *allca*. In Vol. I, 11, of his dictionary, Holguin also gives the term *ticlla*, which has survived as *tijllaa* ('bi-coloured') in modern Quechua (J. Lara, *Diccionario Qheshwa-Castellano – Castellano-Qheshwa*, 1971). For chequerboard designs in textiles see the Inca tunic in Munich (Levenson, loc. cit. n. 7 above), no. 449, and another at Dumbarton Oaks, no. 451. There was also a Quechua term for 'chequerboard' itself: *qolqanpata* ('hill of terraces with storehouses'), and the design seems to have had royal or military connotations.

14 Hernán Cortés, *Letters from Mexico*, ed. and trans. A. Pagden 1986, 104. It is notable that colours and dyes formed an important sector of the goods sold at the market of Coyocan *c.* 1550, in Mexico in the 1540s and 1550s, and at Tlaxcala from the mid-1540s to the mid-1560s (J. Lockhart 1992, *The Nahuas after the Conquest: a Social and Cultural History of the Indians of Central Mexico, 16th through 18th centuries*, 187). It is equally striking that a document of 1610 records the purchase specifically of *caxtilla tlapalli*, 'Spanish colours', as opposed to local ones (ibid., 278). So far there have been few detailed studies of the pigments of Aztec painting, or indeed of that of 16th-century Spain. The few *tonalamatl* which have been analysed technically have revealed the use of some nine hues, some of them mixtures (K. Nowotny 1961, *Codices Becker I/II*, Introduction, 23; idem 1968, *Codex Cospi: Calendario Messicano 4093*, 14-16). The analysis of the painted sculpture at the Mayan site of Palenque has yielded around a dozen nuances (E. Robertson 1983-91, *The Sculpture of Palenque*, Appendices). See also L. Schele, 'Color on Classic Architecture and Monumental Sculpture of the Southern Maya Lowlands' in E. H. Boone (ed.) 1986, *Painted Architecture and Polychrome Monumental Sculpture in Mesoamerica*, 32-4. In the Iberian peninsula of the early 17th century around twenty painters' colours have been listed: Z. Veliz 1986, *Artists' Techniques in Golden Age Spain*, 3, 26.

15 Sahagún (loc. cit. n. 8 above) 1961, Bk X, ch. 21, 77.

16 Ibid. 1952, Bk III, ch. 3, 14: *chichiltic* (chili-red); *coztic* (golden yellow); *tlaztaleolaltic* (flesh-pink); *camopaltic* (violet); *xoxoctic* (green); *matlaltic* (blue); *quilpaltic* (verdigris); *viztecoltic* (whitish, sometimes interpreted as 'orange'); *camiltic* ('dark'-brown); *movitic coioichcatl* (coyote-coloured). For the Spanish version, Fray Bernardino de Sahagún, *Historia General de las Cosas de Nueva España*, ed. A. M. Garibay K. 1956 Mexico, I, 279: *colorado, encarnado, amarillo, morado, blanquecino, verde, azul, prieto, pardo, naranjado, leonado*. Note that the Spanish has only one green, where the Nahuatl has two.

17 For a well-documented overview, F. Brunello 1968, *L'Arte della Tintura nella Storia dell'Umanità*, 77-87.

18 F. Boas, *Primitive Art*, 1955, 46-52.

19 L. N. O'Neale 1933, 'A Peruvian multicolored patchwork', *American Anthropologist*, New series 35, 86-94. The hues include blue, green-blue and turquoise. The textile is in the collection of the Phoebe Apperson Hearst Museum of Anthropology, Berkeley, CA.

20 C. A. Romero (ed.) 1923, 'Razon y Forma en Theoria de los Tintes Reales de Quito…' (1703) in *Inca*, I, 455-74. The Araucan Indians of Central Chile have used more than twenty vegetable dyestuffs, and describe their effects with some ten colour names (Brunello, op. cit. n. 17 above, 84). See also the Chilean Aymara colour-vocabulary for natural and dyed wools in V. Cereceda 1978, 'Sémiologie des tissus Andins: les Talegas d'Isluga', *Annales, Economiques, Sociales, Culturales* 33, 1023.

21 For example the colour-terms used by horse-breeders (Gage 1993, *Colour and Culture*, 79), and for the Andean region, J. A. Flores Ochoa 1978, 'Classification et dénomination des camélides sud-Américains', *Annales*, ESC 33, 1009ff.

22 See, for example, C. B. Mervis and E. M. Roth, 'The internal structure of basic and non-basic color categories', *Language*, 57, 1981, 384-405.

23 For the problems of symbolism, Gage, *Colour and Culture*, 1993, ch. 5.

24 See, for example, K. A. Nowotny 1961, *Tlacuilolli: die Mexicanischen Bilderhandschriften: Stil und Inhalt*, 254. Nowotny also (233) notes

discrepancies in the colouring of the gods in the codices. C. L. Riley, 'Color-direction symbolism. An example of Mexican-South Western contacts', *America Indigena*, 23, 1963, 49-60; K. A. Nowotny 1969/70, 'Beiträge zur Geschichte des Weltbildes, Farben und Weltrichtungen', *Wiener Beiträge zur Kulturgeschichte und Linguistik*, XVII, espec. 215. E. T. Baird, 'Naturalistic and symbolic color at Tula, Hidalgo', in Boone (op. cit. n. 14 above) 124-6; H. B. Nicholson, 'Polychrome on Aztec Sculpture', ibid. 145-6. Baird notes the intimate relationship between 'direction' and the appearance of the sun, rather than with compass-points in the modern Western sense; but although the colours of the sun are not standard (see above p. 23), this hardly accounts for the wide divergences of view exposed by Riley.

25 Riley (loc. cit. n. 24 above) 54.

26 In the case of the rather pale colours of the world-diagram in the Codex Fejervary-Meyer in Liverpool (which may be unfinished), it is notable that Nowotny (op. cit. n. 24 above, 226 f) identifies south as green and west as blue, where the more recent commentary of M. Leon-Portilla has 'bluish-green' and 'greenish-blue' respectively (Levenson, loc. cit. n. 7 above), nos 356, 540. The codex has been reproduced in facsimile: M. Leon-Portilla, *Tonalamtl de los Pochetas: Codice Fejervary-Meyer*, 1985.

27 Sahagún 1963, *Florentine Codex*, Bk XI, ch. 8, 228.

28 Duncan 1968 (op. cit. n. 4 above), 463; 1975, 57. *Rojo* does not appear in Antonio de Nebrija's Spanish-Latin dictionary of 1516, although *roxo* (*rutilus, flavus*) does (A. de Nebrija, *Vocabulario de Romance en Latin*, 1516, ed. G. J. Macdonald 1973).

29 N. M. Holmer, 'Amerindian color semantics', *International Anthropoligical and Linguistic Review*, II, 3-4, 1955-6, 162. For Antiquity, Gage, *Colour and Culture*, 1993, 26-7.

30 For 16th-century Aymara, Ludovico Bertonio, *Vocabulario de la Lengua Aymara*, 1612 (repr. 1956). Holmer, op. cit. 163, has pointed out that *chupica* is also a soup of meat and red chili-peppers.

31 B. Cobo, *Historia del Nuevo Mundo* (1653), Bk XIV, ch. xi, in *Obras*, ed. F. Mateos 1956, II, 258.

32 Sahagún, ed. Garibay, III, 241. The Nahuatl version (*Florentine Codex*, Bk XI, ch. 11, 1963, 239) does not include this passage. For the Spanish reception of cochinal, Brunello (loc. cit. n.17 above) 202-3.

33 Brunello (loc. cit. n. 17 above) 85. In Peru the cinnabar facepaint called in Quechua *ychima* or *llimpi* was also used as tribute (G. Montell 1929, *Dress and Ornament in Ancient Peru*, 219 ff).

34 Alfau de Solalinde (loc. cit. n. 4 above) 95-9, and on *grana*, 112-13. For the general history of *scarlet*, Gage 1993, *Colour and Culture*, 80.

35 A. Castro 1921, 'Unos aranceles de aduana del siglo XIII', *Revista de Filologia Española*, VIII, 348 f.

36 Alonso Fernandez de Palencia, *Universal Vocabulario en Latin y en Romance*, 1490 (repr. 1967), f ccclxxxvii r, describes under *purpurare* the process of dying with *purpura* to achieve, at the third dipping, 'perfecto color quermesi'. For the earlier interpretation of *purpura* simply as a silk cloth of any colour, Gage 1993, *Colour and Culture*, 27. In what must be one of the earliest European references to the Mexican *nochetzli*, it is described as dyeing silk and wool *purpuram seu chermisinum* (G. Cardano 1663, *De Rerum Varietate*, Bk 13, ch. lxvi, in *Opera*, III, 266).

37 Pedro Pizarro (1571), *Relacion del Descubrimento y conquista de los Reinos del Peru*, ed. E. Morales 1944, 64. For a full account of this audience, J. Hemming, *The Conquest of the Incas*, 2nd. ed. 1972, 33-6. Red was also an essential feature of other parts of the Inca's head-dress (Montell, op. cit. n. 33 above, 223).

38 For the adoption of Spanish colour-terms in Nahuatl documents, F. Karttunen and J. Lockhart 1976, *Nahuatl in the Middle Years: Language Contact Phenomena in Texts of the Colonial Period* (University of California Publications in Linguistics, 85) 27, 29, 67, 71, 73.

39 Molina (loc. cit. n. 8 above) I, 66v; Sahagún 1963, *Florentine Codex*, Bk XI, 224.

40 Duncan 1968 (loc. cit. n. 4 above) 467; see also Grossmann (loc. cit. n. 1 above) 170. For a Renaissance example of lips and fingernails, Fernando de Rojas (1502), *Tragicomedia de Calisto y Nemibea*,

ed. 1902, 11, line 6. It is notable that in Spanish Renaissance usage the traditional stigmatization of Judas and the Jews in general for their red hair (R. Mellinkoff 1983, 'Judas' Red Hair and the Jews', *Journal of Jewish Art*, IX, 31-46) was extended to their ostensibly florid complexions: F. Gonzalez Olle, 'Fisiognomia del color rojizo en la literatura española del siglo de oro', *Revista de Literatura*, 43, 1981, 153-63.

41 Sahagún, *Florentine Codex*, Bk XI, ch. 11, 245. Dehouve, however, proposes two independent etymologies for *tlapalli*: 'colouring' and 'red'. The Maya word *chac*, 'red', also had the connotation 'great' (Schele, loc. cit. n. 14 above, 37). It is striking, too, that the dye *colorado*, as described in the 1703 account of dyeing at Quito (loc. cit. n. 20 above, 469), a dye made not with cochineal but with Brasil wood, should, like the ancient 'purple', have shown a particular lustre. For dyeing with Brasil wood, Brunello (loc. cit. n. 17 above) 369.

42 For the problems of identifying the colours of the rainbow, Gage 1993, *Colour and Culture*, ch. 6.

8 The Fool's Paradise

1 C. Merrett in A. Neri 1662, *The Art of Glass*, 229.

2 D. C. Lindberg, 'Optics in sixteenth-century Italy' in P. Galluzzi (ed.) 1983, *Novità Celesti e Crisi del Sapere* (Atti del Convegno Internazionale di Studi Galileiani), *Annuali dell'Istituto e Museo di Storia della Scienza*, Supp. 2, 148. See also T. Frangenberg 1991, 'Perspectivist Aristotelianism: three case studies of Cinquecento visual theory', *Journal of the Warburg and Courtauld Institutes*, LIV, 137-58.

3 For the metaphysics of light, D. Bremer 1973, 'Hinweise zum griechischen Ursprung und zur europaischen Geschichte der Lichtmetaphysik', *Archiv für Begriffsgeschichte*, XVII; D. C. Lindberg 1986, 'The genesis of Kepler's theory of light: light metaphysics from Plotinus to Kepler', *Osiris*, New series 2, 5-42.

4 C. B. Boyer 1959, *The Rainbow, from Myth to Mathematics* (repr. 1970). For a more visually oriented discussion, Gage 1993, *Colour and Culture*, ch. 6.

5 Roger Bacon, *Opus Maius* VI, ii (ed. Bridges 1907, II, 173); Theodoric of Freiberg, *De Iride et Radialibus Impressionibus*, ed. 1914 J. Würschmidt (Beiträge zur Geschichte der Philosophie des Mittelalters, XII), 48, 62 (hexagonal crystal), 49-50 (spherical beryll). In his *De Coloribus*, which was probably written as an adjunct to *De Iride*, Theodoric used the traditional term *Iris* for the hexagonal stone (W. A. Wallace 1959, *The Scientific Methodology of Theodoric of Freiberg*, 369).

6 Pliny, *Natural History*, XXXVII, lii (*Iris*); Isidore of Seville, *Etymologiae*, XVI, xiii, 6; Marbode of Rennes, *De Lapidibus*, XLVII (ed. Riddle 1977, 82); Arnoldus Saxo, *De Virtute Universali*, ch. VIII: *De Lapidibus*, ed. V. Rose 1875, 'Aristotelis de Lapidibus und Arnoldo Saxo', *Zeitschrift für deutsches Altertum*, 18, Neue Folge 6, 427, 439.

7 Solinus, *Collectanea Rerum Memorabilium*, XXXIII, 22f, ed. Mommsen, 2nd ed. 1958, 152; Thomas of Cantimpré, *Liber de Natura Rerum*, XIV, xli, ed. Boese 1973, 364; R. Bacon, *Opus Maius*, VI, ii (1907, II, 173).

8 Albertus Magnus, *The Book of Minerals*, II, ii, ed. D. Wyckoff 1967, 98f.

9 Ibid. II, ii, 98f, I, ii, 30f.; Vannoccio Biringuccio, *De la Pirotechnia*, Venice 1540 (facs. ed. A. Carrugo 1977), II, xiii, f 39v still calls crystal 'di sustantia acquea'.

10 *John Pecham and the Science of Optics: Perspectiva Communis*, III, 20 ed. and trans. D. C. Lindberg 1970, 234-5.

11 Witelo, *Optics*, X, 83 in F. Risner, *Opticae Thesaurus*, 1572 (repr. 1972 with intro. by D. C. Lindberg), 473-4: 'Fit autem colorum distinctio a figura corporis: quoniam a qualibet alia crystallo vel corpore pervio alterius figurae varii apparent, qui secundum situm colorum iridis non sunt distincti.' For the rainbow colours, ibid. X, 67, 460-1.

12 Ibid. X, 84, 474. Boyer (op cit. n. 4 above) 106 suggests that Witelo might have known Bacon's distinction between the colours of the bow and those of the prismatic spectrum (*Opus Maius*, VI, vii; 1907, II, 188).

13 Theodoric 1914 (op. cit. n. 5 above) II, 23, 106-7: 'Magis autem apparet dictorum colorum intensio et claritas, si corpus diaphanum, per quod fit radiatio, esset parvae quantitatis'.

14 R. Grosseteste, *De Iride seu de Iride et Speculo*, ed. L. Bauer 1912 (Beiträge zur Geschichte der Philosophie des Mittelalters, IX), 74-5. See B. S. Eastwood, 'Grosseteste's 'quantitative' law of refraction: a chapter in the history of experimental science', *Journal of the History of Ideas*, 28, 1967, 406.

15 P. Boehner has traced the formulation of 'Ockham's Razor' to the late 13th-century Franciscan theologian Odo Rigaldus, but it is of course best known in Ockham and Duns Scotus after 1300 (William of Ockham, *Philosophical Writings*, ed. P. Boehner 1957, xx-xxi). See also K. Tachau 1988, *Vision and Certitude in the Age of Ockham*, 32, 132-3. For Fermat, A. I. Sabra 1967, *Theories of Light from Descartes to Newton*, ch. 5.

16 R. Grosseteste, *Hexaemeron*, ed. R. C. Dales and S. Gieben 1982, VIII, iv, 7, 222-3. Bacon did not link the Trinity with the rainbow colours, which he believed to be five (*Opus Maius*, VI, xii; 1907, II, 197).

17 Guillaume Digulleville, *Le Pèlerinage de l'Ame*, ed. J. J. Sturzinger 1895, 349, II.10775, 10783; 350-1, II.10799-823. For 'peacock stuffs', Gage 1993, *Colour and Culture*, 60-1; R. G. Kuehni, 'Cangianti: a fabric and a coloristic device in the art of the Renaissance', *Color Research and Application*, 21, 1996, 326-30.

18 'Quoniam idem spatium numero et totum capit quilibet de angulis trianguli, ut patet ad sensum, et tamen veraciter sunt anguli distincti quod est mirabile et creatura, nec alibi reperitur nisi in summa trinitate' (*Opus Maius*, Pt IV; 1907, 219).

19 See G. Stuhlfauth 1937, *Das Dreieck: Die Geschichte eines Religiösen Symbols*. For the Manichean doctrine which, curiously, used the image of sunlight passing through a triangular window, A. Adam 1954, *Texte zum Manichäismus*, 64. For the *Scutum Fidei*, Gage 1993, *Colour and Culture*, 83.

20 A. C. Crombie 1953, *Robert Grosseteste and the Origins of Experimental Science*, 199-200 n. 4. Albertus also argued for the decisive effect of the thickness of the crystal or glass through which the light was to pass: light red in the thinnest part, green in the thickest and yellow (*caeruleus*) in the middle, although he does not appear to have had a clear idea of the role of refraction.

21 B. Boncompagni 1871, 'Intorno a un manoscritto dell'ottica di Vitellione citato da Fra Luca Pacioli', *Bulletino di Bibliografia e di Storia delle Scienze Matematiche e Fisiche*, IV, 78-81. For Ghiberti, Bergdolt 1988 (cit. ch. 6 n. 2 above) xl, xli. For Leonardo, M. Kemp 1981, *Leonardo da Vinci: The Marvellous Works of Nature and Man*, 105, 330.

22 H. S. Matsen 1974, *Alessandro Achillini (1463-1572) and his doctrine of 'Universals' and 'Transcendentals': a Study in Renaissance Ockhamism*.

23 J. Trutfetter 1517, *Philosophie Naturalis Summa*, Erfurt, IV, ii, ff lvii verso-lxi recto on colours; f lix recto on tonal contrast. His discussion does not seem to be related to the late scholastic treatment of depth-perception through contrast studied by P. Marshall 1981, 'Two scholastic discussions of the perception of depth by shading', *Journal of the Warburg and Courtauld Institutes*, XLIV, 170-5. For earlier interest in Theodoric's ideas, Wallace (op. cit. n. 5 above) 249-54.

24 Trutfetter (op. cit.) f lix v.

25 Gregor Reisch 1504, *Margarita Philosophica*, Freiberg, IX, xxii on rainbows and haloes. For the complicated publishing history of this encyclopaedia, R. von Srbik, 'Die Margarita Philosophica des Gregor Reisch', *Akadademie der Wissenschaften in Wien (Matem.-Naturwiss. Klasse), Denkschriften*, 104, 1941, 104-8.

26 G. Cardano 1554, *De Subtilitate Libri XXI*, Leiden, 168; G. B. della Porta 1593, *De Refractione Optices*, Naples, espec.222f.

27 The precise role of each collaborator is uncertain, although they seem to have joined forces about 1565. The fullest discussion is in

J. J. Verdonk 1966, *Petrus Ramus en de Wiskunde*, 72-3. Verdonk concludes that Ramée (Ramus) provided the general concept and framework of the book, as well as the classical material, Reisner the detailed references from Alhazen and Witelo (whose optical works he edited, also with help from Ramée, and published in 1572) and the editing itself. Ramée was murdered at Paris in the St Bartholomew's massacres of 1572; Reisner died in Germany in 1580 or 1581. For Ramée's empiricism, R. Hooykaas 1958, *Humanisme, Science en Reforme: Pierre de la Ramée (1515-1572)*, 91-6.

28 *Opticae Libri Quattuor ex voto Petri Rami novissimo per Fridericum Risnerum eiusdem in mathematicis adjutorum olim conscripti*, Kassel 1606, 239-41.

29 M. Maylender 1929, *Storia delle Accademie d'Italia*, IV, 26.

30 V. A. Scarmilionius 1601, *De Coloribus Libri Duo*, Marburg, 3-4.

31 I have found Scarmigioni's work mentioned only in a single place: Valerio Martini, *Subtilitatum Proprietatum totius Substantiae quae occultae, specificaeque sunt Patefacta*, Venice 1638, I, iv, 7; xi, 20; xvi, 31; xvii, 32, 33, 34, 41; xxiii, 43; xxvi, 46; xxxvi, 66; xxxvii, 74-5, Venice 1638.

32 Scarmilionius 1601, 112, 118-20, 166.

33 This medical context has been discussed briefly by A. Mugnaini 1986, 'Il colore, e il corpo nel panorama scientifico e quotidiano del Cinquecento', *Annali dell'Istituto Storico Italo-Germanico in Trento*, XII, 125-45.

34 Phillipus Mocenicus 1581, *Universales Institutiones ad Hominum Perfectionum*, Venice, 307; Hieronymus Capivaccius 1603, *Tractatus de Urinis*, in *Opera Omnia*, Frankfurt, 211; Giambattista della Porta 1591, *Phytognomica*, Frankfurt, 147. All of these texts were used by Scarmiglioni.

35 T. da C. Kaufmann 1988, *The School of Prague: Painting at the Court of Rudolph II*, 165-6.

36 Scarmilionius 1601, 18, with a reference to an untraced *Tractatus de Temperamentis*.

37 Ibid. 16-18, 106ff.

38 Ibid. 23f. It is conceivable that *coerulea* here means 'yellow' (cf. above, n. 20, and Gage 1993, *Colour and Culture*, 35).

39 Ibid. 21. Scarmiglioni did not share the Aristotelian view that the rainbow colours could not be painted (112).

40 The classic account was Bacon's *De Multiplicatione Specierum*: see D. C. Lindberg 1983, *Roger Bacon's Philosophy of Nature: A Critical Edition with English Translation, Introduction and Notes of De Multiplicatione Specierum and De Speculis Comburentibus*, 3-7, and espec. liv-lviii.

41 Scarmilionius (op. cit. n. 30 above) 19, 21.

42 Ibid. 111.

43 Ibid. 25.

44 Ibid. 105. The 'lucid' colours are *candidus, flavus, puniceus, viridis purpureus* and *coeruleus*.

45 Ibid. 170. For Descartes on the identity of 'real' and 'apparent' colours, Sabra (op. cit. n. 15 above) 67n. For Newton on the identity of 'simple' and 'compound' colours, A. E. Shapiro 1993, *Fits, Passions and Paroxysms*, 10-11.

46 Scarmilionius 1601 (op. cit. n. 30 above) 121; Mocenicus 1581 (op. cit. n. 34 above) 305.

47 Mocenicus (op. cit.) 316.

48 British Library Add. MS 6789, f 148. According to his Will of 1621, Harriot apparently owned grinding and polishing apparatus (E. Rosen, 'Harriot's Science: the Intellectual Background' in J. W. Shirley (ed.) 1974, *Thomas Harriot, Renaissance Scientist*, 1).

49 S. Brugger-Koch 1985, 'Venedig und Paris', die wichtigsten Zentren des hochmittelalterlichen Hartsteinschliffs', *Zeitschrift des deutschen Vereins für Kunstwissenschaft*, XXXIX, 18, 21-2. See also H. R. Hahnloser and S. Brugger-Koch 1985, *Corpus der Hartstein-schliffe des 12-15 Jahrhunderts*, nos 238, 243-4, 326 for multi-facetted objects.

50 Mocenicus 1581 (op. cit. n. 34 above) 313-14.

51 Biringuccio 1540 (op. cit n. 9 above) f 43v. For the chemistry and optical quality of this glass, E. Turrière 1925, 'Introduction à l'histoire de l'optique: le developpement de l'industrie verrière d'art

depuis l'époque vénetienne jusqu'à la fondation des verreries d'optique', *Isis*, VII, 77-104.

52 Turrière (op. cit.) 99; K. Hetteš 1963, 'Venetian trends in Bohemian glassmaking in the 16th and 17th centuries', *Journal of Glass Studies*, V, 38-53; O. Drahtová, 'Comments on Caspar Lehmann, Central European glass and hardstone engraving', ibid. 1981, XXIII, 34-45.

53 A. A. Mills, 'Newton's prisms and his experiments on the spectrum', *Notes and Records of the Royal Society*, 33, 1981, 13-36; and espec. S. Schaffer, 'Glass works: Newton's prisms and the uses of experiment' in D. Gooding, T. Pinch, S. Schaffer 1989, *The Uses of Experiment: Studies in the Natural Sciences*, 67-104.

54 For Harriot's experiments, J. Lohne 1959, 'Thomas Harriot (1560-1621): the Tycho Brahe of optics', *Centaurus*, VI, 119-21. The first extensive precise experiments with the prism are thought to have been those by Harriot's friends Thomas Aylesbury and Walter Warner in 1627, but they remained unpublished (J. Lohne 1963, 'Zur Geschichte des Brechungsgesetzes', *Sudhoffs Archiv*, 47, 160f]. Line's experiments are described in [Kenelm Digby], *Two Treatises* (1644), 2nd ed. London 1658, 329. For Line, C. Reilly, 'Francis Line, Peripatetic (1595-1675)', *Osiris*, 14, 1962, 223-46.

55 J. W. von Goethe 1791-2, *Beiträge zur Optik* (facs. 1964).

56 Arnoldus Saxo (op. cit. n. 6 above) 439.

57 Albertus Magnus, *Metereology* II, iv, 19, in Crombie (op. cit. n. 20 above), 199-200n.

58 Theodoric, *De Iride*, II, i, 1914, 60, on the colours in the bow which, it has been argued (Wallace, op. cit. n. 5 above, 115ff.) were an intrinsic part of the contrarieties among the four elements (cf. *De Iride*, II, ii, 1914, 81-3). For the isolation of red and blue in the prismatic experiments, *De Iride*, II, 23 (1914, 106). In his treatise on colour, however, Theodoric identified the four rainbow colours in the spectrum of the hexagonal stone (*De Coloribus*, VI; Wallace 368f). For Della Porta's rejection of Aristotle's mixed yellow, which was the result of his experiments with coloured glass filters, and of the experience of painters (*neque pictores unquam ex viridi & puniceo flavum colorem efficiunt*), *De Refractione*, 1593, 195.

59 G. Cardano 1663, *De Gemmis et Coloribus* (*Opera*, II, 558) on the 'cristallina prismata': *purpura, amethystina, punicea, candida, coerulea*; but later (566) *viridem, amethystinum, puniceum, purpureumque*. Mocenicus 1581 (n. 34 above) 314: *hyacinthinus, viridis, rubeus*; and 316 on supernumerary colours. Scarmilionius 1601 (n. 30 above), 118-19: yellow-red, green, yellow (*caeruleus*), red, blue-violet (*amethystinus*); but 121: red, green, blue (*hyacinthinus/coeruleus*): 'Appellentur oculi: plane secundum nos pronunciabunt.'

60 J. Lohne, *Dictionary of Scientific Biography*, VI, sv. 'Harriot', 125.

61 Della Porta 1593, 223-4; see also the red, white and blue of the 'most pleasant and delightfull experiment we may perceive in a three square Cristall prisme', described by Henry Peacham 1634, *The Gentleman's Exercise*, 2nd ed. 139-40.

62 Gage 1993, *Colour and Culture*, 232, and Chapter 9 below.

63 The 'prism or triangle of crystal' illustrated in Descartes' *Les Meteores* (1637) is, however, a right-angled prism, using the thinnest part by the smallest angle, of 30 or 40 degrees (R. Descartes, *Discours de la Methode*, ed. J. R. Armogathe *et al.* 1987, 293-300). This prism, the bottom side of which was masked off, with only a small opening to admit the sun's rays to a white paper placed at right-angles to it, allowed Descartes to observe six hues: 'all the colours of the rainbow': *rouge, orange, jaune, verd, 'bleu ou le violet'*, which last was also perhaps '*couleur de pourpre*'.

64 J. Cardan, *The Book of My Life*, trans. J. Stoner 1930, ch. 44, espec. 216 on his simplification of algebra and his reduction of the elements to three and the humours to two. Cardano's father, Fazio, had been the editor of the first printed edition of Pecham's *Perspective* (*Prospectiva communis d. Johannis archiepiscopi Cantariensis...* ed. Facius Cardanus [Milan], Petrus de Cornero [?1482/3] Hain ★9425), and although his work is mentioned by Gerolamo, he makes no reference to the prism.

65 J. Lohne 1968, 'Experimentum Crucis', *Notes and Records of the Royal Society*, 23, 169-99. Newton's manipulation of two prisms had

been anticipated by Marcus Marci in 1648 (174); in one of his earliest notes of 1666, Newton identified his prism as an equilateral one of 60 degrees (179).

9 Newton and Painting

1 William Blake, *Poetry and Prose*, ed. G. Keynes 1956, 115. For Blake and Newton, D. Ault 1974, *Visionary Physics: Blake's Response to Newton*, and Chapter 10 below.

2 M. H. Nicolson 1946, *Newton demands the Muse*; D. Greene 1953, 'Smart, Berkeley, the scientists and the poets', *Journal of the History of Ideas*, XIV, 327-52; R. T. Murdoch 1958, 'Newton and the French muse', ibid. XIX, 323-34; H. Guerlac, 'An Augustan monument: the *Opticks* of Isaac Newton' in P. Hughes and D. Williams 1971, *The Varied Pattern: Studies in the Eighteenth Century*, 131-63.

3 G. Turnbull 1740, *A Treatise on Ancient Painting*, London, 133-4. Turnbull's notion of landscape painting as a science was so close to Constable's that the painter felt obliged to disclaim knowledge of the book before he had delivered similar thoughts in his Royal Institution lectures of 1836 (C. R. Leslie (1843), *Memoirs of the Life of John Constable*, ed. J. Mayne 1951, 323-4).

4 A. Blunt 1966, *The Paintings of Nicholas Poussin: A Critical Catalogue*, no. 1. For Poussin's access to the Zaccolini MSS see espec. J. C. Bell 1988, 'Cassiano dal Pozzo's copy of the Zaccolini Manuscripts', *Journal of the Warburg and Courtauld Institutes*, LI, 102-25. Recent cleaning of the self-portrait has shown that the lettering on the spine of the book was a later addition, based on the engraving by Jean Pesne. For Zaccolini's ideas, J. C. Bell 1993, 'Zaccolini's theory of color perspective', *Art Bulletin*, LXXV, 91-112, espec. 91.

5 B. Teyssèdre, *Roger de Piles et les Débats sur le Coloris au Siècle de Louis XIV*, 1957.

6 Roger de Piles 1672, *Dialogue sur le Coloris*, Paris, 50-1.

7 C. Kutschera-Woborsky 1919, 'Ein kunsttheoretisches Thesenblatt Carlo Marattis und seine aesthetischen Anschauungen', *Mitteilungen der Gesellschaft für vervielfältigende Kunst*, 9-28.

8 R. Boyle 1664, *Experiments & Considerations touching Colours* (repr. 1964), 219-21. For Boyle's crucial influence on Newton, A. Shapiro 1993, *Fits, Passions and Paroxysms: Physics, method, and Chemistry and Newton's Theories of Colored Bodies and Fits of Easy Reflection*, 99-101.

9 Isaac Newton, *Papers and Letters on Natural Philosophy*, ed. I. B. Cohen, 2nd ed. 1978, 47-59. See also R. S. Westfall 1962, 'The development of Newton's theory of color', *Isis*, LIII, 339-58.

10 Isaac Newton, *Correspondence*, ed. H. W. Turnbull 1959, I, 112.

11 A. Shapiro 1980, 'The evolving structure of Newton's theory of white light and color', *Isis*, LXXI, 211-35, and Shapiro 1993 (op. cit. n. 8 above) 98-9, 108-110 for Newton's continuing interest in the complementarity of reflected and transmitted colours.

12 Brook Taylor 1719, 'A new theory for mixing of colours taken from Sir Isaac Newton's Opticks' in *New Principles of Linear Perspective*, London, 67-70. Newton's own interest in colour-mixing has been discussed by A. E. Shapiro 1994, 'Artists' colors and Newton's colors', *Isis*, LXXXV, 600-30.

13 J. Byam Shaw 1967, *Paintings by Old Masters at Christ Church, Oxford*, 21.

14 Ibid. 21-6; F. Rodari (ed.) 1996, *L'Anatomie de la Couleur: L'Invention de L'Estampe en Couleurs*. O. Lilien 1985, *Jacob Christophe Le Blon, 1667-1741: Inventor of Three- and Four-Colour Printing*, 39ff. Also review in *Print Quarterly*, III, 1986, 65-7.

15 *Coloritto* (1725), facs. in Lilien, op cit., 6.

16 L. Gerard-Marchant 1990, 'Les indications chromatiques dans le *De Pictura* et le *Della Pittura d'Alberti*', *Histoire de l'Art*, XI, 23-36; Gage 1993, *Colour and Culture*, 118.

17 G. Wildenstein 1960, 'Jakob Christoffel Le Blon, ou le "secret de Peindre en Gravant"', *Gazette des Beaux-Arts*, LVI, 92; J. M. Friedman 1978, *Color Printing in England, 1486-1870*, Yale Center for British Art, no. 14.

18 J. Gautier d'Agoty 1749, *Chroagenesis, ou Generation des Couleurs,*

contre le Système de Newton. The fullest account of Gautier d'Agoty's version of Le Blon's methods is in Rodari, op.cit. n. 14 above.

19 H. W. Singer 1901, 'Jacob Christoffel Le Blon', *Mitteilungen der Gesellschaft für Vervielfältigende Kunst*, 5. G. Roque has emphasized that Chevreul's preference for the harmony of complementary contrasts was confined to decorative art (G. Roque 1996, 'Chevreul and Impressionism: a reappraisal', *Art Bulletin*, LXXVIII, espec. 35).

20 F. Haskell, *Patrons and Painters*, 2nd ed. 1980, 319n. For Conti and Newton, P. Casini 1978, 'Les débuts de Newtonianisme en Italie, 1700-1740', *Dix-Huitième Siècle*, X, 88-90.

21 Newton, 1978, 192-3. This letter was not published until Thomas Birch included it in *The History of the Royal Society of London, 1757*, III, 263.

22 Shapiro 1993 (op. cit. n. 8 above) 91-2, 192-3.

23 See Gage 1993, *Colour and Culture*, 231-2.

24 T. Christensen 1993, *Rameau and Musical Thought in the Enlightenment*, 109-11, 142-50, 190-3.

25 L. B. Castel 1737, 'J. C. Le Blon, *Coloritto*', *Mémoires de Trévoux*, August.

26 M. Franssen 1991, 'The ocular harpsichord of Louis-Bertrand Castel: the science and aesthetics of an 18th-century *cause célèbre*', *Tractrix, Yearbook for the History of Science, Medicine, Technology and Mathematics*, III, 15-77.

27 Gage 1993, *Colour and Culture*, 243-6.

28 Shapiro 1993 (op. cit. n. 8 above) 52-5, 69.

29 R. W. Darwin (1786), 'On the ocular spectra of light and colours', repr. in E. Darwin, *Zoonomia, 1794-1796* (repr. 1974), I, 548. For the history of 'complementarity' in the 19th century, G. Roque 1994, 'Les Couleurs complémentaires: un nouveau paradigme', *Revue d'Histoire des Sciences*, XLVIII, 405-33.

30 See Gage 1993, *Colour and Culture*, 172-3.

31 For Chevreul and Seurat, see Chapter 16 below.

32 For Kupka's *Discs*, F. Kupka 1989, *La Création dans les Arts Plastiques*, 156-7; M. Rowell, *Frank Kupka: a Retrospective*, New York, Guggenheim Museum 1975, 67-76; V. Spate 1979, *Orphism: the Evolution of Non-Figurative Painting in Paris, 1910-1914*, 126-8, which offers a different interpretation from that suggested here.

33 For Goethe on Castel, *Farbenlehre: Historischer Teil*, ed. D. Kuhn (Leopoldina Ausgabe der Schriften zur Naturwissenschaft, I, 6) 1957, 328-33; for Gautier d'Agoty, 335-42.

10 Blake's Newton

1 David Bindman, who has generously made many corrections and amplifications to the present study, proposes a date in the early 1770s for these copies. M. Butlin 1981, *The Paintings and Drawings of William Blake*, nos 167-70, suggests a date of *c.* 1785. Ghisi's engravings were re-issued as *Pitture dipinte nella Volta della Capella Sistina nel Vaticano presso Carlo Losi l'anno 1773*; and Benjamin Heath Malkin, in his memoir of 1806, has Blake buying and copying prints after Michelangelo from about 1767 (G. E. Bentley, Jr, 1969, *Blake Records*, 422). It is not known if the British Museum series is complete; if so, Blake's choice of the Prophet Daniel, the youthful and energetic interpreter, Butlin fig. 205, was in the light of his subsequent career a happy one.

2 Butlin fig. 211. This free attitude has been held to be characteristic of Blake throughout his career (J. Burke, 'The Eidetic and the Borrowed Image: An Interpretation of Blake's Theory and Practice of Art', *In Honour of Daryl Lindsay: Essays and Studies*, ed. Philipp and Stewart 1964, espec. 120 f).

3 A. Blunt 1938, 'Blake's "Ancient of Days"', *Journal of the Warburg and Courtauld Institutes*, II, 61, no. 6; expanded in idem 1959, *The Art of William Blake*, 35, pl. 30 a.b. The musculature and lighting of Blake's copy is closer to the Abias in the large engraving by Giorgio Ghisi than to the detail version by Adamo; but the genius behind him is closer to the latter source.

4 Lecture II, 1800, cit. E. C. Mason 1951, *The Mind of Henry Fuseli*, 247f.

5 Charles de Tolnay 1945, *Michelangelo, II, The Sistine Chapel*, 89, has characterized Abias, puzzlingly, as a 'great and good king'.

6 G. Schiff 1973, *Johann Heinrich Füssli (1741-1825). Text und Oeuvrekatalog*, nos 471-8.

7 Cf. the characterization of E. Wind 1965, 'Michelangelo's Prophets and Sybils', *Proceedings of the British Academy*, li, 70f.

8 This view seems to go back to G. Keynes 1956, *The Pencil Drawings of William Blake*, ii, at pl. 8; and has been restated by K. Raine 1968, *Blake and Tradition*, ii, 64, and A. T. Kostelanetz, 'Blake's 1795 Color Prints. An Interpretation' in A. H. Rosenfeld (ed.) 1969, *William Blake, Essays for S. Foster Damon*, 126. The watery appearance of some of the plants is probably a result of the colour-printing process, and does not differ from similar features in the *Nebuchadnezzar*, Butlin fig. 393. Blake's convention for rendering figures under water, for example in pl. 6 of *Urizen*, 1794 (facs. in G. Keynes 1965, *William Blake: Poet, Printer, Prophet*, 73) is, *pace* Kostelanetz, quite unlike the *Newton*.

9 'A cave, as we learn from Porphyry…is an apt symbol of the material world: since it is agreeable at its first entrance on account of its first participation of form, but is involved in the deepest obscurity to the intellectual eye, which endeavours to discern its dark foundation. So that, like a cave, its exterior and superficial parts are pleasant: but its interior parts are obscure, and its very bottom darkness itself.' (T. Taylor 1787, *The Hymns of Orpheus*, 131f, cit. G. M. Harper 1961, *The Neoplatonism of W. Blake*, 157.)

10 W. Blake, *Complete Poetry and Prose*, ed. Keynes 1956, 344. All page references are to this edition.

11 Repr. W. Blake, *Vala, or the Four Zoas*, ed. Bentley, 1963, pl. 120; for the identification of the compasses, J. Beer, *Blake's Visionary Universe*, 1969, 351.

12 M. K. Nurmi, 'Blake's "Ancient of Days" and Motte's Frontispiece to Newton's *Principia*' in V. de Sola Pinto (ed.) 1957, *The Divine Vision*, 205-16.

13 The diagram to Bk 1, sect. i, Lemma ix (Sir I. Newton, *Mathematical Principles of Natural Philosophy*, trans. Motte 1729, i, pl. ii), has something in common with Blake's.

14 It is notable that other versions of the *Newton* design, e.g. the pencil drawing in the Keynes collection (Butlin fig. 409) and the 'Newtonian Angel' in an illustration to Young's *Night Thoughts* (repr. de Sola Pinto, op. cit. n. 12 above, facing 200), show either no mathematical figure or only a simple triangle. The chord or arc may symbolize graphically the rainbow spectrum created by the prism.

15 Raine (op. cit. n. 8 above, ii, 136f) has suggested that this cloth is the 'woof of Locke', but in *Jerusalem* (i, 15) this is described specifically as black (*cf.* also *The First Book of Urizen*, v, 12). She has also claimed (i, 420f, n. 38; ii, 158f) Blake's direct knowledge of Newton's *Opticks*, on the basis of some of his language and imagery.

16 Op. cit., i, 238, *cf.* also 239, 'there was no example of any philosophical inquiry conducted with more circumspection [than the *Opticks*], or in which the aid of mathematics was applied with more advantage or address'.

17 Op. cit., ii, 669, 663f. M. K. Nurmi, 'Negative Sources in Blake' (Rosenfeld, op. cit. n. 8 above, 304), has stressed the purely optical connotations of 'single vision' for an 18th-century audience, but without quoting Priestley, who specifically uses the expression, where Newton (*Opticks*, Bk III, pt i, query 15) does not.

18 'Having opened the points of a pair of compasses somewhat wider than the interval of his eyes, with his arm extended, he held the head or joint in his hand, with the points outwards, and equidistant from his eyes, a little higher than the joint. Then fixing his eyes on a remote object, lying in the line that bisected the intervals of the points, he first perceived two pairs of compasses, each leg being doubled, with their inner legs crossing each other. But, by compressing the legs with his hand, the two inner points came nearer to each other, and when they united, the two inner legs also entirely coincided, and bisected the angle under the outward ones; and they appeared more vivid, thicker, and longer, so as to reach from his hand to the remotest object in view, even in the horizen itself…' (ii, 670).

19 139; for Priestley and Newton, 137. Priestley, *History and Present State*, op. cit., ii, 708ff.

20 652; Priestley, op. cit., ii, 716f.

21 Op. cit., ii, 590f.

22 J. Boehme, *Mysterium Magnum*, cit. Raine (op. cit. n. 8 above) ii, 412, n. 37, where, and at i, 6, Raine has followed Yeats in supposing that Blake's scheme is identical, which is clearly not the case.

23 *The Works of James Barry*, 1809, i, 525f.

24 Dante's accounts are in *Purgatorio* XXIX, 77-8 and *Paradiso* XII, 10-12. Neither was published in English until after 1800; but Blake's later associate William Hayley was familiar with the whole *Divine Comedy* by 1782 (H. A. Beers 1901, *A History of English Romanticism in the Nineteenth Century*, 95f). His first connection with Blake, through Flaxman, seems to date from 1784 (Bentley, op. cit. n. 1 above, 27). Both Fuseli and Flaxman knew Dante in the original by the 1770s; but Flaxman's rainbow in his illustration prefacing the *Paradiso*, 1793, has five, not seven colour-divisions.

25 (a) Title-page to *Visions of the Daughters of Albion*, 1793; colour reproduction of A copy (British Museum, *cf*. Sir G. Keynes and E. Wolf 1953, *William Blake's Illuminated Books*, 28) with note by J. Middleton Murry, 1932; C copy (Lord Cunliffe: Keynes and Wolf 29), facs. by Trianon Press, 1959. Copy O (British Museum: Keynes and Wolf 32), which was printed and illuminated after 1815, has the same order on the title-page, which may depend upon a common model, but the new motif of the rainbow-nimbus round the kneeling figure on p. 3 has the colours in reverse.

(b) Watercolour illustrating Night viii of Young's *Night Thoughts*, *c*. 1797: British Museum 1929-7-13-178, Butlin no. 330/335 (our pl. 48).

(c) *Death of the Virgin*, 1803: Butlin no. 572.

(d) *Death of Joseph*, 1803 (reproduced in colour in L. Binyon 1922, *The Drawings and Engravings of William Blake*, 49).

26 (a) *The Four and Twenty Elders*, *c*. 1804-5: Tate Gallery, Butlin no. 575.

(b) *Noah's Sacrifice*, 1805: Harvard University, Houghton Library, reproduced in colour Butlin fig. 577. I am indebted to Miss Carol D. Goodman for examining and reporting the colours of this watercolour.

(c) *Jerusalem*, pl. 14. Copy E, coloured after 1820, reproduced in facs. by the Trianon Press, 1951.

(d) *Beatrice on the Car: Matilda and Dante*, *c*. 1825: British Museum, Butlin no. 812/8, reproduced in colour Binyon (op. cit.) pl. 103.

(e) *Beatrice addressing Dante from the Car*, *c*. 1825: Tate Gallery, Butlin no. 812/88, reproduced in colour fig. 973.

27 The painting is now in the Chamberlayne-Macdonald Coll. See London, Kenwood, *George Romney*, 1961, no. 38. I was able to study the spectrum colours at this exhibition. P. Fagot has also noticed this change in the Newtonian order of Blake's rainbows (P. Fagot, 'Témoignages synoptiques de William Blake et d'Emmanuel Swedenborg sur l'arc-en-ciel' in P. Junod and M. Pastoureau 1994, *Couleur: regards croisés sur la couleur du Moyen Age au XX⁰ Siècle*, 90, 93.)

28 Bryant (op. cit) ii, 1775, 346ff, from Hesiod, *Theogony*, 65. Bryant, however, in this chapter relates the etymology of Iris and Eros, and is anxious to follow the traditional view in interpreting the bow as a symbol of Divine Love.

29 Butlin no. 474, fig. 958.

30 e.g. *The Marriage of Heaven and Hell*, 1793: 'Jesus Christ did not wish to unite, but to separate them [the Prolific and the Devourer], as in the Parable of Sheep and goats...', 188; Blake's key text is Luke 12:51: 'Suppose ye that I am come to give peace on the earth? I tell you, nay, but rather division.' For a discussion of Blake's treatment of the Neo-Platonic idea of division and separation in the Material, see Harper (op. cit. n. 9 above) 228ff. Blunt's interpretation of the compasses and set-square in terms of Redemption (art. cit. n. 3 above, 60) seems unlikely in view of these attributes of Jesus in Blake's mythology.

31 Blunt, loc. cit. n. 3 above. Blake's authorship of an apparently related drawing formerly in the Lowinsky collection (Keynes, cit. n.

8 above, *Pencil Drawings*, pl. 34) is contested by David Bindman and Martin Butlin.

32 Raine (op. cit. n. 8 above) i, 412, n. 37 records a rainbow in a version of Blake's *Ugolino and his Sons* which I have not been able to trace. It is not recorded in the list of Ugolino designs given by A. S. Roe 1953, *Blake's Illustrations to Dante*, 132f. However, the connotations given to the Ugolino design in *The Gates of Paradise* would support the conclusions on the materialism of the rainbow discussed above. The auras and sky-modulations in the Beatrice watercolours are not strictly rainbows, although Dante refers to them as such (*Purgatorio*, XXIX), and Blake's colours are in the Newtonian sequence. Blake's view of Beatrice as Rahab, the fallen state of Vala (Roe, op. cit., 164-71), again reinforces the interpretation set out in this study.

11 Magilphs and Mysteries

1 James Barry to Sir Joshua Reynolds, 17 May 1769 (*The Works of James Barry*, I, 1809, 106 (the context suggests the date should be 1768); cf. also Barry to Burke, 30 Sept. 1768, ibid. 120. The Italian quotation, 'good drawing and muddy colouring', is taken from the life of Annibale Carracci in C. Malvasia (1678), *Felsina Pittrice*, 1841, I, 2. For the 18th- and 19th-century English liking for the unstable oil medium 'megilp', L. Carlyle and A. Southall, 'No short mechanic road to fame' in R. Hamlyn 1993, *Robert Vernon's Gift*, London, Tate Gallery, 23-5.

2 W. Sandby 1862, *The History of the Royal Academy of Arts*, II, 386-7.

3 Field's work has been examined in J. Gage 1989, *George Field and his Circle, from Romanticism to the Pre-Raphaelite Brotherhood*, Cambridge, Fitzwilliam Museum.

4 N. Pevsner 1940, *Academies of Art*, 168, 232. In 1770 the Incorporated Society of Artists made a brief experiment with lectures on chemistry, apparently at the invitation of the chemist, Dr Awsiter, himself (*Walpole Society*, XXXII, 1946-8, 23).

5 For Reynolds's secretiveness about techniques, J. Northcote, *Memorials of an Eighteenth-Century Painter*, ed. S. Gwynn 1898, 49, 225; C. L. Eastlake 1847, *Materials for a History of Oil Painting* (repr. 1960), I, 539. James Ward was obliged to copy out Thomas Bardwell's *Treatise on Oil Painting* for his own instruction (E. Fletcher, ed., 1901, *Conversations of James Northcote with James Ward*, 100).

6 T. Bardwell 1756, *The Practice of Painting...made Easy*, 2.

7 See, for example, Ozias Humphry's notebooks of technical gossip, British Library Add MS 22949-50, and William Buchanan's letter to Julius Caesar Ibbetson asking for his 'gumption' recipe and closing, 'In writing I beg you will also communicate the grand secret of varnish you mentioned...which shall be kept...with inviolate secrecy.' (1801): R. M. Clay 1948, *Julius Caesar Ibbetson*, 85.

8 Reynolds's curiosity is seen most strikingly in his dissection of several Venetian pictures, ruining them (J. Northcote 1813, *Memoirs of Sir Joshua Reynolds*, 227); for Barry, loc. cit.; for West, J. Galt 1820, *Life and Studies...of Benjamin West*, I, 130-1, II, 136-7; for Turner, A. J. Finberg 1909, *Inventory of Turner Drawings*, I, 180-91; for Haydon, *Diary*, ed. Pope 1960, II, 430-4, and *Autobiography*, ed. Penrose 1927, I, 167. It does not seem possible to find this taste reflected in Venetian picture-prices during the period: G. Reitlinger 1961, *The Economics of Taste*, 26 and tables.

9 *The Diary of Joseph Farington*, ed. K. Garlick, A. Macintyre, K. Cave, 1978-84, 17 January 1797 (henceforth 'Farington').

10 Farington, 11 January. W. T. Whitley 1928, *Artists and their Friends in England*, II, 209, gives the grandfather's name as 'Captain Morley'.

11 Ann Jemima Provis had exhibited miniatures at the Royal Academy Exhibition of 1787. John Opie reported (*Lectures on Painting*, 1809, 145) that Miss Provis was 'scarce in her teens' when she offered the Secret, but his information is inaccurate in other respects, and cannot be credited.

12 Farington, 13 February 1797. Dr Monro was the King's physi-

cian, and Miss Provis may have been introduced to him through her father, a member of the Royal Household (Whitley, loc. cit. n. 10 above).
13 Royal Academy, 5172, 25A, 4. I am indebted to the Royal Academy for permission to cite this MS. Two further versions of the 'Secret' are known: one, in the collection of Dr Jon Whiteley, is entitled, *The Venetian manner of Painting particularly laid down, relating to the Practice. by A. J. P.*, and does not yet include the 'Titian Shade', so it may be earlier than the RA version. The copy sold to J. F. Rigaud was summarized by his son in a memoir (1854) published by W. Pressly 1984, *Walpole Society*, L, 99-103.
14 Farington, 1 February 1797.
15 Royal Academy MS, n. p. (notes transcribed in Farington's hand).
16 Ibid. 8.
17 Pressly (op. cit. n. 13 above) 100. Cf. the watercolour manuals of Ibbetson (1794) and J. Laporte (*c.* 1802) in P. Bicknell and J. Munro 1988, *Gilpin to Ruskin: Drawing Masters and their Manuals, 1800-1860*, Cambridge, Fitzwilliam Museum, nos 28, 30.
18 Farington, 18 January 1797, and notes in his hand in Royal Academy MS (cit. n. 13 above).
19 Royal Academy MS 6, 9, and landscape section, 1.
20 Whitley (op. cit. n. 10 above) 213. Antwerp Blue appears to have been a weaker version of Prussian Blue, which had been developed around 1704-7 (R. D. Harley, *Artists' Pigments, c. 1600-1836*, 2nd ed. 1982, 70-5).
21 Farington, 11 January 1797; H. von Erffa and A. Staley 1986, *The Paintings of Benjamin West*, no. 133. Other 'Venetian Secret' pictures are probably no. 22, *Cicero discovering the Tomb of Archimedes* (ill. in col. 120); no. 543: *Raphael West and Benjamin West Jr.* (ill. in col. 134), and possibly *The Cruxifixion* (no. 356).
22 Farington, 5, 6 January 1797.
23 Farington, 5, 18 January.
24 Farington, 18 January.
25 Farington, 13 February. A copy of the agreement is bound with the Royal Academy MS.
26 *Monthly Magazine* in British Museum Print Room, *Whitley Papers*, XIII, 1608.
27 Whitley, *Artists and their Friends* (loc. cit. n. 10 above).
28 Farington, 3, 9 March 1797; W. Sandby, *Thomas and Paul Sandby*, 1892, 91-3. The MS of the poem is now in the Pierpont Morgan Library, New York.
29 Farington, 21 May 1797. Field's comment on Grandi is in a note to his copy of C. L. Eastlake's *Materials*, cit. 78, now in the Canadian Conservation Institute. I owe a transcript of these notes to the kindness of Dr Leslie Carlyle.
30 *Transactions of the Society of Arts*, XVI, 1798, 279-99. It is clear from the MS *Minutes of the Committee of Polite Arts*, 22 Nov. 1797, 97, that Sheldrake's communication was submitted in May 1797. A letter from Charles Smith (ibid.) assured the Society that the method, although advertised as 'similar to that practised in the ancient Venetian School', had nothing to do with the Provis process. It did, however, stress dark absorbent grounds. I am grateful to Dr D. G. C. Allen for showing me the Minute Books.
31 *The Works of Sir Joshua Reynolds*, 1797, I, xxxii-xxxiii n.
32 *The True Briton*, 12 April. *The True Briton* was one of the many newspapers supporting the Secret whose names decorate the wings of Pegasus in Gillray's satire.
33 *Bell's Weekly Messenger*, 30 April; *Observer*, 7 May (*Whitley Papers*, cit. n. 26 above, 1609).
34 Farington, 6 June, 17 July, 26 August 1797.
35 British Museum, *Catalogue of Personal and Political Satires*, ed. M. D. George 1942, VII, no. 9085.
36 Farington, 9 March 1797; F. Owen and D. B. Brown 1988, *Collector of Genius: a Life of Sir George Beaumont*, 94-5, 101.
37 For Fuseli and the Secret, Farington, 29 April 1797; for Turner, *Monthly Mirror* in *Whitley Papers* (cit. n. 26 above) XII, 1513.
38 *The Works of Sir Joshua Reynolds*, 1798, I, lvi-lvii n.
39 Courtauld Institute of Art, *Newspaper Cuttings on the Fine Arts*, I, 182.

40 Whitley, *Artists* (cit. n. 10 above) II, 213. M. B. Amory 1882, *The Domestic and Artistic Life of John Singleton Copley*, 230 f. For Solomon Williams's British School exhibit, Gage, *Field* (cit. n. 3 above) 28, and for his vehicle, Gage 1993, *Colour and Culture*, 213.
41 *Transactions*, XXIV, 1806, 85-9.
42 1821 ed. 1. The identification of the 'Lady' of the pamphlet with Miss Cleaver depends on a pencilled note to the Courtauld Institute's copy of the 2nd edition, on Constable's reference to her as daughter of the late Bishop of Bangor and on the Brighton address he gives (R. B. Beckett, ed., 1964, *John Constable's Correspondence*, II, 347-8).
43 1821 ed. 9.
44 1815 ed. 39.
45 Beckett (op. cit n. 42 above) 348 (30 June and 1 July). The version in C. R. Leslie, *Memoirs of the Life of John Constable*, ed. J. Mayne 1951, 126, omits much of this detail.
46 1821 ed. 20.
47 *St James's Chronicle* in Whitley, *Artists and their Friends in England* (cit n. 10 above) 213

12 Turner as a Colourist

1 Huysmans' description reads in the French:
'Turner…vous stupéfie, au premier abord. On se trouve en face d'un brouillis absolu de rose et de terre de Sienne brûlée, de bleu et de blanc, frottés avec un chiffon, tantôt en tournant en rond, tantôt en filant en droite ligne ou en bifurquant en de longs zig-zags. On dirait une estampe balayée avec de la mie de pain ou d'un amas de couleurs tendres étendues à l'eau dans une feuille de papier qu'on referme, puis qu'on rabote, à tour de bras, avec une brosse; cela semé de jeux de nuances étonnantes, surtout si l'on eparpille, avant de refermer la feuille, quelques points de blanc de gouache.

'C'est cela, vu de très près, et, à distance,…tout s'équilibre. Devant les yeux dissuadés, surgit un merveilleux paysage, un site féerique, un fleuve irradié coulant sous un soleil dont les rayons s'irisent. Un pâle firmament fuit à perte de vue, se noie dans un horizon de nacre, se revérbère et marche dans une eau qui chatoie, comme savonneuse, avec la couleur du spectre coloré des bulles. Où, dans quel pays, dans quel Eldorado, dans quel Eden, flambent ces folie de clarté, ces torrents de jour réfractés par les nuages laiteux, tâchés de rouge feu et sillés de violet, tels que des fonds précieux d'opale? Et ces sites sont réels pourtant; ce sont des paysages d'automne, des bois rouillés, des eaux courantes, des futaies qui se déchèvelent, mais ce sont aussi des paysages volatilisés, des aubes de plein ciel; ce sont les fêtes célestes et fluviales d'une nature sublimée, décortiquée, rendue complètement fluide, par un grand poète.' Huysmans' approach to colour in painting, at the same time sensual and technical, has been studied by J. Dupont, 'La couleur dans (presque) tous ses états', in A. Guyaux, C. Heck, R. Kopp (eds) 1987, *Huysmans: Une Esthétique de la Decadence*, 155-66, esp. 164 for Turner. For the Louvre painting, M. Butlin and E. Joll, *The Paintings of J. M. W. Turner*, 2nd ed. 1984, no. 509.
2 E. and J. de Goncourt, *Journal*, 12 Aug. 1891; R. Gimpel 1963, *Journal d'un Collectionneur*, 88.
3 *Turner en France*, 1981, 395, no. 87 (TB CCLIX-109; W.965).
4 Butlin and Joll (op. cit. n. 1 above) no. 390.
5 G. P. Boyce, *Diary*, 20 June 1857 in Butlin and Joll, no. 291.
6 W. Hall 1881, *David Cox, Artist*, 199. For the painting, Butlin and Joll, no. 427. In the first (1977) edition of their catalogue, Butlin and Joll did not refer to Cox's story or to the vegetables.
7 C. Tardieu 1873 in *Gazette des Beaux-Arts*, VIII, 401; etching by G. Greux in R. Ménard 1875, *Entretiens sur la Peinture*, facing 156.
8 Cit. A. J. Finberg 1961, *The Life of J. M. W. Turner R. A.*, 2nd ed., 200 and R. de la Sizeranne 1897, *Revue des Deux Mondes*, 1 March, 179.
9 Cat. 160a, 167. For the colour-beginnings see E. Shanes 1997, *Turner's Watercolour Explorations, 1810-1842*, Tate Gallery.
10 J. Gage 1969, *Colour in Turner: Poetry and Truth*, 206.

11 Ibid., 210.

12 Butlin and Joll (op. cit n. 1 above) nos 404-5. There is a hidden irony in the fact that the paintings were stolen in 1994 from a Goethe Exhibition in Frankfurt. The most extensive iconographical interpretation of these paintings is in G. Finley 1991, 'Pigment into light: Turner and Goethe's Theory of Colours', *European Romantic Review* 2, 44-60, although Finley is more inclined to credit Turner's interest in symbolic and associative systems of colour than I am (46; cf. Gage 1993, *Colour and Culture*, 204). For Turner's interpretation of Goethe's ideas, Gage (op. cit. n. 10 above) ch.11; Gage 1984, 'Turner's annotated books: Goethe's *Theory of Colours*', *Turner Studies*, IV, 34-52.

13 Butlin and Joll (op. cit n. 1 above) nos 47, 334.

14 Gage (op. cit. n. 10 above) 169.

15 G. Adams, *Lectures on Natural and Experimental Philosophy*, 2nd ed. 1799, 424f; C. O'Brien 1795, *The British Manufacturer's Companion and Calico Printer's Assistant*, 'General Reflections'. Turner knew both books.

16 J. Mitford, *Notebooks*, XV, British Library Add. MS 32573, f. 349.

17 T. S. Cooper 1890, *My Life*, II, 2-3.

18 'R' in *L'Artiste*, XII, 1836, repr. in G. Finley 1979, 'Turner, the Apocalypse and History: the "Angel" and "Undine"', *Burlington Magazine*, CXXI, 696.

19 Gage (op. cit. n. 10 above) 168.

20 R. S. Owen 1894, *The Life of Richard Owen*, I, 263.

21 For Monet, I. C. Perry 1927, 'Reminiscences of Claude Monet from 1889-1909', *American Magazine of Art*, XVIII, 120. In 1900 Monet claimed that 'ninety percent of the theory of Impressionism is in *The Elements of Drawing*' (W. Dewhurst 1911, 'What is Impressionism?', *Contemporary Review* 99, 296). J. Ruskin (1857), *The Elements of Drawing*, 1971, 27n. For the translation by Cross and Signac, P. Signac, *De Delacroix au Néo-Impressionnisme*, ed. Françoise Cachin 1964, 116.

13 'Two Different Worlds' – Runge, Goethe and the Sphere of Colour

1 See the brief modern bibliography Chapter 3, n. 96 above. For handbooks, see for example J. Albers 1963, *Interaction of Color*; and for philosophical studies, J. Westphal, *Colour: a Philosophical Introduction*, 2nd ed. 1991.

2 The fullest modern edition is the facsimile reprint with an introduction by H. Matile, Mittenwald, 1977. Matile's study, *Die Farbenlehre Philipp Otto Runges*, 2nd ed. 1979, is the fullest modern analysis of the book; but there is also a very substantial discussion of Runge's colour-ideas in J. Traeger 1975, *Philipp Otto Runge und sein Werk: Monographie und kritischer Katalog*, 54-61 and *passim*.

3 J. W. von Goethe, *Die Schriften zur Naturwissenschaft: Leopoldina Ausgabe*, ed. Matthaei, Troll, Wolf 1955, I/4, 257.

4 Goethe wrote to Runge on 18 Oct. 1809 that the *Farben-Kugel* '...includes nothing that could not be appended to mine, which does not engage in one way or another with what I have introduced. Since I find my work supplemented here and there by yours, we shall be able to start a lively correspondence.' (*Philipp Otto Runges Briefwechsel mit Goethe*, ed. von Maltzahn 1940, *Schriften der Goethe-Gesellschaft*, 51, 99; hereafter 'von Maltzahn').

5 Matile 1979 (cit n. 2 above) 231 and n. 364 (hereafter 'Matile'). For Runge's circle with red at the top, von Maltzahn 42; and for his other painted circles, Traeger (op. cit. n. 2 above) nos 510-18.

6 Von Maltzahn (op. cit. n. 4 above) 49-51.

7 Traeger (op. cit. n. 2 above) 56, 172, 210, n.146, 501, 507.

8 See the rainbow in the upper margin of *Der Tag* (Traeger no. 282b) and the diagram of 'Monotone Wirkung' in the *Farben-Kugel* (Traeger 1975, 56 pl. 9), with its preparatory study in Hamburg (Traeger no. 521). F. Burwick 1986, *The Damnation of Newton*, 49, has reached similar conclusions about the relationship of Runge to Newton's theory.

9 Runge to Perthes, 14 July 1810, cited from the original version in Matile 1979 (op. cit. n. 2 above), 223.

10 '575. Theory. How yellow pigment changes in the process of being ground from morning to evening – not to be explained by the colour induced in the eye [i.e. by successive contrast], but by the spreading out [*Raum*] [over the slab].' From a letter from Daniel Runge to Goethe, 13 Oct. 1811 (*Hinterlassene Schriften von Philipp Otto Runge*, II, 1841, 434; hereafter '*HS*'). The observation has only the most tenuous connection with Goethe's §575 in the 'Didactic Part' of the *Farbenlehre*.

11 Goethe to Steffens, 9 Oct. 1809 (C. Schüddekopf and O. Walzel 1898, *Goethe und die Romantik, Schriften der Goethe-Gesellschaft*, 13, II, 286-7). Cf. also Goethe to Zelter, 15 Aug. 1806 ((*Briefwechsel zwischen Goethe und Zelter*, I, ed. Riemer, 1833, 241) and Goethe to Runge, 18 Oct. 1809 (von Maltzahn, 99).

12 Matile 1979, 140, following von Maltzahn (cit n. 4 above) 36, suggests that colour might have been a topic on this occasion, but Goethe's words read: 'This agreement from a living person, who knew nothing of me and my efforts until now, gives me a new desire to take them further...'. Goethe had been in touch with Runge since 1801.

13 Von Maltzahn 83; Matile 1979, 224.

14 In his autobiography, *Was ich Erlebte*, IV, 1841, 101, Steffens recalled that he already knew the *Beiträge zur Optik* by the time he met Goethe for the first time in 1799.

15 *HS* II, 504.

16 For Runge's first idea of his colour-system as a *Globus*, to Goethe, Nov. 1807, von Maltzahn 71, and for the letter of 19 April 1808 in which he referred to his connection with Steffens, 'which could not have happened at a better time for me', ibid. 84-5.

17 See Matile 1977 (cit n. 2 above).

18 See especially Steffens to Goethe, 3 Oct. 1809 (Schüddekopf and Walzel 1898, 284-6) and Runge to Goethe, 1 Feb. 1810 (von Maltzahn 100).

19 H. Steffens, 'Über die Bedeutung der Farben in der Natur' in P. O. Runge, *Farben-Kugel*, 35.

20 E.g. F. Schmid 1948, *The Practice of Painting*, 109. Schiffermüller's book has now been fully discussed by T. Lersch 1984, 'Von der Entomologie zur Kunst-theorie', *De Arte et Libris: Festschrift Erasmus*, 301-16.

21 'Colours of two species which are so close on the circle that only one other lies between them, are to be tolerated neither in a dress nor in a painting...Blue and grass-green, olive and orange, red and violet are examples of such colours...When two other species lie between them, they are usually adequately contrasted. Colours separated by three others are described by painters as "rather strident", and those separated by four are "strong and violent", but, then, many like the colourful...But when, finally, the two colours are separated on each side by five other species, so that they lie opposite each other on the circle, then their juxtaposition can generally please those who are used to being touched only by very powerful objects...These last colours can be seen in the country on wooden arm-chairs, spinning wheels and other household objects which are painted *en masse*: experienced artists call such juxtapositions in paintings poisonous and merely box-painting.' (I. Schiffermüller 1771, *Versuch eines Farbensystems*, 15-17).

22 Ibid., 12.

23 J. G. Sulzer 1792, *Allgemeine Theorie der Schönen Kunste*, 214. Matile 1979, 128 has noted Runge's derivation of some of his early terminology from Sulzer, and the painter's conception of allegory may also owe something to him (see Sulzer, I, 100ff).

24 For Runge's experiments with disc-mixture, see especially his letter to Goethe of 19 April 1808 (von Maltzahn 82). Schiffermüller's experiments are described in *Versuch* (cit n. 21 above) 1-3 n. The problem had been taken up in Runge's own day by M. A. F. Lüdicke, who also divided his circle into twelve parts and experimented with harmonious juxtapositions, concluding, like Runge, that those colours which mix to a near-white (i.e. the complementaries) are harmonious. Unlike Runge and Goethe, however, Lüdicke inclined

towards the newer additive primary triad of red, green and violet, which had been proposed in 1792 by Wünsch (M. A. F. Lüdicke 1800, 'Beschreibung eines kleinen Schwungrades, die Verwandlung der Regenbogen-Farben in Weiss darzustellen…', *Gilberts Annalen der Physik*, V, 272ff; cf. also his 'Versuche über die Mischung prismatischer Farben', ibid. 1810, XXXIV, 8ff).

25 Matile 1979, 234-7. For Goethe on colour-harmony to J. H. Meyer in 1798, *Schriften zur Naturwissenschaft* (cit. n. 3 above), I/3, ed. R. Matthaei 1951, 386.

26 Steffens (op. cit. n. 19 above) 35.

27 Moses Harris (?1776), *The Natural System of Colours*, facs. with an introduction by F. Birren, 1963. On 5, Harris states that the 20 gradations of each hue run from saturation at the circumference to near-white at the centre of his circle. For the date of the treatise, J. Gage 1969, *Colour in Turner: Poetry and Truth*, 222, n. 13. The Swedish mathematician Sigfrid Forsius had designed an eccentric colour-sphere along Aristotelian lines about 1611, but it remained unpublished (Gage 1993, *Colour and Culture*, 166). For a contemporary criticism that Runge's *Kugel* was really a two-dimensional system, H. Nägele 1972 in *Jahrbuch des Freien Deutschen Hochstifts*, espec. 286.

28 Steffens to Goethe, 3 Oct. 1809 (Schüddekopf and Walzel 1898, 284).

29 Von Maltzahn 97.

30 Only the beginning of this attack has been included in the reprint of the review in Traeger 1975, 501. See also Sartorius to Goethe on the poor reception of the *Farben-Kugel* in Göttingen (von Maltzahn, 115).

31 Steffens (op. cit. n. 19 above) 59.

32 Steffens 47: '…although red and blue are seen as a lively opposition, yellow is very far from being perceived as a mere difference between these two'. See also ibid. 48, 52. The concept seems to have especially attracted Jens Baggesen in his critique of the *Farben-Kugel* (Nägele, op. cit. n. 27 above, 289).

33 Runge to Daniel Runge, 7 Nov. 1802 (*HS* I, 17). By the end of January 1803 Runge had come to see red as representative of morning and evening, and blue as characteristic of day (*HS* I, 32). In a slightly later scheme devised by the nature-philosopher Lorenz Oken, red stood for fire, love and the Father; blue for air, truth and belief and the Son; green for water, formative power, hope and the Holy Ghost – and yellow for Satan (L. Oken 1810, *Physiophilosophy*, Engl. trans. 1847, 78, §378).

34 Runge to Goethe, 19 April 1808 (von Maltzahn 80). This emphasis is close to Steffens's interpretation by experiment: see his conversation with Wilhelm Grimm in April 1809 (*Briefwechsel zwischen Jacob and Wilhelm Grimm aus der Jugendzeit*, ed. Grimm and Hinrichs 1963, 86-7). A striking example of Runge's increasing 'abstraction' is the abandonment of the sea as a background to the *Large Morning* (Traeger nos 473, 478, 492, 497), which robs the female figure of much of her identity as Venus (in the letter to Goethe cited above she is simply called 'female form' (*weibliche Gestalt*), although the sea is still introduced at this stage). If this is indeed an important iconographical change, the lost oil study of a calm sea and sky (Traeger no. 494) is unlikely to have been connected with the last versions of *Morning*. U. Bichel has pointed to the narrative significance of the colour of the sea in Runge's fairy-tale *The Fisherman and his Wife*, 1805 ('P. O. Runges Marchen 1982, "Von dem Fischer un syner Fru"', sein Aufbau and seine Farbssymbolik', *Niederdeutsches Jahrbuch* 105, 983-5); and transparency was of course one of the keystones of his colour-theory (see espec. Traeger, op. cit n. 2 above, 440f and no. 435; H. Hohl in the exhibition catalogue *Runge in seiner Zeit*, Hamburg, Kunsthalle, 1977, 220ff; S. Rehfus-Dêchene 1982, *Farbengebung und Farbenlehre in der deutschen Malerei um 1800*, 116ff).

35 *HS*, II, 372.

36 *HS*, I, 157-8.

14 Mood Indigo

1 K. Schwitters, *Das Literarische Werk*, ed. F. Lach, I (1973), 150. The first German version (*Die Blume Anna* in *Der Sturm*, XIII/2 March 1922, 176), in ibid. (I, 292) runs:

> …Preisfrage:
> 1. Anna Blume hat ein Vogel.
> 2. Anna Blume ist rot.
> 3. Welche Farbe hat der Vogel?
> Blau ist die Farbe seines gelben Haares.
> Rot ist das Girren deines grünen Vogels.
> Du schlichtes Mädchen im Alltagskleid, du
> liebes grünes Tier, ich liebe dir…

2 I have traced some of the French developments in *Colour and Culture*, 1993, 191-201, 209-12, 222; for Goethe's immediate supporters, 202-3. It is conceivable that Schwitters, who was much concerned with fundamentals, and composed a sound-poem entitled *Ur-Sonate* (1922-32; Schwitters I, 1973, 214-42), was echoing Goethe's *Ur-Farben*, yellow and blue, in his poem on Anna Blume/Blossom: see J. W. von Goethe (1810), *Farbenlehre, Didaktischer Teil* (Didactic Part), §705.

3 Novalis, *Schriften*, ed. P. Kluckhohn and R. Samuel 1960, I, 195-7. Subsequent references in the text and notes are to this edition.

4 W. Wackenroder, 'Die Farben' in *Phantasien über die Kunst*, ed. L. Tieck 1799, repr. W. H. Wackenroder, *Werke und Briefe*, ed. F. von der Leyen 1967, 195f.

5 H. Steffens, 'Über die Bedeutung der Farben in der Natur' in P. O. Runge 1810, *Farben-Kugel*, repr. 1977, 59. C. K. Sprengel, *Das entdeckte Geheimniss der Natur*, ed. P. Knuth 1894, I: 9 (Myosotis): 89 (Iris).

6 J. W. von Goethe 1810, *Farbenlehre, Didaktischer Teil* (Didactic Part), §626.

7 A. Leslie Willson, 'The *Blaue Blume*: a new dimension', *Germanic Review*, 34 (1959), 57. Willson's article reviews the earlier identifications of the blue flower. For a well-illustrated historical study of indigo, see the catalogue of the exhibition *Sublime Indigo*, Musée de Marseille, 1987.

8 Novalis (op. cit. n. 3 above) III, 7676.

9 Novalis refers to Werner's system of classification in a note of 1799/1800 (op. cit. n. 3 above) III, 259. The Wernerian terminology was introduced in *Von den äusserlichen Kennzeichen der Fossilien* (1774; English trans. Dublin 1805), 36-72. Werner noted that flowers were a good example of standard colours, and the majority of his blues, the rarest colour among minerals, had pigment- or flower-names (1805, 49ff). Novalis's notes on colour from Werner are op. cit. III: 147-56.

10 Novalis (op. cit. n. 3 above) III, 295.

11 Goethe's unpublished essay on coloured shadows had been composed in 1793 (*Leopoldina Ausgabe der Schriften zur Naturwissenschaft*, I Abt. 3, ed. R. Matthaei 1951, 66). A reference to Goethe's optical work in a letter from Caroline and A. W. Schlegel to Novalis of Feb. 1799, in *Schriften*, IV (1975), 523, suggests that the young writer was familiar with these researches.

12 For Novalis's scheme of opposites, III, 150, and for another note on colour-polarity, III, 148.

13 Jean-Paul Richter 1793, *The Secret Society (Die unsichtbare Loge)*, I. Theil, 20 Sektor, in *Sämtliche Werke*, ed. E. Berend, I/2 (1927), 165-6. Novalis had read the novel by the end of 1795 (IV, 406).

14 Goethe (op. cit. n. 6 above), Didactic Part §781.

15 Steffens (op. cit. n. 5 above) 48f. For Steffens and Runge, Chapter 13 above.

16 Goethe (op. cit. n. 3 above), Didactic Part §696.

17 J. G. Herder 1793, *Kalligone*, ed. H. Begenau 1955, 32.

18 F. H. Lehr 1924, *Die Blütezeit romantischer Bildkunst: Franz Pforr, der meister des Lukasbundes*, 275-7. See also the discussion in B. Rehfus-Dêchene 1982, *Farbengebung und Farbenlehre in der deutschen Malerei um 1800*, 108. For the red hair of the Jews, R. Mellinkoff 1983, 'Judas' Red Hair and the Jews', *Journal of Jewish Art*, IX, 31-46. The

relationship between hair and skin colour, body-build and tempera-ment was still interesting to German scientists at this time: see D. G. Landgrebe 1834, *Ueber die chemischen und physiologischen Wirkungen des Lichtes*, Marburg, 386f., which continued to categorize in the traditional terms of the four humours: dark for choleric and melan-cholic, fair for the sanguine and phlegmatic.

19 Col. plate in K. Andrews 1964, *The Nazarenes*, pl. 2.

20 Andrews (op. cit.), pl. 3. The letter is published in A. Kuhn 1921, *Peter Cornelius und die geistigen Strömungen seiner Zeit*, 98-99.

21 Goethe (op. cit. n. 6 above) §836. For Goethe and the Nazarenes, C. Lenz 1977, 'Goethe und C. F. Schlosser' in Frankfurt, Städel, *Die Nazarener*, 295-315.

22 For the description, Lehr (op. cit. n. 18 above), 286-92. Lehr points out the changes of mind.

23 Goethe (op. cit. n. 6 above) §840.

24 See now P. F. H. Lauxtermann, 'Hegel and Schopenhauer as partisans of Goethe's Theory of Color', *Journal of the History of Ideas* (1990), 51.

25 A. Cornill 1864, *Johann David Passavant*, I, 56; O. Dammann 1930, 'Goethe und C. F. Schlosser', *Jahrbuch der Goethe-Gesellschaft* 16, 54f. For Schlosser's close contact with Overbeck and Pforr in Rome, M. Howitt 1886, *Friedrich Overbeck: Sein Leben und Schaffen*, I, repr. 1971, 189-90, 219, 228-9.

26 W. Schadow, 'Meine Gedanken über eine folgerichtige Ausbil-dung des Malers', *Berliner Kunstblatt*, I (1828), 266, 270. I am much indebted to Robin Middleton and W. O'Malley for access to this rare periodical. For Schadow's career, K. Gallwitz (ed.) 1981, *Die Nazarener in Rom: ein deutschen Künstlerbund der Romantik*, 220-6. For the unteachability of colour, J. Gage 1969, *Colour in Turner: Poetry and Truth*,, 11-12, and for Goethe's own reluctance to include colour in art-school teaching, Gage (op. cit. n. 2 above) 202-3.

27 J. K. Bähr, *Der dynamische Kreis*,1860, 6f, 228. Bähr, who had been in touch with the Nazarenes in Rome in the 1820s, and was now teaching at the Dresden Academy, also published *Vorträge über Newton und Goethes Farbenlehre*, 1863. He tells us that Karl Beck-mann, Professor of Architecture and Perspective at the Berlin Academy, was an enthusiastic follower of Goethe and that other artists welcomed the most substantial new attempt to vindicate his ideas: F. Grävell, *Goethe im Recht gegen Newton*, 1857.

28 Schadow (op. cit. n. 26 above) 271. The abstractness of the pictorial surface around 1800 was noted by T. Hetzer and by W. Schöne: W. Schöne, *Über das Licht in der Malerei*, 3rd ed. 1979, 214 n. 391.

29 M. Bunge 1990, *Max Liebermann als Kunstler der Farbe*, 52-5. Impasto outdoor painting goes back of course in Germany to Georg von Dillis, J. C. C. Dahl and Adolf Menzel among others in the early part of the century.

30 H. G. Müller, 'Künstlerfarbenmanufakturen im 19 Jahrhundert' in H. Althöfer (ed.) 1987, *Das 19. Jahrhundert in der Restaurierung*, 231-2. For Böcklin, H. Kühn, 'Technische Studien zur Malerei Böcklins' in R. Andrée 1977, *Arnold Böcklin: Die Gemälde*, 106-27.

31 For simultaneous and complementary contrasts, Kühn (op. cit. n. 30 above) 108; H. Rebsamen, 'Farben im Sinnbild: Arnold Böcklins "Heimkehr" 1887' in M. Hering-Mitgau *et al.* (eds) 1980, *Von Farbe und Farben: Albert Knoepfli zum 70. Geburtstag*, 360; H. Althöfer, 'Arnold Böcklin – Maltechniker und Kolorist' in Althöfer (op. cit. n. 30 above) 196-7. W. von Bezold 1874, *Die Farbenlehre im Hinblick auf Kunst und Kunstgewerbe*; American edition 1876, *The Theory of Color in its relation to Art and Art-Industry*, espec. ch. IV. for gold frames, Althöfer (op. cit.); Bezold 1876 (op. cit.) 43. Böcklin's contact with Bezold is documented by E. Berger (ed.), *Böcklins Technik* (1906), Sammlung Maltechnischer Schriften I, 103f.

32 For Stuck on the spatial effect of 'warm' and 'cool' colours, J. Albers in H. Voss 1973, *Franz von Stuck 1863-1928: Werkkatalog der Gemalde mit einer Einfuhrung in seinen Symbolismus*, 66, 89 n. 288. Cf. Bezold (op. cit. n. 31 above) 113, 197-8, 231. Albers gives a brief account of the 'Bezold-effect' in *Interaction of Color*, paperback ed. 1979, XIII.

33 For Böcklin and the *Farbenlehre*, Rebsamen, op. cit. n. 31 above.

For his colour-equivalents, A. Reinle and J. Gantner 1962, *Kunst-geschichte der Schweiz*, I, 217.

34 Voss (op. cit. n. 32 above) 59.

35 F. Naumann 1906, 'Experimentelle Malerei', *Hilfe*, 12, in *Werke*, ed. H. Ladendorf, 1969, VI, 57.

36 J. Cohn 1894, 'Experimentelle Untersuchungen über die Gefuhlsbetonung der Farbhelligkeiten und ihrer Combinationen', *Philosophische Studien*, X, 601.

37 F. Stefănescu-Goangă 1912, 'Experimentelle Untersuchungen zur Gefuhlsbetonung der Farben', *Psychologische Studien*, VII, 287f.

38 Stefănescu-Goangă 309. For association as a secondary colour effect, ibid. and 332.

39 K. Scheffler, 'Notizen über die Farbe', *Dekorative Kunst*, IV, II Heft (1901), 190. On chromotherapy and *audition colorée*, 187, Scheffler saw Böcklin as the greatest modern colourist. Kandinsky mentioned his article in a note to ch. VI of *On the Spiritual in Art* (1912). For his interest in chromotherapy, synaesthesia and the non-associative effects of colour, ibid., ch. V. One of the most outspoken arguments for the idea that the affects of colour, even in chromotherapy, were largely associative came from an art historian turned psychologist: R. Müller-Freienfels 1907, 'Zur Theorie der Gefühlstone der Far-benempfindungen', *Zeitschrift fur Psychologie* 46, 241-74.

40 W. Kandinsky, *Complete Writings on Art*, ed. K. C. Lindsay and P. Vergo 1982, I, 181-2.

41 A. Besant and C. W. Leadbeater, *Thought-Forms*, 6th repr. 1961, 21.

42 See references gathered in Gage 1993, *Colour and Culture*, 298 n.89.

43 Kandinsky (op. cit. n. 40 above), II, 747; see also W. Kandinsky and F. Marc (eds) 1979, *Der Blaue Reiter* (Dokumentarische Neuaus-gabe von K. Lankheit), 263.

44 Gage 1993, *Colour and Culture*, 207. Marc may have been stimu-lated by Runge, although of course his gender scheme is opposite to Runge's, since the Romantic artist had been included in the 1906 *Deutsche Jahrhundert-Ausstellung* in Berlin and his approach to colour, at once mystical and scientific, had been celebrated in the catalogue by Hugo von Tschudi, who became close to the Blue Rider group in Munich, and to whom they dedicated the almanac. See *Austellung deutscher Kunst aus der Zeit von 1775-1875*, 1906, I, xix, repr. in H. von Tschudi, *Gesammelte Schriften zur neueren Kunst*, ed. E. Schwedeler-Meyer 1912, 191.

45 Stefănescu-Goangă (op. cit. n. 37 above) 320.

46 D. Schmidt 1964, *Manifeste Manifeste, 1905-33*, I, 82.

47 For Brass, Gage 1993, *Colour and Culture*, 207. For Kirchner, see espec. Groninger Museum, *Goethe, Kirchner, Wiegers. De Invloed van Goethe's Kleurenleer*, 2nd printing 1985.

48 Goethe (op. cit. n. 6 above), Didactic Part §75.

49 F. Marc, letter of 14 February 1911 in W. Macke (ed.) 1964, *August Macke-Franz Marc Briefwechsel*. Marc's painting, *Liegender Hund im Schnee*, now in the Städelsches Kunsinstitut in Frankfurt, is in K. Lankheit 1970, *Franz Marc: Katalog der Werke*, no. 133, our col. pl. 86.

50 S. Friedländer 1916, 'Nochmals Polaritat', *Der Sturm*, VI, 88; 'Das Prisma und Goethes Farbenlehre', *Der Sturm* (1917-18), VIII, 141-2.

51 A. Segal, 'Das Lichtproblem in der Malerei' in A. Segal and N. Braun (Berlin, 1925), *Lichtprobleme der bildenden Kunst*, n. p. The essay is dedicated to Friedländer-Mynona, who also contributed an article, 'Goethes Farbenlehre und die moderne Malerei' to the catalogue *Sammlung Gabrielson Götheborg*, 1922-3, which included two works by Segal. For Segal see W. Herzogenrath and P. Liška (eds) 1987, *Arthur Segal, 1875-1944*. Liška discusses the *Prismatische Malerei* of 1922/3 (49ff) and see espec. the recollections of Mordechai Ardon of Segal's interest in Goethe's theory (126). Segal's account of his own theory is reprinted on 276. I owe my knowledge of this exhibi-tion catalogue to the kindness of Prof. Norbert Lynton.

52 Goethe (op. cit. n. 6 above), Didactic Part §517-23.

53 W. Kandinsky, *Cours du Bauhaus*, ed. P. Sers 1984, 46-7, from Goethe §765-94; cf. also 65. These notes have still to be published in their original German and in an annotated edition. For *Yellow-Red-*

Blue, P. Derouet and J. Boissel 1984, *Oeuvres de Vassily Kandinsky* (1866-1944), no. 351. See also C. V. Poling 1982, *Kandinsky Unterricht am Bauhaus*, 58f (English ed. 1987).

54 Kandinsky (op. cit. n. 53 above) 53, and for 'Luna', 65.

55 For Runge's great reputation as a colour-theorist at the Bauhaus, J. Traeger 1975, *Philipp Otto Runge und sein Werk*, 195-7; H. Matile, *Die Farbenlehre Philipp Otto Runges*, 2nd ed. 1977, 281-99. For Ostwald at the Bauhaus, Gage 1993, *Colour and Culture*, 259-62.

15 Chevreul between Classicism and Romanticism

1 J. Rewald, *Post-Impressionism from Van Gogh to Gauguin*, revised ed. 1978, 76. This account comes from the reminiscences of Angrand, but on one occasion at least, Signac claimed that Seurat had accompanied him to see Chevreul. The evidence has been assessed in R. L. Herbert *et al.*1991, *Seurat*, 390, and seems to establish firmly only a visit by Signac to the chemist's demonstrator, Émile David, in 1885.

2 M. Schapiro in I. Meyerson (ed.) 1957, *Problèmes de la Couleur*, 288ff.

3 'Mémoire sur l'influence que deux couleurs peuvent avoir l'une sur l'autre quand on les voit simultanément', *Mémoires de l'Académie des Sciences*, XI, 1828, 518.

4 His son M.-H. Chevreul, in the posthumous edition of his book (1889, ii), states that the lecture-series began in 1830.

5 *La Vie Artistique au Temps de Baudelaire*, Paris 1942, 63, referring to the Salon of 1842. The lectures were delivered three times a week. *Le Magasin Pittoresque*, II, 1834, 63, 90f, 98f. See also 'Cours sur le contraste des couleurs par M. Chevreul', *L'Artiste*, 3e ser., I, 1842, 148, 162; C. E. Clerget 1844, 'Lettres sur la Théorie des Couleurs', *Bulletin de l'Ami des Arts*, II, 29-36, 54-62, 81-91, 113-21, 175-85, 393-404. Clerget's articles, which were specifically designed to popularize Chevreul's ideas for artists, arose from the lectures of 1840 and 1842.

6 For Hersent, G. Reynes 1981, 'Chevreul interviewé par Nadar, 1886', *Gazette des Beaux-Arts*, XCVIII, 177 (visit in 1840); for Daguerre, M.-E. Chevreul 1866, 'Des Arts qui parlent aux yeux', *Journal des Savants*, 576. Daguerre was working on dioramas in Paris between 1822 and 1839.

7 Reynes 1981, 176; M. Berthelot 1904, 'Notice historique sur M. Chevreul', *Mémoires de l'Académie des Sciences*, XLVII, 426, on Chevreul and the Vernet family. Reynes mentions a visit of 1844. Vernet may have come across Chevreul's ideas through his friend Lagrenée, who was a designer of textiles for Aubusson and for factories in Lyon (A. Durande 1863, *Joseph, Carle et Horace Vernet*, 348).

8 *Le Magasin Pittoresque* (cit. n. 5 above) 99 already mentions the economic advantages attributed by Chevreul to contrasting uniforms; see also Chevreul 1839, *De la Loi du Contraste Simultané des Couleurs*, §§657-74. Both French editions (1839, 1889) included a critical appendix to this chapter on the French army uniforms of 1838, but this was not included in the English translations.

9 Chevreul in *Mémoires de l'Académie des Sciences*, XLI, 1879, 241f. He was responding, on a visit to London in 1851 as a member of the Jury of the Great Exhibition, to a question from the later English translator of his book, Thomas Delf ('Charles Martel'), about any changes he might want to make. There were to be no changes of principle, and Delf claimed in a popular handbook of 1855 that Chevreul's laws 'do not admit of any question or dispute' (Charles Martel 1855, *The Principles of Colour in Painting*, iv).

10 T. Silvestre (1856), *Les Artistes Français*, 1926, II, 70-1; Durande (op. cit. n. 7 above) 333. See also a Vernet aphorism reported by Félix Bracquemond: 'Tous les ciels sont bleues; tous les arbres sont verts, tous les pantalons sont rouges' (F. Bracquemond 1885, *Du Dessin et de la Couleur*, 41).

11 C. Blanc 1867, *Grammaire des Arts du Dessin*, 613; *Les Artistes de mon Temps*, 2nd ed. 1876, 68ff. For Blanc's idealized analysis of the painting, L. Johnson 1963, *Delacroix*, 69.

12 G. Sand, *Impressions et Souvenirs*, 2nd ed. 1896, 77ff.

13 H. Delaborde 1984, *Notes et Pensées de J. A. D. Ingres* (extracted from *Ingres: Sa Vie, Ses Travaux, Sa Doctrine*, 1870), 133. The painting in question is *Oedipus and the Sphynx* (1808, Louvre). See also 152. On another occasion, however (137), Ingres appealed to Titian, 'le plus grand coloriste de tous' for the supreme importance of liaison between the various parts of a composition, which Ingres himself achieved by a very exact sense of tone. The version of the quoted passage given in Boyer d'Agen 1909, *Ingres d'Après une Correspondance inédite*, 942, includes some variations, and inserts a nonsensical negative into the first sentence.

14 Clerget (op. cit. n. 5 above) 29-36 etc.; J. C. Ziegler 1850, *Études Céramiques*, 234; see also his *Traité de la Couleur et de la Lumière*, 1852, 11-12. A discussion of Chevreul's ideas had already appeared in England: H. Twining 1849, *The Philosophy of Painting*, 236-40.

15 Blanc 1876 (op. cit. n. 11 above) 68ff. For the triangle and notes by Delacroix, Gage 1993, *Colour and Culture*, 173. Lee Johnson has kindly pointed out to me that they are on a loose sheet of paper and probably date from 1834.

16 Musée du Louvre, Cabinet de Dessins, MSS Anonymes I.d.80, n. p.; notes from a lecture of 13 Jan. 1848.

17 For Delacroix's decorative schemes, L. Johnson 1989, *The Paintings of Eugène Delacroix: A Critical Catalogue*, V (The Public Decorations and Their Sketches), nos 507-26, 540-61, 569-74, 578.

18 Berthelot (op. cit. n. 7 above) 406, 426.

19 F. Bracquemond (op. cit. n. 10 above) 241f.

20 See now G. Roque 1997, *Art et Science de la Couleur: Chevreul et les Peintres de Delacroix à l'Abstraction*.

16 The Technique of Seurat – A Reappraisal

1 'L'esprit et le corps de l'art': Seurat to Fénéon, 24 June 1890 in F. Fénéon, *Oeuvres plus que complètes*, ed. J. Halperin 1970, I, 510.

2 First reported by Seurat's friend the painter Charles Angrand to H. E. Cross in 1891 (R. Rey 1931, *La renaissance du sentiment classique*, 95). Also see G. Coquiot 1924, *Seurat*, 41.

3 The reservations expressed by J. R. Hodkinson in his 1966 review (*Journal of the Optical Society of America*, LVI, 262); by R. L. Herbert 1968, *Neo-Impressionism*, New York, 19ff; by the ophthalmologist R. A. Weale 1972, 'The Tragedy of Pointillism', *Palette*, XL, 16ff.; and by Alan Lee 1987, 'Seurat and Science', *Art History*, X, 203-26 have apparently not been widely publicized. The limits of Seurat's scientism had already been discussed briefly by Meyer Schapiro in I. Meyerson (ed.) 1957, *Problèmes de la Couleur*, 248ff. The political dimension of Neo-Impressionist technique has been explored by R. S. Roslak 1991, 'The politics of aesthetic harmony: Neo-Impressionism, science and Anarchism', *Art Bulletin*, LXXIII, 381-90.

4 W. I. Homer 1964, *Seurat and the Science of Painting*, 163-4.

5 M. Schapiro 1958, 'Seurat', in *Modern Art, 19th and 20th Centuries: Selected Papers*, 1978, 10.

6 Letter to Signac, 2 July 1887, in H. Dorra and J. Rewald 1959, *Seurat*, LX.

7 See Seurat's letter of 26 Aug. 1888 to Signac, printed by J. Rewald in N. Broude (ed.) 1978, *Seurat in Perspective*, 105 (French original in J. Rewald 1948, *Seurat*, 115).

8 Broude 37 (French original in Fénéon, 35f, n. 1).

9 Broude 19 (French original in facs. in Rey, op. cit. n. 2 above, opp. 132).

10 Seurat writes to Fénéon that his 'attention was drawn to Rood' ('Rood m'ayant été signalé') by an 'article' by Philippe Gille in *Le Figaro*. Gille's briefest of notices in *Le Figaro*, 26 Jan. 1881, 6, mentioned simply that Rood was 'un éminent professeur de physique', an American, and 'en même temps un peintre amateur distingué'. Seurat's reference is in marked distinction to his statement in the same letter that he had 'read' Charles Blanc. His several notes from Rood (see below) are no necessary indication that he read him systematically.

11 Lee (op. cit. n. 3 above) citing O. Rood 1879, *Modern Chromatics*, 212, 149ff.

12 Broude 16. Charles Blanc's 'Eugène Delacroix' was published 1864 in the *Gazette des Beaux-Arts*, XVI, 5ff, 97ff, and reprinted 1876 in his *Les artistes de mon temps*. I have used the later version here.

13 Blanc 23f. For van Gogh, see E. van Uitert 1966-7, 'De toon van Vincent van Gogh: Opvattingen over kleur en zijn Hollandse periode', *Simiolus*, II, 106ff.

14 See the detail of *La Grande Jatte* in Homer, pl. D, and of *Le Chahut* (1889-90) in A. Callen 1982, *Techniques of the Impressionists*, 149.

15 See espec. *Figure and Trees on the Banks of the Seine*, New York, Marie Coll. (Dorra and Rewald 108) and *Figure on the Bank of the Seine, with Sailing Boat*, Washington, DC, National Gallery of Art, Mellon-Bruce Coll. (Dorra and Rewald 109).

16 C. Blanc 1867, *Grammaire des arts du dessin*, 608. Seurat told Fénéon that he had read this book 'at school' (Broude 16). A. Piron 1865, *Delacroix: Sa vie et ses oeuvres*, 416ff. For Seurat's notes from this source, see R. L. Herbert, 'Seurat's Theories' in J. Sutter (ed.) 1970, *The Neo-Impressionists*, 24.

17 Rood 14 (but see 41 for 'white sunlight'). The most detailed discussion of the colour of sunlight available to Seurat was probably that in Ernst Brücke's *Physiologie der Farben*, 1866, 32, 46ff (French trans. *Des couleurs au point de vue physique, physiologique, artistique et industriel*, 1866), but Brücke's conclusion was that its yellowish or reddish cast was essentially subjective, and could be disregarded by the painter. Seurat may have known the French translation of Brücke's handbook, *Principes scientifiques des beaux-arts*, Paris, 1878, since, as Homer 289 has suggested, a note by the painter of the name of Hermann von Helmholtz in the Signac Archive probably refers to that scientist's essay, 'On the relation of optics to painting', which was published as an appendix to this edition of Brücke's work.

18 L. Nochlin (ed.) 1966, *Impressionism and Post-Impressionism, 1874-1904 (Sources and Documents in the History of Art)*, 127.

19 Fénéon 1886 in Broude, 38.

20 See R. L. Herbert *et al.* 1991, *Georges Seurat 1859-1891*, App. K, 390-1.

21 Homer 40f; Fénéon, whose reading of Rood has been noticed, made his complementaries only approximately those of this writer in his review of 1886, but by the time of his article on Signac in *Les hommes d'aujourd'hui* in 1890, they had become much closer to Rood's (Fénéon 174f).

22 R. L. Herbert 1981, 'Parade du Cirque de Seurat et l'ésthetique scientifique de Charles Henry', *Revue de l'art*, no. 50, 18, fig. 12. Herbert *et al.* (op. cit. n. 20 above), App. L, 392. Seurat's circle probably derives from his reading of Charles Henry, whose summary of Chevreul in *Introduction à une ésthetique scientifique*, 1885, is reprinted by Herbert 22. For Henry's circle, see Homer 195.

23 It is worth noting that Blanc, *Grammaire*, 597ff, n. 1, characterized his 'Rose chromatique' as 'une image mnemonique indispensable', and yet printed two slightly differing arrangements of it in his plate and text.

24 See Herbert (op. cit. n. 3 above) n. 80 (Dorra and Rewald 177).

25 Broude 18. The statement, which Christophe used in his article on Seurat in *Les hommes d'aujourd'hui*, was reprinted by Signac in *De Delacroix au Néo-Impressionisme*, ed. F. Cachin 1964, 107. Homer 135 claimed that Seurat indeed used Rood's complementaries in *La Grande Jatte*, but this seems to be a mistake, and, in any case, the well-known alteration of the pigments make a purely optical analysis hazardous, to say the least. See I. Fiedler 1984, 'Materials used in Seurat's *La Grande Jatte*, including color changes and notes on the evolution of the artist's palette', American Institute of Conservation, *Preprints*, May, 43-51; idem 1989, 'A technical evaluation of *La Grande Jatte*', *Art Institute of Chicago Museum Studies*, XIV/2, 173-9, 244-5.

26 W. I. Homer 1959, 'Notes on Seurat's Palette' in Broude 116ff.

27 For Signac's notes, see Homer 151f, n. 4; also see Callen (op. cit. n. 14 above) 134, 146. Seurat had fewer yellows, blues and greens than Signac, but more reds and oranges.

28 J.-G. Vibert (1891), *The Science of Painting*, 8th ed. 1892, 35-6.

Vibert, who claimed to have been teaching at the École for thirty years, introduced this palette chiefly as a key to harmony.

29 Rood 179-80.

30 Herbert in Sutter (op. cit. n.15 above) 26.

31 Letter to Fénéon, 1889, in C. de Hauke 1962, *Seurat et son oeuvre*, I, XX.

32 Gustave Kahn 1891, in Broude 22.

33 Homer 171ff.

34 Ibid. 294, 103.

35 P. Signac, *Journal*, 22 Nov. 1894, in J. Rewald (ed.) 1949, 'Extraits du journal inédit de Paul Signac', *Gazette des Beaux-Arts*, XXXVI, 108. It is an irony that from this date Signac's brushstrokes become increasingly larger, so that by the end of the 1890s fusion can no longer be in question.

36 Ibid. 114 (29 Dec. 1894). Also see the letter of 1887 to Pissarro, cited by D. Thompson 1985, *Seurat*, 112, and Signac to Seurat on the *Grande Jatte* in Brussels in 1887: Dorra and Rewald 1959, 381-5.

37 See, for example, the contours of the figures in the excellent detail in J. Russell 1965, *Seurat*, 164.

38 J. Carson Webster 1944, 'The Techniques of Impressionism: A Reappraisal', in Broude 99; Lee (op. cit. n. 3 above) 207-8.

39 Signac 1894 (op. cit. n. 35 above). The fullest technical study of this painting is in J. Leighton and R. Thompson 1997, *Seurat and the Bathers*, espec. 76-83.

40 The fullest study is still L. Schmeckebier 1932, 'Die Erscheinungsweisen kleinflächiger Farben', *Archiv für die gesamte Psychologie*, lxxxv, espec. 25-7. Schmeckebier (33) stresses the need for variable viewing distances in the case of 'Impressionist' pictures.

41 M. Schapiro in Meyerson (op. cit. n. 3 above) 25. But see now P. Smith 1990, 'Seurat: the natural scientist?', *Apollo*, CXXXIII, 381-5.

42 Fénéon 175.

43 Nochlin (op. cit. n. 18 above) 116 (French original in De Hauke, op. cit. n. 30 above, I, xxiv, n. 27).

44 Rey (op. cit. n. 2 above) 130f, 21.

45 D. C. Rich 1969, *Seurat and the Evolution of 'La Grande Jatte'*, 19.

46 Signac (op. cit. n. 24 above) 108.

47 Following Helmholtz (op. cit. n. 17 above), a number of French theorists of the period argued that the relative feebleness of the artists' materials meant that they must paint the *effects* of nature's contrasts themselves: see G. Guéroult 1882, 'Formes, couleurs, mouvements', *Gazette des Beaux-Arts*, XXV, and J.-G. Vibert (op. cit. n. 27 above) 47, n. 24. Seurat's strategies in this instance serve to undermine J. A. Richardson's interesting characterization of his style as aiming to construct 'a phenomenal image first hand, an image that would possess all the brilliance and variability of the world of light itself because it was constructed with regard to the laws governing the visual mechanics of that world (J. A. Richardson 1971, *Modern Art and Scientific Thought*, 67, a reference I owe to the kindness of Prof. Herbert).

48 See, for example, the well-informed popularizations of A. Guillemin 1874, *La lumière et les couleurs (Petite encyclopaedie populaire des sciences et de leurs applications)*, espec. 258ff; E. Véron 1878, *L'esthétique*, Paris (English ed. London 1879), chap. iv; Guéroult (op. cit. n. 47 above), espec. 174ff, n. 43, which cite Helmholtz's complementaries. Guillemin's book was in the library of Duranty (M. Marcussen 1979, 'Duranty et les Impressionistes', *Hafnia*, VI, 29), who also owned the French trans. of Brücke and Helmholtz; and Huysmans used Véron's work in his critique of Impressionism (O. Reutersvard 1950, 'The Violettomania of the Impressionists', *Journal of Aesthetics and Art Criticism*, IX, 108-9).

49 Fénéon 72, 174; A. Thorold (ed.) 1980, *Artists, Writers, Politics: Camille Pissarro and His Friends*, 38, n. no. 94. Pissarro did have reservations about Fénéon's account of reflections and solar orange.

50 Fénéon, xv, 174, n. 1. Signac warned Fénéon not to take too much notice of Henry's views, as he was too obsessed with complementary contrast, an obsession very likely to commend him to Seurat.

51 M.-E. Chevreul (1839), *The Principles of Harmony and Contrast of*

Colours, trans. C. Martel, 3rd ed. 1860, 237. But for the restriction of this principle to painting in 'flat tints', see above Chapter 15, and G. Roque 1996, 'Chevreul and Impressionism: a reappraisal', *Art Bulletin*, LXXVIII, 35.
52 Rood ch. xvi.
53 For Seurat's distortion of the record, see Thompson (op. cit. n. 36 above) 97f.

17 Seurat's Silence

1 For the music in *Le Chahut*, W. I. Homer 1964, *Seurat and the Science of Painting*, 296-7.
2 P. Smith 1997, *Seurat and the Avant-garde*, 107-55.
3 Seurat to Signac, 26 August 1888, in H. Dorra and R. Rewald 1959, *Seurat*, LXV. See also M. Zimmerman 1991, *Les Mondes de Seurat: Son oeuvre et le Débat artistique de son Temps*, 213f. For a contrary view, that Seurat, 'from all reports, talked obsessively about his artistic theories', M. Ward, 'The rhetoric of independence and innovation' in C. S. Moffett *et al.* 1986, *The New Painting: Impressionism 1874-1886*, 436. These reports include those of Gustave Kahn (N. Broude 1978, *Seurat in Perspective*, 21), Émile Verhaeren (ibid. 28, 30) and Charles Angrand (ibid. 35), who also says, however, that Seurat 'was usually silent and embarrassed'.
4 See P. Smith 1992, '"Parbleu": Pissarro and the political colour of an original vision', *Art History*, XV, 225.
5 H. von Helmholtz 1852, 'Ueber die Theorie der zusammengesetzten Farben', *Poggendorffs Annalen der Physik und Chemie*, LXXXVII, 45-66; 1852-3, 'Sur la Théorie des couleurs composées', *Cosmos*, II, 112-20. I am grateful to Carol Coe for alerting me to this article. The French version may be by Jean-Bernard Léon Foucault, since it adds a note that he was about to produce a 'plus rationnel et plus simple' method of experiment, on which he had been working for several years. This was published as 'Sur la recomposition des couleurs du spectre en teintes plates' (ibid. 232-3). It was a method which had first been taught by Pouillet at the Sorbonne in 1849.
6 A. Laugel 1869, *L'Optique et les Arts*, 150; E. Véron (1878), *Aesthetics*, 1879, 229. Véron, however, pointed out that the scheme 'does not furnish accurate information for painters'.
7 Laugel (op. cit.) 151-2.
8 E. Brücke 1878, *Principles Scientifiques des Beaux-Arts. Essais et Fragments de Théorie...Suivis de L'Optique et la Peinture de H. Helmholtz*, 7. For Henry and Leonardo, J. A. Argüelles 1972, *Charles Henry and the Formation of a Psycho-Physical Aesthetic*, 45, 78-9.
9 Helmholtz in Brücke (op. cit.) 207, here quoted from the English version, 'On the relation of optics to painting', *Popular Lectures on Scientific Subjects*, trans. E. Atkinson 1900, II, 118. The lectures were originally published as 'Optisches über Malerei', *Populäre wissenschaftliche Vorträge*, 1876.
10 Helmholtz (op. cit. n. 5 above) 207-9, 1900, II, 119-21. D. Sutter 1880, 'Les phenomènes de la vision', *L'Art*, XX, 216.
11 See the version of Seurat's *Esthétique* (1890) in Herbert *et al.* 1991, *Seurat 1859-1891*, 381. Homer has surveyed the evidence for Seurat's knowledge of Helmholtz without reaching a conclusion (op. cit. n. 1 above, 288-90). One channel may have been through Pissarro's friend Bracquemond, who referred to the Young-Helmholtz theory of the primaries somewhat slightingly in *Du Dessin et de la Couleur*, 1885, 245. Pissarro, however, did not include Helmholtz with Chevreul and Maxwell in the important letter on theory to Durand-Ruel in November 1886 (A. Thorold 1980, *Artists, Writers, Politics: Camille Pissarro and his Friends*, Oxford, Ashmolean Museum, 2).
12 O. Rood 1879, *Modern Chromatics*, 190-1 on Helmholtz's primaries, complementaries and colour-mixing.
13 Rood (op. cit) 113. Young's work is discussed in P. D. Sherman, *Colour Vision in the Nineteenth Century: The Young-Helmholtz-Maxwell Theory*, 1981. Dubois-Pillet owned a copy of Rood, which he was lending to Fénéon in Sept. 1887 (L. Bazalgette 1976, *Dubois-Pillet, sa Vie et son Oeuvre (1846-90)*, 107).

14 J. Christophe 1890, 'Dubois-Pillet', *Les Hommes d'Aujourd'hui*, 8, no. 370, repr. in Bazalgette (op. cit. n. 14 above), 95f. For an English translation of the whole passage, J. Rewald, *Post-Impressionism from Van Gogh to Gauguin*, rev. ed. 1978, 109, 116. The remarks on the application to painting are not in Rood.
15 Camille to Lucien Pissarro, 30 Nov. 1886, in J. Bailly-Herzberg (ed.) 1986, *Correspondence de Camille Pissarro*, II, 77.
16 G. Dulon and C. Duvivier 1991, *Louis Hayet 1864-1940, Peintre et Théoricien du Néo-Impressionisme*, 61.
17 Ibid., 166-74.
18 Ibid., 62, 185, and also 148 for Hayet's objection to Seurat's 'system'.
19 Ibid. 188-9. This autobiographical note was written in 1923, about the same time as Malevich was proposing a similar plan in *Light and Colour*: see the French edition, K. Malevich, *La Lumière et la Couleur*, ed. J. Marcadé 1981, 87.
20 Camille to Lucien Pissarro, 10 Jan. 1892 (Bailly-Herzberg, op. cit. n. 16 above, III, 1988, 185): A. Thorold (ed.) 1993, *The Letters of Lucien to Camille Pissarro, 1883-1903*, 276.
21 Pissarro to Fénéon, 21 Feb. 1889: J. U. Halperin, *Félix Fénéon, Aesthete and Anarchist in Fin-de-Siècle Paris*, 1988, 105 (not in Bailly-Herzberg). See also Fénéon to Pissarro, 18 February 1889 (Bailly-Herzberg II, 266), Pissarro to Fénéon, ?Oct. 1886 (BH II, 73), Pissarro to Signac, April 1887 (BH II, 153-4).
22 J.-G. Vibert (1891), *La Science de la Peinture*, 1902 (repr. 1981), ch. IV and 80.
23 G. Kahn 1891, 'Seurat', in Broude (op. cit. n. 3 above) 22.
24 R. L. Herbert 1962, *Seurat's Drawings*. For Fantin, Gage 1993, *Colour and Culture*, 185.
25 See G. Roque 1992, 'Les Symbolistes et la Couleur', *Revue de l'Art* 96, 70-6.
26 Seurat to Signac, 25 June 1886 in Dorra and Rewald (op. cit. n. 3 above) L-LI.
27 Vibert (op. cit. n. 22 above) 72; Bracquemond (op. cit. n. 11 above) 55. Blanc's *Grammaire*, 1867, 612 had spoken of Delacroix's technique of optical mixture in *The Women of Algiers* as having produced 'un troisième ton indéfinissable qu'on ne peut nommer avec précision...'.
28 Gage 1993, *Colour and Culture*, 190, 206.
29 'Even when applied in the same way, one and the same stimulus may be perceived as stronger or weaker by one subject or organ than by another, or by the same subject or organ at one time as stronger or weaker than at another. Conversely, stimuli of different magnitudes may be perceived as equally strong under certain circumstances.' (G. T. Fechner (1860), *Elements of Psychophysics* trans. H. E. Adler 1966, 38).
30 Seurat to Fénéon, 20 June 1890, in Broude (op. cit. n. 23 above) 16.

18 Matisse's Black Light

1 *Verve*, IV, 13, 1945. In *Jeune Fille devant la Fenêtre: Robe Blanche et Ceinture Noire* (1942) the scarlet lake, light ultramarine blue and cobalt violet are attributed to Lefranc, and the pot-plant in *Michaella* (1943) was painted with 'Vert comp. N° 2 Lefranc'. Matisse had been using some of Lefranc's materials at least since the early 1920s, but at that time his colours were supplied largely by the Belgian firm of Blockx (see C. Moreau-Vauthier 1923, *Comment on peint aujourd'hui*, 30, 84, and Gage 1993, *Colour and Culture*, 222, 296 nn. 54, 83). The first scholar to draw attention to these 'palettes' was probably Alfred Barr Jr, who reproduced that for *Danseuse, Fond Noir, Fauteuil Rocaille*, together with a black and white reproduction of the painting, in *Matisse: His Art and his Public*, 1951, 488.
2 See the long note on the painting of the red check tablecloth in *Citrons et Saxifrages* (1943), which uses the past tense: *Verve*, loc. cit., 49, col. ill. 50.
3 H. Matisse, *Écrits et Propos sur l'Art*, ed. D. Fourcade 1972, 197. Fourcade gives this text the title *De la Couleur*, but in *Verve* it was not

directly associated with Matisse's title-page, but was printed on 9-10, and J. Flam, in his anthology of Matisse's writings, gives it the more neutral title, *Observations on Painting* (J. D. Flam 1973, *Matisse on Art*, 101).

4 Matisse, op. cit. 202-3. Flam, op. cit 106-7, also points out that these thoughts were recorded at the time of an exhibition, *Le Noir est une Couleur*, at the Maeght Gallery in December 1946. Matisse told André Masson in the early 1930s that Renoir, who admired Matisse's use of black in the first painting he showed the older painter, had also demonstrated 'par sa franchise et son honnêté' that black was a light as well as a colour (A. Masson 1974, 'Conversations avec Matisse', *Critique*, XXX, 324, 394-5). I owe this reference to the kindness of Nicholas Watkins.

5 E. de Goncourt 1895, 'Hokusai: les albums traitant de la peinture et du dessin avec ses préfaces', *Gazette des Beaux-Arts*, XXXVI (3ᵉ per. XIV), 442. The translation here is based on A. Reinhardt (1967), 'Black as Symbol and Concept' in B. Rose (ed.) 1975, *Art as Art: the Selected Writings of Ad Reinhardt*, 86. Hokusai's book is the *Yehon Saishiki Tsu (An Illustrated Book on the proper use of Colours)*, published in two volumes in 1848.

6 Durand-Ruel had the *Astruc* between 1895 (or 1899) and *c.* 1908, and the *Breakfast* between 1894 and 1898 (see Paris, Grand Palais/ New York, Metropolitan Museum of Art, *Manet, 1832-1883*, 1983, nos 94, 109, for the fullest accounts of these paintings). Matisse will also have had the opportunity of studying the *Breakfast* at Bernheim-Jeune's Gallery in 1910.

7 J. Flam 1986, *Matisse: the Man and his Art, 1869-1918*, 78.

8 Flam (op. cit) 114.

9 Flam (op. cit) 51.

10 For *The Balcony*, Manet, 1983, no. 115.

11 Flam (op. cit) 394; I. Monod-Fontaine, 'A Black Light: Matisse (1914-1918)' in C. Turner and R. Benjamin (eds.) 1995, *Matisse*, Brisbane, Queensland Art Gallery/ Canberra, National Gallery of Australia/ Melbourne, National Gallery of Victoria, 87.

12 Flam (op. cit) 394.

13 On this series, see espec. Monod-Fontaine 1995, 87-8.

14 J. Elderfield 1978, *Matisse in the Collection of the Museum of Modern Art*, 112.

15 D. Giraudy 1971, 'Correspondance Henri Matisse-Charles Camoin', *Revue de l'Art*, 12, 17-18.

16 See R. L. Herbert *et al.* 1991, *Georges Seurat, 1859-1891*, New York, Metropolitan Museum of Art, nos 69, 71, 146. Other Seurat drawings of this type which may have been known to Matisse include *The Housepainter* (1883-4; Herbert no. 46), which belonged to Pissarro, and *Scaffolding* (1886-7; Herbert no. 174), which belonged to Signac.

17 For example, Flam (op. cit.) 405.

18 Gage 1993, *Colour and Culture*, 118; van Gogh to Bernard, June 1888 in *Complete Letters of Vincent Van Gogh*, 1958, II, 490.

19 I assume that this is the underlying rationale of Malevich's remark in 1920, 'I consider white and black to be deduced from the colour spectra' (K. S. Malevich, *Essays on Art*, ed. T. Andersen 1969, I, 126-7).

20 N. Watkins 1984, *Matisse*, 139.

21 Flam (op. cit.) 133 (1951).

22 Matisse (op. cit. n. 3 above), 94.

23 Flam (op. cit.) 38. For Matisse's 'scientific' bias in the Fauve period, 1904-5, Gage 1993, *Colour and Culture*, 211.

24 Barr (op. cit. n. 1 above) 185; Flam (op. cit.) 21, 243-4, 388-9. M. Antliff 1993, *Inventing Bergson: Cultural Politics and the Parisian Avant-Garde*, 198-9, has questioned Matisse's direct knowledge of Bergson before 1909.

25 R. Escholier 1960, *Matisse from the Life*, 98. Poincaré does not speak in so many words of the 'destruction of Matter' in *Science and Hypothesis*, although the argument, so exciting to Matisse, is implicit in several places, especially ch. X. Matisse was probably reporting his discussion of the book with the librarian Galanis who, according to Matisse, had 'found the origin of cubism' in this text.

26 Poincaré (op. cit. n. 25 above) 1905, 173. Poincaré, who was

concerned to show that scientific hypotheses were no more compelling than poetic metaphors, argued that the second tendency of modern science was precisely the opposite, 'towards diversity and complication', but that only the first made science possible: 'the true and only aim is unity' (177).

27 This account of Le Bon's work draws largely on M. J. Nye 1974, 'Gustave Le Bon's Black Light: a study in physics and philosophy in France in the turn of the century', *Historical Studies in the Physical Sciences*, IV, 163-95.

28 G. Le Bon (1907), *The Evolution of Forces*, trans. F. Legge 1908, 279. The whole of Bk IV of this work, which ran into at least three editions before 1918, is devoted to Black Light.

29 A. Dastre 1901, 'Les nouvelles radiations: rayons cathodiques et rayons röntgen', *Revue des Deux Mondes*, LXXI, 5ᵉ per. VI, 696. Le Bon was happy to quote this passage in his *Evolution of Matter* (1905), 3rd. ed., trans. Legge 1907, 29.

30 Le Bon (op. cit. n. 28 above) 202.

31 Ibid. 284-5.

32 Ibid. 290-291.

33 Flam (op. cit. n. 7 above) 392. The author, Xavier Pelletier, seems to have been thinking of the 'N-rays' mooted in 1903-4 as emanating from animal and plant tissue, but the experiments were soon discredited (Nye, op. cit. n. 27 above, 180). For a detailed study of the 'N-ray' scandal, M. J. Nye 1980,'N-rays: an episode in the history and psychology of science', *Historical Studies in the Physical Sciences* 11, 125-56, espec. 133. Carol Coe kindly directed me to this article.

34 Nye (op. cit. n. 27 above) 190-1.

35 They include *Reader on a Black Background*, 1939 (Paris, Musée National d'Art Moderne) and *Dancer and Rocaille Armchair on a Black Background*, (1942).

36 For the series of black chasubles, J. Cowart, J. Flam, D. Fourcade 1977, J. H. Neff, *Henri Matisse: Paper Cut-Outs*, nos 148-55, espec. no. 155.

19 Colour as Language in Early Abstract Painting

1 'Reminiscences' (1913) in *Kandinsky: Complete Writings on Art*, ed. Lindsay and Vergo 1982, I, 370.

2 C. Lévi-Strauss (1964), *The Raw and the Cooked*, trans. Weightman 1970, 19f, 25. E. H. Gombrich 1963, 'The Vogue for Abstract Art', *Meditations on a hobby-horse*.

3 S. Bann 1980, 'Abstract Art – a Language?' in London, Tate Gallery, *Towards a New Art: Essays on the Background to Abstract Art, 1910-20*, 144.

4 A. Besant and C. W. Leadbeater (1901), *Thought-Forms*, Madras 1961, 20.

5 Kandinsky (op. cit. n. 1 above) 183.

6 W. Wundt (1874), *Grundzüge der physiologischen Psychologie*, 5th ed. 1902, II, 145.

7 Kandinsky (op. cit. n. 1 above) 182; Wundt (op. cit.) 352 n. 1; G. T. Fechner (1877), *Vorschule der Aesthetik*, II, 1898, 216.

8 Lévi-Strauss, loc. cit., n. 2.

9 See M. Foucault 1966, *Les mots et les choses*, ch. IV. The fullest account of the work of Schiffermüller and Harris is now T. Lersch 1984, 'Von der Entomologie zur Kunsttheorie' in *De Arte et Libris: Festschrift Erasmus*, 301ff.

10 I am thinking especially of G. Field 1850, *Rudiments of the painter's art; or a Grammar of Colouring*; E. Guichard 1882, *Grammar of Colour*.

11 Rood 1879, *Modern Chromatics*, 250; W. I. Homer, 'Notes on Seurat's Palette' in N. Broude 1978, *Seurat in Perspective*, 116ff.

12 V. Huszár 1917, 'Iets over die Farbenfibel van W. Ostwald', *De Stijl*, I, 113ff.

13 E. A. Carmean Jr 1979, *Mondrian: The Diamond Compositions*, Washington, National Gallery of Art, 79-83. Rood (op. cit. n. 11 above) 136, had found that spectral red could be matched in pigments by a glaze of carmine over vermilion.

14 For Mondrian, see espec. *Composition XIII*, 1920 (Bartos Coll., Seuphor 457), reproduced in colour in Cologne, Galerie Gmurzynska, *Mondrian und De Stijl*, 1979, 181. He does not, however, seem to use yellow and green in the same work and his yellows at this period are sometimes very greenish. For a fuller discussion of Mondrian and green, Gage 1993, *Colour and Culture*, 258.

15 See van Doesburg's texts in J. Baljeu 1974, *Theo van Doesburg*, espec. 160, 178.

16 B. van der Leck 1917, 'De Plaats van het moderne schilderen en de architectuur', *De Stijl*, I, i, in English in P. Hefting and A. Van der Woud 1976, *Bart van der Leck, 1876-1958*.

17 'Inzicht' (1928), trans. T. M. Brown, *The Work of G. Rietveld, Architect*, 1958, 160.

18 G. Vantongerloo 1924, *L'Art et son Avenir*, espec. 28ff.

19 For Mondrian, see E. Hoek in C. Blotkamp *et al.* 1986, *De Stijl: The Formative Years*, 69 and cf. P. Mondrian (1917), 'The New Plastic in Painting' in H. Holtzman and M. S. James (eds) 1987, *The New Art – The New Life: the Collected Writings of Piet Mondrian*, 36.

20 R. Bolton 1978, 'Black, white and red all over; the riddle of color term salience', *Ethnology*, 17/3, 287-311; A. Jacobson-Widding 1979, *Red-White-Black as a Mode of Thought* (Acta Universitatis Upsaliensis).

21 The fullest study of this triad in modern European languages is J. de Vries (1942), 'Rood-wit-zwart', *Kleine Schriften*,1965, 35ff.

22 K. Malevich, *Suprematism, 34 drawings* (1920) in *Essays on Art*, ed. T. Andersen 1969, I, 123-7.

23 Ibid. 126. See also *Suprematism as pure knowledge* (1922) in K. Malevich, *Suprematismus: die gegenstandlose Welt*, ed. W. Haftman 1962, 164, and *Essays on Art*, trans T. Andersen 1971, II, 126. Malevich was probably thinking of white light as the sum of the spectral colours and of the black interference (Fraunhofer) lines dividing the spectrum into bands.

24 For the icon revival in general, M. Betz 1977, 'The Icon and Russian Modernism', *Artforum*, Summer, 38ff and espec. 42-3. A. C. Birnholz, in the fullest discussion of Malevich's white paintings, refers in passing to the white-grounded icons: 'On the meaning of Kasimir Malevich's "White on White"', *Art International*, XXI. 1977, 14f. A further colouristic dimension to Malevich's interest in icons is suggested by his hanging of his *Black Square* (on a white ground) at the '0-10' exhibition in Petrograd in 1915 high up across the 'red' corner of the room, so exhibiting his favourite triad of colours (pl. 126).

25 K. Malevich, 'Non-objective creation and Suprematism' (1919) in *Essays* (cit. n. I above) 121-2.

26 For Belyi see A. Steinberg, 'Andrei Belyi's experimental poetry' in A. McMillin, ed. 1992, *Symbolism and After*, espec. 67. J. Peters 1981, *Farbe- und Licht-Symbolik bei Aleksandr Blok*, 51, 92, 300f.

27 For an English translation of the opera, *Drama Review*, XV (4), 1971, 107ff.

28 For *audition colorée*, see below Chapter 21. Rimbaud's poem was well-known in Russia: it was cited by the abstract poet Nikolai Burliuk in an essay of 1914 (P. Railing 1989, *From Science to Systems of Art: on Russian Abstract Art and Language, 1910/20*, 106), and formed the starting-point for Belyi's 1917 poem *Utro* (Steinberg in McMillin, op. cit. n. 26 above, 63f).

29 For Jakobson's friendship with Malevich, S. Barron and M. Tuchman, eds., *The Avant Garde in Russia, 1910-1930, New Perspectives* (Los Angeles, Los Angeles County Museum, 1980), 18. R. Jakobson and M. Halle, *Fundamentals of Language*, 2nd ed. 1975, 4 n; R. Jakobson 1968, *Child Language, Aphasia and Phonological Universals*, 82-4.

30 V. Chlebnikov, *Werke*, trans. Urban 1972 II, 311-15. For the universality of Khlebnikov's language, R. Cooke 1987, *Velimir Khlebnikov: a Critical Study*, 73-85.

31 W. Kandinsky, *Écrits*, ed., Sers. III, 1975, 381; and cf. his programme for the Moscow Institute of Artistic Culture (1920), in op. cit. n. I above, 460. For a comparison of the programmes of the Russian and German post-war art schools, R. Wick 1982, *Bauhaus Pädagogik*, 59-63, and espec. C. Lodder, 'The VkhUTEMAS and the Bauhaus' in G. Harrison Roman and V. Hagelstein Marquardt

1992, *The Avant-Garde Frontier: Russia Meets the West, 1910-1930*, 196-240.

32 The most impressively comprehensive programme for the experimental study of colour in the Soviet State Art Workshops was drawn up about 1924 by N. T. Fedorov, and has been published in an Italian translation: *Casabella*, n. 435, April 1978, 59f. See also C. Lodder 1983, *Russian Constructivism*, 125 and n. 160.

33 I. Klyun (1919), 'The Art of Colour' in J. E. Bowlt (ed. and trans.) 1976, *Russian Art of the Avant Garde: Theory and Criticism, 1902-1934*, 142f. Cf. also Vantongerloo (op. cit. n. 18 above) 22f. The Latvian critic V. Matvejs had already argued in 1910 that colour should, on the analogy with music, free itself from slavery to nature: 'The world of colour must be another world. When colour frees itself from its slave duties, it opens up new worlds with new poetics and new secrets.' (J. Howard 1992, *The Union of Youth: An Artists' Society of the Russian Avant-Garde*, 64).

20 A Psychological Background for Early Modern Colour

1 H. G. Keller and J. J. R. MacLeod 1913, 'The Application of the Physiology of Color Vision in Modern Art', *Popular Science Monthly*, LXXXIII, 45ff.

2 J. Cohn 1894, 'Experimentelle Untersuchungen über die Gefühlsbetong der Farbenhelligkeiten und ihre Combinationen', *Philosophische Studien*, X, 562ff. For the later controversy over this work, A. Minor 1909, *Zeitschrift für Psychologie*, 50, 43ff. F. Stefănescu-Goangă 1912, 'Experimentelle Untersuchungen zur Gefühlsbetonung der Farben', *Psychologische Studien*, VII, 284ff.

3 E. Harms 1963, 'My Association with Kandinsky', *American Artist*, XXVII, 36ff. The edition of Goethe's *Farbenlehre* which Harms says Kandinsky was studying was that in *Kürschners Deutsche National-Literatur: Goethes Werke, XXV, Naturwissenschaftliche Schriften III* (1891), with an introduction and notes by Steiner. In his introduction Steiner used the term 'inner necessity', which became a key concept in *On the Spiritual in Art*. Steiner may himself have found the term, and a variant 'innerer Nöthigung', in P. O. Runge 1841, *Hinterlassene Schriften*, II, 354, 386, 405, 467, to which Heinz Matile has drawn attention in the context of Kandinsky (H. Matile, *Die Farbenlehre Philipp Otto Runges*, 2nd ed. 1979, 370).

4 For a Delaunay study of 1912 from the glass at Laon (Bern, Kunstmuseum), S. Buckberrough 1979, 'The Simultaneous Content of Robert Delaunay's Windows', *Arts Magazine*, Sept., 110, fig. 10. At exactly the same time the Italian Divisionist painter Angelo Morbelli was addressing the problem of transparency, and saw the technique of glazing as the key to luminosity, referring as an example to medieval stained glass (T. Fiori, ed. 1968, *Archivi del Divisionismo*, 142ff). The theorist of Divisionism G. Previati also gave a good deal of attention to transparency and glazing in 1906 (*Principi scientifici del Divisionismo*, 2nd ed. 1929, 77, 142ff) and his account of a luminous landscape seen through a window (154ff) may have been the starting-point for Giacomo Balla's late Divisionist work *Window in Düsseldorf*, 1912 (M. Fagiolo dell'Arco, *Futur Balla*, 1970, pl. xiii). Previati's book was discussed by Milesi 1907 in *Les Tendances Nouvelles*, no. 29, 537-9, and was published in French in 1910. For Kupka's parallel studies of stained-glass windows about 1910, V. Spate 1979, *Orphism*, 126.

5 F. Gilles de la Tourette 1950, *Robert Delaunay*, 50. A French psychologist had recently treated the night sky towards its zenith as the exemplar of depth: it seemed to be a gelatinous or glass substance. (E. Claparède 1906, *Archive de Psychologie*, V, 128, cit. Katz. 1911, 67n.).

6 For the textiles, M. Hoog, *Inventaire des Collections Publiques Françaises: Paris, Musée National d'Art Moderne: Robert and Sonia Delaunay*, 1967, no. 71; for the book-bindings, Paris, Bibliothèque Nationale. *Sonia and Robert Delaunay*, 1977, no. 354ff. Spate (op. cit n. 4 above) 357 n. 54, dates the earliest collages of Sonia Delaunay to 1913.

7 P. Francastel (ed.) 1957, *Du Cubisme à l'Art Abstrait*, 184. The most detailed technical analysis of the *Disc* is in H. J. Albrecht 1974, *Farbe als Sprache*, 30ff. The *Disc* (private collection) is reproduced in colour in Albrecht (pl. 1).

8 V. Huszár 1917, 'Iets over die Farbenfibel van W. Ostwald', *De Stijl*, I, 113ff.

9 See *Composition VIII: The Cow*, 1917, and *Composition in Discords*, 1918 (Mrs M. Arp-Hagenbach), in J. Baljeu 1974, *Theo van Doesburg*, 33, 36. In his *Principles of Neo-Plastic Art* (1925), 1969, 15 and fig. 1, Van Doesburg opted for the *three* primaries, red, yellow and blue, but it is not certain whether this represents his views in 1915 and 1917, when the MS was said to have been completed. Green is not among the colours discussed in the first published version of his theory: T. van Doesburg (1919), *Grondbegrippen van de nieuwe beeldende Kunst*, ed. S. V. Barbieri, C. Boekrad, J. Leering 1983, 22. For a fuller discussion of Mondrian and Ostwald, Gage 1993, *Colour and Culture*, 257-9.

10 R. P. Welsh and J. M. Joosten1969, *Two Mondrian Sketchbooks, 1912-14*, 21. Mondrian's reading of Kandinsky is suggested by his phrase 'an inner feeling of necessity' (44). But see also n. 3 above.

11 See R. P. Welsh, 'Mondrian and Theosophy', *Piet Mondrian: Centennial Exhibition*, New York, Guggenheim Museum, 1971, 35ff. *Thought-Forms* had been translated into Dutch in 1905.

12 For Mondrian's complex relationship with Huszár, Gage 1993, Colour and Culture, 257-8.

13 *De Stijl*, I, 3, 1918, 30, in H. Holtzman and M. James (eds.) 1987, *The New Art – The New Life: The Collected Writings of Piet Mondrian*, 36. Shoenmaekers' doctrines had been published in *The New Image of the World (Het nieuwe Wereldbeeld)*, 1915, and *Principles of Plastic Mathematics (Beginselen der beeldende Wiskunde)*, 1916. For Kandinsky's reputation in Holland, W. Kandinsky, *Regards sur le Passé*, ed. Bouillon 1974, 237. For Van Doesburg's interest in Kandinsky, Baljeu (op. cit. n. 9 above) 16, 21-4.

14 For Mondrian's use of yellow-green, above Chapter 19, n. 14, and Gage 1993, *Colour and Culture*, 258 and pl. 201.

15 Holtzman and James (op cit. n. 13 above) 36.

16 See R. P. Welsh 1966, *Piet Mondrian*, espec. no. 84, 89; and *Piet Mondrian: Centienniel Exhibition*, New York, Guggenheim Museum, 1971, nos 69, 73, 75-7, 81, 89. See also Van Doesburg's *Composition XI*, 1918, and *Rhythms of a Russian Dance*, 1918.

21 Making Sense of Colour – the Synaesthetic Dimension

1 The mosaics have been discussed briefly by G. Delfini Filippi, 'La Basilica dal Seicento all'Ottocento' in C. Pietrangeli (ed.) 1989, *La Basilica di S. Pietro*, 156-62; see also F. di Federico 1983, *The Mosaics of St Peter's decorating the New Basilica*.

2 J. D. Forbes 1849, 'Hints towards a classification of colours', *Philosophical Magazine*, 3rd ser., XXXIV, 177-8.

3 K. Pearson, *The Life, Letters and Labours of Francis Galton*, 1914-30, II, 224f.

4 H. Conklin 1955, 'Hanunóo color categories', *South Western Journal of Anthropology*, II, 340, quotes estimates of perceptible nuances – hues with variations of brightness and saturation – of between 7.5 and 10 million; see also R. W. Brown and E. H. Lenneberg 1954, 'A study of language and cognition', *Journal of Abnormal Social Psychology*, XLIX, 457. A. Chapanis 1965, 'Color names for color space', *American Scientist*, LIII, 344 suggests that there are some 50 usable colour-names for the whole of colour-space.

5 See above Chapter 3 and G. Roque 1991, 'Portrait de la couleur en femme fatale', *Art & Fact* (Revue des historiens de l'art, des archaeologues, des musicologues et des orientalistes de l'Université de Liège), X, 4-11.

6 See above Chapter 2 and B. J. Kouwer 1949, *Colours and their Character: a Psychological Study*, 52f.

7 Kouwer, op. cit., is still the most extensive study.

8 For the early history of synaesthetic ideas, L. Schrader 1969, *Sinne*

und Sinnesverknüpfungen: Studien und Materialien zur Vorgeschichte der Synästhesie; T. Tornitore 1988, *Scambi di Sensi: Preistorie delle Sinestesie*. See also S. Baron-Cohen and J. E. Harrison (eds.) 1996, *Synaesthesia: Classic and Contemporary Readings*.

9 J. Müller, *Elements of Physiology*, trans. W. Baly (1833-8). For a useful summary of Müller's work and its influence, E. G. Boring 1942, *Sensation and Perception in the History of Experimental Psychology*, 68-78; and for its effect on 19th-century concepts of representation, J. Crary 1990, *Techniques of the Observer: on Vision and Modernity in the Nineteenth Century*, ch. 3. For Elliot's *Philosophical Observations on the Senses* (1780), J. D. Mollon 1987, 'John Elliot MD, 1747-1787', *Nature* 329, 19-20.

10 G. T. Fechner (1876), *Vorschule der Aesthetik*, I, 1897, 176ff; idem (1877), II, 1898, 315-19.

11 The fullest study of the early history of *audition colorée*, a term which seems to have been a French translation of the English 'coloured hearing', but was usually cited in French, is F. Mahling 1926, 'Das Problem der *Audition colorée*', *Archiv fur die gesamte Psychologie*, LVII, 165-257. For more recent work, J. Davidoff 1991, *Cognition through Color*, 111-13; P. Junod 1994, 'De l'audition colorée ou du bon usage d'un mythe' in P. Junod and M. Pastoureau, *Couleur: Regards croisés sur la couleur du Moyen Age au XXᵉ Siècle*, 63-81. J. Harrison and S. Baron-Cohen 1994, 'Synaesthesia: an account of coloured hearing', *Leonardo*, 27/4, 343-6. For the long history of colour-music analogies, Gage 1993, *Colour and Culture*, ch. 13.

12 For Newton's colour-musical concerns, see above Chapter 9, and espec. D. Topper 1990, 'Newton on the number of colours in the spectrum', *Studies on the History and Philosophy of Science*, 21/2, 269-79.

13 See, for example, L. E. Marks 1975, 'On colored-hearing synaesthesia', *Psychological Bulletin*, LXXXII, 303-31; S. Baron-Cohen, M. A. Wyke, C. Binnie 1987, 'Hearing words and seeing colours: an experimental investigation of a case of synaesthesia', *Perception*, XVI, 761-7.

14 A. de Rochas 1885, 'L'Audition colorée', *La Nature*, II, 275, where the poem is attributed to Verlaine, who had published it for the first time in *Lutèce* in 1883 and again in *Les Poètes Maudits* in 1884 (A. Rimbaud, *Oeuvres Complètes*, ed. A. Adam 1972, 898). For Rimbaud's disclaimer, *Un Saison en Enfer* (1873) in W. Fowlie (ed. and trans.) 1966, *Rimbaud: Complete Works*, 192. It is particularly notable that in the course of the poem Rimbaud's *rouge* becomes elided with *pourpre*, and his *bleu* with *violet*:: he seems to be more concerned with the resonance of colour-ideas than with colour-perceptions.

15 A. Binet 1892, 'Le problème de l'audition colorée', *Revue des Deux Mondes*, CXIII, 586, 607. Rimbaud's poem is cited as the most famous instance of the phenomenon on 609. The Symbolist theorist of language René Ghil was much concerned with *audition colorée* in the early versions of his *Traité du Verbe* (1885), adducing Rimbaud's poem, but attacking his rendering of the 'simple' vowel U with the 'compound' colour green and proposing yellow instead (R. Ghil, *Traité du Verbe. États Successifs 1885, 1886, 1887, 1888, 1891, 1904*, ed. T. Goruppi 1978, 60, 82, 108). Ewald Hering had of course already shown in 1874 that green is, phenomenologically, a 'pure' colour (E. Hering 1878, *Zur Lehre vom Lichtsinne*, 107-21).

16 Lind's typescript of 1900, *The Music of Color and the Number Seven*, formerly British Museum 1752 a.8, was destroyed during the 1939-45 war; an earlier version, *Music of Color* (1894) is in the George Peabody Library, Johns Hopkins University, Baltimore, and has been published in facs. by the library. Here I have used the extracts from the British Museum version given by A. B. Klein 1937, *Coloured Light, an Art Medium*, 14-16.

17 R. Redgrave (1853), *A Manual of Colour, with a Catechism*, 1884, iii; G. Field, *Chromatography* (1835), 2nd ed. 1841, 15, 191; D. R. Hay, *The Laws of Harmonious Colouring adapted to Interior Decoration, Manufactures and other Useful Purposes*, 5th ed. 1844. Hay's diagram is close to several which had been published by Field since the 1st ed. of his *Chromatics* in 1817, the 2nd ed. of which (1845) has a very extended discussion of the topic. For Redgrave's work at the School

of Design (but without reference to the colour-manual), A. Burton, 'Redgrave as art educator, museum official and design theorist' in S. Casteras and R. Parkinson (eds) 1988, *Richard Redgrave, R.A., 1804-1888*, 48-70.

18 F. Galton (1883), *Inquiries into Human Faculty and its Development*, 1907, 107. Galton's principal source-book was the earliest substantial gathering of case-histories, E. Bleuler and K. Lehmann, *Zwangsmässige Lichtempfindungen durch Schall und verwandte Erscheinungen auf dem Gebiete der anderen Sinnesempfindungen*, 1879 (2nd ed. 1881).

19 Klein (op. cit. n. 16 above) 14.

20 Pearson (op. cit. n. 3 above) II, 214. Cf. the discussion of the use of coloured lights to treat hysterics in C. Féré 1887, *Sensation et Mouvement*, 43-6.

21 E. A. Fletcher 1910, *The Law of the Rhythmic Breath*, 284-5. I have been unable to trace a report of this case in Lombroso's published work.

22 See D. G. Landgrebe 1834, *Ueber die Chemischen und Physiologischen Wirkungen des Lichts* (largely on plants and animals); R. Hunt 1844, *Researches on Light in its Chemical Relations* (on plants).

23 See also *The Lancet*, March 29 1919, 519-22. For Germany, see the work of the Bauhaus-trained designer Lou Scheper at the University Clinic in Münster in 1924 (E. Neumann 1971, *Bauhaus und Bauhäusler*, 94). For a positive evaluation of the treatment, M. Anderson 1979, *Colour Healing: Chromotherapy and How It Works*; and for a critical survey of recent work, P. K. Kaiser 1984, 'Physiological response to color: a critical review', *Color Research and Application*, IX, 29-36.

24 See espec. S. Baron-Cohen, J. Harrison, L. H. Goldstein, M. Wyke 1993, 'Coloured speech-perception: is synaesthesia what happens when modularity breaks down?', *Perception*, XXII, 419-26; R. E. Cytowic (1993), *The Man Who Tasted Shapes*, 1994, espec. 97, 108, 166. I am grateful to Dr Simon Baron-Cohen for this reference.

25 W. Kandinsky, *Complete Writings on Art*, ed. and trans. K. C. Lindsay and P. Vergo 1982, I, 158. See also E. Heimendahl 1961, *Licht und Farbe: Ordnung und Funktion der Farbwelt*, 210ff. Cytowic (op. cit. n. 24 above) 121, has emphasized the abstractness of colour-synaesthetic experiences.

26 See Gage 1993, *Colour and Culture*, 209.

27 Galton (op. cit. n. 18 above) 111. Many discrepancies in cases recorded since 1812 have been tabulated by Schrader (op. cit. n. 8 above) 37; see also L. E. Marks 1978, *The Unity of the Senses*, 87-9.

28 C. Scott (*c.* 1916), *The Philosophy of Modernism (and its Connection with Music)*, 111, 115. I am grateful to David Chadd for this reference.

29 A. Besant, 'Thought-Forms', *Lucifer, a Theosophical Monthly*, XIX, Sept. 1896-Feb. 1897, 67f. For Scriabin's synaesthesia, K. Peacock 1985, 'Synaesthetic perception: Alexander Scriabin's color hearing', *Music Perception*, II, 483-506. Peacock does not refer to Scriabin's links with Theosophy, for which see Gage 1993, *Colour and Culture*, 299 n.122. For Belyi, A. Steinberg, 'Andrei Belyi's experimental poetry' in A. McMillin (ed.) 1992, *Symbolism and After*, 61-9. Prof. Robin Milner-Guilland kindly introduced me to this article. For Kandinsky and Theosophy, espec. S. Ringbom, 'Transcending the visible: the generation of the abstract pioneers' in M. Tuchman *et al.* 1986, *The Spiritual in Art: Abstract Painting 1890-1985*, 131-53.

30 Baron-Cohen *et al.* (op. cit. n. 24 above) 422.

31 G. A. Reichard, R. Jackobson, E. Werth 1949, 'Language and Synaesthesia', *Word*, V, 232-3.

32 Cytowic (op. cit. n. 24 above) 59.

33 E. Downey 1929, *Creative Imagination: Studies in the Psychology of Literature*, 95.

34 R. Cooke 1987, *Velimir Khlebnikov, a Critical Study*, 84-5; J. Padrta, 'Malevitch et Khlebnikov' in J. C. Marcadé (ed.) 1979, *Malevitch: Actes du Colloque International*, 31-41; and see above Chapter 19

35 Gerome-Maïsse (Alexis Mérodack-Jeaneau), 'L'Audition colorée', *Les Tendances Nouvelles* (1907), 656.

36 Reichard *et al.* (op. cit. n. 31 above) 225f. For Jacobson's continuing concern for coloured hearing, R. Jakobson 1968, *Child-Language, Aphasia and Phonological Universals*, 82-4; R. Jakobson and M. Halle, *Fundamentals of Language*, 2nd ed. 1975, 45n.

37 Baron-Cohen *et al.* (op. cit. n. 24 above) 420. This study also proposes a possibly sex-linked genetic base for the faculty (423). See also B. Shanon 1982, 'Color associates and semantic linear orders', *Psychological Research* 44, 76. There may of course be social reasons why the response to a BBC Radio 4 programme was predominantly female, just as the reasons for the largely male sample of subjects in one of the earliest studies may have had a social origin (F. Suarez de Mendoza 1890, *L'Audition Colorée. Étude sur les Fausses Sensations Secondaires Physiologiques et Particulièrement sur les Pseudo-Sensations de Couleurs Associés aux Perceptions objectives des Sons*, Paris: 39 female cases out of 134). Mérodack-Jeaneau (see n. 35 above) may have been a patient of this Angers doctor, and quotes the book extensively in his 1907 article.

Select Bibliography

BIBLIOGRAPHIES OF COLOUR

Alexander, S. M. 1969, 1970. 'Towards a history of art materials – a survey of published technical literature in the arts', *Art and Archaeology Technical Abstracts*, Supplements VII, VIII.

Avril, F. 1967. *La Technique de l'Enluminure d'après les Textes Medievaux: Essai de Bibliographie.*

Berlin, B. and P. Kay, 1991. *Basic Color Terms*, 2nd ed.

Buckley, M. and D. Baum, 1975. *Color Theory: a Guide to Information Sources.*

Doran, M. 1974. 'Colour theory: publications issued before 1900 and their later editions and reprints', *ARLIS Newsletter*, March 1974.

Grossmann, M. 1988. *Colore e Lessico: Studi sulla Struttura Semantica degli Aggettivi di Colore in Catalano, Castigliano, Italiano, Romano, Latino ed Ungherese.*

Gullick, M. 1995. 'A bibliography of medieval painting treatises' in L. Brownrigg (ed.) *Making the Medieval Book: Techniques of Production.*

Herbert, R. L. 1974, 1978. 'A color bibliography', *Yale University Library Gazette*, 49, 52.

Herman, A. and M. Cagiano di Azevedo, 1969. 'Farbe', *Reallexikon für Antike und Christentum*, VII.

Indergand, M. 1984, 1990. *Bibliographie de la Couleur.*

Kühn, H. 1974. 'Farbe, Farbmittel, Pigmente und Bindemittel in der Malerei', *Reallexikon zur deutschen Kunstgeschichte*, VII.

Lakowski, R. and A. Dermott, 1966. *A Bibliography on Colour.*

Lersch, T. 1974. 'Farbenlehre', *Reallexikon zur deutschen Kunstgeschichte*, VII.

Maniaci, M. and P. F. Munafò, 1993. *Ancient and Medieval Book Materials and Techniques.*

Massing, A. 1990. 'Painting materials and techniques: towards a bibliography of the French literature before 1800' in *Die Kunst und ihre Erhaltung: Rolf E. Straub zum 70. Geburtstag.*

Richter, M. 1952, 1963. *Internationale Bibliographie der Farbenlehre und ihre Grenz-gebiete*, I, 1940-9; II, 1950-4.

Schiessl, U. 1989. *Die deutsch-sprachige Literatur zu Werkstoffen und Techniken der Malerei von 1530 bis ca. 1950.*

Skard, S. 1949. 'The use of color in literature: a survey of research', *Proceedings of the American Philosophical Society*, XC.

Strauss, E. 1983. *Koloritgeschichtliche Untersuchungen zur Malerei seit Giotto*, 2nd ed., ed. L. Dittmann.

Yale University Art and Architecture Library, 1982. *Faber Birren Collection of Books on Color: a Bibliography.*

ESSAY–COLLECTIONS

Backhaus, W. G., K. R. Kliegl and J. S. Werner (eds) 1998. *Color vision: Perspectives from Different Disciplines.*

Baron-Cohen, S. and J. E. Harrison (eds) 1996. *Synaesthesia: Classic and Contemporary Readings.*

Byrne, A. and D. Hilbert. 1997. *Readings on Color.*

CUERMA, 1988. *Les Couleurs au Moyen Age.*

Eco, R. (ed.) 1985. *Colore: Divieti, Decreti, Discute* (*Rassegna*, Sept. 1985).

Harrison, A. 1987. *Philosophy and the Visual Arts: Seeing and Abstracting.*

Hering-Mitgau, M. *et al.* 1980. *Von Farbe und Farben: Albert Knoepfli zum 70. Geburtstag.*

Hess, T. B. and J. Ashbery (eds) 1969. *Light: from Aten to Laser* (Art News Annual, XXXV).

Istituto Storico Lucchese/Scuola Normale Superiore di Pisa, 1996. *Il Colore nel Medioevo: Arte, Simbolo, Tecnica.*

Junod, P. and M. Pastereau 1994. *La Couleur: Regards Croisés sur la Couleur du Moyen Age au XX Siècle* (Cahiers du Léopard d'Or, 4).

Kramer, H. and O. Matschoss 1963. *Farben in Kultur und Leben.*

MacAdam, D. L. 1970. *Sources of Color Science.*

Meyerson, I. (ed.) 1957. *Problèmes de la Couleur.*

Nassau, K. (ed.) 1998. *Color for Science, Art and Technology.*

The Realms of Colour, 1972 (Eranos Yearbook).

Roque, G. (ed.) 1992. *L'Experience de la Couleur* (Verba Volant 3).

Studium Generale, 1960. XIII.

Torney, S. (ed.) 1978. *Voir et Nommer les Couleurs.*

Wallert, A., E. Hermens, M. Peek (eds) 1995. *Historical Painting Techniques, Materials and Studio Practice.*

UNPUBLISHED ACADEMIC THESES

Amster, A. A. 1971. *The Evolution of Color as a Primary Element in Painting.* PhD diss., New York University.

Bell, J. 1983. *Color and Theory in Seicento Art. Zaccolini's 'Prospettiva del Colore' and the Heritage of Leonardo.* PhD diss., Brown University.

Brailsford, C. M. 1984. *Cézanne and Phenomenology: a Common Objective.* MA thesis, University of Georgia.

Callen, A. 1980. *Artists' Materials and Techniques in 19th Century France.* PhD diss., London University.

Caron, L. K. 1981. *The Use of Color by Painters in Rome from 1524 to 1527.* PhD diss., Bryn Mawr College.

Cowardin, S. 1963. *Some Aspects of Color in 15th Century Florentine Painting.* PhD diss., Harvard University.

Dunlop, L. J. V. 1988. *Colour in Parisian MS Illumination, c. 1320-c.1420.* PhD diss., Manchester University.

Hargreaves, D. 1973. *Thomas Young's Theory of Color Vision: its Roots, Development and Acceptance by the British Scientific Community.* PhD diss., University of Wisconsin, Madison.

Johnson, L. 1958. *Colour in Delacroix: Theory and Practice.* PhD diss., Cambridge University.

Kaufmann, T. D. 1972. *Theories of Light in Renaissance Art and Science.* PhD diss., London University.

Larne, G. R. 1985. *A Theory of Autonomous Color: David Katz and Modernist Painting* (Germany). MA thesis, Hunter College of the City University of New York.

Pardo, M. 1984. *Paolo Pino's 'Dialogo di Pittura': a Translation with Commentary.* PhD diss., University of Pittsburgh.

Parris, N. G. 1979. *Adolf Hoelzel's Structural and Color Theory and its Relationship to the Development of the Basic Course at the Bauhaus.* PhD diss., University of Pennsylvania.

Petzold, A. 1987. *The Use of Colour in English Romanesque MS Illumination.* PhD diss., London University.

Poling, C. V. 1973. *Color Theories of the Bauhaus Artists.* PhD diss., Columbia University.

Ratcliffe, R. 1960. *Cézanne's Working Methods and their Theoretical Background.* PhD diss., London University.

Raulerson, S. 1987. *The Psychological Significance of Color use in Painting.* MA thesis, Florida Atlantic University.

Rosell, K. J. 1986. *Color: a Credible Link between the Paintings of Eugène Delacroix and the Music of Hector Berlioz.* PhD diss., Ohio University.

Royce-Roll, D. 1988. *The Influence of the 12th Century Glass Texts,*

Theophilus's 'De Diversis Artibus' and Eraclius's 'De Coloribus et Artibus Romanorum' for Understanding the Technology and the Colors of Romanesque Stained Glass. PhD. diss., Cornell University.

Rüth, U. M. 1977. *Die Farbgebung in der Byzantinischen Wandmalerei der Spätpalaologischen Epoche (1341-1453).* PhD diss., Rheinisch Friedrich-Wilhelms Universität, Bonn.

Sauvaire, N. 1978. *Le Rôle de la Famille Haro, Marchand de Couleurs, dans l'Oeuvre de Delacroix.* Thèse de Maitrise, University of Paris IV.

Seibold, U. 1987. *Zum Verständnis des Lichts in der Malerei J. M. W. Turners.* PhD diss., Heidelberg University.

Shearman, J. 1957. *Developments in the Use of Colour in Tuscan Painting of the Early 16th Century.* PhD diss., London University.

Shiff, R. 1973. *Impressionist Criticism, Impressionist Color, and Cézanne.* PhD diss., Yale University.

Siebenhühner, H. 1935. *Über den Kolorismus der Fruhrenaissance, vornehmlich dargestellt an dem Trattato della Pittura des L. B. Alberti.* PhD diss., Leipzig.

Thornton, J. A. 1979. *Renaissance Color Theory and some Paintings by Veronese.* PhD diss., University of Pittsburgh.

Watkins, N. 1979. *A History and an Analysis of the Use of Colour in the Work of Matisse.* M. Phil thesis, London University.

Weale, R. A. 1974. *Theories of Light and Colour in Relation to the History of Painting.* PhD diss., London University.

PRINCIPAL PRIMARY SOURCES

Antiquity

Aristotle, *De Audibilibus.*

—. *De Sensu.*

—. *Meteorologica.*

Arnim, J. ab. 1903. *Stoicorum Veterum Fragmenta*, II.

Augustine of Hippo. *The City of God*, XXII, xxiv.

Cleomedes, *Caelestia*, II, i.

Freeman, K. 1966. *Ancilla to the Pre-Socratic Philosophers.*

The Greek Anthology, 1969. ed. W. K. Paton.

Nahm, M. C. 1964. *Selections from Early Greek Philosophy*, 4th ed.

Ovid, *Metamorphoses*, II, 5.

Philoponus, Johannes. 1901. *In Aristotelis Meteorologicorum Librum Primum Commentarium*, ed. M. Hayduck.

Philostratus. *Imagines*, I, 28

Pliny the Elder. *Natural History*

Plotinus. *Enneads*, IV.

Plutarch. *Moralia.*

Pollitt, J. J. 1974. *The Ancient View of Greek Art.*

Pseudo-Aristotle, *De Coloribus.*

—. *De Mundo.*

Ptolemy. 1956. *Optique*, ed. A. Lejeune.

Seneca. *Epistolae*, LXXXI.

—. *Natural Questions*, I, iv, 7.

Solinus, 1958. *Collectanea Rerum Memorabilium*, ed. T. Mommsen, 2nd ed.

Statius, *Silvae*, I, 5.

Stobaeus, Johannes. 1792. *Eclogarum Physicarum et Ethicarum Libri Duo*, I.

Tertullian, 1961. *De Spectaculis*, ed. E. Castorina.

Theophrastus. 1917. *De Sensu*, in G. M. Stratton, *Theophrastus and the Greek Physiological Psychology before Aristotle.*

Vitruvius Pollio. *Ten Books on Architecture.*

The Middle Ages

Abrahams, H. J. 1979. 'A 13th-Century Portuguese Work on MS Illumination', *Ambix*, XXVI.

Albertus Magnus, 1967. *The Book of Minerals*, trans. D. Wyckoff.

Alessandri, L. and F. Penacchi, 1914. 'I piu antichi inventari della Sacristia del Sacro Convento di Assisi (1338-1433)', *Archivum Franciscanum Historicum*, VII.

Alexander of Villa Dei. 1958. *Ecclesiale*, ed. and trans. L. R. Lind.

Alhazen (Ibn al-Haytham). 1989. *The Optics*, ed. and trans. A. I. Sabra.

[Anon.] 1932. *Compositiones ad Tingenda Musiva*, ed. H. Hedfors.

[Anon.] 1974. *Mappae Clavicula*, ed. C. T. Smith and J. G. Hawthorne (Transactions of the American Philosophical Society, LXIV/4).

Anonymus Bernensis. 1932. *De Clarea*, ed. D. V. Thompson, *Technical Studies in the Field of Fine Arts*, III.

—. 1965. *De Clarea*, ed. R. Straub, *Jahresbericht des Schweizerisches Institut für Kunstwissenschaft*, 1964.

Bacon, Roger. 1907. *Opus Maius*, ed. J. H. Bridges.

—. 1983. *Roger Bacon's Philosophy of Nature: a Critical Edition with English Translation, Introducton and Notes of De Multiplicatione Specierum and De Speculis Comburentibus*, ed. D. C. Lindberg.

Baroni, S. 1996. 'I ricettari medievali per la preparazione dei colori e la loro trasmissione', in Istituto Storico Lucchese, *Il Colore nel Medioevo: Arte, Simbolo, Tecnica.*

Bartholomeus Anglicus. 1975. *On the Properties of Things: John of Trevisa's Translation of Bartholomeus Anglicus De Proprietatibus Rerum*, ed. N. Seymour, II.

Bateson, M. (ed.) 1899. *Records of the Borough of Leicester*, I.

Bischoff, B. 1984. *Anecdota Novissima: Texte des Vierten bis Sechzehnten Jahrhunderts.*

Bommarito, D. 1985. 'Il MS 25 della Newbery Library: la tradizione dei ricettarii e trattati sui colori nel medioevo e rinascimento veneto e toscano', *La Bibliofilía*, LXXXVIII.

Brunello, F. 1975. *De Arte Illuminandi e Altri Trattati sulla Tecnica della Miniatura Medievale.*

Caley, E. R. 1927. 'The Stockholm Papyrus', *Journal of Chemical Education*, IV.

Castro, A. 1921. 'Unos aranceles de aduana del siglo XIII', *Revista de Filologia Española*, VIII.

Cennini, Cennino. 1933. *The Craftsman's Handbook*, ed. and trans. D. V. Thompson.

—. 1971. *Il Libro dell'Arte*, ed. F. Brunello.

Coomaraswamy, A. 1935. 'Medieval aesthetic, I. Dionysius the Pseudo-Areopagite and Ulrich of Strasburg', *Art Bulletin*, XVII.

Diehl, E. 1925. *Inscriptiones Latinae Christianae Veteres.*

Digulleville, Guillaume. 1895. *Le Pèlerinage de l'Ame*, ed. J. J. Sturzinger.

Dionysius of Fourna. 1974. *The Painters' Manual*, ed. and trans. P. Hetherington.

Giacosa, P. 1886. 'Un recettario del secolo XI esistente nell'Archivio Capitolare d'Ivrea', *Memorie della Reale Accademia delle Scienze di Torino*, 2ª ser. XXXVII.

Gregory the Great, 1971. *Homiliae in Hiezechihelem Prophetam*, ed. M. Adriaen (Corpus Christianorum Series Latina, CXLII).

Grosseteste, Robert. 1912. *De Iride seu de Iride et Speculo*, ed. L. Bauer (Beiträge zur Geschichte der Philosophie des Mittelalters, IX).

—. 1982. *Hexaemeron*, ed. R. Dales and S. Gieben.

Haskins, C. H. 1960. 'A list of text-books from the close of the 12th century' in *Studies in the History of Medieval Science*, 2nd ed.

Hunt, T. 1995. 'Early Anglo-Norman receipts for colours', *Journal of the Warburg and Courtauld Institutes*, LVIII.

Isidore of Seville. *Etymologiae.*

Lehman-Brockhaus, O. 1938. *Schriftquellen zur Kunst-geschichte des 11 und 12 Jahrhunderts für Deutschland, Lothringen und Italien*, I.

Maier, C. and R. Suntrup, 1987. 'Zum Lexikon der Farbenbedeutungen im Mittelalter. Einführung zu Gegenstand und Methode, sowie Probeartikel aus dem Farbenbereich "Rot"', *Frühmittelalterlichen Studien*, XXI.

Mango, C. 1972. *The Art of the Byzantine Empire.*

Marbode of Rennes. 1977. *De Lapidibus*, ed. B. Riddle.

Menzel, W. 1842. 'Die Mythen des Regenbogens' in *Mythologischen Forschungen und Sammlungen.*

Merrifield, M. (ed.) 1967. *Original Treatises on the Arts of Painting.*

Mesarites, N. 1957. *The Description of the Church of the Holy Apostles at Constantinople*, ed. and trans. G. Downey (Transactions of the

American Philosophical Society, NS, 47/6).

Nequam (Neckham), Alexander. 1863. *De Naturis Rerum*, ed. T. Wright.

—. 1991. *De Nominibus Utensilium* in T. Hunt, *Teaching and Learning Latin in 13th Century England*, I.

Ockham, William of. 1957. *Philosophical Writings*, ed. P. Boehner.

Pecham, J. 1970. *Perspectiva Communis*, ed. and trans. D. C. Lindberg in *John Pecham and the Science of Optics*.

Petzold, A. 1995. 'De coloribus et mixtionibus: the earliest MSS of a Romanesque illuminators' handbook' in L. Brownrigg (ed.), *Making the Medieval Book*.

Photius. 1958. *Homilies*, ed. C. Mango.

—. 1960. *La Bibliothèque*, ed. R. Henry, II.

Pseudo-Dionysius. *Oeuvres Complètes*, ed. M. de Gandillac.

—. 1958. *Hiérarchie Céleste*, ed. R. Rocques.

Rabanus Maurus, *De Universo*, XXI, xxi (Migne, *Patrologia Latina*, CXI, col. 579).

Romano, C. G, 1996. *I Colori e le Arti dei Romani e la Compilazione Pseudo-Eracliana*.

Rose, V. 1875. 'Aristotelis de Lapidibus und Arnoldus Saxo', *Zeitschrift für deutsches Altertum*, 18, N.F.6.

Schlosser, J. von. 1896. *Quellenbuch zur Kunstgeschichte des abendländischen Mittelalters*.

Silva, R. 1978. 'Chimica tecnica e formole dei colori nel manoscritto lucchese 1939 del secolo XIV', *Critica d'Arte*, XLIII, facs.160-2.

Silvestre, H. 1954. 'Le MS Bruxellensis 10147-58 et son Compendium artis picturae', *Bulletin de la Commission Royale d'Histoire*, CXIX.

Suidae Lexicon. 1935. ed. A. Adler.

Theodoric of Freiberg. 1914. *De Iride et Radialibus Impressionibus*, ed. Würschmidt (*Beiträge zur Geschichte der Philosophie des Mittelalters*, XII).

—. 1959. *De Coloribus*, in W. A. Wallace, *The Scientific Methodology of Theodoric of Freiberg*.

Theophilus. 1963. *On Divers Arts*, trans. J. G. Hawthorne and C. S. Smith.

—. 1986. *De Diversis Artibus*, ed. C. R. Dodwell, 2nd ed.

Thomas of Cantimpré. 1973. *Liber de Natura Rerum*, ed. H. Boese.

Thorndyke, L. 1959. 'Medieval texts on colors', *Ambix*, VII.

—. 1960. 'Other texts on colors', *Ambix*, VIII.

Tolaini, F. 1996. 'Proposte per una metodologia di analisi di un ricettario di colori medievali' in Istituto Storico Lucchese, *Il Colore nel Medioevo: Arte, Simbolo, Tecnica*.

Tosatti Soldano, B. 1978. *Miniatura e Vetrate Senesi del Secolo XIII*.

—. 1991. *Il Manoscritto Veneziano*.

Urso of Salerno. 1959, *De Coloribus*, ed. L. Thorndyke, *Ambix*, VII.

—. 1976. *De Commixtionibus Elementorum Libellus*. ed. W. Stürner.

Van Acker, L. (ed.) 1972. *Petrus Pictoris Carmina nec non Petri de Sancto Audemaro Librum de Coloribus Faciendis* (Corpus Christianorum Continuatio Medievalis, XXV).

Vieillard, J. 1963. *Le Guide du Pèlerin de Saint-Jacques de Compostelle*, 3rd ed.

Witelo (1572). 1972. *Perspectiva* in F. Risner (ed.) *Opticae Thesaurus*.

The Fifteenth to Eighteenth Centuries

Adams, G. 1799. *Lectures on Natural and Experimental Philosophy*. 2nd ed.

Alberti, L. B, 1960-1973. *Opere Volgari*, ed. C. Grayson, I, III.

—. 1966. *De Re Aedificatoria*, ed. G. Orlandi and P. Portoghesi.

[Anon.] 1858. *Sul Modo di Tagliare ed Applicare il Musaico*, ed. G. Reali.

Antonio da Pisa.1976. *Il Trattato di Antonio da Pisa sulla Fabbricazione delle Vetrate Artistiche*, ed. S. Pezzella.

Bardwell, T. 1756. *The Practice of Painting Made Easy*.

Barry, J. 1809. *The Works of James Barry*.

Baxandall, M. 1971. *Giotto and the Orators*.

Bellori, G. P. 1976. *Le Vite*, ed. E. Borea.

Bentley, G. E. Jr. 1969. *Blake Records*.

Berkeley, G. 1709. *An Essay Towards a New Theory of Vision*.

Bertonio, Ludovico. 1956. *Vocabulario de la Lengua Aymara*.

Biens, C. P. (1636) 1982. 'De Teecken-Const, een 17de eeuws Nederlands traktaatje', ed. E. A. de Klerk, *Oud Holland*, XCVI.

Birch, T. 1757. *The History of the Royal Society of London*, III.

Biringuccio, Vannoccio (1540). 1977. *De la Pirotechnia*, ed. A. Carrugo.

Blake, William. 1956. *Poetry and Prose*, ed. G. Keynes.

Boyle, Robert (1664). 1964. *Experiments & Considerations touching Colours*, ed. R. B. Hall.

Cappivacius, Hieronymus. 1603. *Tractatus de Urinis* in *Opera Omnia*.

Cardano, Gerolamo, 1554. *De Subtilitate Libri XXI*.

—. 1570. *Opus Novum de Proportionibus*.

—. 1663. *De Gemmis et Coloribus; De Rerum Varietate*, in *Opera*, II, III.

—. 1930. *The Book of My Life*, trans. J. Stoner.

Castel, Louis-Bertrand, 1737. 'J. C. Le Blon, "Coloritto"', *Mémoires de Trévoux*, August 1737.

Cellini, Benvenuto. *Del'Oreficeria*, in *Opere*, ed. P. F. Maier.

Cobo, B. 1956. *Historia del Nuevo Mundo*, in *Obras*, ed. P. F. Mateos, II.

Cortés, Hernán. 1986. *Letters from Mexico*, ed. and trans. A. Pagden.

Courtauld Institute of Art. *Newspaper Cuttings on the Fine Arts*.

Cropper, E. (ed.) 1984. *The Ideal of Painting. Pietro Testa's Düsseldorf Notebook*.

Darwin, R. W. 1974. 'On the ocular spectra of light and colours' (1786) in E. Darwin, *Zoonomia* (1794-6), I.

Descartes, René. 1987. *Discours sur la Méthode*, ed. J.-R. Armogathe et al.

[Digby, Sir Kenelm] 1658. *Two Treatises, in the One of Which, the Nature of Bodies... is Looked Into*. 2nd ed.

Du Fresnoy, C. A. 1852. *The Art of Painting*, trans. W. Mason in H. W. Beechey (ed.), *The Literary Works of Sir Joshua Reynolds*, II.

Eastlake, C. L. 1960. *Materials for a History of Oil Painting*, I.

Euler, L. 1746. *Nova Theoria Lucis et Colorum*.

Even, E. van. 1898. 'Le contrat pour l'éxécution du triptique de Thierry Bouts de la Collégiale Saint-Pierre à Louvain (1464)', *Bulletin de l'Académie des Sciences, des Lettres et des Beaux-Arts de Belgique*, 2e ser., XXXV.

Farington, J. 1978-1984. *Diary*, ed. K. Garlick, A. Macintyre, K. Cave.

Filarete, A. 1965. *Treatise on Architecture*, trans. J. R Spencer.

Fiorilli, C, 1920. 'I dipintori a Firenze nell'Arte dei Medici, Speciali e Merciai', *Archivio Storico Italiano*, LXXVIII, ii.

Forsius, S. A. 1952. *Physica*, ed. J. Nordström, Uppsala Universitets Årsskrift, X.

Gautier d'Agoty, J. 1749. *Chroagenesis, ou Génération des Couleurs, contre le Système de Newton*.

Ghiberti, Lorenzo, 1947. *I Commentari*, ed. O. Morisani.

—. 1988. K. Bergdolt, *Der dritte Kommentar Lorenzo Ghibertis: Naturwissenschaften und Medezin in der Kunsttheorie der Frührenaissance*.

Glasser, H. 1977. *Artists' Contracts in the Early Renaissance*.

Harris, Moses. c. 1776. *The Natural System of Colours*.

Hermens, E. 1995. 'A 17th-century Italian treatise on miniature painting and its author(s)' in A.Wallert, E. Hermens, M. Peek (eds), *Historical Painting Techniques, Materials and Studio Practice*.

Hire, P. de la. 1685. *Dissertations sur les différens Accidens de la Vue*.

Hofmann, W. J. 1971. *Über Dürers Farbe*.

Holguin, D. Gonzales (1608). 1952. *Vocabulario de la Lengua General de Todo el Peru*.

Hübner, J. 1727. *Curieuses Natur- Kunst- Berg- Gewerck und Handlungs-Lexicon*.

Kant, I. 1952. *Critique of Judgement*, trans. J. C. Meredith.

Kepler, J. 1858. *Opera Omnia*, ed. C. Frisch, I.

Le Blon, J. C. (1725). 1985. *Coloritto; or the Harmony of Colouring in Painting* in O. Lilien, *Jacob Christophe Le Blon, 1667-1741. Inventor of Three- and Four-Colour Printing*.

Leonardo da Vinci. 1988. *Leonardo on Painting. An Anthology of Writings by Leonardo da Vinci with a Selection of Documents relating to his Career as an Artist*, ed. M. Kemp and M. Walker.

Lersch, T. 1984. 'Von der Entomologie zur Kunsttheorie', *De Arte et Libris: Festschrift Erasmus, 1934-1984*.

Locke, J. 1700. *An Essay on Human Understanding*, 4th ed.

Malone, E. (ed.). 1797. *The Works of Sir Joshua Reynolds* (2nd ed. 1798).

Mancini, G. 1956. *Considerazioni sulla Pittura*, ed. G. Marucchi.

Mander, K. van. 1973. *Den Grondt der Edel Vry Schilder-Const*, ed. and trans. H. Miedema.

Manzoni, L. 1904. *Statuti e Matricole dell'Arte dei Pittori delle Città di Firenze, Perugia, Siena*.

Martini, Valerio. 1638. *Subtilitatum Proprietatum totius Substantiae quae Occultae Specificaeque sunt Patefacta*.

Miglio, L. 1977-8. 'Tra chimica e colori alla meta del Cinquecento; le ricette del MS 232 della biblioteca della città di Arezzo', *Annali della Scuola Speciale per Archivisti e Bibliotecari dell'Università di Roma*, XVII-XVIII.

Milanesi, G. 1854. *Documenti per la Storia dell'Arte Senese*.

Mocenicus, P. 1581. *Universales Institutiones ad Hominum Perfectionum*.

Molina, A. de (1571). 1970. *Vocabulario en Lengua Castellana y Mexicana, y Mexicana y Castellana*.

Müntz, E. 1888. *Les Collections des Médicis au XV^e Siècle*.

—. and A. L. Frothingham, 1883. *Il Tesoro della Basilica di S. Pietro*.

Nebrija, A. de. 1973. *Vocabulario de Romance en Latin*, ed. G. J. Macdonald.

Neri, A. 1662. *The Art of Glass*, trans. C. Merrett.

Newton, Sir Isaac. 1730. *Opticks*, new ed.

—. 1959. *Correspondence*, ed. H. W. Turnbull, I.

—. 1978. *Papers and Letters on Natural Philosophy*, ed. I. B. Cohen, 2nd ed.

—. 1984. *The Optical Papers*, ed. A. C. Shapiro, I.

Northcote, J. 1813. *Memoirs of Sir Joshua Reynolds*.

—. 1898. *Memorials of an 18th century Painter*, ed. S. Gwynn.

O'Brien, C. 1795. *The British Manufacturer's Companion and Calico Printer's Assistant*.

Opie, J. 1809. *Lectures on Painting*.

Ottonelli, G. D. and P. Berrettini, 1973. *Trattato della Pittura e Scultura: Uso et Abuso Loro*, ed. V. Casale.

Palencia, Alonso Fernandez de. 1967. *Universal Vocabulario en Latin y en Romance*.

Peacham, H. 1634. *The Gentleman's Excercise*, 2nd ed.

Piles, R. de. 1672. *Dialogue sur le Coloris*.

Pizarro, Pedro (1571). 1944. *Relación del Descubrimento y Conquista de los Reinos del Peru*, ed. F. Morales.

Poggi, G. 1909. *Il Duomo di Firenze*.

Porta, G. B. della. 1591. *Phytognomica*.

—. 1593. *De Refractione Optices*.

Priestley, J. 1772. *History and Present State of Discoveries Relating to Vision, Light and Colours*.

Ramée, Pierre de la and Friedrich Reisner, 1606. *Opticae Libri Quattuor*.

Reisch, Gregor. 1504. *Margarita Philosophica*.

Rigaud, S. F. D. 1984. *Facts and Recollections of the XVIII century in a Memoir of John Francis Rigaud, R.A.*, ed. W. Pressly, Walpole Society, L.

Rojas, Fernando de. 1902. *Tragicomedia de Calisto y Nemibea*.

Romero, C. A. (ed.) 1923. 'Razon y Forma en Theoria de los Tintes Reales de Quito (1703)', *Inca*, I.

Sahagún, Fray Bernardino de. 1956. *Historia General de las Cosas de Nueva España*, ed. A. M. Garibay K., I.

—. 1961. *Florentine Codex: General History of the Things of New Spain*, ed. and trans. A. J. O. Anderson and C. E. Dibble, X, XI.

Scarmilionius, G. A. 1601. *De Coloribus*.

Schiffermüller, I. 1771. *Versuch eines Farbensystems*.

Sheldrake, T. 1798 in *Transactions of the Society of Arts*, XVI.

Sulzer, J. G. 1792. *Allgemeine Theorie der Schönen Kunste*.

Taylor, Brook. 1719. *New Principles of Linear Perspective*, 2nd ed.

Telesius, B. 1590. *Liber de Coloribus*, in *Bernardini Telesii Varii Naturalibus*.

Toscanelli, Paolo dal Pozzo. 1964. *Opera di Prospettiva*, in A. Parronchi, *Studi su la Dolce Prospettiva*.

Traversari, Ambrogio. 1968. *Latinae Epistolae*, ed. P. Cannetus and L. Mehus, 2nd ed.

Trutfetter, Jodocus. 1517. *Philosophie Naturalis Summa*.

Turnbull, G. 1740. *A Treatise on Ancient Painting*.

Vandamme, E. 1974. 'Een 16e-eeuws zuid-nederlands recepten boek', *Jaarboek van het Koninklijk Museum voor Schone Kunsten Antwerpen*.

Vasari, G. 1878-1881. *Le Vite*, ed. G. Milanesi.

Veliz, Z. 1986. *Artists' Techniques in Golden Age Spain*.

Vespasiano da Bisticci. 1963. *Renaissance Princes, Popes and Prelates*, ed. M.Gilmore.

Waller, R. 1686. 'A catalogue of simple and mixt colours', *Philosophical Transactions of the Royal Society of London*, XVI.

Wallert, A. 1995. '"Libro Secondo di Diversi Colori e Sise da Mettere a Oro", a 15th century technical treatise on manuscript illumination' in A. Wallert, E. Hermens, M. Peek (eds), *Historical Painting Techniques, Materials and Studio Practice*.

Werner, A. G. 1774. *Von den äusserlichen Kennzeichen der Fossilien*.

Whitley, W. T. 1928. *Artists and their Friends in England*.

—. *Notes on Artists* (The Whitley Papers), British Museum Department of Prints and Drawings.

Wildenstein, G. 1960. 'Jakob Christoffel Le Blon, ou le "secret de Peindre en gravant"', *Gazette des Beaux-Arts*, LVI.

The Nineteenth Century

[Anon.] 1842. 'Cours sur le contraste des couleurs par M. Chevreul', *L'Artiste*, 3^e ser. I.

[Anon.] 1872. 'Painters and the accidents of sight', *The British and Foreign Medico-Chirurgical Review*, 50.

Badt, K. 1981. *Die Farbenlehre Van Goghs*, 2nd. ed.

Bähr, J. K. 1860. *Der Dynamische Kreis*.

—. 1863. *Vorträge über Newtons und Goethes Farbenlehre*.

Binet, A. 1892, 'Le problème de l'Audition Colorée', *Revue des Deux Mondes*, CXIII.

Blanc, C. 1867. *Grammaire des Arts du Dessin*.

—. 1876. *Les Artistes de Mon Temps*. 2nd.ed.

Bracquemond, F. 1885. *Du Dessin et de la Couleur*.

Broude, N. (ed.) 1978. *Seurat in Perspective*.

Brücke, E. 1866. *Physiologie der Farben*.

—. 1878. *Principes Scientifiques des Beaux-Arts*.

Burnet, J. 1822. *Practical hints on Composition in Painting*.

Cassagne, A. 1875. *Traité d'Aquarelle*.

Chevreul, M.-E. 1828. 'Mémoire sur l'influence que deux couleurs peuvent avoir l'une sur l'autre quand on les voit simultanément', *Mémoires de l'Académie des Sciences*, XI.

—. 1839. *Les Lois du Contraste Simultané des Couleurs* (2nd ed. 1889).

—. 1854. *The Principles of Harmony and Contrast of Colours*, trans. C. Martel.

—. 1866. 'Des arts qui parlent aux yeux', *Journal des Savants*.

—. 1879. 'Complément des études sur la vision des couleurs', *Mémoires de l'Académie des Sciences*, XLI.

[Chevreul]. 1834. *Le Magasin Pittoresque*, II.

Christophe, J. 1976. 'Dubois-Pillet' in J. Bazalgette, *Dubois-Pillet, sa Vie et son Oeuvre*.

[Miss Cleaver] 1815. *An Account of a New Process in Painting by Means of Glazed Crayons; with Remarks on its General Correspondence with the Peculiarities of the Venetian School*. (Brighton. 2nd ed. London 1821).

Clerget, C. E. 1844. 'Lettres sur la théorie des couleurs', *Bulletin de l'Ami des Arts*, II.

Cohn, J. 1894. 'Experimentelle Untersuchungen über die Gefühlsbetonung der Farbhelligkeiten und ihre Combinationen', *Philosophische Studien*, X.

Cooper, T. S. 1890. *My Life*.

Corot, J.-B.-C. 1946. *Corot Raconté par Lui-même*.

Darwin, Charles. 1985. *Correspondence*, ed. F. Burkhardt and S. Smith, I.

—. 1990. *Marginalia*, ed. M. A. di Gregorio.

Delaborde, H. 1984. *Notes et Pensées de J.-A.-D. Ingres*.

Delf, T. ('Charles Martel') 1855. *The Principles of Colour in Painting*.

Dorra, H. and J. Rewald, 1959. *Seurat*.

Dulon, G. and C. Duvivier, 1991. *Louis Hayet, 1864-1940, Peintre et Théoricien du Néo-Impressionisme*.

Fechner, G. T. 1897-1898. *Vorschule der Aesthetik*, 2nd ed.

—. 1966. *Elements of Psychophysics*, trans. H. E. Adler.

Fénéon, F. 1970. *Oeuvres plus que Complètes*, ed. J. U. Halperin.

Féré, C. 1887. *Sensation et Mouvement*.

Field, G. 1845. *Chromatics*, 2nd ed.

—. 1841. *Chromatography*, 2nd ed.

—. 1850. *Rudiments of the Painter's art; or, a Grammar of Colouring*.

Fletcher, E. 1901. *Conversations of James Northcote with James Ward*.

Forbes, J. D. 1849. 'Hints towards a classification of colours', *Philosophical Magazine*, 3rd ser. XXXIV.

Gage, J. 1969. *Colour in Turner: Poetry and Truth*.

—. 1984. 'Turner's annotated books: Goethe's *Theory of Colours*', *Turner Studies*, IV/2.

Galt, J. 1820. *The Life and Studies of Benjamin West*.

Galton, F. 1907. *Inquiries into Human Faculty and its Development*.

Garnier, J. 1869. *A Travers les Arts*.

Ghil, R. 1978. *Traité du Verbe*, ed. T. Goruppi.

Goethe, J. W. von, 1833. *Briefwechsel zwischen Goethe und Zelter*, ed. F. W. Riemer.

—. 1898. *Goethe und die Romantik*, ed. C. Schüddekopf and O. Walzel (*Schriften der Goethe-Gesellschaft*, XIII).

—. 1951- . *Die Schriften zur Naturwissenschaft*, ed. D. Kuhn, R. Matthaei, W. Troll, K. L. Wolf, I, vi; II, vi.

—. 1964. *Beiträge zur Optik* (facs.).

—. 1970. *The Theory of Colours*, trans. C. L. Eastlake, intro. D. Judd.

Goncourt, E. de. 1895. 'Hokusai: les albums traitant de la peinture et du dessin avec ses préfaces', *Gazette des Beaux-Arts*, 3ᵉ per. XIV, XXXVI.

—. and J. de, *Journal*.

Grandi, S. 1806 in *Transactions of the Society of Arts*, XXIV.

Grävell, F. 1857. *Goethe im Recht gegen Newton*.

Grimm, W. and J. 1963. *Briefwechsel zwischen Jacob und Wilhelm Grimm*, ed. H. Grimm and G. Hinrichs.

Guéroult, G. 1882. 'Formes, Couleurs, Mouvements', *Gazette des Beaux-Arts*, 2ᵉ per. XXV.

Guichard, E. 1882. *Grammar of Colour*.

Guillemin, A. 1874. *La Lumière et les Couleurs*.

Hauke, C. de and P. Brame, 1961. *Seurat et son Oeuvre*.

Hay, D. R. 1844. *The Laws of Harmonious Colouring adapted to Interior Decoration, Manufactures and other Useful Purposes*, 5th ed.

Haydon, B. R. 1927. *Autobiography*, ed. A. P. D. Penrose.

—. 1960- . *Diary*, ed. W. B. Pope.

Hayter, C. 1813. *An Introduction to Perspective adapted to the Capacities of Youth*.

Helmholtz, H. von. 1852-3. 'Sur la théorie des couleurs composées', *Cosmos*, II.

—. 1871. 'L'Optique et la peinture' in E. Brücke, 1878.

Henry, C. 1885. *Introduction à une ésthetique scientifique*.

Herbert, R. *et al.* 1991. *Seurat, 1859-1891*.

Herder, J. G. 1955. *Kalligone*, ed. H. Begenau.

Hering, E. 1878. *Zur Lehre vom Lichtsinne*.

Hunt, R. 1844. *Researches on Light in its Chemical Relations*.

Huysmans, J. K. 1889. 'Turner et Goya', *Certains*.

Klein, A. B. 1937. *Coloured Light: an Art Medium*.

Kuhn, A. 1921. *Peter Cornelius und die geistgen Strömungen seiner Zeit*.

Landgrebe, D. G. 1834. *Ueber die chemischen und physiologischen Wirkungen des Lichts*.

Larmor, J. (ed.) 1907. *Memoir and Scientific Correspondence of the late Sir George Gabriel Stokes, Bt.*

Laugel, A. 1869. *L'Optique et les Arts*.

Lehr, F. H. 1924. *Die Blütezeit romantischer Bildkunst: Franz Pforr, der Meister des Lukasbundes*.

Liebreich, R. 1872. 'Turner and Mulready – on the effect of certain faults of vision on painting', *Notices of the Proceedings of the Royal Institution*, VI.

Lüdicke, M. A. F. 1800. 'Beschreibung eines kleinen Schwungrades, die Verwandlung der Regenbogen – Farben in Weiss darzustellen', *Gilberts Annalen der Physik*, V.

—. 1810. 'Versuche über die Mischung prismatischer Farben', *Gilberts Annalen der Physik*, XXXIV.

Mérimée, J. F. L. 1981. *De la Peinture à l'huile*.

Millais, J. G. 1899. *Life and Letters of Sir J. E. Millais*.

Nochlin, L. 1966. *Impressionism and Post-Impressionism, 1874-1904* (Sources and Documents).

Novalis (Friedrich von Hardenberg). 1960-75. *Schriften*, ed. P. Kluckhohn and R. Samuel.

Oken, L. 1847. *Physiophilosophy*.

Owen, R. S. 1894. *The Life of Richard Owen*.

Pearson, K. 1914-30. *The Life, Letters and Labours of Francis Galton*, II.

Piron, A. 1865. *Delacroix: sa Vie et ses Oeuvres*.

Pissarro, C. 1986-1988. *Correspondance*, ed. J. Bailly-Herzberg, II, III.

Pissarro, L. 1993. *The Letters of Lucien to Camille Pissarro, 1883-1903*, ed. A. Thorold.

Previati, G. 1929. *Principi Scientifici del Divisionismo*, 2nd. ed.

Purkinje, J. E. 1918. *Beobachtungen und Versuche zur Physiologie der Sinne*, II (1825) in *Opera Omnia*, I.

'R'. 1979. 'Notice sur J. M. W. Turner', *L'Artiste*, XII, 1836, repr. by G. Finley, *Burlington Magazine*, CXXI.

Ratliff, F. 1990. *Paul Signac and Color in Neo-Impressionism*.

Redgrave, R. 1884. *A Manual of Colour, with a Catechism*.

Rewald, J. 1949. 'Extraits du journal inédit de Paul Signac', *Gazette des Beaux-Arts*, XXXVI.

Rey, R. 1931. *La Renaissance du Sentiment Classique*.

Reynes, G. 1981. 'Chevreul interviewé par Nadar (1886)', *Gazette des Beaux-Arts*, XCVIII.

Richter, Jean-Paul, 1927. *Sämtliche Werke*, ed. E. Berend, I.

Rimbaud, A. 1966. *Complete Works*, ed. and trans. W. Fowlie.

Rochas, A. de. 1885. 'L'Audition colorée', *La Nature*, 1885/2.

Rood, O. 1879. *Modern Chromatics*.

Runge, P. O. 1940. *Philipp Otto Runges Briefwechsel mit Goethe*, ed. H. von Maltzahn (Schriften der Goethe-Gesellschaft, LI).

—. 1965. *Hinterlassene Schriften*, I.

—. 1977. *Farben-Kugel*, ed. H. Matile.

Sand, George. 1896. *Impressions et Souvenirs*, 2nd ed.

Sandby, W. 1862. *History of the Royal Academy of Arts*.

Schadow, W. 1828. 'Meine Gedanken über eine folgerichtige Ausbildung des Malers', *Berliner Kunstblatt*, I.

Schrader, J. 1969. *Sinne und Sinnesverknüpfungen: Studien und Materialien zur Vorgeschichte der Synästhesie*.

Signac, P. 1978. *De Delacroix au Néo-Impressionisme*, ed. F. Cachin, 2nd ed.

—. 1990. See Ratliff.

Silvestre, T. 1926. *Les Artistes Français*.

Sprengel, C. K. 1894. *Das entdeckte Geheimniss der Natur*, ed. P. Knuth.

Steffens, H. 1841. *Was Ich Erlebte*.

Suarez de Mendoza, F. 1890. *L'Audition Colorée. Étude sur les fausses Sensations Secondaires Physiologiques et Particulièrement sur les Pseudo-Sensations de Couleurs associés aux Perceptions Objectives des Sons*.

Sutter, D. 1880. 'Les phenomènes de la vision', *L'Art*, XX.

Syme, P. 1821. *Werner's Nomenclature of Colours, adapted to Zoology, Botany, Chemistry, Mineralogy, Anatomy and the Arts*, 2nd ed.

Thorold, A. 1980. *Artists, Writers, Politics: Camille Pissarro and his Friends*. Oxford, Ashmolean Museum.

Tornitore, T. 1988. *Scambi di Sensi: Preistorie delle Sinestesie*.

Twining, H. 1849. *The Philosophy of Painting*.

Van Gogh, Vincent. 1958. *Complete Letters*.

Véron, E. 1879. *Aesthetics*.

Vibert, J.-G. 1981. *La Science de la Peinture*.

Wackenroder, W. H. 1967. *Werke und Briefe*, ed. E. von der Leyen.

Wundt, W. 1902. *Grundzüge der physiologischen Psychologie*, 5th ed., II.

Ziegler, J. 1850. *Études Céramiques*.

—. 1852. *Traité de la Couleur et de la Lumière*.

The Twentieth Century

Albers, J. 1963. *Interaction of Color*.

Allesch, G. J. von. 1925. 'Die aesthetische Erscheinungsweise der Farben', *Psychologische Forschung*, VI.

Anderson, M. 1979. *Colour Healing: Chromotherapy and How it Works*.

Baljeu, J. 1974. *Theo van Doesburg*.

Berenson, B. 1965. *Selected Letters*, ed. A. K. McComb.

Besant, A. 1896-7. 'Thought-Forms', *Lucifer, a Theosophical Monthly*, XIX

—. and C. W. Leadbeater, 1961. *Thought-Forms*.

Brass, A. 1906. *Untersuchungen über das Licht und die Farben*, I Teil.

Brown, T. 1958. *The Work of Gerrit Rietfeld, Architect*.

Chlebnikov, V. 1972. *Werke*, trans. P. Urban, II.

Cytowic, R. E. 1994. *The Man who tasted Shapes*.

Delaunay, R. 1957. *Du Cubisme à l'Art Abstrait*, ed. P. Francastel.

—. and S. 1978. *The New Art of Color*, ed. A. Cohen.

Doesburg, T. van. 1969. *Principles of Neo-Plastic Art*

—. 1979. *Scritti di Arte e di Architettura*, ed. S. Polano.

—. 1983. *Grondbegrippen van de Nieuwe Beeldende Kunst*, ed. S. V. Barbieri, C. Boekrad, J. Leering.

Downey, E. 1929. *Creative Imagination: Studies in the Psychology of Literature*.

Escholier, R. 1960. *Matisse from the Life*.

Fedorov, N. T. 1978. *In Casabella*, No. 435, April 1978.

Fiori, T. (ed.) 1968. *Archivi del Divisionismo*.

Fletcher, E. A. 1910. *The Law of the Rhythmic Breath*.

Friedländer, S. 1916. 'Nochmals polarität', *Der Sturm*, VI.

—. 1917-18. 'Das prisma und Goethes Farbenlehre', *Der Sturm*, VIII.

Gérome-Maësse, 1907. L'Audition colorée, *Les Tendances Nouvelles*.

Gimpel, R. 1963. *Journal d'un Collectionneur*.

Giraudy, D. 1971. 'Correspondance Henri Matisse-Charles Camoin', *Revue de l'Art*, 12.

Hahl-Koch, J. (ed.) 1984. *Arnold Schoenberg-Wassily Kandinsky: Letters, Pictures and Documents*.

Harms, E. 1963. 'My association with Kandinsky', *American Artist*, XXVII.

Heimendahl, E. 1961. *Licht und Farbe: Ordnung und Funktion der Farbwelt*.

Herzogenrath, W. and P. Liska (eds), 1987. *Arthur Segal, 1875-1944*.

Hess, W. 1981. *Das Problem der Farbe in den Selbst-Zeugnissen der Maler von Cézanne bis Mondrian*, 2nd ed.

Hofmann, H. 1967. *The Search for the Real*, 2nd ed.

Huszár, V. 1917. 'Iets over die Farbenfibel van W. Ostwald', *De Stijl*, I.

Jakobson, R. 1968. *Child Language, Aphasia and Phonological Universals*.

—. and M. Halle. 1975. *Fundamentals of Language*, 2nd ed.

Kandinsky, W. 1975. *Écrits*, ed. P. Sers, III.

—. 1980. *Die Gesammelte Schriften*, ed. H. Roethel and J. Hahl-Koch.

—. 1982. *Complete Writings on Art*, ed. K. Lindsay and P. Vergo.

—. and F. Marc, 1979. *The Blue Rider Almanac*, ed. K. Lankheit, 3rd ed.

Keller, H. G. and J. J. R. MacLeod, 1913. 'The application of the physiology of color vision in modern art', *Popular Science Monthly*, LXXXIII.

Klee, P. 1973. *The Nature of Nature*, ed. J. Spiller.

—. 1974. *Beiträge zur bildnerische Formlehre*, ed. J. Glaesemer.

—. 1976. *Schriften, Rezensionen und Aufsätze*, ed. C. Geelhaar.

Klyun, I. 1976. 'The art of colour' in J. E. Bowlt (ed. and trans), *Russian Art of the Avant-Garde: Theory and Criticism, 1902-1934*.

Knight, V. 1988. *Patrick Heron*.

Kupka, F. 1989. *La Création dans les Arts Plastiques*, ed. E. Abrams.

Le Bon, G. 1907. *L'Évolution des Forces*.

Leck, B. van der. 1976. 'The place of modern painting in architecture' (1917) in P. Hefting and A. van der Woud (eds), *Bart van der Leck, 1876-1958*.

Lüscher, M. 1949. *Psychologie der Farben*.

—. 1971. *The Lüscher Colour Test*, ed. and trans. I. Scott.

Macke, W. (ed.) 1964. *August Macke – Franz Marc Briefwechsel*.

Maerz, A. and M. R. Paul, 1950. *A Dictionary of Color*, 2nd ed.

Mahling, F. 1926. 'Das Problem der "audition colorée"', *Archiv für die gesamte Psychologie*, LVII.

Malevich, K. 1962. *Suprematismus: die gegenstandlose Welt*, ed. W. Haftman.

—. 1969-78. *Essays on Art*, ed. and trans. T. Andersen.

—. 1981. *La Lumière et la Couleur*, ed. J. Marcade.

—. 1986. *Écrits*, ed. A. Nakov.

Marc, F. 1978. *Schriften*, ed. K. Lankheit.

—. and W. Kandinsky, 1979. See Kandinsky.

Masson, A. 1974. 'Conversations avec Matisse', *Critique*, XXX.

Matisse, H. 1972. *Écrits et Propos sur L'Art*, ed. D. Fourcade.

—. 1973. *Matisse on Art*, ed. J. Flam.

—. 1976. 'Autres Propos', ed. D. Fourcade, *Macula*, I.

Mondrian, P. 1986. *The New Art – The New Life: The Collected Writings*, ed. H. Holzmann and M. James.

—. 1969. *See* Welsh, R. P. and J. Joosten.

Moreau-Vauthier, C. 1923. *Comment on Peint Aujourd'hui*.

Müller-Freienfels, R. 1907. 'Zur Theorie der Gefühlstone der Farbenempfindungen', *Zeitschrift für Psychologie*, 46.

Nicholson, W. 1987. *Unknown Colour: Paintings, Letters, Writings*.

Perry, I. C. 1927. 'Reminiscences of Claude Monet from 1889-1909', *American Magazine of Art*, XVIII.

Reichard, G. A., R. Jacobson, E. Werth, 1949. 'Language and Synaesthesia', *Word*, V.

Rose, B. (ed.) 1975. *Art as Art: the Selected Writings of Ad Reinhardt*.

Rotzler, W. 1978. *Johannes Itten: Werke und Schriften*, 2nd ed.

Sacks, O. 1995. 'The case of the colour-blind painter' in *An Anthropologist on Mars*.

Scheffler, K. 1901. 'Notizen über die Farbe', *Dekorative Kunst*, IV.

Schmidt, D. 1964. *Manifeste 1905-33*.

Schwitters, K. 1973. *Das Literarische Werk*, I.

Scott, C. *c.*1916. *The Philosophy of Modernism (And its Connection with Music)*

Segal, A. and N. Braun, 1925. *Lichtprobleme der bildenden Kunst*.

Sérusier, P. 1950. *ABC de la Peinture*, 2nd ed.

Stefănescu-Goangă, F. 1912. 'Experimentelle Untersuchungen zur Gefühlsbetonung der Farben', *Psychologische Studien*, VII.

Tschudi, Hugo von. 1912. *Gesammelte Schriften zur Neueren Kunst*, ed. E. Schwedeler-Meyer.

Vantongerloo, G. 1924. *L'Art et son Avenir*.

Venzmer, W. 1982. *Adolf Hoelzel: Leben und Werk*.

Welsh, R. P. and J. Joosten, 1969. *Two Mondrian Sketchbooks, 1912-14*.

Wingler, H. M. 1976. *The Bauhaus*, 3rd ed.

Wittgenstein, L. 1978. *Remarks on Colour*.

List of Illustrations

Measurements are given in centimetres and inches, height preceding width

Frontispiece: The German illuminator Brother Rufillus, self-portrait painting the letter 'R' from a shell. From a *Passionale* from Weissenau Abbey, *c.* 1170–1200. Bibliotheca Bodmeriana, Geneva, Cod. Bodm. 127. f. 244.

1 Johannes Itten, *Colour-sphere*, 1921. From B. Adler (ed.), *Utopia - Dokuments der Wirklichkeit*, Weimar 1921 (© DACS 1998).

2 Rembrandt van Rijn, *Self-portrait holding his Palette, Brushes and Maulstick*, *c.* 1663. Oil on canvas 114 x 97 (45 x 38). Kenwood House, London, courtesy The Trustees of the Iveagh Bequest.

3 Henri Matisse, *The Snail*, 1952. Gouache on paper 286.4 x 287.9 (112¾ x 113). Tate Gallery, London (© Succession H. Matisse/DACS 1998).

4 Charles Hayter, 'Painter's Compass'. From Hayter, *An Introduction to Perspective*, London 1813.

5 A. Maerz and M. R. Paul, 'Blue'. From *A Dictionary of Color*, 3rd ed. New York 1953.

6 Ignaz Schiffermüller, *The Bright Colours*, coloured engraving, Schiffermüller, *Versuch eines Farbensystems* (Essay on a System of Colours), Vienna 1771.

7 Patrick Syme, 'Blues'. From Syme, *Nomenclature of Colours*, Edinburgh 1821.

8 Winifred Nicholson, *Colour Chart*, 1944, From Nicholson, *Unknown Colour: Paintings, Letters and Writings of Winifred Nicholson*, London 1987 (© Trustees of Winifred Nicholson).

9 Winifred Nicholson, *Starlight and Lamplight*, 1937. Oil on canvas 76.2 x 88.9 (30 x 35). Tate Gallery, London (© Trustees of Winifred Nicholson).

10, 11 Edouard Manet, *A Bar at the Folies-Bergère*, 1881–2. Oil on canvas 96 x 130 (37¾ x 51⅛). The Courtauld Institute Galleries, London.

12 Aribert, Crucifixion book-cover, 11th century. Enamel 42.6 x 33.9 (16¾ x 13⅜), Cathedral Treasury, Milan. Photo Scala.

13 Red and white discs to illustrate the complementary colour (after-image) of red.

14 Paul Klee, *Crystal Gradation*, 1921. Watercolour on paper mounted on card-board 24.5 x 31.5 (9⅝ x 12⅜).Offentliche Kunstsammlung, Basel. Photo Martin Bühler (© DACS 1998).

15 King David window, Augsburg Cathedral, *c.* 1135. Photo AKG, London/Erich Lessing.

16 Jan van Eyck, the Virgin, the Ghent Altarpiece, 1432 (detail). Oil on panel 350 x 461 (11'5¾ x 15'1½). Cathedral of Saint Bavo, Ghent. Photo AKG, London.

17 Dieric Bouts, Altarpiece of the *Last Supper*, 1464–8. Oil on panel, central panel 182.9 x 152.7 (72 x 60⅛). Church of St Pierre, Louvain (Leuven). Photo Stedelijke Musea, Leuven.

18 Jean-François Millet, *The Gleaners*, 1857. Oil on canvas 83.8 x 111.8 (33 x 44). Musée du Louvre, Paris.

19 Andrej Rublev, *The Trinity*, 1411. Tempera on panel 144 x 142 (56¾ x 55⅞). Tretyakov Gallery, Moscow. Photo AKG, London.

20 Edouard Manet, *The Balcony*, 1868–9. Oil on canvas 169 x 125 (66½ x 49¼). Musée d'Orsay, Paris.

21 *The Transfiguration*, mosaic, *c.* 1100. Church of Daphni. Photo Josephine Powell.

22 *Moses receiving the Law*, mosaic, *c.* 560, Monastery of St Catherine, Sinai.

23-4 *Crucifixion* scene, mosaic, *c.* 1180. Church of Daphni.

25-6 *The Covenant of Noah*, mosaic, *c.* 1180-90. Monreale Cathedral. Photo Alinari.

27-8 Georges Seurat, *A Sunday Afternoon on the Island of La Grande Jatte*, 1884-86 (details of divisionist technique). The Art Institute of Chicago. Helen Birch Bartlett Memorial Collection.

29 Georges Seurat, *Les Poseuses*, 1886-7. Oil on canvas 200.6 x 250.8 (79 x 98¾). The Barnes Foundation, Merion.

30-1 Tomaso da Modena, Cardinals Hugh de St Cher and Nicholas de Fréauville, *c.* 1352. Frescoes, Chapter House, S. Nicolò, Treviso. Photo Orio Frassetto Fotografo, Treviso.

32-3 Willem Key, *Portrait of an Illuminator*, 1565. Oil on panel. National Museum of Fine Arts, Valletta.

34 Painting from a palette, detail of the letter 'P'. From a French Bible of *c.* 1300. Rheims, Biblio. Municipale MS 40, f. 83v.

35 James Le Palmer, painting the letter 'C'. From *Omne Bonum*, 14th century. British Library, London. MS Royal 6E.VI f. 329r.

36 Brother Rufillus, self-portrait painting the letter 'R' from a shell. From a *Passionale* from Weissenau Abbey, *c.* 1170–1200. Bibliotheca Bodmeriana, Geneva, Cod. Bodm. 127, f. 244.

37 Cast of Antique cornelian carved with *Apollo and Marsyas*, with a setting, first half of sixteenth century, by Lorenzo Ghiberti. Staatliche Museen, Berlin. Photo BPK.

38-9 Antique cornelian carved with *Rape of the Palladium*. Museo Nazionale, Naples. Photos DAI, Rome.

40 Inca poncho woven with black-and-white chequerboard motif, 1476–1534. Courtesy of the Museum of Fine Arts, Boston. William Francis Warden Fund.

41 Aztec cosmic map, *Codex Féjérvary Mayer*, p. 1. Courtesy The Board of Trustees of the National Museums and Galleries on Merseyside.

42 Antonio da Pisa?, after a design by Lorenzo Ghiberti, St Barnabas window, 1441, Florence Cathedral.

43 Mixtec mask, inlaid with jadeite and turquoise mosaic. Museo Nazionale Preistorico e Etnografico, Rome. Photo Scala.

44 Inca royal tunic, Late Horizon. Tapestry weave 91 x 76.5 (35⅞ x 30⅛). Dumbarton Oaks Research Library and Collections, Washington DC.

45 Giuseppe Arcimboldo, *Earth*, *c.* 1570. Oil

on panel 70.2 x 48.7 (27⅝ x 19⅛). Private collection.

46 Claude Boutet, artist's colour-circle. From Boutet, *Traité de la Peinture en Mignature*, The Hague 1708.

47 František Kupka, *Discs of Newton*, 1912. Oil on canvas 100.3 x 73.7 (39½ x 29). Philadelphia Museum of Art, The Louise and Walter Arensberg Collection (© ADAGP, Paris and DACS, London 1998).

48 William Blake, illustration to Young's *Night Thoughts*, VIII, 1797. Pen and grey ink with grey wash and watercolour 42 x 23.2 (16½ x 9⅛). Copyright British Museum, London.

49 John Everett Millais, *The Blind Girl*, 1856. Oil on canvas 82.6 x 62.2 (32½ x 24½). City Museums and Art Gallery, Birmingham.

50 Theodoric of Freiberg, *Refraction-diagram*, c. 1304, from *De Iride* (after Würschmidt).

51 Robert Grosseteste, *Scutum Fidei*, before 1231. Copyright of the Dean and Chapter of Durham. MS A III.12, f. 14v.

52 Giovanni Battista della Porta, prismatic diagram. From Della Porta, *De Refractione*, 1593.

53 René Descartes, prism-diagram, 1637. From Descartes, *Opera Philosophica*, 1656. By permission of the Syndics of Cambridge University Library.

54 Thomas Harriot, crystal triangular prism, c. 1610. By permission of The British Library, London. Add. MS 6789, f. 148.

55 Sir Isaac Newton, *Experimentum crucis*, 1666-72. By permission of the Syndics of Cambridge University Library. MSS Add. 4002, f. 128a.

56 After Carlo Maratta, *The Academy of Design*, engraving 1677/83. Ashmolean Museum, Oxford.

57 After Nicholas Poussin, *Self-portrait*, 1649. Jean Pesne, engraving, 17th-century.

58 Sir Isaac Newton, colour-circle. From Newton, *Opticks*, Book I, Part ii, London 1704.

59 Moses Harris, prismatic circle. From *The Natural System of Colours*, c. 1776. T. Phillips, *Lectures on the History and Principles of Painting*, London 1833.

60 Sir Isaac Newton, *Spectrum and Musical Scale*, 1670s. From T. Birch, *The History of the Royal Society of London*, III, London 1757.

61 Sir Isaac Newton, *Colours of Thin Plates* ('Newton's Rings'). From Newton, *Opticks*, Book I, Part ii, London 1704.

62 František Kupka, *Newton's. Wheel*, version of Newton's colour-circle, c. 1910. From Kupka, *Tvoření V Umění Výtvarném* (*Creation in the Plastic Arts*), Prague 1923 (© ADAGP, Paris and DACS, London 1998).

63 William Blake after Michelangelo, *Abias*, 1770s. Pen and grey ink, grey wash on paper 24.4 x 174 (9⅝ x 6⅝). Copyright British Museum, London.

64 William Blake, *Newton*, c. 1795. Watercolour 46 x 60 (18⅛ x 23⅝). Tate Gallery, London.

65 Henry Fuseli, *Twelfth Night*, 1777. Pen and brown ink with grey wash over graphite on paper 35.5 x 20.8 (14 x 8¼). Copyright British Museum, London.

66 Giorgio Ghisi after Michelangelo, *The Persian Sibyl*. Engraving, sixteenth century. 56.8 x 43 (22⅜ x 17).

67 Sir Isaac Newton, refraction through a prism. From Newton, *Opticks*, Book I, Part ii, London 1704.

68 After George Romney, *Newton and the Prism*, 1803-4. From William Hayley, *Life of George Romney*, 1809. By permission of the Syndics of Cambridge University Library.

69 James Basire after William Blake, vignette of *The End of the Deluge*, 1774. From Jacob Bryant, *A New System...of Ancient Mythology*, III, 1774.

70 Benjamin West, *Venus Comforting Cupid (Cupid stung by a Bee)*, c. 1796-1802. Oil on canvas 76.8 x 65.7 (30¼ x 25⅞). The Nelson-Atkins Museum of Art, Kansas City, Missouri (Purchase: Nelson Trust).

71-5 James Gillray, *Titianus Redivivus; or The Seven Wise-Men consulting the new Venetian Oracle*, 1797. Etching and watercolour 54.5 x 41 (21½ x 16⅛). Copyright British Museum, London.

76 J. M. W. Turner, *Shade and Darkness: the Evening of the Deluge*, 1843. Oil on canvas 78.7 x 78.1 (31 x 30¾). Tate Gallery, London.

77 J. M. W. Turner, *Light and Colour (Goethe's Theory): the Morning after the Deluge – Moses writing the Book of Genesis*, 1843. Oil on canvas 78.7 x 78.7 (31 x 31). Tate Gallery, London.

78 J. W. von Goethe, frontispiece to *Die Farbenlehre*, Tübingen 1810.

79 Philipp Otto Runge, *Colour-Sphere (Farben-Kugel)*. From Runge, *Die Farben-Kugel*, Hamburg 1810.

80 J. M. W. Turner, *Landscape with a River and a Bay in the Distance*, c. 1845. Oil on canvas 94 x 124 (37 x 49). Musée du Louvre, Paris.

81 J. M. W. Turner, Colour-circle No. 2, c. 1825. Watercolour 54 x 74.3 (21¼ x 29¼). Tate Gallery, London, The Turner Collection.

82 J. M. W. Turner, *Rouen Cathedral*, c. 1832. Gouache on paper 14 x 19.4 (5½ x 7⅝). Tate Gallery, London.

83 Claude Monet, *Rouen Cathedral*, 1892-4. Oil on canvas 99.7 x 65.7 (39¼ x 25⅞). The Metropolitan Museum of Art, New York. Bequest of Theodore M. Davis, 1915.

84 Philipp Otto Runge, *The Small 'Morning'*, 1808. Oil on canvas 109 x 88.5 (42⅞ x 34⅞). Hamburg, Kunsthalle.

85 Franz Pforr, *Sulamith and Maria*, 1811. Oil on wood 34.5 x 32 (13½ x 12⅝). Private collection.

86 Franz Marc, *Blue Horse I*, 1911. Oil on canvas 112 x 84.5 (44 x 33¼). Städtische Galerie im Lenbachhau, Munich. Bernhard Koehler-Stiftung.

87 Franz Marc, *The White Dog*, 1910-11. Oil on canvas 62.5 x 105 (24⅝ x 41⅜). Städelscher Museumsverein e V. Frankfurt.

88 Wassily Kandinksy, *Yellow-Red-Blue*, 1925. Oil on canvas 128 x 210.5 (50⅜ x 82⅞). Musée National d'Art Moderne, Paris.

89 Arthur Segal, *Fisherman's House on Sylt I*, 1926. Oil on canvas 142.5 x 133 (56 x 52⅜). Musée Petit Palais, Geneva.

90 Philipp Otto Runge, *Ideal and Real Colours*, c. 1809. From Runge, *Hinterlassene Schriften*, Hamburg 1840.

91 Friedrich Overbeck, *Italia and Germania*, 1828. Oil on canvas 94.4 x 104.7 (37⅛ x 41¼). Neue Pinakothek, Munich.

92 Wassily Kandinsky, Table I. From Kandinsky, *On the Spiritual in Art*, 1911-12. (Engl. trans ed. K. Lindsay and P. Vergo, New York 1982). (© ADAGP, Paris and DACS, London 1998).

93 Horace Vernet, sketch of M.-E. Chevreul, c. 1850. Bibliothèque de l'Institut de France, Paris. Photo Jean-Loup Charmet.

94 Horace Vernet, *The Battle of Hanau*, 1824 (detail). Oil on canvas 174 x 289.8 (68½ x 113¾). National Gallery, London. Reproduced by courtesy of the Trustees.

Index

Figures in *italics* refer to plate caption numbers